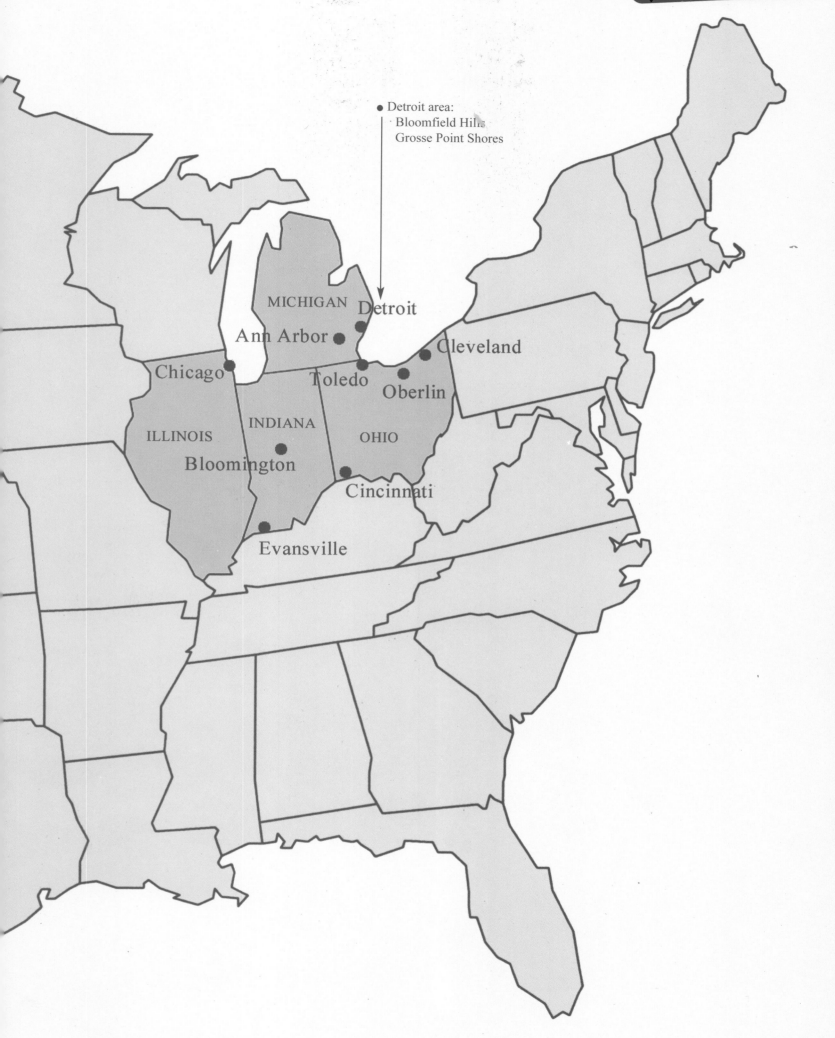

Detroit area:
Bloomfield Hills
Grosse Point Shores

MICHIGAN Detroit

Ann Arbor

Chicago Cleveland

Toledo

Oberlin

ILLINOIS INDIANA OHIO

Bloomington

Cincinnati

Evansville

CORPUS VITREARUM
UNITED STATES OF AMERICA

STAINED GLASS
BEFORE 1700
IN THE COLLECTIONS
OF THE MIDWEST
STATES

CATALOGUES TO BE PUBLISHED IN THE SERIES
CORPUS VITREARUM — USA

CORPUS VITREARUM
UNITED STATES OF AMERICA
PART VIII

STAINED GLASS
BEFORE 1700
IN THE COLLECTIONS
OF THE MIDWEST
STATES

Virginia Chieffo Raguin · Helen Jackson Zakin
WITH CONTRIBUTIONS FROM
Elizabeth Carson Pastan

VOLUME ONE
ILLINOIS · INDIANA · MICHIGAN

HARVEY MILLER PUBLISHERS
for CORPUS VITREARUM INC

HARVEY MILLER PUBLISHERS
An Imprint of Brepols Publishers
London / Turnhout

British Library Cataloguing in Publication Data
A catalogue record for this book
is available from the British Library

ISBN 1 872501 00 1

© 2001 American Corpus Vitrearum, Inc.

The Corpus Vitrearum is published
under the auspices of the
Union Académique Internationale

Composition and design Pardoe Blacker Ltd, Lingfield, Surrey
Color origination by Neue Schwitter AG, Basle, Switzerland
Printed and bound by Graphiche Milani, Milan, Italy

Preface

WE ARE PLEASED to introduce the first volume to be published in the series, *Stained Glass before 1700 in the United States*, a project representing a long collaborative effort by the Corpus Vitrearum. The publication is part of the activity undertaken by the International Corpus Vitrearum, which has published scholarly analyses of stained glass since its foundation directly after World War II. Since the temporary, protective removal of stained glass windows during World War II, a massive effort to photograph, study, and publish these works has been underway. To date, more than fifty volumes have appeared. The Midwest volume in this new series of studies in the United States includes catalogue entries from the Midwest collections totaling 182 panels, illustrated with close to 600 black and white photographs and 46 color plates.

Medieval and Renaissance stained glass exists in the United States because of the phenomenon of collecting works of art. The panels themselves, as well as their present settings, reveal fascinating histories of changing taste, social status of collectors, and the development of our institutions. Our dedication to the acquisition of objects of the Medieval and Renaissance eras has been long-standing. In large- and small-scale works, we have endeavored to show different media and function to the eyes of the modern viewer. Stained glass, as an architectural art, presents particular challenges. Its conservation is demanding and its installation in our galleries has caused us to take seriously the integration of works of art whose readability is achieved through transmitted as opposed to reflected light. These objects thus bring us into the presence of an art that is at once painting, metalwork, and building. The fascination of the public today for these walls of colored light testifies to an enduring art form.

Like its European analogues, this American publication represents the essential "state of the question" of conservation as well as comprehensive contextual, iconographic, and stylistic description. In addition, through the identification of related works in these museums, it has been possible to develop thematic analyses of the medieval and Renaissance workshops, methods of artistic production, and relationships of large- and small-scale works, in particular the link between the print and the monumental window. Current topics in artistic theory, such as narrative structure, reception of art, and artistic personality are also included. This work then enables scholars in the fields of history, painting, manuscripts, graphic arts, and architecture to integrate our information about patronage, iconography, and styles into their work.

JAMES WOOD, *President and Director, Art Institute of Chicago*
DR. SALLY METZLER, *Director, Martin D'Arcy Museum of Art, Loyola University of Chicago*
ADELHEID M. GEALT, *Director, Indiana University Art Museum, Bloomington*
JOHN STREETMAN, *Executive Director, Museum of Arts and Science, Evansville*
JAMES STEWARD, *Director, University of Michigan Museum of Art, Ann Arbor*
GREGORY WITTKOPP, *Director, Cranbrook Art Museum*
GRAHAM W. J. BEAL, *Director, The Detroit Institute of Arts*
THE VERY REV. STEPHEN H. BANCROFT, *Dean, Cathedral Church of St. Paul, Detroit*
JOHN FRANKLIN MILLER, *President, Edsel & Eleanor Ford House, Grosse Pointe Shores*
TIMOTHY RUB, *Director, Cincinnati Art Museum*
KATHARINE LEE REID, *Director, Cleveland Museum of Art*
THE VERY REV. TRACEY LIND, *Dean, Trinity Cathedral, Cleveland*
THE VERY REV. NICHOLSON B. WHITE, *Rector, St. Paul's Episcopal Church, Cleveland Heights*
SHARON F. PATTON, *John G.W. Cowles Director, Allen Memorial Art Museum, Oberlin College*
ROGER M. BERKOWITZ, *Director, Toledo Museum of Art*

*This first volume
published in the
Corpus Vitrearum series
is dedicated to*
JANE HAYWARD
*First President of
the United States
Committee*

Acknowledgments

THE WORK FOR THIS VOLUME began with the decision of the Corpus Vitrearum of the United States to first locate and survey all extant panels of stained glass before 1700 in this country. These results first appeared as a four-volume series of checklists: *Stained Glass before 1700 in American Collections*, in the National Gallery of Art publications, *Studies in the History of Art* (1985, 87, 89, and 91). Much of the initial examination of the panels in the Midwest states was accomplished during this first stage of study, supported by funding from the National Endowment for the Humanities, the Kress Foundation, and the Getty Foundation. Continued research trips needed for examination of these objects, often in the company of Corpus Vitrearum colleagues, was financed in a variety of ways, sandwiched before and after papers delivered at the International Congress of Medieval Studies at Kalamazoo, excursions by car, invited talks, travel grants from our academic institutions, and through the generosity of tolerant family members and colleagues who provided housing and hospitality.

To the owners, curators, conservators, preparators, and other keepers of these treasures, we are grateful for access and often precious information about the history of the object. The first obligation of our work was an analysis of the extent of restoration in each of the panels we examined, and much insight concerning nineteenth-century and earlier restoration practices and their philosophical framework was acquired by collaborative examinations and by consultations with our Corpus Vitrearum colleagues in the United States and Europe. The citations under each entry endeavor to list their individual contributions. We thank especially our United States Corpus colleagues, Madeline Caviness, Tufts University, chair of the Editorial Committee, and initiator of the grants that supported the bulk of our on-site visits and photography; Michael Cothren, President; Timothy Husband, Editorial Committee; and Mary Shepard, Secretary. Most crucial, and most regretted among our European colleagues is the late Sibyll Kummer-Rothenhäusler, who reviewed every panel of possible Swiss and Southern German origin, and whose deep culture and good humor enlivened every moment of our research collaboration. Nicholas Rogers of Oxford, England, has been invaluable in the analysis of heraldry. For the late Catherine Brisac, Commission des Monuments Historiques, France; Ann Granboulan, Corpus Vitrearum, France; Michael Archer, the Victoria and Albert Museum; Linda Cannon, and all members of the International Corpus Vitrearum – we are grateful for aid and illuminating exchanges. We cite in particular Paul Binski, Claudine Lautier, Katia Macia-Valdez, Richard Marks, and Jean-François Luneau. We are particularly indebted to Rüdiger Becksmann, and Hartmut Scholz, Freiburg i B.; Ulrike Brinkmann, Cologne Cathedral; Chantal Bouchon, Bibliothèque des Arts Décoratifs, Paris; Sarah Brown, National Buildings Record, England; Michel Hérold, and Guy Michel Leproux, CNRS, France; Barbara Giesicke, Switzerland; Linda Papanicolaou, California; Helena Malkiewicz, Corpus Vitrearum, Poland; Caterina Pirina, Milan; Yvette Vanden Bemden, University of Naumur, Belgium, and Elgin van Treek-Vaassen, Munich, not only for advice but for their aid in facilitating research and obtaining photographs. To our institutions, the College of the Holy Cross and the State University of New York at Oswego, for technological support, such as Xerox machines, computers, and e-mail, for interlibrary loan services, office space, and much more, we are extremely grateful.

Particular help in the United States for this volume was provided by Susan Atherly, Andrea Gibbs, Peter Barnet, Eckhard Bernstein, Barbara Butts, Marilyn Conrad, Alan Darr, Maureen

Devine, Annette Dixon, T. C. Eckersley, Stephen Fliegel, Roberta Frey Gilboe, Gladys Haddam, Sylvia Inwood, Naomi Reed Kline, Marianne Letasi, Meredith Lillich, Rita E. McCarthy, Sally Metzler, Margaret Nelson, Robert Saarnio, Myra Orth, Karen Serota, Josephine Shea, Annamarie Poma-Swank, and Patricia Whitesides. Marilyn Beaven not only made a special contribution to the introduction of this volume, but her extensive research is responsible for much of the localizing of the history of the collecting of panels evident in almost all catalogue entries. Our spouses have been not only supportive of this work and its many commitments to time and travel, but have often given crucial assistance on technical matters in this electronic age.

We are deeply grateful for the acumen and the dedication of Elly Miller of Harvey Miller Ltd. The format of this first publication in the 'collections' series for the International Corpus Vitrearum owes much to her inspiration. We also wish to acknowledge all the work and the detailed attention given by Elwyn Blacker and his colleagues.

The labor and printing costs that a scholarly work entails are staggering. All who have helped, including those not specially mentioned by name here or within the text, have our thanks. In particular for publication subsidies we are grateful to the Kress Foundation, the Research and Publications Fund of the College of the Holy Cross, and the State University of New York at Oswego.

THE COLLECTIONS OF STAINED GLASS
BEFORE 1700 IN THE MIDWEST STATES

Stained Glass: Form and Meaning

In the Middle Ages and the Renaissance great art was public art. Even the most personal object, such as a prayer book, liturgical vestment, or reliquary, was but one element in a coordinated public ceremony taking place within the most significant social locus of the community, the church. The great narrative themes of the Christian faith were carried on the exterior of buildings by sculpture, and on the interior by glass and wall painting. Thus the emotional and intellectual effect of stained glass programs was of extraordinary importance. Indeed, the majority of buildings in this era were inconceivable without their glazing. Architects designed their elevations to house these great tapestries of colored light, which integrated the architectural space and served as narrative planes.[1]

Stained glass, considered a "precious object," was linked in the twelfth and thirteenth centuries to the aesthetics of precious stones and metalwork; it thus received a place of honor in the building. The most important reliquaries were set in areas highly visible to pilgrims, such as the shrine of Thomas Becket by Elias of Durham in the center of the Trinity Chapel, behind the main altar of Canterbury Cathedral.[2] The resplendent colors of the twelve surrounding windows recounting Becket's life and miracles reiterated the glow of the precious stones and richly worked metals of the shrine. The Renaissance continued to emphasize the placement of windows, and, as was frequent in the Middle Ages, often set aside the space over the altar as a place of privilege for the image in stained glass.[3]

In the best supported building campaigns, great window programs were conceived for all openings of a building and were most often underway as the stonework was achieving completion. Madeline Caviness describes the re-use and alteration of cartoons in the glazing of the choir of Saint-Remi, Reims, even as the architecture was in the process of completion: "the sequence suggested here shows artists designing in series, each modification based on a critique of completed panels viewed in their intended position in the building."[4] A hierarchy of placement affected decisions about the relationship of figural windows with their selected narrative structures, and non-figural or grisaille windows. Grisaille windows, however, were often primary means of figuring meditative concepts, particularly for those in Cistercian houses.[5]

The importance of glazing programs may be explained by a prevailing attitude towards light as metaphor in pre-modern Europe. In the Old Testament light is associated with good, and darkness with God's displeasure. The very first verses of Genesis announce to the reader that "the earth was void and empty, and darkness was upon the face of the deep," when God created light and "saw the light that it was good" (Gen.1:2–3). Light was associated with knowledge and power, "the brightness of eternal light, and the unspotted mirror of God's majesty" (Wisdom 7:26). Light also functioned as a symbol of God's protection. The Book of Wisdom proclaimed God's shepherding for the Israelites as they fled from Egypt, when "the whole world was enlightened with a clear light." For the impious Egyptians the opposite was true: "over them only was spread a heavy night, an image of that darkness which was to come upon them" (Wisdom 17:19–20). New Testament references are even more explicit and allude to the nature of God,

"God is light, and in him there is no darkness" (I John 1:5). The Gospel of John further associated light with the nature of Christ and the means of spiritual awakening; "In him was life, and the life was the light of men. And the light shineth in the darkness, and the darkness did not comprehend it . . . That was the true light, which enlighteneth every man that cometh into this world" (John 1:4–5, 9).

The importance of Neoplatonic and Augustinian philosophy in the Middle Ages and Renaissance further encouraged the elaboration of light metaphysics in theology. Bernard McGinn reminds us that "in the Middle Ages, aesthetics was an aspect of theology . . . beauty (*pulchrum*) was a transcendental predicate, so that all beauty below was analogical and teleological."[6] Creation is a process of emanations of Divine Light, from the "first radiance," Christ, down to the lowliest speck of matter. In order to ascend from the lowest to the highest, one searches for the trace of Divine Light in all creatures. God is not only Light, but also harmony and beauty. Thus the radiant beauty of sparkling stones and stained glass became for many of this period an intimation of God's very nature and important as a contemplative aid. As a transparent as well as a colored material, glass resonated profoundly with the concepts of clarity and opacity that functioned as primary dichotomies for both moral and ontological systems.[7] Light was transparent as it left the Creator, acquiring color, and thus its ability to be visible, as it penetrated the material world. Thus colors can be seen as imperfections, but betray the radiance of their origin.

Light is central to the works of the late fifth-century author known as Pseudo-Dionysius the Areopagite, believed in the Middle Ages to have been a disciple of St. Paul. His highly influential texts, *On the Celestial Hierarchies* and the *Divine Names*, described God as "the superessential Light" or the "invisible Sun" and in a transcendent leap of negative theology, to describing this light as so totally beyond human comprehension to be "Divine Darkness".[8] John Gage and Meredith Lillich, respectively, discuss the impact of such interpretations on the deeply saturated color of the glazing program of Saint-Denis's ambulatory windows, and on the lighter grisaille glazing of the thirteenth century at Saint-Denis and elsewhere in France.[9]

Suger, abbot of Saint-Denis in the mid-twelfth century, wrote explicitly of color, light, and brilliance, all qualities of stained glass, as essential aspects of the purpose of religious architecture. He maintained that his "delight in the beauty of the house of God – the loveliness of the many-colored gems" allowed him to redirect his thoughts from his temporal obligations to the immaterial world of divine virtues.[10] The hierarchy of experiences linking the mundane to the transcendent was vividly a part of Renaissance writing, evident not only in philosophical discourses but also in more artistic expressions, such as Michelangelo's poetry.[11] Michelangelo conceived of the ability to create earthly beauty as a divinely given power. One poem, written on the verso of a sheet bearing a sketch for the Medici tombs, concerns the anagogical power of love, a force leading the lover to transcend the physical. Light is similarly a part of Renaissance thinking, to cite Michelangelo: "From the highest stars descends a brilliant light that pulls desire toward them, and down here is called love."[12]

Such commentary on the importance of color and light reinforces the assumption that to medieval and Renaissance spectators the church was a premonition of the Heavenly Jerusalem. The colors of stained glass windows corresponded to the stones of the twelve gates of the Heavenly City. Authors such as Marbode of Rennes (1035–1123) attributed magical powers to the color and clarity of precious stones. He, as did other writers, also developed symbolic commentaries linking human virtues to different stones.[13] One of the most frequently quoted commentaries, and one particularly cited during the Ecclesiological revival of the nineteenth century, was by

Durandus of Mende (c. 1220–96), who wrote: "For the material church, wherein the people assemble to set forth God's holy praise, symbolizes that Holy Church which is built in Jerusalem of living stones."[14] References to gems as part of the building materials formed part of the texts read during the dedication rite of churches, and Suger even suggested that precious stones were placed in the foundation of the walls during the dedication of Saint-Denis.[15]

The symbolism of stained glass windows was pervasive and even their physical properties, such as protection against the elements, gave rise to analogies. Honorius of Autun (1080–1156) explained that windows, which let in light but separate us from storms, are the doctors of the Church.[16] Durandus compared the windows' iron lattice work to prophets and teachers.[17] More specifically, the miracle of the Virgin Birth was likened to light passing through glass without breaking it – in the same way as the Word of God, light of the Father, penetrated the womb of the Virgin. The concept appeared in popular circumstances, such as the verse play the *Miracle of Theophilus* by Rutebeuf (d.1280).[18] Mingling the tragic and the comic, the play explained Mary's virginity "comme l'on voit le soleil chaque jour," entering and leaving a window without breaking it. Depictions are known both in windows themselves and in panel painting, such as the *Annunciation* panel of the *Mérode Altarpiece, c.* 1435, in the Metropolitan Museum of Art, Cloisters Collection.[19] In this well-known painting, complete with donor heraldry as pot-metal inserts in clear lattice windows, a tiny Christ Child, holding the cross of his death and destined for his mother's womb, is carried on a sunbeam through the window. The same metaphor appears in stained glass, with the rays of light entering through the painted window, even as the light pierces through the actual window to bring the story to the spectator.

Chronological Development

TWELFTH AND THIRTEENTH CENTURIES

The armature so necessary to the structural support of the window was also an integral part of window design, especially in the twelfth and thirteenth centuries. In many early windows the iron bars followed the pattern of the medallions. The choir windows of Canterbury, dated 1175–1220, display an extraordinary diversity of armature designs to parallel the sophistication of the iconography. The boss from the window in Canterbury Cathedral (DIA 2) is part of a window of narrative scenes showing the martyred archbishop of Canterbury, Thomas Becket, intervening to rescue a man from drowning, to resurrect another, and to cure a nun and a child. Medallion window designs and borders in deeply saturated color, such as the fluid leaves within circles from Canterbury (MDGA 1; Col. pl. 6), as well as narrative scenes, were common to German, French, and English art of that time. Similar ecclesiastical patrons and even royal marriage alliances meant that a panel from Soissons (DIA 1; Col. pl. 2) in northern France and a panel from Canterbury in southern England could have similar concepts of medallion structure. The Canterbury glazing is particularly revealing of the mobility of ideas in early Gothic Europe. A French architect, William of Sens, was called to supervise the rebuilding of the ruined choir. Windows in the cathedral of Sens were then executed by a workshop that accompanied the Canterbury monks into French exile from 1207 to 1213, during the interdict leveled against King John. The vigorous style of the thirteenth-century painting is seen in the small image of the *Elder of the Apocalypse from a Last Judgment Series* in Chicago (AIC 1), the *Seraph* from the west rose of the cathedral of Reims (UMMA 1; Col. pl. 1), as well as in the Soissons clerics (DIA 1; Col. pl. 2).

Since stained glass is an architectural art, the size, importance, and composition of stained glass windows evolved with architectural changes. Equally, it is possible to suggest that architectural change was in part dependent on artistic transformations in the window. The figural medallion set against a dense mosaic ground was not the only choice for a glazing program. Non-figural windows, often in grisaille glass, and windows mixing grisaille and figures, were constant alternatives. Often densely colored windows dominated an eastern wall, whereas the sides used windows of pure grisaille, or figures placed within a wide grisaille border. Several important examples in the Midwest collections are of grisaille glass. Over two and a half feet in height, a *Grisaille with Colored Border* (CMA 1) is from Alsace, very probably Strasbourg. Such windows can be found elsewhere in the Rhineland, and in Switzerland and Austria. In the Strasbourg panel naturalistic leaves arranged in four-part patterns with colored disks in their centers are placed over a grid of stylized leaves. The contrast is enhanced by the use of hatched grounds behind the naturalistic leaves and solid grounds behind the stylized foliage. Further embellishment is provided by a pearled fillet at the sides, abutting the red, yellow, and green border of stylized acanthus leaves. The richness of such work is clear testimony of the importance of the non-figural window. *Four Grisaille Panels* (TMA 1–4) from Salisbury Cathedral contain glass fragments that span the thirteenth century and Richard Marks reports that grisaille played an important role in the cathedral's glazing. Over sixteen different patterns of grisaille appear in the extant glass, thus making them "the largest single repository of thirteenth-century grisaille designs not only in England but probably Europe".[20]

FOURTEENTH CENTURY

In the narrow, multi-lancet windows of the fourteenth through the fifteenth centuries, the art of stained glass was dominated by the figure under an arcade. The Toledo Museum of Art's *Bishop Saint* and *Deacon Saint* (TMA 5–6; Col. pl. 4), c. 1300, illustrate the shift from the more abstract and densely hued figures of the early thirteenth century to the less saturated colors of standing figures under canopies prevalent in the fourteenth and fifteenth centuries. Almost seven feet in height, the two panels are representative of the large-scale figure designs often used in side chapels and almost universally adopted for glazing clerestory areas. The figures sway to the left and turn slightly in space to give the viewer some inviting variation within the vertical form of the narrow lancet. Gestures are emphatic, hands rise in blessing or grasp a crosier or palm. Large oval eyes appear in elongated faces. Clearly these figures are meant to be read from a distance, and their individual stances enhance the liveliness of row upon row of saintly intercessors.

The small but almost perfectly preserved image of *St. Margaret* (MDGA 2; Col. pl. 3) exemplifies another type of installation, the tracery light. She has for counterparts, in the fifteenth century, tracery lights of the *Prophets and Psalmists after the "Biblia Pauperum"* (DIA 5–16; Col. pls. 5, 46) from Cologne; and, in the sixteenth century, the *Tiburtine Sibyl* (CMA 6), and the *Tracery Light of Angels holding Instruments of the Passion* (MIPC 1) in a Michigan private collection. *St. Margaret* demonstrates the continued emphasis on both pattern and figure in medieval design. The delicate leaf pattern in negative relief and the interior frame bordering the panel act like the background of a manuscript initial. The vertical grace of the saint and horizontal power of the dragon are exquisitely fitted into the undulating form of the light. She gently sways, the beast coils, powerful legs counterbalancing its toothy jaws. The *Half-figure of John the Baptist* (DIA 3) from Torun, Poland, shows much the same vigor of expression. In a tondo shape, the panel incorporates the

gesture, silhouette, and fall of the drapery into a series of curves and counter-curves welding the image into a cogent whole.

Uncolored glass, whether in architectural canopies or in non-figural patterns, became more important as Late Gothic buildings became more attenuated in form. Architecture was designed as a cage in which tapestries of light shimmer instead of walls, reflecting on the concept of the diaphanous (*diaphanum*), or transparent, in theological discourse.[21] The delicacy of the stonework was linked to the increased translucency in the windows. Colored panels float upon the shimmer of grisaille-filtered light. England was particularly important in developing systems that integrate both grisaille and figural glass. The extraordinary disposition of the reworked choir of the cathedral of Gloucester (*c.* 1351–67) serves as an example. The eastern wall has ceased to exist as a weight-bearing element. In its place hangs a great curtain of glass, containing rows of figures under architectural canopies in a heavenly chorus of thanksgiving for the victory over the French at the battle of Crécy (1346). English stained glass of the fourteenth and fifteenth centuries is distinguishable for its great delicacy of draftsmanship and for the importance of grisaille, articulated with the entire gamut of silver-stain yellows. The great rows of English saints under arcades in the glass parallel the English love of the sculpted facade filled with statues in niches, such as the great program of the cathedral of Wells. In the cathedral church of St. Paul, Detroit, the figure of an English *Female Saint* (CCSP 1) is modelled in a particularly elegant combination of tonal shading and delicate linear touches.

FIFTEENTH AND SIXTEENTH CENTURIES

The color harmonies of red, green, and gold that frequently dominate German programs create an entirely different effect from the blue and red contrasts that characterize French windows of the High Gothic era. We find yellow-pink, reddish-purple, blue-green, yellow-green, pale yellow, orange-red, and both pale and deep blue in the north windows of the nave of the Carmelite monastery of Boppard-am-Rhein (DIA 4; Col. pl. 7) in the Detroit Institute of Arts. The large program built in the expanded north aisle of the church in 1444, is now divided between the Metropolitan Museum of Art, New York, the Schnütgen Museum, Cologne, the Burrell Collection, Glasgow, and other collections. The canopy window format continues to develop, canopies becoming living structures, especially in the products of the Strasbourg Workshop Cooperative which introduced a widely imitated integration of architectural and organic motifs in canopy designs. This direction is exemplified by Detroit's *Three Standing Figures of Saints* (DIA 19–21), Andrew, Jerome, and Christopher. The tradition is continued in full-blown Renaissance installations, as in the *Four Standing Figures in Architectural Settings* (DIA 35–38), French, Ile-de-France or Berry, about 1525–50.

The German cities of Cologne and Nuremberg supported great programs of stained glass both as installations in new churches and as embellishment to the old. The fifteenth century, especially in the Rhineland, saw a revival of glazing. In the early sixteenth century the north nave aisle of Cologne Cathedral was glazed by workshops associated with two panel painters, known as the Master of the Holy Kinship and the Master of St. Severin. Cloister glazing opened a rich new field for the glass painter. Each of the four sides of a late medieval cloister could have numerous multilight windows, and the panels were most often arranged in registers, as many as three to a light. Narrative systems, placing one scene after another sequentially, reached a peak of popularity at this time. They were exploited to great effect for the extensive and often thematically

complex glazed cloisters at the monasteries of St. Cecilia in Cologne, Altenberg, Mariawald, Steinfeld, and the Charterhouse of Louvain.

Midwest collections have a number of panels related stylistically to those produced by the workshop that glazed the now-destroyed cloister of the Abbey of St. Cecilia, at present in the Sacraments Chapel, Cologne Cathedral.[22] The Detroit Institute of Arts has *Prophets and Psalmists after the "Biblia Pauperum"* (DIA 5–16) that appear to have been tracery lights for an extensive cloister cycle. Duplicates and triplicates of St. Cecilia's cloister panels have migrated to other British and American collections. The Toledo Museum's *Crucifixion* (TMA 7; Col. pl. 10) belongs to this workshop's production, as do two panels in Cleveland's Trinity Cathedral, a *Nailing of Christ to the Cross* and an *Entombment* (TC 1–2, Col. pls. 8, 9). Another *Entombment* is housed in Cologne Cathedral (TC 2/fig. 1), and a third is at Great Bookham, Surrey (TC 2/fig. 2; DIA 5–16/fig. 7). Two Kreuzbrüder abbeys, one at Schwarzenbroich bei Düren and the other in Cologne, may have been the locations for two of these versions of the *Entombment*.[23]

Panels of *Christ in the Garden of Gethsemane* and the *Kiss of Judas* (CMA 16–17; Col. pl. 11) were part of the glass from the Cistercian Abbey of Mariawald, near Cologne. The Cleveland panels belonged in the two lights of the bay at the north end of the east gallery of the cloister. In the organization of the program, donor panels filled the lowest register in each light, New Testament subjects the second, and Old Testament types in the third register.[24] Each subject is a discrete entity, although also an element in a series. The stained glass framing devices, such as the representation of sculptured pilasters, originally slid out from behind stone jambs like a stage curtain behind a proscenium arch. Thus the frames encapsulate the figures within the landscape background so that the scenes can be envisioned as happening in the cloister garth.

A panel of the *Massacre of the Innocents* in Chicago (AIC 2) allows us to study the nature of narrative systems at this time. It could have been one scene in the glazing program of a cloister. It could also have been one of a series of scenes in a large multilancet Late Gothic window. The rectangular scenes would be arranged in horizontal rows, to read from left to right, like the illustrations in a book. This became the standard way of presenting narrative in Late Gothic and Renaissance windows.[25] Only with an unusual circumstance, such as the construction of the Jesse Tree windows from Boppard containing the image of *The Three Marys* (DIA 4/fig. 3), where the scenes of the Passion are differentiated with red and blue backgrounds,

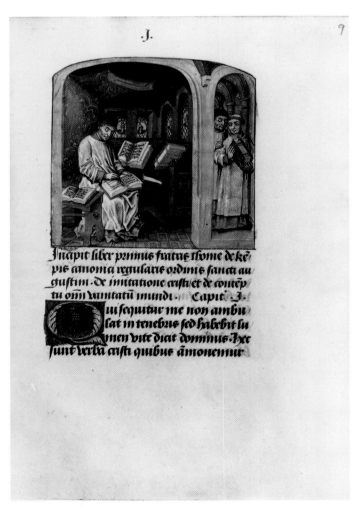

1. *Thomas à Kempis writing the "Imitation of Christ"*, shortly after 1481, from Bruges, made for Baudouin de Lannoy. Vienna, Österreichische Nationalbibliothek, Cod. 1576, fol. 9

Colour Plates

Contents

VOLUME ONE

VOLUME TWO

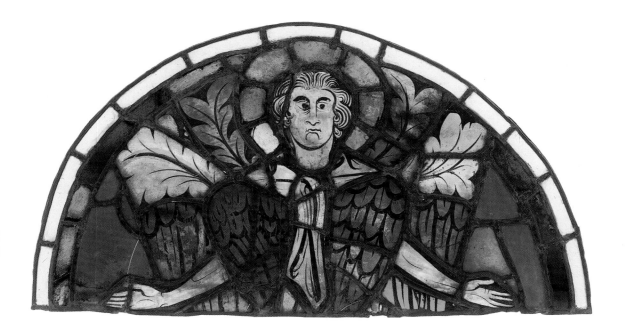

Plate 1. *Seraph*, end of
the 13th or beginning
of 14th century. Ann
Arbor, University of
Michigan Museum of
Art (UMMA 1)

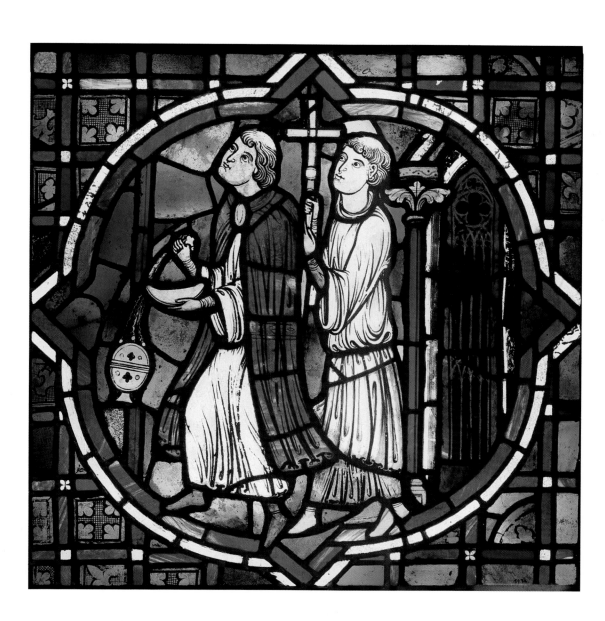

Plate 2. *Two clerics*,
1205–12. Detroit
Institute of Arts (DIA 1)

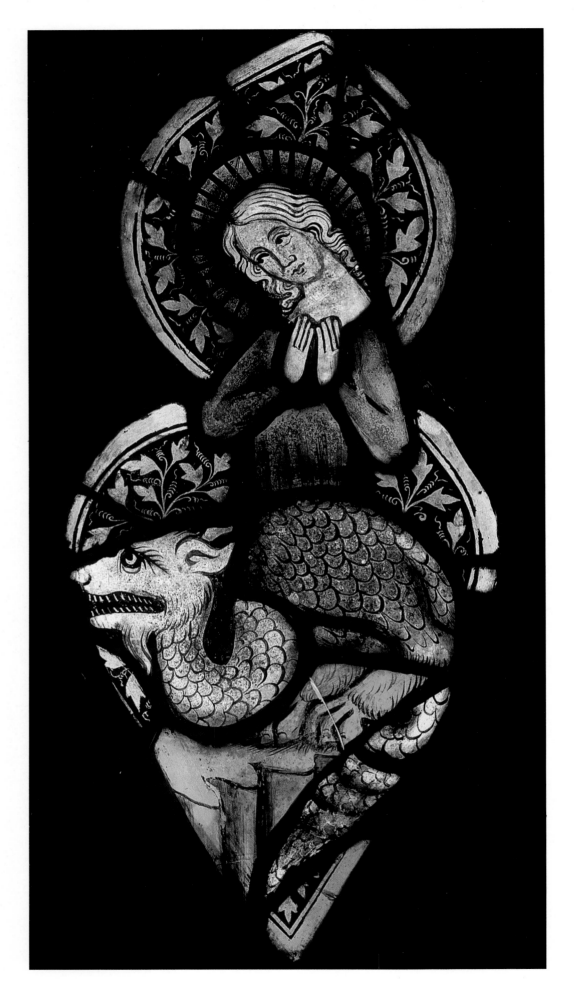

Plate 3. *St. Margaret*,
mid-14th century. Chicago,
Loyola University, Martin
D'Arcy Gallery of Art
(MDGA 2)

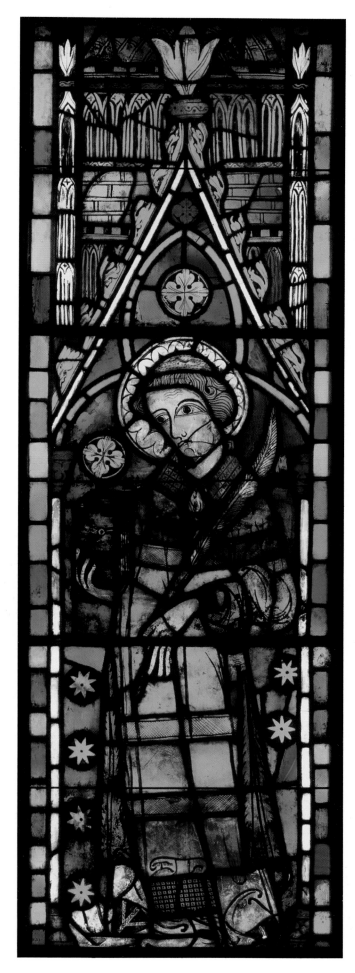

Plate 4. *Deacon Saint*,
1298–1308. Toledo Museum
of Art (TMA 6)

Plate 6. Border, *c.* 1200. Chicago, Loyola University, Martin D'Arcy Gallery of Art (MDGA 1)

Plate 7. *The Three Marys,* 1444.
Detroit Institute of Arts (DIA 4)

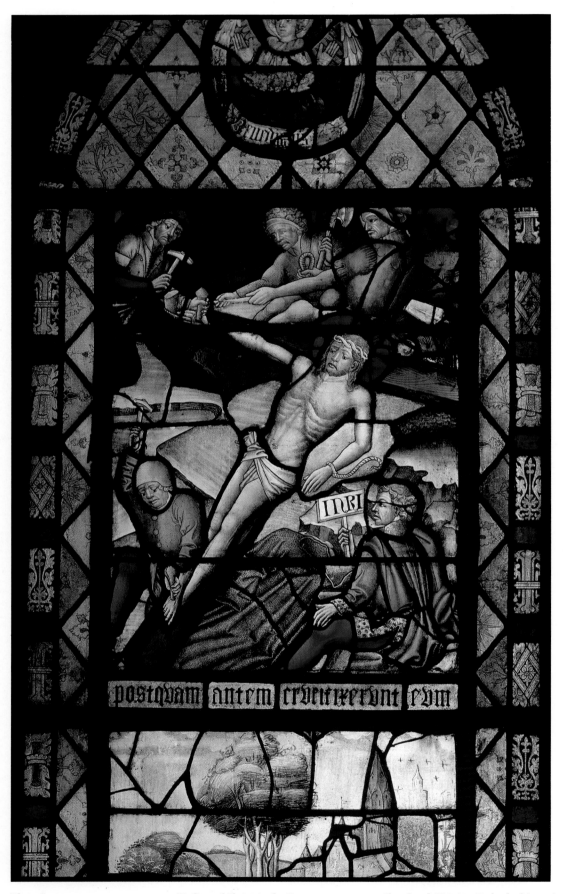

Plate 8. ST. CECILIA WORKSHOP: *Nailing of Christ to the Cross, c.* 1470–75. Cleveland, Trinity Cathedral (TC 1)

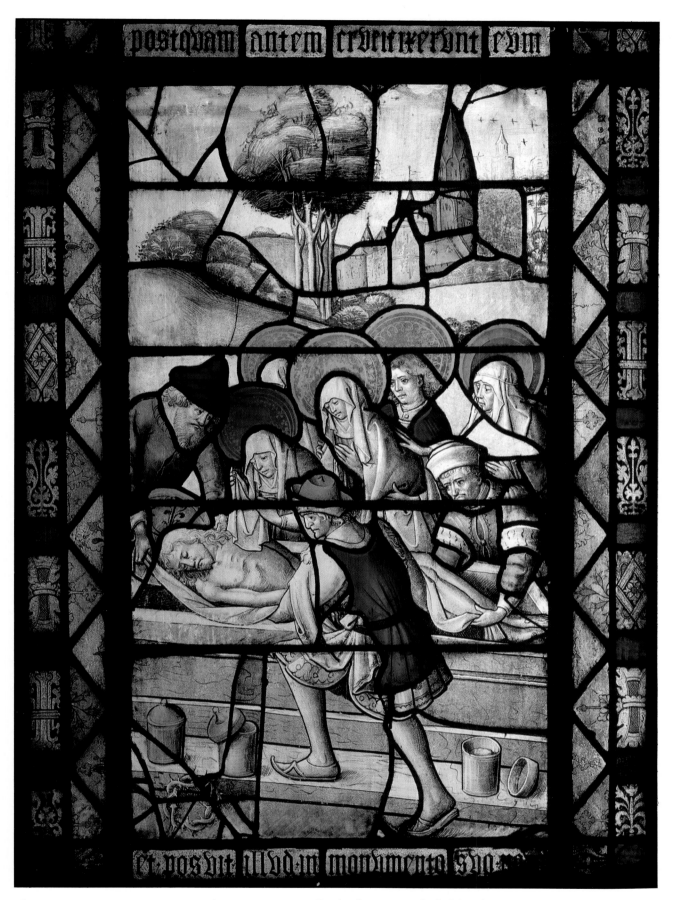

Plate 9. ST. CECILIA WORKSHOP: *Entombment, c.* 1470–75. Cleveland, Trinity Cathedral (TC 2)

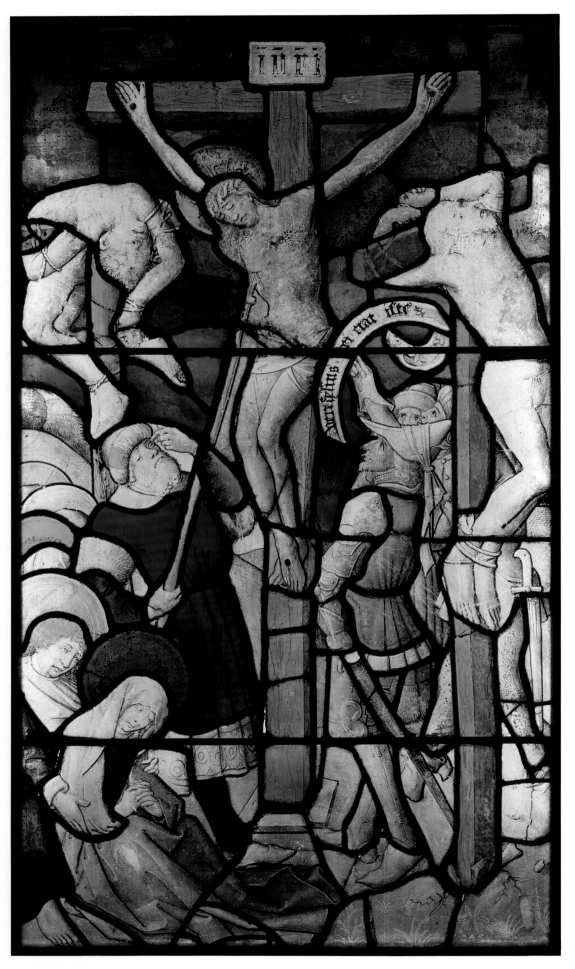

Plate 10. ST. CECILIA
WORKSHOP: *Crucifixion,*
c. 1470–75. Toledo Museum
of Art (TMA 7)

do later programs approach the complexity of placement of their twelfth- and thirteenth-century predecessors. The central window of the west façade at Chartres, for example, resembles a checkerboard because of the red and blue alternation of the backgrounds of the many individual scenes.

The images of a *St. John and Donatrix* and *Christ and the Samaritan Woman at the Well* (AIC 6–7) suggest even more possibilities. Similar in their materials, techniques, style and state of conservation, the windows are assuredly from the same program. The scene of Christ and the Samaritan Woman might have been installed originally in a narrative cloister program. The panel of the kneeling female religious before her patron, however, is slightly smaller. It is possible that the devotional/commemorative scenes of the nun at prayer might be placed in a sitting room or private location. Private ecclesiastical spaces were provided with stained glass, as exemplified by an image from about 1481 showing Thomas à Kempis copying his manuscript of the *Imitation of Christ* (Text. ill. 1).[26] The author is placed within his cell in the monastery of Agnietenberg, the space clearly separated from the cloister arcade, in which two other canons carry away a completed manuscript. Lattice windows adorn all the openings, their blank quarries in uncolored glass framing circular, figurative panels.

An elaborate typological cloister glazing program at the Louvain Charterhouse brought together some of the most gifted early sixteenth-century glass painters, including Bernard van Orley and Dirick Vellert.[27] Panels now in Cleveland (CMA 12–15; Col. pls. 13, 20, 21), Bloomington (IUAM 1; Col. pl. 12), Cranbrook (C-CEC 1; Col. pl. 32), and Chicago (AIC 5; Col. pl. 24) establish the richness and complexity of the enterprise. Margaret of York, widow of Charles the Bold, had founded this Brabantine Charterhouse in 1489.[28] In the late fourteenth and early fifteenth centuries Philip the Bold, Charles's great-grandfather, had funded the construction and decoration of the Carthusian house in the Burgundian capital of Dijon, the site of his entombment.[29] Thus we can see the continuous tradition of Burgundian patronage of the Carthusian order.

SIXTEENTH CENTURY: THE RENAISSANCE

The early sixteenth century saw the emergence of major artists such as Arnoult de Nimègue in Normandy and the Le Prince family in Beauvais. The area around Paris also experienced renewed activity in glazing, in the capital at Saint-Germain l'Auxerrois, or in nearby towns such as Ecouen. Large figural compositions, for example the *Martyrdom of St. Eustache* (DIA 41; Col. pl. 14) from Saint-Patrice in Rouen, ignore the mullion divisions and operate as if vast populated scenes were taking place behind a stone grille. In its color sensitivity, composition, and draftsmanship, painting on glass became the dominant pictorial medium of the French Renaissance. Whether in the highly sophisticated and Romanized body type and modeling of the St. Eustache window, or in more local styles, such as that of a *Dormition and Assumption of the Virgin* (AIC 9), the architectural nature of the installation is emphasized. Although a consistent theme unifies the great windows, the composition defines separate narrative areas. For example, the Virgin's Assumption is framed by a mandorla at the apex of the window, and the Apostles, Holy Women, and recumbent Virgin occupy separate sections. The strong colors, graphic vigor, and consistent facial types of the Chicago window contribute to the clarity of the design.

Italy also imported glass painters, a phenomenon documented in building records, but it is frequently impossible to identify hands or even workshops from specific foreign areas. Milan Cathedral's vast program (1400–86) embodies styles linked to northern Italian sculpture and painting of the time.[30] Italy, especially in the north, used stained glass extensively from the late

thirteenth to the sixteenth century. The scholarly attention given to fresco painting has tended to overshadow the crucial didactic and liturgical functions performed by stained glass, yet the cost and the brilliance of imaged windows made them the choice for the most prestigious locations of imagery. The Basilica of San Francesco, Assisi, contains extensive cycles of the Life of St. Francis and history of the Order.[31] Glazing traditions were seen to harmonize with the great fresco cycles of the building. In some highly important buildings, such as the Cathedral of Florence, the architecture was designed to operate with windows as the exclusive carriers of an iconographic program. Installed between 1405 and 1445, the cathedral's windows include designs by Uccello, Ghiberti, Castagno, and Donatello.[32] Stained glass was regularly employed above Renaissance altars as a means of focusing attention on the centrality of the liturgy, as Luchs has shown in a study of figural windows in Italian churches, from Brunelleschi to Bramante.[33] The Midwest is extremely fortunate in having a window by Guillaume de Marcillat, the *Nativity* (DIA 30; Col. pl. 15). Marcillat was a major Renaissance figure. Originally a native of Berry in France, he made a career in Italy as head of a workshop producing stained glass, including windows for Arezzo and Cortona; panels from these commissions are now in the Victoria and Albert Museum in London, as well as in Detroit.[34]

THE LOWLANDS AND THE DEVELOPMENT OF THE ROUNDEL

The artists of the South Lowlands, such as Jan Swart van Gronigen, Bernard van Orley, and Dirick Vellert (C-CEC 2; Col. pl. 16), lived and worked in major commercial and political centers, such as Antwerp, Brussels, or Mechelen. The busiest European port in the first half of the sixteenth century, Antwerp was an important center for art production. Panel paintings were mass-produced and sold commercially, and roundels may very well have been marketed in the same way. Vellert painted and produced designs for monumental compositions at King's College Chapel, Cambridge, and for smaller panels such as the *Judgment of Solomon* (CMA 14; Col. pl. 20), *Esther interceding before Assuerus* (CMA 15; Col. pl. 21) and the *Son of Zaleucus accused of Adultery* (MDGA 4).[35] He entertained Dürer during the Nuremberger's visit to the city in 1520–21. Dürer's figure drawings and perspectival constructions were innovative developments for northern art. They influenced an entire generation including van Orley, whose shop was geared to court production, and from whom Margaret of Austria commissioned window designs for Brussels Cathedral. This glass fills multilight openings; royal figures and their patron saints occupy vast, elaborate architectural constructs. The concept dominated architectural glazing in both the North and South Lowlands throughout the third quarter of the sixteenth century, as the documented work of the Crabeth brothers in St. John's, Gouda, demonstrates.[36]

Stained glass could be different in size, subject matter, and destination. Artists such as Jan Swart, van Orley, Vellert, or the Crabeths, to whom is attributed the roundel design of *Huntsmen and a Dice Thrower* (DIA 42), worked in several media, designing not only for stained glass but also for tapestries and oil paintings. The roundel, a new object in glass, a single pane painted with vitreous paints and silver stain, emerged as a major element in glazing programs. It was in part a response to the increased value of the graphic media of drawings and prints, but also responded to a new market for glass in more intimate settings. Distinctions between the secular and the ecclesiastical, as used in modern times, are as inappropriate for the Renaissance as they are for medieval settings. A prominent ecclesiastic, such as a canon, might install a roundel in his private quarters, in the same manner that a magistrate might commission an image for his parlor, or for

the windows of a hall of justice, as may be supposed for Vellert's exquisitely painted judgment scene (MDGA 4). Rather than attempt to force modern distinctions on the past, we find it preferable to define the issue as one of scale. The roundel must function within an intimate setting, one where the viewer has a personal sense of importance within the space.

The roundel is a phenomenon of Northern Europe, with its greatest popularity in the Lowlands; it is intimately linked to the tradition of printmaking in the Lowlands and Germany.[37] Although many roundels appear to come from well-defined series, as demonstrated by the multiple references provided by Timothy Husband's survey of roundels in American collections, others raise more questions.[38] Patrons of a stained glass studio selecting a panel design for personal or corporate placement would often isolate an exemplary scene: David confronting Goliath, as in a panel dated 1646 from Toggenburg, Switzerland, and now in Harvard University Art Museums is such a scene.[39] It would be integrated, as in the Harvard example, into a personal matrix of patron saints, biblical citations or other confessional texts, and lengthy biographical inscriptions including location and profession. Series of the Prodigal Son were also popular, frequently presented in four scenes as in the panels in the Harvard University Art Museums and the Los Angeles County Museum, showing the Departure, Gambling, Herding Pigs, and Return.[40] The Midwest is fortunate in possessing two versions of an image from the cycle known as *Sorgheloos and Lichte Fortune* (C-CAM 5; TMA 8; Col. pl. 17). These are based on the same design but were painted by two different artists and come from two different series. A variant on the theme of the Prodigal Son, this popular Lowlands tale demonstrates the evils of gambling and loose living, using allegorical figures such as Careless (Sorgheloos), Fickle Fortune (Lichte Fortune), Ease, Luxury, and Poverty. The scene of the foolish young man wagering in the tavern is one of the more readable in the series of presumably six. The survival of two versions may suggest, however, that this scene, showing the turning point from a life of wealth to one of poverty, was the crucial one in the cycle. Thus a Sorgheloos series could be expanded or contracted as long as this event was included. Panels could also be executed in a summary or graphically complex rendition. The placement of the image as well as the taste and resources of the patron would be factors in the final appearance of the image.

The ability of workshops to respond to varying demands of production has been studied in several prominent analyses of manuscript painting. Robert Branner described the flexibility of workshops in thirteenth-century Paris, able to work in simpler or more complex styles. He traced what "in a comparable twentieth-century situation we would call . . . a cheaper or quicker, or perhaps simply, more routine manner" of painting. The illuminator of a "routine" painting would "sometimes seem to 'step up' to a more distinguished" stylistic category.[41] Jonathan Alexander has used the term "an easily copied style," as opposed to a more individualistic expression, to describe difference in images. He suggests that these differences are not necessarily due to different hands, but to varying levels of execution, developed by illuminators to meet a changing market in the thirteenth century.[42] It would seem reasonable to see the dynamics between patron and workshop, with its complicated process involving models, designers, and painters, as a part of life in Late Medieval and Renaissance times. A wealthier patron, for example, a prominent merchant or a collegiate chapter, might commission an entire series of roundels, on the Prodigal Son[43] or the Life of Christ,[44] as exemplified in the two splendid series in the Metropolitan Museum and the Cloisters. A less affluent client might select a single subject, such as the *Flight into Egypt* (DIA 32) or the *Last Supper* (DIA 31).

Sometimes additions to the image appear to indicate a singular, programmatic usage. The roundel

of *Christ being led away from Herod Antipas*, c. 1515–20 (see page 68), from the North Lowlands, possibly Amsterdam, now in the Cloisters, carries a Dutch inscription in the form of a rhyming couplet typical of the Picture Bible popular at the time:[45] "Bemit dat recht dat unrecht haet / ende des Wysheits licht anthiert./ So zalt voortgae Wat ghy bestaet,/ ghy die volck ende lat regert" (Love justice, hate injustice and employ the light of moral wisdom. Then that which you begin you will succeed, you who rule over the people and the country.)[46] The representation is encoded as a reference to issues of justice and human action, just as the inscription specifically addresses "you who rule". Christ is not the central figure; he is led off to the side and is a relatively calm and passionless form. Herod is larger, dressed in ermine-trimmed robes. Their complex folds across his lap attract our attention. Framed by the canopied throne and flanked by advisors, he is the embodiment of the secular ruler. Thus the inscription and the construction of the image would argue that the intent was to emphasize justice as a specific virtue. Justice, in medieval and Renaissance thought, was one of the Four Cardinal Virtues (with Prudence, Temperance, and Fortitude) that could be achieved through human reason. The Theological Virtues – Faith, Hope and Charity, in contrast – were beyond human learning and accessible only through the mystery of God's Grace.[47] All seven are illustrated in the Toledo roundel of the *Tower of Virtue* (TMA 9). Prudence and Temperance appear as if attached to the trompe-l'oeil architectural frame in the heraldic panel of Franz Güder (AIC 12). In the New York panel, Justice is personified by action rather than by the traditional, isolated female form. Specific aspects of narrative, then, could be structured as moral tales according to the emphasis and position of standard elements in the story. The roundel has neither added nor subtracted any iconographic feature common to the story of Christ's confrontation with Herod. Rather, the manner of depicting the story has changed. It has received an identifying label, designed to convey a pointed moralizing lesson to the viewer.

Thus, we may interpret the Detroit roundel of the *Last Supper* (DIA 31; Col. pl. 18) either as an independent image or as part of a series of the Passion. Whether taken from a printed source and selected out of a series, or from a single model and placed into a series, these images were part of a common store available for different needs. Similarly, the roundel of *St. Benedict* (DIA 40) might have been designed as a single subject, but it is also possible that it was intended to be part of a series of the founders of monasticism. Or perhaps the roundel was to be juxtaposed with one of St. Scholastica, producing a reading that would confirm the validity of monastic life for both male and female members. The juxtaposition of Benedict and Scholastica was part of the original disposition of a panel in the Chicago Art Institute showing the arms of Abbot Fridolinus Summerer of Muri (AIC 13). The juxtaposition of two panels might also recall the dexter and sinister positioning of representations of married couples, or evoke the flanking supporters of heraldic representation, as in Summerer's arms. Such considerations encourage the conclusion that the meaning of an image is to a great extent embedded in its installation, context and use.

Narrative Discourse in Stained Glass

Studies in the narrative structure of paintings have multiplied in recent years. Whether narratives imbedded in a single image of the modern era, as in recent work on Degas and Manet, or in large systematic studies of wall paintings, and altarpieces, the concern has been to see the coded messages and determine the language(s) employed by makers and receivers.[48] Madeline Caviness, Wolfgang Kemp, Colette Manhes-Deremble, and Alyce Jordan, among others, have addressed stained

2. The Good Samaritan window at Chartres Cathedral

glass imagery in the context of current critical opinions concerning medieval literary narrative and cognitive theory.[49] Windows may be large, public statements but may also display unusual complexity in narrative scenes, much like the images on Roman triumphal arches and columns. Common patterns were essential to find one's way into the story. For example, figures seated at table evoked various possibilities and the spectator's eye moved to isolate distinguishing elements: a dancing woman for Herod's Feast, a group of wine jars for the Marriage at Cana, a central nimbed figure with a man leaning over another's chest for the Last Supper, or a seated figure between only two men for the Supper at Emmaus. Similar actions but a change in placement might enable the viewer to identify individual scenes and their importance in a larger narrative. For example, the Good Samaritan window at Chartres (Text. ill. 2) is organized around three vertically aligned quatrefoils linked by small round medallions. The medallion above the central quatrefoil shows Adam and Eve eating the forbidden fruit (loss of Grace). The medallion immediately below shows the Good Samaritan leading the wayfarer to the inn (return to Grace). Equally contrasting with the journey towards salvation would be the image of Adam and Eve thrust away from Paradise, just above the medallion of their sin. In the right quadrants of the top and bottom quatrefoils, Cain strikes Abel (the first murder) and robbers attack the wayfarer (the inheritance of sin).[50]

The armature and medallion patterns in these windows reveal an emphasis on abstract relationships, not as a superficial or "artistic" concern, but as an integral part of the era's view of the significance of lived events or narrated history. To the medieval thinker events had little significance in themselves but took on meaning only in their relationship to other elements in God's great plan for salvation. Manuscripts, wall painting, metalwork, all employed similar systems of framed and interrelated images. The great Moralized Bibles made in thirteenth-century Paris show the same dense composition with medallions as the Soissons narrative window, to which a panel in Detroit belongs (DIA 1; Col. pl. 2). The parallels are constant, not because of slavish copying or precedence of one medium over the other, but, as Peter Brieger stated of English Gothic art: "because the geometric order establishing sequences and relations was the natural and logical as well as the aesthetically appropriate one to be used by artists, who were taught to visualize human and divine relations in terms of eternal validity, satisfying reason and faith and independent of change in time and space."[51]

Medieval windows cannot be interpreted as a sequential elaboration of story in the manner familiar to modern literature. Nor could they have been installed simply as a catechism for pastoral work, as they were characterized frequently in the nineteenth century.[52] The Middle Ages remained a highly structured society, in which repetition, elaboration, and embellishment were the major concerns of expression in the visual or the verbal arts. The episodic, self-reflective, and symbolic presentation of images and ideas was particularly suited to medieval glazing systems.

Renaissance windows offered new opportunities and challenges. Narratives were constructed within large programs of panels, such as that in the Cologne Sacraments Chapel, or the windows

of Louvain and Mariawald cloisters. An exploration of the roundel, discussed above, provides additional opportunities to understand the structure of visual narrative. The story of Esther may be taken as an example. It had been depicted in a complex window in the Sainte-Chapelle in Paris. Alyce Jordan's assessment of the differences between the visual images and the biblical text shows that the window was an independent retelling of the story.[53] The amplification of episodes and the sequence of presentation was linked to the courtly setting and the subject. The flexibility of the theme was similarly welcomed in the Renaissance. It could function as a story of individual heroism, princely magnanimity, a warning against conspiracy, or even a romantic tale of inter-personal affection. Most common images selected from the narrative were those of Esther before Assuerus.[54] The Chicago roundel *Mardochai overhears the Conspiracy from the Story of Esther* (AIC 4) is unusual in that it places the conspiracy of Bagathan and Thares in the foreground (Esther 2:21–23, 6:2). The conspiracy is not even that of the primary narrative strain, the threats against the Jews. Bagathan and Thares, disgruntled porters, plot to assassinate the king. The selection cannot be haphazard, since another roundel based on the same model has been identi-fied in an English collection. The subject and its particular structure clearly communicated a spe-cific message to its contemporary audience.

The foreground presents a highly dramatic moment, when conspirators planning an assassi-nation are overheard by an individual who later will be threatened himself. He is revealed to the spectator, peeking out from behind an archway in ruin. The conspirators are therefore located "outside" the civilizing structure of the city, with its prosperous buildings intact. Directly behind the listener, as if happening at that moment, is the second stage of the tale. Esther, warned by Mardochai of the conspiracy, conveys a message to King Assuerus. In the far background, on the right, the spectator is shown the final episode. The two conspirators are condemned and hanged. The depiction of the condemned men in silhouette, the executioner on a ladder and spectators to the side, is not unlike the iconographic schema in the roundel of the *Hanging of Aman*, 1530–40, in the Cloisters collection.[55] Thus, an episode in the book of Esther is presented, but encoded as a lesson on the evils of abuse of civic trust. The "low" crouching stances of the conspirators and their base physiognomy are derived from traditional representations of evil men, especially indi-viduals in the act of committing evil, such as the tormentors at Christ's Passion, so being visibly differentiated from the other characters in the scene.[56] Peeking in and facing the spectator, Mardochai makes the spectator an active part of the drama. If we can see Mardochai peeking in, then Mardochai can see us. We are in his line of sight, and therefore his counterparts. The moral imperative is for the spectator to measure, against Mardochai's example, how he responds to threats to civic tranquillity.

Dirick Vellert's *Esther interceding before Assuerus* (CMA 15; Col. pl. 21) contrasts Aman's hubris with Esther's courage by showing sequential events as if they are simultaneous. Knowing that her predecessor had been exiled for violating protocol, Esther has come to see the king without an invitation (Esther 1:12, 19; 4:11, 5:1–2). She will ask him to a banquet at which she will reveal Aman's plot to kill the Jews, of which she, unbeknownst to Assuerus, is one (Esther 5:4). While the king receives Esther, Aman proudly flourishes the ring that the king had given to him, the seal of the kingdom. Aman used it to authenticate the documents sent in the king's name ordering the Jews's extermination. Courtiers behind Assuerus hold the box of treasure, payment for the executioners (Esther 3:8–15). In the left background, Esther lies on her bed, as if resting, Aman kneels by her side, and Assuerus strides in the doorway. Vellert has effectively, albeit somewhat

inaccurately, illustrated the moment during the feast when the king goes out to walk in the garden and Aman asks Esther to mediate for him (Esther 7:7–8). Assuerus is shocked at Aman's plot, and moved to action by the perception that Aman is assaulting his wife. The outcome – Aman's hanging – appears on the right. Vellert depicts the well-known episode in the foreground, conflates key episodes and adds an abbreviated explanation of the denouement.

Another panel in the Chicago Institute of Art's collection, *Birth and Naming of John the Baptist* (AIC 3) confirms the common structure of condensing three episodes, one dramatic moment commanding the foreground, and prior and subsequent events in the background.[57] Zachary is presented as a high priest. Struck dumb as punishment for doubting the promised birth of a son to a couple in advanced age (Luke 1:20), Zachary is forced to write the name told him by the angel Gabriel. His kin had objected, since there was no one in the family of that name. He lifts his quill after writing "JOHN" on the piece of paper, witnessed by three rustics kneeling with mouths agape. Zachary is seated in a heavy medieval chair, dressed as a contemporary bishop, with bejeweled mitre and cope. In the immediate center, seen through the open window of the temple, is John's birth. Five women attend Elizabeth. One, traditionally, is expected to be the Virgin Mary. To the right, at the top of circular steps leading to the door of a building, is the circumcision ceremony of the infant John. The grouping of figures in the foreground brings many contemporary social issues into play. Most striking is the controlling power of a wealthy, literate clergy over an illiterate peasant class. Clerical wealth is conspicuous in the impressive display of flagons and plates on an altar-type structure. Literacy is revealed as empowering by the contrast between Zachary's elevated status and the open-mouthed peasants. At this time in the Lowlands, literacy assumed great importance, and centers such as Antwerp saw the rise of publishing houses, books printed on paper, and texts in the vernacular as well as in Latin.

Workshop Structure

One of the most probed issues in past scholarship on medieval and Renaissance art has been the genesis, development, and propagation of distinctive styles and the identification of workshops, masters, assistants, and hands. Such work has assumed the value of the identification of a master's work and the ability of the art historian, in the absence of written records, to apportion artistic responsibility on the basis of purely visual analysis. The earliest stained glass artists, like most of the specialized craftsmen in the early Middle Ages, were probably ecclesiastics. A reference from the episcopate of Geoffroy de Champallement, Bishop of Auxerre (1052–76), mentions a canon who would serve as a glass painter for the windows of the Romanesque cathedral.[58] Suger (1144), however, speaks of imported labor, "the exquisite hands of many masters from different regions."[59] Clerical workers probably dominated the craft in the early period, but during the Gothic era secular, and presumably mobile, workshops produced the majority of windows.[60]

Caviness posited traveling workshops for the production of clerestory windows at Canterbury, Saint-Remi in Reims, and Saint-Yved at Braine.[61] She also observed similarities in the glass used, so it must follow that either the glass blowers traveled from site to site or that the glass was transported by the painters. Of primary importance was her study of patterns of ornament, exemplified in the Midwest by the *Border* from Canterbury (MDGA 1; Col. pl. 6) in the Martin D'Arcy Gallery of Loyola University.[62] By placing tracings of the leads of Canterbury border patterns directly on top of the leads of border patterns in the Cathedral of Sens, she was able to demonstrate that the

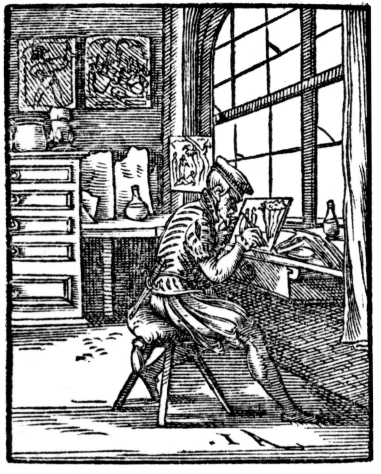

3. JOST AMMAN: *The Glass Painter,* New York, Metropolitan Museum of Art

windows were constructed from the same cartoons, and not simply inspired by a common motif.[63] If we define a workshop as a group of glass workers who own a set of templates or cartoons, it follows that a Canterbury workshop must have traveled to Sens. Styles, on the other hand, often enjoyed wide currency. The classicizing sculptured garments, and noble faces with long oval-shaped and regular features in the window of the clerics from Soissons (DIA 1; Col. pl. 2) are found also in Lyon (Lyonnais), Notre-Dame at Dijon (Burgundy), Troyes (Champagne), Chartres (Beauce), and Saint-Quentin and Soissons (Soissonais), among other sites.

In the 1460s and 1480s, artists such as Peter Hemmel von Andlau coordinated large stained glass workshops, made their own designs, and took an active part in the painting of windows.[64] By the turn of the century, however, work had become more subdivided, with many individuals producing designs only, and important dynasties of glass painters, such as the Hirsvogel of Nuremberg, fabricating windows for other artists. By the early years of the sixteenth century, for example, the production of stained glass in Nuremberg involved major artists whose designs were used also for prints, panel paintings, and the decorative arts. They included Albrecht Dürer, Hans Baldung Grien, Hans Suess von Kulmbach, H. L. Schäufelein, and Hans Sebald Beham.[65]

We see this codified half a century later in the illustrations of Jost Amman (Text ill. 3) for his survey of mechanical and sedentary occupations (*Panoplia Illiberalium Mechanicarum aut Sedentariarum Artium,* 1568). His woodcuts show three separate crafts involved with the production of stained glass, the designer or draftsman (*der Reisser*), the glazier (*der Glaser*), and the glass painter (*der Glasmaler*).[66] Similarly, account books for the great Netherlandish commissions of the second quarter of the sixteenth century clearly distinguish between payments to designers, such as Bernard van Orley, and payments to the glass painter.[67] This study of Midwest collections, however, demonstrates that workshops do not appear to be structured in the manner that is assumed in many studies of "masters" in painting. That is, organizational hierarchy is not evident in stained glass workshops in most cases. The interaction among the various members of the shop often appears to be fluid, with considerable variety in the execution. The two distinct hands of the glass painters in the *Standing Figures of Three Saints and Two Representations of the Virgin and Child* (DIA 23–27; Col. pl. 42) are evident. The artists obviously enjoyed great independence.

Workshop Methods: the Sketch, the Model, and the Cartoon

The production of designs within the workshop would involve at least two kinds of drawings. One, called a model, is a small-scale rendering of the window design. The other, the cartoon, is a full-scale (1:1) working drawing. The cartoon was the same size as the panel or the window opening, and had the lead lines marked on it. It was used in all the stages of stained glass window production: cutting, painting, and leading. Originally cartoons were drawn on white-washed tables and were not portable.[68] By the fifteenth century, paper was available for this purpose, although cloth would be especially useful for large projects.[69]

The St. Cecilia workshop, operating in Cologne in the third quarter of the fifteenth century, replicated at least three narrative designs represented in Ohio collections: Cleveland's *Nailing of Christ to the Cross* and *Entombment* (TC 1, 2; Col. pls. 8, 9) and Toledo's *Crucifixion* (TMA 7; Col. pl. 10). A second *Nailing of Christ to the Cross* is at Stoke d'Abernon, Surrey (TC 1/fig. 1); a second *Crucifixion* is in Cologne (TMA 7/fig. 1); a second *Entombment* is also in Cologne (TC 2/fig. 1), and a third at Great Bookham, Surrey (TC 2/fig. 2). No two versions of any subject were based on the same working cartoon. When the lead lines of the Cleveland, Cologne and Great Bookham *Entombments* are compared, it is apparent that the placement of the leads differs markedly, which must indicate different cartoons. The two *Nailing of Christ to the Cross* panels and both versions of the Crucifixion also show enough divergence for us to conclude that the same cartoons could not possibly have been employed.

Yet the cartoons for each of these three subjects clearly derive from one model, that is, one small-scale design. The shapes of the Nicodemus heads and those of the tops of the halos of the three mourners to the left are more or less the same in all three versions of the *Entombment*. It would have been difficult, if not impossible, to achieve these results if the glass painter had made a completely new cartoon from the small-scale model for each window in each series. The glass painters undoubtedly used some sort of intermediate method to transfer the designs, so that, although dimensions of the window openings varied, some lead lines remained the same. In reference to late fifteenth- and early sixteenth-century windows in Paris and Champagne that repeat the same subjects and even the same figure silhouettes, Hérold proposed the *patron à l'échelle d'exécution*, a full-scale model used as a reference cartoon.[70] Tracings of this full-scale pattern could be reworked to make near-duplicate windows for different buildings. As if to prove the point, most extant sixteenth- and seventeenth-century Flemish cartoons show no lead lines and no nail holes, which they would do if the glass had been leaded up on them. Evidently they were not used as working drawings; rather, they served as a pattern for tracings.[71] If the full-scale pattern were pounced, the glass painter could make a new copy by dusting it with charcoal powder.[72] Alternatively, the full-scale design could be transferred to another piece of paper using a "carbon paper" method. The latter technique, recorded by Vasari, who had trained as a glass painter, was probably a traditional workshop practice.[73] Evidence of tracing turns up in Flemish fifteenth-century panel paintings,[74] as do instances of pouncing.[75]

Transferring silhouettes, that is, using full-scale cut-outs, would explain the differences between the Toledo and Cologne *Crucifixions* (TMA 7; Col. pl. 10, 7/fig. 1). The same figures appear in both panels in the same poses, but the compositions are different. It is as if the glass painter had traced the Toledo window *patron d'échelle d'éxecution*, cut it apart and then reassembled it to fit a window with different measurements. The arms of Christ are spread out horizontally in the Cologne

Crucifixion, not for iconographic reasons, but rather because the St. Cecilia panel is shorter and wider. It would have been relatively simple to cut the arms off a traced silhouette of the Toledo Christ, shift their position, glue them back on and use the finished pattern for the St. Cecilia window. Cennini, in his commentary on how to make a stained glass window cartoon, mentions the practice of gluing pieces of paper together.[76]

The borrowing of figure silhouettes for iconographically different compositions is not uncommon.[77] A tracing of Christ from the full-scale model for the Toledo *Crucifixion* was the basis for the Christ in the Cologne *Mocking of Christ* (TMA 7/fig. 2). In fact, the silhouette in the Toledo *Crucifixion* is more like that in the Cologne *Mocking* than that in the Cologne *Crucifixion*. As another example, the cartoon maker borrowed the mourners from the *patron d'échelle d'éxecution* in the *Entombment* and added them, with variations, to the top of the Stoke d'Abernon *Nailing of Christ to the Cross* (TC 1/fig. 1). Especially helpful for the glass painter would be the re-use of specific segments of a *patron d'échelle d'éxecution*: for example, that for the head of Nicodemus in the *Entombment*. The three Nicodemus faces (Cleveland, Cologne, and Great Bookham) are both specific and consistent. They can only represent three interpretations of one *patron d'échelle d'éxecution*, and not separate interpretations of a small scale model.

The *Bishop Saint* and *Deacon Saint* (TMA 5–6; Col. pl. 4) from Sens Cathedral, and the panels inspired by them presently in the cathedral's choir chapels, present a curious nineteenth-century example of the practice of copying designs. In this case, the restorer used part of the imagery from the early fourteenth-century windows to which he had access. The architecture in the window depicting the deacon served as a model for restoration of the missing canopy in the medieval companion window (TMA 5); it was also the basis for an entirely new creation in a neo-Gothic mode (TMA 6/fig. 1).

The question of who produced the models, the *patrons d'échelle d'éxecution*, the cartoons, and the windows themselves deserves special attention. It is often assumed that Cologne panel painters produced the small-scale models. Rode suggested that the cycle of panels now in the Sacraments Chapel, Cologne Cathedral, was conceived by two groups of artists. The first were followers of Stephan Lochner, preparing the panels up to the *Presentation in the Temple*.[78] The remaining designs were, according to Rode, the work of the Master of the Life of Mary and other artists in his circle, such as the Master of the St. George Legend and the Master of the Lyversberg Passion. In addition, he proposed that the Master of the Life of Mary, who is most well known for a series of panel paintings dated between 1460 and 1480, designed and painted the panel depicting *Christ among the Doctors*.[79] The Cologne artists' guild – to which artists and craftsmen who worked in that city had to belong – enacted a regulation in 1449 stipulating that the roles of panel painters and glass painters would henceforth be distinct and separate, which indicates that previously there had been no strict division of labor between them.[80] There may not have been uniform compliance with such ordinances.

Workshops charged with commissions to glaze the broad window openings of late medieval buildings developed methods of streamlining assembly, as well as design. Sorting marks have been identified in the *Four Standing Saints* (EMAS 1) in the Evansville Museum of Arts and Science. The back of panes in the lower two panels display symbols similar to the "mason's marks" found on building sites. These may have been used as a way of assessing the extent of work accomplished by individual glass painters, for purposes of payment; or, more plausibly, they were a means of sorting, so that after firing a workshop could quickly reassemble the individual panes of glass. Sorting marks such as these have been found on small heraldic panels, where similarity of motifs could complicate assembly, such as the arms now in the Julius Böhler collection, Munich.[81]

The range of projects undertaken in the Nuremberg workshops indicates that craftsmen there were expected to have multiple skills. The Pleydenwurff shop, operating in the third quarter of the fifteenth century, produced panel paintings, stained glass, and other types of art objects.[82] Under Pleydenwurff's successor and the heir to the shop's stock of models, Michael Wolgemut, the organization undertook commissions for panel paintings and stained glass windows, as well as printed books. Wolgemut, along with his co-workers, produced the choir windows in the church of St. Lawrence in Nuremberg.[83]

By the sixteenth century, however, glass designing and painting were often separate trades. In some cases, panel painters – such as Baldung and van Orley – supplied models or cartoons to workshops that specialized in making windows.[84] These were not always treated reverently by the glass painters. A Strasbourg glazier drew lead lines on a Baldung cartoon that had to be corrected by using the early sixteenth-century version of "white out," and then redrawn.[85] Some shops, such as that of Jan Swart van Groningen, specialized in producing stained glass designs, a situation that is clear evidence of the increase in stained glass commissions in the Lowlands.[86]

The interrelationship of workshops demonstrates the degree of cooperation and interdependence that continue to characterize the production of late medieval and Renaissance works of art. A Workshop-Cooperative (*Werkstattgemeinschaft*) in Strasbourg operating from 1477 to at least 1481, produced models and also painted glass. This cooperative group of five workshops organized themselves in order to avoid competing with each other. Peter Hemmel, once defined as the head of the workshop, had the responsibility of finding commissions and working out the business details, and therefore his name shows up on contracts. The artistic development of the shop may actually have gravitated to younger, more innovative artists, as posited by Hartmut Scholz. The five shops divided the work among themselves and shared their respective cartoons.[87]

Windows from the Cistercian Abbey of Mariawald and the north aisle of Cologne Cathedral share specific details of designs by Master Matheus, *c.* 1505–6, for the side panels of the Kalkar Altarpiece. The *Resurrection of Lazarus* from the Mariawald cloister reproduces features of the Kalkar underdrawing for this subject, made visible by infrared photography. Likewise, the Cologne panel of the *Resurrection of Christ* reproduces features of the underdrawing for its counterpart on the altarpiece. Early sixteenth-century Cologne panels and frescoes show that other painters, working on different surfaces, had access to the Kalkar designs; but the Mariawald *Resurrection of Lazarus* is closer to the model than most of the other versions.[88]

The role of the glass painter as opposed to that of the glass designer is a hotly contested subject, especially because workshop situations varied widely. The Hirsvogel shop in Nuremberg, or the Brussels glass painters who carried out the designs of Bernard van Orley, were trained specialists who could produce windows on the basis of a designer's model.[89] The Hirsvogel glass painters evidently selected colors.[90] The Cologne shops working in the early sixteenth century seem to have operated differently. The Master of the Holy Family (*Meister der Heiligen Sippe*) to whom two of the multilight windows in the north aisle of Cologne Cathedral are attributed, was associated with a shop that also produced panel paintings. Infra-red photographs of underdrawings of panel paintings revealing color notations prompt the deduction that those who applied the paint did not produce the underdrawings: the color notations were instructions.[91] None of the cartoons – technically the equivalent of underdrawings – for the windows in the north aisle of Cologne Cathedral are extant. If they were, would we find color notations, and if we did, would we find that the Cologne glass painters had followed them?[92]

The Print and the Dissemination of Designs

The monastic cloister glazing in Cologne, Altenberg, Mariawald, and Steinfeld was extensive and often thematically complex. These new programs were often connected to illustrated concordances, such as the *Biblia Pauperum* and the *Speculum Humanae Salvationis*, popular spiritual guides that encouraged an understanding of Christ's message through juxtaposition with precedents from Old Testament tradition.⁹³ For example, the series of *Prophets and Psalmists* in Detroit (DIA 5–16, Col. pls. 5, 46) is the remaining part of a program of now-lost narrative scenes, with the prophets and their prophetic utterances in the tracery lights. The glass painters did not copy the printed illustrations, but rather used the pattern of juxtapositions and the images themselves as a basis for further elaboration. Sometimes it is difficult to interpret the relationship between prints or drawings and the larger stained glass programs, or single works of art. The *Quatrefoil Roundel with Boar-hunting Scenes* (DIA 17; Col. pl. 22), for example, is closely linked to the manner of draftsmanship used by the Housebook Master, but whether this is because a glass painter copied a model produced by the workshop, or whether the glass painter trained within this circle is open to speculation.

Prints became models for glazing early on, a way of expanding the repository of available designs and also a way of finding already established cognitive icons for the patron. The circulated image meant that a common language of representation became possible over large geographic areas and even long duration. Several examples in the Midwest collections show varying ways in which prints by Albrecht Dürer informed imagery in stained glass. The roundel of the *Flight into Egypt* (DIA 32; Col. pl. 19), although altered, is based on the Dürer woodcut printed in 1503 for his series on the *Life of the Virgin*. The second register, still in place in the church of Saint-Patrice, Rouen (DIA 41/fig. 1), above the *Martyrdom of St. Eustache* (DIA 41; Col. pl. 14), is a faithful rendition of Dürer's engraving of St. Eustace, who is transfixed by a vision of a stag with the crucifix between its antlers.⁹⁴ The small *Crucifixion with the Virgin and St. John and Angels* (DIA 29; Col. pl. 23) is a product of the drafting and glazing traditions that developed in Nuremberg at the time of Dürer. Less important than the identification of a single design source, is, to us, the contemporary exploration of shared iconographic and stylistic principles for images on paper, glass, or panel.

An example of influence at a further remove, but one typical of the direction of a large part of monumental glazing programs, is the *Assumption of the Virgin* (TMA 10) from the Abbey of Autrey, Vosges, France, dated *c.* 1543–4. Its origins suggest a French workshop using German models or prints, especially those of Dürer and his circle. Prominent in this group was Hans Baldung Grien (*c.* 1484/5–1545), a Strasbourg and Nuremberg artist who worked in a variety of two-dimensional media. His works for stained glass, as well as his prints, exerted great influence on subsequent developments of the art. His style is evoked, for example, in a powerful image of the suicide of Judas as he is suspended from the tree (AIC 5; Col. pl. 24).

Heraldic Commemoration

The motivation for the display of heraldry and its structure reveal much about the self-imaging of societies. This art was of immense importance in the thirteenth century with the developing representation of secular power, and virtually the dominant art of the later Middle Ages, as seen in

the painting of a Dutch interior of the first quarter of the seventeenth century, *Lazarus at the Rich Man's Door*, by Bartholomeus van Bassen and Esaias van de Velde (Text. ill. 4).[95] Heraldic display allowed the creation of a desired lineage and the retrospective construction of family history.[96] During the nineteenth century, Hassop Hall, Derbyshire, displayed displaced arms (DIA 50–53, 54–62) of family members from a long-past era; the Fords, American industrial royalty, purchased those of English nobility (EEFH 2–18); and the museums of the Midwest now display these heraldic badges to a new cultural elite.

The impetus to define and advertise self through the patronage of art and architecture may be as old and as universal as the constructed monument. The dedicatory inscription as well as the portrait image have been common means of establishing such status. Despite its seeming specificity, however, the donor portrait, as used in the Middle Ages and the Renaissance, must be seen as an abstract distillation of symbols of class, gender, and social context, rather than as a portrait in the modern sense.

The image of Abbot Suger kneeling at the feet of the Virgin Annunciate in the axial chapel at Saint-Denis, is obviously not a realistic portrait.[97] Rather, as shown by Lillich, it is a construction framed by monastic spiritual concepts that encouraged the monk to imagine being present at

4. BARTHOLOMEUS VAN BASSEN (architecture) and ESAIAS VAN DER VELDE (figures): *Lazarus at the Rich Man's Door*, first quarter of the 17th century, San Francisco, Fine Arts Museums

moments in sacred history.[98] For a monk meditating on the meeting of Elizabeth and Mary at the Visitation, Abbot Aelred of Rievalux urged, "Run and take part in such joy, prostrate yourself at the feet of both."[99] Although identified with the inscription, *Sugerus Abba*, the image is less of Suger as an individual in our modern sense, than of the practice of being a monk and abbot in Suger's culture. The image telescopes biblical time with the time of Suger's meditation on the Annunciation, and further, with the prospective time of subsequent monastic brothers, looking to this depiction and identifying with Suger through their own experience of monastic "work". Heraldry, through a vocabulary of signs, operates in the same manner, connecting the memory of a past, ancestral presence, with the depiction of a present within the image, and prospectively calling to a future of subsequent viewers.

In a world where dress was an identification of selfhood, as testified by the strenuous efforts of the self-constructed mystic, Margery Kempe, to acquire the privilege of wearing virginal white, color and pattern defined far more than personal, momentary fashion decisions.[100] In the panel of *St. Catherine with kneeling Male Donor* (CMA 4; Col. pl. 25), despite his prayers of *miserere mei deus* (Have mercy on me, O God), the cleric is richly dressed in a jewel-trimmed cope and an ermine amice. Heraldic display became an essential part of ritual dress, whether at temporal events such as tournaments, marriages, or royal visitations, or in fixed loci, such as altarpieces, tomb sculpture, and stained glass. Figures depicted in the windows of Holy Trinity parish church, Long Melford (Suffolk), show a conflation of both the donor portrait and donor heraldry.[101] Most of the windows now in the north aisle were originally in the clerestory of the nave, and date to the 1490s. The rebuilder of the church, John Clopton, apparently commissioned depictions of family members and associates. He depicted his grandfather, Sir Thomas Clopton (d.1383), the first Clopton to occupy Kentwell Hall, Long Melford, having married the heiress Catherine Mylde. Sir Thomas is now placed between his wife and daughter-in-law, Elizabeth Pygot. Of particular interest is the heraldic dress of the women, their bodies with the arms of Clopton impaling those of their own families. Their bodies are literally their family's lineage; they bear their family's representation, just as they bore the family's progeny. The men in the Long Melford program wear heraldic dress only when they are in armor. When in secular dress, they are most often depicted as representing their profession.[102]

By the 1550s, however, the Reformation had so changed the structure of artistic patronage in the institutional church that what many have termed the largest production of large-scale stained glass in the history of Europe, namely that of the twelfth through sixteenth centuries, had come to an end. Stained glass, however, continued, and the armorial window came into its own in a new era. Armorial windows and roundels, unipartite panels, exemplify the major forms of German and Swiss painting in the period from the Reformation to the Enlightenment. Typically they are about sixteen inches high and twelve inches wide (about 40 by 30 cm), hence suitable for almost any window; and, since they demonstrated family and community pride, they were very popular.

These Renaissance panels were not without their medieval precedents. A late fourteenth- or early fifteenth-century heraldic panel (CMA 2) fittingly reflects the historical context of the earlier period. Its counterparts can be found in the north rose of Chartres Cathedral, where the arms of France and Castile evoke the presence and policies of St. Louis and possibly also those of his mother Blanche of Castile. Below the central image of St. Anne carrying the Virgin, for example, is the equivalent of Cleveland's image of "France ancient". The royal arms, covered with fleurs-de-lis, is so named to differentiate it from "France modern," which shows just three of these heraldic

lilies. In France this modification took place in the mid-fourteenth century during the reign of Charles VI.[103] In England Edward III bore *azure semy-de-lis*, for France, quartered with English lions after 1340 in reference to his claim over the kingdom of France. His grandson, Henry IV, adopted France Modern in 1411. France Modern can be seen in the two heraldic panels in the Detroit Institute of Arts (DIA 43–44) showing the *Royal Arms of England* (for Henry VIII and Edward, Prince of Wales) from the mid-sixteenth century, and in a panel in Cleveland (CMA 7). During the Renaissance, smaller panels of the state and rulers were also produced, such as the *Knight and a Lady with the Shield of the Archduchy of Austria* (CMA 10; Col. pl. 26), of *c.* 1515. The presence of royal, or ducal, arms in a panel is not necessarily proof that the window was funded by the ruler. It could easily have been the product of a patron desirous to honor a sovereign, to link his or her status to royal favor, or even a retrospective commemoration of patronage, whether desired or actual.

The laicization of European society is evident in the popularity of the self-standing donor shield in stained glass compositions of this period. Both phenomena are represented in the windows behind the *Virgin and Child* in a votive panel painted by Hans Memling for Martin van Nieuwen-howe in 1487 (Bruges, Hospital of St. John).[104] Lack of aristocratic status was not a bar to dis-playing family shields. That of Emanuell Wollaye (SPEC 1; Col. pl. 28) from Harlow, Essex, dated 1604, is an example of a merchant's arms. Harlow lies a short distance north of London, on the road to the rich wool-producing area of East Anglia. Wollaye may have been a wool merchant, and like many others of the East Anglian mercantile class acquired considerable wealth during the fifteenth century. Some like John Clopton of Long Melford, discussed above, reconstructed churches, endowed chantry chapels, and set portraits of family and friends in stained glass win-dows. Wollaye apparently commissioned a brass for his family and stained glass.[105] His shield, obviously, is an example of canting arms, two woolpacks set against a green ground. The arms of Heinrich Bodmer (CMA 18) contain silver sleigh bells, as well as the more traditional charge of a red lion rampant. Bodmer was not an aristocrat, but an important figure in the city councils of Zurich. The elegance of the female supporter of the shield is complemented by a scene of feasting, and a couple strolling arm in arm in a wooded setting. Another Swiss panel shows a husband and wife, but with a spiritual rather than a worldly narrative theme. The *Welcome Panel of the Scherer Family* (DIA 39), canting arms displaying gold shears on a red ground, can be dated *c.* 1530–5, the time of strife between Catholics and Reformers in Switzerland. Above the couple, pilgrims are on their way to Santiago de Compostela, as indicated by their scallop-shell badges and by the image of the *Virgén del Pilar*, the statue seated on a column of jasper, that commemo-rated the apparition of the Virgin, to St. James and his followers at Saragossa. Thus the venera-tion of relics and belief in the power of the intercession of the saints are proclaimed for this Catholic couple.

Swiss and Rhenish heraldic panels were made throughout the sixteenth and seventeenth cen-turies in great numbers. States, religious associations, and families commissioned them and gave them to other organizations to commemorate new buildings. The *Heraldic Panel with the Arms of Fridolinus Summerer, Abbot of Muri* (AIC 13), showing the patron saints of the monastery and a depiction of the abbey itself, was probably made for such a site, possibly another monastery engaged in the reconstruction of its conventual buildings. Stained glass takes on the role of talis-man, uniting and safeguarding the community. Seven Electors sit above the arch beside the Emperor (CMA 21; Col. pl. 29) in a mid-sixteenth-century panel that shows the shield of the free

5. English galleries, Detroit Institute of Arts

imperial city of Überlingen on Lake Constance. Each holds the shield of his principality. Apart from occupying the center position, the Emperor asserts his rank with crown and scepter. An *Ämterscheibe* symbolizes Zurich, a Swiss canton (CMA 22) represented by the arms in the center: the shields of the towns and cities that Zurich administered appear on the perimeter. Berne and Fribourg also commissioned *Ämterscheiben*, as exemplified by the shield of Berne at Cranbrook (C-CEC 7). A panel bearing an identifying inscription represents La Maigrauge, a Swiss Cistercian abbey near Fribourg (CMA 20). Here two supporters, Saints Bernard (left) and Benedict (right), flank a shield with the arms of Clairvaux. The laity's role in the embellishment of places that had been clerical preserves can be seen in a similar panel, the *Assumption of the Virgin with Saints George and Irenaeus* (C-CAM 17; Col. pl. 30), which was presumably made for the parish church of St. George in Sursee, Switzerland. A layman, not an ecclesiastic, represents the Catholic doctrine of the Assumption of the Virgin, flanked by representations of the patron saint, George, on the dexter side, and St. Irenaeus, an Early Christian martyr honored locally, above the arms of St. Michael's church council of Sursee. Two representations of military strength guard the Virgin in this gift of a donor identified as *Herr Camerer*, a jurist and secretary of the church council.

The fragmentary remains of such heraldic sequences have found new life in modern settings outside museum confines. Shields were frequently reinstalled in Gothic Revival buildings, such as the hall of Corpus Christi College, Cambridge. They were also bought by American collectors. One might find deeply ethical or historical meaning in the acquisition of this material by the American mercantile nobility, such as the Wideners, Fords, William Randolph Hearst, and

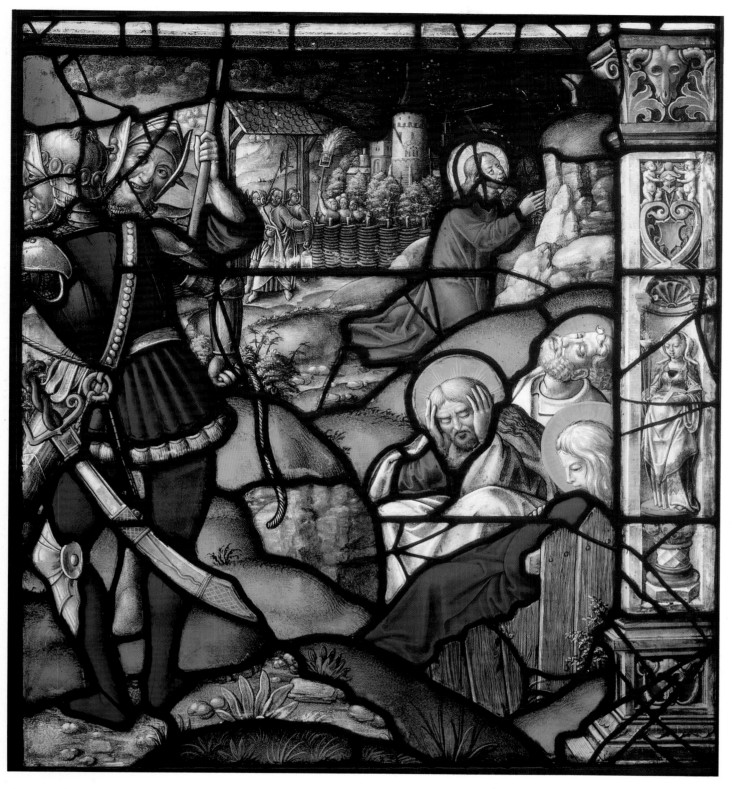

Plate 11. *Christ in the Garden of Gethsemane, c.* 1524. Cleveland Museum of Art (CMA 16)

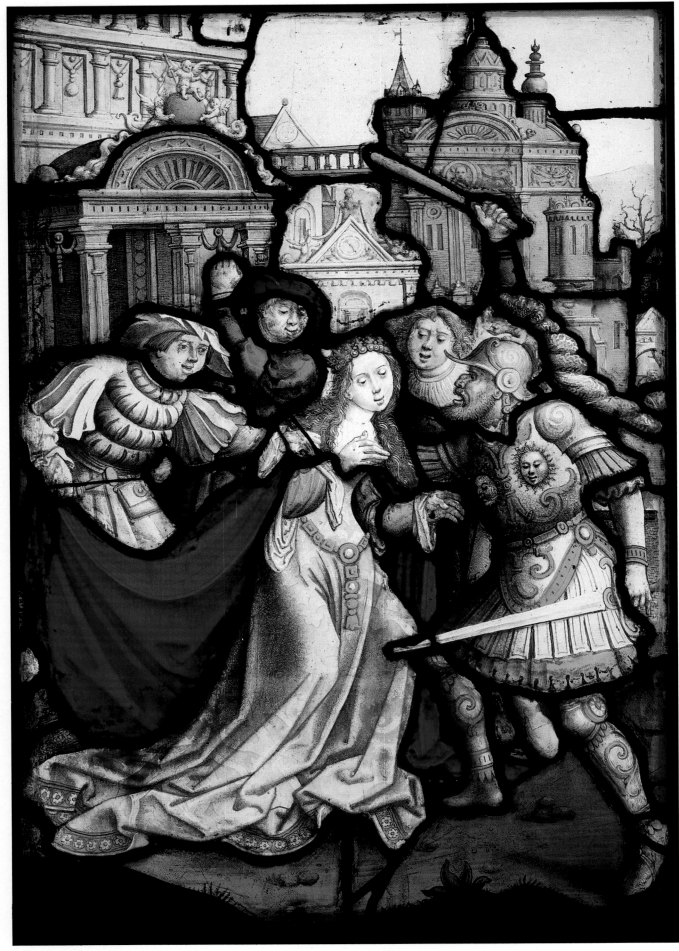

Plate 12. *St.Catherine seized for Martyrdom, c. 1520–30.* Bloomington, Indiana University Art Museum (IUAM I)

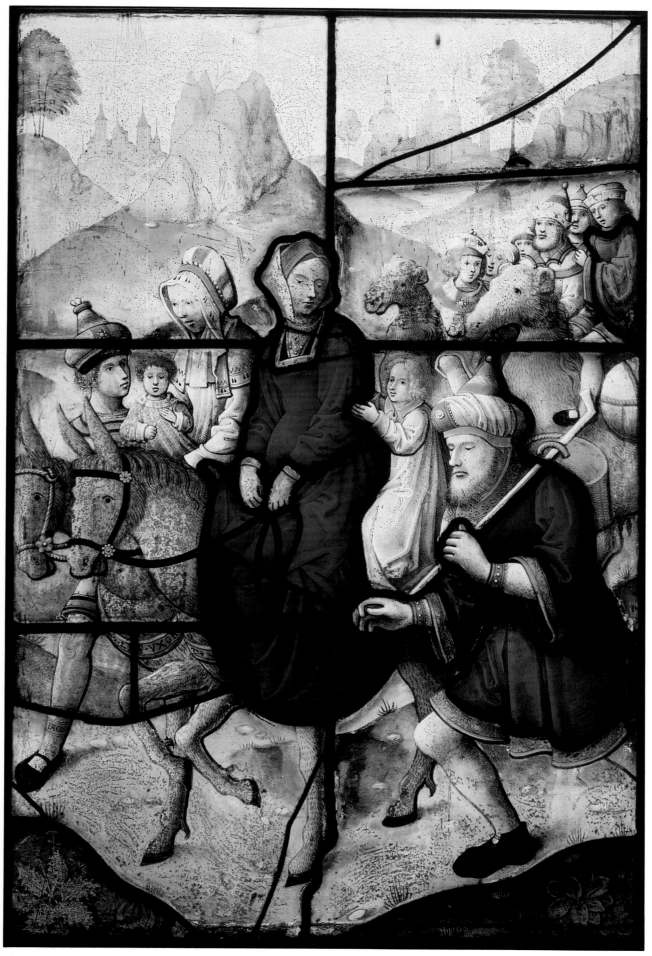

Plate 13. *Jacob returning to Chanaan, c.* 1525. Cleveland Museum of Art (CMA 12)

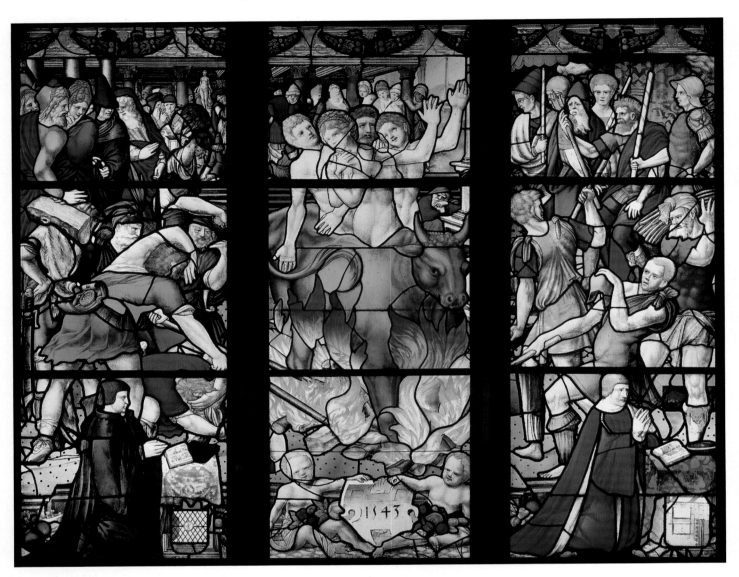

Plate 14. FOLLOWER OF ENGRAND LE PRINCE: *Martyrdom of St. Eustache*, 1543. Detroit Institute of Arts (DIA 41)

(*opposite*) Plate 15. GUILLAUME DE MARCILLAT: *The Nativity*, 1516. Detroit Institute of Arts (DIA 30)

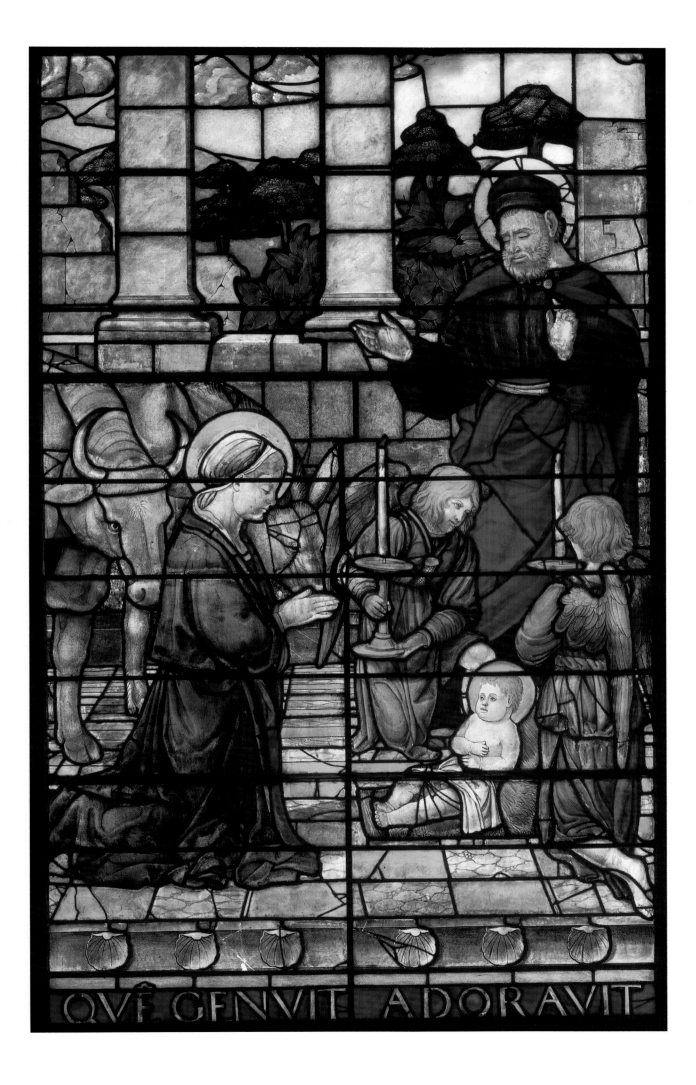

QVÊ GENVIT ADORAVIT

Plate 16. After DIRICK VELLERT: *Marcus Curtius riding into the Fiery Hole,* 1520–30. Bloomfield Hills, Cranbrook Educational Community (C-CEC 2)

Plate 17. PETER CORNELISZ., KUNST: *Sorgheloos and Lichte Fortune,* 1525. Toledo Museum of Art (TMA 8)

Plate 18. AFTER JACOB CORNELISZ.,
VAN OOSTSANEN: *Last Supper,*
1514–25. Detroit Institute of Arts
(DIA 31)

Plate 19. MASTER OF THE SEVEN
ACTS OF MERCY: *Flight into Egypt,*
1515–25. Detroit Institute of Arts
(DIA 32)

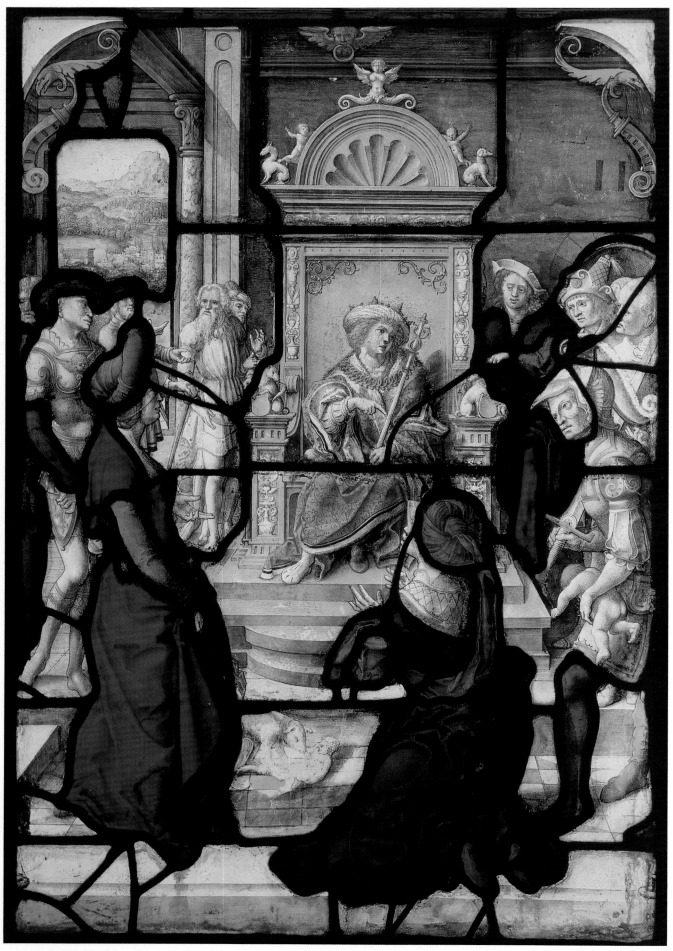

Plate 20. DIRICK VELLERT: *Judgment of Solomon, c.* 1525. Cleveland Museum of Art (CMA 14)

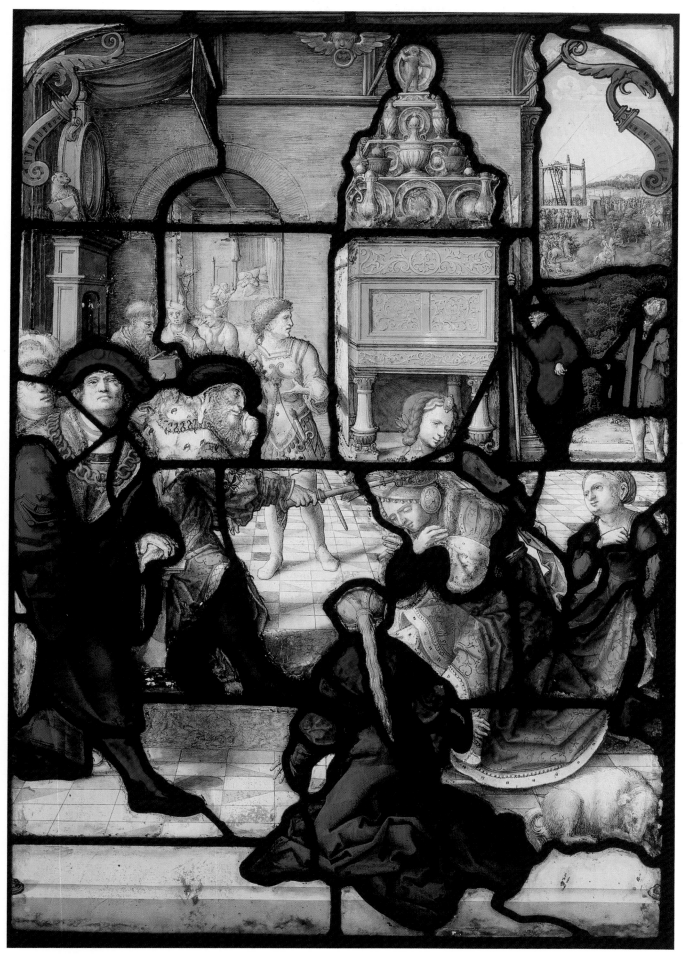

Plate 21. DIRICK VELLERT: *Esther interceding before Assuerus, c.* 1525. Cleveland Museum of Art (CMA 15)

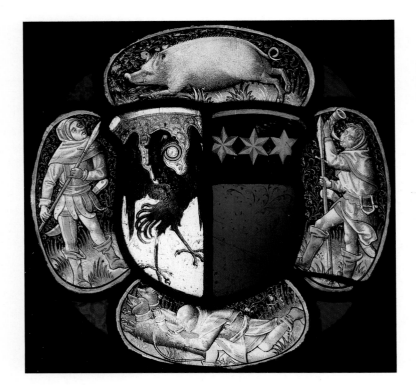

Plate 22. HOUSEBOOK MASTER (circle of):
Quatrefoil Roundel with Boar-hunting scenes,
1475–85. Detroit Institute of Arts (DIA 17)

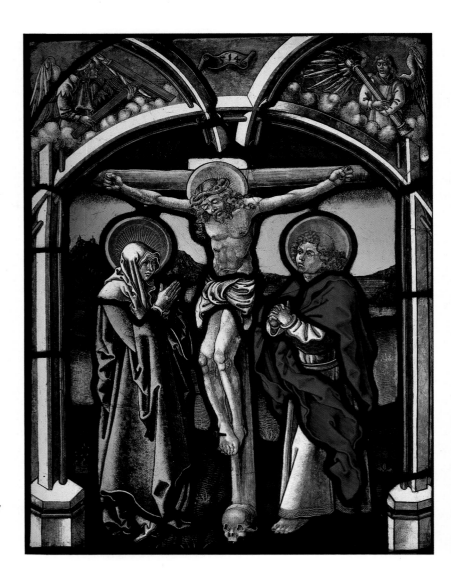

Plate 23. FOLLOWER OF ALBRECHT
DÜRER: *Crucifixion with the Virgin,
St. John and Angels*, 1514.
Detroit Institute of Arts (DIA 29)

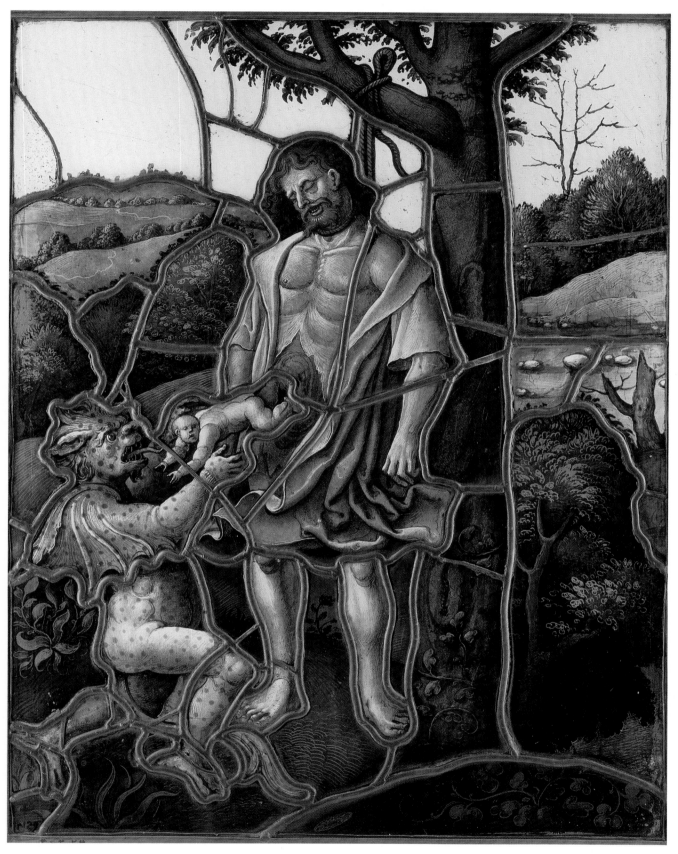

Plate 24. *The Hanging of Judas, c.* 1520. Art Institute of Chicago (AIC 5)

Plate 25. *St. Catherine with kneeling Male Donor,*
c. 1450–60 and 15th century, last quarter.
Cleveland Museum of Art (CMA 4–5)

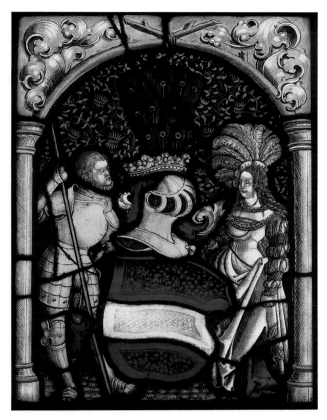

Plate 26. *A Knight and a Lady with the arms of the Archduchy of Austria, c.* 1515. Cleveland Museum of Art (CMA 10)

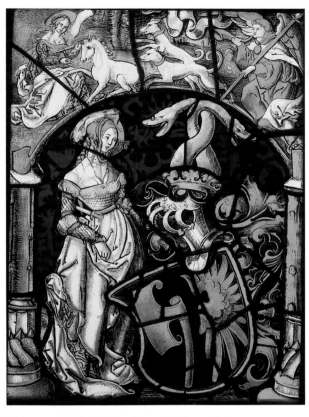

Plate 27. *Shield of Lichtenfels and Unicorn Hunt, c.* 1515. Cleveland Museum of Art (CMA 9)

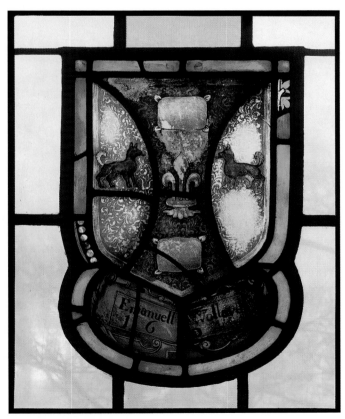

Plate 28. *Shield of Emanuell(?) Wollaye,* 1604. Cleveland Heights, St. Paul's Episcopal Church (SPEC 1)

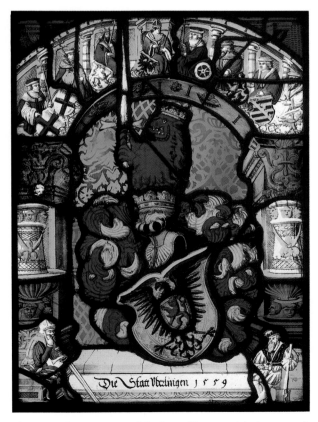

Plate 29. *The Emperor and the Seven Electors with the arms of Überlinge,* 1559. Cleveland Museum of Art (CMA 21)

Plate 30. HANS JAKOB BUCHER: *Assumption of the Virgin with Saints George and Irenaeus*, 1692. Bloomfield Hills, Cranbrook Art Museum (C-CAM 17)

Plate 31. *Arms of John Winthrop of Groton and Thomasine Clopton, c.* 1615. Detroit Institute of Arts (DIA 65)

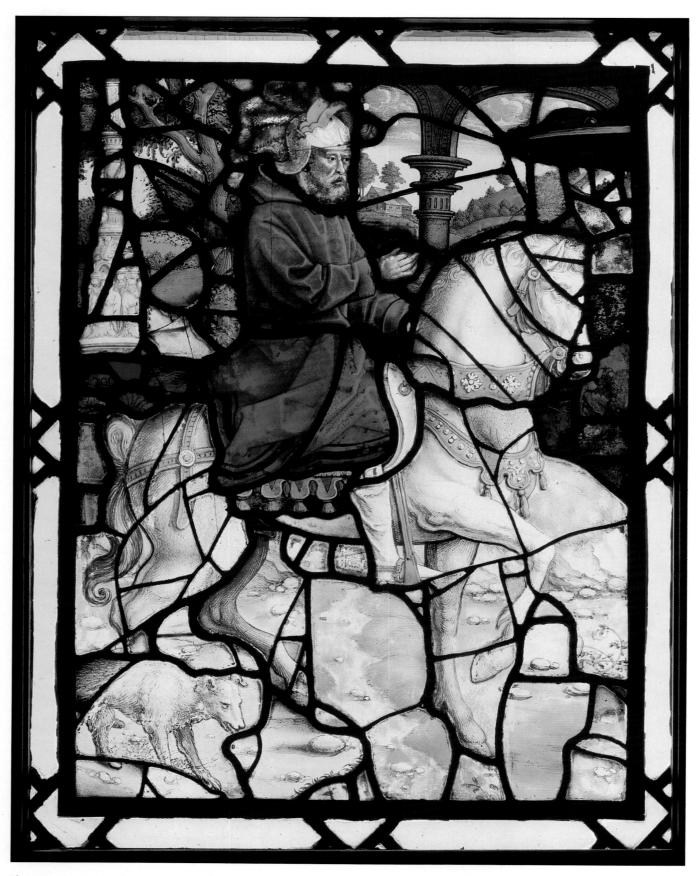

Plate 32. *Horse and Rider, c.* 1520–30. Bloomfield Hills, Cranbrook Educational Community (C-CEC 1)

William G. Mather. Eleanor Widener Dixon had installed more than a hundred heraldic panels in her English Tudor mansion, Ronaele Manor, now mostly a part of the collection of the Philadelphia Museum of Art.[106] Edsel and Eleanor Ford's "Cotswold" home in Grosse Pointe, Michigan (Col. pls. 33, 34), shows a large collection of heraldry. William Randolph Hearst's collection is dispersed, but a considerable number of heraldic panels once in his possession are now displayed in the Detroit Institute of Arts (DIA 43–44, 45–46, 50–53, 54–62, 65). The installation by the museum allows some visual reincorporation of the Tudor interior (Text. ill. 5). A panel now important in this context is that showing the arms of John Winthrop (DIA 65; Col. pl. 31), who served either as governor or deputy governor of the Massachusetts Bay Colony from 1630 through 1649. Perhaps such persistence of function should be perceived as programmatic and not disjunctive. Heraldic display was invariably retrospective. A patron might reincorporate an entire lineage of ancestors; a panel of the arms of Sir Edward Seymour, Lord Protector (DIA 58), was installed in the late sixteenth century in windows of the Elizabethan Warkworth Manor, almost fifty years after his disgrace and death. It now resides, also retrospectively, in the Detroit Institute of Arts.

Collecting and the Construction of Taste

The stained glass in Midwest collections offers a fascinating insight into changing taste and the varied motivations for collecting, as can be seen in the description of their acquisition and display in museums. Windows that reached the art market from buildings that remained standing had often been rejected during restoration campaigns. The Toledo Museum of Art's *Bishop Saint and Deacon Saint* (TMA 5–6; Col. pl. 4) provide good examples. They were removed from their original location, most probably the Cathedral of Sens, during a restoration campaign and never reinstalled. In 1843 Baron François de Guilhermy, on a visit to Sens, noted the presence of old glass in the nave chapels.[107] These were demolished in the mid-nineteenth century, and Alfred Gérente and Adolphe-Napoléon Didron were commissioned to make new windows for reconstructed chapels between 1868 and 1871.[108] About 1877, after a visit to the atelier, Guilhermy noted that Didron had acquired glass from various parts of the cathedral. Cathedral records mention that glass taken from the nave chapels was to be reinstalled in three choir chapels, then glazed only with "scraps of grisaille." The atelier of Félix Gaudin was charged with the project, but it seems that Gaudin did not simply rework old panels.[109] Some of the windows that he installed in 1897 do contain a small amount of old glass; others are reinterpretations of old designs. Several panels from the late thirteenth- or early fourteenth-century windows of the nave chapels, including those now in Toledo, found their way onto the art market.

It is interesting to compare the window of *Deacon Saint* (TMA 6/fig. 1), a modern window in the choir patterned after an old design, with the late thirteenth-century *Bishop Saint and Deacon Saint* that served as models. This reveals both what the restorers valued and what they rejected in the medieval model. The Toledo panels show figures standing under canopies. Heads are large, the faces long ovals, almost concave in form. Eyes are shaped as long, low arcs extending from the bridge of the nose to the temple. The features seem asymmetrical, almost as if representing a face in motion. The regularizing of this medieval design is one of the key transformations of the model. Although provided with large eyes and curving brows, the modern face of St. Lawrence is a small symmetrical oval, much gentler than its medieval counterpart. The medieval figures sway and twist slightly, while

their heads turn toward the viewer's left but the canopies are flat, eschewing a perspectival construction. The modern window actually augments the concept of two-dimensionality. It sets the figure more emphatically on a flat plane and increases the surface of decorative motifs by adding a modified checkered appliqué to the shafts of the flanking columns and a small diagonal grid with inscribed dot (a "bank-note" style of engraving pattern) to the arch. The rows of arcading above the pediment are smaller, actually less believable as an emulation of architecture than the original Sens pattern. Yet the horizontal bands in Lawrence's dalmatic undulate to follow the folds of the garment in proper perspective, a concept absent from the mind of the medieval glass painter. It is significant that when the panels were prepared for sale, the *Bishop Saint* (TMA 5) was provided with a new canopy after the medieval model, not a Gothic Revival frame. The modern canopy copies the extant one closely, but creates a new pattern of breaks and mending leads so as not to appear an exact duplicate.

A reconstruction of the events that eventually brought the window to the twentieth-century art museum might be as follows. After the Toledo windows were removed from their original location, they would have remained in the studio of the *peintre-verrier*. That such a practice was usual, even praiseworthy, is verified by the comments of Bourassé and Manceau, two canons from Tours, who visited the Gérente studio in Paris in the 1840s while researching a book on the stained glass of their cathedral's thirteenth-century choir. They stated that they had seen the "magnificent collection of M. Henri Gérente, among which several examples date to the early years of the eleventh century, these having been found among fragments of glass from later periods".[110] One of the heads was the famous *tête Gérente*, very probably from Saint-Denis.[111] The authors elaborate that the dating can be verified by comparison with the draftsmanship of contemporaneous manuscripts. Unconnected to an aesthetic or iconographic program, these objects were of little service to the church since their retention, however "authentic," was at odds with the oft-cited Medieval Revival principles of ideological and visual harmony.[112] They reached the art market in the twentieth century, when taste had changed and when there was no longer any use for them as models in the shop.

The Toledo *Bishop Saint* and *Deacon Saint* found few admirers in the first half of the twentieth century. In a letter of 23 February 1943, Mitchell Samuels of French & Co. reported that the architect Thomas Hastings had bought them from the Parisian dealer Raoul Heilbronner, about 1900, for use in Blairsden, the house that Hastings designed for Ledyard C. Blair, Bernardsville, New Jersey. Samuels added that the windows were never installed. Rather, Blair sold them to French and Co., in partnership with Arnold Seligmann, Rey & Co. in 1933. The *Bishop* and *Deacon Saint* remained unsold until 1945, when Blake Godwin, director, acquired them for Toledo.[113] We might assume that it was mid-century avant-garde taste for abstraction and planar composition that widened the perimeters of acceptability for museum purchases and public display. In this case, developments in early twentieth-century painting may have led to the more enthusiastic reception of these panels. The facial structure of the Toledo *Deacon Saint* is analogous to that of the two central figures in Picasso's *Les Demoiselles d'Avignon*, 1907, acquired in 1939 by the Museum of Modern Art, New York.

The American taste for the early medieval, and the art of the twelfth and thirteenth centuries in particular, is characteristic of the twentieth century. It was spawned in the Arts and Crafts movements, which prioritized the material's "natural" form. Popular and professional journals such as the *Decorator and Furnisher* and *Harper's Monthly* carried essays on stained glass, invariably mentioning

its medieval origins and incorporating a telescoped history that presented the thirteenth century as its epitome and later centuries as a decline. Caryl Coleman's articles in the *Architectural Record*, for example, were illustrated with numerous line drawings, mostly of the twelfth- and thirteenth-century windows of Chartres.[114] The writer expounded the principles of the art by explaining the nature of the materials and the moral basis of medieval art, claiming that the stained glass windows of the Middle Ages "were looked upon as the Bible of the poor and the uninstructed". According to these authors, glass painting declined because the painters had become oblivious to the principles that brought it into harmony with architecture. "Abandoning the traditions of the great school of the thirteenth century they forgot the rule that all ornaments should consist of enrichment of the essential construction of the building . . . that the glazier cannot be successful where he acts independently of the architect." In the later Middle Ages (and by analogy, in the nineteenth century) "the abuse of materials, and the exaggeration of individualism were suicidal steps".

The writings of Henry Adams were also a factor in the taste for Early Medieval. In 1905 Adams advised Isabella Stewart Gardner to purchase a window of about 1205 from Soissons Cathedral (GMB Inv. No. C28s2), then thought to be from Saint-Denis. Her earlier purchases included late medieval panels, from the Cathedral of Milan, from Austria, and Germany.[115] Adams's bias is communicated by his dismissing "some 14th century pieces. . . which are not bad, but quite a different thing. *The* window is from Saint-Denis, early 13th century."[116] Scholarship, however, has not always recognized that the marketing of Adams's taste was accomplished through the support of architects practicing historical revival styles, parallel to the revival styles of the stained glass artists. The 1913 second edition of Adams's *Mont-Saint-Michel and Chartres*, for example, included an introduction by the architect Ralph Adams Cram, who praised the author for perceiving the unity of art, philosophy, politics, economics, and religion in "the greatest epoch of Christian civilization".[117]

Although this enthusiasm for the art of the "age of Great Cathedrals" was a strong influence, many of the objects found in the Midwest collections are the product of different cultures and varying priorities. George G. Booth's purchases of medieval and Renaissance glass enrich both the Detroit Institute of Arts and the Cranbrook Academy. His discernment for fine craftsmanship in different periods of art supported an independence of taste. Booth was born in Toronto, the son of an English emigré from the town of Cranbrook, in Kent, and his interest in the arts was conditioned to a great extent by his family. He worked for a short time for his uncle Henry Langley, an architect in Toronto, who also possessed a collection of works of art. The family moved to Detroit, where his father worked as a manager and designer in an ornamental ironworks company in Windsor, Ontario. In 1883 George was hired as a salesman and designer and by the mid-1880s had purchased the firm. In 1887 he married Ellen Warren Scripps, the daughter of James E. Scripps, the founder of the *Evening News*, later called the *Detroit News*. In 1888 Booth became the business manager of the paper and eventually president of The Evening News Association until he retired in 1929 to devote all his attention to the schools and institutions at Cranbrook.

Booth's early involvement with crafts, the legacy of his father, and his own direction of a decorative ironworks firm must have played an important part in encouraging his interest in the newly developing Arts and Crafts movement in the United States. In 1906 he helped to found the Detroit Society of Arts and Crafts, and in 1911 the Detroit School of Design, which two years later, as the result of his efforts, became affiliated with the Museum. He was an active member of the American Federation of Arts and was largely responsible, in 1922, for an exhibition of American crafts sponsored by the Smithsonian Institution at the National Museum in Washington.

Booth's vision was associated with an Arts and Crafts emphasis on purity of design, simplicity, honesty in materials, and the belief that the artisan working in a unified society would produce art that testified to universal, if subliminal, truths. Objects from such a culture were manifestations of a world in which the dignity of labor, beauty of materials, and spiritual values were believed to have been a part of common life.[118]

Booth's taste might have been conditioned by earlier patronage of works in the Arts and Crafts mode by individuals such as Martin Brimmer, founding director of the Museum of Fine Arts in Boston. Brimmer introduced the first Burne-Jones/William Morris collaborative work to America by selecting the firm to execute dedicatory windows for his parents in the south transept of Trinity Church, Boston, in 1880. In 1882, *David's Charge to Solomon*, a window produced by the Burne-Jones/William Morris workshop, was installed in what is now the baptistery of Trinity Church, Boston.[119] Morris re-used the same cartoon for a tapestry *David instructing Solomon in the Building of the Temple*, exhibited in 1920 at the Detroit Society of Arts and Crafts. George Booth and his wife Eleanor Scripps Booth purchased the tapestry as a key symbol in the construction of Christ Church, Cranbrook, Bloomfield Hills, Michigan. The Detroit Society of Arts and Crafts, supported by the Booths, was instrumental in the building and furnishing of Christ Church and the Episcopal Cathedral of St. Paul, Detroit, which was decorated with re-used medieval figural windows (CCSP 1–14, 9–15) and with glass by Charles J. Connick of Boston, and others, in medievalizing modes.[120] The interpolation was not confined to Detroit. Clement Heaton, an English artist working also in the United States and Switzerland, produced windows, now lost, for the Holden Gallery at the Cleveland Museum of Art, and windows in a thirteenth-century style for the baptistery at Trinity Cathedral between 1915 and 1916.[121]

In 1925 Booth, buying for his Cranbrook Academy in Bloomfield Hills, Michigan, acquired stained glass by Connick[122] and in the following year he purchased, through Connick, a panel by Michael Healy of *An Tur Gloine*, an Irish stained glass movement inspired by the English artist Christopher Whall. As Whall explained in his book *Stained Glass Work*, he believed that for a window to be successful, the studio system must be altered to encourage greater communication among all workers involved in a window's fabrication, essentially the exaltation of the medieval craftsperson, as presented by Morris.[123] In the Detroit Institute of Arts, the Willet Studio's installation in 1948 of the *Prophets and Psalmists after the "Biblia Pauperum"* (DIA 5–16) demonstrates the lasting influence of Arts and Crafts (Text. ill. 6). The lattice infill is characteristic of the Whall style, using colored and uncolored glass of uneven thickness, broad painterly application of the trace, and a color scheme of rich jewel-like tones against a silvery background of patterned quarries. This same style of window appears in the Willet Studio installations in Trinity Cathedral, Cleveland, and the Connick Studio's windows in the aisles of the Cathedral of St. Paul in Detroit, whose chancel houses medieval works.

The appeal to the discriminating collector was a part of the Arts and Crafts movement's marketing strategy. One of the most telling points of comparison between an Arts and Crafts studio and the "commercial" studio is to be found in the number of commissions and the method of advertising to potential clients. The catalogue issued by Whall & Whall, Ltd. in 1929 lists 169 commissions.[124] The pamphlet was printed on high-grade rag paper, with, as frontispiece, a meticulously executed print of the *Holy Spirit* window in Holy Trinity Church, Sloane Square, London. The catalogue, clearly, was not designed for a large distribution. The catalogues of studios such as Heaton, Butler & Bayne (London) were printed on commercial grade paper, and the

number of commissions per studio numbered well into the thousands. These studios acted as brokers and museum collaborators. One of the earliest publications mentioning stained glass in Midwest collections is by Orin Skinner, a collaborator of Charles J. Connick. He and Connick published observations on historic and modern glass in American cities in a series of articles in *Stained Glass*, the trade journal of the Stained Glass Association of America.[125] Thus the stained glass designers were a source of information and expertise on the medium, and had a serious impact on collecting.

The influence of practitioners on the perception of the history of glass was pervasive. Belief in the superiority of twelfth- and thirteenth-century windows, as developed by Adams, soon became the key arguments in the publications of Connick and Lawrence Saint. Saint was particularly influential due to the popularity of his watercolor illustrations for Hugh Arnold's text, *Stained Glass of the Middle Ages in England and France*, published in London, 1913, which were for long the standard images of medieval windows known to architect, collector, and general reader. Saint's 1936 article on "the lost art" demonstrates how the definition of materials and their perceived correct usage became a validation of a specific period aesthetic.[126] Thus the twelfth century was praised as the purest moment of glass painting. Chartres's west windows and the Crucifixion window of the Cathedral of Poitiers were characterized as "the greatest windows in the world" (see below for the Detroit Institute of Arts's replica of a panel from Chartres).

Transition from an Arts and Crafts aesthetic to a doctrinaire analysis of the twelfth- and thirteenth-century medallion mode as "true" can be seen in the contrast of two publications by Connick. In 1924 he produced an evenhanded review of contemporary glass painters of the Arts and Crafts movement in *International Studio*.[127] His 1937 book,

6. Series of *Prophets and Psalmist after the "Biblia Pauperum"*, c. 1470. Detail, DIA 7-10, from Cologne, Germany

37

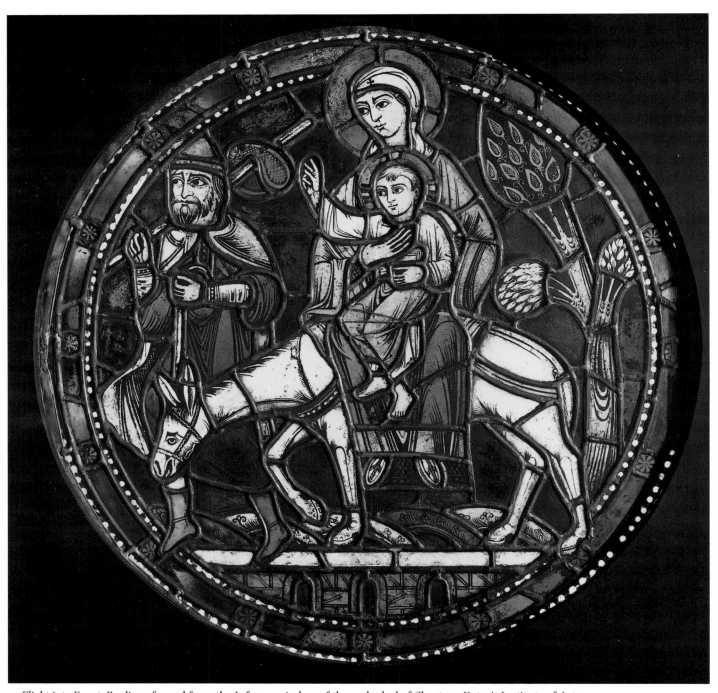

7. *Flight into Egypt*. Replica of panel from the Infancy window of the cathedral of Chartres, Detroit Institute of Arts

Adventures in Light and Color: An Introduction to the Stained Glass Craft, which is still read as a standard text on the art of making historic windows, narrows the canon.[128] Almost all of the profuse illustrations in watercolor or line drawing are his own historicizing windows or twelfth and thirteenth-century examples *in situ*, allowing a confusion between the modern and the historic. A rediscovery of the true principles of stained glass work is consistently played out as a theme.

The Replica, the Restoration, and the Fake

Interest in the art of the past is often accompanied by a desire to replicate, not simply through photographic record, but through objects on the same scale and in the same materials. Similar to the ubiquitous production of plaster casts of sculpture for museums, art schools, and collectors,

38

the copying of ancient glass was an aspect of the art from its revival in the early nineteenth century. The Detroit Institute of Arts (DIA accession no. 55.30) possesses a reproduction of the *Flight into Egypt* (Text ill. 7) from the Infancy window in the west wall of the Cathedral of Chartres.[129] There is no attempt at creating false age and the panel is a well executed copy of a justifiably famous window. Like other replicas of this type, it restores the lost integrity of the original; the obvious mending leads that interrupt the body of the donkey, garments, and above all, the faces of Joseph, Mary and the Child in the twelfth-century original are omitted. Clearly the demonstration of the importance and longevity of the art, as well as the proof of the necessary technical expertise to produce great windows, supported the production of the replica. Louis Comfort Tiffany, (Text ill. 8) for example, placed an advertisement in the magazine *Architecture* showing the martyrdom of a saint with the label "Reproduction of a XIIIth Century Panel executed by Louis C. Tiffany Studios".[130] Good marketing on the part of studios led them to encourage interest in historic windows and to depict themselves as both interested in and capable of reproducing the art of the past.

During the period when Adams, Connick, and Cram were influential, important Renaissance windows often went unsold. Examples are the breathtaking series of *Standing Figures of Three Saints and Two Representations of the Virgin and Child* (DIA 23–27) of 1510–25 or the *Martyrdom of St. Eustache* (DIA 41; Col. pl. 14), inscribed 1543, which were "scooped up" as part of a lot of post-auction stock in the late 1950s. At the same time, inauthentic panels produced in thirteenth-century styles were apparently finding a market.[131]

8. Advertisement, Louis C. Tiffany Studios, *Architecture* (after Duncan, *Tiffany Windows*)

Gothic Revival panels, created in nineteenth-century studios for incorporation into town halls, private homes, and lodges in Europe, such as Munich's Town Hall (destroyed) sometimes came on the market as medieval.[132] The Art Institute of Chicago acquired several panels of *Classical and Medieval Authors* in the style of the fifteenth century; they had been destined originally, in all probability, for a Gothic Revival-style library or other nineteenth-century secular installation.[133] The Detroit Institute of Arts purchased a medallion window showing scenes from the *Life of Saints Peter and Paul* from the Hearst collection in 1944.[134] Despite its presence in several collections, its modern, un-antiqued surface and stylistic coherence suggest that it was not constructed as a fake, but as a church window in a medievalizing mode. This was quite common. The windows installed in the Cathedral of Sens, discussed above, typify a preference for the medieval style for glass to be inserted into historic buildings, and into new constructions in period styles.

Authentication of stained glass demands the sensitivity to period styles that is required in all

Reproduction of a XIIIth Century Panel executed by

Louis C. Tiffany Studios
Stained Glass Windows
Mosaics, Indoor Memorials
Church Decorations
Monuments, Mausoleums
46 West Twenty-Third Street, New York City

9. *Seated Christ.* 20th century, Art Institute of Chicago

connoisseurship. Stained glass, in addition, demands experience in the examination of the production techniques of painting and abrasion applications, evidence of cutting tools, and of the type and condition of the lead cames that form its matrix. The glass must be examined from the front and back by touch and under both transmitted and raking light. Such was the technique used to evaluate a panel showing the *Seated Christ* (AIC 1945.287)[135] that had been acquired by the Art Institute of Chicago as French, school of Rouen, thirteenth century (Text ill. 9). It was purchased directly after World War II from Seligmann, Rey & Co., who told the museum that it came

from the collection of Michel Acézat, Paris.[136] It appears to be a modern pastiche. The subject is similar to the image of the *Majestas Domini* from the north transept oculus of the Cathedral of Rouen, as published by Ritter in 1926.[137] The Alpha and Omega symbols appear to be exact duplicates of those in the Rouen window. The figural stance is extremely close, although the style of drapery is dissimilar. The resemblance is too close. The piece appears to have been patched together, with perhaps even some core of old glass in the head and torso, acid wiped to remove old paint, and then repainted. Antique grozing methods were used to cut the edges.

When viewed as whole, the panel does not exhibit the coherence of glass types, painting surface, leading pattern, or weathering marks that characterize an authentic medieval object. The very similarity to the Rouen panel is troubling. Medieval painters actually had a wide range of compositional choices. It is easier for us to suppose that a highly skilled restorer with a good experience of handling medieval glass exploited some fragments that were lying useless in a shop. The restorer even appears to have reused old leads. Too narrow for the thirteenth century, they may date from the fifteenth. The creator either used Ritter's plate as a model, or had access to the original Rouen panel, since the window was taken down in 1939 as a protective measure. The modern glass painter then constructed such a piece during the lean years of World War II, when the restoration of medieval glass had virtually come to a standstill.

During 1944, a panel entitled *Fragment: Head of an Apostle* (?) (AIC 1945.415)[138] had also been acquired as French, early thirteenth century (Text ill. 10). The basic core appears to be pre-modern, a slightly tinted transparent glass treated with acid to remove any original paint. The exterior and the unpainted areas of the interior do not exhibit the three-dimensional pitting that is commonly an aspect of medieval glass exposed to the elements over time. All appearances of antique patina come from applied paint. The paint is rubbed into the straw marks (marks produced from the straw on which the glass rests while it cools in the annealing oven) and has a whitish surface that approximates the "bloom" of minuscule pitting that is often acquired by the softer types of medieval glass. The interior shows two levels of paint application, a dense mat of medium dark defining contour over which very dark trace outlines the brow, nose, lips, ear, and waves of the hair.

10. Fragment: *Head of an Apostle* and back of fragment, 20th century. Art Institute of Chicago

The Art Institute's files contain an instructive note written by Jean Lafond on 3 August 1968 responding to Allen Wardwell (Curator of European Decorative Arts): "Of course I presume that (the head) is genuine, but it is not like anything that I have seen in France or England. You are quite right in refusing the suggestion that it might be from Reims." Lafond's memory for medieval glass was unparalleled, and he stated unequivocally that he had seen nothing like it. We are looking at a modern artist's hand. The painter is aware of techniques described in medieval texts, but the practice, obviously, is alien. Theophilus's text on methods of painting in the twelfth century describes three applications of paint, which we would characterize as a soft contour wash, a darker layer for additional depth, and trace to establish contour. Although the painting of the head is differentiated, one layer is applied over the other as if they were conceived independently

11. *Royal Arms of England*. Replica of DIA 43–44, 19th century. Detroit Institute of Arts

of each other. To the medieval artist, this application of modeling was not an abstraction, but a natural way of defining the image. In contrast, the modeling in three layers of wash in the torso of the cleric carrying a cross in the Soissons panel (DIA 1; Col. pl. 2) shows the fluid integration of areas of light wash, darker linear overlay, and undiluted trace for contour. In addition, the structure of the paint system leaves areas untouched by paint. These have acquired the light pitting typical of age. In the Chicago head, the laborious nature of the modern application results in paint that is thick and almost three dimensional. Therefore it is clear that we are looking not at a head with some original structure that has been overpainted by a modern restorer, but at an object that has been counterfeited to mimic such a history.

All major collections studied by the American team of the Corpus Vitrearum have included such constructions. The methods have been varied, but for the most part they have been the product of individuals with access to old glass and enough skill to know the appearance of antiquity. In some instances a medallion is composed of both uneven and antiqued modern glass, and old glass that has been acid wiped and repainted (palimpsest). The jumbled and uneven core is given a border made up of obviously new glass in what would appear to be an historic glazing pattern. Thus the contrast between the uniformity of the border and the apparent age of the medallion is a deliberate ploy to co-opt a buyer's discrimination. The buyer could see the difference in the two sections and would then accept the central medallion as old.

The Midwest collections include several interesting examples of replications, as opposed to forgeries. The Detroit Institute of Arts possesses two authentic Renaissance heraldic shields with the *Royal Arms of England* (DIA 43–44) and six replicas (DIA accession nos. 58.120, 121, 122, 124, 156, and 157), clearly produced as a set. The originals date from the mid-sixteenth century; the others (Text ill. 11) are well-crafted copies made by a restorer, probably during the second half of the nineteenth century. The copies use modern cathedral glass and the effects of aging are achieved by adroit handling of the mat paint. Probably, the two authentic panels had been acquired by an individual who desired a set of eight for an architectural emplacement. The owner, very possibly Lord Sudeley, must have made the originals available to a studio which furnished the six replicas after close study of the models. Hans Lehmann, director of the Schweizerisches Landesmuseum, Zurich, reviewed the Sudeley collection for its 1911 sale. He obviously knew the difference between the Renaissance pair and the replicas, since the Sudeley sale catalogue illustrated only the authentic panels, but he listed the other six as forming a set, all under the rubric, "15th century".

The two original panels were modified from the standard oval garter presentation to achieve a round format. The royal crowns have been lost and the extending lower belt of the garter truncated. Both panels were given modern jeweled borders in an outer rim, and between shield and garter. The panels are made up of pot-metal colors and uncolored glass treated with silver stain. In both original panels the fleurs-de-lis were inserted into an unbroken blue ground (Text. ill. 12), a rather sophisticated technique called a *chef d'oeuvre*. Stress has caused cracks, now strengthened by mending leads and edge gluing. The glass painter who executed the six replicas, however, adopted the less demanding technique of dividing the blue fields into leaded segments, allowing the fleurs-de-lis to be more easily set into the field. The replicas also substitute acid etching for the original abrasion used to achieve the gold lions on red flashed glass. Unlike the abraded, acid-wiped, old glass, and manipulated elements of a fake panel, the six new shields were simply meant to blend visually with the old. The modern cathedral glass is left "clean". All subtleties of

12. *Royal Arms of England*. Detail of *chef d'oeuvre* insertion, mid-16th century, DIA 43; from England, Toddington Castle or Hailes Abbey, Gloucestershire

aging are produced by painting on the interior surface. The painter showed remarkable sensitivity, but made no attempt to falsify the evidence of the work.

Restorations are also made sometimes not to deceive but rather to complete a truncated or damaged design and render it legible. Five panels in the Toledo *Assumption* were added by the Metz glass painter Michel-Frédéric Thiria about 1900 (TMA 10/a). After a few moments, any viewer can tell the difference between the old and the new. The colors of the 1900 glass segments are different, and the painting style, while clearly related, is not imitative of that of the old panels. The recent restorations in the Chicago *Dormition*, among them the head of St. Peter, are also easy to identify (AIC 9/a). Paint was spattered on the back of the modern pieces so that they would harmonize with the old glass when seen from the front: there is no attempt to make the paint look like corrosion or to "antique" the new glass. An earlier restoration in the Toledo *Assumption*, the head of the Virgin Mary, appears to be much closer to the original, however (TMA 10/6). Perhaps the broken sixteenth-century head was available for the restorer to copy.

Collecting Stained Glass and its European Origins

The availability of stained glass for private or public collections is dependent on its loss of context, either by the destruction of entire buildings or the selective removal of windows from their architectural settings. In the changing taste of the seventeenth and eighteenth centuries, medieval and Renaissance figural windows were often removed and replaced with clear glass. The process

44

was encouraged by disfavor toward royal and feudal symbols during the period of the French Revolution, as well as by a later society's unwillingness to expend resources on the upkeep of deteriorating leaded windows.[139] This phenomenon was widespread; in an oft-quoted letter dated 1788, John Berry, glazier at Salisbury, offered to sell stained glass panels to a Mr. Lloyd of London, since, as Berry frankly states, it was less trouble to sell the glass intact than to break it in order to get at the [valuable] lead.[140] With its destruction came an awakening interest among some collectors in owning stained glass.

In England, Romantic neo-medievalists like Horace Walpole and Lord Radnor bought Flemish roundels and installed them in their houses.[141] A London commercial gallery organized an exhibition of Flemish roundels in 1761.[142] In France, an interest in history and genealogy led Montfauçon to publish engravings of medieval antiquities, including stained glass, that document pre-Revolutionary French monuments. In Switzerland (Text ill. 13), the medieval settings with their glazing systems had become attractive to artists, exemplified by Ludwig Vogel's watercolor of the cloister of Muri. Recognizing the importance of Swiss heraldic glass, the poet and painter Johann Martin Usteri collected it and also wrote descriptions of the glazing at Königsfelden, Baden, Wettingen, and Stein-am-Rhein.[143] The merchant Johann Nikolaus Vincent purchased panels on his business trips through the Swiss countryside, beginning in 1816. As early as 1833 his holdings were exhibited in the Capitalsaal beside the cathedral in Constance.[144] However, the only eighteenth-century collection of Swiss and German glass that remains intact is that assembled by the Swiss writer and patriot Johann Caspar Lavater (1741–1801). This was acquired by Prince Leopold Friedrich Franz of Anhalt-Dessau in 1782, who had his purchases installed in a "folly," a neo-Gothic

13. LUDWIG VOGEL: Cloister of the Abbey of Muri, watercolor, 1830, Zurich, Schweizerisches Landesmuseum

45

house in a park at Wörlitz where they remain today.[145] During a period of challenges to persisting feudal patterns of government, royal and aristocratic patrons nostalgic for, or intent on, clinging to their traditional privileges amassed considerable holdings of Swiss glass. Much of the glass in the Hermitage State Museum, St. Petersburg, Russia, consists of Swiss and German heraldic panels from the Tsarskoe Selo Arsenal, founded by Tsar Nicholas I (1796–1855).[146]

The possibilities for stained glass collecting in the nineteenth century were vastly improved by the secularization of church property in France, Belgium, and the Rhineland. The activities of John Christopher Hampp serve as a recurring theme in this catalogue.[147] Hampp was a German emigré living in Norwich, who bought glass on the Continent and took it to England, where it was sold to private collectors and church authorities. Among those who purchased crates of Hampp's glass were Sir William Jerningham at Costessey Hall, the first Earl Brownlow of Ashridge and Sir Thomas Neave of Dagnam Park, whose Flemish glass has ended up in American museums in Bloomington (IUAM 1; Col. pl. 12), Chicago (AIC 5), Bloomfield Hills (C-CEC 1; Col. pl. 32), and Cleveland (CMA 12–15; Col. pls. 13, 20, 21). Not all the glass alienated from monasteries and churches was taken by Hampp to England. In Cologne and the Rhineland Johann Baptist Hirn, Heinrich Schiefer, Christian Geerling, and Wilhelm Düssel also gathered up panels. The holdings of the Baron Hans Carl von Zwierlein, who purchased much of his collection from these four German collectors, were most impressive. Rather than collecting for himself, Grand Duke Ludwig I (1753–1830), an admirer of the medium, founded the Hessisches Landesmuseum, Darmstadt, for the preservation and display of stained glass.[148]

English collectors also bought glass directly on the Continent. In 1815, one John Winn bought 780 Swiss panels for Nostell Priory, Yorkshire. Thomas Charles Hanbury-Tracy purchased glass in Switzerland for his father, the first Lord Sudeley, in the second decade of the nineteenth century.[149] A number of panels from this important collection are now in Detroit (DIA 39, 43, 44, 47, 48, 49, 66, 67), Bloomfield Hills (C-CAM 3, 10, 13, and C-CEC 6, 7, 14), and Cleveland (CMA 9, 22; Col. pl. 27). In the nineteenth century, the Sudeley glass was installed in the cloister of Toddington, a manor house designed by the first Lord Sudeley, Charles Hanbury-Tracy, and begun about 1820. Given that there was less interest in archaeological accuracy in the Romantic medievalism of the early nineteenth century, the house includes both ecclesiastical and secular neo-Gothic features and draws on a number of models. The fact that the Tracys had held land near the former Cistercian Abbey of Hailes, not far from Toddington, and had occupied the abbot's house after the Dissolution, probably inspired the project in the first place.[150]

A large collection of heraldic panel portions now in the Detroit Institute of Arts represent English antiquarian collecting (DIA 45–46, 50–53, 54–62). They were made in the late sixteenth century for Warkworth Manor, Northamptonshire, home of the Chetwode family. In 1805 the property was sold at public auction and the house dismantled. Francis Eyre, the owner, removed the panels and reinstalled them in a staircase window and in a bay window in the dining room of his residence at Hassop Hall, Derbyshire. There they remained until dispersed in 1910.

A similar pattern of acquisition for the purpose of re-use in a private setting appears in the history of the glass from Boppard-am-Rhein. In 1818 Count Hermann Pückler of Muskau was able to acquire windows from the north nave of the former Carmelite church in Boppard. His intention, like that of Sir William Jerningham at Costessey Hall, near Norwich,[151] England, was to install the glass in a family chapel, in this case on his estate at Muskau on the Polish border.[152] The project was never realized. Save for one window, the glass remained in its packing crates and was finally

sent for restoration fifty years later, prior to its resale, to Friedrich Spitzer of Paris shortly after 1871. Spitzer's collection was sold in 1893 and the panels were widely dispersed.[153]

A number of important private collections, like that of Spitzer, were sold in the late nineteenth and early twentieth century, among them those of von Zwierlein (1887),[154] Vincent (1891),[155] and the aforementioned Sudeley (1911).[156] The Vincent collection contained a large collection of Swiss *Kabinettscheiben*, one of which represents the arms of the monastery of La Maigrauge (CMA 20). The purchasers included those who wanted to restore their country's patrimony, such as the Swiss. The Schweizerisches Landesmuseum, Zurich, was founded to house stained glass and other national antiquities in 1898. Likewise, a German purchaser bought a series of fifteenth-century cloister panels at the von Zwierlein sale and had them installed one year later in the Church of St. Katharine, Oppenheim. Not surprisingly, since all the panels probably come from Cologne or environs, and can be dated to the second half of the fifteenth century, the Oppenheim glass is related to panels in Cleveland (TC 1, 2; Col. pls. 8, 9), Detroit (DIA 5–16; Col. pl. 5), and Toledo (TMA 7; Col. pl. 10).[157]

Wealthy captains of industry and finance, such as Alexander Stieglitz and Walter von Pannwitz,[158] were also buyers in the late nineteenth and early twentieth centuries. Stieglitz (1814–84) was one of the most important collectors of applied art in St. Petersburg. After his death, his daughter and her husband built a museum on the model of the Victoria and Albert Museum, which they had visited in London. Their acquisitions of stained glass in Germany, Austria, and France included some entire collections, for example, the Ricard collection, Frankfurt. The museum building still exists on Solanoy Street; what remains of the glass is in the Hermitage. Five Renaissance panels showing Swiss and German heraldic images now in the Cleveland Museum (CMA 9–10, 20–22) were once in the von Pannwitz collection.

The situation of Grosvenor Thomas was apparently that of collector and amateur turned dealer.[159] Writing to William G. Mather of Cleveland in 1915, Thomas was adamant in stating that he was foremost a landscape painter, who had, "for many years been forming my stained glass collection of old stained glass ... but in the past two or three years I have been disposing of some panels to different museums etc."[160] Within the Midwest catalogue alone, over forty panels[161] were brought to America and sold by Thomas or the successor firm of Thomas and Drake, which carried on after his death in 1923. The Hassop Hall set of panels in Detroit (DIA 50–53, 54–62) was part of Thomas's collection and he may well have bought the stained glass at the time of the 1910 sale.[162] Thomas recognized that heraldic stained glass, especially when it represented a genealogical series, had great value. This was confirmed by the success of his "exhibition," in 1913 at the Charles Gallery, New York, which included over two hundred and fifty heraldic panels.[163]

The four shields of Hals from Keynedon House (EEFH 15–18; Col. pl. 37), bought by Edsel and Eleanor Ford in 1939 to decorate the windows of their Cotswold manor style home in Grosse Pointe, Michigan (Col. pls. 33, 34, 36), illustrate the lasting appeal of such colorful but non-figural stained glass. Keynedon House, Devon, was partly demolished in the nineteenth century, and probably before 1900 the panels were in Grosvenor Thomas's collection. They can be positively identified in the Charles Gallery sale catalogue, where they were highlighted by Maurice Drake, the author, as "A most remarkable series in perfect condition ... almost unique."[164] At this time they were bought as part of a large selection by Elizabeth Mills Reid (Mrs. Whitelaw Reid) of Purchase, New York. Recently widowed, Mrs. Reid was adding a large west wing to Ophir Hall,

her McKim, Mead and White "stone castle". She wished to augment all her windows with stained glass medallions in lattice windows, to produce an American version of the traditional English manor house. The practice would have been well known to Mrs. Reid who accompanied her husband Whitelaw to England as a special envoy in 1897 and later as ambassador to the Court of St. James from 1905 to his death in 1912.[165] Although the tall windows at the landing of the Ophir Hall stairway contained figures of standing saints, the entrance way and the Great Library windows were filled with heraldic glass. The Hals medallions were placed in the library.[166]

In 1935, after Mrs. Reid's death, the furnishings of Ophir Hall were sold at auction. Knowing the value and whereabouts of the stained glass sold by his father, Roy Grosvenor Thomas, now president of Thomas and Drake, Inc., New York, went to the Reid sale and purchased the Hals medallions along with thirty-two other heraldic panels. Roy Thomas described and sketched the glass purchases in the firm's sale books under the heading "Reid Sale".[167] The note to the right of the entry indicates that the medallions were sold to Frank Partridge, a London dealer of stained glass and antiques. Later Partridge returned the panels to America and they were bought by Edsel Ford. In fact, it is possible that Thomas and Partridge collaborated on the Reid purchases, since Thomas knew of Ford's interest in heraldic glass, having earlier in 1928 sold Edsel some panels, including the striking shield of Lord Beaumont (EEFH 4; Col. pl. 38), for the entrance stairwell (Col. pl. 36).

One need not necessarily characterize these two families, the Reids and the Fords, as wealthy Anglophiles surrounding themselves with heraldic emblems in the spirit of a new American aristocracy; rather their display of stained glass created an aura of continuity with an older time. Paul Bourget, a French observer at the turn of the century captured this feeling well: "In this country, where everything is of yesterday, they hunger and thirst for the long ago".[168] It is possible that heraldic pieces like those of the Fords were spied originally by these Americans when touring in England. In country churches of Lincolnshire such heraldry is still visible in the tracery lights of windows. At Billingborough and Wickenby, the arms of Beaumont form counterparts to the installation now in Grosse Pointe.[169] One wonders if the owners were aware that several of the shields were borne by women, such as Margaret Stanley (EEFH 11; Col. pl. 35), only daughter of the second Earl of Derby, who married Robert Radcliffe, Earl of Sussex, and attended the ill-fated Anne Boleyn. A Norfolk family is represented by the arms of Margery Clifton (EEFH 7; Col. pl. 39), whose family were bitter rivals of the Pastons, their cousins, in the rich wool-producing area of East Anglia.

While the breakup of English estates during and after World War I, represented an unusual opportunity for Grosvenor Thomas to buy English or Swiss heraldic panels, it also represented an unprecedented opportunity to buy Continental figural glass. The Midwest collectors profited from Thomas's purchases of such panels from the Costessey, Cassiobury, and Neave collections.[170] It was Englishmen of the early 1800s who had made the original investment in the stained glass that, one hundred years later, found new homes in America, but the intention and taste of the collectors differed. William Jerningham celebrated the return of public tolerance for Catholic practice by installing figural stained glass gathered from closed Continental monasteries and churches in his Gothic Revival chapel at Costessey Hall.[171] But in 1916, when William Mather was celebrating the establishment of an episcopal seat in Cleveland by building Trinity Cathedral, he rejected stained glass of the same character.[172] Grosvenor Thomas offered him six historiated panels from the Neave collection, but Mather chose instead to fill the lancets at either end of the

48

Plate 33.
ALBERT KAHN:
Edsel & Eleanor Ford
House, exterior,
1927–28

Plate 34.
ALBERT KAHN:
Gallery, Edsel &
Eleanor Ford House,
1928

Plate 35. *Heraldic Panel: arms of Margery Clifton, wife of John Wyndham* and *arms of Margaret Stanley, wife of Robert Radcliffe, Earl of Sussex,* 16th century after 1532. Grosse Pointe Shores, Edsel & Eleanor Ford House (EEFH 7 & 11)

(*below*) Plate 36. Stairwell landing window with four heraldic panels, 16th–17th centuries. Grosse Pointe Shores, Edsel & Eleanor Ford House (EEFH)

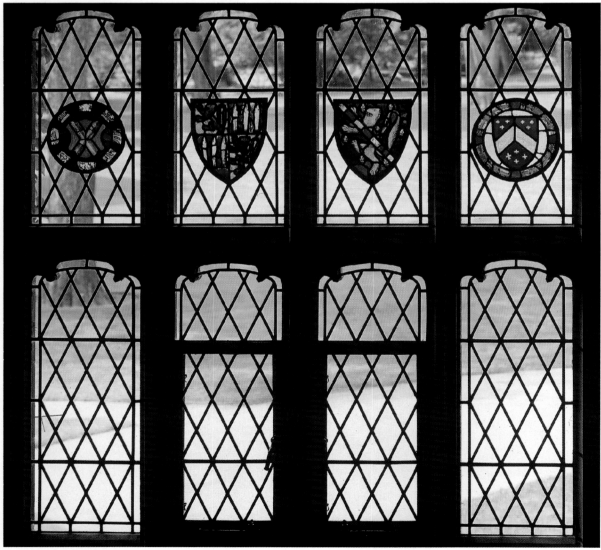

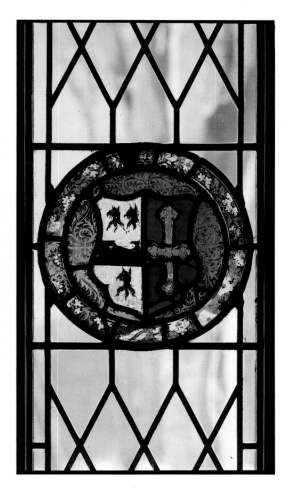

(*left*) Plate 37. *Arms of Richard Hals of Keynedon*, 16th century, second quarter. Grosse Pointe Shores, Edsel & Eleanor Ford House (EEFH 16)

(*right*) Plate 38. *Heraldic Panel: arms of Lord Beaumont*, mid-15th century. Grosse Pointe Shores, Edsel & Eleanor Ford House (EEFH 4)

(*left*) Plate 39. *Heraldic Panel: arms of Margery Clifton, wife of John Wyndham*, 15th century, third quarter. Grosse Pointe Shores, Edsel & Eleanor Ford House (EEFH 7)

(*right*) Plate 40. *Arms of Sir John Cheyne, Lord Cheyne*, 15th century. Grosse Pointe Shores, Edsel & Eleanor Ford House (EEFH 8)

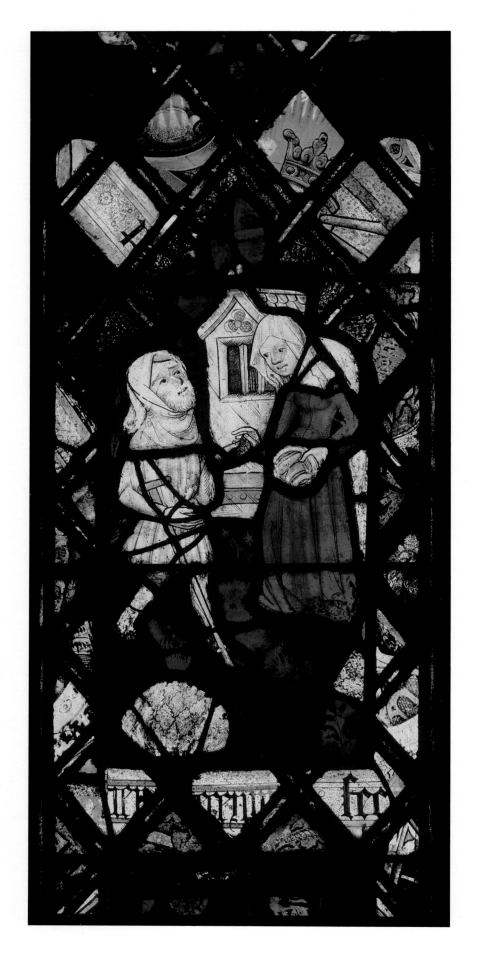

Plate 41. *St. Elizabeth of Hungary,*
15th century, third quarter.
Cleveland, Trinity Cathedral (TC 7)

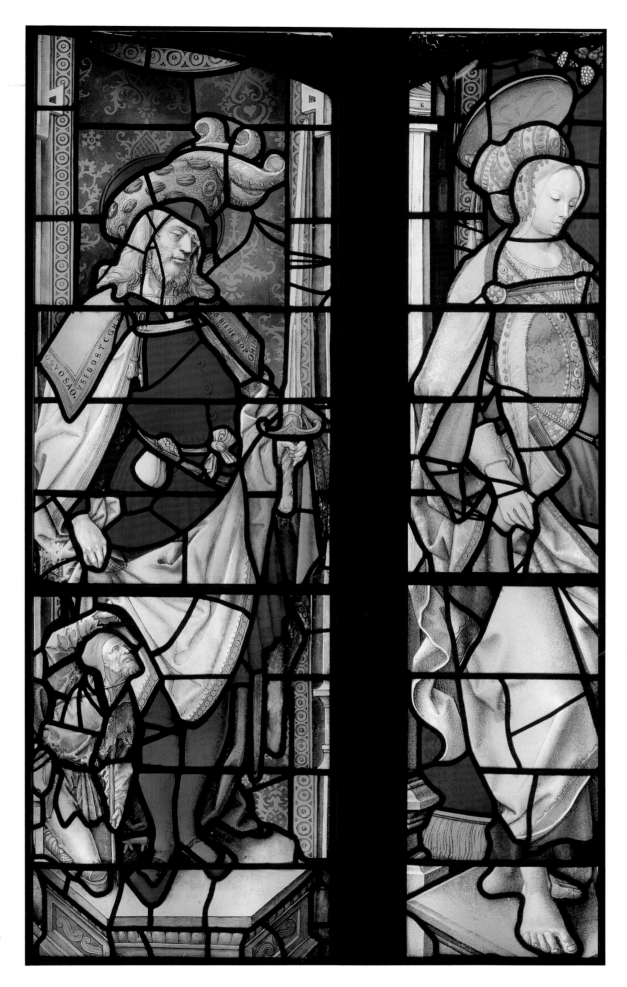

Plate 42.
St. Wenceslas of Bohemia, 1510–25.
Detroit Institute of Arts (DIA 25)

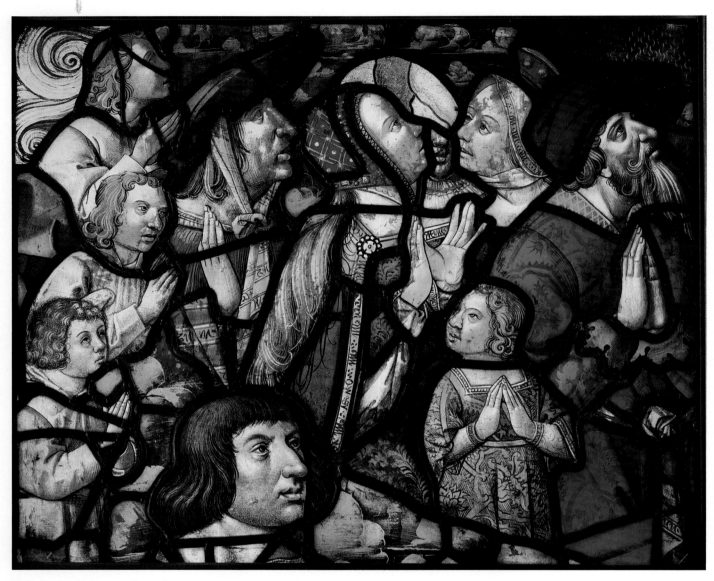

Plate 43. Fragments, early 16th century. Art Institute of Chicago (AIC 15)

Plate 44. *St. George*, second quarter of the 15th century. Cleveland Museum of Art (CMA 3)

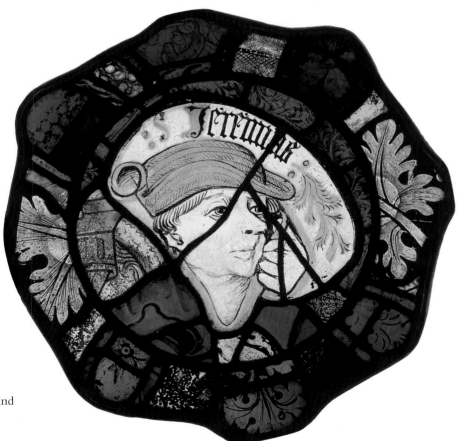

\Plate 45. *Jeremias, c.* 1525. Cleveland Museum of Art (CMA 11)

Plate 46. Chapel from the Château of Lannoy, Herbéviller, now in the Detroit Institute of Arts

transept with made-up panels of fourteenth and fifteenth-century English ornamental fragments and isolated figural elements, such as the image of *St. Elizabeth of Hungary* feeding the poor (TC 7; Col. pl. 41).

Two points are clear: first, Grosvenor Thomas was correct when he chose to promote the sale of his "ancient stained glass collection," especially rich in heraldic panels, many in genealogical series, to the American audience. Second, Thomas was an important "transfer agent," a latter-day Hampp, so to speak. Whereas, in the early nineteenth century, Hampp, joined by the antiquarian Stevenson, swept up complete Continental cloister or church furnishings of stained glass, so too, Thomas familiarized himself with English estates that were in decline and swept up the complete furnishings of the manor house and chapel. It was the spirit of nineteenth-century English antiquarianism and piety that initially preserved many Continental stained glass panels. For Thomas, in the twentieth century, there was both a spirit of preservation and an intuition that such glass could be passed on to an American clientele, newly enthusiastic about the pleasures of collecting and the Gothic Revival.

The American Home and European Glass

The pleasures of collecting are exemplified by three prominent Midwest manufacturing families, whose purchases followed the European models. Like their predecessors, they viewed the home as a setting for display. During the first quarter of this century in Cleveland the Mathers constructed their town house on Euclid Avenue, while in the suburbs of Detroit the Fords built a country home in Grosse Pointe and the Booths a manor in Bloomfield Hills. Fortunes that had been made in industry were invested in art and music, encouraged by both intense personal interests and the new American philanthropic impetus to view the support of culture as a civic responsibility.

THE MATHERS

Michigan and Ohio had grown quickly in wealth and population after the Civil War, in large part because of the industrial development of the states bordering on the Great Lakes. By the 1870s Detroit had its great copper and iron smelters, and was a manufacturing center for railway cars, stoves, pharmaceuticals and carriages. Its growth as the nation's center of automobile manufacture is one of the great American industrial legends.[173] By 1900 it ranked twelfth among American cities in size and population, and by 1920 it was fourth.[174] Cleveland had also enjoyed boomtown growth in the last third of the nineteenth century and the first decades of the twentieth. Samuel Mather was president of Pickands, Mather, one of the largest iron-ore mining and shipping firms on the Great Lakes. William Gwinn Mather, Samuel's brother, was president of Cleveland Cliffs Iron Co., which owned massive reserves of iron ore in northern Michigan and Minnesota. Together they brought the iron ore from the north and, with coal from the Appalachians, turned Cleveland into a great steel-making center.[175]

The Mathers built the Midwest industries and formed a new elite. In Cleveland, most of the grand new houses were on Euclid Avenue, a street that was compared in the local press to the Nevsky Prospekt and the other great avenues of Europe. Mansions in various styles, from Victorian Tuscan to Tudor, lined both sides. The independent and businesslike Flora Stone who grew up in one of them, married Samuel Mather, who, at his death in 1931, was reputed to be the city's richest citizen with a fortune estimated at over $100,000,000.[176] Their home (Text. ill. 14)

14. CHARLES SCHWEINFURTH: Home of Samuel Mather, Euclid Avenue, Cleveland, 1912

reflected their wealth and tastes. Designed by Charles Schweinfurth and decorated by Elsie de Wolfe, it included an office for Flora, who was an active patron of the city's charities, hospitals, and educational institutions.[177] The setting of the home and its surroundings were as important as the structure itself. It was set across Euclid Avenue from Trinity Church (TC ill. 1), also built by Schweinfurth, where a number of panels discussed in this volume were installed. Designed in an English fifteenth-century Gothic style, then a popular choice for ecclesiastical structures, Trinity was completed in 1907, but the medieval and Renaissance windows that complement the interior were installed slightly later.

The Mather residence was finished in 1912. Flora Stone Mather had died tragically in 1909 and never used the impressive new home. As attested by the receipts of purchases and the inventory of the furnishings, the house was provided with stained glass.[178] For the staircase landing, Mather bought two two-and-half-foot-square Renaissance windows on the theme of the Passion of Christ, *Christ in the Garden of Gethsemane* and the *Kiss of Judas* (CMA 16–17; Col. pl. 11), attributed here to

the Rhenish Abbey of Mariawald.[179] The realism of the Renaissance style may have been appealing, since Samuel's taste appears to have been firmly practical and Anglo-Saxon. He furnished his private rooms with old English furniture and bought books about English architecture and porcelain for his library. The styles of Louis XIV and the French rococo, on the other hand, were thought more suitable for Flora Mather's private rooms.

This hierarchy of styles followed a long-standing tradition. Almost a century before these Midwest homes were built, Lord Sudeley, whose collection of Swiss heraldic stained glass was to furnish important works for the Cranbrook Museum and the Detroit Institute of Arts, built a country seat, Toddington Castle, in the Gothic style. The furniture and decorative elements of different rooms, however, were modeled on other period styles. Although Gothic remained for the great hall, Elizabethan was used in the library and Louis XVI for the drawing room.[180]

Samuel's brother, William Gwinn Mather, built his home – Gwinn – on the shore of Lake Erie in Bratenahl, to the east of Cleveland. He could walk out onto his terrace and see the ships bringing ore into the port. Charles Platt, at one time an apprentice in the firm of McKim, Mead and White, designed this residence in the Italian Renaissance style. When viewed from the lake, it resembles the White House.[181] From 1913 to 1916, William Mather was negotiating with Grosvenor Thomas concerning the windows that are now in the east and west transepts of Trinity, and also stained glass for his home. Interestingly Mather consulted Platt in the process, who made drawings to show how the glass might be arranged, but left the decision as to which windows to buy to Mather. These panels are now in the Cleveland Museum (CMA 2, 12, 13, 19). Mather also acquired six panels that Thomas had not been able to use in the Trinity transepts (now CMA 3, 6, 7, 11, 23, 28).[182]

ELIZABETH MILLS REID

Other panels now in Midwest collections have had similar domestic provenances. *Four Grisaille Panels* (TMA 1–4), originally from Salisbury Cathedral, were once in the Grosvenor Thomas collection, and later acquired by Elizabeth Mills Reid. She had them installed in her home, Ophir Hall (Purchase, New York), which had been rebuilt by White after a fire in 1887. He imported large numbers of medieval and Renaissance panels. White was a partner in the most prestigious architectural firm of the period, McKim, Mead and White, and his use of stained glass in the firm's buildings, such as the Pierpont Morgan Library, New York City (finished 1907), was critical for the spread of this fashion.[183] Panels from J. Pierpont Morgan's collection not only decorated the Library but were also bequeathed to other institutions, notably the Metropolitan Museum.[184] Undoubtedly inspired by White, every room in Ophir Hall was fitted out with stained glass. In 1912, after White's death, a library was added to the house and Elizabeth Reid purchased the Toledo grisailles and installed them in the west window.[185]

GEORGE F. HARDING JR.

The major stained glass collector in Chicago was George F. Harding Jr. (1868–1939), who owned a city house that looked like a castle and functioned like a museum. Built by 1927, at 4853 Park Avenue, it displayed his collection to the public during his life and for more than two decades after his death. Harding's tastes were extraordinarily eclectic but his specialty was armor.[186] He inherited the impetus and the beginnings of the collection from his father. In addition to a strong interest in Italian work, he and Bashford Dean, then curator of Arms and Armor at the Metropolitan Museum of Art, purchased Spanish armor, including the famous Beardmore suit that had

belonged to Philip II.[187] Harding did not buy the stained glass merely to provide a background for his armor, as photographs of the interior of his house/museum show (Text ills. 15, 16). Rather his heraldic panels and roundels were installed in bull's eye windows among a welter of objects dating from various periods, including ship models, medieval and Renaissance furniture, and paintings and bronze sculptures by the artist of the American West, Frederick Remington.[188] The objects were arranged without any stylistic or chronological consistency, in a fashion that goes by the general heading of Victorian. More than likely, this phenomenon represents Harding's admiration for craftsmanship, in the manner pioneered by William Morris, as well as a typically American, Romantic attraction to distant times and places. In 1961, however, threatened by urban changes, the collections were put in storage. The house was destroyed in 1965 and, in 1982, the Harding collection was permanently transferred to The Art Institute of Chicago.

A similar collection of twenty-nine panels of stained glass, of Lowlands, Austrian, French, English, and German origin, dating from the twelfth through the seventeenth century, was amassed by George A. Douglass of Greenwich, Connecticut. After Douglass's death in 1995, three roundels and two pieces of leaded glass from his holdings entered an Indiana private collection. This will be dealt with in the volumes dedicated to New England collections.[189]

EDSEL AND ELEANOR FORD

Both the Edsel Ford and George Booth homes were vast suburban residences; but despite their scale, the spatial design and furnishings achieved a sense of intimacy. One has since become a museum, the other part of an educational and cultural complex. Edsel Ford (1893–1943) was the only child of Clara Bryant and Henry Ford, founder of the Ford Motor Company. He married Eleanor Clay (1896–1976) in 1916. Ten years later they constructed a sixty-room home set on a landscape promontory overlooking Lake St. Claire, modeled by Albert Kahn on English late medieval domestic architecture of the Cotswolds, in Gloucestershire (Col. pl. 33). Surrounding buildings included a gate lodge, implement shed, power house, and playhouse, all in the same late medieval style. "The stone for the shingles was imported from England and was split and laid by English artisans in the authentic Cotswold style of gradually decreasing size towards the peak. In order to give the house the long-established look and feel, moss was grown on the roof and English grape ivy was planted about the walls."[190] Begun in 1926, the building was finished in one year, but it took another year to custom-fit the architectural elements, such as the mantelpieces and wood paneling that had been imported from abroad. The family acquired panels of high authenticity. Most of the coats of arms can be dated to the life of their owners, for example John Cheyne, Lord Cheyne, KG (EEHF 8; Col. pl. 40). Ceilings were plastered with decorative motifs, such as Tudor strapwork on the curved vault of the Gallery (Col. pl. 34), that bring the wood floors, rugs, paneling, leaded windows, furniture, and paintings into a harmonious ensemble. In a division along gender lines, akin to that of the Mather home in Cleveland, Eleanor's sitting and dressing room were designed in French rococo, whereas those of Edsel, the sons, and the family recreation room were in a modern Art Deco by Walter Dorwin Teague. The Ford home, like Cranbrook, strove to combine the best of contemporary design with revivalist inspiration.

The Fords presumably became acquainted with William Valentiner, Director of the Detroit Institute of Arts, through Eleanor's first cousin, Robert Hudson Tannahill, who was a prominent collector of modern art. Later, in 1940, Tannahill would contribute an important work of

15 & 16.
Home of George F.
Harding, Jr., Chicago,
Lake Park Avenue;
interior showing
St. John and Donatrix.
(AIC 6), and *Christ
and the Samaritan
Woman at the Well.*
(AIC 7)

medieval art to the Institute, *Diptych with Scenes of the Life of Christ*, a Parisian ivory carving dated 1325–50,[191] as well as paintings by Cézanne, Gauguin, Degas, and Picasso, among others, and establish the Robert H. Tannahill Foundation Fund.[192] Significant medieval sculptures were given to the Museum by the Fords: in 1927 the marble *Virgin and Child*[193] by Nino Pisano, 1350–60, and in 1930 the polychrome wood *Virgin and Child Enthroned*[194] from Italy, 1200–50. In 1961 Eleanor Ford gave an oak sculpture depicting the *Lamentation*[195] from Brussels, 1460–70. These remain highlights of the medieval collections. The Fords did not bequeath any stained glass to the Museum, as their own collection had been acquired for specific architectural installation in the Great Hall and main stairwell, but Eleanor Ford's will transferred many other important works purchased for their home to the Detroit Institute of Arts. Edsel served as a member of the Arts Commission from 1924 until his death in 1943, and Eleanor from 1943 through 1976.

WILLIAM R. VALENTINER

The influence of William R. Valentiner, who served as advisor to the Detroit Institute of Arts from 1921, and as director from 1924 to 1945, was pervasive. He was one of the major forces in the transformation of the American museum into a world-class institution. In a fifty-two-year career, he served the Metropolitan Museum of Art, Detroit Institute of Arts, Los Angeles County Museum of Art, J. Paul Getty Museum, Malibu, California, and North Carolina Museum of Art. Born in Karlsruhe, Germany, in 1880, Valentiner studied at the university of Heidelberg where he was introduced to the Jugendstil and the French Impressionists and developed a life-long interest in Rembrandt and painters of the Lowlands.[196] In 1906 he became the assistant to Wilhelm von Bode, Director of the Kaiser Friedrich Museum, Berlin. Valentiner came to the United States in 1908 after being selected by J. Pierpont Morgan to install the Hoentschel collection at the Metropolitan Museum, where he was appointed Curator of Decorative Arts. In 1913 he founded the journal *Art in America*. Valentiner affected the collecting of many prominent patrons, such as Eleanor and Edsel Ford, Ralph Harman Booth, George G. and Eleanor Scripps Booth, and Julius Haass. Along with this demonstrable interest in medieval art and paintings of the Lowlands, Valentiner collected and supported German Expressionist art. He arranged the first exhibit of German Expressionists in the United States at Anderson Galleries in New York in 1923. In 1937 he mounted a loan exhibit of the works of Ernst Ludwig Kirchner for Detroit. By way of context, the Museum of Modern Art purchased Picasso's *Demoiselles d'Avignon* in 1939. In California in 1948, Valentiner arranged for the loan of a Max Beckmann show for the Los Angeles County Museum of Art. The exhibition had been organized by Perry Rathbone, once Valentiner's assistant in Detroit, then Director of the St. Louis Art Museum.[197]

A review of Valentiner's career reveals basic themes that encouraged the inclusion of stained glass in the canon of the great art museum. His early experience as a curator included work in the decorative arts, for example an exhibition of Oriental rugs at the Metropolitan Museum in 1910.[198] Despite his deep expertise in the painting of the Lowlands, he avoided any hierarchical bias concerning media, supporting the acquisition of the stained glass roundel, as well as the oil painting and the print. Three Lowlands roundels were acquired in 1936: a panel of the *Huntsmen and a Dice Thrower* (DIA 42), presumably after Dirick Pietersz. Crabeth, North Lowlands, Gouda, 1549–60; a roundel of the *Last Supper* (DIA 31; Col. pl. 18), after Jacob Cornelisz. van Oostsanen, North Lowlands, Amsterdam, 1514–25; and a splendid *Flight into Egypt* (DIA 32; Col. pl. 19), attributed to the Master of the Seven Acts of Charity, Pieter Cornelisz., North Lowlands, Leiden,

54

1515–25. The Museum's acquisition of the Renaissance panel of the Nativity (DIA 30; Col. pl. 15) by Guillaume de Marcillat in 1937 also demonstrates Valentiner's breadth of artistic interests.

The bridging of historical and modern taste is evident from remarks that he made at the opening of the Detroit exhibition of works on loan from the New York World's Fair art exhibit, on 10 November 1939. Due to the outbreak of World War II, the objects had not been returned to Europe as scheduled, and Valentiner seized the opportunity. He suggested that Hieronymus Bosch's *Temptation of St. Anthony* would be as popular with Detroit visitors as it had been with the crowds in New York because of the imaginative subject matter – a subject matter also found in modern Surrealism.[199] In *Origins of Modern Sculpture*, published in 1946, Valentiner was explicit about his conviction of the common aesthetic formula for art of the past and the present, not simply the primitive inspiration frequently cited by modernist critics, but the Western European art of the Middle Ages and later.[200] He juxtaposed the sculpture of Wilhelm Lehmbruck with medieval statues from Nuremberg and that of Georg Kolbe with Benin bronzes. He cited the Detroit marble *Virgin and Child* by Nino Pisano as a model of painted works, and connected Diego Rivera, whom he commissioned to paint murals for the Museum in 1931, to Morris Graves.[201]

Valentiner's enthusiasm for the Expressionists, in particular the woodcuts of Karl Schmidt-Rottluff, who made a woodcut portrait of him, resonates with his taste for the abstraction inherent in late medieval German art.[202] He had published a study on Schmidt-Rottluff in 1920, and two years later one on the sculptor Kolbe.[203] The late medieval stained glass purchased during his tenure share some of their qualities. Most significant are the *Three Standing Figures of Saints* (DIA 19–21), acquired in 1931 with income from the Edsel B. Ford Fund of the Founders Society, and the *Three Marys* (DIA 4; Col. pl. 7) from the Carmelite Church of Boppard-am-Rhein, acquired in 1940 with funds from the Anne E. Shipman Stevens Bequest. Valentiner's description of Schmidt-Rottluff's woodcut of *St. Francis* of 1919 might be an analysis of the head of St. Andrew (DIA 19): "mit welcher Sicherheit ist auf der Fläche Hell und Dunkel verteilt, mit welcher Energie sind die Konturen durchgezogen, wie schlagen die Streiflichter gleich Blitzen über die Fläche" (With what sureness are dark and light divided on the plane, with what energy are the contours drawn, how like lightning does the spotlight hit over the planar surface).[204] The vocabulary is evocative of the most progressive concepts of design; resonating with that of Wassily Kandinsky's seminal publication for the Bauhaus, *Punkt und Linie zu Fläche*, of 1926. Valentiner combined the nineteenth-century and the modern concept of "the museum" in that, for all his modernity, he saw art as an index of a nation's culture, and a means of demonstrating the continuity between historic and contemporary cultures. All important art, he would claim, is the "höchster Ausdruck der Ideen der Zeit und des Volkes" (best expression of the ideas of the period and the people).

GEORGE GOUGH BOOTH AND THE CRANBROOK COMMUNITY

George Gough Booth (1864–1949) also believed in continuity between past and present artistic expression, especially in the art of design, as discussed previously. In the early 1900s he and Eleanor Warren Scripps Booth (1863–1948) purchased a 300-acre farm about 25 miles north of downtown Detroit as the site of their home. Booth's father had emigrated from the village of Cranbrook in Kent and both the craft traditions of the Booth family and nostalgia for the values of the rural village encouraged the selection of the same name for the American site. The Booths first constructed a family residence, Cranbrook House, in 1908, and a library wing in 1918, in a half-timbered English style by Albert Kahn, the architect who went on to design the Edsel and

Eleanor Ford house. In the early 1920s, began the complex development of what would become Cranbrook Community, a project that reflects Booth's long-term involvement in art education and the promotion of both the study and application of design. He was aware of current programs in architecture and design on the Detroit and University of Michigan campuses, but was interested in promoting an educational community that would have as its focus the practical training and appreciation of a broad range of crafts. A trip to Europe in 1922, when he made his first purchases of stained glass, was a fact-finding mission on the status of the arts and art schools. His choice of the Finnish architect Eliel Saarinen as the first director of Cranbrook Academy was carefully considered. Saarinen came recommended both by Albert Kahn, who had brought him to the University of Michigan as visiting lecturer in 1923, and by Booth's son Henry, who had been a student in the architectural school and a member of Saarinen's first undergraduate seminar.

The Cranbrook Community was envisioned as a complex of institutions to display, as living museums, the material and spiritual values of education in a broad range of arts. The experiment was to encourage interplay among authentic objects from the past, historicizing styles, and contemporary design. Christ Church Episcopal, originally an integral part of the community, was designed by Bertram G. Goodhue Associates in an English Gothic style, and an elementary school called Brookside School Cranbrook was built in half-timbered style like Kahn's Cranbrook House. The church includes replicas of medieval sculpture, as well as authentic della Robbia terra-cotta relief sculpture, sixteenth-century French and Italian woodwork, carvings by the contemporary American John Kirchmayer, Pewabic tile and mosaics from Detroit, and Morris & Co. tapestries from London, to cite but a few of the furnishings. The artists for the stained glass were key figures in the American Gothic Revival of the 1920s, including G. Owen Bonawit (New York), J. Gordon Guthrie (New York), Wright Goodhue (Boston), and Nicola d'Ascenzo (Philadelphia). The Cranbrook School (preparatory school for boys), Kingswood (preparatory school for girls), Cranbrook Institute of Sciences, and the Cranbrook Academy of Art, however, were designed by Eliel Saarinen in contemporary style.

OBERLIN COLLEGE AND ANN ARBOR

Oberlin College's Allen Memorial Art Museum, designed by Cass Gilbert (Text ill. 17) and finished in 1917, was built to resemble a Renaissance villa. Like Kahn's Cranbrook House, it was decorated throughout with period reproductions, including glazed terra-cotta tympana in the della Robbia mode and Elizabethan woodwork. Stone arcades with composite capitals define the exterior and the main hall, a two-story structure off which the other rooms branch. Much of the funding came from the bequest of Dudley P. Allen (d.1915) through his widow Mrs. F. F. Prentiss. Both played a major role in founding and building the collection of the Cleveland Museum as well; the Allen fund financing the purchase of the Museum's panel of *St. Catherine with Kneeling Male Donor* (CMA 4–5; Col. pl. 25).

The use of stained and leaded glass for the embellishment of domestic architecture is echoed by other sites of Booth's acquaintance.[205] The University of Michigan at Ann Arbor saw the construction of its Law Quadrangle from 1919 through 1933.[206] Despite the somewhat rigorous Gothic mode, the effect of setting Arts and Crafts medallions in a grisaille or quarry surround was quite similar to Renaissance traditions. Stained glass is particularly prominent in the Legal Research Building and dining hall, the latter based on the late medieval model of King's College Chapel at

Cambridge. The figural windows at King's, executed in fully saturated pot-metal colors, were eschewed in favor of a secular model, heraldic medallions in a quarry surround, in one location on the theme of the signs of the Zodiac.[207] The architect Philip Sawyer wrote that he had studied old windows in Oxford colleges and at the Victoria and Albert Museum to learn how to design glass. Admiration for authentic heraldic glass, such as that purchased by the Fords, was at the base of these contemporary constructions in the English heraldic mode. Revival styles incorporating heraldic shields or *Kabinettscheibe* panels were also popular at contemporary East Coast colleges. At Yale, Owen Bonawit executed glass for the architect William Gamble Rodgers; at Boston College, Earl Sanborn glazed the Babst Library for architects Maginnis and Walsh; and at Princeton, Charles Connick and William Willet, among others, installed glass for the buildings of Ralph Adams Cram.[208]

WILLIAM RANDOLPH HEARST

The collecting of William Randolph Hearst (1863–1951), although not for a "home" in the Midwest, nonetheless merits inclusion here. Hearst, publisher, editor, and political figure, was born in San Francisco and died in Beverly Hills. He was the son of George Hearst, who had made a fortune in mining, had served in the United States Senate, and was the owner of the *San Francisco Examiner*. After studying two years at Harvard, William left college for his father's newspaper; two year later he was running it. By 1925 he had built up a newspaper and journal chain with dailies,

17. CASS GILBERT: Oberlin College's Allen Memorial Art Museum

including the Chicago *Examiner*, in seventeen cities, and magazines such as *House Beautiful*, *Harper's Bazaar*, and *Cosmopolitan*. He was also collecting art assiduously, in particular large-scale furniture, tapestries, and stained glass, and was building residences, San Simeon in southern California (1919–25) and Wyntoon in northern California (1930);[209] these will be discussed in the Corpus Vitrearum volume dedicated to California's public collections. Had his collections on both the West and East Coast remained intact, they would have constituted the largest holding of stained glass in the United States, outside of the Metropolitan Museum and the Cloisters. With rare exceptions, it had not been installed in his residences, although Hearst was well aware of the extent of his collection, and had plans for its display.[210]

Pressed by business concerns and inheritance taxes, however, he began to sell off his panels during his lifetime. He made major gifts to several California institutions. In 1941 Gimbel Brothers, a department store in New York, organized a sale of 199 lots of Hearst stained glass at the Hammer Galleries, at which the Allen Memorial Art Museum, Oberlin College, purchased its Stendhal panel (OCAM 1). Most of the glass came from the Hearst warehouse in the Bronx. Despite the reduced prices – panels that once cost several thousands selling for several hundreds – the sale was very slow with only half of the lots purchased. In 1943 Gimbel's offered an 80 percent reduction on the unsold lots. The Detroit Institute of Arts acquired twenty works of stained glass from the Hearst Foundation in 1958 (DIA 23–27, 35–38, 41, 43–44, 45–46, 50–53, 54–62, 63–64, 65), many, like the *Martyrdom of St. Eustache*, large-scale, multi-sectioned windows. It was the most significant single acquisition for the Museum and made it a major site for the display of the medium.

Reconstructed Panels and Art as Education

After the 1876 Centennial Exhibition in Philadelphia, America witnessed a movement to develop the crafts as a means of social welfare. Approximately thirty societies came into being, largely due to the efforts of Candace Wheeler, a one-time associate of Louis Comfort Tiffany in the Associated Artists.[211] The Chicago Society of Decorative Art, founded in 1878, had as its goal the education of women to use their skills to create hand-crafted objects, mostly needlework, so that they could support themselves.[212] In Cincinnati, an organization of the same genre led directly to the foundation of the Art Museum as early as 1886. Eventually the Antiquarian Society, the descendant of the Society of Decorative Art, gave up its function as a marketing center for women's handicrafts and devoted itself to education. Establishing a fund in 1891 for the acquisition of works of decorative art for the museum, the Society was responsible for notable purchases, including a fourteenth-century gilded silver altar cross from the Guelph treasure.[213] In 1930 the fund supported the purchase of *Praying Figures and Donor* (AIC 15; Col. pl. 43),[214] predating by almost a decade the acquisition of other works in stained glass. The very first panel bought for the Art Institute, then, was connected to an interest in the decorative arts for their social and economic function.

The panel of *Praying Figures and Donor* is a reconstruction using fragments of a single window or, very possibly, fragments from several windows in the same series. When the work was acquired, however, it was not viewed as an object in a fragmentary state. It was seen rather as representing a selection of the best elements in a painting, much like the page from a great draftsman's notebook. Drawings are still prized by collectors, even if they are not complete compositions, for example, the studies of the human body in Leonardo's notebooks in the Royal Library,

Windsor Castle. Cleveland's two heads, *St. George* (CMA 3; Col. pl. 44) and *Jeremias* (CMA 11; Col. pl. 45), although framed separately, are treated very much like the *Praying Figures and Donor*. William G. Mather bought the panels, with finely drawn heads from England and the Lowlands surrounded with similar borders, from Grosvenor Thomas in 1915. The result recalls a framed drawing, quite similar to the manuscript reconstructions popular with collectors in the mid-nineteenth century.[215]

What the Antiquarian Society purchased, however, can also be characterized as a "teaching panel," showing a variety of heads and torsos similar to other such reconstructions produced by studios with access to historic stained glass in a fragmentary state.[216] This Chicago panel had a distinguished pedigree. It was once part of the collection of the Earl of Carrington, Wycombe Abbey (Buckinghamshire) and later in the possession of Ambrose Monell, Tuxedo Park, New York, until 1930. It is also finely executed, its three-dimensional Renaissance modeling of the heads showing sensitive chiaroscuro, fluidity in the stickwork and trace lines in hair and beards, and the enriching use of sanguine. Many other such head panels were assembled. The Department of European Sculpture and Decorative Arts at the Metropolitan Museum, the Glencairn Museum, and the Harvard University Arts Museums, Busch-Reisinger Collection, all possess such compositions.[217] The Worcester Art Museum's teaching panel and that of the Royal Ontario Museum, Ottawa, are a different but interesting type, set up as a grid where fragments of different periods illustrating techniques and styles of the different periods are arranged in chronological order, from the simple pot-metal and bold trace of the thirteenth century, to the three-dimensional modeling and enamel embellishment of the seventeenth.

The appearance of such a composition is remarkably evocative of sheets of Renaissance drawings, such as the *Study with Twenty Heads* (Text. ill. 18) by the Master of the Death of Absalom, about 1500–1510.[218] Constructions like these take us back to the traditions that first animated Gérente's studio, discussed above, where ecclesiastics, amateurs, and artists visited to see authentic examples of the art of the past as a basis for reconstructing a modern world. The foundation of the Victoria and Albert Museum represents another effort to bring the arts of the past into the service of the present. The architect of the University of Michigan's Law School, Philip Sawyer, used the museum to just that purpose.

Exhibiting Stained Glass

Stained glass, an inherently period object, has been displayed in different ways. Two approaches divide exhibition policy, one, to construct an historic setting for the object, the other, to display it in a neutral setting that emphasizes its intrinsic impact. However well executed each installation may be, these opposing concepts of display inevitably overlap. No object can be on display in a museum and still be within a period setting, giving us a true context of use. Neither do works of art communicate totally as self-sufficient entities, but are conditioned by what is displayed around them and the vantage point of the spectator. Nonetheless, the Midwest collections display very satisfying examples of both exhibition policies.

In Cleveland, fifteenth and sixteenth-century stained glass is installed in a large window in Gallery 215, which also contains a selection of fifteenth-century panel paintings and sculpture, including works of Albrecht Bouts, Gerard David, and Tilman Riemenschneider.[219] The synchronic display creates an evocative ambiance for the thoughtful viewer. The Toledo Museum of Art chose

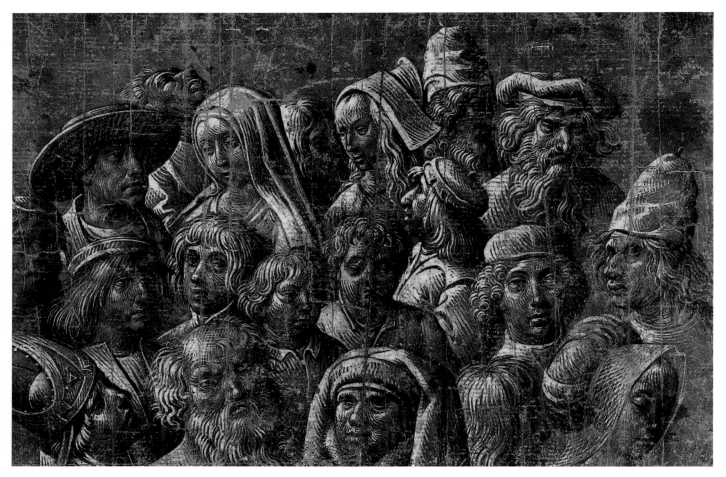

18. MASTER OF THE DEATH OF ABSALOM: *Study with twenty heads, c.* 1500–10, Amsterdam, Rijksmuseum, Rijksprentenkabinet

its cloister as the site for three panels, the *Crucifixion* (TMA 7; Col. pl. 10), almost three and a half by two feet, and the two large standing figures of a *Bishop Saint* (TMA 5) and *Deacon Saint* (TMA 6; Col. pl. 4), each over six feet high. The *Crucifixion* was designed for a cloister, and the standing saints for a chapel where the viewer could see them intimately. The Toledo cloister incorporates twelfth- and thirteenth-century capitals from Espira de l'Agly (Roussillon) or a site associated with a Cuxa workshop, in the Pyrenees; Saint-Pons-de-Thomières (Hérault); as well as late fourteenth- or early fifteenth-century arches from Notre-Dame-de-Pontaut (Gascony).[220] Installed in 1932, it dates one year after the completion of the cloister in the Philadelphia Museum of Art.[221] The opportunity for American collectors to acquire such important architectural works came after World War I; a catalyst for the display of such large-scale works was the erection of the Cloisters sales gallery of George Grey Barnard in Washington Heights, New York.[222] Barnard finished his structure in 1914, at which time it was open to the public. The Metropolitan Museum acquired it in 1925.[223]

William R. Valentiner was intimately involved in determining appropriate settings for works of art in the Detroit Institute of Arts. The superb early sixteenth-century chapel from the château of Lannoy, Herbéviller, in Lorraine, France (Col. pl. 46) retains much of its original glazing in the tracery lights and lancet heads. Negotiations for the acquisition of the Lannoy chapel began in 1922, and the completed installation was open to the public on 7 October 1927. Valentiner's ideas on the installation of such works in museums are revealed in his correspondence in 1931 with John D. Rockefeller Jr., who asked for advice on building the Cloisters Museum in New York.

60

Valentiner urged the installation of works in many media within the same gallery: "What would be more impressive than to see, next to Romanesque and Gothic sculpture, representations of the art of miniatures, of glass paintings, of tapestries and textiles?"[224] He expressed disapproval, however, of recreating period-style objects: "every imitation (of the medieval style) will prove to every sensitive person that the essentials, the spiritual side of it, which alone has value, are entirely lacking."[225] Rockefeller did not heed Valentiner's injunction to avoid mixing authentic works and recreations, although he and others evidently approved of exhibiting different media together. Cross-media juxtaposition was achieved for the Lannoy chapel through the acquisition of stained glass in 1948. By the insertion of twelve bust-length portraits of *Prophets and Psalmists* (DIA 5–16; Col. pl. 5) created in Cologne about 1460, set in modern strapwork surrounds, the chapel is given a sense of aesthetic completeness. No other setting in the museum attempts a period placement for stained glass.

Valentiner's philosophy has been applied with success in recent times. During the 1980s, the Northern Renaissance and English and Renaissance galleries in Detroit were renovated. Peter Barnet, then Associate Curator, and Alan Phipps Darr, Curator, Department of European Sculpture and Decorative Arts, guided a remarkably sensitive installation of objects that juxtaposes minor arts, panel painting, sculpture, and large and small-scale works in stained glass. The principle of representing all media, but in contemporary museum spaces, not architectural replicas, echoes

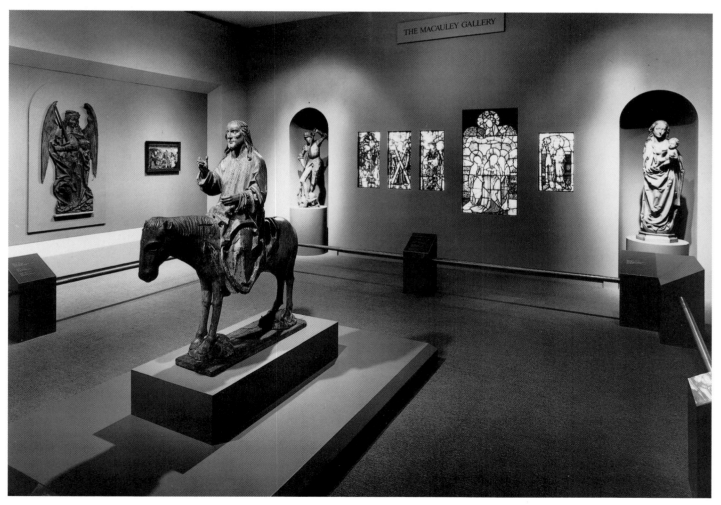

19. Renaissance gallery (Macauley Gallery), Detroit Institute of Arts

Valentiner's suggestions for the Cloisters. The Detroit rooms do not attempt a reconstruction of a period setting, but juxtapose objects as they would have been in normal use. The view of the Macauley Gallery (Text. ill. 19) shows windows aligned to evoke the massing of color in the side of a church, with figures of the Virgin and Child and St. George, intended for three-quarter views, set in niches to orient the modern spectator. The wall carries a painted panel whose color and narrative subject connect to the stained glass. By placing the three-dimensional sculpture of a *Palm Sunday Effigy of Christ on a Donkey*[226] in the center of the room, its original mobility is evoked, for it would have been brought into a church, past the stained glass to an altar embellished with a painted retable.

Medieval and Renaissance stained glass in the United States is imported and obviously therefore not in its original context. It is now in museums, residences, and churches. Hence the Corpus Vitrearum volumes serve simultaneously as art-historical documentation, museum catalogues, and narratives of collecting. Gothic Revival taste, a mid-eighteenth-century English development, begins the modern fascination with the stained glass medium. This appreciation gained momentum as it spread across the English Channel and eastward ultimately as far as Russia. The market for old glass developed simultaneously with the supply in the eighteenth and nineteenth centuries, and reached the United States with the Arts and Crafts movement. Henry Adam's influential *Mont-Saint Michel and Chartres* cemented the taste of educated American collectors who felt a need to implant themselves in a diachronic continuum. They bought and created space for the different varieties of stained glass panels that continue to speak to us on emotional as well as intellectual levels. The Midwest "captains of industry" acquired windows both to decorate their homes and to enhance the collections of the museums that they supported.

The modern interest in old stained glass has brought with it inevitably chicanery and profiteering, resulting in the production of copies and combinations of old and new glass. Hence the need for the close reading and charting of its material aspect. This critique of authenticity goes hand in hand with the ongoing theoretical analysis of stained glass. Of high contemporary interest are the complexities and varieties of organization in medieval and Renaissance narrative panels, exemplifying the demands of educated patrons and the skills of designers. Questions of workshop practice, and the use of varied types of patterns for the serial production of windows, may be related to economic issues and the wider late medieval mass production of art objects. Corporate history, namely that of families and ecclesiastical and political institutions, constitutes the literal subject matter of heraldic panels. Beyond the scope of textual sources, the Swiss and South German panels in particular, reveal the complexity of sixteenth and seventeenth-century experiences in different social strata. Indeed, if something is to be said in the end, in praise of this medium, it is its ability to integrate the decorative and the architectural elements of our built environment and to explain our past, becoming a text, more complex, compelling, and seductive than words.

NOTES

1 *Artistic Integration in Gothic Buildings*, ed. Virginia Raguin, Kathryn Brush and Peter Draper, Toronto, 1995; Caviness 1990.

2 Millard F. Hearn, "Canterbury Cathedral and the Cult of Thomas Becket," *AB*, 76, 1994, pp. 19–52.

3 Luchs 1985.

4 Caviness 1990, pp. 107–17, quote on p. 116.

5 Helen Zakin, "Light and Pattern: Cistercian Grisaille Windows," *Arte medievale*, 2nd ser., 8/2, 1994, pp. 9–22.

6 Bernard McGinn, "From Admirable Tabernacle to the House of God: Some Theological Reflections on Medieval Architectural Integration," in *Artistic Integration in Gothic Buildings*, ed. Virginia Raguin, Kathryn Brush and Peter Draper, Toronto, 1995, pp. 41–56, quote p. 54.

7 Anca Vasiliu, "Le mot et le verre: une définition médiévale du 'diaphane,'" *Journal des Savants*, Jan.–June 1994, pp. 135–62.

8 *The Mystical Theology and the Celestial Hierarchies*, 2nd ed., trans. The Editors of the Shrine of Wisdom, Fintry, Brook, near Godalming, Surrey, 1965.

9 Meredith Parsons Lillich, "Monastic Stained Glass: Patronage and Style," in *Monasticism and the Arts*, ed. Timothy Gregory Verdon, Syracuse, 1984, pp. 207–54. Lillich analyses the 9th-century translation of *On the Celestial Hierarchies* produced for Abbot Hilduin, and used by Suger, where the color blue is rendered as the image of the Godhead's "hidden light." See also John Gage, "Gothic Glass: Two Aspects of a Dionysian Aesthetic," *Art History*, 5/1, March 1982, pp. 36–58.

10 *De Administratione*, XXXIII: Panofsky 1979, pp. 21, 63.

11 Michelangelo Buonarotti, *Complete Poems and Selected Letters*, trans. Creighton Gilbert, New York, 1963; Robert J. Clemens, *The Poetry of Michelangelo*, New York, 1965, pp. 228–37; William E. Wallace, *Michelangelo. Selected Scholarship in English*, 5 vols., Hamden, Conn., 1995.

12 *The Poetry of Michelangelo*, annotated trans. by James M. Saslow, New Haven, 1991, pp. 32, 239, Sonnet 107, c. 1534–42.

13 Marbode of Rennes, *P.L.* clxxi, 1735–70; Marbode of Rennes, *De Lapidus ... together with Marbode's Minor Works on Stones*, ed. and trans. John M. Riddle, Wiesbaden, 1977; Joan Evans, *The Magical Jewels of the Middle Ages*, Oxford, 1923, pp. 33–7, 54–94.

14 *Rationale Divinorum Officiorum*, trans. John Mason Neale and Benjamin Webb, *The Symbolism of Churches and Church Ornaments*, Leeds, 1843, p. 22.

15 Panofsky 1979, pp. 102–3. "Certain persons also (deposited) gems out of love and reverence for Jesus Christ, chanting: 'Lapides preciosi mones muri tui.'" Panofsky identifies the text as appearing in the Roman Breviary, *Commune Dedicationes Ecclesia*, 5th antiphon, that continues "et turres Jerusalem gemmis aedificabuntur" (and the towers of Jerusalem shall be built of gems).

16 Honorius Augustodunensis, *P. L.* series 2a, 1854, clxxii, 1109–76. Durandus compared glass windows to the Holy Scriptures, which expel all things hurtful but admit "the light of the True Sun, that is God, into the hearts of the faithful," *The Symbolism of Churches*, as above (n. 14), p. 28.

17 *The Symbolism of Churches*, as above (n. 14), p. 29.

18 See Millard Meiss, "Light as Form and Symbol in some Fifteenth-Century Paintings," *AB*, 27, 1945, pp. 175–81. For the Miracle of Theophilus, see Léon Clédat, *Rutebeuf*, Paris, 1902, p. 78; Zakin 1979, pp. 145–9.

19 Brown 1992, p. 94, ill.; Snyder 1985, pp. 120–2, pl. 19.

20 Marks 1993, p. 127; Marks 1996.

21 See Vasiliu, as above, n. 7, pp. 155–60.

22 Rode 1974, pp. 149–62, pls. 19–23, figs. 358–410.

23 Von Witzleben 1977; see below Trinity 1–2, TMA 7, DIA 5–16.

24 Conrad 1969, p. 99.

25 *Mémoire de verre*, ills. on pp. 5, 15, *et al.*

26 *Thomas à Kempis writing the "Imitation of Christ"*, Bruges, shortly after 1481, made for Baudouin de Lannoy, Vienna Österreichische National-bibliothek, Cod. 1576, fol. 9; Christopher de Hamel, *A History of Illuminated Manuscripts*, London, 1986, rev. ed. 1994, fig. 208.

27 Wayment 1988, pp. 60ff, 70–4, pls. 2, 3; see below, CMA 12–15.

28 See below, CMA Introduction and nos. 12–15.

29 The Cleveland Museum owns three marble sculptures of mourners carved by Claus Sluter and Claus de Werve for Philip's tomb, which was formerly inside the church. Sluter's famous *Well of Moses* stands in the center of what used to be the cloister, and the paintings that were commissioned for it are now in various museums. Kathleen Morand, *Claus Sluter: Artist at the Court of Burgundy*, London and Austin, 1991; Christian de Mérindol, "Art, spiritualité et politique: Philippe de Hardi et la chartreuse de Champmol, nouvel aperçu," *Les Chartreux et l'art: XIVe–XVIIIe siècle*, Paris, 1989, pp. 93–115; Snyder 1985, pp. 64ff; Cuttler 1968, pp. 21–5; Wixom 1967, pp. 234–5, 238–9, 256–7, nos. VI 10, 12, 21; *The International Style: The Arts in Europe around 1400* [exh. cat., WAG, 23 October–2 December], Baltimore, 1962, pp. 24–8, frontispiece, pls. IV–V.

30 Pirina 1986.

31 Marchini 1956, pp. 14–21 for upper church, 21–9 for lower; Hans Belting, *Die Oberkirche von San Francesco in Assisi*, Berlin, 1977, pp. 45–50; Frank Martin, *Die Apsisverglasung der Oberkirche von S. Francesco in Assisi. Ihre Entstehung und Stellung innerhalb der Oberkirchenausstattung*, Worms, 1993.

32 Marchini 1956, pp. 43–52.

33 Luchs 1985.

34 Mancini 1909.

35 Helbig and Vanden Bemden 1974, pp. 275–81; Wayment 1972, passim; id. 1988, pp. 60, 204–5, no. 51a; Konowitz 1987; id. 1995; Cole 1993, passim.

36 For illustrations and bibliography, see Husband 1995, pp. 198–211; Vanden Bemden 1994, pp. 39, 41, 44, n. 16; Henny van Harten-Boers and Zsusanna Ruyven-Zeman, *The Stained Glass Windows in the Sint Janskerk at Gouda: The Glazing of the Clerestory of the Choir and of the former Monastic Church of the Regulars*, Corpus Vitrearum, The Netherlands, 1, Amsterdam, 1997, pp. 7, 16, 22, 26–7, 35–6, 46–50, 101–2, 113–17, 127–37, pls. 1–2, 4, 6–12, figs. 5, 8–10, 14–16, 20–4, 27–39, 62–5, 67–113.

37 Konowitz 1990/91. Research in this field has been facilitated by the establishment of the Fichier International de Documentation du Roundel, begun in 1976 and now, with 2,000 entries, housed in the Institut Royal du Patrimoine Artistique in Belgium. This international resource seeks to group related material around each roundel, including prints, drawings, and other known versions of the same composition.

38 Husband in *Checklist IV*.

39 Naumburg Room, glass XXVIII, window sII CI, Caviness in *Checklist I*, p. 55.

40 Naumburg Room, glass VII, window sI CI, Caviness in *Checklist I*, p. 55; and LACMA 45.21.36, Hayward in *Checklist III*, pp. 78–9.

41 Robert Branner, *Manuscript Painting in Paris during the Reign of Saint Louis*, Berkeley, 1977, esp. p. 47.

42 Alexander 1992, p. 101, mentions an "easily copied style may have made it attractive to the newly developing class of lay illuminators."

43 Metropolitan Museum ESDA 41.190.439–46, Husband in *Checklist IV*, pp. 165–6.

44 Cloisters 32.24.1–8, Husband in *Checklist IV*, pp. 130–1.

45 Cloisters 32.24.67, Husband in *Checklist IV*, p. 152; Husband 1995, p. 76–7, no. 21, pl. 7. The inscription should be turned 180 degrees, so that it begins with *Bemit*.

46 *Bemint dat recht, dat onrecht haet/ Ende des wÿsheits lich anthiert./ So zalt voortgaen wat ghÿ bestaert,/ Ghÿ die volck ende lant regert.* Explication of the inscription was provided by Wim van Anrooij, through the kind assistance of Gary Schwartz and Myra Orth.

47 Jaroslav Pelikan, *The Christian Tradition 3: The Growth of Medieval Theology (600–1300)*, Chicago, 1978, pp. 23–33. Thomas Aquinas, *Summa Theologica: Human Acts*, 2/1, Q 63, Art. 1.

48 Marilyn Aronberg Lavin, *The Place of Narrative: Mural Decoration in Italian Churches 431–1600*, Chicago, 1991; and Henk W. van Os, *Sienese Altarpieces: Form Content, Function*, Groningen, 1984.

49 Madeline Caviness, "Biblical Stories in Windows: Were They Bibles for the Poor?," in Caviness 1997, pp. 103–47; Wolfgang Kemp, *Sermo Corporeus: Die Erzählung der mittelalterlichen Glasfenster*, Munich, 1987 (trans. *The Narratives of Gothic Stained Glass*, Cambridge, 1996); id., "Parallelismus als Formprincip. Zum Bibelfenster der Dreikönigskapelle des Kölner Domes," *Kölner Domblatt*, 1991, pp. 259–94; Colette Manhes-Deremble, *Les Vitraux narratifs de la cathédrale de Chartres: Etude iconographique* (Corpus Vitrearum France, Etudes II), Paris, 1993; Alyce Jordan, "Narrative Design in the Stained Glass Windows of the Sainte-Chapelle in Paris," Ph. D. Dissertation, Bryn Mawr College, Ann Arbor, Mich, 1994.

50 See, for example, the discussion of the windows of the Good Samaritan at Chartres and Sens by Manhes-Deremble, ibid., pp. 154–63, col. pl. 44; and Wolfgang Kemp, "Les cris de Chartres: Rezeptionsästhetische und andere Uberlegungen zu zwei Fenstern der Kathedale von Chartres," in *Kunstgeschichte – aber wie?*, Berlin, 1989, pp. 195–201, fig. 5.

51 *English Art 1216–1307: The Oxford History of English Art*, Oxford, 1957, p. 95.

52 Caecilia Davis Weyer, *Early Medieval Art 300–1150*, Sources and Documents, Toronto, 1986, p. 48; Madeline Caviness, "Biblical Stories in Windows: Were They Bibles for the Poor?," in Caviness 1997, pp. 103–47.

53 Jordan, as above (n. 49), pp. 476–502.

54 See, in particular, the panel of *Esther kneeling before Assuerus, as He extends his Scepter to Her*, c. 1530, South Lowlands, New York, The Brooklyn Museum, 55.84–4, Hayward in *Checklist* I, p. 88; Cole 1993, lists seven roundels on the themes of Esther crowned by Assuerus or Esther before Assuerus. No other element of the story is represented more than twice.

55 32.24.40, Manner of Jan Swart von Groningen, Husband in *Checklist* IV, p. 169.

56 James Marrow, *Passion Iconography in Northern European Art of the Late Middle Ages and Early Renaissance: A Study of the Transformation of Sacred Metaphor into Descriptive Narrative*, Ars Neerlandica, 1, Kortrijk, 1978, and Ruth Mellinkoff, *Signs of Otherness in Northern European Art of the Late Middle Ages*, Berkeley, 1993.

57 See a very similar version in a circular format in the Baltimore Museum of Art (1941.399.2b) Husband in *Checklist* IV, p. 89.

58 *Gesta pontificum Autissiodorensium*, Auxerre, Bibliothèque municipale, MS 142, ed. Louis Duru, *Bibliothèque historique de l'Yonne*, Auxerre, 1850, p. 396; Raguin 1982, pp. 19–22.

59 Panofsky, p. 36; p. 42, and further: "The best painters I could find from different regions;" p. 57, "the most experienced artists from divers parts;" p. 73, "many masters from different regions."

60 One of the first to trace a traveling workshop was Louis Grodecki, who described a workshop that he called the Master of the Good Samaritan working at Bourges and at Poitiers, "A Stained Glass 'Atelier' of the Thirteenth Century," *Journal of the Warburg and Courtauld Institutes*, 11, 1948, pp. 87–110.

61 Caviness 1990, esp. pp. 99–103, 125–6, pls. 265–7.

62 See, for discussion on the equal importance of ornament and figural image, Michael Cothren, "Suger's Stained Glass Masters and their Workshop at Saint-Denis," *Paris, Center of Artistic Enlightenment*, Papers in Art History from The Pennsylvania State University, 4, 1988, pp. 47–75.

63 Caviness 1977, esp. pp. 88–9, figs. 73–4, 175–8.

64 Becksmann and Scholz, as below (n. 87).

65 Scholz 1991, *Painting on Light*.

66 The woodcut showing the glass painter is illustrated in Jane Hayward, "Techniques of Stained Glass, Illustrations to the Introduction," *MMA Bulletin*, 30, December 1971–Jan. 1972, fig. 5.

67 Helbig and Vanden Bemden 1974, pp. 88, 125, 126, 128, 129, 131, 165–67, 251; Jean Helbig, "Bernard van Orley et la peinture sur verre au XVIe siècle," in *Bernard van Orley 1488–1541*, Brussels, 1943, pp. 119–43.

68 Theophilus, *On Divers Arts: The Foremost Medieval Treatise on Painting, Glassmaking and Metalwork*, trans. and introd. John G. Hawthorne and Cyril Stanley Smith, New York, 1979, pp. 61–2; and Joan Vila-Grau, "La table du peintre-verrier de Gérone," *Revue de l'Art*, 72, 1986, pp. 32–4.

69 Rüdiger Becksmann, "Tables de bois avec projets pour la fenêtre axiale de la cathédrale de Gérone," *Les bâtisseurs des cathédrales gothiques* [exh. cat., Ancienne Douane], Strasbourg, 1989, pp. 466–7.

70 Zakin 1998; Michel Hérold, "'Cartons' et pratiques d'atelier en Champagne méridionale dans le premier quart du XVIe siècle," in *Mémoire de verre*, pp. 62, 66–74; id., "Dans les coulisses de l'atelier: modèles et patrons à grandeur," in *Vitraux parisiens*, pp. 172–7; id., "La production normande du Maître de la Vie de saint Jean-Baptiste. Nouvelles recherches sur l'usage des documents graphiques dans l'atelier du peintre-verrier à la fin du Moyen Âge," in Fabienne Joubert et Dany Sandron, eds., *Pierre, lumière, couleur: Etudes d'histoire de l'art du Moyen Age en honneur d'Anne Prache*, Paris, 1999, pp. 469–85. For the dissemination of prints and the impact on workshop practices, see Peter Schmidt, "Rhin supérieur ou Bavière/ Localisation et mobilité des gravures au milieu du XVe siècle," *Revue de l'art*, 120, 1998, pp. 68–88.

71 Vanden Bemden et al., 1994, pp. 42–3.

72 Cennino Cennini, *The Craftsman's Handbook*, trans. Daniel V. Thompson Jr., New York, 1954, p. 87.

73 *Vasari on Technique*, trans. L. S. Maclehose, London, 1907, pp. 215, 231.

74 Molly Faries, "Underdrawings in the Workshop Production of Jan van Scorel: A Study with infrared Reflectography," *Nederlands Kunsthistorisch Jaarboek*, 26, 1975, pp. 26, 145, 213, n. 84.

75 Stephen H. Goddard, *The Master of Frankfurt and his Shop*, Brussels, 1984, p. 100, n. 55.

76 *Craftsman's Handbook*, as above (n. 72), p. 111.

77 Eva Frodl-Kraft, "Zur Frage der Werkstattpraxis in der mittelalterlichen Glasmalerei," in *Glaskonservierung, Historische Glasfenster und ihre Erhaltung*, Munich, 1985, p. 15; Scholz 1991, pp. 252–3.

78 Rode 1974, pp. 35, 155, figs. 358–71; *Herbst des Mittelalters: Spätgotik in Köln und am Niederrhein* [exh. cat., Kunsthalle, Cologne, 20 June to 27 September], Cologne, 1970, pp. 57, 59–60; Rode 1959, p. 94.

79 Herbert Rode, "Ein Glasbild vom Meister des Marienlebens," *Mouseion: Studien aus Kunst und Geschichte für Otto H. Förster*, Cologne, 1960, pp. 214–7, figs. 225, 228; Rode 1974, pp. 155, 158, figs. 378, 380.

80 Scholz 1991, p. 9; Frodl-Kraft, as above (n. 77), p. 13.

81 Gottfried Frenzel, "Die Farbverglasung des Münsters zu Ingolstadt," *Ingolstadt-Festschrift*, 1974, pp. 373–97; Gloria Ehret, *Hans Wertinger, Ein Landshuter Maler an der Wende der Spätgotik zur Renaissance*, Munich, 1976: esp. pp. 60–85, 163–70. For the Julius Böhler collection, ibid., p. 84.

82 *Nuremberg 1986*, pp. 90, 157–8; Snyder 1985, pp. 234–5.

83 *Nuremberg 1986*, pp. 90–1, 174–6

84 Scholz 1991, pp. 83–120.

85 Andersson and Talbot 1983, pp. 54, 56–7, no. 1.

86 Husband 1995, pp. 166–74.

87 Hartmut Scholz, "Monumental Stained Glass in Southern Germany in the Age of Dürer," *Painting on Light*, pp. 17–22, 75–7; Rüdiger Becksmann, "Zur Werkstattgemeinschaft Peter Hemmels in den Jahren 1477–1481," *Pantheon*, n. s. 28, 1970, pp. 183–97; Becksmann 1986, pp. LIV–LVII, 273–8; Scholz 1994, pp. LVIII–LXII, 92–96; Becksmann 1995, pp. 205–17.

88 Gorissen 1973, pp. 164–9, figs. 41–61.

89 For Baldung see *Painting on Light*, pp. 235–46; Scholz 1991, pp. 83–99;

Becksmann 1995, pp. 221–2; for Van Orley, Helbig and Vanden Bemden 1974, pp. 77, 85–6, 88, 106, 124–5.

90 *Painting on Light*, pp. 79–80; Scholz 1991, pp. 98–9, n. 235 with bibliography.

91 Lesa Mason, "A Late Medieval Cologne Artistic Workshop: The Master of the Holy Kinship the Younger, a Technical and Art Historical Study," diss., Indiana University (Ann Arbor: University Microfilms International), 1991, pp. 156–7.

92 Rode 1974, p. 190, n. 28, suggests that the Heilige Sippe Master was Master Lambert von Luytge (Liège), documented as the city painter from 1500 to 1506; for more information about Cologne glass painters, see id., in *Herbst*, as above (n. 78), p. 57.

93 See Becksmann and Korn 1992, pp. 29–74, especially the nunnery of Ebsdorf with cloister program *c.* 1400 based on the *Speculum Humanae Salvationis*.

94 Strauss 1973, pp. 70–1, no. 34.

95 51.4.4, Fine Arts Museums of San Francisco.

96 Marks 1993, esp. sections "Donors and Patrons," pp. 3–25, and "Domestic Glass," pp. 92–102; Caviness 1996, pp. 70–2.

97 Louis Grodecki, *Les Vitraux de Saint-Denis* (Corpus Vitrearum Medii Aevi, France, Etudes, I), Paris, 1976, p. 82, figs. 68–75. For a profile of Suger, see Clark Maines, "Good Works, Social Ties, and the Hope for Salvation: Abbot Suger and Saint-Denis," *Abbot Suger and Saint-Denis*, ed. Paula Lieber Gerson, New York, 1986. See also Lindy Grant, *Abbot Suger of St-Denis: Church and State in Early Twelfth-Century France*, London, 1998, pp. 28–31, 234–74, 300 for a new interpretation of Suger's role in the rebuilding of Saint-Denis.

98 Meredith Lillich, "Monastic Stained Glass, Patronage and Style," *Monasticism and the Arts*, ed. Timothy Verdon, Syracuse, 1984, p. 213.

99 Ibid., p. 213.

100 Written 1436/38, London, BL, Add. MS 61823, *The Book of Margery Kempe*, trans. B. A. Windeatt, London, 1985, ch. 37, p. 128.

101 H. Munro Cautley, *Suffolk Churches and their Treasures*, Cambridge, 1982, first ed. 1937, pp. 196–214, col. pl. V; Woodforde 1950, pp. 74–127, pls. XXIII–XXVI.

102 Woodforde 1950, pl. XXIII, John Haugh and Richard Pygot represented as jurists. Clopton was executor to many leading personages, several of whom are represented in the windows.

103 It was used occasionally by French kings from Philip the Bold to Charles V: Père Anselme, *Histoire généalogique et chronologique de la maison royale de France*, 1, Paris, 1726, pp. 88–110.

104 Snyder 1985, p. 182, figs. 173–4.

105 For the brasses, especially of the merchant classes, see John Sell Cotman, *Engravings of Sepulchral Brasses in Norfolk*, London, 1838, pp. xxii–iii, 3–5, 7–8, pls. II, III, VII; Herbert W. Macklin, *The Brasses of England*, London, 1907.

106 Morgan and Rogers in *Checklist* II, pp. 150–3, 157–79.

107 Paris BN MS fr. 6109, XVI. fol. 164.

108 Charles Porée, "Monuments religieux: Cathédrale de Sens," *CA*, 74, 1907, p. 214. For Didron, see also Jean Nayrolles, "Deux approches de l'iconographie médiévale dans les années 1840," *Gazette des Beaux-Arts*, 128/ 1534, 1996, pp. 201–6, 211–2.

109 France *Recensement* III, pp. 174–5, 180. For Gaudin, see Jean-François Luneau, "L'*Arbre de Jesse de Vic-Le-Compte*, un vitrail de Grasset et Gaudin," *Histoire de l'art*, nos. 33–4, May, 1996, pp. 55–65.

110 (Canons) Jean-Jacques Bourassé and Manceau, *Verrières du coeur de l' église metropolitaine de Tours*, Paris, 1849, p. 9. The book is illustrated with color lithographs of the windows.

111 Michael Cothren, "Is the 'Tête Gérente' from Saint-Denis?" *Journal of Glass Studies*, 35, 1993, pp. 57–64.

112 Virginia Raguin, "Revivals, Revivalists, and Architectural Stained Glass," *The Journal of the Society of Architectural Historians*, 49, 1990, pp. 310–29.

113 TMA Curator's file, 1945.21–2; Barr Ferree, *American Estates and Gardens*, New York, 1904, pp. 5–11; Obituary, *New York Times*, 8 Feb. 1949, p. 25.

114 Caryl Coleman, "A Sea of Glass," *Architectural Record*, 2, Jan.–March 1893, pp. 264–85. The article is quite similar in intent to mid-19th-century English and French publications by Adolphe-Napoléon Didron, "Peinture sur Verre: Vitrail de la Vierge," *Annales archéologiques*, 1, 1844, pp. 47–153, or Edmond Lévy, *Histoire de la peinture sur verre en Europe et particulièrement en Belgique*, Brussels, 1860.

115 Caviness in *Checklist* I, pp. 40–4.

116 Caviness, Beaven, and Pastan 1984, p. 6; Letter from Adams, Museum Archives, inv. no. C28s2. Adams discovered the panels in the antique shop of Bacri Frères. Three letters record his correspondence, suggesting that Mrs. Gardner consider purchasing them since the price was beyond his means. Harold Dean Cater, *Henry Adams and his Friends: A Collection of his Unpublished Letters*, Boston, 1947, pp. 584–7.

117 Henry Adams, *Mont-Saint-Michel and Chartres*, Princeton, 1981, p. v; Robin Fleming, "Picturesque History and the Medieval in Nineteenth-Century America," *American Historical Review*, 100, 1995, pp. 1061–94.

118 Harrison 1980, pp. 39–44; Wendy Kaplan, *The Art that Is Life: The Arts and Crafts Movement in America* [exh. cat., Museum of Fine Arts, Boston], Boston, 1987; Peter Stansky, *Redesigning the World: William Morris, the 1880s, and the Arts and Crafts Movement*, Princeton, 1985.

119 Sewter 1974–5, p. 224.

120 *Arts and Crafts in Detroit 1906–1976* [exh. cat., The Detroit Institute of Arts], Detroit, 1976, introductory essays, unpaginated; Burne-Jones tapestry, fig. 41.

121 TC Archives; CMA Archives, Frederick Allen Whiting (I), p. 116; Nicole Quellet-Soguel, *Clement Heaton, 1861–1940, London, Neuchâtel, New York*, Hauterive, Switzerland, 1996, pp. 58–9, ill.

122 Noreen O'Gara, "Retrospective . . . Charles J. Connick," *Stained Glass*, 82/1, 1987, pp. 44–9, 59–60, with chronology and illustrations of early work.

123 Christopher Whall, *Stained Glass Work: A Textbook for Students and Workers in Glass*, Arts and Crafts Series of Technical Handbooks, ed. W. R. Lethaby. New York, 1905, pp. 268–9. See also Peter D. Cormack, *Christopher Whall 1849–1924: Arts & Crafts Stained Glass Worker* [exh. cat., William Morris Gallery, London], London, 1979; Harrison 1980, pp. 63–75, esp. figs. 68–9, Brown 1994, pp. 140–7.

124 Whall & Whall Ltd., Stained Glass Artists, founded by C. W. Whall in 1887, incorporated by him in 1922. Directors: Veronica Whall and C. J. Whall, Secretary, F. H. Campbell MBE, 1 & 2 Ravenscourt Park, King Street, Hammersmith W6, *List of Windows*, May 1929.

125 The SGAA, was begun as the Ornamental Glass Association, founded in 1903 as a means of confronting foreign competition and lobbying for duties on imported windows.

126 "Is Stained Glass a Lost Art," *Bulletin of the American Ceramic Society*, 15/11, 1936, pp. 375–82.

127 "Modern Glass – A Review," *International Studio*, 80, no. 329, 1924, pp. 40–53.

128 Published New York, 1937.

129 It was given in 1955 by John L. Booth with no previous provenance noted. Thus it would appear that the work was seen as a replica. The date of production is unknown, but it could have been made in the 20th century.

130 Alastair Duncan, *Tiffany Windows*, New York, 1980, ill. p. 183.

131 See for a broad-ranging treatment of the practice of recreating the object of the past, Mark Jones, Paul Craddock, and Nicolas Marker, eds., *Fake? The Art of Deception* [exh. cat., British Museum, London], London, 1990.

132 San Francisco acquired a panel by Carl de Bouché, who painted a window for Munich's city hall, now destroyed. The work is a well-painted image after Dürer's engraving of Pirkheimer.

133 *Four Panels of Prophets and Classical Authors*, AIC 37.869, 37.870, 37.871, 37.872, Ryerson collection. The classical authors and prophets are shown in half-length portraits. The backgrounds vary: 37.870 and 37.871 show Gothic arch frames and a damascene background; 37.872 shows classical architecture; and 37.869 is set in a wooded

landscape. Those under architecture hold books; the figure in the landscape gestures as if pointing or speaking. The model on which these panels are based is mid-15th-century German glass painting, both in the draftsmanship and the design of the half figure under an architectural canopy. A reasonable imitation is produced, especially when the panels are seen in black and white photographs. When the panels are examined physically, however, their modern origin is immediately apparent. The glass is all of a uniform texture and machine rolled. The artist has attempted an antique look by flicking a loaded brush across the surface, to resemble the fine pitting that frequently is acquired by medieval glass with age. While the panels emulate medieval works, they do not appear to be forgeries made for an art market.

134 (DIA 44.83) Founders Society, Membership Funds. Formerly Musée van Stolk, Haarlem, The Netherlands; A. Seligmann & Rey, New York; then William Randolph Hearst; sales agent, the Gimble Brothers. The work is executed in a lively early 13th-century style using all modern (late 19th-century glass), with no attempt to create false breaks or repairs.

135 The Lucy Maud Buckingham Medieval Collection. Purchased through the Buckingham Gothic Room Accessions Fund.

136 The dealership was founded by Jacques Seligmann, d. 31 Oct. 1923, see Janet Southorn, in *Dictionary of Art*, 28, New York, 1996, p. 384.

137 Ritter 1926, pl. XXVIII.

138 The Lucy Maud Buckingham Medieval Collection. Purchased through the Buckingham Gothic Room Accessions Fund.

139 Kummer-Rothenhäusler 1987, p. 243.

140 J. D. LeCouteur, *English Mediaeval Painted Glass*, London, 1978, 2nd ed., p. 164.

141 Richard Marks, "The Reception and Display of Northern European Roundels in England," *Gesta*, 37, 1998, pp. 217–24; John A. Knowles, "Exhibitions of Stained Glass in London," *Journal of the British Society of Master Glass Painters*, 11, 1951–2, p. 44; *Himmelslicht*, pp. 334–5, no. 91.

142 Cole 1993, p. xxiii.

143 Boesch 1955b, p. 172.

144 Rahn 1886–90, pp. 181–2.

145 Boesch 1955b, p. 172; Barbara Giesicke, *Glasmalereien des 16. und 17. Jahrhunderts im Schützenhaus zu Basel*, Basle, 1991, pp. 17–8, pl. II.2; Daniel Hess, "'Modespiel' der Neugotik oder Denkmal der Vergangenheit? Die Glasmalereisammlung in Erbach und ihr Kontext," *Zeitschrift des Deutschen Vereins für Kunstwissenschaft*, 49–50, 1995–96, pp. 227–48; *Himmelslicht*, pp. 336–9.

146 Vlademir de Bélinsky, "Les vitraux armoriés suisses du Musée de l'Ermitage à St-Pétersbourg," *Schweizer Archiv für Heraldik*, 28/1, 1914, pp. 1–6, pl. 1; id., "Les vitraux armoriés suisses du Musée de l'Ermitage à St-Pétersbourg," *Schweizer Archiv für Heraldik*, 28/2, 1914, pp. 57–65; id., "Les vitraux armoriés suisses du Musée de l'Ermitage à St-Pétersbourg," *Schweizer Archiv für Heraldik*, 28/3, 1914, pp. 113–7. Bélinsky published brief descriptions and the inscriptions of 53 heraldic panels in the Hermitage collection, twelve of which remain there today after the sales of the Stalin era. See also Paul Boesch, "Schweizerische Glasgemälde in der Ermitage in St. Petersburg," *Zeitschrift für Schweizerische Archäologie und Kunstgeschichte*, 1, 1939, pp. 211–34, pls. 87–94; id., "Schweizerische Glasgemälde im Ausland: Die ehemalige Sammlung in der Ermitage in St. Petersburg," ibid., 6, 1944, pp. 149–63.

147 Von Witzleben 1972, pp. 227–8, Wayment 1988, pp. 23–4, and Marks 1993, p. 243, have addressed the roles of Geerling, Hampp and Thomas as stained glass dealers.

148 Beeh-Lustenberger 1973, p. 3. For Geerling, see *Himmelslicht*, pp. 346–7, nos. 97.1–97.3.

149 Kummer-Rothenhäusler 1987, p. 245.

150 David Verey, *Gloucestershire*, 2, *The Vale and the Forest of Dean*, The Buildings of England, Middlesex, 1980, pp. 59, 386–8, fig. 80; Richard Hanbury-Tenison, "1st Lord Sudeley as an Amateur Architect," in *The Sudeleys – Lords of Toddington*, Thetford, 1987, pp. 226–8, fig. 3; Doreen Winkless, "Hailes Abbey and the Tracy Family," in ibid., pp. 148–55.

151 Shepard 1995.

152 Lymant 1982, p. 105.

153 They eventually enriched the collections of the Hessisches Landesmuseum, Darmstadt; the Schnütgen Museum, Cologne; the Burrell Collection, Glasgow; the Metropolitan Museum of Art; New York; the San Francisco Fine Art Museums; and the Detroit Institute of Arts (DIA 4; Col. pl. 7).

154 *Die Freiherrlich von Zwierleinschen Sammlungen von gebrannten Glasfenstern, Kunstsachen und Gemälden zu Geisenheim* [sale cat., J. M. Heberle, 12–15 Sept.], Cologne, 1887.

155 J. Rudolf Rahn, *Katalog der reichhaltigen Kunstsammlungen der Herren C. und P. N. Vincent in Konstanz am Bodensee* [sale cat., Constance, J. M. Heberle, 10–11 Sept.] Cologne, 1891. The stained glass entries are based on Rahn 1886–90.

156 *Sudeley* sale, 1911.

157 Von Witzleben 1972, pp. 237–9, figs. 14–24; Rüdiger Becksmann, "Die mittelalterliche Farbverglasung der Oppenheimer Katharinenkirche," in *St. Katharinen zu Oppenheim, Lebendige Steine – Spiegel der Geschichte*, Alzey, 1989, pp. 390–2, figs. 27–30.

158 Von Falke 1925.

159 This segment detailing the activities of Grosvenor Thomas (1858–1923) was written by Marilyn Beaven. Born in Australia and having arrived in Glasgow by 1885, Thomas participated in the artistic revival in that city as one of the "Glasgow boys" painters. He was an associate of the International Society of Sculptors, Painters and Gravers and won prizes at the Munich and Dresden salons of 1901. At the end of his life he maintained two homes, one in Glasgow, and one in Kensington. The Costessey collection was first shown in his Glasgow home, see Linda Canon, *Stained Glass in the Burrell Collection*, Edinburgh, 1991, pp. 9–10 and n. 13. Obituary, *Journal of the British Society of Master Glass Painters*, 1, 1924, pp. 29–31 and *The Times*, London, 9 Feb. 1923, p. 12, col. 5.

160 TC Archives. Letter G. Thomas to W. G. Mather, 22 June 1915.

161 All of the stained glass in the Edsel and Eleanor Ford home appears to have been purchased through Thomas (EEFH 1–18; documentation missing for 8, 10), as was all the glass installed in Trinity Cathedral, Cleveland (TC 1–16). Substantial parts of other collections passed through the hands of Grosvenor Thomas or the later partnership of Thomas and Drake: C-CAM and C-CEC 1, 4, 15; DIA 1, 2, 17, 31, 32, 40, 42, 50–3, 54–63; CMA 2, 3, 6, 7, 11, 12, 13, 23, all purchased by William Mather, and probably 16–17, property of Samuel Mather; TMA 1–4, 7; AIC 3, 4, 5, 10; IUAM 1.

162 Shaw 1909, pp. 191–220; Shaw 1910, pp. 182–208.

163 *Drake* sale 1913.

164 *Drake* sale 1913, pp. 3–4, no. 1a.

165 For Elizabeth Mills Reid, see *Notable American Women*, E. T. James ed., Cambridge, Mass., 1971, 3, pp. 132–3 and *An Old House in Paris: The Story of Reid Hall*, Paris, c. 1950, pp. 10–12, privately published for Reid Hall Inc., New York. For Whitelaw Reid, see *Dictionary of American Biography*, Dumas Malone ed., New York, 1935, pp. 482–6. Ophir Hall is now the administration building for Manhattanville College. We would like to thank Aida K. Pisani of the college for her assistance.

166 *Art Treasures and Furnishings of Ophir Hall, Residence of the Late Mrs. Whitelaw Reid*, [sale cat., American Art Assoc. Anderson Galleries, Inc., 14–18 May] New York, 1935, p. 364, lot 1471. Called "Three Stained and Painted Glass Armorial Roundels," in error, there were four.

167 Grosvenor Thomas Stock Book, Norwich, private library Dennis King, Thomas and Drake, Inc. stock books, unpublished. Microfiche copies at The Cloisters, Metropolitan Museum of Art and the library of the Corning Stained Glass Museum.

168 Paul Burget, *Outre-Mer: Impressions of America*, New York, 1896, p. 53.

169 Hebgin-Barnes 1996, pp. 35, 349.

170 The collection of Sir William Jerningham is represented in the Midwest by panels from a Cologne Passion series (TC 1–2; TMA 7). The collection of Sir Thomas Neave of Dagnam Park, Essex, IUAM 1; C-CEC 1; CMA 12–15.

171 Shepard 1995, p. 188.

172 His reasoning was that the Renaissance panels would not be legible in the windows he was trying to fill (TC Archives).

173 John D. Rae, *The American Automobile: A Brief History*, Chicago, 1965; id., *The American Automobile Industry*, Boston, 1984; Donald Finlay David, *Conspicuous Production: Automobiles and Elites in Detroit, 1899–1933*, Philadelphia, 1988.

174 John B. Catlin, *The Story of Detroit*, Detroit, 1923.

175 For biographies of the Mathers and details of Cleveland history, see David D. Van Tassel and John J. Grabowski eds., *The Encyclopedia of Cleveland History*, Bloomington, 1987.

176 Ella Grant Wilson, *Famous Old Euclid Avenue of Cleveland*, Cleveland, 1932, p. 145.

177 Regenia A. Perry, "The Life and Works of Charles Frederick Schweinfurth – Cleveland Architect – 1856–1919," Ph. D. diss., Western Reserve University, 1985 (University Microfilms International, Ann Arbor, MI, 1967, pp. 80–7, 93–4, 101–3, 106–7, 113–4, 122–6, 150–1, 157–9, 196–209). Charles was the brother of three other architects, the sons of a German emigrant. The older brother, Julius, worked in the firm of Peabody and Stearns, Boston. One of the younger brothers went to California, where he designed "Mission Style" houses and churches (Mary Schofield, "The Schweinfurth Brothers," *Nineteenth Century*, 2, 1992, nos. 1–2, pp. 20–5).

178 WRHS Mather, container 6, folder 7, "Catalogue of Furnishings".

179 Drake 1913, pt. I, pp 17–18, nos. 4–5. Although undocumented, the acquisition was probably through Grosvenor Thomas.

180 "Furniture at Toddington," in *The Sudeleys – Lords of Toddington*, Thetford, 1987, pp. 239–40, figs. 3, 4.

181 Keith N. Morgan, *Charles A. Platt: The Artist as Architect*, New York, 1985, esp. p. 110, fig 69; Robin Karson, "William G. Mather's House and Gardens in Bratenahl, Ohio," *Antiques*, 147/3, 1995, pp. 442–53; Royal Cortissoz, introd., *Monograph of the Work of Charles A. Platt*, New York, 1913, figs. 23–42; Robin Karson, *The Muses of Gwinn: Art and Nature in a Garden designed by Warren H. Manning, Charles A. Platt, & Ellen Biddle Shipman*, Sagaponack, N.Y., 1995.

182 TC Archives.

183 Hayward and Caviness in *Checklist* III, pp. 14–15. Stanford White renovated parts of the New York City residence of Elisabeth and Whitelaw Reid, the former Villard House at 451 Madison Avenue (David Garrard Lowe, *Stanford White's New York*, New York, 1992, pp. 206, 118; Paul R. Baker, *Stanny: The Gilded Life of Stanford White*, New York, 1989, p. 294). Mrs. Reid's father and another White client, Darius Ogden Mills, collected the Renaissance glass that is now in St. Margaret's Episcopal Church, Staatsburg, N.Y, (Lillich and Zakin in *Checklist* I, pp. 201–2; Lawrence Wodehouse, *White of McKim, Mead and White*, New York, 1988, p. 272).

184 Morgan bought the Hoentschel collection of medieval art (*Collections Georges Hoentschel acquises par M. J. Pierpont Morgan et prêtées au Metropolitan Museum de New-York*, Paris, 1908, I). The Hoentschel stained glass is now in the Victoria and Albert Museum, London (Helen Zakin, "Morgan's Stained Glass: Narrative and Non-narrative," paper read at Corpus Vitrearum colloquium, Siena, Italy, 19 June 1995). Most of the other pieces are at MMA ("The Pierpont Morgan Gift," *MMA Bulletin*, 13/1, 1918, pp. 2–20).

185 *Reid* sale 1935, "Foreword"; see below, TMA I–4.

186 For additional treatment of the collection, see Walter J. Karcheski Jr., *Arms and Armor in the Art Institute of Chicago*, Boston, 1995. The house is described, pp. 100–1.

187 Leonid Tarassuk, *Italian Armor for Princely Courts: Renaissance Armor from the Trupin Family Trust and the George F. Harding Collection* [exh. cat., The Art Institute of Chicago], Chicago, 1986.

188 *Age of Belief: An Exhibition of Religious Art from the Harding Collection* [exh. cat., Saint Paul Art Center], Saint Paul, Minn., 1966.

189 Hayward in *Checklist* I, pp. 22–9; Husband in *Checklist* IV, p. 64.

190 James A. Bridenstine, *Edsel & Eleanor Ford House*, Gross Pointe Shores, Mich., 1988, p. 13.

191 Acc. no. 40.165, *DIA Guide*, p. 158.

192 70.161, 69.306, 70.160, 70.167, 70.168, 70.192, 70.190, 70.193, *DIA Guide*, pp. 224–7, 274–5.

193 Acc. no. 27.150, *DIA Guide*, p. 165.

194 Acc. no. 30.383, *DIA Guide*, p. 164.

195 Acc. no. 61.164, *DIA Guide*, p. 167.

196 Sterne 1980, long list of publications on Rembrandt, Frans Hals, Pieter de Hooch, Carel and Barent Fabritius, William Drost, Aelbert van Ouwater, Jan de Vos, and many general collections of Lowlands paintings; W. H. Peck, *The Detroit Institute of Arts: A Brief History*, Detroit, 1991.

197 Beckmann had taught at Washington University in St. Louis after the War.

198 *Catalogue of a Loan Exhibition of Early Oriental Rugs at the Metropolitan Museum of Art*, New York, 1910.

199 Sterne 1980, p. 266.

200 William R. Valentiner, *Origins of Modern Sculpture*, New York, 1946, esp. pp. v–vi of the introduction; Raguin 1998, pp. 247–8.

201 See Sterne 1980, pp. 288–97, for meeting with Graves and visiting his wilderness home outside of Seattle; pp. 188–204, for Rivera's murals, the gift of Edsel Ford.

202 Woodcut (51.107), 19 1/2 × 15 1/16 in, by Schmidt-Rottluff in 1923, gift of Mrs. Ralph Harman Booth: Sterne 1980, p. 169. See also Horst Uhr, *Masterpieces of German Expressionism at the Detroit Institute of Arts*, Detroit, 1982; Raguin 1998, pp. 246–7, fig. 5.

203 *Schmidt-Rottluff*, Bibliothek der Junge Kunst, 2, pt. 16, Leipzig, 1920; and *Georg Kolbe: Plastik und Zeichnung*, Munich, 1922, bronze, lifesize head of Valentiner sculpted in 1920, pl. 17.

204 Valentiner, *Schmidt-Rottluff*, as above (n. 202), p. 4; see also Valentiner's article, "The Front Plane Relief in Medieval Art," *Art Quarterly*, 2, 1939, pp. 155–77.

205 Many contemporary homes could be cited. Chief among them might be the John Dodge Mansion, Grosse Pointe (110 rooms), in the Tudor-style drawing-room project to have stained glass panels in leaded windows (1918–20; demolished 1942); University Club Detroit 1931; and Meadow Brook Farms, Rochester, Michigan, 1926–29. John B. Cameron, *Meadow Brook Hall: Tudor Revival Architecture and Decoration* [exh. cat. Meadow Brook Art Gallery, Oakland University], Rochester, Michigan, 1979.

206 Ilene H. Forsyth, *The Uses of Art: Medieval Metaphor in the Michigan Law Triangle*, Ann Arbor, Michigan, 1993.

207 Ibid., pp. 46–51, figs. 28–33, also Hutchins Hall, pp. 52–3.

208 Institutions in the Midwest displaying neo-Gothic inspiration are many. The University of Chicago, largely built in this style, has a large opalescent-style window of *Rowena Crowning Ivanhoe* by Edward Peck Sperry, 1904, in the Bartlett Gymnasium. See Jean F. Block, *The Uses of Gothic: Planning and Building the Campus of the University of Chicago 1892–1932* [exh. cat., The Joseph Regenstein Library, University of Chicago], Chicago, 1993, fig. p. 112. Charles Schweinfurth, who designed Trinity Cathedral and the Samuel Mather House in Cleveland also designed neo-Gothic buildings for Western Reserve University, and Kenyon College, Gambier, Ohio, both founded in large part with Mather bequests.

209 Ken Murray, *The Golden Days of San Simeon*, foreword by Ronald Reagan, Garden City, NY, 1971, pp. 12–19; John Tebbel, *The Life and Good Times of William Randolph Hearst*, New York, 1961, p. 413; Thomas R. Aidala, *Hearst Castle; San Simeon*, New York, 1981.

210 See the Hearst Archive, now at C. W. Post University in Greenvale, New York, and Hayward and Caviness in *Checklist* III, pp. 16–23.

211 Constance Cary Harrison, "Some Work of the 'Associated Artists,'" *Harper's Magazine*, 69, 1884, pp. 343–51; Wilson H. Faude, "Associated Artists and the American Renaissance in the Decorative Arts," *Winterthur Portfolio*, 10, 1975, pp. 101–30; Kathleen D. McCarthy, *Women's Culture: American Philanthropy and Art, 1830–1930*, Chicago, 1991.

67

212 *Antiquarian Society*, p. 10.

213 de Winter 1985, p. 136, fig. 148.

214 *Antiquarian Society*, p. 10. Because the Antiquarian Society started donating works to the AIC before the AIC was organized as it is now, the objects that it donated are now in several different departments.

215 Sandra Hindman, "Collage and the Taste for Manuscript Illumination in 19th-Century France and England," Paper presented at the College Art Association Annual Conference, New York, 1997.

216 Madeline H. Caviness, "Some Aspects of Nineteenth-Century Stained Glass Restoration, Membra Disjecta et Collectanea; Some Nineteenth-Century Practices," *Crown in Glory*, Peter Moore ed., Norwich, 1982, pp. 69–72; *Himmelslicht*, pp. 344–5, no.96.

217 Caviness in *Checklist* I, p. 57; Cothren in *Checklist* III, pp. 146–7 esp. nos. 03.SG.123 and 03.SG.163.

218 Amsterdam, Rijksmuseum, Rijksprentenkabinet, inv. no. RP-T 1921: 474, Karel G. Boon, *Netherlandish Drawings of the Fifteenth and Sixteenth Centuries*, Catalogue of the Dutch and Flemish Drawings in the Rijksmuseum, 2, The Hague, 1978, p. 192, no. 515; Husband 1995, p. 74, fig. 4.

219 CMA 51.354, 58.320, 59.42–43; *CMA Handbook*, pp. 62, 68, 70.

220 Ricki D. Weinberger, *TMA News*, 21/3, 1979, pp. 53–71; Kathryn Horste, "The Toledo Museum of Art, " in Walter Cahn, *et. al.*, *Romanesque Sculpture in American Collections*, 2, *New York and New Jersey, Middle and South Atlantic States, the Midwest, Western and Pacific States*, Turnhout, Belgium, 1999, pp. 188–95; *Toledo Treasures: Selections from the Toledo Museum of Art*, New York, 1995, p. 56.

221 *Toledo Treasures*, p. 56.

222 Elizabeth Bradford Smith, "George Grey Barnard: Artist/Collector/Dealer/Curator," in *Medieval Art*, pp. 133–42. Barnard, whose major profession was that of a sculptor, was seeking buyers for the objects that he had acquired, primarily from sites in France.

223 *Medieval Art*, pp. 135–56.

224 Sterne 1980, pp. 234–40, quote p. 240.

225 Ibid. p. 237.

226 *Palm Sunday Effigy of Christ on a Donkey*, acc. no. 57.97.

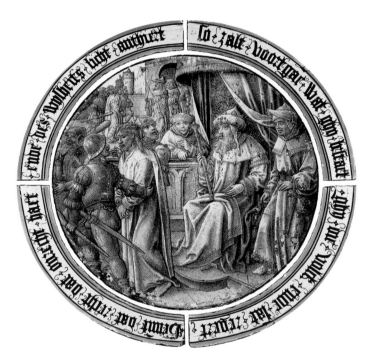

Christ being led away from Herod Antipas,
c. 1515–20. New York, Metropolitan
Museum of Art, the Cloisters Collection

THE
CATALOGUE

Note to the Reader

UNLESS SPECIFIED AS SIGHT, the dimensions given are to the outside of the outer leads. Sight measurements comprise the extent of an installed panel that is visible, that is normally at least two widths of a lead came smaller than the outer limits.

The Corpus Vitrearum numbering system is used here for churches for which there are no published plans i = the axial window on the aisle level; I = the axial window on the clerestory level Numbering precedes sequentially to north and south: i.e., siv = fourth window from the axis on the aisle level; NII = second window from the axis on the clerestory level. The letters a (A), b (B), c (C), and d (D) correspond to the individual lancets, where a (A) is the left most lancet and so on. The arabic numbers correspond to the level of a panel within a lancet, 1 being the lowest. Thus s: iv.a 3 is equivalent to the fourth window on the south from the axis at aisle level, the leftmost lancet, and the third panel from the bottom. In certain cases (AIC 9 and TMA 10) the letters and arabic numbers are used to indicate the present position of a particular panel within a museum frame.

ABBREVIATIONS FOR SITES

AIC	Art Institute of Chicago, Chicago, Ill.
AKB	Albright-Knox Gallery, Buffalo, N.Y.
ACM	Amherst College, Mead Art Museum, Amherst, Mass.
ASU	Arizona State University Art Collections, Tempe, Ariz.
BMA	Baltimore Museum of Art, Baltimore, Md.
BMFA	Museum of Fine Arts, Boston, Mass.
BNY	The Brooklyn Museum, Brooklyn, N.Y.
BJU	Bob Jones University Collection of Sacred Art, Greenville, S.C.
C-CAM & C-CEC	Cranbrook Art Museum and Cranbrook Educational Community,Bloomfield Hills, Mich.
CAM	Cincinnati Art Museum, Cincinnati Ohio
CCC	Christ Church, Episcopal, Corning, N.Y.
CCSP	Cathedral Church of St. Paul, Detroit, Mich.
CGA	The Corcoran Gallery of Art, Washington, D.C.
CHM	Cooper-Hewitt National Design Museum, Smithsonian Institution, New York, N.Y.
CIP	Carnegie Institute, Pittsburgh, Pa.
CMA	The Cleveland Museum of Art, Cleveland, Ohio
CMG	The Corning Museum of Glass, Corning, N.Y.
CVUS	Corpus Vitrearum United States
DAM	The Denver Art Museum, Denver, Colo.
DIA	Detroit Institute of Arts, Detroit, Mich.
DO	Dumbarton Oaks Research Library & Collection, Washington, D.C.
DUMA	Duke University Museum of Art, Durham, N.C.
EEFH	Edsel & Eleanor Ford House, Grosse Pointe Shores, Mich.
EMAS	Evansville Museum of Arts & Science, Evansville Ind.
FLMP	Forest Lawn Museum, Forest Lawn Memorial Park, Glendale, Calif.
GM	Glencairn Museum: The Academy of the New Church, Bryn Athyn, Pa.
GMB	Isabella Stewart Gardner Museum, Boston, Mass.
HAW	Higgins Armory Museum, Worcester, Mass.
HCGF	Hyde Collection, Glens Falls, N.Y.
HFNS	Frontier Nursing Service, Hyden, Ky.
HMBR	Harvard University Art Museums, the Busch-Reisinger Museum, Cambridge, Mass.

HMF	Harvard University Art Museums, the William Hays Fogg Art Museum, Cambridge, Mass.
IC	Ithaca College, Gannett Center, Ithaca, N.Y.
IUAM	Indiana University Art Museum, Bloomington, Ind.
LACMA	Los Angeles County Museum of Art, Los Angeles, Calif.
LAM	Lyman Allen Museum, New London, Conn.
MAGR	Memorial Art Gallery of the University of Rochester, Rochester, N.Y.
MDGA	Loyola University, Martin D'Arcy Gallery of Art, of Chicago, Chicago, Ill.
MKM	Marion Koogler McNay Art Museum, San Antonio, Tex.
MIA	The Minneapolis Institute of Arts, Minneapolis, Minn.
MIT	Massachusetts Institute of Technology, Cambridge, Mass.
ML	The Pierpont Morgan Library, New York, N.Y.
MMA	The Metropolitan Museum of Art, New York, N.Y.
MMA-CC	The Metropolitan Museum of Art, The Cloisters Collection, New York, N.Y.
NA	The Nelson-Atkins Museum of Art, Kansas City, Mo.
NCMA	North Carolina Museum of Art, Raleigh, N.C.
NMAA	National Museum of American Art, Smithsonian Institution, Washington, D.C.
OBCH	Planting Fields Foundation, Coe Hall, Oyster Bay, N.Y.
OCAM	Oberlin College, Allen Memorial Art Museum, Oberlin, Ohio
PA	Portsmouth Abbey, Portsmouth, R.I.
PC	Private Collection
PMA	Philadelphia Museum of Art, Philadelphia Pa.
PMA	Philadelphia Museum of Art, Philadelphia, Pa.
PS	Pomfret School, Chapel, Pomfret, Conn.
PU	Princeton University, The Art Museum, Princeton, N.Y.
RCNY	Riverside Church, New York, N.Y
RISD	Rhode Island School of Design, Museum of Art, Providence, R.I.
SBMA	Santa Barbara Museum of Art, Santa Barbara, Calif.
SD	Saint David's School, Chapel, New York, N.Y.
SFAM	San Francisco Fine Arts Museums, San Francisco, Calif.
SLAM	St. Louis Art Museum, St. Louis, Mo.
SBNY	St. Bartholomew's Church, New York, N.Y.
SMEC	Saint Margaret's Episcopal Church, Staatsburg-on-Hudson, N.Y.
SML	J. B. Speed Art Museum, Louisville, Ky.
SPEC	St. Paul's Episcopal Church, Cleveland Heights, Ohio
SUMA	Stanford University Museum of Art, Stanford, Calif.
TMA	Toledo Museum of Art, Toledo, Ohio
TC	Trinity Cathedral, Cleveland, Ohio
UKMA	University of Kansas, Spencer Museum of Art, Lawrence, Kans.
UMMA	Michigan Museum of Art, Ann Arbor, Mi.
VMFA	Virginia Museum of Fine Arts, Richnmond, Va.
WAG	Walters Art Gallery, Baltimore, Md.
WAM	Worcester Art Museum, Worcester, Mass.
WC	Wellesley College, Davis Museum and Cultural Center, Wellesley College, Mass.
WM	The Henry Francis Du Pont Winterthur Museum, Inc., Winterthur, Del.
WRHS	Western Reserve Historical Society, Cleveland, Ohio
YUG	Yale University Art Gallery, New Haven, Conn.

OTHER ABBBREVIATIONS

col.:	column	intro.:	introduction
comm:	commentary	n.:	note
exh. cat.:	exhibition catalogue	n.p.:	not paginated
fig.:	comparative figure	Ps.:	psalm
ill.:	illustration	pt.:	part

CORPUS VITREARUM UNITED STATES RESTORATION SYMBOLS

original pieces

pieces replaced in the last restoration

pieces replaced in the restoration that preceded the last

pieces replaced in an undocumented 19th–20th century restoration

pieces replaced replaced prior to the 19th century

pieces probably replaced in the last restoration

pieces probably replaced in the restoration which preceded the last

pieces probably replaced in a documented or undocumented restoration

pieces probably replaced prior to the 19th century

(stopgaps) unaltered old glass used to fill missing parts or as additions to a panel

contemporary stopgaps from the same window or series of windows

(palimpsest) altered or repainted old glass used to fill missing parts or as additions to a panel

repainted original glass

pieces reversed or flipped

Art Institute of Chicago

CHICAGO, ILLINOIS [AIC]

W HILE MOST OF THE CHICAGO ART INSTITUTE'S STAINED GLASS dates from the sixteenth century, the museum has unique pieces ranging in date from the late thirteenth through the seventeenth century. The roundels are of special interest for their iconography (AIC 1, 3, 4, 6, 7, 8, and 10). Glass painters often used prints as models for the images on these unleaded circles and small rectangles of colorless glass. Hence the methodology for analyzing them has been to identify the original design or designer. We continue that practice here, with the caveat that the reader will also want to take into consideration the role of the glass painter who had a considerable impact on the style and imagery.

The *Elder of the Apocalypse from a Last Judgment Series* (AIC 1) is an early example of the genre. Many of the extant twelfth, thirteenth, and early fourteenth-century roundels depict grotesque creatures or animals. In that way they resemble the imaginary figures commonly found in the margins of manuscripts.[1] The Chicago Elder is delicately painted and wears a gracefully draped gown. His closest relatives appear in a series of medallions depicting human heads that are inserted in the center of grisaille or colorless panels painted with foliage patterns that have been attributed to the royal abbey of Saint-Denis, near Paris.[2]

Chicago's early sixteenth-century *Hanging of Judas* (AIC 5: Col. pl. 24), from Alsace or South Germany, stands out as unusual for its subject matter as well as its high level of execution. It is possible that the panel was once a part of a program of a glazed cloister, similar to the typological program discussed in this volume for the series of narrative windows attributed to the Louvain Charterhouse.[3] On the other hand, for this panel to be accommodated in a typological program such as one based on the *Concordantia Caritatis* that shows the Hanging of Judas, the program would need to be vast. To date, however, no comparable scenes of similar size or execution have been found that parallel Chicago's Judas. The panel may also have been part of a program or even a single window on Virtues and Vices, the example of Judas often appearing in manuscript illumination as a counterpoint for the virtue of Hope.

Because it represents a monumental project that would be conspicuous within an architectural setting, the *Dormition and Assumption of the Virgin* (AIC 9) directs our attention to major issues of the first quarter of the sixteenth century. The article of faith now known as the Immaculate Conception focused the thinking of writers who took varied positions on the role of Mary in the church, and the role of the church in society. Had her mother, St. Anne, immaculately conceived Mary, she would be a more fitting mother for her son, Christ. As this image illustrates, she would ascend into heaven immediately after her death and could then be an intercessor for mankind at the Last Judgment. In the early sixteenth century, these matters were debated within the context of theology; in the late twentieth, within the context of gender theory.

The design of this three-light window fascinates as much as its imagery. Although it is clearly impossible to identify the earliest example of these compositional ideas, the viewer can imagine this window as a conflation of at least three images: a lost composition by the Master of Flémalle; Dürer's version of the subject; and one by the Master of Frankfurt. The Master of Flémalle apparently painted a panel showing this subject in approximately this manner: his known works date

from *c.* 1415 to *c.* 1440. His painting is lost, but a panel by Petrus Christus is thought to reproduce it in a general way.[4] Hugo van der Goes produced a painting on this subject, which is also lost but known through many copies;[5] one of these—a drawing, albeit reversed—comes fairly close to Chicago's window.[6] Dürer's woodcut of the *Dormition*, 1510, provides us with more elements, for example the apostle holding the cross on the far left.[7] The format of the Chicago window's depiction of Mary's Assumption, in the upper middle light, closely resembles that in the Master of Frankfurt's *Dormition*, dated to the early sixteenth century.[8] That the designer of the Art Institute's *Dormition* never saw these specific works of art is relatively certain, but the workshop would very likely have had a collection of drawings or prints that reflected them or their models.

The spectacular examples of heraldic glass at the Art Institute illustrate a variety of seventeenth-century treatments. The panel depicting the Abbey of Muri is clearly the most exciting in respect to the beauty of its enamels and the compelling imagery (AIC 13). Saints Benedict (now replaced) and Scholastica, his sister, occupy the arcades. An image of the monastery itself also appears. In another Swiss panel (AIC 14), dated 1695, we see the martyrdom of John the Baptist vividly portrayed, flanked by images of the Baptist and St. Ulrich, the name-saint of the donor. Samson and the Lion (AIC 11) emerges as a subject associated with Uri, the Swiss canton where the donor lived: the scene appears in a medallion on an Uri canton shield now in Basle.[9]

History of the Collection

The Art Institute's earliest stained glass acquisition, a gift from the Antiquarian Society, occurred in 1930.[10] The Buckingham Fund financed two important purchases, catalogued here, in 1949 (AIC 1, 5: Col. pl. 24). All the others came from two collections: Ryerson and Harding.[11] The *Dormition and Assumption of the Virgin* (AIC 9), a Ryerson gift, arrived in 1932. The Ryersons probably never intended to exhibit the window in their home, but rather bought it for the museum. The rest of their panels (AIC 3, 4, 10) were given to the museum after the death of Carrie Ryerson in 1936. The Harding panels came into the museum as a result of the dissolution of the Harding museum: the Art Institute formally accessioned them in 1990 (AIC 2, 6–7, 8, 11, 12, 13, 14: text ills. 15–16).

Besides bequeathing a large sum to the city of Chicago for a memorial to Alexander Hamilton, Kate Sturges Buckingham (1858–1937) donated a collection of medieval objects to the Art Institute in 1923 in memory of her sister, Lucy Maud Buckingham.[12] Later she gave the Art Institute additional funds for medieval purchases.[13] The Art Institute used her gift to buy the impressive *Elder of the Apocalypse* roundel (AIC 1)[14] and the *Hanging of Judas* (AIC 5: Col. pl. 24) as well as an early thirteenth-century sculpted head from a French site (1944.413),[15] and an early thirteenth-century champlevé enamel plaque in the style of Nicholas of Verdun (1943.38).[16]

In 1931 Kate Buckingham bought three fourteenth- and fifteenth-century reliquaries from the Guelph Treasure, which was exhibited in Chicago in April, 1931 (1931.480–2).[17] They are now in the Art Institute along with the five Guelph objects purchased by Mrs. Chauncey McCormick (1962.90–3). An early fourteenth-century cross, one of Mrs. McCormick's acquisitions, was obtained for, and officially donated by, the Antiquarian Society (1931.263).[18]

The Ryersons were the Art Institute's most important patrons. From their collection came three roundels (AIC 3, 4, 10) that had probably been installed in their home, and the large-scale

Dormition and Assumption of the Virgin (AIC 9). This impressive and highly colorful window shares many qualities with the Toledo *Assumption* (TMA 10). Both are large, multi-sectioned compositions glorifying the Virgin, and both reflect compositional and stylistic developments in painting and printmaking of the Renaissance. In the second and third decades of the twentieth century, many museums were acquiring large-scale works and seeking to create a setting evoking the intersection of sculpture, architectural elements and stained glass of the European site.[19] The Ryersons bought the Chicago *Dormition* in 1932 and just one year after the Libbeys bought the *Assumption* window for Toledo.[20]

Martin A. Ryerson, an heir to a lumber fortune, and Carrie Ryerson, his wife, lived in a Richardsonian Romanesque house at 4851 Drexel Avenue. Treat & Foltz built it in 1887.[21] Ryerson had attended Harvard Law School, *c.* 1875–80, at the same time that Charles Elliot Norton was teaching at Harvard, and was trustee of the Art Institute of Chicago and vice president during the period from about 1890 to 1932.[22] The Ryersons were personal friends and traveling companions of the Hutchinsons,[23] Charles Hutchinson having been president of the Art Institute from 1882 to 1924, during its formative years. Ryerson, a largely uncelebrated American collector, assembled a major collection of Old Masters that he left to the Art Institute. A preliminary catalogue of Ryerson's collection was prepared by William Valentiner, long-time director of the Detroit Institute of Arts, but it was never published.[24]

BIBLIOGRAPHY

UNPUBLISHED SOURCES: Colleen Becker, letter 15 May 1996; "Time-Line for the Art Institute of Chicago," (unpublished pamphlet, AIC Archives), n. d.

PUBLISHED SOURCES: Obituary of Kate Sturges Buckingham, *Chicago Tribune*, 15 December 1937; Art Institute of Chicago, *Handbook of the Lucy Maud Buckingham Medieval Collection*, Chicago, 1945; Helen Lefkowitz Horowitz, *Culture and the City: Cultural Philanthropy in Chicago from the 1880s to 1917*, Lexington, 1976, pp. 50, 73, 234; John Maxon, *The Art Institute of Chicago*, London, rev. ed., 1977, p. 11; *Antiquarian Society*, pp. 10, 250–1; *AIA Guide to Chicago*, Perry R. Duis, introd., New York, 1993, p. 405; Martha Wolff, "Introduction," in Christopher Lloyd, *Italian Paintings before 1600 in The Art Institute of Chicago: A Catalogue of the Collection*, Chicago, 1993, pp. xiv–vi; Walter J. Karcheski, Jr., *Arms and Armor in the Art Institute of Chicago*, Boston, 1995, pp. 10–1, 13–4.

NOTES

1 On the subject of grotesques in manuscripts see, Lillian Randall, *Images in the Margins of Gothic Manuscripts*, Berkeley, 1966.

2. Hayward in *Cloisters*, pp. 306–7, 309–10, 313–4, 318.

3 See C-CEC I, CMA 12–15, IUMA I, and CMA Introduction.

4 Maryan W. Ainsworth, *Petrus Christus: Renaissance Master of Bruges* [exh. cat., MMA], New York, 1994, pp. 146–53, no. 15.

5 Friedrich Winkler, *Hugo van der Goes*, Berlin, 1964, pp. 134–41, 215–8.

6 Friedländer, 4, 1969, pl. 23, fig. 14c.

7 Kurth 1963, fig. 220.

8 Beginning of the sixteenth century, Winkler 1964, fig. 175.

9 Barbara Giesicke, *Glasmalereien des 16. und 17. Jahrhunderts im Schützenhaus zu Basel*, Basel, 1991, pp. 54–7, no. 4.

10 See Introduction to this volume.

11 For the Ryersons, see below; for Harding, see the Introduction to this volume.

12 "Kate Sturges Buckingham is taken by Death," *Chicago Tribune*, 15 Dec. 1937; Hayward and Caviness in *Checklist* III, pp. 24, 34, n. 83.

13 "Time Line for the Art Institute of Chicago," AIC *Archives*, unpublished pamphlet; *Buckingham Medieval Collection*, 1945; Maxon 1977, p. 11.

14 *Buckingham Medieval Collection*, p. 68, no. 42.

15 Ibid., p. 62, no. 6; *The Year 1200*, pp. 12–3, no. 15.

16 Ibid., p. 190 no. 197; *Buckingham Medieval Collection*, pp. 66–7, no. 29.

17 Ibid., p. 68, nos. 38–40; de Winter 1985, pp. 127, 136, 141: nos. 57–8, 142: no. 73, fig. 160.

18 *Antiquarian Society*, pp. 250–1, no. 319; de Winter 1985, pp. 118, 124, 136, 141: nos. 41, 44, 59, p. 142: nos. 74, 76, figs. 148, 170; Bruhn, "The Guelph Treasure," in *Medieval Art*, p. 201, no. 70.

19 See Introduction: Exhibition in Museum Collections.

20 See Introduction to the Toledo Museum of Art and TMA 10.

21 *AIA Guide to Chicago*, p. 405.

22 Horowitz 1976, pp. 73, 234.

23 Ibid., p. 50.

24 Wolff 1993, pp. xiv, xvi.

AIC 1. Elder of the Apocalpyse from a Last Judgment Series

Northern France, Paris (?), or England (?)
c. 1250–75
Circle: diameter 15.4 cm (6$\frac{1}{16}$ in)
Accession no. 1949.209, Buckingham Fund, The Art Institute of Chicago

Ill. nos. AIC 1, 1/figs.1–2

History of the glass: L.-J. Demotte, New York, owned this roundel (*Stained Glass*, no.9), and it was in the Brummer Gallery, New York. The Art Institute purchased it from Joseph Brummer in 1949 with funds from the bequest left to the museum by Kate Buckingham in memory of her sister (AIC Curator's file). [In storage]

Original location: The probable home of this roundel was in northern France or England (see below, **Style**).

Reconstruction: Among a series of Flemish grisaille roundel fragments dating from the late thirteenth and fourteenth centuries is a fourteenth-century group that must have come from Last Judgment compositions (Antoine de Schryver, Yvette Vanden Bemden, Guido J. Bral, *Gothic Grotesques in Ghent: The Medieval Stained-Glass Fragments found in the Dominican Monastery*, Kortrijk, 1991, pp. 108–13, 115b).

Bibliography

UNPUBLISHED SOURCES: Meredith Lillich, letter of 30 October 1992; AIC Curator's file.

PUBLISHED SOURCES: *Stained Glass from the XIIth to XVIIIth Centuries* [exh. cat., Demotte], New York, 1929, no. 9, ill.; Husband in *Checklist* IV, p. 76.

Description: A single, monumental seated figure on a decorative ground fills this tondo.

Condition: There is slight corrosion on the interior face of the panel along the lines where the glass not covered by paint meets the glass that is covered by paint. A cogent, authentic, weathering pattern does not appear on the exterior face. This side has probably been cleaned with acid: it has a dull rather than a shiny surface. Large chips occur

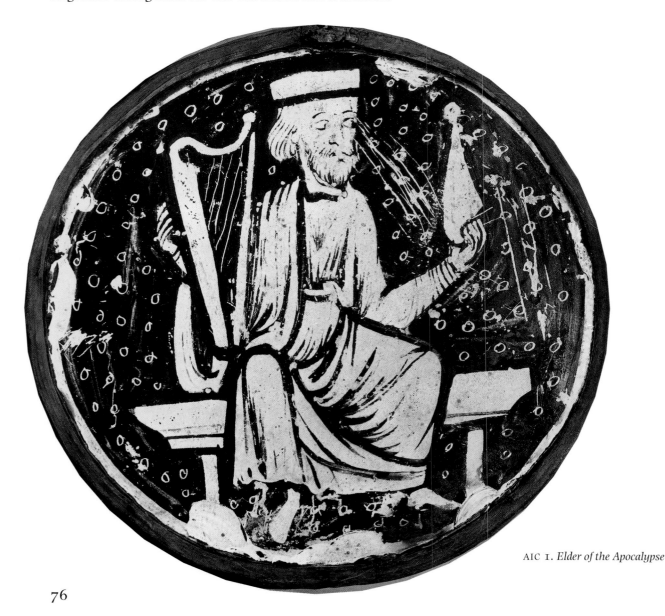

AIC 1. *Elder of the Apocalypse*

around the interior and exterior edges of the panel, as if it had been chiseled out of its original setting in the eighteenth or nineteenth century. The glass itself is thick, greenish and slightly cloudy. Much paint was applied to produce the background, but it is now badly scratched.

Iconography: The Elder holds a harp and an incense jar (?) or viol (?). He is crowned and wears an ankle-length gown with a mantle around his shoulders. The Elders accompany Christ and the symbols of the Four Evangelists in Last Judgment images (Apocalypse 5:8).

Technique: The materials include uncolored glass and black paint. The ground was painted while reserving a clear silhouette for the figure and the bench. The trace lines within the figure were then added. Details, such as the harp strings and the small rings in the ground, were scratched out with a pointed tool.

Style/Date: The Chicago roundel closely resembles a pot-metal leaded tondo showing a crowned, seated figure holding a sword and a musical instrument. The figure is identified as *un roi musicien*, and now occupies bay 8 in the ambulatory of the Abbey Church of Saint-Denis (AIC I/fig. 1). This mid-thirteenth-century panel is not from Saint-Denis itself. It shares a lancet with three other round panels whose original locations are likewise not known. One of the other three, a Wise Virgin, holds objects in her hands with gestures that closely resemble those of the Chicago Elder (Grodecki 1976, pp. 59–60, fig. 230). The Baron Ferdinand de Guilhermy, known for his accurate descriptions of medieval glass in French cathedrals, offers another intriguing connection with Saint-Denis. In 1842, he saw thirteenth-century grisaille glass along with a thirteenth-century roundel showing a seated king holding "a viol [*viole*] and a bow [*archet*]" and another of the same date showing a seated king holding a "sceptre [*scepter*]" installed in a crypt chapel there (Jane Hayward, "Two Grisaille Glass Panels from Saint-Denis at The Cloisters," in *Cloisters*, pp. 312, 323, n. 87; see also *Himmelslicht*, no. 65, pp. 270–1). On the other hand, fourteenth-century roundels are found in various sites in Lincolnshire (Hebgin-Barnes 1996, p. 124, n: V.c1, ill.; pp. 145–6, n: VII. A1–A2, ill.). There is another in the Burrell Collection, Glasgow (*Burrell* 1965, p. 21, no. 47, ill.). All these English examples show figural images that contrast with painted grounds decorated with stickwork squiggles. A fourteenth-century fragment at Spalding, Lincolnshire (Hebgin-Barnes 1996, p. 267, 2b) depicts a blessing Christ whose pose is not unlike that of the Elder in Chicago.

Figural grisaille roundels occur as early as the second half of the twelfth century, as evidenced by a set of eight panels at Sainte-Ségolène, Metz. The Sainte-Ségolène roundels, measuring *c.* 9–12 cm in diameter, depict birds and animals. Technically they are very similar to the Chicago panel: the silhouettes of the animals were left blank,

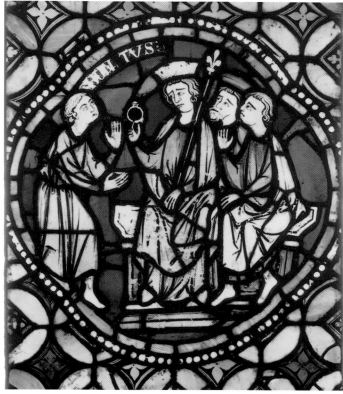

AIC I/fig. 1. (*above*) *Musician King*, c. 1250, from Northern France, Abbey Church of Saint-Denis

AIC I/fig. 2. (*below*) *King Sigebert gives St. Bonnet the Seal*, c. 1250, Cathedral of Clermont-Ferrand, choir chapel window s: iia3

while the grounds behind them were painted black. Spirals and stickwork circles, like those behind the Elder, enliven the painted areas in the Metz panels. They are now in a two-light window on the north side of the choir, and probably came from an earlier church on the same site (Franz X. Kraus, *Kunst und Alterthum in Elsass-Lothringen:*

Beschreibende Statistik, 3, Strasbourg, 1889, p. 442, figs. 100–2; Wentzel 1954, pp. 22, 106, text fig. 10; Grodecki 1977, pp. 20–1, 284–5, figs. 5, 6; France *Recensement* V, pp. 16, 107–9, figs. 97, 112). Arguably the griffon medallions in the mid-twelfth-century decorative windows at Saint-Denis, although leaded pot-metal, belong to the same genre in the sense that they show fantastic beasts within tondos (Grodecki 1976, pp. 122–6, pl. XV, figs. 21–2, 183–92).

The Chicago figure wears a robe of pliant cloth that clings slightly and is looped across his knees. Sections of parallel, parabolic curves define the folds. This pose is not unusual in northern French glass dated in the middle and third quarter of the thirteenth century. There are examples at the Sainte-Chapelle, Paris (Aubert 1959, pl. 49 H-7, pl. 57 F-21) and the cathedral of Clermont-Ferrand, Puy-de-Dôme, *c.* 1265–75 (AIC 1/fig. 2).

AIC 2. Massacre of the Innocents

France, Normandy or Ile-de-France (?)
c. 1500–1510
Rectangle: 59.5 × 61 cm (23¼ × 23¾ in); top border 9 cm (3¾ in)
Accession no. 1990.589, George F. Harding Collection

Ill. nos. AIC 2, 2/a, 2/figs. 1–3

History of the glass: George F. Harding owned the panel and it was displayed in the Harding Museum, Chicago. A photograph of the installation (AIC Curatorial file) shows the panel of the *Massacre of the Innocents* below a window of bull's-eye glass and above an oval painting in a heavy gold rectangular frame. The panel was given to the Art Institute of Chicago in 1990. [In storage]

Composition: The panel must have been part of a series, either an Infancy or a Life of Christ. It can be associated with other large-scale programs that could combine vignettes, like pages in a book, lined up one after another in large multilight windows. See, for example the eighteen scenes from the creation of the world to the story of the children of Adam and Eve, church of Saint-Florentine (Yonne), about 1525 (France *Recensement* III, p. 162, pl. VIII).

Bibliography
UNPUBLISHED SOURCES: AIC Curator's file; Elizabeth Pastan, correspondence 10 August 1990 with AIC. Michel Hérold, letter to author, 1997.

Condition: The panel is well preserved. The pattern of leading is intact, evidenced by the legibility of the image in terms of the contours of the glass segments. The identification of separate figures, the background, and the dra-

matic action is possible even seen in raking light on the reverse. There is a consistent pattern of back-painting across almost all of the panel. Several exceptions are areas of the head and arms of the isolated soldier with a sword and one head and several helmet tops to the right of the frontal screaming woman at the left. These segments show a different pattern of exterior corrosion from the other segments of glass. The interior, however, does not reveal a substantially different paint application on these pieces. One is led to conclude that the segments are authentic, but that the composition of the glass has caused a different susceptibility to degradation. The selection of glass, certainly in what must have been a very large program covering a significant window space, may have allowed the mingling of different kinds of glass, hence the different weathering patterns. This seems a more likely explanation than the identification of an extremely adept restorer. In some areas, especially on the lower edge near the body of the dead child on the ground, the paint is abraded substantially.

The border may be an authentic part of the panel, although painted on a different kind of glass. Although at first glance it appears incongruously Italianate in style next to the late-medieval disposition of the panel, this stylistic juxtaposition is observed in windows of the time. The church of Saint-Sulpice in Nogent-le-Roi (Eure-et-Loire) shows a similar border in white glass with silver stain (AIC 2/fig. 1) for a series of windows of the Life of Mary Magdalene (bay 5, Michel Hérold in *Vitraux parisiens*, p. 73, ill. 81a; France *Recensement* II, p. 75). A half-length figure blowing a horn arises from leafy tendrils at the center of the decorative border, quite similar to the disposition of the border in the Chicago panel.

AIC 2/a: Restoration chart

AIC **2**. *Massacre of the Innocents*

Color: The palette is subdued. The panel is dominated by uncolored glass treated with light brown paint and medium yellow silver stain. The background architecture is a dull light violet, a dull medium red-violet, and a dull medium blue violet. A few patches of deep color, such as warm medium red or dark blue, appear in the clothes of the women.

Iconography: The *Massacre of the Innocents* is one of the well-known episodes from the Infancy of Christ. The event is described in the Gospel of Matthew (2:1–18). Herod, King of Judea, learns from the Magi that they have seen a star in the East and are come to worship "he that is born king of the Jews". He asks the Magi, in secret, to make inquiries and when they find the child, to bring word so that he too might go and worship. The Magi, however, are warned in a dream not to return to Herod. An angel warns Joseph to take the infant Jesus and his mother

AIC 2/fig. 1: Border in white glass with silver stain, Nogent-le-Roi (Eure-et-Loire), Church of St. Sulpice

Mary and flee Herod's power. Unaware of the flight, and in an effort to eliminate his potential rival, Herod orders his soldiers to kill all the boys in Bethlehem two years old or under. Matthew's text consistently relates these events to Old Testament prophecies, such as Micheas (5:2) fore-telling that the savior will come from Bethlehem. He para-phrases from Jeremias (31:15) comparing the mothers to Rachel: "weeping for her children, and refusing to be com-forted for them, because they are not." That these refer-ences were common is attested by the *Biblia Pauperum*, a standard iconographic reference for this time with both Old Testament image and prophetic text arranged as pro-totypes for the life of Christ. For the *Massacre of the*

Innocents we find the same text from Jeremias, "A voice was heard on high of lamentation, of mourning, and weeping" (blockbook page g, Henry 1987, pp. 62, 94–5).

Technique/Style: The panel is predominately uncolored glass with two shades of silver stain and one shade of grisaille paint. Pot-metal appears in segments of light green for a segment of grass, dark green for a soldier's leggings and a segment of grass to the left of the dead child, deep red in a woman's hat, another's dress, and another's cloak, and blue in the cloak of the woman to the far left. An extensive, unmodulated, back-painting is used to set a tonal depth to the areas represented in shadow. This modeling is shown in the landscape background and the right sides, as well as the heads of the frontal screaming woman and the sol-dier approaching her, among many others. When the panel is seen in raking light from the exterior, the back-painting is particularly visible in the upper areas, where spears and axes stand out as unpainted smooth glass. The interior is defined primarily through mat and trace. The mat is re-moved through the dry brush technique and the image is further defined through an application of trace, mostly by hatching.

The scene is vigorously composed, showing a great den-sity of figures. The women on the left and right are in pro-file, leading the spectator's gaze to the center where a soldier is seen in the act of stabbing a child; another soldier lunges forward. In the very middle, at the bottom, is the body of a child. The juxtaposition of the prone white corpse with the running child whose hands are extended for help, to the left, emphasizes the futility of its efforts to escape the soldiers. Similarities appear in the panel of Mary Magdalene distributing her jewels (AIC 2/fig. 1) from Nogent-le-Roi. The relationship of figure to architecture and the compression of pictorial space that places the two men in the distance on the same plane as the Magdalene have similar artistic roots. Michel Hérold's discussion of the Master of the Life of St. John the Baptist to whom he attributes the five ambulatory windows of Nogent-le-Roi (*Vitraux parisiens*, pp. 62–81) brings out the complex rela-tionships of patrons, glass painters, and ateliers in Paris in the years around 1500. The styles labeled Parisian are often found in neighboring areas, such as Nogent-le-Roi, near Chartres, and especially in Normandy. Exportation trans-ferred windows made in Paris to Normandy sites. Artists from Paris such as Jehan de Paris or Parisy, could transfer their ateliers to cities such as Rouen (ibid., p. 74). Design projections, exact size models, and cartoons appear to have traveled with glass painters. Hérold argues for the importance of Paris as a site of major influence, which today is difficult to estimate because of the losses of so much historic glass.

The head of the frontal screaming woman represents the typical painting style. The eyebrows are drawn as a number of thin strokes over which is placed a broad sweep

AIC 2/fig. 2: *Virgin of the Lamentation*, Paris, St. Gervais

of the brush with its darkest intensity paint. The features are large, especially the eyes, the nose is shorter and with a blunt tip. Eyes are defined through double outline for both upper and lower eye lids. The folded turban never achieves a true three-dimensional illusion, although worked by removing paint to form the highlights. The artist consistently relies on edge definition via trace line, which is particularly limiting through the single medium intensity line that encircles the face, dividing the head from the headdress. On the shaded side of the face, the back-painting is supported by vertical hatching that follows the oval shape of the head. These techniques are found in Parisian

AIC 2/fig. 3: *Life of St. Isabelle of France*, Paris, St. Gervais

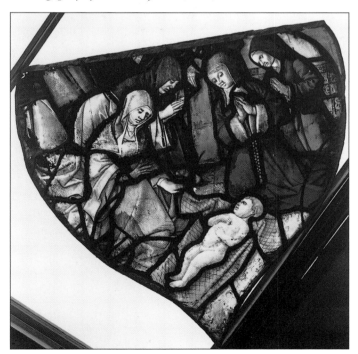

glass painting of about 1510. In St. Gervais in Paris, the *Virgin of the Lamentation* (AIC 2/fig. 2: bay 7, Françoise Gatouillat and Claudine Lautier in *Vitraux parisiens*, p. 60, ill.) shows the same use of hatching around the eyes, nose, and the cast shadows around her face. The folds in the garments employ the same distribution of mat and smear shading with hatching. Nonetheless, as Hérold has communicated, there is no question of attributing the glass to the circle of the artist called the Master of the Life of Jean the Baptist, whose richness of costumes, architectural decor, and composition are quite dissimilar. The techniques of application of paint, modeling in space, etc., are general Parisian tendencies, possibly more similar to the panels of *The Fall of Troy*, beginning of the sixteenth century, in Ecouen, Musée National de la Renaissance. In these two panels illustrating the Greek story, presumably from the Parisian region, the figures are more densely packed and the stocky proportions of the bodies more similar to those of the Massacre panel.

The running child at the woman's feet is a particularly telling example of the glass painter's concepts of modeling. The body is modeled in granular washes, accented by limited hatching to indicate the roundness of the thigh or the structure of torso. A comparison can be made to the infant in a scene of the healing of a child from the *Life of St. Isabelle of France* (AIC 2/fig. 3) in St. Gervais (Françoise Gatouillat and Claudine Lautier in *Vitraux parisiens*, pp. 58–9, ill.). Yet, ultimately, the painting appears to float across the surface, rather than attempt to define the geometric structure of the form as was common in German painting of the time. German examples can be seen in the *Standing Figures of Three Saints and Two Representations of the Virgin and Child* (DIA 23–7) dated 1510–25 or *Crucifixion with the Virgin, St. John and Angels* (DIA 29) dated 1514.

Date: A date of *c.* 1510 or slightly later is suggested though stylistic associations with French narrative windows of this time. At Nogent-le-Roi, the five windows of the ambulatory by the Master of the Life of St. Jean the Baptist are dated 1500. The windows cited from St. Gervais in Paris are dated to *c.* 1510–17.

Photographic reference: AIC: Harding Collection

AIC 3. Birth and Naming of John the Baptist
North Lowlands, Leiden
Pieter Cornelisz. Kunst (1489/90–1560/61) (?)
c. 1525
Rectangle: 28.5 × 20.2 cm (11¼ × 8 in)
Accession no. 1937.864, The Mr. and Mrs. Martin A. Ryerson Collection

Ill. no. AIC 3

History of the glass: Grosvenor Thomas, London, owned this panel in 1913 when it was displayed at the Charles Gallery (*Drake* sale 1913, pt. 2, p. 13, no. 51). Mr. and Mrs. Martin A. Ryerson, Chicago, might have purchased it after seeing that exhibition. They gave it to the Art Institute in 1937. [In storage]

Related material
Birth, Circumcision, and Naming of John the Baptist: (1) roundel, *c.* 1510–20, Baltimore Museum of Art, Baltimore, 1941.339.2b (Husband in *Checklist* IV, p. 89); (2) roundel, *c.* 1525, Church of St. Mary the Virgin, Glynde, East Sussex (Cole 1993, p. 93, no. 777); (3) roundel, Popham file, Rijksbureau voor Kunsthistorische Documentatie, Old Master Drawings Department, file I, map 5.

Zacharias at the Altar: (1) roundel, *c.* 1525, Church of St. Mary the Virgin, Glynde, East Sussex (Cole 1993, p. 92, no. 763); (2) ink on paper, *c.* 1520–5, different design, attributed to Jan de Beer, Musée des Beaux-Arts, Lille (Husband 1995, p. 180, fig. 3).

Bibliography
UNPUBLISHED SOURCES: G. B. Krebber, letter of 17 Oct. 1996; AIC Curator's file.

PUBLISHED SOURCES: *Drake* sale 1913, pt. 2, p. 13, no. 51; Husband in *Checklist* IV, p. 77.

Description/Color: The figures interact with each other in three clearly separated architectural zones—foreground, middle ground, and right background—each of which could stand on its own, in the sense that the design of each zone is autonomous. Zacharias's garments are colored deep amber with silver stain, and those of the peasants, light yellow.

Inscription: IOHAN [John], on the tablet the priest holds.

Condition: The breaks, not grozed, are mended with leads. There are minor surface scratches. Some paint at the top is rubbed, but this probably happened before the firing. The panel is mounted in a substantial modern metal frame. A dealer's number, 50, is in the lower right hand corner.

Iconography: This image is strikingly similar to *Mardochai overhears the Conspiracy from the Story of Esther* (AIC 4): both narrate popular biblical stories in unusual ways.

Here Zacharias's miter indicates his station as high priest (Luke 1:5; *Golden Legend,* pp. 321–2) as he writes the name. One shepherd speaks as if exclaiming about the name. Another holds the ink well. The large flagons, plates, and pitchers on the altar-type structure in the niche behind Zacharias illustrate the wealth of the treasury of the Temple of Jerusalem.

In the birth scene, Mary wears a cloak that covers her head and leans across the bed toward Elizabeth (*Golden Legend,* p. 323). Four more women attend Elizabeth: the midwife in the foreground prepares to bathe the swaddled baby, an image borrowed from the Nativity of Christ (*Herder Lexikon,* 7, col. 179). The bathing of John prefigures his baptism of Christ (Réau, 1956, 2/I, p. 446). The other midwife wears a double-horned coif that identifies her as the Mary Salome who doubted that the Virgin Mary could give birth. Late medieval English sermons include misogynist references to hats like this one (G. R. Owst, *Literature and Pulpit in Medieval England,* Oxford, 1961, p. 403). The ox skull in the tympanum above the double arch leading to the Circumcision references the Old Testament custom of animal sacrifice.

In a roundel illustrating *Zacharias at the Altar* (see **Related material** 1), Zacharias wears a miter, cope, and gloves as he does in the Chicago panel. Another image of Zacharias vested as a bishop to designate him as a high priest of the temple occurs in a drawing for a roundel attributed to Jan de Beer (see **Related material** 2).

Technique: Uncolored glass, paint, and silver stain of several values constitute the materials. The mats are stippled and the needlework, as on the vases, is very precise. There is no back-painting.

Style/Date: The delicacy and concern for genre details that characterize the birth scene are typical of the work of Rogier van der Weyden, as in the *Altarpiece of the Seven Sacraments,* *c.* 1453–5, or the *St. John the Baptist Altarpiece,* 1440s (Snyder 1985, figs. 123–4; J. R. J. van Asperen de Boer, J. Dijkstra and R. van Schoute, "Underdrawings in Paintings of the Rogier van der Weyden and Master of Flémalle Groups," *Nederlands Kunsthistorisch Jaarboek,* 41, 1990, 41, pp. 249–51). Rogier also separates events by means of architecture as is true of these two panel paintings. The roundel in Chicago shares this concept. The design for the roundel might be based on sketches taken from his paintings or on copies of drawings from his shop; but it probably dates from the period after Rogier's activity, since this extends only into the 1460s. The immediate model is more likely to be the work of Pieter Cornelisz. Another roundel in the Art Institute, *Mardochai overhears the Conspiracy from the Story of Esther* (AIC 4), is also attributed to this artist here. Pieter Cornelisz. is sometimes known as the Monogramist PC or the Master of the Acts of Mercy (Husband 1995, p. 108). Cole believed that he

AIC 3. *Birth and Naming of John the Baptist*

83

produced the models for two panels in the same St. John the Baptist series at Glynde, entitled *The Naming of John the Baptist* and *Zacharias at the Altar* (Cole 1993, pp. 92–3, nos. 763, 777). The elements to note include Pieter Cornelisz.'s expressive facial types that are not idealized and his tendency to place the protagonists at oblique angles in relationship to the picture plane. Other qualities include his manner of compartmentalizing different stages in the narrative in different spatial units, a concept shared by this panel and the work of Rogier as noted above. Cornelisz. used the architecture and perspective construction of a drawing, *Feeding the Hungry*, 1524, to accomplish this goal (Husband 1995, p. 113, fig. 2). Compare as well the profiles of Zacharias and the left kneeling figure in the *Martyrdom of Saint Eustace* (Walter S. Gibson, "Pieter Cornelisz. Kunst as a Panel Painter," *Simiolus*, I, 1966–67, p. 44, fig. 7). Pieter Cornelisz. is said to have been a glass painter: he is best known for his drawings, dated 1524, 1531, and 1532, all but one of which bear a PC monogram (Husband 1995, p. 108).

Photographic reference: A 13596

AIC 4. Mardochai overhears the Conspiracy from the Story of Esther

North Lowlands, Leiden
Circle of Pieter Cornelisz. Kunst
(1489/90–1560/61) or Lucas van Leyden
(1489?–1533)
c. 1525
Rectangle: 28.2 × 20 cm (18 × 13½ in)
Accession no. 1937.863, The Mr. and Mrs. Martin A. Ryerson Collection

Ill. no. AIC 4

History of the glass: Chicago's roundel appears in the catalogue of the 1913 Grovesnor Thomas exhibition (*Drake* sale 1913, pt. I, p. 13, no. 51). Evidently the buyers were Mr. and Mrs. Martin A. Ryerson who later gave it to the Art Institute. [In storage]

Related material: Rectangular panel, Glasgow, Provand's Lordship, Simson's Chamber 5c, Glasgow Museums and Art Galleries, 21.5 × 17.5 cm (Cole 1993, p. 90, no. 757/5c). This appears to be based on the same design and possibly the same cartoon, but the upper part and a section on the left edge are missing. It is likely that the top and left edges of the original drawing or print were cropped so that it would fit on the Glasgow panel, which is smaller than that in Chicago.

Bibliography
UNPUBLISHED SOURCES: AIC Curator's file

PUBLISHED SOURCES: *Drake* sale 1913, pt. I, p. 13, no. 51; Husband in *Checklist* IV, p. 77.

Description/Composition: A dramatic, complex narrative occupies the architectural and landscape spaces that separate the different events. The composition centers on the two conspirators who stand on the checkerboard stage that isolates them in the foreground. Plants grow from the stones that remain of this classical ruin.

Condition: Despite some paint loss from the landscape and background buildings, the panel is in good condition: there are no break leads. "51," Grosvenor Thomas's catalogue number, is on the back of the glass at lower right (Drake 1913, pt. I, p. 13, no. 51). This roundel is set into a modern metal frame.

Iconography: A Cleveland panel, *c.* 1525–30 (CMA 15), evidences the popularity of the Esther story in the first third of the sixteenth century. Yet this Chicago roundel emphasizes a less familiar moment: Mardochai overhears Bagathan and Thares conspiring against King Assuerus at the gateway of the palace. Mardochai reveals to Esther what he has overheard, and she tells the king (Esther 2:21–23). Subsequently, Aman becomes the king's Prime Minister. In the end, Aman is hanged because Esther reveals to Assuerus Aman's plan to kill the Jews of the kingdom. Esther before Assuerus and the hanging of Aman appear in the left middle ground and right background respectively.

In the mid-thirteenth-century Sainte-Chapelle stained glass narrative, Mardochai overhearing the plotters and the ensuing events are carefully spelled out (Alyce Jordan, "Narrative Design in the Stained Glass Windows of the Ste. Chapelle in Paris," Ph.D. Dissertation, Bryn Mawr College, 1994, pp. 488, 505–6, pl. C2, C-156–63; see also, Aubert 1959, pp. 261–2, pls. 74–6, C-180–7). Likewise Philips Galle devoted one entire print to the conspiracy, *Mardochai overhears the Treason of Bagathan and Thares* (Ill. *Bartsch*, 56, p. 66, pl. 017:2, after a drawing by Maerten van Heemskerck). In general, though, Renaissance redactions of the Esther story spotlighted Esther: a fifteenth-century Italian cassone painter placed Esther in the foreground and Mardochai with the plotters in the background thereby reversing the narrative emphasis (Paul Schubring, *Cassoni*, Leipzig, 1923, pl. 80).

Technique: The artist used one hue of brownish black paint on uncolored glass. Soft removal of the mat produced the complex chiaroscuro, especially on the conspirators in the foreground. Stickwork defines the beards and the edges of the architecture. Silver stain on the exterior face of the glass and paint on the interior face construct stripes on the costumes. Stippled mat shading and a

AIC 4. *Mardochai overhears the Conspiracy from the Story of Esther*

painterly use of silver stain animate the architecture and landscape. A very pale and diluted mat designates clouds.

Style: Cole suggested Pieter Coecke as the designer of the Glasgow panel, which is most likely based on the same drawing or print (Cole 1993, p. 90, no. 757). Nevertheless an artist associated with Pieter Cornelisz., Kunst, also known as the Monogramist PC and the Master of the Seven Acts of Mercy (c. 1489/90–1560/61) or his contemporary, Lucas van Leyden (1489?–1533), will be put forward here. The Chicago and Glasgow panels could have been designed within the ambit of either.

Poses, body types, and spatial arrangements of drawings by Pieter Cornelisz. Kunst illustrating the Seven Acts of Mercy connect him to the Chicago and Glasgow panels. In three of the drawings, dated 1524, a male protagonist stands at an oblique angle with his back facing the viewer in the lower left corner of the composition (Husband 1995, p. 113, figs. 1, 2, 114, no. 49). His companion(s) stand more or less parallel with him and face him. Three drawings and an unsigned roundel, dating c. 1510–24, show architectural forms that lead back into space on the left (ibid., pp. 109, 113, nos. 46, 48, figs. 1, 2); the ground plane tilts up toward the viewer. Pieter Cornelisz.'s figures may stand with legs spread or crouching, as at Chicago. Beak-like noses and closely spaced eyes are typical and so are parallel, tubular folds that fall down the belted coats. Calf muscles are prominent.

The work of Lucas van Leyden, primarily an engraver and a contemporary of Pieter Cornelisz., can also be related to the Chicago Mardochai roundel. Lucas van Leyden chooses atypical moments to illustrate, for example, *Mahomet and the Monk Sergius*, 1508 (Jacobowitz 1983, pp. 60–3, nos. 11–2). He likes striped and exotic costumes (*Putiphar's Wife accusing Joseph*, 1512, ibid., p. 101, no. 302; *Adoration of the Magi*, 1513, ibid., pp. 126–7, no. 41) as well as stooped poses (*The Beggars*, c. 1520, ibid., pp. 206–7, no. 78). In addition, van Leyden produced at least two prints illustrating other episodes of the story of Esther (*Esther before Assuerus*, 1518, ibid., pp. 186–7, no. 68; *The Triumph of Mordecai*, 1515, ibid., pp. 142–3, no. 48).

Date: Given that van Leyden's prints on the Esther theme range from 1515 and 1518, and Pieter Cornelisz.'s most closely related drawings are dated 1524, the Chicago and Glasgow roundel design probably belongs in the decade between 1515 and 1525.

Photographic reference: A 13595

AIC 5. The Hanging of Judas
Alsace or South Germany
c. 1520
Rectangle: 54.6 × 42.5 cm (21½ in × 16¾ in)
Accession no. 1949.494, Buckingham Fund
Ill. nos. AIC 5, 5/figs 1–3; Col. pl. 24

History of the glass: This small but well preserved panel has passed though some famous collections, beginning with Hampp, the Norwich wine merchant responsible for large numbers of panels imported to England from the Rhineland around 1802–4, then Sir Thomas Neave, Dagenham Park, Essex. It was then acquired by Grosvenor Thomas, to be transferred to the dealership Thomas and Drake, New York, then R. G. Thomas & Co., London. In 1949 Roy Grosvenor Thomas sold it to Myric Rogers, representing the Art Institute of Chicago. [In gallery]

Bibliography

UNPUBLISHED SOURCES: AIC Curator's file. Roy Grosvenor Thomas; expertise of glass by Wolfgang Stechow, 28 Jan. 1950; Jane Hayward; correspondence on iconography from Rosalie Green, Walter Cook; Hans Weirauch, Hans Wentzel, technical notes by Alyce Jordan and Meredith Lillich; Victor Beyer, Corpus Vitrearum France, oral communication to Meredith Lillich; James Crump, "'The Hanging of Judas' in the Art Institute of Chicago: A Study of 'Change' in Late Gothic Germany," seminar paper for Elizabeth Pastan, 1991, Department of Art History, University of Indiana; Hartmut Scholz, Corpus Vitrearum, Germany, correspondence with author, 1996; Myra Orth 1997 correspondence with the author.

PUBLISHED SOURCES: Grosvenor Thomas Stock Book 1, pp. 102–3, no. N-29; Oswald Goetz, "Hie hencktt Judas," *Form und Inhalt, Kunsgeschichtliche Studien Otto Schmitt zum 60. Geburtstag*, ed. Hans Wentzel, Stuttgart, 1950, pp. 105–37, fig. 1; AIC *Bulletin*, 44/4, 1950, ill; C. J. Bulliet, "Art in Chicago," *The Art Digest*, 25/6, 15 Dec. 1950, p. 15; Gert von der Osten, *Hans Baldung Grien, Gemälde und Dokumente*, Berlin, 1983; Lillich in *Checklist* III, p. 126; *Painting on Light*, pp. 234–46.

Condition: There appear to be no replacements and the surface is almost completely free from abrasion. The panel is in excellent condition for retention of authenticity. There are a number of cracks that have been repaired with mending leads, but the additional lead lines do not detract substantially from the legibility of the panel.

Color/Technique: The color harmonies are subdued and seem appropriate for the intensity of the subject matter. A pale blue sky and dull green foreground are the pot-metal colors. All else is achieved with several warm brown shades of vitreous paint and at least two shades of silver stain on uncolored glass. With these restricted means, the

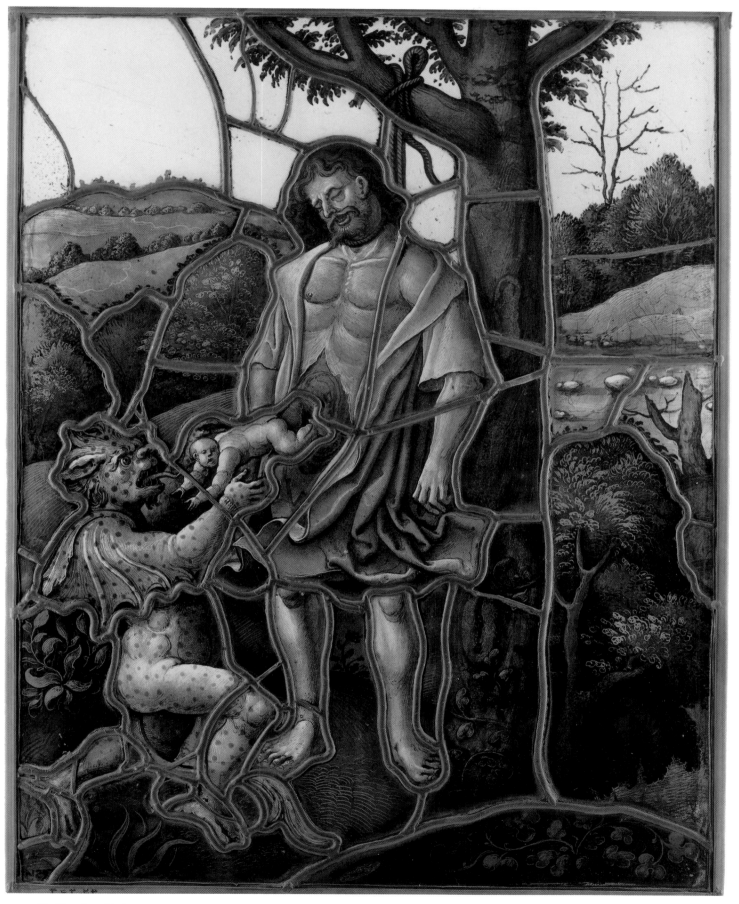

AIC 5. *The Hanging of Judas*

viewer has the impression of a wide range of tones within shades of medium warm brown, yellow brown, dull orange yellow, and dull medium green. The glass is a thick gently undulating type and the application of paint is of an exceptionally high quality. The spots on the devil, produced with silver stain, create a curious and unusual effect.

Iconography: The subject of Judas, and the complexity of issues that encouraged so dramatic an act as suicide, have been open to differing interpretations throughout western art (*Herder Lexikon*, 2, cols. 444–8). The subject is grounded in Gospel tradition. After agreeing to betray Christ, pointing him out to the soldiers in the Garden of Gethsemane, "he said, Hail Rabbi. And he kissed him" (Matt. 26:49). Afterwards Judas regretted his act and attempted to return the price of betrayal, the thirty pieces of silver, to the chief priests. They refused to accept it, but Judas cast down the pieces of silver "and went and hanged himself with an halter"(Matt. 27:5). The image is elaborated in the Acts of the Apostles, adding what became in art the signature detail of the protruding bowels: "and being hanged, (Judas) burst asunder in the midst: and all his bowels gushed out"(Acts 1:18).

The image of the suicide of Judas has a long history and had become a common element of sculpted programs in the twelfth century. Devils appear in many of these scenes, such as a twelfth-century capital from the cathedral of Autun (Goetz 1950, fig. 4) showing a demon pulling on the rope that suspends Judas. In the *Queen Mary Psalter* of 1310 (British Library, Royal MS 2 B.VII; Goetz 1950, fig. 10), in the upper right, a demon flies off with his soul. In Last Judgment portals, Judas appears as a reminder that hell was a reality against which Christ's redemptive act would rescue believers, such as in the cathedral of Strasbourg and on the west portal of the Münster of Freiburg (*Herder Lexikon*, 2, col.446), In Freiburg coins fall from Judas's hand as his entrails spill from his abdomen, and in the tree, demons carry off his soul. Judas's suicide, hanging from a tree with protruding bowels, was virtually indispensable for the ivory Passion diptychs carved in Paris in the second half of the fourteenth century (Louvre OA 4089; Walters Art Gallery 71.179, 71.272, 50.300; Minneapolis Institute of Arts 83.72; Victoria and Albert Museum 291–1867: *Images in Ivory, Precious Objects of the Gothic Age*, ed. Peter Barnet [exh. cat., DIA], Detroit, 1997, pp. 170–9, nos. 30–3).

The reasoning behind these images was codified in the late thirteenth century in the *Golden Legend* (p. 174) in a characteristic structure giving meaning to each element. Repeating the phrasing of the Acts on the manner of Judas's death, the text adds that he could not vomit his soul from his mouth "because his mouth could not be defiled, having touched the glorious face of Christ." The *Legend* explains that his entrails burst because it was from

his belly that his evil plan arose, and his throat was closed with a rope since his throat, that is, his voice, had been the instrument of betrayal. He died in mid-air, suspended from a rope, because he had given offense to both the angels of the air and the inhabitants of earth, so he "deserved to be punished between earth and Heaven".

The dramatic possibilities of such a scene, as displayed in the Chicago panel, are shared across media. Veronique Plesch explores the image of Judas in theatre and sermons as well as art ("Pictorial 'ars praedicandi' in Late Fifteenth-Century Paintings," *Word and Image*, Interactions II, Atlanta, 1999, pp. 173–86; id. "L. Brigue 1492: Anti-Semitic Iconography in a Savoyard Pilgrimage Sanctuary," *Studies in Iconography*, 23, 2002, forthcoming). The four-day cycle by Arnould Greban provides an exemplar: *Le Mystère de la Passion* (before 1452, ed. Gaston Paris and Gaston Raynaud, Paris, 1878: Geneva: Slatkine Reprints, 1970). In Passion plays, the issues of damnation and redemption are particularly clear. Stephaton remains obdurate; Longinus, the Centurion, believes. Dismas, the good thief acclaims Christ; the bad thief rejects his chance for salvation. Demons as well as angels crowd scenes, the demons seizing the soul of the bad thief as it leaves his mouth, while angels welcome the good soul similarly exiting from Dismas. Judas, however, has kissed the mouth of Christ (verses 22021–9). Despair, who comes to Judas before he hangs himself, repeats the *Golden Legend*'s explanation: *et par ceste bouche maligne/ qui toucha a chose tant digne/ l'ame ne doit ne peust passer* (and by that evil mouth that touched the one so worthy, it should not and cannot pass). Berich, the demon to whom Despair speaks, has a solution: *Si luy fault la pance casser,/ fendre, et tous les boyaulx tirer,/ affin qu'il puist mieulx expirer: Le veux tu,/ ma seur?* (it will be necessary to break his gut and to pull out all the entrails. Thus he will die better. How about it, my sister?). Despair is willing, and keeping within the meter of the verse, replies: *Je l'ottroie./ Courons nous en, j'ay nostre proie;/n'y a que de tirer pays* (I'm for it. Let's run on, I have our prize, it only remains to get out of here). With this rhyming triplet and the high drama of disemboweling, achieved for the audience by the release of sheep's tripes spilling to the ground, the scene ends.

One of the images closest in time and iconography to Chicago's panel is in the manuscript of the *Mystery of the Passion*, attributed to Eustache Marcade (Bibliothèque municipale d'Arras, MS 697; Jules-Marie Richard, *Le Mystère de la Passion: texte du manuscrit 697 de la Bibliothèque municipale d'Arras*, Geneva, 1891: repr. 1976; Gustave Cohen, *Le Theatre en France au moyen âge*, 1, *Le Theatre religieux*, Paris, 1928, p.45; Goetz 1950, p.121). The work was written in the first half of the fifteenth century and richly illustrated. The drawing of Judas's death (AIC 5/fig. 1) shows him hanging from a tree with a devil of human form, but with scales, claws, and reptilian fins

around the face, tearing at his entrails. The juxtaposition of the two protagonists, Judas and the demon, is similar in the Chicago panel.

The question of the placement of such a scene within a glazing program is unresolved. Judas's suicide was not a part of two popular programs of salvation images, the *Biblia Pauperum* or the *Speculum Humanae Salvationis*. It does appear in the *Concordantia Caritatis*, written by Ulrich of Lilienfeld (d. 1358) (*Concordantia*, Alfred A. Schmid in RDK, 3, 1954, cols. 833–54, esp. 845–6). The *Concordantia* was not a common source for monumental imagery, and the scene of Judas's suicide is simply compared to two Old Testament images of hanging: Achitophel commits suicide (2 Kings 17:23) and Absalom is suspended from the oak (2 Kings 18:9). If within a system, Judas as a personification of the vice of despair would more easily respond to medieval antiphonal narrative structure. Hope must be contrasted to despair, heaven against hell, and the damned set against the saved. One of the best-known examples of Judas as Despair appears in the *Belleville Breviary* c. 1323–6 (Paris, Bibliothèque nationale, MS. lat. 10483–4: Kathleen Morand, *Jean Pucelle*, Oxford, 1962, pp. 9–13, 43–5, no. 10, pl. VIa). At the bottom of the page (AIC 5/fig. 2), the cadaver of the suspended Judas is set against the standing figure of Hope portrayed as a crowned and haloed woman.

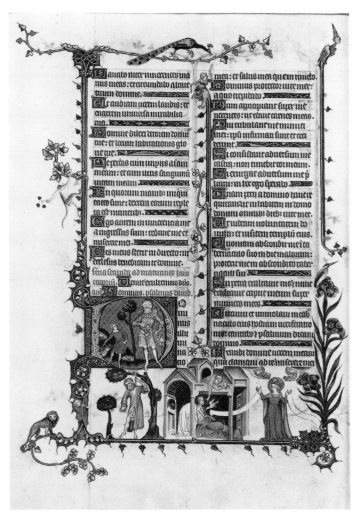

AIC 5/fig. 2. JEAN PUCELLE: *Belleville Breviary*, c. 1323–6, Paris, Bibliothèque nationale

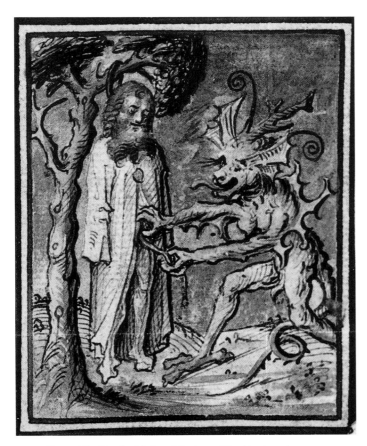

AIC 5/fig. 1: *The Death of Judas, Mystery of the Passion*, Arras, Bibliothèque municipale

In the center a man on his sick bed receives the sacrament of Extreme Unction. He is visited by a dove representing the gifts of the spirit that follows the banderole issuing from Hope's hand. The small size of the Chicago panel and its unusual subject matter suggest that it was set within some type of program, not as an isolated image. If the panel were a part of a narrative cycle, the program would have been quite extensive. Myra Orth notes a full page image of Judas, dated c. 1537, from an elaborate French picture cycle of the Passion, repeated in three manuscripts, one of which is in New York, Pierpont Morgan Library, MS M 147, fol. 22.

Style: The panel belongs to an extremely interesting period in the history of art, the time shortly after 1500 when influences from Italy were meshed with Northern European traditions to produced an intensified formal and psychological dimension to the visual arts. At an early point in research on the panel, Victor Beyer (communication with Meredith Lillich) suggested the atelier of Hans Gitschmann von Ropstein, a glazier who used cartoons of

AIC 5/fig. 3. HANS BALDUNG GRIEN: *Holy Family in the Wilderness,*
Vienna, Akademie der bildenen Künste

Hans Baldung Grien. Although it now does not seem possible to link the glass painter with the work of Gitschmann, the suggestion of inspiration after the work of Baldung Grien, earlier noted by Goetz (1950, p. 106), seems viable. The exceptionally high quality of the painting and the tense drama of the scene encourage us to see the panel originating from a context exposed to Baldung Grien's works. His paintings and prints enjoyed a wide circulation and he was also a designer in stained glass between 1512 and 1517, producing windows of great psychological intensity for the Carthusian foundation of Freiburg im Breisgau (*Painting on Light*, pp. 240–3, nos. 113–14, figs. 86–8). *Christ at the Martyr's Column*, a woodcut of 1517 (Marianne Bernard, *Hans Baldung Grien: Handzeichnung, Druckgraphik*, Munich, 1978, p. 327) shows some of the same type of beard and bodily tension as the Chicago panel, especially for the form of the demon. The tousled hair of Judas and strong linear accent appear throughout Baldung's work, such as his painting of Adam of 1525 (Budapest, Szépmüvészeti Museum, no. 1888: von der Osten 1983, pp. 171–3, no. 57) Landscape connections from Baldung Grien's painting such as *The Holy Family in the Wilderness*, (AIC 5/ fig. 3), *c.* 1511–14 (Vienna, Akademie der bildenen Künste, Nr. 545: von der Osten 1983, pp. 74–6, no. 14, col. pl.) also seem germane. The technique of delineating clumps of plants and segments of ground is very close to the segmentation by color and brushstroke and stickwork seen in the stained glass. The proportion of the size of the figure to landscape elements, and similar recession in space are similar.

Date: A date of *c.* 1520 is suggested by stylistic comparison with artists such as Hans Baldung Grien.

Photographic reference: E15415

AIC 6–7. TWO PANELS: ST. JOHN AND DONATRIX, AND CHRIST AND THE SAMARITAN WOMAN AT THE WELL
South Germany
c. 1530

History of the glass: In 1880 the panels were in the collection of Eugen Felix, Leipzig. They were subsequently owned by Dr. John D. Stillwell until 1927 (Dr. John E Stillwell Collection, 12/2/27). The next documented owner was George F. Harding who displayed them in the Harding Museum, Chicago. It is unknown at what date they were inserted into the modern bull's eye surrounds. They were given to the Art Institute of Chicago in 1990 as part of the Harding bequest. [In storage]

Origin/Composition: The two panels, as isolated objects, make it difficult to project a placement or a series. It is even possible these two panels are the entire series, having been commissioned for two windows in a private chamber such as a bedroom or an audience room. That they were commissioned for a female donor is clear from the image of the kneeling nun before the image of St. John. She is identified as a donor by the *Hausmark* [sometimes called a merchant's mark] on the shield before her. Families who did not have coats of arms would use these marks. The original placement of these panels probably entailed blank glazing of bull's eye or grisaille lattice.

Condition: The figural proportions of the panels appear to be completely genuine. The borders of leaves, flowers and strapwork are more problematic. Visually they harmonize with the panels. Close inspection, however, does not reveal degradation of the glass that comes from the exposure to weather since the 1500s. The paint is uniform, without any abrasion or irregularities. It is hard to imagine that the border of panels once *in situ* and now removed to a new surround would have escaped all damage. It is very possible that the borders are modern copies of the fragmentary originals. The narrowness of the leads suggest that they may date to the sixteenth century.

Although the original placement of these panels undoubtedly was within blank-glazed windows, the technical execution of the modern bull's eye surround from the Harding collection installation diminished the impact of the panels. The craftsperson, instead of selecting off-white and semi-opaque glass, if this were essential, has applied a surface paint as a light dampening method. This is now very uneven, grimy, and coming off in patches. It obscures the very real charm of the panels, and their extremely high interest in terms of social history.

Technique: The panel is pot-metal and uncolored glass with some silver stain, limited to John's hair and cup, and to the tree in the background to the right of Christ. Back-painting of an unmodulated mat is used on both panels to accent areas represented in shadow. This modeling is seen in AIC 7,

in the landscape background, the right of the well, and the right sides of both the figures of Christ and the Samaritan woman. In AIC 6, the robes of the donatrix, the upper portions of the shield, the *Hausmark* itself, and the right side of John's face are shadowed with similar back-paint. The interior receives its definition primarily through the application of a uniform mat. It is modeled through the dry brush and some stipple that emphasizes soft transitions. Christ's head, for example, has almost no stickwork, and the youthful beard shows application of trace paint in short, dark strokes. Stickwork, although used to accent some of the garments, is primarily a delineating graphic. It outlines the forms of the grass or the leaves to the left of Christ.

Iconography: The difference in size in the two panels might suggest a narrative series of images from the life of Christ set in the cloister, and a meditative image, such as the donor at prayer before a patron saint for the abbess's private quarters. The representation of donor in proximity to the saint, or even inserted into a narrative structure, was a common device of the later Middle Ages. The use of the image as a device for fixing the viewer's attention in meditative proximity to the events of Christ's life was a key feature. Spiritual guides from the time, such as Julian of Norwich's *Revelations of Divine Love* (London, 1966) or *The Cloud of Unknowing* (trans. Clifton Wolters, New York, 1978), are replete with the concept of "actually being there" through the power of prayer. After death, these donor representations served to remind the living to pray for the soul of the deceased, so that they had a prospective and a retrospective function.

Style/Date: The panels appear to be South German, but executed by what we might call a provincial painter. The short, rather stocky figures and the damask background suggest a southern German location, possibly Bavaria. Although stylistic associations encourage a date of around 1530, it is presumptuous to suggest a precise date by trying to fit the panels too closely into a sequence of period styles. Stylistic change was one method of competition among artists. Change happened more rapidly when artists were part of an art market where individual styles could be recognized and prized by a client, but less quickly when practiced outside the major urban centers. The donor panel appears more antiquated, but it is more likely that the highly traditional nature of the kneeling donor and saint worked to keep the composition less progressive.

Bibliography

UNPUBLISHED SOURCES: AIC Curator's file; *Dr. John E. Stillwell Collection 12/2/27*, [DIA 6] no. 493, ill. 210; [DIA 7] no. 492 . ill. p. 209; Hartmut Scholz and Rüdiger Becksmann, Arbeitstelle, Corpus Vitrearum, Freiburg i/B, Germany, correspondence.

PUBLISHED SOURCES: A. von Eye and P. E. Borner, *Die Kunstsammlung von Eugen Felix in Leipzig*, Leipzig, 1880, no. 1499, p. 149.

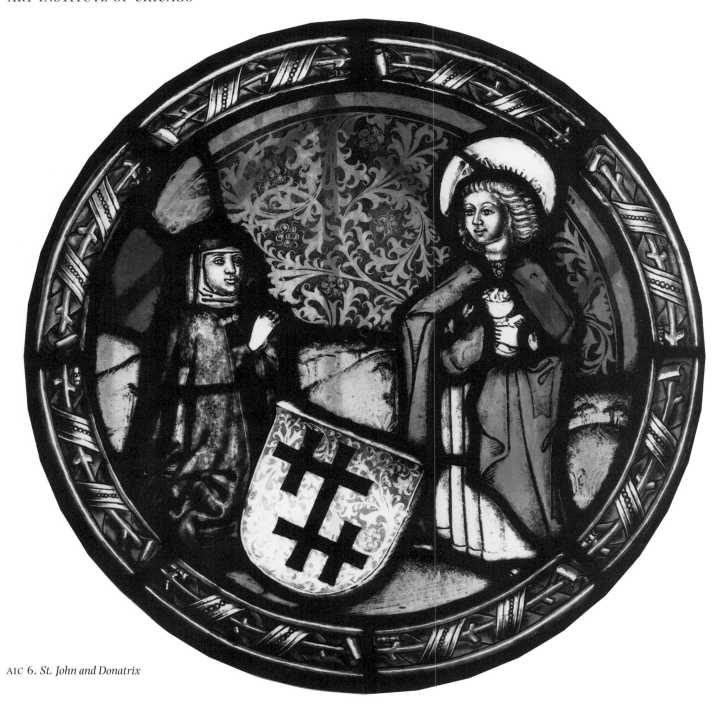

AIC 6. *St. John and Donatrix*

AIC **6. St. John and Donatrix**

Circle: diameter 24.4 cm (9¾ in); diameter
including border 30.5 cm (12⅛ in)
Accession no. 1990.585, George F. Harding
Collection

Ill. nos. AIC 6, 6/a, 6/fig. 1

Condition: Only a few replacement pieces appear in the
blue background to the left and right of the donatrix. The
damask of the background, as well as the ground, show
some abrasion. The border is problematic. The reverse
shows a smooth texture different from that of the glass in
the medallion. The interior surfaces show no abrasion and
the leading division does not appear to be the result of
breakage. Such borders, however, showing branches or
switches wrapped with ribbons appear from the early
fifteenth-century onwards and well into the sixteenth cen-
tury, mainly in glass from Upper Bavaria.

Color: John wears a medium red robe over a light blue
tunic. The nun is in very dark brown, presumably a way of
representing a black Benedictine habit. Light medium green
is used for the ground. A medium value blue is used for the
background. The ground is modulated by grisaille wash
and stickwork to evoke blades of grass. In the background,

a flat tonal wash is relieved by lifting off paint in a damask design. The white shield with its black *Hausmark* is similarly embellished with a damask pattern.

Iconography: The nun, presumably an abbess, kneels before an image of John the Evangelist, easily identified by his beardless face and his symbol of the cup and snake. Aristodemus, a pagan priest hostile to Christians, gave John a poison produced from the crushed bodies of venomous snakes and toads. When the saint made the sign of the cross over the cup, the venom coalesced into its animal form and escaped, leaving the drink pure (*Golden Legend*, pp. 61–2; Raguin 1982, pp. 143–5, figs. 70–1).

A donor in proximity to the saint is an extremely common subject (Rüdiger Becksmann and Stephen Waetzoldt, *Vitrea Dedicata: Das Stifterbild in deutschen Glasmalerei des Mittelalters*, Berlin, 1975). The religious was often portrayed in juxtaposition to a patron saint of the monastery or of the Order. Religious were encouraged to imagine themselves in the presence of the saint, or even to be able to witness events of sacred or hagiographic tradition. The stained glass panel for the Cistercian Abbey of Wettingen (ibid., pp. 74–6, fig. 8), showing St. Bernard about to be embraced by Christ reaching down from the cross, conveys multiple sequences of imaginative places. Bernard imagines himself at the foot of the cross (AIC 6/fig. 1), not at a limited historic moment, but gazing at the transcendent cross from which Christ can proclaim an eternal redemptive love. Bernard's followers, presumably, the brother monks as the Order extends through time, recollect him by their participation. To the right, occupying a

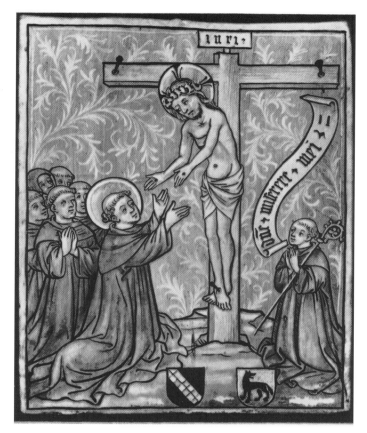

AIC 6/fig. 1: St. Bernard before Christ on the Cross with Abbot Wülfinger, donor, *c.* 1440, Abbey of Wettingen

separate space, the donor Abbott Wülfinger includes himself in the collective tradition with his gaze and his banderole with his "fixed" ejaculation, "Oh Lord, have mercy on me". The damask background further increases the sense of timelessness, a single rich and significant present where faith unites believers.

Heraldry: *Hausmark* (unidentified)

Photographic reference: AIC, Harding collection

AIC 7. Christ and the Samaritan Woman at the Well

Circle: diameter 32 cm (12½ in); including border 39 cm (15½ in)
Accession no. 1990.586 George F. Harding Collection

Ill. nos. AIC 7, 7/a, 7/fig. 1

Condition: The panel appears to be completely genuine with the exception of the border. The border with its energetically intertwining leaves and flowers, however, is similar to a border surrounding a panel depicting the *Christ carrying the Cross* (AIC 7/fig. 1), once in Berlin but destroyed during World War II (Schmitz 1913, p. 133,

AIC 6/a. Restoration chart

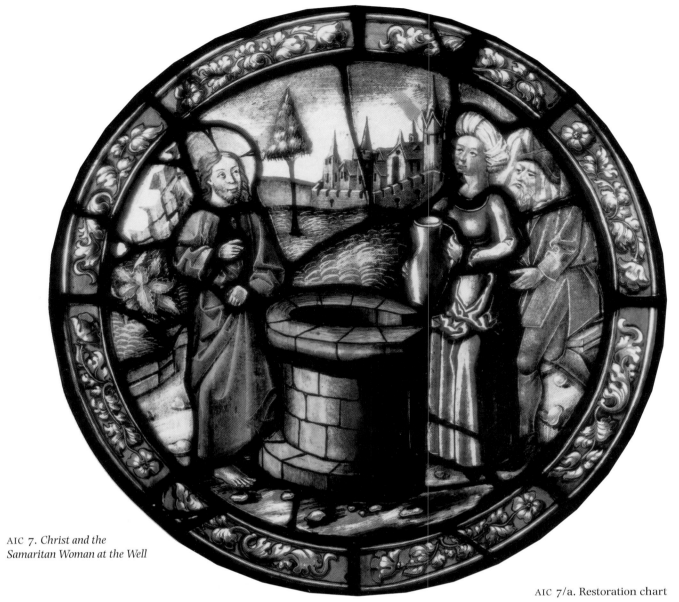

AIC 7. *Christ and the Samaritan Woman at the Well*

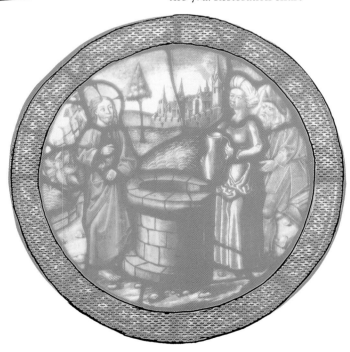

AIC 7/a. Restoration chart

no. 190, pl. 34). Schmitz localized the panel to Northern Swabia and to Dürer's influence *c.* 1530. The border may be a later copy carefully based on an original, or it may be an original aspect of the panel, but using different texture of glass and paint. This juxtaposition may be a result of a division of labor within a workshop.

Color: Light medium green is used for the ground. The Samaritan's dress and blue background are of the same light color as John's tunic. The well, however, is in a more orange red than John's robe in the companion panel, and distinctively different from the back, showing an opaque dull red surface. Christ's robe is a dark gray-blue.

Iconography: The subject matter of the Samaritan woman (John 4) is clearly of great significance, perhaps even supporting a socially subversive meaning for the female religious. The Apostles had left Christ, and in their absence he asked the Samaritan woman, of a race shunned by the Jews, to draw water for him. He speaks to her, revealing

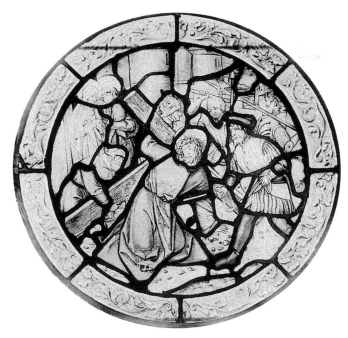

AIC 7/fig. 1. *Christ carrying the Cross*, c. 1530, Formerly Berlin, Königliches Kustgewerbemuseum

truths, and she then acts as a means of conversion for her people. The Apostles, upon return, "wondered that he talked with the woman" (4:27) but "many of the Samaritans believed in him for the word of the woman giving testimony" (4:39). Christ even has harsh words for the Apostles, telling them that "it is one man that saweth, and it is another that reapeth" (4:37). Whether laboring at prayer hidden from the world in a fully cloistered community, or laboring in support of the sick and the dying, as in the semi-cloistered female houses, women religious would easily see themselves as the Samaritan woman to whom Christ spoke, and who believed in him as the Messiah even before his death and resurrection.

Photographic reference: AIC, Harding collection

AIC 8. Dives at his Table with Lazarus at the Gate

Lowlands
1520s (?)
Circle: diameter 28.1 cm (11⅛ in)
Accession no. 1990.588, George F. Harding Collection

Ill. nos. AIC 8, 8/fig. 1

History of the glass: The panel is recorded (AIC Curator's file) as having been in the collection of George F. Harding and was displayed in the Harding Museum, Chicago, before being given to the Art Institute of Chicago in 1990. [In storage]

Bibliography

UNPUBLISHED SOURCES: AIC Curator's file; Elizabeth Pastan, correspondence 10 August, 1990.

Condition: The panel, with one modern panel from the Harding collection, is presently set in a window with modern bull's eye background. Six breaks are repaired with heavy mending leads. One corner is shattered. There is some area of abrasion in the lower right.

Color: The two shades of yellow and both shades of brown paint combine to create a warm tonality. The loose shift between the yellow tones is particular striking in the floor.

Technique: Two shades of silver stain and two shades of vitreous paint are easily visible. The mat has a granular quality providing variation even in unmodulated areas. Heavy applications appear throughout the panel, for example the shadowed legs of the dog, the architecture to the right, and the tunic and hair of the servant pouring wine. For most areas, however, the painter lays on a mat and then uses varying strokes of the quill to remove paint. Most striking is the depiction of Dives: parallel strokes for the linen of his shirt, shorter curling strokes for the fur of his mantle, sweeping circles for the velvet of his hat, and short lines that delineate the planes of Dives's face.

Iconography: The panel has been incorrectly referred to as the *Feast for the Returning Prodigal Son*. The Prodigal Son story was popular as a subject for Lowlands roundels so that the confusion is reasonable. The image of Lazarus at the gate, however, is incontrovertible; Lazarus is seated outside the gate to Dives's courtyard and dogs lick his sores. The image illustrates the parable from the Gospel of Luke (16:19–31). The story of Lazarus and the rich man (*dives* in Latin) was a traditional theme in medieval art, both as an admonition to practice charity and as confirmation of the afterlife with punishments for evil and rewards for good. The theme was often set in places of didactic display, such as the side reliefs of the twelfth-century Apocalypse Portal of Moissac Abbey (Millard F. Hearn, *Romanesque Sculpture*, Ithaca, 1981, p. 174, fig. 130). The theme of retribution for sins, with demons seizing the soul of the Unjust, and angels transporting the soul of the Just, is reiterated in the popular printed books of the era of the roundel, such as the *Ars Moriendi* (*The Way of Dying*; block book, c. 1496, New York, The Metropolitan Museum of Art, Husband 1995, p. 83, fig. 7).

In the panel, three separate incidents are shown. In the dominant one, a man accompanied by a handsome woman is feasting in the arcaded courtyard of a magnificent Renaissance style building. The countryside is visible in the distance. Wealth and comfort are depicted via the latest style in architecture, thus a newly constructed building and richly draped table. A servant pours wine from a flagon into a goblet while another approaches, clearly

AIC 8. *Dives at his Table with Lazarus at the Gate*

responding as his master turns to give a command. Dives, a vigorous figure reminiscent of the type of Henry VIII, is dressed as if he stepped from a Holbein portrait. At the entrance to the courtyard, the poor man, Lazarus, is about to be beaten by the rich man's servant to encourage him to beg elsewhere.

Finally, in the landscape beyond the feasting scene, the concluding moments of the drama unfold. Both Lazarus and Dives have died. We find the rich man, depicted as a naked soul, engulfed by flames beyond the stone arch of the gate of hell to the left. The tip of the servant's club leads our eye to the image. Dives reaches out with imploring hands to an image of God the Father in the upper center of the panel, framed by the courtyard's arcade. Abraham's bosom, as mentioned in the parable, has now become the Christian God, who holds the soul of Lazarus. Dives begs that Lazarus dip the tip of his finger in water so that a few drips might cool his tongue. The iconography is common to this time. See an early sixteenth-century Book of Hours of the use of Rome, from Rouen, now in the Morgan Library, New York (MS M 431. fols. 113v–4). In an illustration for the first reading in the Office of the Dead, Lazarus is shown in the bosom of Abraham, represented as an enthroned man with angels on either side. Dives appears below in flames and he points to his tongue. A Book of Hours for the use of Toulouse in the Walters Art

Gallery (MS 449), dated about 1524, has two miniatures of this event illustrating the Office of the Dead, folio 90v showing Dives feasting, and folio 95 with Dives in hell and Lazarus in Abraham's bosom (Lillian M. C. Randall, *Medieval and Renaissance Manuscripts in the Walters Art Gallery*, 2, Baltimore, 1992, p. 530, no. 209). For the composition of Dives at his table, see the image in the *Spinola Book of Hours* (AIC 8/fig. 1), South Lowlands, *c.* 1515 (Los Angeles, J. Paul Getty Museum MS Ludwig IX 18, fol. 21v; Ruth Mellinkoff, *Signs of Otherness in Northern European Art of the Late Middle Ages*, Berkeley, 1993, fig. II.35). Dives is portrayed as a corpulent man with two women at his side. His dogs, as in the roundel, take aggressive notice of the beggar at the gate.

Style: The composition constructs a very strong, three-dimensional image. The recession into space is believable and the modeling of the forms, whether architecture or figure, presents these as tactile entities of illusionistic plasticity. Dramatic and highly readable, the scene draws atten-

AIC 8/fig. 1. *Dives feasting*, Spinola Book of Hours, South Lowlands, *c.* 1515, Los Angeles, J. Paul Getty Museum

tion to the feasting Dives. The painting style is exciting and vigorous. The solid, bulky figures of an artist like Jacob Cornelisz. van Oostsanen, are not unlike the three-dimensional characters of the artist of the Dives roundel (Husband 1995, pp. 98–107). The architectural vistas of Dirick Vellert were accomplished in the 1520s through 1530s (Husband 1995, pp. 148–54), and compare well with the spatial illusion in the Chicago roundel.

Date: The date is based on references to technique and style. The decade of the 1520s seems likely because of the three-dimensional modeling and the architecture. The figures show no sign of mannerist expression and so would not seem to be from the mid-century.

Photographic reference: AIC, Harding collection

AIC 9 a–c. Dormition and Assumption of the Virgin

France, Marne (?)
c. 1525–30
Accession no. 1932.7, Gift of Mr. and Mrs. Martin A. Ryerson

Ill. nos. AIC 9, 9/a

History of the glass: This panel came to the Art Institute as the gift of Mr. and Mrs. Martin A. Ryerson in 1937. [In storage]

Original location: Lorraine has been suggested as the probable home of this window (Bennett in *AIC Bulletin*, p. 23); but a site in the Champagne seems more likely (see below **Style**).

Condition: The new heads have paint spattered on the back to look like the pitting on the original pieces. The result is that from the inside the new heads are seen as "matching" the original pieces. The window was repaired by Drehobl Bros. Art Glass Co., Chicago, in 1965 (AIC Curator's file).

Iconography: In this Dormition the funerary rites take place in the room where the Virgin has died. St. Peter, center, holds an aspergillum and wears a cope as the officiating priest. Another apostle, right of center, holds a censer (Réau, 2/2, p. 608). At the foot of the bed Christ holds a book and gestures. An apostle at the left holds a cross. Several figures carry or read books, a very prominent feature in this version. At the head of the bed are St. John the Evangelist who carries a palm and the "three virgins who were present" and who washed Mary's body (*Golden Legend*, p. 452).

Northern examples of the Dormition that depict Mary lying in bed vary between foreshortened scenes and those

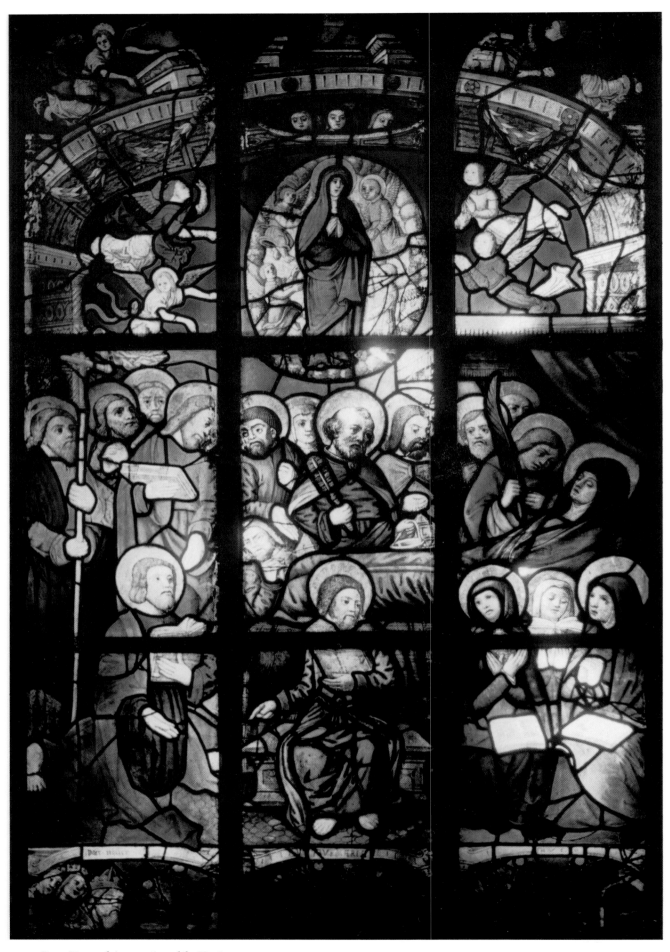

AIC 9. *Dormition and Assumption of the Virgin*

AIC 9/a. Restoration chart

that show the bed parallel to the picture plane. Among the well-known foreshortened compositions are those of Hugo van der Goes, *c.* 1480 (Snyder 1985, fig. 165) and Albrecht Dürer, 1510 (Kurth 1963, fig. 220). The *Dormition* of Dürer shares many elements with the Chicago window, apart from the design. He included the apostle with the cross, apostles with books, St. Andrew with the censer, and a vested, asperging St. Peter.

Dormition scenes that depict a bed parallel to the picture plane include another design by Hugo van der Goes, *c.* 1475, known only from copies (Friedrich Winkler, *Hugo van der Goes*, Berlin, 1964, pp. 134–41, 215–8). A further example is a German woodcut, *c.* 1465–70 (Richard S. Field, *Fifteenth Century Woodcuts and Metalcuts* [exh. cat., National Gallery of Art], Washington, D.C., 1965, no. 105). Finally there is a panel from the workshop of the Master of the Life of Mary, after 1473–*c.* 1480 (Schiller 1980, 4/2, p. 396, fig. 695; Stange 1969, p. 48). The layout of these three pictures and of the Chicago window appears in twelfth- and early thirteenth-century Gothic imagery: a well-known stained glass example is in a south aisle window at Chartres, 1205–15 (Delaporte and Houvet 1926, no. VII; France *Recensement* II, pp. 33–4, bay 42).

The Assumption is represented in the upper tier in the window. Because she was the mother of God, Mary overcomes death and rises into heaven immediately: she does not have to wait until the Last Judgment. This manner of depicting the subject – that is, Mary standing in a mandorla with four angels who carry her upward – derives from the Early Christian *imago clipeata* (*Herder Lexikon*, 2, col. 279). The Master of Frankfurt shows this event almost as it appears in the Chicago window (Winkler 1964, fig. 175). The Toledo *Assumption*, *c.* 1543–44, (TMA 10) depicts the mandorla as a cloth of honor of brocade, held up by the angels behind Mary. Unlike the Chicago glass, the TMA scene focuses on Mary's Ascent and Coronation: the Dormition is not included.

These events in the Life of the Virgin are often represented as a multiscene narrative cycle. Dürer's influential woodcut series, dated 1500, originally comprised seventeen prints to which he added three more in 1510–11, the *Virgin in Glory*, the *Dormition*, and the *Coronation* (Kurth 1963, figs. 175–91, 219–21). Apocryphal texts (Pseudo-Melito) and the 15 August entry for the Feast of the Assumption in the *Golden Legend* (pp. 449–65) constitute the literary sources for the Dormition and Assumption, but the imagery evolved independently. The Immaculate Conception, the thesis implied by this depiction, was not codified until 1854 although it was a subject of continuous debate from at least the twelfth century,

Technique: Pot-metal (including lovely greens and purples) and uncolored glass, brownish paint, silver stain, and sanguine were used. The painting techniques include hatching and stickwork as well as back-painting on the center panel. Jewels (*chefs d'oeuvre*) are set into the trees of the lower panels, called here the predella.

Style: The composition seems to be based on Hugo's lost *Dormition, c.* 1475, of which many copies exist (see above, **Iconography**). Short, stocky figures crowd into the limited space of the Chicago *Dormition*. At least three painters worked on the faces, but all share certain features: full lips; rounded upper eyelids; and eyebrows with one long horizontal curving line feathered with short strokes. The images of Hugo as well as those of an anonymous Burgundian panel painter working *c.* 1470–80, supply prototypes (for Hugo, Winkler 1964, figs. 99, 142, 148; for the Burgundian, Grete Ring, *A Century of French Painting, 1400–1500*, London, 1949, no. 236a, fig. 133). A gently rounded arch in correct perspective and with coffered barrel vault floats in space behind the mullions. Rosettes attach the festoons to the dentil-like face of the arch. A trace line outlines the *tori* of the drapery folds, and stipple shading tones the *scotiae*.

Features such as some of those mentioned above and the color range—red, green, blue, amber, and blue purple — suggest that the original site of this glass probably lies in

the Marne. A detail from a *Flight into Egypt* panel at Notre-Dame, Epernay, 1545, reveals similar stereometric eye lids, trim beards and hair painted carefully with brushstrokes that do not overlap, and noses that tip up at the ends (Jean Rollet, *Les Maîtres de la lumière*, Paris, 1980, p. 52, ill.).

Expressive faces analogous to those of the apostles in the Chicago panel and colorful fruit trees that resemble the fragments in the predella of the Art Institute window can be found in a *Creation* window, 1506 or 1516, at the Cathedral of Châlons-sur-Marne. Inscriptions arranged in upward arching banderoles also appear there (France *Recensement* IV, pl. XXII). A donor at Châlons-sur-Marne has a square face that parallels the head shapes in Chicago (*Vitrail français*, p. 223). Lafond pointed out that glass painters from Troyes worked at Chalons, Epernay and neighboring sites (ibid., pp. 218–9). That might explain affinities between the *Dormition* and various windows in the Aube as at Les Riceys, end of the fifteenth century (France *Recensement* IV, p. 174, fig. 160), Chavange, first third of the sixteenth century (France *Recensement* IV, p. 82, fig. 61), and Troyes Cathedral (André Marsat, *La Cathédrale de Troyes: les vitraux*, Troyes, 1987, pls. 14–6; France *Recensement* IV, pp. 232–3, fig. 218).

Two details point to a date of *c.* 1525 or a little later for the Chicago window. A damask pattern like that of the left figure here occurs on an amber gown under a blue cloak at Saint-Nizier, Troyes, 1522 (*Vitrail français*, pl. XXV). Angels with elaborately conceived flying drapery, such as that at the upper left and upper right of the Chicago *Dormition*, appear in the tracery at Notre-Dame-en-Vaux, Châlons-sur-Marne, 1526 (France *Recensement* IV, pl. XXIV).

Bibliography
UNPUBLISHED SOURCES: Michel Hérold, letters of 6 January and 18 September 1986; Alyce Jordan and Meredith Lillich, notes; Elizabeth Pastan, rubbing.

PUBLISHED SOURCES: Bessie Bennett, "The Decorative Arts Department," *AIC Bulletin*, 1933, p. 23; Lillich in *Checklist* III, p. 127.

AIC 9/1. Predella and Body of Apostle with Book (a1)
Rectangle: 70.3 × 46 cm (27¹¹⁄₁₆ × 18⅛ in)

Inscriptions: *pater noster* (our father)

Condition: In the predella or lower register there are stopgaps from same series.

Color: Bright yellow-orange, bright medium red, clear medium blue and green, and light dull blue purple represent the full range of hues in this panel.

Technique: The glass cutter took advantage of the variation of the depth of the flashing on the red glass to produce the chiaroscuro effect on the kneeling figure's robe.

Photographic reference: Raguin, CVUS

AIC 9/2. Apostles (a2)
Rectangle: 72.7 × 47.8 cm (28⁹⁄₁₆ × 18⅞ in)

Condition: The second head from left is new. Replacements are also found at the upper left. The paint has rubbed off the right edge of panel.

Iconography: Two of the apostles hold books. The standing figure on the right with the book is Jesus who points to a seated figure with a book, probably St. Paul.

Technique: Hatched trace lines are found on the faces; stickwork reinforces the texture in the hair and the beards. A brocade pattern on amber glass embellishes the left figure's gown.

Photographic reference: Raguin, CVUS

AIC 9/3. Angels and Architectural Ornament (a3)
Rectangle with rounded top: 82.3 × 47.8 cm (32⅜ × 18¹³⁄₁₆ in)

Condition: There are three stopgaps and many replacements in the ground around the lower angels.

Color: This panel includes only bright yellow-orange, clear light blue, and bright medium red.

Photographic reference: Raguin, CVUS

AIC 9/1. Seated Figure (b1)
Rectangle: 71.5 × 45.8 cm (28³⁄₁₆ × 18 in)

Condition: There are replacements to the left of the figure and on the lower edge of the panel, in addition to the stopgaps from the same series.

Color: Here we see clear medium red and green, bright light purple red, pale blue purple, and bright yellow-orange.

Technique: The back-painting gives depth to the drapery.

Photographic reference: Raguin, CVUS

AIC 9/2. Apostles and Saint Anne (b2)
Rectangle: 71.5 × 45.8 cm (28³⁄₁₆ × 18 in)

Iconography: The apostle in the center, St. Peter, holds a censer and aspergillum; the right apostle holds an ampulla; Judas is at the foot of the bed.

Color: A rainbow of hues appears here, including: clear medium blue, bright yellow-orange, yellow green, medium bright red, blue purple, and bright purple red.

Technique: Back-painting is found on most of the old glass, including the blue bed cover.

Photographic reference: Raguin, CVUS

AIC 9/3. Assumption of the Virgin (b3)
Rectangle with rounded top: 82.3 × 48 cm (32⅜ × 18¾ in)

Condition: The ground behind the mandorla and angels is new, as is the top part of panel above the arch.

Iconography: The mandorla contains the Assumption of Virgin that is observed by three angels above.

Color: Here we see bright yellow-orange, clear light blue, and bright medium red.

Photographic reference: Raguin, CVUS

AIC 9/1. The Three Women (c1)
Rectangle: 72 × 47.7 cm (28 × 18¹³⁄₁₆ in)

Inscriptions: AVE W [upside down M]

Condition: The heads of these three figures are modern. There are replacements at the upper left corner. The inscription below the figures is original but all else consists of stopgaps from the same series and replacements. The M of the inscription is upside down and reversed.

Color: Medium yellow green, dark blue and dark purple red represent the hues here.

Photographic reference: Raguin, CVUS

AIC 9/3. Angels and Architectural Ornament (c3)
Rectangle with rounded top: 82 × 47.8 cm (32 × 18¹³⁄₁₆ in)

Condition: One angel's wing is new, as are a few pieces at the upper left.

Color: Medium yellow green, bright medium red, clear medium blue and red-purple appear in this panel.

Photographic reference: Raguin, CVUS

AIC 10. Allegorical Scene: A Man serving a Woman
North Lowlands
1520–30
Circle: diameter 23 cm (9 in)
Accession no. 1937.862, Gift of Mr. and Mrs. Martin A. Ryerson

Ill. no. AIC 10, 10/figs. 1–2

History of the glass: The history of the glass is not known before its acquisition by Mrs. and Mrs. Martin A. Ryerson. In 1937 they gave the panel to the Art Institute of Chicago. [In storage]

Bibliography
UNPUBLISHED SOURCES: AIC Curatorial file.

PUBLISHED SOURCES: Husband in *Checklist* IV, p. 77.

Inscription: *WAEBT ONBENIIT THIS/ SONDER ARCH* (unidentified) on banderoles.

Condition: The panel is composed of very heavy, uneven, uncolored glass with pronounced whorls and some large bubbles and numerous imbedded impurities. A pale yellow and an orange-yellow silver stain are used. The paint is also of two shades, dark reddish brown, and a cooler neutral. A single break through the center of the roundel has been repaired with a thick mending lead. There is no paint loss.

Color: The image has a warm and sprightly tone given the contrast of reddish and more neutral paint and the extensive use of silver stain.

Technique: Throughout the panel the artist has applied the paint with a sure and consistent hand. A fluid, free style of draftsmanship appears not only in the brushwork, but in the dappling of the silver stain over areas like the ground and the flagon. The robes show the characteristic build-up from a medium tone of mat to a darker mat in the folds such as those of the man's sleeves. Lighter areas are achieved by narrow parallel strokes in stickwork, then broad sweeps for the highlights. These highlighted folds are defined with a broader stroke in the man than in the woman, giving an impression of a contrast of strength and delicacy. Trace is used sparingly, mostly for the edges of the figures, such as the lower edge of the woman's extended arm and the man's left leg. There is elegant needlework on the hat to evoke the softness of a rich fabric.

Description/Iconography: In an enclosed garden, a man and a woman are seated on the ground. The residence they appear to have left, with its high wall, is seen behind the man's head. Behind them is a low garden wall with greenery at the back and to the left of the woman, a hedge. The richly dressed young man offers the woman a shallow bowl into which he has poured a liquid. With his left hand he still holds the flagon with its carrying strap. A dragon flies overhead, hovering between the two, but looking at the woman, and breathing on the liquid. Between the two, but appearing closer to the man, is a dish filled with small fruit. In her lap, the woman holds a large broad-brimmed hat adorned with two ostrich plumes.

The subject matter is as yet unidentified, although the panel is clearly in the tradition of Lowlands moralizing images, most often associated with popular sayings or stories, and frequently presented in rhymed verse format. The inscription is divided between the couple, the dragon's curling tail leading the viewer's eye to the curling banderole carrying the letters *waebt onbeniit* behind the woman.

AIC 10. *Allegorical Scene:*
A Man serving a Woman

The inscription continues on a banderole that begins in front of the man's mouth, seeming to place him in the act of speaking: *this/ sonder arch*. The attractive woman and man and the offering of food would suggest an issue of sensuality. The woman holds a man's plumed hat in her lap. Could this be the memento of a past lover she is being encouraged to forget? Is it a gift that she wishes to present to the young man offering her the drink, marking him as the object of her choice? The dragon's fiery breath adds an ominous note to the proceedings.

The subject of lovers in a garden invites comparison with one of the most popular of medieval texts on love, the *Roman de la Rose* begun by Guillaume de Lorris about

1220 and completed by Jean de Meun later in the century. Highly popular, the poem is second only to the Dante's *Divine Comedy* in the number of surviving manuscript copies. Approximately 250 are known, and by *c.* 1500 eight printed editions had been issued; one of these, dated *c.* 1487 from Lyons is the source for the text of a sumptuous manuscript showing lovers in a garden. The paintings are attributed to the "Master of the Prayer Books" of *c.* 1500, and were probably executed in Bruges between 1490 and 1500 (London, BL MS Harley 4425, Thomas Kren, ed., *Renaissance Painting in Manuscripts: Treasures from the British Library*, New York, 1983, pp. 49–58; Comte Paul Durrieu, *La Miniature flamand au temps de la Cour de*

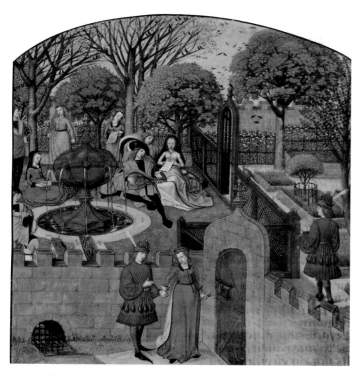

AIC 10/fig. 1. Lovers' garden, *Roman de la Rose*, 1490–1500, London, British Library

Bourgogne 1415–1530, Brussels, 1921, p. 72, pl. CII). Folio 12 (AIC 10/fig. 1) shows a meeting of lovers in a secluded garden where well-dressed young people sit on the grass and entertain each other by singing and playing instruments. The garden setting, although part of a very different kind of story, is found in roundels of the story of *Susanna and the Elders* (MMA-CC: 1990, 1990.119.I, and London, Victoria and Albert Museum, 5636–1859 Husband 1995, nos. 64–5, pp. 140–1, cover ill.). The same type of small leafy plant in the foreground appears there, as well as the technique of outlining edges of ground and leaves with darker tones.

Costume: The man wears a knee-length tunic with loose sleeves that seem to be pulled together at the wrist. A finely pleated shirt shows through at his neck around which he wears a long and heavy gold chain. He wears broad striped stockings and blunt-toed shoes. His long flowing curls are topped by a soft beret with an upturned ear-flap. The woman's outer robe has a voluminous skirt that flows in complex folds as she sits; the sleeves are long and trailing. Her arms are covered with a tight, dama-scened sleeve with a flaring cuff covering the back of the hand. Through the v-shaped closure of the outer robe, we see an inner garment terminating in delicate white pleats at the neck. Around her waist a long sash loops and then flows across her skirt. Her head-dress frames her face with a flat, thin pleated layer of cloth curving to form a heart shape. A soft snood covers the rest of her hair. Costume comparisons can be made with Flemish manuscripts of the 1520s and 30s, for example, Gerard Horenbout's

Sforza Hours (London, BL MS Add. 34294, Georges Dogaer, *Flemish Miniature Painting in the 15th and 16th Centuries*, Amsterdam, 1987, pp. 161–4, figs. 103–4). In 1515 Horen-bout became court painter to Margaret of Austria, Regent of the Netherlands, and between 1519 and 1521 exe-cuted sixteen additional miniatures of the Sforza Hours. See also the dress, especially the man's plumed hat, in the tapestries of the Carrabarra story, manufactured in Tournai, first third of the sixteenth century (Magdeburg, Kaiser Friedrich Museum, Heinrich Göbel, *Tapestries of the Lowlands*, New York, 1924, rep. 1974, p. 57, fig. 228).

The man's dress parallels that of the protagonist in a Sorgheloos series discussed in this volume in entries for TMA 8 and C-CAM 5. The roundel of *Sorgheloos and Weelde dancing* (1970,7684, Leiden, Stedelijk Museum de Laken-hal, Husband 1995, p. 31, fig. 31) shows similar festive clothes (AIC 10/fig. 2). Sorgheloos wears a pleated shirt under a square neck tunic, gold chains, blunt-tipped shoes, and knee length tunic with embroidered hem. He has an elaborate plumed hat. In an image from this same series showing *Sorgheloos and Lichte Fortune* (TMA 8; C-CAM 5), Sorgheloos appears to have given Lichte For-tune his plumed hat and he is wearing a soft beret as in the Chicago panel. This play with hats may suggest the connotation of power, or semblance of being in control, when bedecked with the fancy head-dress.

Style: An exact correspondence for the painting style has not been defined. There are many similarities already cited with the types of figures from the Sorgheloos series and the manner of execution of landscape from the Susanna

AIC 10/fig. 2. *Sorgheloos and Weelde dancing*, Leiden, Stedelijk Museum de Lakenhal

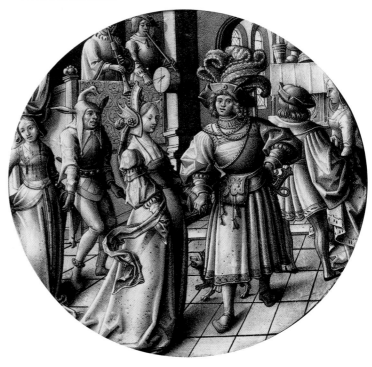

roundel. The Pseudo-Ortkens Group, as discussed by Husband, especially *Susanna and the Elders* (1995, no. 64, pp. 134–41), seems a reasonable association for the present.

Date: The date of 1520–30 is determined by the definition of costume and of similarities between the panels in the Sorgheloos series dated *c.* 1520, and the Pseudo-Ortkens Group 1520–40.

Photographic reference: AIC negative

AIC 11. Heraldic Panel of Samson and the Lion

Switzerland, Uri

1615

Rectangle: 29.9 × 40.7 cm. (16 × 11⅞ in)

Accession no. 1990.587e, panel 5, George F. Harding Collection

Ill. nos. AIC 11, 11/a

History of the glass: This heraldic panel was in the collection of Cornelia, Countess of Craven, at Coombe Abbey, Coventry, and was sold on 12 April 1923 to Liberty (*Craven sale* 1923, p. 15, no. 113). Liberty and Co., London, had it until 23 July 1927 (?), when George F. Harding, Chicago, bought it (AIC Curator's file). The AIC accessioned it in 1990. [In storage]

Bibliography

UNPUBLISHED SOURCES: Elizabeth Pastan, notes; AIC Curatorial files, 1990.587e (formerly 1990.587b).

PUBLISHED SOURCES: *Craven sale* 1923, 15, no. 113 (AIC 11).

Description/Color: In the middle field, a man wrestles a lion in the foreground of a landscape with a city and lake in the distance behind them. The leaded fragments above the architrave to the right show a sword-wielding figure. At upper left, there are two cephalophoric saints, a stopgap. All the primary and secondary colors appear here.

Inscriptions: *IHS; H bassiund bern/ von hall und der/ grafschaft tiroll sen/ haft zuo sillenen/ in Uri 1615* [the first three letters of Jesus in Greek]; Herr Bassiund Bern of Hall and the county of Tirol. Residing at Silenen in [the canton of] Uri. 1615)

Condition: The panel has an integral core and stopgaps at the upper and lower left. The upper right corner was broken and reassembled. The framing pieces with tassels are perhaps stopgaps.

Iconography: The central image is Samson (Judges 14:16). A medallion showing Samson and the lion appears above

the Uri shield in a panel dated 1565 (Barbara Giesicke, *Glasmalereien des 16. und 17. Jahrhunderts im Schützenhaus zu Basel*, Basle, 1991, pp. 54–7, no. 4). Clearly signifying strength, this image personifies that Swiss canton. Uri lies in a particularly rugged region of the Alps: glaciers occupy a fifth of the region. It retained its allegiance to the Roman church at the time of the Reformation.

Heraldry: Or, in chief horseshoe argent, a rose or, in base a mount proper.

Technique: The materials include uncolored and potmetal glass, vitreous paint, silver stain, sanguine, and several different enamels: blue, purple and green. Precise and elegantly crafted stickwork animates the central scene.

Style: The dynamic presentation of the central figures is congruent with an early seventeenth-century composition. The painter emulated the appearance of a woodcut with the sharply defined, parallel stickwork strokes that articulate the lion's mane and Samson's hair. Although Dürer's Samson woodcut, *c.* 1498, cannot be the only source of the Chicago image, they share compositional features such as the placement of the figures in respect to the space, and the distant lake and cityscape (Kurth 1963, fig. 103).

Date: 1615 [inscription]

Photographic reference: E32947HAR

AIC 11/a. Restoration chart

AIC II. *Heraldic panel of Samson and the Lion*

AIC 12. Heraldic Panel of Franz Güder
Switzerland, Berne
1616

Rectangle: 32.8 × 21.4 cm (12⅝ × 8 7/16 in)
Accession no. 1990.587b, panel 2, George F. Harding Collection

Ill. no. AIC 12

History of the glass: George F. Harding, Chicago, owned this panel and the AIC accessioned it in 1990. It is thought to have been purchased by Liberty's at the sale of stained glass belonging to Cornelia, Countess of Craven, on 12 April, 1923 (*Craven sale 1923*). According to Christie's records, Liberty bought nothing at that sale that corresponds to this panel. A Harding did buy no.145, which consisted of two panels: the catalogue description is general but the AIC Güder piece may have been one of them (*Catalogue of Old English*, p. 19).

Bibliography

UNPUBLISHED SOURCES: Elizabeth Pastan, notes; the Archive Department, Christie, Manson, & Woods, London, annotated catalogue; Petra Schön, letter of 14 Aug. 1997; Marianne Howald, letter of 4 Sept. 1997; I. A. Reiprich, letter of 8 Sept. 1997; Annelies Hüssy, letter of 22 Sept. 1997; Rolf Hasler, letter of 12 Feb. 1998.

PUBLISHED SOURCES: Ernst von Hartmann-Franzenshuld, "Zwei Stammbücher von Siena," *Jahrbuch des heraldisch-genealogischen Vereins "Adler" in Wien*, 1876, 3, pp. 114, 120; *Catalogue of Old English and Italian Furniture, Early Swiss Stained Glass, Faience and Stoneware, the property of the Right Hon. Cornelia Countess of Craven and removed from Coombe Abbey, Coventry* [sale cat., Christie, Manson, Woods, 11–12 April], London, 1923, p. 19, no. 145; HBLS, 3, 1926, p. 789; Rietstap 1967, 3, pl. CX; id. 1972, 1, p. 844.

Description/Color: The shield with mantling, helmet, crest, and motto fills the middle field. Above the architrave, a man, possibly a traveler, leans on a staff at the left; water pours into and out of a square trough from which a boy drinks in the center; and another man, possibly also a traveler, stands on the right. The woman on the right, beside the achievement, pours water. The woman on the left holds a mirror and has a snake wound around her left arm. The colors span the spectrum.

Inscriptions: *POST NVBILM PHAEBVS*; *Hr Franz Güder/der Jünger 1616* (after darkness the sun [Phoebus Apollo] will come; Herr Franz Güder the Younger 1616). A drawing for a panel showing the shield of Franz Güder the Elder (d. 1631) bears the same adage (Rolf Hasler, *Die Scheibenriss-Sammlung Wyss: Depositum der Schweizerischen Eidgenossenschaft im Bernischen Historischen Museum*, Berne, 1997, 2, p. 37, no. 397).

Condition: Some breaks are mended with leads, and there are also breaks that are not mended. All the pieces are original.

Iconography: The female figure to the right, her face depicted in profile, represents Temperance, one of the Four Cardinal Virtues. She pours water into wine to dilute its potency (cf. Jacob Mathan, *Temperance*, in *Ill. Bartsch*, 4, 1980, p. 120, no. 131 [164]); Friedrich Thöne, *Daniel Lindtmayer, 1552–1606/07: Die schaffhauser Künstlerfamilie Lindtmayer*, Zurich, 1975, p. 338, fig. 104). Prudence, another Cardinal Virtue, is on the left. Her snake refers to Matthew 10:16, "Be ye therefore wise as serpents" (Hasler, pp. 34–5, no. 395; Thöne, p. 359, fig. 156).

Heraldry: Azure two swords per saltire proper within a bordure or nebuly argent; crest: two arms counter-embowed or and azure holding two swords per saltire proper; mantling azure and or. Franz Güder (1587–1651) was a member of a select group of Berne burgher families that had the right to occupy government positions (Howald; HBLS, 3, 1926, p. 789, no. 10; Rietstap 1967, 3, pl. CX; id. 1972, 1, p. 844). Over the course of his lifetime he held public offices in the city of Berne and the Republic of Berne as well as in two towns in the modern Canton of Vaud. In 1609 he contributed an entry to a heraldic album that was compiled at the University of Padua. Güder was probably a student there at the time (Reiprich; von Hartmann-Franzenschuld, pp. 114, 120). He married his first wife in 1610 and his second in 1630. The family originally came from the Canton of Zug and died out in Berne in 1774 (Hüssy).

Technique: The painter used pot-metal and uncolored glass, vitreous paint, silver stain, sanguine, as well as blue, green, and purple enamel. The mat in the spandrel scene is stippled. There is some stickwork.

Style: The roll work decoration around the inscription appears in sixteenth-century prints illustrating perspective constructions, such as those of Lorenz Stoer (Andersson and Talbot 1983, pp. 343–5, nos. 194–5). A Jost Amman Bible frontispiece, 1565, includes both rollwork framing and a spandrel figure spilling water from a vase (*Ill. Bartsch*, 20/1, p. 244, no. 1a [365]).

Date: 1616 (by inscription)

Photographic reference: E 32944 HAR

AIC 12. *Heraldic Panel with Shield of Franz Güder*

AIC 13. Heraldic Panel with the Arms of Fridolinus Summerer, Abbot of Muri

Switzerland, Zug (?)

1670

Rectangle: 34.5 × 25.3 cm (13⅝ × 10 in)

Accession no. 1990.587, George F. Harding Collection

Ill. nos. AIC 13, 13/a, 13/figs. 1–2

History of the glass: George F. Harding owned the panel and it was displayed in the Harding Museum, Chicago, before being given to the Art Institute of Chicago in 1990. [In storage]

Origin: This is a highly impressive panel connected to one of the richest surviving monastic programs of the Baroque era in Switzerland. The Benedictine Abbey of Muri was founded in 1027 as part of Hapsburg dynastic strategy. Monks from the Abbey of Einsideln settled the foundation and began a school, the first in the Canton of Aargau. In 1534 the building of the Late Gothic cloister was begun and most of the glazing program completed by 1605. The Chicago panel commemorates the abbot of this monastery, and was probably a gift from the abbot to another religious house.

Bibliography

UNPUBLISHED SOURCES: AIC Curator's file; Elizabeth Pastan, correspondence 10 August, 1990 with AIC.

Inscriptions: lower: *Fridolinus Von Gottes/ Gnaden Abbte des Würdig/ en Gottsh[..]s Muri 1670* (Fridolinus, by the grace of God, abbot of the worthy monastery of Muri, 1670); above in medallion: *DEUS Prouidebit* (God will provide); right: *S Scholastica* (written by removing mat paint) (St. Scholastica); left: *Benedictus* (written with trace paint) (Benedict).

Condition: The panel is presently leaded with four others in a window with a clear bull's-eye lattice surround. Although substantially intact, it is marred by the intrusive presence of repair leads and one stopgap female saint on the left. Also on the left, the green capital over a red column without base is glued to the back like a sandwich and not of the same form as the architecture in the rest of the panel. The different form of the halo, a scallop pattern as opposed to the rays in the other three saints, supports the conclusion that the figure is brought in from another provenance. The same color enamels and the red flashed and abraded dress show the same technique, if not exact style, as the rest of the panel. Therefore the stopgap is close in time, possibly even from the same or similar workshop.

Heraldry: Per pale azure a serpent or in chief vert a crenelated wall argent (Abbey of Muri); argent, a band sable with seven drops or in chief vert two pinnacles terminat-

ing in fleurs-de-lis or (Fridolinus Summerer). Crest: a mitre having an image of the Virgin and Child, crosier with panacelsus.

Hans Ludwig Summerer (1628–74) was born in Baden, Argau, and in 1644 entered the Abbey of Muri, taking the name of Fridolinus. He became abbot in 1667 (Schneider 1970, p. 321). The Schweizerisches Landesmuseum in Zurich has two roundels showing the abbot's arms. One presents Fridolinus's arms and inscription *Fridolinus Von Gottes Gnaden Abbte Des Würdigen Gottshausz Muri 1667* (AIC 13/fig. 2) below the *Adoration of the Magi* (Schneider 1970, no. 632, LM 640a/IN 736). The image reproduces an engraving by Matthäus Merian from a popular illustrated Bible first published in 1630. The second roundel (Schneider 1970, no. 641, LM 6914), is similar, but dated 1670, and presents St. Mark writing his gospel in a prosperous city with a lion at his side, an image also based on Merian's engraving. The panel was given in 1670 by the abbot to the Bailiff (*Ammann*) of Brandenberg in Zug as a present for his new house.

Color: The panel is a lively, brightly colored composition structured by the interaction of the primary colors of red, blue and yellow. The blues are bright, intense hues, particularly dominant in the upper narrative panels. The reds are more of a medium brown tone for the enamel colors, those

AIC 13/a. Restoration chart

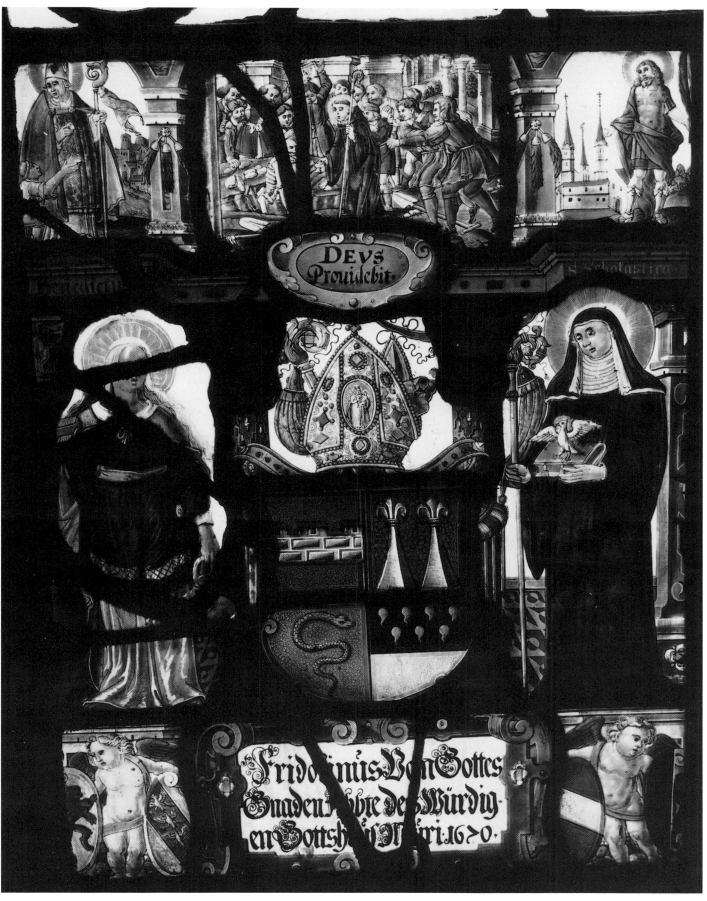

AIC 13. *Heraldic Panel with the Arms of Fridolinus Summerer, Abbot of Muri*

MONASTERIVM MVRI; QVOD FVNDATVM EST A RATHBOTO COMITE
DE HABSBVRG, ET ITA DE LOTHARINGIA EIVS CONIVGE ANNO M.XXVI.

R.^{mo} DÑO D. IOAN. IODOCO
MONASTERII MVRI ABBA-
TI: NEC NON VEN. CONV.
F. IO. CASPAR⁹ WINTER-
LIN EIVSDEM CONVENTVS
OFF. L. D. A° 1615. 20 AVG

AIC 13/fig. 1. JOHAN CASPAR WINTERLIN: Engraving of Abbey of Muri, 1615

(right) AIC 13/fig. 2. *Adoration of the Magi with Arms of Fridolinus
Summerer*, 1667. Zurich, Schweizerisches Landesmuseum

of the pot-metal glass in the shield are warm, medium hues.
Yellows provide accents throughout. The composition of
the abbot's shield, with both light yellow and deep brown-
ish yellow, bright blue and red for the jewels, and blue mate-
rial of the panacelsus creates a sprightly image.

Technique: The panel is executed primarily in uncolored
glass with vitreous paint, sanguine, blue, green, and purple
enamel colors, and two hues of silver stain, typical of such
late productions. The glass is a visibly impure material
with many small bubbles. Red flashed pot-metal glass
appears in the abbot's shield and yellow-brown pot-metal
in the segment above carrying the Latin motto. Trace line
and mat are applied simply, with little use of stickwork or
needlework; the panel's main eye-appeal is the use of the
range of enamel colors and the complexity of the imagery.

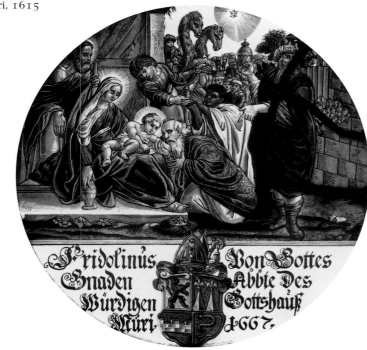

110

Iconography: The panel shows thematic issues connected to Fridolinus and the abbey itself. At the upper left, St. Martin gives coins to a beggar at his feet. The beggar stretches out his arms holding a bowl. Martin is the patron of the abbey, and in an early seal affixed to a document of 26 June 1312, he is depicted on horseback, dividing his cloak with the beggar (Anderes 1974, p. 20, fig. 4). Dating from 1344, however, he is shown as bishop, dressed in full regalia of miter, cope, and crosier, dispensing coins. He is thus depicted in the view of the abbey (AIC 13/fig. 1) in the engraving of 1615 by Johan Caspar Winterlin (Zurich, Zentralbibliothek, Graphische Sammlung). The same iconography for St. Martin is found in a window of 1557 from Muri's own cloister (west IIIa, Anderes 1974, p. 130, pl. 36).

In the upper center of the panel, surrounded by an animated crowd, a tonsured monk stretches out his hand to a skeleton rising from an open grave. This is St. Fridolinus, the Irish monk who was believed to have founded the double monastery of Säckingen. The legend depicted is the story of a wealthy landowner named Ursus who had promised land to Fridolinus. He died before finalizing the transaction and his brother claimed the inheritance. Ursus, therefore, was forced to rise from the grave and appear as a skeleton at the Provincial court to confirm his donation. The legend is cited in Muri's cloister in a window of 1557 (east VIa, Anderes 1974, p. 146, pl. 44). Fridolinus is shown as a tonsured monk with a skeleton at his side holding a document with three seals.

A similar representation of the saint is found in the panel of Fridolinus Lindacher dated 1692 now in the Pierpont Morgan Library collection (Hayward in *Checklist* I, p. 185). On the right of the Chicago panel is a military saint holding a martyr's palm with an image of the abbey in the background. This is probably St. Leontius whose remains were transferred from Rome to the abbey in 1647 (Andreres 1974, p. 21), an acquisition which transformed the abbey into a much frequented site of pilgrimage. The depiction of the abbey with its two west towers and lower crossing tower is quite close to the image in the 1615 engraving.

At either side of the arms are two saints. Only St. Scholastica, to the right, is original. She is dressed as a Benedictine nun in black, holding a book on which a dove rests. These are her traditional attributes. Scholastica was the sister of Benedict and she settled at Monte Cassino, near her brother, seeing him at rare moments. Tradition holds that a community of nuns grew up around her and that when she died, Benedict had a vision of a dove flying to heaven. An inscription, *Benedictus*, remains on the left and it is most probable that an image of St. Benedict was in the place of the stopgap female saint. This would correspond to the dexter and sinister heraldic protocol where the male would be on shield's dexter side (our left). Thus the revered patrons of the Benedictine order would be the heraldic supporters of the abbot's coats of arms.

Style: The panel is well executed and shows a painting style typical for the time. The figures are modeled in three-dimensional space. The cartouches display chubby putti at the sides and exuberant baroque strapwork framing. The two roundels in Zurich connected to Abbot Fridolinus have been attributed to workshops in Zug. It is possible that Fridolinus commissioned additional glass from Zug.

Date: The panel is dated 1670 by the inscription, the same year the abbot commissioned a roundel for a bailiff in Zug (see above, **Heraldry**).

Photographic reference: AIC, Harding Collection

AIC 14. Heraldic Panel with the Beheading of St. John the Baptist
Switzerland
1695
Rectangle: 21 × 25.8 cm (8¼ in × 10¼ in)
Accession no. 1990.587 D, George F. Harding Collection

Ill. nos. AIC 14, 14/a, 14/fig. 1

History of the glass: The panel is recorded (AIC Curator's file) as having been in the collection of Carmelia (sic), Countess Craven. Swiss stained glass was included in a sale of the collection of Cornelia, Countess of Craven (*Catalogue of Old English and Italian Furniture, Early Swiss Stained Glass Faience and Stoneware, the property of the Right Hon. Cornelia Countess of Craven and removed from Coombe Abbey, Coventry* [sale cat., Christie, Manson & Woods, 11–12 April], London, 1923) but this panel does not correspond to any of the 75 lots listed. Some panels in this sale are known to have been purchased by Harding (copy of annotated catalogue courtesy of Christie, Manson & Woods, Ltd.). Curatorial notes further state that the panel was purchased from Liberty and Co., Ltd., London, also noted as a buyer at the Craven sale, 23 July 1927, by George F. Harding. It was displayed in the Harding Museum, Chicago before being given to the Art Institute of Chicago in 1990. [In storage]

Bibliography
UNPUBLISHED SOURCES: AIC Curator's file; Elizabeth Pastan, correspondence 10 August, 1990 with AIC.

Inscriptions: *[.]llerich Basse[n?] in der/ parrochian Rechhasten/ und Magdalena Byrbaum sein hausfauro* 1695 (Ulrich Bassen of the parish of Rechhasten and Magdalene Birbaum, his wife, 1695).

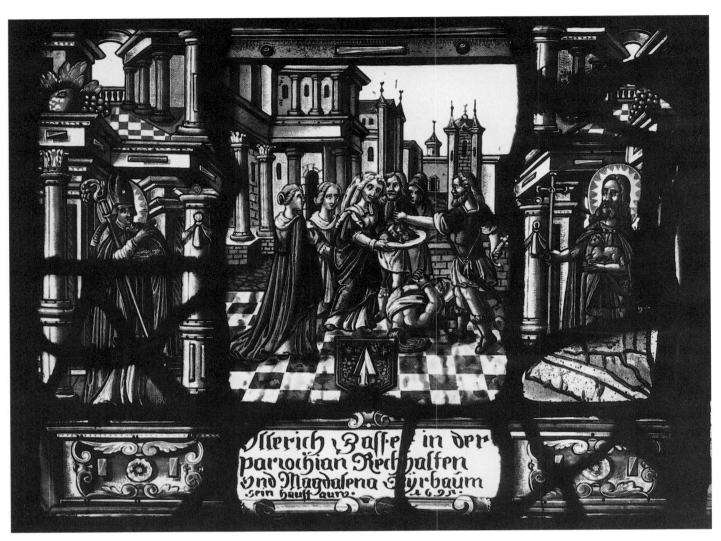

AIC 14. *Heraldic Panel with the Beheading of St. John the Baptist*

AIC 14/a. Restoration chart

Condition: The panel is presently leaded with three others in a window with a clear bull's-eye lattice surround. It is substantially intact except for an awkward replacement in the base of the standing image of John the Baptist and a minor replacement in the architecture above him. The repair leads, however, are intrusive, marring substantially the readability of the panel. The inscription plate may be renewed; the glass undulates but does not show much wear. The high profile of its vitreous paint almost reads as a relief, unlike the paint application on other areas of the panel. An alternative, and more persuasive, conclusion is that the inscription was painted separately in the shop by the workshop's specialist in lettering.

Heraldry: Azure a plowshare argent in chief two mullets of six points or (Ulrich Bassen?).

Color: The color harmonies are highly restricted, the panel being composed of uncolored glass with yellow silver stain, red enamel, and a warm brown tone in the vitreous paint. The combination of the warm medium yellow and warm medium red dominate the visual plane. Contrast is

mainly limited to the interplay of the extensive detail in brown paint and the many lighter areas, some, like the tile courtyards, picked out with yellow.

Technique: The panel is executed completely in uncolored glass with vitreous paint, red and blue enamel, and silver stain. A flat uniform wash appears as back-painting behind the columns of the architecture. This style of execution is typical for panels of the late Baroque era in Switzerland. The painting is applied conservatively, that is, a medium tone of granular wash is laid across the areas needing shading. With very small strokes, the painter removes the wash where needed to blend the edges with the unpainted areas and to lighten some of the shadow. See, for example, the shading on the columns or the cross hatching on the walls of the large buildings behind Salome and her companions.

Iconography: The central scene presents the beheading of John the Baptist. The executioner, holding his sword in his right hand, is striding forward to place the severed head on the salver held by Salome. She is accompanied by two women companions. To her right, behind her, appear two men, one with beard and mustache. The body of the Baptist is on the ground, the red of his blood touching the edge of the heraldic shield. On the right, in the framing panel, John the Baptist holds the lamb of God, his traditional symbol. To the left is St. Ulrich, bishop of Augsburg (d. 973), the husband's name saint. Ulrich, identified by his bishop's robes and crosier, holds a book with two fishes. This representation depicts the legend that tells of Ulrich having once been given meat on a Friday, a day of abstinence, and the meat having turned into fish. Another Ulrich, Ulrich Püntiner, from an important family of the Canton Uri, in 1597 placed his shield protected by St. Ulrich in the cloister of the Benedictine monastery of Muri, Aargau (south IIc, Anderes 1974, p. 98, pl. 20).

Style: Most striking in the composition is the use of architecture both as setting and as frame. The central image presents the scene as if taking place in a courtyard surrounded by Renaissance architecture, with buildings of several stories, colonnaded arcades, and towers. The courtyard is paved in alternating dark and light squares of *opus sectile* and dabs of silver stain attempt to reproduce the effect of a striated surface. Majestic architecture continues at the sides where the figures of the saintly bishop and the Baptist are amidst elaborate two-storey buildings with upper walkways and columns that are festooned

AIC 14/fig. 1. ANDREA ZOAN AFTER BRAMANTE: *A street with various Buildings, Colonnades, and an Arch,* engraving, *c.* 1500, Washington, D.C., National Gallery of Art

with ribbons. Similar horizontal panels echoing stage set concepts as framing devices now in the Cooper Hewitt Museum (1937–28–20 and 21), New York, New York, are also dated 1695 and carry inscriptions of Swiss donors from Lucerne (Hayward in *Checklist* I, p. 90).

It is likely that the architecture is drawn from print sources, for instance publications of Renaissance architectural theory by authors such as Bramante or Sebastiano Serlio. Serlio's late fifteenth-century treatise was published by Pieter Coecke van Aelst, in Antwerp in 1553 as *De tweedeen boeck van architecturen* (Filedt Kok 1986, p. 408, fig. 298c). A print representing a tragic stage set by Andrea Zoan after Bramante (AIC 14/ fig. 1; c. 1500, *Ornament and Architecture: Renaissance Drawings, Prints and Books* [exh. cat., Bell Gallery, Brown University], Providence, 1980, p. 101, no. 90) shows the same kind of compositional division between two flanking colonnaded structures and a central recession.

The figural style is decidedly more awkward. The artist even gives the impression that he is extremely dependent on his models, probably any one of the illustrated Bibles or other image books with bible stories with elaborately framed scenes popular at this time. He sets the scene of the execution against an architectural space but makes no effort to integrate the figures into the depicted architectural perspective. St. Ulrich is a common type for a bishop saint, depicted with attention to the proportion of the figure. The image of John the Baptist, however, appears to be made up from two sources, one for the head, substantially larger than that of the bishop's, and one for the body, producing an incongruous juxtaposition.

Date: The panel is dated 1695 by the inscription.

Photographic reference: AIC Harding Collection

AIC 15. Fragments
Eastern France
Early sixteenth century
Rectangle: 61 × 71 cm (24 × 28 in)
Accession no. 1930.947, Gift of
the Antiquarian Society

Ill. no. AIC 15; Col. pl. 43

History of the glass: The previous owners include Jacques Seligmann, until 1909 (?); the Earl of Carrington, Wycombe Abbey, Buckinghamshire; and Ambrose Monell, Tuxedo Park, N.Y., until 1930 (*Monell* sale, 1930, no. 50). In 1930 the Antiquarian Society purchased it for the Art Institute of Chicago at the Monell sale (*Art News*, p. 31). [In storage]

Related material: There were five more panels containing collections of heads that are closely related to these in the Monell collection (*Monell* sale, 1930, nos. 45–50). One of them titled *St. Sebastian*, although actually a collection of heads with the head and nude torso of a male saint holding an arrow, was on the art market in 1941 (*Hearst* sale 1941, p. 146, no. 405–1, ill.).

The following have also been associated with Loisy-en-Brie: *Annunciation*, 1460–80, Axt Coll., Altadena, California (Caviness and Hayward in *Checklist* III, p. 44); *Nativity*, *Adoration of the Magi*, and *Crucifixion*, 1460–80, NA (Papanicolaou in *Checklist* III, pp. 196–7; see also: Hayward and Caviness in *Checklist* III, pp. 25–7, 35 n. 105, fig. 6).

A panel of fragments from Blénod-lès-Toul resembles the one in Chicago (Michel Hérold, 'Les Vitraux de Blénod-lès-Toul,' *CA*, 1991, p. 68, fig. 4).

Original location/Style: This panel has been attributed to Loisy-en-Brie (Lillich in *Checklist* III, p. 127) but a number of points argue against this premise. The *Monell* sale catalogue text states: "The six panels (nos. 45–50) depicting groups of saints with their emblems were removed from Wycombe Abbey, the residence of the Earl of Carrington. The five panels (nos. 51–5) with incidents from the life of Our Lord are from a church in the Brie distinct of France (foreword, unpaginated)." Two groups of panels are described. The six made up of fragment heads are not said to have come from Brie, as are the latter five (the narrative panels).

All the panels in the *Checklists* published as coming from Loisy-en-Brie are said to have been in the possession of Jacques Seligmann in 1909, yet the Loisy-en-Brie windows were restored in 1913 (France *Recensement*, IV, p. 372). The Chicago panel is the only one of the six head fragment panels whose present location is known. Four of the five narrative panels are in the United States (one in California, *Checklist* III, p. 44 and back cover, color ill.; three in Missouri, *Checklist* III, p. 196–7): the location of the fifth, on the US art market in 1941 (*Checklist* III, pp. 25–6, fig. 6), is currently unknown.

The five Brie narrative panels differ in composition and style from the one in Chicago. On the one hand, none of the decorative motifs in Chicago AIC 15, such as fillets with calligraphic ornament or brocades, appear in the Brie panels. On the other hand, none of the decorative motifs found in the Brie panels, such as the border motif seen on the costume of the California angel, appear in AIC 15. Clothing styles are not analogous. The Chicago figures have fingernails, whereas the Missouri and California figures do not. The practice of using sanguine to shade flesh does not appear in the California *Annunciation*. The stippled mat shading tones in the California panel are more generalized than are those, for example, in the Chicago "donor's" head (bottom left). The hair of the Missouri and California figures appears more carefully groomed than that of the Chicago heads.

Finally, the sensitivity of the chiaroscuro, the fluidity of stickwork and trace lines in hair and beards, and the extensive use of sanguine in the Chicago panel would argue for a date in the early sixteenth century. The Missouri and California windows, painted with the more painterly modeling that is characteristic of late medieval traditions, are more reasonably dated 1460–80. It is likely that the Chicago panel came from eastern France: see, for example, Joinville (France *Recensement* IV, pp. 420–2, figs. 401–3), or the sites that relate to it, especially Herbisse (ibid., pp. 114–7), or Ricey-Bas (ibid., pp. 173–5).

History of the building: The site originally proposed for the windows, but argued against here, has been researched by the Corpus Vitrearum (France *Recensement* IV, p. 372). Two choir windows at the parish church of Saint-Georges, Loisy-en-Brie, were glazed in the early sixteenth century. The glass was badly restored in 1913 and some fragments remain in the church. Fragments of an *Annunciation to the Shepherds* that are stylistically similar to the panels in California and Missouri are at Givry-les-Loisy (France *Recensement* IV, p. 369). The Givry-les-Loisy fragments do not resemble those in Chicago.

Bibliography

PUBLISHED SOURCES: *The Antiquarian*, 15 no. 6 (December 1930), p. 96, ill.; American Art Association, Anderson Galleries, *Collection of the late Colonel Ambrose Monell*, New York, 1930, no. 50, ill.; "Painted Glass Panel from the Monell Sale shown in Chicago," *Art News*, 29/24, (14 March 1931), p. 31; "Report for the Year 1931," *AIC Bulletin*, 26/2, (February 1932), pt. 2, pp. 20 and 39, ill.;

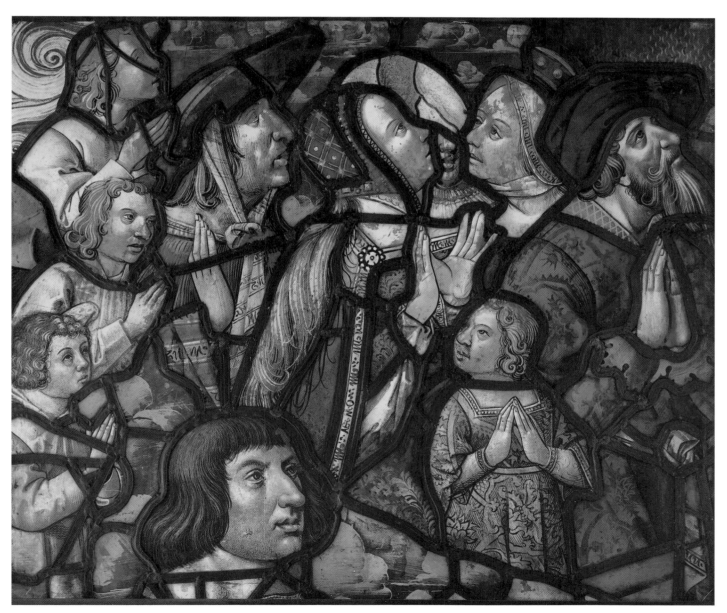

AIC 15. Fragments, early 16th century, from Eastern France

Antiquarian Society, p. 255, no. 324; Lillich in *Checklist* III, p. 127; and France *Recensement* IV, pp. 369, 372, 407.

Condition: This panel is made up of old heads and fragments of drapery that are surrounded by stopgaps and modern pieces. The hands and arms of the male on the far right do not belong to this figure.

Color: A variety of hues appear here including blue, green, purple red, red, and silver stain yellows.

Ornament: Fillets decorated with a calligraphic motif ornament several costumes. A checkerboard-like design embellishes the center female's hat. Several fabrics are painted to resemble brocades.

Technique: The materials are pot-metal and uncolored glass, vitreous paint, silver stain and sanguine. The flashed red glass is abraded and stained to produce the hat of the central female. One glass painter used stickwork and brownish trace lines in combination with sanguine to produce chiaroscuro effects on faces and hands (angel on middle left, two female faces in center). The "donor" painter, responsible for the head at the lower edge of the panel, employed stippled mat, with a darker stipple and stickwork to produce this shading.

Date: Early sixteenth century.

Photographic reference: E14008 EDA

Martin D'Arcy Gallery of Art, Loyola University
CHICAGO, ILLINOIS [MDGA]

THE COLLECTION consists of four works in glass, two panels of painted and leaded glass and two roundels. All four are superb examples of the periods they represent. The first is a segment of *Border* (MDGA 1) from Canterbury cathedral, and the earliest panel in any Midwest collection. The panel is almost completely intact and in excellent condition. Elements of borders from the windows of the choir and Trinity Chapel had been placed in the Cathedral's southwest transept window during an eighteenth-century restoration, and during that process, segments retained in the restorers' shops. In the early years of the twentieth century, many of these elements, separated from the Cathedral, entered the art market as sales or as gifts. The *Border* at Loyola University is particularly important since it represents a time in medieval artistic construction when the so-called decorative element was considered as important to the meaning of the ensemble as the narrative image. Stained glass was one part of an architectural whole (see Introduction) where an-iconic, aesthetic, issues of color, light, and pattern were seen to evoke most profoundly the ineffable mysteries at the heart of religious ritual.

The small tracery light of *St. Margaret* (MDGA 2; col. pl. 3) over the dragon is also in superb condition. There are no replacements. At the time of its purchase it was assumed to be of Austrian origin, but it is more likely to be English, of the mid-fourteenth century. *St. Margaret* is as telling of the function of image for the Middle Ages as is the repetitive beauty of the Canterbury *Border* for pattern. Margaret was viewed in the Middle Ages as the insurer of safe birth. She was invoked by women in labor, and her image, emerging unharmed from the body of the dragon evoked the hoped-for passage of the child from womb to its waiting family. Despite its restricted size, the image is remarkably subtle in shifts of color, handling of paint to evoke three-dimensional form, and contrast of the beast and the maiden.

The *Agony in the Garden* (MDGA 3) from the North Lowlands, painted about 1500 to 1510, is a roundel, demonstrating a conceptual shift from images to be seen at a distance to the small-scale meditative image. This object, as well as the roundel following, demand a close point of vantage for the spectator. Its design includes a narrative within the small, circular space. The events depicted take place over time, yet they are placed in physical juxtaposition. The viewer enters the story by mentally stepping over, and presumably empathizing with, the prone figure of an exhausted St. Peter asleep on the ground. Beyond is Christ in agony as he confronts the angel with the cup, announcing his Passion, and finally to the left, Christ is led off as a prisoner. The sources for the design are dependent on prints, also an art form for private, individual contemplation.

The *Son of Zaleucus accused of Adultery* (MDGA 4), South Lowlands, dated c. 1530, is associated with a workshop known for large scale work, roundels, and prints. Attributed to Dirick Vellert, or his workshop, the roundel is therefore related to an artist who designed the huge windows of King's College Chapel, Cambridge, England, and leaded panels in cloisters such as the Charterhouse of Louvain, Belgium, and who made prints, and painted roundels.[1] The theme of Judgment as a subject matter in the pictorial arts received great attention at a time of the development of the Early Modern state, with its ascendancy of commercial and bourgeois interests which brought the need for abstract, impersonal laws and administration of justice. Whether stories

from classical antiquity, such as that of the ruler Zaleucus of the Greek city-state of Locri, from the Old Testament, such as Susanna and the Elders, or from the Gospels, especially Christ before Pilate, or Christ and the Adulterous woman, the admonition was that justice was protected by the highest authority and essential for civil tranquillity and prosperity.

History of the Collection

The purpose of the collection is impossible to characterize without some understanding of the man whose name it bears. Martin Cyril D'Arcy (1888–1976) was a Roman Catholic priest of the Jesuit Order, widely admired for his charismatic personality and profound yet accessible writing. His mother, Madeline Keegan, was Irish, and his father, Martin Valentine D'Arcy, English of Norman extraction. His early education was at Stonyhurst College, Lancashire, then the Jesuit seminary attached to the school, followed by Oxford, and later the Gregorian University of Rome where he received his doctorate in Theology in 1926. He became lecturer in the Faculty of Philosophy at Oxford University in 1927, a post he retained until 1945. In 1933 he assumed the post of Master of Campion Hall, the first Roman Catholic college to be established at Oxford since the Reformation. He rebuilt Campion Hall, with Sir Edwin Lutyens designing a new hall on Brewer Street, and began a collection there of works of art, all gifts from friends, which was to become the model for the gallery at Loyola University. The collection is still intact and distributed through the hall rather than grouped in a single display area. From 1945 to 1950 Fr. D'Arcy became Provincial Superior of the English Jesuits. He resided at the Jesuit House on Farm Street, London, where he published *The Mind and Heart of Love* in 1947 and *The Meaning of Matter and History* in 1959. His status as a leading thinker for both historical as well as philosophical issues was recognized by his election in 1956 as a Fellow of the Royal Society of Literature.

In the foreword to *The Martin D'Arcy Gallery of Art, The First Ten Years*, John Pope-Hennessy characterized the personality of Fr. D'Arcy: "I met Father D'Arcy in the early nineteen-thirties, when he was Master of Campion Hall at Oxford and I was a Balliol undergraduate — and at once I fell under his spell. It was a lucky moment for Catholics at the University — the Chaplain was Monsignor Ronald Knox — and in a world where philosophers were kings, Father D'Arcy, with his combination of conviction and open-mindedness, his intellectual brilliance and psychological acuity, and his incomparable, sometimes searing use of language, reigned supreme."

The Martin D'Arcy Gallery was founded to provide a specific focus and meaning to a collection serving the students at Loyola University. The University is a Jesuit institution, dedicated to the continuation of the work of a society begun in 1534 in Paris when Ignatius of Loyola vowed, with six companions, to live in poverty and chastity and to offer their service to the Holy See. Pope Paul III approved the fundamental charter of The Society of Jesus with a papal bull in 1540. Early on, education characterized the Society's work; the Jesuit constitution defined the Society, in distinction to the medieval religious orders, as mobile, free of communal worship obligations, rhetorically skilled, and independent of geographic locus. The patronage of art, especially art of a dramatic, emotional impact has been associated with Jesuit rhetorical strategies. Thus the foundation of the Martin D'Arcy Gallery follows the Society's earliest activities.

Donald F. Rowe, S.J., began to construct the collection in 1969, during the lifetime of the gallery's namesake. From 1956 to the early 1970s, Fr. D'Arcy lectured in the United States for some months of the year and thus became known to many Americans, such as Mr. and Mrs.

Charles W. Engelhard, who were the initial donors to the Gallery. Many of the objects came from the Jesuits at Stonyhurst College, Lancashire, or the English Province of the Society of Jesus.[2] Fr. D'Arcy bequeathed five items, an Italian terra-cotta sculpture of John the Baptist of the early sixteenth century, a seventeenth-century Flemish sculpture of the Lamentation with St. Francis, a fifteenth-century Italian processional cross, a German enameled and jeweled ring from the sixteenth century, and a Spanish painting by a follower of Pedro Berruguete.[3] The collection is focused on work of the medieval, Renaissance, and Baroque periods and although there are some paintings, most objects are small-scale three dimensional works. There is a sense of intimacy evoked by the scale of the private and personal object, of objects for a private chapel and the devotional moment. Viewers have the sense that each of these objects might have been, as some apparently were, a part of Fr. D'Arcy's life in Campion Hall.

The donor of the Canterbury *Border* and her late husband, Gertrude and John Hunt, were admirers of Fr. D'Arcy. In 1975 the Hunts had donated an alabaster sculpture of Christ on the Cross from Nottingham, dated to the first half of the fifteenth century.[4] Other objects were acquired by Fr. Rowe from the Hunts financed by gifts Fr. Rowe sought for the Gallery, for example a candlestick base in the form of a harpy, probably North Italian from the late twelfth century.[5] After her husband's death, and also that of Fr. D'Arcy, Gertrude Hunt wrote to Fr. Rowe concerning a gift, "Now it occurred to me that what Father D'Arcy would have liked more than anything else, would be a border of stained glass from Canterbury of which I have two[6] and these two are in the best condition of any of the Canterbury glass and Canterbury is the sort of dream of anyone interested in english (*sic*) religious art ect. (*sic*)" (18 Nov. 1976, copy of letter in MDGA files). The panel was given in memory of John Hunt and to commemorate Rev. Martin D'Arcy, S.J. The other three works in glass were purchased by Fr. Rowe in 1977, 1976, and 1983 with the support of The Friends of the Gallery.

BIBLIOGRAPHY

UNPUBLISHED SOURCES: MDGA Curatorial files; Rita E. McCarthy, 1998 Acting Director, MDGA.

PUBLISHED SOURCES: Donald F. Rowe, S.J., *The Martin D'Arcy Gallery of Art: The First Ten Years*, Chicago, 1979.

NOTES

1 In this volume Vellert is associated with panels CMA 12–15, IUMA 1, and C-CEC 1 See also (Konowitz 1987, pp. 22–8; Konowitz 1992).

2 Rowe 1979, nos. 18, 19, 20, 30, 33, 35, 37, 39, 48, 51, 54, 57, 64, 71, 72, 73, 78, 81, 90, 94, 96, 97, 98, 99, 120.

3 Ibid., no. 7, Acq. no. 15.70; no. 22, Acq. no. 14.70; no. 40, Acq. no. 5.70; no. 59, Acq. no. 17.69; and no. 111, Acq. no. 14.72.

4 Ibid., no. 3, Acq. no. 22.75.

5 Ibid., no. 25. Acq. no. 10.76, Gift of Mr. and Mrs. Robert L Metzenberg; See also no. 27, Acq. no. 5.77, Gift of Solomon Byron Smith, and no. 34, Acq. no 20.77, Gift of Mr and Mrs. John W. Clarke.

6 Border Type A. Caviness 1981, p. 314; Jane Hayward in *The Year 1200*, pp. 223–4, no. 227, ill.

MDGA 1. **Border**
England, Canterbury, Christ Church Cathedral,
ambulatory or "triforium" of the choir
or Trinity Chapel
c. 1200
Rectangle: 22.3 cm × 77 cm (8¾ × 30¼ in)
Accession no. 22.76, Gift of Gertrude Hunt in
memory of John Hunt and to commemorate the
Rev. Martin D'Arcy, S.J.

Ill. nos. MDGA 1, 1/a; Col. pl. 6

History of the glass: In the eighteenth-century efforts to
consolidate the glazing of the cathedral, many border
panels were placed in the southwest transept window, but
some obviously remained alienated from the site. These
borders were evidently taken from the lower windows as
well as the clerestory (Caviness 1981, p. 216). Caviness's
study concluded that most of the borders appear to have
been in fragmentary condition, few reaching the height of
a window. In the reworking of the glass to fit the new
placement, all the curving segments of the tops of win-
dows were eliminated or cut up. Many of the border
designs are so fragmented that they would not be recog-
nizable save for the preservation of similar motifs else-
where. This is the case for the design motif labeled by
Caviness as Type I (of types A–L), whose largest extant
border segment is found in the panel now in the Martin
D'Arcy Gallery. [In storage]

The glazier S. Caldwell Junior apparently inherited a
significant amount of displaced glass from his father who
had restored windows of the cathedral. Caviness (1981,
p. 309) explains that after several generations of presence
in a shop, windows came to be regarded as the property of
the restorer, and a large amount of glass appears to have
found a market in the early years of the twentieth century.
This border, as well as significant other pieces, passed
from Caldwell to Philip Nelson of Liverpool in 1908.
Nelson, a medical Doctor, had been Holt Fellow in the
University of Liverpool as well as Vice-President of the
British Numismatic Society. In his book, *Ancient Painted*

Glass in England (London 1913), he treated Canterbury in
detail but did not list the glass from the cathedral that had
come into his possession. At Nelson's death in 1953, the
Chicago panel was acquired by John Hunt, Nelson's exec-
utor. John (d. 1975) and Gertrude Hunt, collectors of
antiquities, were then in London and about 1967 moved
to Dublin. The Hunts were admirers of Martin D'Arcy and
in 1976 Gertrude Hunt gave the panel to The Martin
D'Arcy Gallery in memory of her husband and to com-
memorate the Rev. Martin D'Arcy, S.J.

Related material: Two segments of same border design:
18.5 × 44 cm, London, Victoria and Albert Museum,
C. 8-1959 (Hayward 1970, no. 230, pp. 225–6, ill.).

Fragments in Canterbury Cathedral window SXXVIII, a–h
II, d 9, c 7, f 7, a–h 3 (Caviness 1981, p. 218, fig. 375).

History of the building: Christ Church Canterbury occu-
pied an important position in English ecclesiastical and
architectural history from its foundation in the fifth cen-
tury. Bishop Lanfranc constructed a completely new church
around 1070 whose eastern end was rebuilt around
1100. This was the building in which Thomas Becket was
murdered in 1170 by agents of King Henry II. In 1174 a
fire destroyed the eastern portions of the church and new
construction began in September 1175. Due to the rising
popularity of Canterbury's martyred bishop, work pro-
ceeded quickly and the first campaign was directed by a
French architect, William of Sens. After the architect's fall
from a scaffold in 1178 and subsequent return to France,
William the Englishman directed the work. The south
ambulatory of the Trinity chapel with the stonework was
completed in under seven years, about 1182 (Caviness
1977, p. 26. See also contemporary accounts by Gervase of
Canterbury, *Tractatus de Combustione et Reparatione Cantuar-
iensis Ecclesiae in Gervasii Cantuariensis Opera Historica* [Rolls
Series 73], ed. W. Stubbs, 1, London, 1879, pp. 19–29).
The stained glass, however, due to a number of financial
and political impediments was probably postponed until
1199 when the monks were preparing the cathedral for
the translation of Becket's relics. In 1207 work must have

MDGA 1. Border

been interrupted since under the Interdict against King John, the monks went into exile in France, returning only in 1213. The translation of Becket's relics finally took place in 1220, by which time all the ambulatory windows appear to have been in place.

Bibliography

UNPUBLISHED SOURCES: MDGA Curatorial file.

PUBLISHED SOURCES: Hayward 1970, pp. 225–6, no. 230; *The Martin D'Arcy Gallery of Art, New Acquisitions … Highlights of the Collection*, Chicago, 1977, p. 9; Rowe 1979, no. 28, col. ill.; Caviness 1981, p. 314, fig. 375; Caviness and Lillich in *Checklist* III, p. 128.

Description/Color: Caviness (1981, p. 218) gives a succinct description: "On a blue ground, between plain red and beaded yellow edges, white stems inscribe a kidney shape enclosing sideways-growing palmettes of green, white, and yellow with paired leaves of rose purple and yellow. Between these are curious leafy knots of green, with again rose purple and yellow paired, and a cluster of white berries."

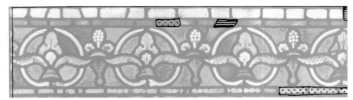

MDGA 1/a. Restoration chart

Condition: The border is almost completely intact, save for several segments of unpainted glass, and in excellent condition. It was releaded in 1909 by S. Caldwell of Blackfriars, North Canterbury, just after it was acquired by Philip Nelson. A letter from Caldwell to Nelson reads, "These old borders take a great amount of time to relead. I will do my best to get the window off as soon as possible" (8 October 1909; copy in MDGA Curatorial file). Some slight pitting is evident on the inner surface except where protected by paint. The blues and some purples are particularly well preserved, with the backpainting on the purples intact. The yellows and some of the paler purples show more corrosion.

Technique: The glass is entirely of pot-metal and uncolored glass. Paint is applied in both mat and trace. The mat is most visible in the shading of the sideways-growing purple leaves where it creates the illusion of depth. In general a double stroke is used to define the veins in all the leaves. The underside of the laterally growing leaves, however, shows single strokes for contrast.

Style/Original location: In the absence of a sculptural program the windows at Canterbury assumed a particular importance for they carried almost the entire weight of the iconographic and decorative program. The medallion

designs and the richly worked backgrounds and borders, such as that exemplified in the Martin D'Arcy Gallery panel are essential aspects of the windows. The richness of the leafy tendrils, in particular their folding over, evokes a three-dimensional effect. The scale and delicacy of the execution, as noted by Caviness (1981, p. 218), suggest that they be associated with the ambulatory or "triforium" windows of the middle period.

Date: Caviness places the border as part of the work of the middle period of cathedral glazing, *c.* 1200.

Photographic reference: MDGA

MDGA 2. St. Margaret
England
Mid-fourteenth century
Irregular tracery light form: 45 cm × 22 cm
(19 × 8¾ in)
Accession no. 10.77, Gift of the Friends
of the Gallery
 Ill. nos. MDGA 2, 2/figs. 1–4; Col. pl. 3

History of the glass: The glass passed through the dealer Sibyll Kummer-Rothenhäusler, Zurich, to Timothy Husband, of New York, and then to the Blumka Gallery, New York before its acquisition in 1977 by the Martin D'Arcy Gallery. Its purchase was facilitated by the support of the Friends of the Gallery. [In storage]

Original location/Reconstruction: Although the panel's precise location is uncertain, its can be identified as appropriate to a tracery light of the decorated period in English architecture (1300–1350). The upper central tracery light (MDGA 2/fig. 1) of a window in Hedon, Yorkshire (Edmund Sharpe, *Decorated Windows*, London, 1849, unpag.) shows the probable architectural setting. Tracery lights (MDGA 2/fig. 2) somewhat similar in shape to the MDGA panel, from the east window of the north transept chapel at St. Mary's in Cogges (Newton 1979, pp. 69–70, pl. 24b) retained much less of their original glass. Cogges's tracery forms and window design can be dated to the second quarter of the fourteenth century. Similar tracery shapes are found in Sleaford, Lincolnshire, dated 1360–70 (Nikolaus Pevsner and John Harris, *The Buildings of England: Lincolnshire*, London, 1964, p. 625, ill.).

Patterns of destruction of historic glazing in England encourage the belief that the tracery light could come from this country. The first wave accompanied the dissolution of the monasteries from 1536 to 1541 under Henry VIII, when, although windows were not targeted for attack, destruction or conversion of many monastic buildings

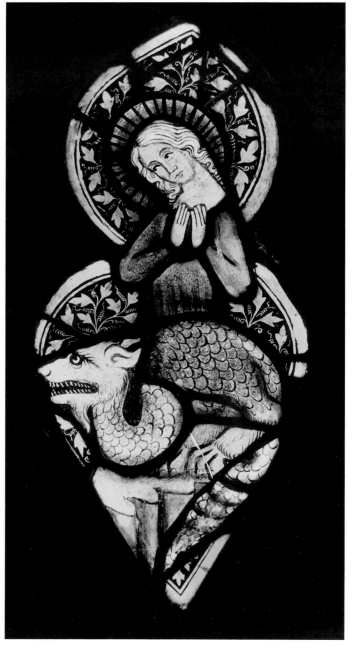

MDGA 2. *St. Margaret*

Jesus on the roof of the church and cherubims with crosses on the breasts, "all which, with divers pictures, in the Windows, which we could not reach" (*The Journal of William Dowsing*, ed. C. H. Evelyn White, Ipswich, 1885, pp. 6–7, in Woodforde 1950, p. 207. See also Margaret Aston, *England's Iconoclasts*, Oxford, 1988). Dowsing adds that "neither would they help us to raise the ladders" so that he left a warrant with the constable to complete the destruction within fourteen days. The survival of such a panel as the tracery light of *St. Margaret* might very well have been from the happy circumstance that it was hard to reach.

MDGA 2/fig. 1. Window in Hedon, Yorkshire

MDGA 2/fig. 2. Tracery lights, Cogges, St. Mary's

resulted in major losses (Marks 1993, pp. 229–39). A new owner, however, might allow a small tracery light, especially of a subject associated with safe birth, to remain. It was the Puritan campaign against "superstitious pictures" that truly robbed England of a rich heritage of medieval glass. William Dowsing, for example, was appointed Parliamentary Visitor in Suffolk (Woodforde 1950, pp. 202–13; Marks 1993, pp. 237–8) and with utmost zeal swept through the county, visiting 150 churches between 1643 and 1644 and recording his destruction of nearly 7,000 works of art. Often his description includes details of the objects and his methods. In his visit to Covehithe, 6 April 1643, he described breaking 200 pictures, but was frustrated in his efforts to remove inscriptions of the name of

Bibliography

UNPUBLISHED SOURCES: MDGA Curator's file; letter of 11 April 1978 to Fr. Rowe from Ernst Bacher, Corpus Vitrearum, Austria; Rüdiger Becksmann, Corpus Vitrearum, Germany, Eva Frodl-Kraft, Corpus Vitrearum, Austria, oral communications.

PUBLISHED SOURCES: 1979; Rowe 1979, no. 32, col. ill.; Caviness and Lillich in *Checklist* III, p. 128; *Medieval Monsters: Dragons and Fantastic Creatures* [exh. cat., Katonah Museum of Art, 15-January-16 April], Katonah, NY, 1995, pp. 16–17, cover ill.

Condition: The panel is excellent condition, with no replacements and almost no abrasion or paint loss. It is possible

that the panel retains some old leads. Cracks repaired with mending leads appear in the background above the saint's head, the tail of the dragon and in the background by the head and to the right, and by the haunch. In January 1995 Mary Clerkin Higgins restored the panel. Four breaks were mended, one across the saint's neck, two in the yellow rock at the foot of the dragon, and one in the bottom-most section of the patterned background. The cracks were edge-glued with epoxy. A yellow colored fill was done to replace missing glass along the crack of the dragon's feet (Higgins's report in MDGA Curatorial files).

Iconography: St. Margaret is one of the most popular of the late medieval saints. With Catherine and Barbara, she formed one of the three "Holy Maidens" and members of the Fourteen Auxiliary or Helping Saints (*Herder Lexikon*, 7, cols. 494–500; Réau, 3/2, pp. 877–82; Künstle, 3, pp. 421–5). Born in Antioch, Syria, she was the daughter of a pagan and was converted by her nurse. Thus she was at enmity with her father, and also with the prefect of the region, Olybrius, who wished to have her in marriage; but she refused. After spectacular tortures on the rack she was beheaded. The *Golden Legend* (pp. 351–5) starts her life with the traditional philological narration. Her name *margarita* means pearl, white, small, and endowed with virtue. She wears the white of her virginity, is small because of humility, and like the pearl, has the power to work miracles. This special power was of particular importance to Margaret's devotees for she was prayed to for help in childbirth. The *Golden Legend* (p. 354) records that before she died she asked leave to pray for her tormentors, asking also "that whenever a woman in labor should call upon her name, that child might be brought forth without harm". In Van Eyck's *Arnolfini Wedding* (Snyder 1985, pp. 111–3. pl. 18) an image of Margaret is sculpted on the bedpost of the marriage bed, where the hoped-for offspring of the union were to be conceived and born. The standard image of her emerging from the dragon, and thus her efficacy in childbirth come from her encounter with the Devil while she was imprisoned. The evil one approached in the form of a dragon and swallowed her. When she made the sign of the cross, the monster split and she emerged unscathed.

In England her cult was particularly strong, especially in the later Middle Ages. Margaret was one of the most popular names given to women, and many churches were named after Margaret. Osbern Bokenham's *A Legend of Holy Women*, c. 1440 (trans. Shiela Delany, Notre Dame, 1992), placed Margaret at the beginning of the narrative of twelve great women, even before St. Anne.

Color: The panel shows extraordinary subtlety. Against a light red-violet background, St. Margaret emerges above a multi-hued dragon. The monster's head and snaky neck are a pale yellowish-white; his haunches a medium blue-green brushed with yellow. His tail remains an unadulterated light blue-green. His feet and the rock on which he perches blend in a deep warm yellow. Margaret's halo is a bright warm blue and she wears a simple tunic of dull yellow-green.

Technique: Pot-metal glass is used throughout the panel. The glass painter is highly adept at modulating the light through adroit handling of paint. The dragon is an excellent example of the combination of mat, brush, and scumble application of grisaille. The dragon's muzzle is very light, with little modeling of the mat, while back across the head, and intensifying in the back of the neck appears a grisaille in a blotchy application, evoking the scaly texture of the monster's hide. Similarly, a swath of silver stain cuts across the lower part of his haunches, suggesting the illusion of a curving, weighty body. The trace outlining features of the dragon, scales, teeth and eyebrows, is intense. The background is achieved through a uniform application of an opaque mat and removal of the paint to form the leaves and tendrils of the foliate design.

Style/Ornament: When the panel was sold by the Blumka Gallery, New York, the piece was identified as coming from the Mariakirche in Strassengel, Austria (Steiermark). This association might be understood in the light of the almost standard use of the tendril and leaf ground for the windows of the pilgrimage church that date to the second half of the fourteenth century (Ernst Bacher, *Die mittelalterlichen Glasgemälde in der Steiermark, 1: Graz und Strassengel, Corpus Vitrearum Austria* III, Vienna, 1979, esp. figs. 300–10, 431–9). In Alsace as well, a similar type of decorative work appears in a window in the church of St. Stephen in Mulhouse (France *Recensement* V, fig. 294).

A more viable alternative appears to be England. St. Margaret was a very popular saint in England in the fourteenth century and similarly shaped decorated tracery lights were commonly a part of window design. The parish church of Westminster Abbey, for example, was dedicated to St. Margaret. The distinguishing aspect of background leaf pattern is the tightly coiled, corkscrew shaped tendrils between the leaves. A close comparison is found in an English panel of a donor couple (MDGA 2/fig. 3) dated to the second half of the fourteenth century (Victoria and Albert Museum, C. 202–1912, 52.5 cm [20⅝ in], Herbert Read, *English Stained Glass*, London, 1926, repr. 1973, p. 121, fig. 26; Rackham 1936, pp. 44–5, pl. 12). The multi-lobed panel tracery light carries the inscription *Villms cele et matilda uxor ei* (William Cele and Matilda, his wife), and shows several strong similarities to *St. Margaret*. Both panels use a damascene background of leaves and distinctive corkscrew tendrils interspersed between the leaves. The mat paint of the damascene pattern stops several centimeters before the edge of the glass to leave a colorful, unmodulated border. The rendering of drapery in simple

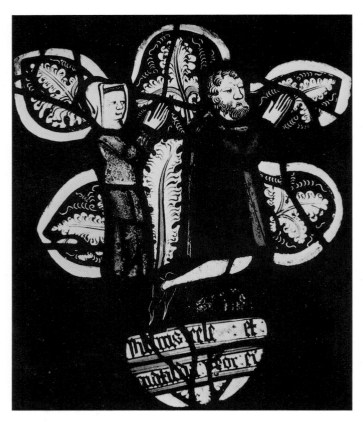

MDGA 2/fig. 3. Donor couple, 1350–1400. London, Victoria and Albert Museum

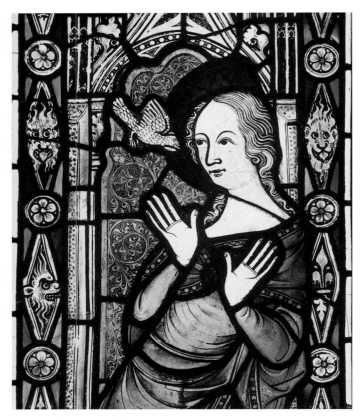

MDGA 2/fig. 4. *Virgin Annunciate from Hazdor, c.* 1330–50. Ely Cathedral, Stained Glass Museum

vertical folds and the strong use of trace parallel lines for the hair suggest similar concepts of representation. Further comparisons can be seen in other tracery lights from English locations, such as the kneeling priest William de Luffwyk, 1335–80, from Aldwincle, Northamptonshire (Marks 1993, fig. 2a).

The specific handling of the canon of proportions for the faces on the donors, square heads, with broad noses and heavily lidded eyes is very different, however, from the elongated proportions of Margaret's face. It is not suggested that the two panels are from the same studio or even locality. More similar is the face of the Virgin Annunciate (MDGA 2/fig. 4) from Hazdor, dated *c.* 1330–50 from a West Midlands workshop, now on loan to the Stained Glass Museum in Ely Cathedral (Marks 1993, p. 162, fig. 130). The gentle oval of the face and the flow of curls across her neck are similar to the representation of St. Margaret.

Additional comparison with English sites supports the provenance. The shape of the dragon with snaky neck, large rear feet, and curly tail is common to England, appearing in tracery lights dated to the second quarter of the fourteenth century in South Newington (Church of St. Peter ad Vincula, Newton 1979, pp. 175–7, pl. 43 b, c). Similar dragons can be found in Wigtoft, Parish Church of Saints Peter and Paul, and other fourteenth-century sites in Lincolnshire (Hebgin-Barnes 1996, pp. 350–51). The

corkscrew tendril ground appears in a tracery light of the Coronation of the Virgin dated to the second quarter of the fourteenth century from the Church of the Assumption of St. Mary the Virgin, Beckley (I AI., Ibid., pp. 29–30, pls. Ib, 16a). It seems to be used in quarry designs (Ibid., quarry diagram figs. 10, 17–21, and 25), for example, the quarries surrounding an image of St. Michael weighing a soul, early fourteenth century, from Eaton Bishop, Hereford (Christopher Woodforde, *English Stained and Painted Glass*, London, 1954, pl. 15).

Date: The middle of the fourteenth century is suggested by the relatively simple shape of the tracery light, the bold decorative format, and the painting style.

Photographic reference: MDGA

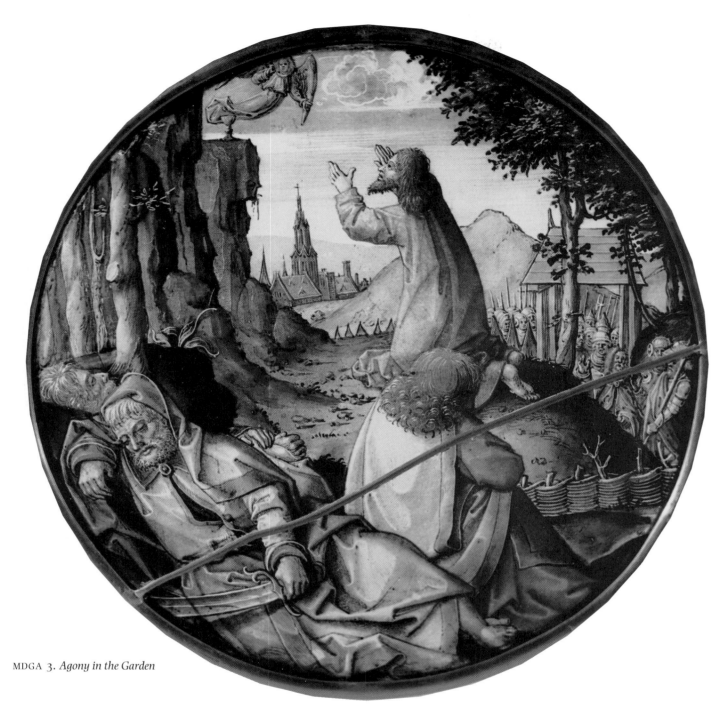

MDGA 3. *Agony in the Garden*

MDGA 3. Agony in the Garden

North Lowlands
1500–10
Circle: diameter 23.5 cm (9¼ in)
Accession no. 8–76, Gift of the Friends
of the Gallery

Ill. nos. MDGA 3, 3/fig. 1

History of the glass: Sibyll Kummer-Rothenhäusler, Zurich,
and Timothy Husband, New York, owned this panel. The
Martin D'Arcy gallery purchased it from the Blumka Gallery,
New York.

Bibliography

UNPUBLISHED SOURCES: MDGA Curatorial files; Letter 7 June
1983 from C. J. Berserik, The Hague, suggesting Jacob
Cornelisz. van Oostsaenen as designer.

PUBLISHED SOURCES: *Stained Glass of the Middle Ages and
Renaissance* [exh. checklist, MMA, The Cloisters] New York,
1971–72, no. 43; Rowe 1979, no. 57, pl. 47; Husband in
Checklist IV, p. 78.

Description: While the designer incorporates a number of
figures to show a sequence of events happening over a
period of time, he has also arranged them to fit the roundel
format. Three zones of figures set against landscape forms

MDGA 3/fig. 1. *Agony in the Garden*, 1491, woodcut from Schatzbehalter, published by Anton Koberger, Nuremberg, Germany

and an architectural backdrop constitute the elements that are judiciously balanced in this composition.

Condition: The one break was repaired with a lead.

Iconography: After the Last Supper, Christ retreats to the Mount of Olives to meditate, as is shown in the foreground. Then the Roman soldiers come to arrest him (see also CMA 16–17). The three apostles who accompanied Christ—Saints John, Peter, and James—sleep while Christ prays. The cup is standard in Renaissance art (Matthew 26:39, 26:42); the angel is not always included.

Technique: Uncolored glass, paint, silver stain, and sanguine. The glass is "satiny" to the touch on the exterior. There is back-painting, especially on the robe of Christ and the mantle of St. Peter. Sanguine appears on the exterior face of the glass to color the tunic and undergarment of St. John and the soldiers' robes. Several values of amber silver stain are applied in a compositional or painterly way, spilling over contours. Unobtrusive stippling appears in the garments. Stickwork also appears: very thin, delicate stickwork was used for the hair of Christ and of St.

Peter. A range of values of wash creates subtle chiaroscuro effects in the garments of St. John, the rocky cliff, the tree on the left, and the mountains in the distant background.

Style: A woodcut illustrating the *Agony in the Garden* and published by Anton Koberger, 1491, shows St. James with a profile head beside St. Peter who holds the knife. This must have been one of the models for the Loyola roundel. The print includes St. John, as if seen from the back, with his hair pulled flat across the top of his head and fluffy curls around the sides (MDGA 3/fig. 1). North Lowlands variations in print form include the *Agony in the Garden* in the *Round Passion* version of Lucas van Leyden, 1509, which also shows the back of St. John's head although the poses of the other apostles differ (Jacobowitz, 1983 p. 79; *Ill. Bartsch*, 12, 198, fig. 66 (375)). The design of the middle ground in the Loyola panel (Christ, rock cliff, angel and cup) is similar to Jacob Cornelisz.'s *Round Passion Agony*, 1512 (Jacobowitz, 1983 p. 270, fig. 111b; Hollstein 1949, pp. 5, 8, no. 68). Similarly, the background on the glass resembles that of the print (wattle fence, soldiers coming from the right), and the pose of St. Peter on the roundel is more or less the reverse of St. Peter's pose in the foreground of Cornelisz.'s woodcut. See also DIA 31.

Date: Considering the dates of the probable model and graphic variants, Husband's dating of the composition to the decade between 1500 and 1510 seems reasonable (*Checklist* IV, p. 78).

MDGA 4. The Son of Zaleucus accused of Adultery

Design by Dirick Jacobsz. Vellert
(active *c.* 1511–40), or his workshop.
South Lowlands
c. 1530
Square rounded on lower side: 23.5 × 20.7 cm
(9¼ × 8⅛ in)
Accession no. 7–80, The Martin d'Arcy Gallery
of Art

Ill. no. MDGA 4

History of the glass: Sibyll Kummer-Rothenhäusler, Zurich, and Hilary C. Wayment, Cambridge, owned this panel before the Martin D'Arcy Gallery acquired it in 1983 (MDGA Curator's file). [In storage]

Related material: *The Son of Zaleucus accused of Adultery*: roundel, *c.* 1530, probably based on a design by Dirick Vellert, Baltimore, Baltimore Museum of Art (Husband in *Checklist* IV, p. 91).

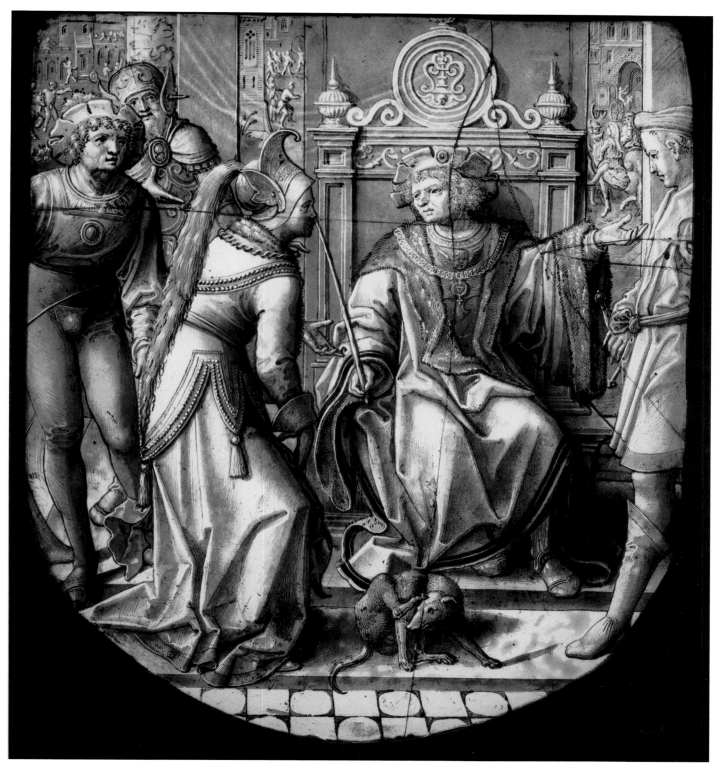

MDGA 4. *Son of Zaleucus accused of Adultery*

The Blinding of Zaleucus: (1) roundel, probably based on a design by Dirick Vellert, Cambridge, King's College Chapel, chapel R, window 51 (Wayment 1988, p. 204, no. 51a, fig. 51a, dates it *c.* 1525–35; Cole 1993, p. 44, no. 382, prefers *c.* 1521; (2) roundel, replica, *c.* 1525, Mentmore, Buckinghamshire, Maharishi University of Natural Law, Meru Seminar Room (Cole 1993, p. 149, no. 1202); (3) roundel, replica, *c.* 1530, Baltimore, Baltimore Museum of Art (Husband in *Checklist* IV, p. 91); (4) roundel, Chapelle Castrale, Enghien, Belgium (Jean Helbig *De Glasschelderkunst in Belgie, Repetorium en Documenten*, Antwerp, 1951, p. 2, pl. 27, fig. 84); (5) heraldic panel, version, early seventeenth century (?), California, private collection (Caviness, Pastan, and Husband in *Checklist* III, p. 112).

Bibliography
UNPUBLISHED SOURCES: MDGA Curatorial files; Letters of 2 July 1983 and 15 January 1986 from C. J. Berserik, The Hague, suggesting Dirick Vellert as designer.
PUBLISHED SOURCES: Husband in *Checklist* IV, p. 78.

Description: A group of men and women clustering around an enthroned figure forms the focus of the composition. Supplemental events take place in the left and right backgrounds against the backdrop of the city.

Condition: There are nine glued breaks. The panel has an unusual shape; perhaps it was cut down from a rectangle.

Iconography: Zaleucus codified the laws of the Greek city-state of Locri. That his son is imputed of congress with a woman to whom he is not married will have dire consequences. Zaleucus had decreed that the male offender have both his eyes put out in such cases. Since the Locrians will not allow this punishment to take place, Zaleucus commands that both he and his son lose one eye.

Zaleucus points his scepter directly toward a woman with hair flowing down her back, one of the parties in question. In the right background, the same woman (?) rides through the city gate; just to the left of the throne, someone is stoned; on the far left a nude man stands with one arm outstretched, a speaking gesture. Another roundel in the series (see above, **Related material**) depicts the blinding of Zaleucus, foreground, and his son, left background.

Technique: The painter used uncolored glass, a reddish paint, and two values of silver stain. Blotches of silver stain produce the effect of marble for the floor. Stickwork outlines forms and delineates details, such as the pearled fillets on the woman's dress. The background figures were scratched out from a mat that darkens the buildings.

Style: Vellert often uses compositions that include additional scenes to left and right, as in the Loyola roundel. Examples include *St. Luke Painting the Virgin*, signed and dated 1526 (Jacobowitz 1983, p. 322, no. 139; Hollstein, 33, p. 196) and the *Opening of the Fourth Seal* (N. Beets, "Dirick Jacobsz. Vellert, peintre anversois, IV, dessins postérieurs à 1520," *L'art flamand & hollandais*, 18, 1912, p. 135). An allegorical figure strides in on the right in *The Triumph of Time* and Cambyses stands on the right, more stiffly, in *The Judgment of Cambyses* (Husband 1995, pp. 156–7, pl. 15, no. 80). Otanes (*The Judgment of Cambyses*), Solomon (CMA 14) and Zaleucus sit solidly in contrapposto poses, and stretch forth foreshortened arms. Chain necklaces and loop ribbons dangle on their chests, re-emphasizing the three dimensional forms.

Silver stain is used here to create depth. The glass painter applied a lighter value of silver stain for the throne and a darker one for the cloth behind it on the roundel at Loyola illustrating the *Son of Zaleucus accused of Adultery*. Another painter applied a lighter value for the collar of Otanes and a darker one for the regal backdrop on the panel at Loyola illustrating *The Judgment of Cambyses*. Curvilinear blots and smudges of stain simulate marble in both.

Published dates for the Baltimore replica of the Loyola roundel and the companion panels range from *c.* 1525 to *c.* 1535 (see above, **Related material**). The middle of the 1520s is preferable given Vellert's interest in elaborately detailed architecture at that time (*The Vision of St. Bernard*, 1524, fig. C-CEC/2; *St. Luke Painting the Virgin*, 1526, Jacobowitz 1983, p. 322, no. 139; Hollstein, 33, p. 196), therefore *c.* 1525.

Indiana University Art Museum
BLOOMINGTON, INDIANA (IUAM)

SOON AFTER HIS APPOINTMENT as president of Indiana University in 1937, Herman B. Wells began plans to establish Bloomington as a midwestern "cultural crossroads." The art museum that was central to his vision nonetheless took several decades to evolve. Between 1941 and 1980, Indiana University put on six hundred exhibitions of an astonishing variety. Fully one-third of these exhibits consisted entirely of loans, which helped foster interest in the arts while the permanent collection continued to build. As the catalogue for the inaugural exhibit, *Brown County Painters*, stated, "The purpose of the Art Center Gallery . . . is to bring temporary loan exhibitions to the campus so that students may have an opportunity to study and see original works of art. Examples of diverse character will be brought to this gallery in order to show the multiple aspects of art both past and present."[1]

True to Indiana University's mandate, the medieval collection consists of representative pieces from all epochs and countries, including monumental sculptures from the twelfth to fifteenth century, Byzantine jewelry, Limoges enamels, Spanish polychromed panels, and a Gothic ivory. They came to the collection in a variety of ways, although gifts from alumni benefactors formed the basis of the collection. The panel of St. Catherine is the sole example of stained glass from the medieval period; there is also a modern composition by Theo van Doesburg (IUAM 75.85.1).

I.M. PEI AND PARTNERS: Indiana University Fine Arts Building, 1973

History of the Collection

Having been housed in various campus buildings, including the current Student Services Building and Mitchell Hall, at that time one of the oldest wooden structures on campus, the collection found a permanent home in a Fine Arts Building constructed in 1962. The steady expansion of the collection, however, led to the need for a new art museum. When Thomas T. Solley, an important patron, was appointed director in 1971, planning began for a new building. In 1973, the present structure, a bold, geometrical design with large, flexible gallery spaces culminating in a light-filled atrium, was commissioned from I.M. Pei and Partners.

The greatest number of medieval works were purchased from the dealer Dikran Kélékian of New York, but the stained glass panel of *St. Catherine seized for Martyrdom* was acquired from Raphael Stora. Stora, a dealer with offices in New York, London and Paris, was not known for stained glass, but he stored the inventory of Thomas & Drake when the gallery was forced to close in 1942 due to the war. Roy's father, Grosvenor Thomas had sold the panel to Julias Haass of Grosse Pointe, Michigan in 1924. At some undetermined time Haass sold the panel to Stora who then sold it to the Indiana gallery.

Although the files are mute on the circumstances surrounding Indiana's purchase, it seems reasonable to infer that the St. Catherine panel was selected for its ability to represent late medieval glass painting in this teaching collection.

BIBLIOGRAPHY

UNPUBLISHED SOURCES: Adelheid Gealt, director, Indiana University Art Museum, Megan E. Soske, acting curator of Western Art, and Nan Brewer, curator of Prints and Drawings. For information on New York dealers: Marilyn Beaven, drawing from the uncatalogued archives of Joseph Brummer's files and the Stock Books of the Grosvenor Thomas collection.

PUBLISHED SOURCES: Herman B. Wells, *Being Lucky: Reminiscences & Reflections*, Bloomington, Indiana, 1980; *Guide to the Collections: Highlights from the Indiana University Art Museum*, Bloomington, Indiana, 1980; *Indiana University Art Museum, Dedication Brochure*, Bloomington, Indiana, 1982; *Indiana University Art Museum, Golden Anniversary Report*, Bloomington, Indiana, 1992; Wolf Rudolph, *A Golden Legacy, Ancient Jewelry from the Burton Y. Berry Collection*, Bloomington, Indiana, 1995; Elizabeth Pastan entries on the Indiana University Art Museum in Dorothy Gillerman ed., *Gothic Sculpture in America*, 2, New York: Garland Publishers, forthcoming.

NOTES
1. Cited in *Dedication Brochure*, p.5.

IUAM I. St. Catherine seized for Martyrdom

South Lowlands, Louvain, Charterhouse?

c. 1520–1530

Rectangle: 71 × 47 cm (28 × 18.5 in)

Accession no. 58.43, museum purchase

Ill. nos. IUAM I, I/a, I/figs.I–4, Col. pl. I2

History of the glass: Paul V. Maes ('Nicolaas Ruterius en de Brandglassuite met de Geschiedenis van Sint-Nicolaas,' *Arca Lovaniensis* 2, 1973, pp. 181–211) connected dispersed stained glass panels from the Life of St. Nicholas with an early chronicle's description of a Nicholas cycle in the Charterhouse of Louvain. Building on his work, scholars have sought to reconstruct the glazing program of this late fifteenth-century Carthusian monastery. Vanden Bemden and Kerr (1983–4) drew attention to a group of 35 narrative stained glass panels and other fragments in British churches that they associated in a general way with cloister glazing in the Lowlands. They were able to trace this glass back to the collection of the Neave family of Dagenham, Essex, who had acquired it from the prominent importer of Continental glass, Christopher Hampp of Norwich. In works published in 1988 and 1989, Wayment considerably expanded the number of examples attributed to the Charterhouse of Louvain, incorporating many of the stained glass panels discussed by Vanden Bemden and Kerr, to yield a corpus of nearly one hundred panels of roughly uniform dimensions scattered through England, Wales and Scotland, the United States, Canada, and the Low Countries. With the publication of the Corpus Vitrearum checklists, it has been possible to include more glass from the United States; it was here that the hitherto unpublished Indiana University Art Museum panel of *St. Catherine seized for Martyrdom* was first associated with this group.

It is clear that much of the glass in America attributed to Louvain came from the Neave collection and through the dealer Grosvenor Thomas (see *Checklist* I, pp. 141–8, 189; *Checklist* III, pp. 130, 271); accordingly, the collecting history of the present panel is suggestive of a provenance in Louvain. It was one of three so-called "Flemish" panels sold by Grosvenor Thomas in the period between 1924 and 1933 (Grosvenor Thomas, Stock Book I, nos. 1139, 1138, and 1145, respectively, pp. 186–9): on 12 November 1924 Thomas sold to Julius Haass of Grosse Pointe, Michigan, both the St. Catherine panel now at Indiana and a "Day of Judgement" panel, while on 23 January 1933 he sold a panel of *St. Nicholas preventing the Execution of Three Children.* All three works shared the same dimensions (71 × 47 cm; 28 × 18.5 in) and suggested Flemish provenance as other panels associated with the Charterhouse of Louvain. Besides the subject matter and dimensions, Haass's purchase of the St. Catherine panel now in Indiana is confirmed by the de-

scription, "château in the background," which accurately characterizes the ornate architectural backdrop of the scene. In 1958 Haass evidently returned the St. Catherine panel to the dealer Raphael Stora, who had taken over Thomas's stock during the Second World War. It was from Stora that Indiana acquired the panel.

Related material: Complicating attribution to the Charterhouse of Louvain is the fact that the Great Cloister was glazed over several decades in the early sixteenth century and by several different workshops (for work related to Dirick Vellert see, CMA 14–15). The Indiana panel relates in style to two of Wayment's hands: the St. Gregory Master and Bernard van Orley. Those panels closest in style or iconography include:

St. Gregory Master, *Catherine Boelen presented by her Namesaint*, Victoria and Albert Museum, London (69.8 × 47 cm; 27. 50 × 18.5 in) (IUAM I/fig. 1) (Wayment 1989, fig. 30)

Bernard van Orley, *Saul arming David*, King's College Chapel, Cambridge (56.5 x46.8 cm; 22.25 × 18. 44 in) (IUAM I/fig. 2) (Wayment 1988, pl. 2)

St. Gregory Master, *The Raising of Lazarus*, Llanwellwyffo, Anglesey (c. 70 × 47 cm; 27.375 × 15.75 in) (IUAM I/fig. 3) (Wayment 1989, fig. 23)

St. Gregory Master, *Moses burning the Golden Calf*, King's College Chapel, Cambridge (56 × 45.5 cm; 22 × 17.75 in) (IUAM I/fig. 4) (Wayment 1988, pl. 3)

St. Gregory Master, *A Donor of the Boelen Family (Allert Andries?) presented by St. Andrew*, Walters Art Gallery, Baltimore (70.2 × 47.6 cm; 27. × 18.75 in) (Wayment 1989, fig. 28; Hayward in *Checklist* II, p. 63)

History of the building: The Charterhouse of St. Mary Magdalene at the Foot of the Cross on Mount Calvary was established at the end of the fifteenth century on a large site outside Louvain (see also CMA 12–15). The foundation stone was laid by Margaret of York in 1489 and the church completed in 1499, while the Great Cloister was built gradually over the years 1491–1528. Already in fragmentary condition, it was suppressed by decree of Joseph II in 1783; in 1786 windows of the Great Cloister that had not been previously withdrawn were sold by auction; and in 1806 the church was demolished.

The Great Cloister, thought to be the original location of the many dispersed stained glass panels, was unusually large—nearly half a mile in its entire circumference (see McNab 1982, with illustrations). It consisted of 21 individual cells that opened onto a paved, roofed and walled walkway. Adorning the walls that faced inwards towards the garth were multi-lanceted glazed windows. Wayment employed the chronicles of the Charterhouse to establish the progress of the building campaign, noting that "funds for the construction of the cells were given by individual

donors, who normally, but not always, made themselves responsible for the adjacent bays of the cloister, and sometimes also for their windows" (Wayment 1989, p. 72). Based on earlier descriptions and a nineteenth-century drawing made after the monastery's demolition in 1806, Wayment calculated that if the cloister held 96 glazed bays, each consisting of a window with two lancets, and these lancets in turn could hold two rectangular panels, that the cloister would then accommodate 384 individual stained glass panels (Wayment 1989, pp. 71–2).

The Great Cloister was not the only structure of the period in Louvain with stained glass by any means (Wayment 1989, pp. 89–91). Windows with scenes from the Passion were installed in the choir of the Charterhouse church in 1532. In that same year, the side chapels, the chapter house, the Holy Cross Chapel and the east side of the Little Cloister were also glazed (Wayment 1988, p. 55). While specifics are lacking, these nonetheless serve as a useful reminder of other structures within the Charterhouse itself that could have held stained glass.

Iconographic program: Reports of the glazing program of the Charterhouse are tantalizing but vague. An eighteenth-century guidebook described the ensemble of the Great Cloister as "representing different stories from the Old and New Testament," suggesting that the windows employed a typological program (Wayment 1989, pp. 70-1, quoting *Le guide fidèle contenant la description de la ville de Louvain, tant ancienne que moderne*, Brussels, 1762). The only specific subject of the Great Cloister mentioned in the early chronicles is a St. Nicholas cycle, which included the arms of the donor Nicolas de Ruytere, Bishop of Arras (Wayment 1988, p. 58, and see n. 10 for the 6–7 extant panels in the series). Therefore, saints' lives must also have figured in the Great Cloister. Besides the Nicholas cycle, Wayment associated two stained glass panels of St. John now at Bramley Church, Hampshire (Wayment 1989, fig. 16), with an early campaign in the northern gallery of the Cloister. The presence of St. John is explained in two ways: not only is the scene of *St. John and the Angel* a type for the Reward of the Righteous in the *Biblia Pauperum*, but a document of 19 June 1517 names John Lord of Berg as the donor of stained glass panels that the glazier Jan Diependale had been dilatory in completing (Wayment 1989, pp. 73–6). Thus, Wayment argued that the scenes involving the saint belong to the Great Cloister both because they could relate to the typological program and because of their relation with a known donor who bears the saint's name.

In the case of St. Catherine, there is no established typological connection, but the scene may have referred to a donor's name. Wayment associated the panel of *Catherine Boelen presented by her Name-saint* (IUAM 1/fig. 1) in the Victoria and Albert Museum in London with the Louvain cloister on the basis of style, arguing that it was one of several panels of prominent Amsterdam families executed by the artist he calls the St. Gregory Master. The St. Gregory Master's style is evident among panels associated with the Charterhouse (Wayment 1989, pp. 83–7). The panel also reveals another connection with the Louvain Cloister. An inscription which has undoubtedly been added to the bottom of the panel reads, *None tres viros misi in fornace. Ecce ego video viros quatuor et spes qrti silis filio dei. Danielis. 3.* (Did we not cast three men ... in the midst of the fire ... behold I see four men ... and the form of the fourth is like the son of God. Daniel 3: 91–2) As McNab noted (Victoria and Albert Museum files), this inscription probably belongs to a panel attributed to the Charterhouse of Louvain, the *Three Men in a Furnace* now in Prittlewell church, Essex. Such a scene would be a plausible inclusion in the typological program of the Great Cloister. The use of this inscription as a stopgap on the donor's panel with St. Catherine may indicate that the donor's panel once belonged to the same series as the biblical panel.

It was on the basis of the merchant's mark (or *Hausmark*) in the upper corners, that the donor presented by St. Catherine was recently identified as Catherine Boelen, wife of Allert Andries Boelen, a descendant of the burgomaster (Wayment 1989, p. 29, n.65), Andries Boelen of

IUAM 1/a. Restoration chart

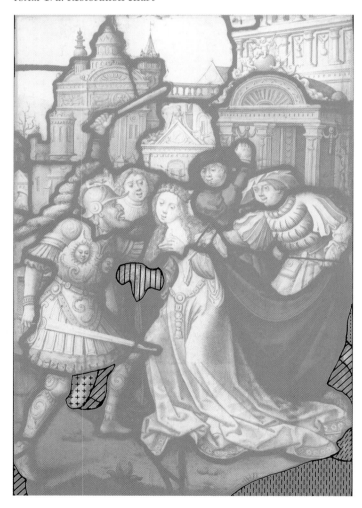

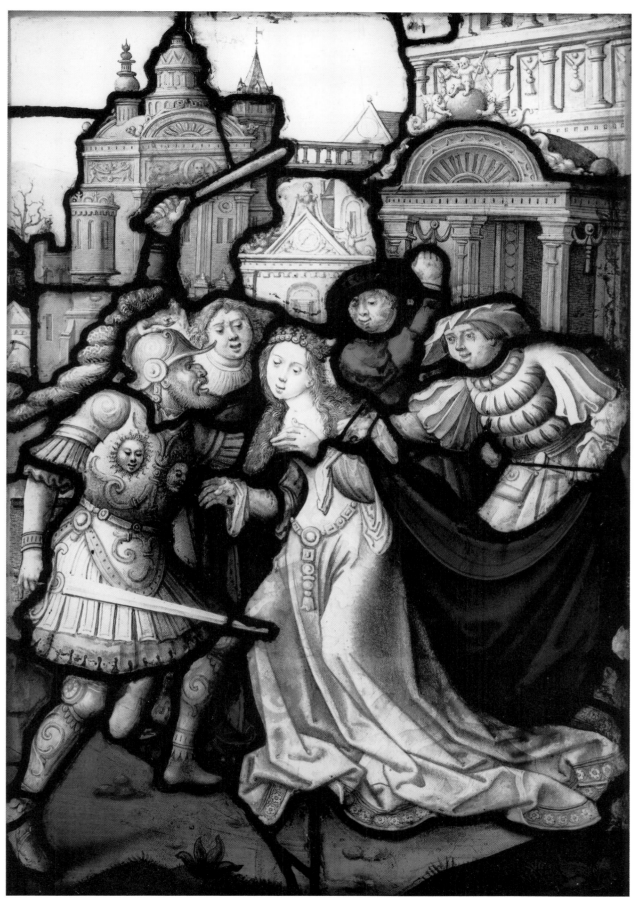

IUAM 1. *St. Catherine seized for Martyrdom*

Amsterdam (1455–1519). In a separate panel with identical merchant's marks now in the Walter's Art Gallery, Baltimore, Allert Andries is depicted being presented by his name saint, St. Andrew. Wayment suggested a three-part composition: Allert Andries Boelen on the left facing to the right and Catherine Boelen on the right facing to the left, flanking a panel of *The Holy Family* now at Llanwellwyffo, Anglesey, which bears the same merchant's mark as the pair. Since there are other donor panels with members of the Boelen family (Wayment 1989, p. 84), and at least one of them, *The Virgin and Child between St. Catherine and St. Barbara* at Llanwellwyffo, Anglesey (Vanden Bemden and Kerr 1983–84, fig. 13d), appears to be much closer stylistically to the Allert Andries and Catherine Boelen donor panels, a number of different combinations and pairings are possible. Panels of the martyrdoms of saints Catherine and Andrew could have also formed diptychs with the donor panels; but no martyrdom of St. Andrew to correspond to the Indiana panel of *St. Catherine seized for Martyrdom* has yet come to light.

Reconstruction: It is difficult to reconstruct the Great Cloister of the Charterhouse with any precision. One aspect of the program is particularly troubling. As alluded to above, Wayment proposed a stained glass "triptych" composed of a male and a female donor on either side of a panel of the Holy Family (Wayment 1989, pp. 63–5, 89–90). In addition to the composition incorporating the panels of Allert Andries and Catherine Boelen, he suggested several other trios, including Geldulph de Nausnydere and his wife Martha, framing yet another Holy Family panel now in Earsham church, Norfolk. Yet all the apertures in the engravings after the Great Cloister show two-lancet windows, and Wayment failed to address how such donor triptychs could be accommodated in the Charterhouse and instead proposed an origin in a different building in Louvain. Papanicolaou, however, persuasively reconstructs several panels and tracery fragments into triple-lancet windows.

This suggests the difficulties inherent in an attribution to the Great Cloister. Perhaps both the Boelen and De Nausnydere donor ensembles belonged in triple-lancet windows in the Great Cloister of Louvain not accurately reproduced in the nineteenth-century reconstructions, but one or both could equally be from contemporaneous undertakings such as chapels within the church, the smaller cloister of the Charterhouse, or even Pope Adrian VI's College elsewhere in Louvain. While noting the compatibility of dimensions, the stylistic similarity of the Indiana panel with glazing from the Charterhouse, and its suggestive relation to the donor panel of Catherine Boelen which has an inscription taken from a typological program, it is perhaps wisest to maintain some skepticism about its precise location within this ensemble or a related undertaking.

Bibliography

UNPUBLISHED SOURCES: G. King & Son of Norwich, Grosvenor Thomas, Stock Book I, no. 1139, pp. 186–7; Papanicolaou, 1994; Curator's files, Victoria and Albert Museum, London (courtesy of Michael Archer); Mary Clerkin Higgins, Conservation Treatment Report, 1994 (courtesy of the author).

PUBLISHED SOURCES: Hayward in *Checklist* III, pp. 9, 130, col. ill (reversed).

Description/Composition/Color: Five figures command the grassy foreground of the composition. At the center, the languid curve of her body in marked contrast to the four men attacking her, is St. Catherine. A single pane of uncolored glass that is a softer, pinker shade than other whites in the composition depicts her head, shoulders, and upraised left hand. Her garments, like those of her chief assailant approaching at left with a menacing sword, are white with silver-stained accents. These are offset by the saint's voluminous dark red cape, which arcs behind her to the right, as well as by the dark green and purple accents in the clothing of her other attackers. In the background is an architectural vista consisting of four ornate façades in light brown, gray-white, light blue and tan, respectively.

Condition: The panel is in excellent condition, having been cleaned and conserved by Mary Clerkin Higgins in October 1994. Most noteworthy is the significant percentage of old leading discovered by Higgins during conservation.

Iconography: Although St. Catherine was tortured by wheels studded with nails, and the wheel therefore became one of her most distinctive attributes, she was in fact killed by beheading (*Golden Legend*, pp. 708–16). The Bloomington panel appears to depict the moment just before she is beheaded, since her assailant at left wields a large sword and gazes at her head intently. One might argue that this episode could depict the seizing of any number of virginal female saints (including saints Agatha, Agnes, Cecilia, and Margaret), all of whom can be depicted wearing the crown of martyrdom (Emile Mâle, *Religious Art in France. The Thirteenth Century*, trans, Marthiel Mathews, ed. Harry Bober, Princeton, 1984, p. 282; Seraphim M. Zarb, "Origins and Development of the Cult of St. Catherine," in Mario Buhagiar, ed., *St. Catherine of Alexandria: her Churches, Paintings and Statues in the Maltese Islands*, Malta, 1979). Yet St. Catherine is most likely to be represented with a crown before her martyrdom because it refers to her status as a princess of Alexandria. There is therefore no reason to dispute the tradition going back to the entry in Grosvenor Thomas's inventory of 1924 which designated the Bloomington panel as St. Catherine (Stockbook, I: pp. 186–7, no. 1139).

134

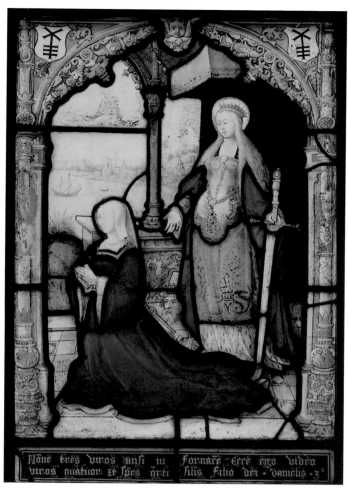

IUAM I/fig. I. ST. GREGORY MASTER: *Catherine Boelen presented by her Name-saint*, London. Victoria and Albert Museum

Technique: Pot-metal and uncolored glass, paint and silver stain were used. The surface is varied through extensive use of stickwork and back-painting, which is concentrated on St. Catherine, the soldier at left with a sword, and the architecture. It was probably the back-painting that caused the panel to be mounted and exhibited the wrong way round for many years. Back-painting in a damascene pattern is used on Catherine's gown, while it also creates an impression of plasticity and enhances contrasts in the armor of her left attacker, her red cloak, and the brown and blue buildings to either side in the background.

Style: The St. Catherine panel offers close analogies to panels attributed to the Great Cloister of Louvain. The architecture in the background of the panel of *The Raising of Lazarus* at Llanwellwyffo (IUAM I/fig. 3) is quite similar, although it is painted on uncolored glass, whereas the Indiana panel uses panes of pot-metal glass for different buildings. Also similar is the panel of *Saul arming David* in King's College Chapel, Cambridge (IUAM I/ fig. 2). Not only is the ornate Roman armor comparable, but the palette consisting of a green ground with a dominant use of white and silver stain contrasted by dark accents of purple, red and blue is very close.

Wayment sought to distinguish several workshops participating in the Great Cloister. He underscored the differences between the two panels now at King's College Chapel, *Saul arming David* and *Moses burning the Golden Calf* (IUAM I/figs. 2, 4). He associated the *Saul arming David* panel with the circle of Bernard van Orley, drawing attention to the robust, stocky, and square-headed figures. This is in fact also a good description of the assailants in the St. Catherine panel.

There are also similarities with the other style identified by Wayment, that of the St. Gregory Master, found in the panel of *Moses burning the Golden Calf* (IUAM I/fig. 4). In the Moses panel, Wayment drew attention to the tall stately figures with cloaks that fall in long, parallel curving folds and this more nuanced style provides analogies for the portrayal of St. Catherine herself in the Indiana panel. Her position, in a half-kneeling, almost fainting stance, offers analogies to the praying St. Gregory in a roundel in the Victoria and Albert Museum (Wayment 1989, p. 82, fig. I).

The composition of *St. Catherine seized for Martyrdom* parallels other panels in the group identified with the Great Cloister in Louvain. The scenes of *The Raising of Lazarus* (IUAM I/fig. 3) and the *Arrest of Christ* (Vanden Bemden and Kerr 1983–84, fig. 15a) in particular employ a very

IUAM I/fig. 2: BERNARD VAN ORLEY: *Saul arming David*, Cambridge, King's College Chapel

IUAM I/fig. 3: ST. GREGORY MASTER: *The Raising of Lazarus.*
Anglesey, Llanwenllwyfo

IUAM I/fig. 4: ST. GREGORY MASTER: *Moses burning the Golden Calf.*
King's College Chapel, Cambridge

similar composition with a notably tranquil, left-facing central protagonist. The reuse of this format not only focuses attention on the most important figure in each scene, but also draws analogies among the martrydoms of the different figures.

Date: Wayment attempted to narrow the dating of windows from the Charterhouse of Louvain by citing analo-

gies with drawings by Bernard van Orley and a painted panel by Jacob Cornelisz that influenced the work of the St. Gregory Master. These comparisons led him to date the two King's College Chapel panels, with which the Indiana panel shares features, to the 1520s. In addition, he assigned the date of 1526–27 to the donor trio involving St. Catherine and the Boelen family (Wayment 1989, pp. 84–5).

Although the Indiana panel of St. Catherine cannot be placed with precision within the complex of the Charterhouse of Louvain or a related monument, Wayment's comparanda nonetheless underscore the likelihood of an origin in the second or third decade of the sixteenth century from Louvain.

Photographic reference: IUAM.

Evansville Museum of Arts and Science
EVANSVILLE, INDIANA (EMAS)

THE EVANSVILLE MUSEUM OF ARTS AND SCIENCE has a diverse collection presenting examples of both art and technology. Not only does it house a Planetarium and Science Center, an anthropology gallery, and paintings and graphic works from the sixteenth century to the present, but a railroad on the museum grounds recalls Evansville's past as a busy railway town.[1]

The collection contains one early sixteenth-century German stained glass window. The window consists of four panels of individual saints that have been put together into a single, arched composition. Particularly telling of the modern, composite character of the current arrangement are the grisailles depicting architectural arches and towers placed at the bottom of the window.

History of the Collection

It was the success of several local art exhibitions organized by the Ladies Literary Club in Evansville that led to the creation of a public museum. In 1904, a group of citizens attended the World's Fair in St. Louis, Missouri, expressly to obtain works of art for the collection. Purchases, including Hindu ornaments from the Philippines exhibit, curios from the Chinese pavilion, and Danish pottery, became the basis of the museum's collection.

The collection has been housed in three different locations. In 1904 the Ladies Literary Club raised money for the purchase of a building on the Ohio riverfront. When this structure was condemned in 1910, the newly formed Vanderburgh County Historical Society and the Society of Fine Arts and History led the effort to reorganize the collection, and in 1927 succeeded in purchasing Evansville's former downtown YMCA to serve as its second museum. The third and current building was built in 1959 on the riverfront. A major renovation and reinstallation of the permanent collection was undertaken in 1997, and this provided the stained glass window with a more intimate setting amidst other sixteenth- and seventeenth-century works of art in the collection.

When Siegfried Weng moved to Evansville in 1950 from the Dayton Art Institute, where he had served as director, he began an ambitious acquisition program. Among his contacts of many years acquaintance was Donald F. Tripp, an executive with the Grip Nut Company (a producer of industrial parts), of South Whitley, Indiana. Evidently, the Tripp family was known for its art collecting. Donald Tripp's brother, Chester Dudley Tripp, a financial consultant in Chicago, was featured in a 1961 exhibition at the Art Institute of Chicago entitled, *Treasures of Chicago Collectors.*[2] After its arrival nearly two years previously, Donald Tripp formally gave the impressive sixteenth-century *Four Standing Saints* window to the Evansville Museum on 18 December 1958.

BIBLIOGRAPHY

UNPUBLISHED SOURCES: Mary Schnepper, curator of collections.

NOTES

1. On 17 April 2001, too late to incorporate in this volume, the name of the Evansville Museum of Arts and Science was changed to the Evansville Museum of Arts, History and Science.
2. *Treasures of Chicago Collectors* (exh. cat., The Art Institute of Chicago), Chicago, 1961: n.p. Among the Tripp's holdings are a number of early works, including: an early Renaissance bronze doe from Padua, a twelfth-century bronze griffin from the Rhineland, and an Italian enameled basin, also from the twelfth century.

EMAS 1. Four Standing Saints

Lower Bavaria, Circle of Hans Wertinger
c. 1510–1530
Rectangle: 203.5×71 cm (80.125 × 28 in)
A. *Architectural panel. Rectangle*: 18.8 × 33.3 cm (7.75 × 13.13 in)
B. *Architectural panel. Rectangle*: 18.8 × 33.3 cm (7.75 × 13.13 in)
C. *Theologian Saint. Rectangle*: 83 × 32.5 cm (32.69 × 12.08 in)
D. *Archbishop Saint. Rectangle*: 83 × 32.5 cm (32.69 × 12.08 in)
E. *Philosopher Saint. Rectangle*: 94.6 × 33 cm (37.25 × 13 in)
F. *St. Stephen, Martyr. Rectangle*: 94.6 × 33 cm (37.25 × 13 in)
Accession no. 58.321, Gift of Donald F. Tripp
Ill. nos. EMAS 1, 1/a, 1/1–5, 1/figs. 1–4

History of the glass: On 18 December 1958, Donald Tripp formally gave this stained glass window to the Evansville Museum of Arts and Sciences. According to Mr. Tripp's recollection, the Evansville window had been purchased for him by Paul VonBaarn in the fall of 1927, "in a sale of a Spanish estate at the American or Anderson Galleries, whichever it was called at that time. The sale lasted two or three days and this window, with description, had a full page black and white picture in the catalogue." However, efforts to locate the sale have proved unsuccessful: while Anderson Galleries had a large stained glass sale in November, 1927, and American Galleries had a Spanish estate sale in November, 1929, neither contained material corresponding to this window.

When first published in 1989 (Hayward in *Checklist III*, pp. 131–2), the Evansville window was attributed to Nuremberg, Bavaria at the end of the fifteenth century. Correspondence with scholars in Germany has helped to pinpoint Lower Bavaria and the circle of Hans Wertinger, in the first quarter of the sixteenth century, as the most likely provenance. An exact location has thus far proved

EMAS 1/a. Restoration chart

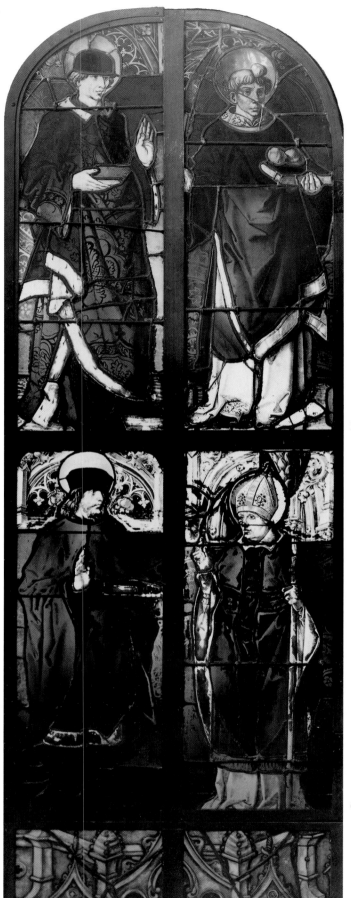

E & F

C & D

A & B

EMAS 1. *Four Standing Saints*

elusive. Stylistic similarities, while present, are not the primary reason for attributing the work to Wertinger; it is the workshop practice of etching small symbols known as sorting marks onto the back of the glass to aid in assembly that associates the Evansville window with Wertinger's circle.

Related material:
Neuötting, Annakirche, window in left nave, *Pietà and Donors Erasmus of Trennback and Family*, c. 1510–14 (Liedke 1973, p. 74) (EMAS I/figs. 1–2)

Freising, Andreaskirche, *Bishop Philip von Freising presented by St. Philip*, c. 1515 (now destroyed, known through image in Schmitz 1913, 2, pl. 32, fig. 199) (EMAS I/fig. 3)

Munich, Bayerisches Nationalmuseum, formerly in the parish church of Mining, *Dr. Peter Baumgartner presented by St. Peter*, c. 1524 (Liedke 1973, p. 72) (EMAS I/fig. 4)

Bibliography

UNPUBLISHED SOURCES: 2 January 1957 letter from Donald F. Tripp to Siegfried R. Weng, director, EMAS; 18 December 1958 letter from Donald F. Tripp to Siegfried R. Weng, director, EMAS; EMAS Curator's files, courtesy of Mary Schnepper; correspondence with the author from Daniel Hess, Hartmut Scholz, and Eva Fitz, Corpus Vitrearum Medii Aevi, Germany.

PUBLISHED SOURCES: Fritz Geiges, "Das Annen-Fenster im jetzingen Alexander-Chörlein," *Freiburger Münsterblätter* 4, 1908 pp. 41–81; Schmitz 1913, 1: pp. 126–8, and 2: pl. 32, figs. 199–201; Volker Liedke, "Hans Wertinger und Sigmund Gleismüller, zwei Hauptvertreter der Altlandshuter Malerschule," *Ars Bavarica*, 1, 1973 pp. 50–83 (refers to the window in Mining as the donation of Dr. Peter "Paumgartner"— see inscription in his figs. 6 and 7); Frenzel and Ulrich 1974, pp. 373–97; Gloria Ehret, *Hans Wertinger, Ein Landshuter Maler an der Wende der Spätgotik zur Renaissance*, Munich, 1976, esp. pp. 60–85, 163–70; Hayward in *Checklist* III, pp.131–2; Eva Fitz, "Eine Folge von vier Kabinettscheiben nach Kartons des Hans Süss von Kulmbach," *Zeitschrift für Kunstgeschichte*, 58, 1995, pp. 39–54; Hartmut Scholz, "Dürer et la genèse du vitrail monumental de la Renaissance à Nuremberg," *Revue de l'Art*, 107, 1995, pp. 27–43.

Description/Composition/Color: Two panels of architectural elements on uncolored glass enlivened by silver stain occupy the lowest zone of this composition (A and B). Although clearly by a different hand, these grisailles are not dissimilar to the architectural niches that appear above the shoulder level of the four saints. Yet their illogical placement at the bottom reveals their inclusion as mere fillers. Above are four separate panels of standing figures with haloes, the panels of the upper two figures drawing into a round-headed arch at the top. The figures are shown in shallow spaces, with silver-stained architec-

tural niches beginning anywhere from the shoulder level to the eye level of each figure. In the middle zone, behind the figures, hang damask cloths, blue behind the two figures to the left, and red behind the figures on the right. Although the individual panels clearly come from the same stained-glass series, the stance, gestures and dress of each figure vary slightly:

C. The so-called *Theologian Saint* turns to our right, holding a book in his left hand and making a gesture of benediction with his right. He is bearded, with shoulder-length, silver-stained, wavy hair and a dark brown hat (EMAS I/1). He wears a shorter tunic hemmed in white fur, and a mid-length red mantle.

EMAS I/1. Detail, head of *Theologian Saint*

D. The *Archbishop Saint* turns to our left and clasps a truncated crozier in his left hand, making a gesture of benediction with his right. He wears a gem-studded, silver-stained miter (EMAS I/2), and a blue pallium with contrasting burgundy material forming a cross that extends the length and breadth of it. Beneath the pallium a burgundy dalmatic with green fringe is visible above a white alb.

E. The *Philosopher Saint* turns to our right, holding a book in his right hand and raising his left (EMAS I/3). The tallest of the group, he has a dark biretta, and a voluminous dark brown damask robe trimmed in white fur.

F. *St. Stephen, Martyr* is recognized by the two stones with which he was martyred that are shown on the book he carries in his right hand (EMAS I/4). A third stone is represented on his head, although this glass is probably a restoration. Over a long white alb, Stephen wears a mid-length dalmatic, the outer vestment worn by a deacon, edged in gold made by silver staining.

Condition: The glass is only in fair condition. Dirt and varnish have built up on a number of the panes, obscuring the color. Cracking and paint loss have also occurred. A number

EMAS 1/2. Detail, head of *Archbishop Saint*

of saddle bars have been added to help stabilize the glass and this breaks up the composition.

Iconography: The iconography is neither erudite nor elaborate. One of the more notable characteristics of the figures, with the exception of the *Archbishop Saint*, is that they carry books, symbolic of both knowledge and their authority. The books are held high, at right angles to the chest, almost as if they were carrying patens. The manner in which the books are held recalls Hans Suess von Kulmbach's drawing of St. Nicholas (DIA 29/fig. 3) dated *c.* 1511 (*Nuremberg*, no. 163, pp. 344–5) Kulmbach's saint further parallels the Evansville window, for Nicholas, like St. Stephen here (EMAS 1/4), carries the implements of his martyrdom on the book before him.

Like the majority of early sixteenth-century German panels in this country (see *Checklist* I: pp. 43, 138–9, 208; *Checklist* II: frontispiece and p. 50; *Checklist* III: pp. 97, 174–5), the Evansville window is essentially a series of superimposed niches. Even taking into account the fact that the figures have been cut down and stacked into their current polyptych arrangement, they are without continuity in the representation of space. The Evansville *Four Standing Saints* window therefore remains a Late Gothic work, outside of the new formal Renaissance elements that may be traced in Nuremberg glass painting from *c.* 1510 (*Painting on Light*, pp. 27–33). As Scholz points out,

the shallow niches, damask backdrops and discontinuous frames were probably inspired by traditional church furnishings such as altarpieces (Scholz 1995, p. 28; Scholz 1991, pp. 265–79).

If the format is a traditional one, however, the dress reflects contemporary trends. The representation of similar fashions and attributes in other works of art from the time imparts to the figures a kind of generic contemporaneity. A number of elements found in the Evansville panels are present in Hans Baldung Grien's *Altarpiece of St. Sebastian*, signed 1507, now at the Nuremberg Germanisches Nationalmuseum (*Nuremberg*, no. 178, pp. 373–4, col. pls.). These include the rich brocade garments, both fringed and fur-trimmed, the curling beard and long blond hair of St. Sebastian (compare EMAS 1/1), and the shorter tunic with leggings worn by the onlooker, said to be a self-portrait of Baldung. In addition, the drawing and glass panel of Sixtus Tucher attributed to Dürer and executed by Veit Hirsvogel are not dissimilar in dress to the *Theologian Saint* from Evansville at the upper left. Tucher (1459–1507), a professor of jurisprudence and prelate of the Lorenzkirche

EMAS 1/3. Detail, *Philosopher Saint*

in Nuremberg, is likewise shown in a biretta, in a long and an impressive, fur-trimmed gown with full sleeves (*Nuremberg*, nos. 116–17, pp. 286-9; *Painting on Light*, no. 20, pp. 110–11).

EMAS I/4. Detail, *St. Stephen, Martyr*

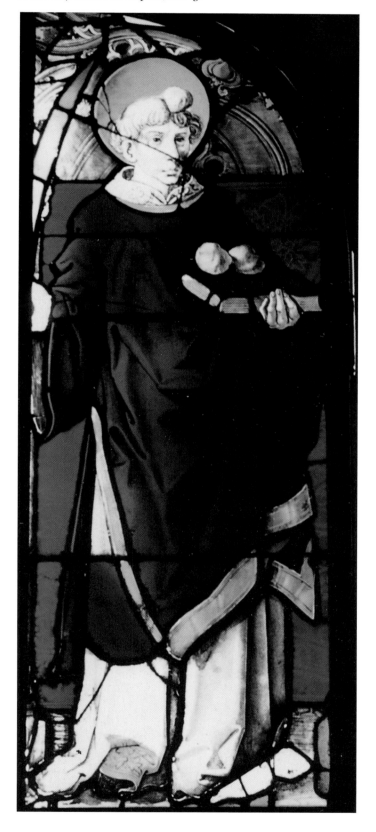

Technique: The figures are composed of uncolored and pot-metal glass in deeply saturated hues, complemented by accents in silver stain for the canopies and haloes, and on some of the trim and attributes. A range of painting techniques manipulates the incoming light and creates a varied surface. These are also reinforced with backpainting on a few portions of the garments. The subtlety of effects is most remarkable in the head of the *Archbishop Saint* (EMAS I/2), with its thinly applied matting, brushed out to reflect light on the gems and band of the miter, and in the stickwork used to create scintillation in the wavy hair and beard of the *Theologian Saint* at lower left (EMAS I/1). The application of silver stain is rather unpredictable: in some of the books and attributes and in the trim of *St. Stephen*'s garment (EMAS I/4), it covers entire panes as though these were of yellow pot-metal glass, while in a number of the subtler passages such as the architectural canopies, the blond hair of the *Theologian Saint* (EMAS I/1), and the halo of the *Philosopher Saint* at upper left (EMAS I/3), it is applied more selectively.

Most noteworthy from a technical point of view are the symbols etched on the back of panes in the lower two panels. These consist of a backwards "L" on the lower-left figure of the *Theologian Saint*, and forms ressembling the word "all" on the *Archbishop Saint* at lower right (EMAS I/5). Sometimes called "mason's marks," after similar ciphers that are found on building sites, they have been interpreted as indications that work had been completed by a particular craftsman (Frenzel and Ulrich 1974, p. 393; Ehret 1976, p. 82) and was ready to be reimbursed. They may more plausibly be explained as sorting marks (Geiges

EMAS I/5. Detail showing "mason's marks" on the *Archbishop Saint*

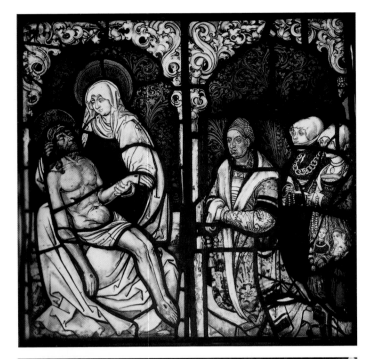

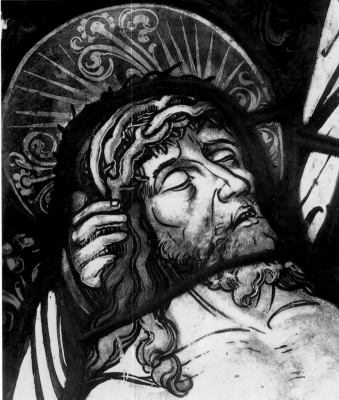

EMAS 1/fig. 1 & 2. *Pietà and Donors Erasmus Trennback and Family,*
c. 1510–14. Neuötting, Annakirche (after Liedke 1978)
(*below*) Detail of the head of Christ

those now in the Julius Böhler collection in Munich (Ehret
1976, p. 84), and why the a different mark is used for each
of the two lower figures in the Evansville window.

To date, only a few examples of these sorting marks
have been found on German glass outside of Wertinger's
workshop. Exceptions include four small circular panels in
the Fürst-Pückler Museum in Cottbus, which are associ-
ated with Hans Seuss von Kulmbach (Fitz 1995, p. 40, n.
3), the window of St. Erasmus from the third quarter of
the fifteenth century in the Nicolaikirche in Bad Wilsnack
in Brandenburg (correspondence with Fitz), and four
clerestory windows from Freiburg Münster dated 1512 by
Hans von Ropstein (Geiges 1908, p. 60; correspondence
with Scholz). In all these cases, a single mark is used to
distinguish the panes of a given panel. Nonetheless, the
usage of these symbols was probably not very widespread
around 1500. Their appearance on the Evansville *Four*

EMAS 1/fig. 3. *Bishop Philip von Freising presented by St. Philip, c. 1515.*
Freising, Andreaskirche, destroyed (after Schmitz, 1913, 2)

1908, p. 60; correspondence with Scholz), which allowed
workshops to reassemble quickly the individual panes of
glass for a single panel after the paint had been fired on.
This may explain why they can be found on small heraldic
panels where accurate assembly was essential, such as

Standing Saints window is a strong indication that the panels are from the circle of Hans Wertinger because of his sustained use of them.

Style: The donor portraits in glass that Hans Wertinger executed for the nobility of Lower Bavaria offer good comparisons for the composition of the Evansville panels. Those in the south choir and left nave of the Annakirche at Neuötting (EMAS I/fig. I), generally dated 1510–14, show figures before a damask cloth in a broadly defined Late Gothic architectural setting (Ehret 1976, nos. 56–9, pp. 164–5). The reliance on the three-quarter view of the figures, with prominent eyes, a long nose and full lips, is analogous. Comparisons for the standing saints may be found in the panels dated by inscription to 1515 from the Andreaskirche in Freising (EMAS I/fig. 3; Ehret 1976, nos. 78–81, p. 170). Now known only in the black-and-

white photographs taken for Schmitz's catalogue 1913, (Schmitz 2, pl. 32, figs. 199–201), they are closer to the rather wan gestures and positioning of the figures in the Evansville panels than to later works such as the donor portraits of 1524 once in the presbytery of the parish church at Mining (EMAS I/fig. 4), and now preserved in the Bayerishes Nationalmuseum in Munich (Ehret 1976, nos. 68–9, pp. 167–8). The panel of St. Peter with his name sake, Dr. Peter Baumgartner, from Mining exhibits both a greater breadth and monumentality in the figures themselves, as well as a relatively more convincing architectural enframement, complete with Renaissance elements.

The palette, however, distances the Evansville panels from the comparanda at Neuötting, Freising, and Mining. Wertinger came to rely increasingly on white as the predominant color for his compositions, contrasting it with sparing use of saturated colors (Ehret 1976, pp. 62, 68). The Evansville panels do just the reverse. Nonetheless, other workshop techniques, including similar surface manipulation and the use of sorting marks, are apparent. For this reason, the panels of the *Four Standing Saints* window may belong to Wertinger's circle, rather than Wertinger himself.

Date: Within the chronology of work established by Ehret (1976), it is possible to suggest a rather precise dating. It is only in panels executed between 1512, when windows were undertaken at the church of Kriestorf near Vilshofen, and 1526–27, the date of small round panels executed for Ingolstadt University now in the collection of Julius Böhler in Munich, that etched markings appear on the backs of panels. Further, donor panels from Mining dated 1524 appear too robust in the handling of the figure and composition to compare closely to the Evansville glass. Therefore, the *Four Standing Saints* panels are likely to have been undertaken in the second two decades of the sixteenth century.

Photographic reference: EMAS.

EMAS I/fig. 4. *Dr. Peter Baumgartner presented by St. Peter*, from Mining, Parish Church, *c.* 1524. Munich, Bayerisches Nationalmuseum (after Liedke 1978)

The Detroit Institute of Arts

144

Detroit Institute of Arts
DETROIT, MICHIGAN [DIA]

THE COLLECTION of the Detroit Institute of Arts is distinguished for its quality and breadth; virtually all important period styles and countries are represented. There is no more significant collection of glass in the United States outside of the east coast holdings at the Metropolitan Museum of Art, New York, and the Pitcairn Collection, Glencairn, Pennsylvania.[1] The collection contains 67 panels of medieval and Renaissance stained glass. The earliest panels, *Two Clerics* (DIA 1; Col. pl. 2) from Soissons Cathedral in France and the *Ornamental Boss* (DIA 2) from Canterbury Cathedral in England, date from the early thirteenth century. Unique among American collections are the fragments, including a heraldic badge (DIA 33–34), remaining in the tracery of the Late Gothic chapel of Lannoy from Herbéviller in northern France (Col. pl. 46), dated 1522–24.

The collection's greatest strength lies in its fifteenth- and sixteenth-century glass, especially that from German-speaking lands. *The Three Marys* (DIA 4; Col. pl. 7) from the Rhenish abbey church of Boppard-am-Rhein can be connected to a large and theologically complex program now dispersed in the Burrell Collection, Glasgow, the Metropolitan Museum of Art, the Schnütgen Museum, Cologne, and a number of private collections. *Three Standing Figures of Saints* (DIA 19–21), portraying Saints Christopher, Jerome, and Andrew, show a less sophisticated but arguably more vivid characterization, typical of the inventiveness that distinguished the late medieval art struggling to incorporate three-dimensional volume while still retaining the power of the planar conventions of the past. The five life-size images, the panels of *Standing Figures of Three Saints and Two Representations of the Virgin and Child* (DIA 23–27), that include Saints Wenceslas (Col. pl. 42), Anthony Abbot, and Barbara, are some of the best-preserved panels of early sixteenth-century North European glass painting in existence.

Small individual panels, sometimes called *Kabinettscheiben* represent German and Swiss examples. A heraldic panel associated with the workshop of the Housebook Master, *Quatrefoil Roundel with Boar-hunting scenes* (DIA 17; Col. pl. 22), *c.* 1475–85, shows the close correspondence between the art of the print and the art of painting on glass towards the end of the Middle Ages. The panel of the *Crucifixion with the Virgin, St. John, and Angels* (DIA 29; Col. pl. 23), dated 1514, is characteristic of the art of the German Renaissance and the artistic milieu of the great city of Nuremberg during the time of Albrecht Dürer. The date corresponds to the height of Dürer's career when he was engaged in the production of his three great "master engravings" *St. Jerome in his Study*, *Melencolia I*, both of 1514 and *Knight, Death and the Devil* of the previous year. Wolf Traut, Hans Suess von Kulmbach, Hans Leonard Schäufelein and Hans Baldung Grien were all active at this time, and have been associated with the design for such small panels as well as windows for large architectural openings.

Roundels

Roundels from the North Lowlands and the Rhineland are represented by objects of high quality in the Detroit collection. Whether taken from a printed source and selected out of a series, or whether from a single model and placed into a series, the roundels allow a particularly close

relationship to prints. The panel of the *Huntsmen and a Dice Thrower* (DIA 42), appears to have been based on a drawing by Dirick Pietersz. Crabeth and was probably executed in Gouda, between 1549–60. The roundel of the *Last Supper* (DIA 31; Col. pl. 18), after the print cycle of scenes of the Passion by Jacob Cornelisz. van Oostsanen, was most likely executed by a workshop in Amsterdam *c.* 1514–25. The *Flight into Egypt*, (DIA 32; Col. pl. 19) attributed to the Master of the Seven Acts of Mercy, was produced in Leiden 1515–25, and appears to be inspired by Dürer's 1503 print on the same theme. *St. Benedict* (DIA 40) shows a style of painting common to the Rhineland, and has been attributed to the Master of the St. Alexius Roundels, 1530–40, from Cologne.[2] The relationship of such roundels to series in prints or series executed in glass is discussed in the general introduction.

Swiss and South German Heraldic Panels of the Renaissance

The small individual panels of sixteenth- and seventeenth-century Swiss glass in the Detroit collection display particularly fine craftsmanship. The area of northeastern Switzerland is most heavily represented. The domestic panels produced in Switzerland display a keen interest in heraldry and testify to the religious and social preoccupations of that country. One of the frequent subjects was the standard bearer representing the arms of a city or canton. Two panels show the arms of cities, Brugg in the canton of Aargau, northwest of Zurich, and Steckborn in Thurgau, on the south shore of the Bodensee, just west of Constance. The *Heraldic Panel of the Town of Brugg* (DIA 48) are supported by bears dressed in a mailcoat and in citizens' parade attire, and in the *Arms of the City of Steckborn* (DIA 67) lions support the arms. Such heraldic panels of family and state were not restricted to Switzerland but were also popular in southern Germany and Alsace. The panel of the city of Steckborn, for example, was executed by Wolfgang Spengler of Constance, a city that provided heraldic glass of this type for both German and Swiss clients. A *Heraldic Panel with Shipping Image* (DIA 66) containing unidentified arms showing a rampant demi-lion, was produced by a glass painter in the circle of Batholomäus Lingg, of Strasbourg.

Three sixteenth-century panels show the arms of the burger classes. The variety with the husband alone is represented by the *Heraldic Panel of Hans Stöckli* (DIA 49) where the figure of Hans Stöckli stands between two large columns and above a single shield with inscription. The more common representation of the married couple, the Welcome Panel, is exemplified by the *Heraldic Panel of Immenhuser and Vilhälmin* (DIA 47); here the couple of Hans Immenhuser and Madelena Vilhälmin are each above their family coat of arms and identifying inscription. The panel with missing inscription, *Welcome Panel of the Scherer Family (Heinrich or Jacob Scherer of Uri?)* (DIA 39), shows a couple flanking a single heraldic shield bearing the motif of a silhouette of shears. Two of Switzerland's most distinguished designers, Felix Lindtmayer the Younger and Anton Schitterberg, are associated with the construction of these panels.

The context of these small panels of late medieval and Renaissance glass demands an augmented introduction. The small "independent" panels were absolutely ubiquitous in public buildings such as town halls, law courts, inns, or even religious buildings from the fifteenth through the seventeenth century in Switzerland, Southern Germany, and the Upper Rhine. That the panels were considered obligatory elements of public architecture is borne out by textual evidence. In 1542, for example, the *Bürgermeister* of Stein-am-Rhein surveying the newly finished town hall expressed the "earnest wish that our gentlemen and distinguished individuals would each claim

a window in which to install an honorific shield."³ Such civic obligations, it seems, involved the production of panels for guild halls and other corporate buildings, as exemplified by the panel given in 1599 by Johann Hugwart to the hall of the tailor's guild in Strasbourg, similar to the Detroit panel, *Heraldic Panel with Shipping Image* (DIA 66), from the circle of Barthomäus Lingg the Younger.⁴ Thus the panels are highly interesting as records of cultural expectations of their time. Unlike English and French heraldic custom, in the lands of the Holy Roman Empire every free man was entitled to design and display his own coat of arms. When elected to the City Council, he was even required to designate his arms. Thus the German and Swiss panels in the Museum's collection demonstrate a bourgeois context of their donors' heraldic badges, quite removed from that of the hereditary class of nobles. Private citizens often developed shields with images of plow-shares, vinedressing knives (*Rebmesser*), pretzels, or even a pun based on their own names, such as the beehive for Immenhuser in *Heraldic Panel of Immenhuser and Vilhälmin* (DIA 47). Images of the donors themselves appear in the panels, as richly dressed citizens, husband and wife, and invariably with events drawn from their own lives, such as the family's livelihood, or a pilgrimage to Spain (DIA 39) for the Scherer family.⁵

The panels were produced often by highly sophisticated glass painters living in large towns, or by individuals in smaller locali-ties, such as Brugg, where Jakob Brunner exercised the profession of innkeeper as well as painter of stained glass panels, fres-cos, and other architectural designs. Several generations the Spengler family of Con-stance produced painted glass vessels as well as leaded panels and single pieces of glass called roundels. The availability of printed sources at this time allowed for many cross influences. Both the figural compositions and the architectural formats were often taken from popular books. These

panels were not produced for a specific architectural installation, but for the individual commis-sioner, who presumably could choose from a variety of design formats. The patterns for the images remained remarkably uniform, and thus qualifications such as progressive or *retardataire* are not applicable in assessing their development. This was a truly popular art, one dominated by individuals keen on preserving their family traditions, and thus eager for the reassurance that their own "marriage panel" reflected the format and design of that of their grandparents.

English Heraldry

A large number of English heraldic panels make the Detroit collections one of the most important for this area in the United States. Most are from the Tudor era, displaying the arms of the recently elevated nobility of Henry VIII. The importance of the English heraldry is rivaled only by the col-lection of the Philadelphia Museum of Art whose 66 English heraldic panels were once a part of the collection of Mr. and Mrs. FitzEugene Dixon, and installed in Ronaele Manor, Elkins Park,

Pennsylvania.[6] Detroit's panels are in two major groups: nine (DIA 54–62), are heraldic shields set in a cartouche of Renaissance architectural forms decorated with fruit and date from the late sixteenth century; four (DIA 50–53) can be dated between 1589 and 1593 and display the arms within a border of the Order of the Garter, crowned with a coronet. Two heraldic supporters (DIA 45–46), a lion and dragon, presumably belong to the same series of the Order of the Garter. An additional heraldic panel (DIA 65; Col. pl. 31) is of particular importance because it records the early life of John Winthrop (1588–1649) who was the first colonial governor of Massachusetts. Winthrop's arms are impaled by those of second wife, Thomasine Clopton. In all probability, the panel had been made for a window in his estate at Groton Manor, Suffolk, before he converted his holdings into a cash income and set sail for Salem, Massachusetts, in 1630.

Renaissance Narrative Windows

The French glass includes an extremely large and important representation of the *Martyrdom of St. Eustache* (DIA 41; Col. pl. 14), dated 1543, from the church of St. Patrice in Rouen (Normandy). It was once part of a window showing two additional episodes from the saint's life, the vision of the miraculous stag that led to Eustache's conversion, and the test of his faith as he witnessed wild animals carrying off his two sons. The *Four Standing Figures in Architectural Settings* (DIA 35–38) are over ten feet tall and show Isaias, the Tibertine Sibyl, St. Raphael, and St. Faith, very probably from a program in the area of the Ile-de-France. These four panels and two others, now part of the Forest Lawn Memorial Park collection, were once in the William Randolph Hearst collection.

A distinguished window of the Italian Renaissance is well displayed in the Institute's galleries. The *Nativity* (DIA 30), dated 1516, over eight and a half feet high, was made by Guillaume de Marcillat for the Cathedral of Cortona. A companion panel of the *Adoration of the Magi* is on view in the Victoria and Albert Museum, London.

History of the Collection

Some of the earliest gifts to the Institute were made by George G. Booth, publisher of the *Detroit News* and founder of Cranbrook Academy. In 1922, he and his wife, Eleanor Scripps Booth, made an extensive tour of Europe and purchased a number of panels for their home in Bloomfield Hills, designed by Albert Kahn and now a part of the Academy, and known as Cranbrook House. Six panels of unusual quality (DIA 39, 47, 48, 49, 66, 67) were given by Booth to the Institute in 1923. All except the panel showing the arms with a rampant demi-lion had formerly been a part of the celebrated collection of Lord Sudeley, Toddington Castle, Gloucestershire. Booth purchased the panels from Theodor Fischer, Lucerne, on 18 March 1922 as part of a lot of twelve, "all positively guaranteed Antique quality more than 150 years old."[7] Booth appears to have given the more artistically sophisticated panels to the museum and installed the rest in his home where he also placed contemporary work in glass.

The influence of William R. Valentiner, who served as advisor to the Museum from 1921 and as Director from 1924 to 1945, is felt in the selections of stained glass as it is for so many aspects of the Museum's collections. It is unknown whether Valentiner collaborated with George G. Booth in his purchase of the Swiss *Kabinettscheiben* in 1922. It is certain, however, that he was a motivating force behind the acquisition of the Italian panel of *John the Baptist* (DIA 18) in 1926,

purchased through Fougoli of Florence and presented to the museum by Mr. and Mrs. Ernest Kanzler. Valentiner had published the discovery of the window of the *Nativity* (DIA 30; Col. pl. 15) by Guillaume de Marcillat when it was in the private collection of Richard and Eleanor J. Mortimer in 1922. In 1937 he was able to purchase the window from the estate sale of the late Eleanor J. Mortimer through the General Membership and Donations Fund of the Founders' Society. Valentiner was equally sensitive to the bold draftsmanship of late medieval German glass painting and three important works were acquired during his tenure: in 1931, the *Three Standing Figures of Saints* (DIA 19–21), Christopher, Jerome, and Andrew, with the Edsel B. Ford Fund of the Founders Society; in 1936, the Housebook Master's panel of hunting scenes (DIA 17; Col. pl. 22) with the Octavia W. Bates Fund of the Founders Society; and, in 1940, *The Three Marys* (DIA 4; Col. pl. 7) from the Carmelite Church of Boppard-am-Rhein with funds from the Anne E. Shipman Stevens Bequest. A man of unusual breath and discernment, Valentiner had a keen interest in early modern art and was a close personal friend of Karl Schmidt-Rottluff, who made a woodcut portrait of him. He also collected and exhibited work of other major German Expressionists.[8] This progressive taste undoubtedly facilitated an appreciation for the graphic power of the late medieval German panels.

Valentiner developed strong relationships with prominent patrons of the museum who shared his passion for the arts, and, it seems, his understanding of late medieval expression. Often these patrons traveled with, or at least met with Valentiner in Europe. Valentiner acted as an agent for supporters of the museum, very probably with the hope that such purchases would eventually become part of the museum's collections. Ralph Harman Booth, first President of the Arts Commission of the City of Detroit, served from 1919 to 1930. His correspondence from Europe in 1922 is revealing, stating that Valentiner had spent the sum allocated from the City of Detroit for the museum itself and that he had also spent a considerable sum of Booth's own money.[9] Booth and his wife Mary did give significant works to the Museum. Many of the objects were of the medieval or early Renaissance periods. Most notable is the statue given by Booth in 1922 of the Virgin and Child by a sculptor from the circle of Michel Erhart, active 1469–1522 in Ulm.[10] The tradition continued with a late medieval Madonna and Child from the workshop of Tilman Riemenschneider in lindenwood given by Mrs. Ralph Harman Booth in memory of her husband in 1943.[11]

The acquisition of the series of twelve mid-fifteenth-century prophets associated with a *Biblia Pauperum* model and most probably executed by the workshop of the cloister of St. Cecilia, Cologne, reveals not only discernment but long-range planning. The late Gothic chapel from the château of Lannoy at Herbéviller was purchased for the Museum in 1922, but the costs were assumed by the Booths. This was the most generous single donation they had made to the museum and the chapel became an important feature of the new building which opened in 1927.[12] The chapel was already provided in its tracery with glass from the original foundation, the *Arms of Jean Bayer de Boppard and Eve d'Isenberg and Other Elements of Architectural Decoration* (DIA 33–34). This is a most unusual feature. To our knowledge no other collection in the United States possesses stained glass remaining *in situ* in its original architectural frame.

From the outset, the Booths appear to have projected the eventual purchase of suitable glass to fill the lower windows of the chapel which had lost their original glazing. Mr. Booth died in 1931, while he held the post of the United States Minister to Denmark. His wife continued making acquisitions in view of gifts to the Institute. In 1931 she gave the panel of *St. Augustine* (DIA 22)

from a south German workshop dating about 1500. The panel of the *Crucifixion with the Virgin, St. John, and Angels* (DIA 29; Col. pl. 23), dated 1514, from the workshop of Veit Hirsvogel, Nuremberg, had been part of the Booth collection and was presented to the Institute in 1937.

Stained glass for the chapel was presented in 1949 with the donation of the *Prophets and Psalmists after the "Biblia Pauperum"* (DIA 5–16; Col. pl. 5). The purchase was made via the intermediary of Dr. Ernst Scheyer, Associate Professor of the History of Art at Wayne State University, who served as private curator of the Ralph and Mary Booth Collection at the Booth home in Grosse Pointe. Dr. Scheyer bought the pieces from a dealer in Zurich, presumably a Mr. Frank, who communicated the information that the pieces had been in the collection of F. E. Sidney of Moreton, Holly Place, Hampstead, London until 1937. The Philadelphia stained glass studio of Henry Lee Willet provided a setting of grisaille strapwork in late 1947 and the windows were installed in February 1948, the context in which they are found today.[13] In 1955 John Lord Booth of Grosse Pointe, continued his parents' tradition by donating a small panel of the *Half figure of John the Baptist* (DIA 3) dating from the late fourteenth century, now identified as originally from the Franciscan church in Torun, Poland.

The four roundels in Detroit Institute of Arts arrived in the collection between 1936 and 1940. Two Lowlands roundels were acquired in 1936 as a Founders Society Purchase through the Octavia W. Bates Fund. The panel of the *Huntsmen and a Dice Thrower* (DIA 42), presumably after Dirick Pietersz. Crabeth, probably executed in the North Lowlands, Gouda, between 1549–60, had been in the stock of the dealership of Thomas and Drake of New York. The roundel of the *Last Supper* (DIA 31; Col. pl. 18), after Jacob Cornelisz. van Oostsanen, probably executed in the North Lowlands, Amsterdam, between 1514–25, came from the same source. Four years later in 1940, the Museum acquired the splendid *Flight into Egypt* (DIA 32; Col. pl. 19) attributed to the Master of the Seven Acts of Charity, Pieter Cornelisz. North Lowlands, Leiden, 1515–25, from Thomas and Drake, a purchase also supported by the Octavia W. Bates Fund. The same year Mrs. Lillian Henkel Haass and Mrs. Trent McNath donated the roundel of *St. Benedict* (DIA 40), 1530–40, by the Master of the St. Alexis Roundels, from Cologne. The roundel appears to have been acquired by Julius Haass of Grosse Pointe, Michigan, very probably encouraged by Valentine, a significant force in the acquisition of significant Netherlandish paintings to the museum, in conjunction with Ralph Harman Booth in 1923.[14] The dealership was the same Thomas and Drake from which the Detroit Institute of Arts was to make its later purchases. The roundel had been a part of the inventory left to Roy Grosvenor Thomas at the death of his father Grosvenor Thomas in 1923. From Julius Haass it passed to the possession of Lillian Henkel Haass, his wife, and Mrs. Trent McNath, Detroit. Mrs. Lillian Henkel Haass contributed to the Institute's collections in several areas. She became a member of the Board of Trustees in 1934 and served as president of the Founders Society from 1948 to 1955.[15]

It was in 1958, however, with the acquisition of a large amount of stained glass formerly in the collection of William Randolph Hearst that the Detroit Institute of Arts achieved the extent and significance of its glass holdings. All the panels purchased from the Hearst estate, with the exception of three of the Stoke Poges figures, discussed below, were made through the generous gifts of K. T. Keller. Hearst's collection was vast, and continued to include medieval and post-medieval works numbering more than twenty thousand items.[16]

Artistically most significant may be the five standing figures once in the parish church of Stoke Poges (Buckinghamshire), to the west of London. Colonel Shaw of Stoke Poges Manor consigned

the panels to the dealer, P. W. French & Co., New York, in 1929, and they were auctioned by Sotheby's in London, 16 May 1929. The six panels were in the possession of William Randolph Hearst of Los Angeles until offered for sale by Gimbel Brothers, New York, through Hammer Galleries in 1941. The companion piece, *St. Adrian in Armor*, was purchased by the Higgins Armory Museum, Worcester, Massachusetts, from this sale. The Detroit Institute of Arts purchased the remaining five panels *Standing Figures of Three Saints and Two Representations of the Virgin and Child* (DIA 23–27), from the Hearst Foundation in 1958. The panels of *St. Anthony Abbot* and the *Virgin with Christ Child holding a Ball* were donated by Mrs. Edsel B. Ford. The purchase of *St. Barbara* was made possible by the generosity of Mr. and Mrs. James S. Whitcomb. K. T. Keller funded the purchase of *St. Wenceslas* (Col. pl. 42) and the *Virgin with Christ Child holding a Top and Spinning String*.

French glass from Hearst's collection is equally noteworthy. The *Four Standing Figures in Architectural Settings* (DIA 35–38), from an Ile-de-France program, have two companion figures that are now a part of the Forest Lawn Memorial Park collection, Glendale, California. The four standing figures, like the English heraldic panels, had remained in museum storage until the campaign to renovate the English and Renaissance galleries in 1986. The window showing the *Martyrdom of St. Eustache* (DIA 41; Col. pl. 14) from the church of Saint-Patrice in Rouen has been described, since the early nineteenth century, as an extraordinary example of French Renaissance painting, and frequently cited in the literature on stained glass. Its presence in Detroit is fortuitous. At some time, presumably in the early twentieth century, and very possibly in the context of Hearst's known interest in medieval stained glass, a French studio made an exact copy of the Rouen panels and substituted the replicas in the church. The originals were sold to Hearst, although we do not know the precise intermediary, or the dates of the "restoration" campaign that allowed the windows to be dismantled and copied.[17] *Two Heraldic Panels Commemorating the Marriage of Charles VIII of France and Anne of Brittany and the Treaty of Sablé, 1490* (DIA 63–64), had been considered to be French and were also purchased from the Hearst estate. The arms of France accompanied by those of subsidiary towns commemorating the Treaty of Sablé of 1490 were believed at the time of purchase to represent French work of the early sixteenth century by Nicholas Desangives. Further investigation suggests that the panels are German or Swiss and date about a century later.

English heraldic glass purchased from the Hearst estate is extensive. The panels had been set in modern surrounds of clear glass in window frames housing two medallions each. Two series of arms, one surrounded by the sash of the Order of the Garter, *Four Heraldic Panels* (DIA 50–53), and the other surrounded by an architectural border, *Nine Heraldic Panels* (DIA 54–62), as well as the two panels showing supporters of the Tudor Arms (DIA 45–46) were once in Warkworth House, Northamptonshire, until removal to Hassop Hall, Derbyshire, about 1805. It is obvious from the appearance of stopgaps, that is, original segments of painted glass re-used in the shields, that the series must have been much larger, and the nineteenth-century restorers must have exploited the less complete panels as a mine for glass to repair the others. Similar series, presumably from the same workshop, but showing slightly different designs in the arrangement of the cartouche appear in the Philadelphia Museum of Art. The panel displaying the *Arms of John Winthrop of Groton and Thomasine Clopton* (DIA 65; Col. pl. 31), unrelated to the Warkworth House series, was included as part of the second series of nine panels, and thus also entered the Museum's collection.

A third series, was originally acquired as a set of eight panels showing *Royal Arms of England* (DIA 43–44). They display the arms of Henry VIII of England and his son, the short-lived Edward VI. Of the eight, only two are authentic. The panels were in the collection of Lord Sudeley, Toddington Castle, Gloucestershire, before 1911 and were eventually purchased by Hearst. Taken as a set, both original panels and the six meticulously executed replicas, are fascinating examples of the importance of heraldic decoration to a later age. The copies (Text ill. 11), highly convincing from a distance, were presumably commissioned for a specific architectural placement.

Detroit's earliest panels were two of its latest acquisitions, yet they represent, once again, the influence of Valentiner and the shared enthusiasm of the very early supporters of the museum. In a letter of 1922, Ralph Harman Booth mentions that he has visited Europe with Julius Haass and introduced him to some dealers, and that Haass had made purchases.[18] The two important panels given to the Museum from the Haass collection are known to have been part of the stock of the dealership of Thomas and Drake until 1924. It is most probable that Julius H. Haass purchased the panels in that year from Thomas and Drake directly. In 1958 his widow Lillian Henkel Haass, Grosse Pointe, donated the *Ornamental Boss* (DIA 2) from Canterbury Cathedral, England, and, in the following year, she presented the panel showing *Two Clerics* (DIA 1; Col. pl. 2), recently identified as from the Cathedral of Soissons, France.

BIBLIOGRAPHY

Margaret Sterne, *The Passionate Eye, The Life of William R. Valentiner*, Detroit: Wayne State University Press, 1980;

William. H. Peck, *The Detroit Institute of Arts: A Brief History*, Detroit, 1991.

NOTES

1 Hayward in *Checklist* I, pp. 92–178, Cothren in *Checklist* II, pp. 102–47 and CVUS volumes in preparation.

2 The relationship of such roundels to series in prints or series executed in glass is discussed in the General Introduction.

3 Reinhard Frauenfelder, *Die Kunstdenkmäler des Kantons Schaffhausen, 2, Der Bezirk Stein am Rhein*, in *Die Kunstdenkmäler der Schweiz*, 39, Basle, 1958, p. 188. Thirteen windows were donated in the same year. In the mid-18th century, however, the Town Hall was remodelled and the heraldic panels dispersed. The present arrangement of shields in the windows is a modern disposition.

4 Beeh-Lustenberger 1967 and 1973, p. 247, no. 230, fig. 213.

5 For additional explanation of heraldic custom see Ottfried Neubecker, *Heraldry, Sources, Symbols and Meaning*, New York, 1976.

6 Morgan in *Checklist* II, pp. 157–78.

7 Cranbrook Archives. I am grateful to Mark Coir, Archivist.

8 DIA 51.07, gift of Mrs. Ralph Harman Booth. Ellen Scharp, "Discerning Connoisseurship," *Apollo*, December 1986, p. 54. See also Horst Uhr, *Masterpieces of German Expressionism at the Detroit Institute of Arts*, Detroit, 1982, and Raguin 1998.

9 He pointed out that "all of the things shipped are not for the museum." Letter dated 30 July 1922, Gd. Hotel le la Ville, Florence, copy, DIA Archives. I am grateful to William Peck, Curator of Ancient Art.

10 DIA 22.3. Peter Barnet, "Late Gothic Wood Sculptures from Ulm," *DIA Bulletin*, 64/4, 1989, pp. 33–8, figs. 7–8; William R. Valentiner "Late Gothic Sculpture in Detroit," *Art Quarterly*, 6/4, 1943, pp. 276–304.

11 Ac. no. 43.2, *DIA Guide*, p. 167.

12 Francis Robinson, "The Gothic Chapel of the Detroit Institute of Arts," (Detroit Institute of Arts, 1949?); Emile Ambroise, "Le Château de Lannoy à Herbéviller," *Revue Lorraine illustrée*, 4, Nancy, 1909, pp. 60–4; id., *Les Vieux Châteaux de la Vésouz*, Nancy, 1910, opp. p. 96.

13 Correspondence between Henry Lee Willet and Mary Booth, 15 February 1949, Willet Archives.

14 George S. Keyes, "The Netherlandish Paintings in the Detroit Institute of Arts: a Brief Introduction," *DIA Bulletin*, 72/1&2, 1998, pp. 4–7.

15 Sterne 1980, p. 220.

16 Caviness and Hayward, "Introduction," *Checklist* III, p. 16.

17 Hearst must not have been unaware of the use of the copy to "liberate" the panel he purchased. When he was made aware of a similar situation for panels he had purchased where copies had been made for a church in Fécamp, he returned the original panels (Caviness and Hayward, "Introduction," *Checklist* III, p. 32, n. 50.). The Rouen substitution was only discovered during the 1987 research on the collection for the Corpus Vitrearum Checklist publications. David O'Connor, University of Manchester, England, initially brought this issue to the museum's attention.

18 "I have started Mr. Julius Haas (sic) of Detroit to become a collector of fine paintings and other things." Letter 30 July 1922, see above, n. 9 and also Edgar Preston Richardson, "A Memoir: the Early History of the Detroit Institute of Arts," *Archives of American Art Journal*, 32/1 1992, pp. 37–40.

DIA I. Two Clerics

France, Soissons, Cathedral of Saints Gervais
and Protais
1205–12
Square: 73 × 73.5 cm (28¾ × 29 in)
Accession no. 59.34, gift of Lillian Henkel Haass
 Ill. nos. DIA I, I/a, I/I, I/figs. I–4; Col. pl. 2

History of the glass: The panel was once part of a narrative window in one of the five radiating chapels of the east end of the Cathedral of Soissons. The cathedral's history presents a story of deliberate destruction, neglect, catastrophes, and unsupervised restoration campaigns. (For a summary of these events see Caviness and Raguin 1981, pp. 192–4; Caviness, Beaven, and Pastan 1984, 9–11; Caviness 1990). The cathedral presumably lost a major part of its glass during the Huguenot attack of 1567, when accounts describe the smashing of windows as well as the destruction of altars. The remaining glass was then transferred to the other windows. This kind of consolidation of a fragmentary glazing program was typical of repairs at this time, as exemplified by the parallel decisions made for the Cathedral of Auxerre (Raguin 1982, pp. 30,

DIA I. *Two Clerics*

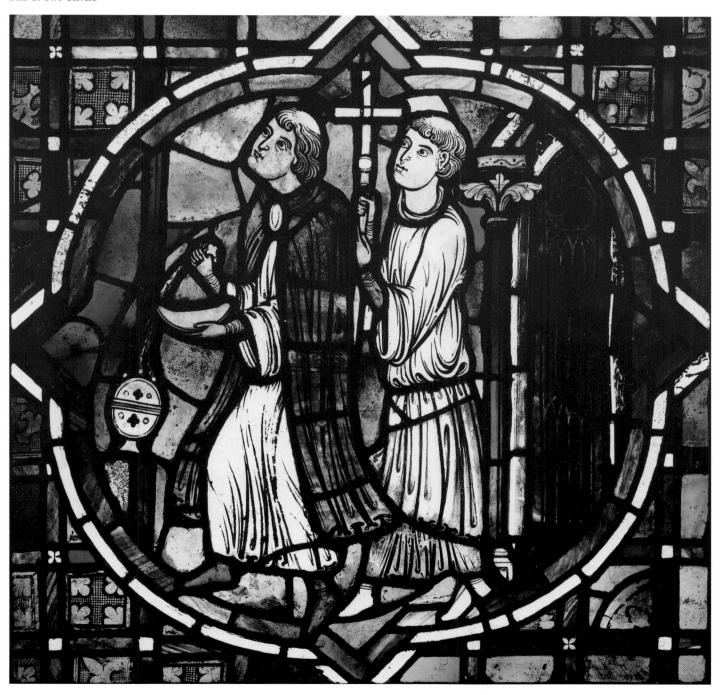

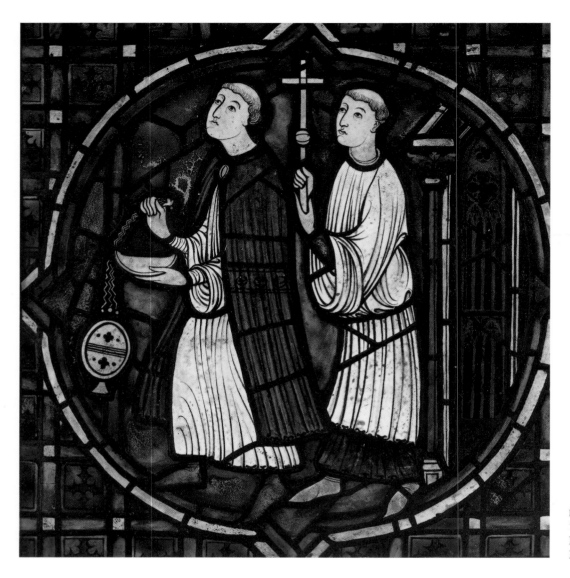

DIA I/fig. I. WILFRED DRAKE:
Two Clerics, watercolor.
London, Victoria and Albert
Museum

119, 131–71). In 1812 additional windows were destroyed by the explosion of powder magazine near the cathedral. At this date in Europe, studios had all but abandoned the tradition of producing stained glass windows in pot-metal glazing techniques. The restoration between 1817 and 1820, therefore, was doubly burdened by largely inexperienced glaziers and a corpus of glass in an extremely fragmentary state. The glass was radically rearranged, primarily to achieve the maximum effect of color in areas closest to the spectator. The large figures of the clerestory were transferred to openings in the choir chapels, a shift that necessitated bifurcating the images to accommodate the vertical bars in the center of each window opening. Remaining legendary panels, including the Detroit panels of the *Two Clerics,* were grouped together and used to fill several clerestory openings. It was also probably during this same campaign that glass from the near-by Abbey of St.-Yved in Braine was set into openings of the cathedral to fill in gaps.

This confused state was the one facing a comprehensive

glazing restoration begun in 1855. It was first undertaken by the well-known Gothic revival and restoration studio of Adolphe-Napoléon Didron (d. 1867), succeeded by his nephew Edouard Didron (often referred to as Didron the Younger). In 1891 the rival studio of Félix Gaudin won the contract by outbidding Didron (Caviness, Beaven, and Pastan 1984, p. 9.) Caviness, Pastan, and Beaven also evaluated the visits of Baron François de Guilhermy to the cathedral from the 1840s to the 1860s. He was able to verify his notes on the glass (Paris, Bibliothèque Nationale MS nouv. acq. fr. 6109, f. 257) during later visits to the Didron atelier during the restoration. Caviness, Pastan, and Beaven (1984, p. 9) have documented that considerable irregularities appeared during this restoration, among them the disappearance of the Nicasius and Eutropia window from the cathedral. Panels from that window can now be identified as having been the ones sold to the Isabella Stewart Gardner in 1906 by Bacri et Frères, a Parisian dealership, as well as the panels acquired in 1905 and 1907 by the Louvre.

154

Beaven suggests that the Detroit panel may have been one of the panels described by Guilhermy as "several scenes from the life of a holy bishop" originally from a choir chapel window but placed in clerestory window 104 and repaired in Didron's shop in 1864, where Guilhermy could observe it closely (Beaven 1989 and below). A distinguished member of the first wave of archeologically correct restorers, Didron based his painting on original heads as models. The repainting of the effaced head of the first cleric is clearly in the Didron mode and reproduces the Soissons type. The stopgap surround is of medieval glass of the same type but the design and painting style is cruder than the work of either Didron or Gaudin.

It is tempting to assume that the Detroit panel probably reached the art market via the same route as that followed by the Boston *Nicasius and Eutropia* window. One suspects that the glass was retained by the Didron studio, very possibly to make up for losses incurred by unrealistically low bids, storage costs, and delays of payment during periods of high inflation, and possibly reassembled into a coherent panel. Caviness has documented examples of this process (Madeline H. Caviness, "Some Aspects of Nineteenth-Century Stained Glass Restoration, Membra Disjecta et Collectanea; Some Nineteenth-Century Practices," *Crown in Glory*, Peter Moore, ed., Norwich, 1982, pp. 69–72). The panel presumably came on the market after the death of Didron the Younger in 1902. Its first known appearance was in the collection of Raoul Heilbronner, described in the 1921 sales catalogue as "*Vitrail en Couleurs, representant un diacre tenant un encensoir et la navette, il est suivi d'un clerc en surplis blanc portant la croix. Fond de carrelages en bleu et rouges.*" At the Heilbronner sale in Paris it was purchased by the dealer Roy Grosvenor Thomas of New York. A watercolor drawing of the panel (DIA I/fig. I) was executed by Wilfred Drake, and is now in the Victoria and Albert Museum. The Thomas sale books record what must be the Soissons Detroit panel purchased by Julius Haass, November 12, 1924, "Circular subject medallion on a field of blue and ruby glass in geometrical pattern. Probably French, middle of the XIII century." Lillian Henkel Haass, Grosse Pointe, inherited the panel from her husband. She bequeathed it to the Detroit Institute of Arts in 1959. [Medieval Treasury]

Related materials:

Saints Nicasius and Eutropia, (DIA I/fig. 3) window from the Cathedral of Saints Gervais and Protais, Soissons. Isabella Stewart Gardner Museum, Boston (C28s2).

Panels from the *Life of St. Blaise* in a composite window of panels from the Cathedral of Saints Gervais and Protais, Soissons. The Corcoran Gallery of Art, Washington, D.C., William A. Clark Collection (26,793).

Two panels from the *Life of St. Nicholas* (DIA I/fig. 3), from the Cathedral of Saints Gervais and Protais, Soissons. Metropolitan Museum of Art, New York, Gift of the Glencairn Foundation (1980.263.2 and 3) (Beaven 1992).

Three panels from the *Life of St. Blaise*, from the Cathedral of Saints Gervais and Protais, Soissons, Musée Marmottan, Paris.

Origin/Reconstruction: The cathedral's late twelfth- and thirteenth-century choir program exemplified Gothic systems of placing large figures in the upper windows, and smaller legendary narratives in the ambulatory and radiating chapels. Little remains of what must have been an extraordinary glazing cycle. Caviness has made a convincing reconstruction of the glazing program of the upper choir of large scale figures of Apostles and Prophets around an axial window of a Tree of Jesse. (Madeline H. Caviness, "Rekonstruktion der Hochchorglasfenster in der Kathedrale von Soissons. Ein Spiel des Zusammensetzens," *Bau- und Bildkunst im Spiegel internationaler Forschung* [Festschrift Edgar Lehmann] Berlin, 1989, pp. 41–51; Caviness 1990). The windows of the choir chapels are more problematic. They very probably included local and universal saints, including windows dedicated to St. Blaise, St. Nicholas, Saints Nicasius of Rheims and Eutropia, St. Thomas, and Saints Gervasius and Protasius. Beaven has associated the acquisition of relics from the Fourth Crusade, the head of St. Stephen, the finger and head of St. Thomas, and the crown of the head of St. Blaise, in particular. The Detroit panels must have come from one of the windows of the chapels of the choir (DIA I/fig. 2), but it is not possible to say which one.

DIA I/fig. 2. Soissons Cathedral, plan of choir, after France *Recensement* I

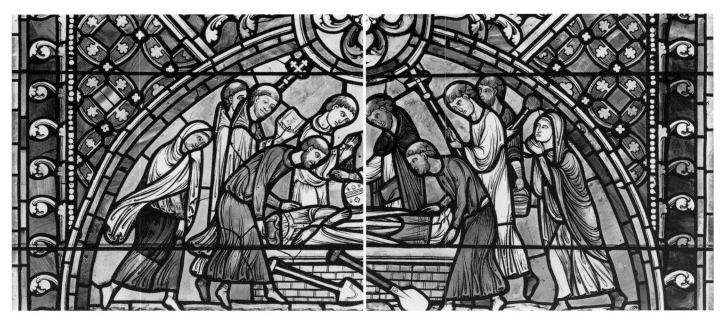

DIA 1/fig. 3. *Saints Nicasius and Eutropia*, detail, *Burial of a Bishop*, from Soissons Cathedral, 1207–12. Boston, Isabella Stewart Gardner Museum

The intermediary nineteenth-century placement, however, is sure. Guilhermy described the south clerestory window (now 104) that had been taken down about 1863 and was in Didron's shop. He identified a mix of large clerestory figures from the *Life and Death of the Virgin* and of small figural panels from the life of a holy bishop: *Ce vitrail se trouvant à Paris, pour cause de restauration, au mois d'aout 1864, dans les ateliers de mon ami, M. Edouard Didron ou je l'ai vu. Mort de la Vierge: le Christ et l'âme de sa mère; anges; la Vierge en gloire; XIIIe siècle. Verrière très confuse mais très endommagée, raccommodée avec des médallions de petits sujects du même temps...Voici la note que j'avais prise sur le 5e fenêtre (104) avant qu'elle fut déposée: Verrière très raccommodée et confuse. Beaucoup de petit médallions provenant d'ailleurs. Une garde qui décapite un personnage. Plusieurs sujets de la vie d'un saint évêque, entre autres une sepulture...*(Paris, Bibliothèque Nationale MS nouv. acq. fr. 6109, f. 256). Beaven suggests that as many as fourteen out of 36 panels were small-scale subjects. She also suggests that it is likely that the *Two Clerics* panel seen in this window once belonged to a window depicting the legend of Saints Gervasius and Protasius, the patron saints of the cathedral.

Although the two clerics in the Detroit glass are now isolated within a decorative surround by square decorative pieces, it is more probable that the original composition included a larger group of figures. The Master of the Bishop's Legends, the glass painter to whom the panel is attributed, would have taken full advantage of the width of the Soissons ambulatory windows and would have spread his scenes across the entire central zone. Subtracting some space for narrow borders, the composition might have been as wide as 120 cm (47 in.). Such a complex grouping can be seen in the *Burial of the Bishop* episode from the

Lives of St. Nicasius of Reims and St. Eutropa window (DIA 1/fig. 3), another of the Master's compositions, now in the Isabella Stewart Gardner Museum.

History of the building: The cathedral of Soissons is one of the major monuments of northern France. Its Gothic phase began with the south transept, dated after 1176 and completed about 1190 (Sandon 1998, pp. 79, 145). Work on the west bays of the choir began by 1197 or 1198 (Carl F. Barnes, Jr., *The Architecture of Soissons Cathedral: Sources and Influences in the Twelfth and Thirteenth Centuries*, Ann Arbor, Mich, 1967, p. 136; Sandon 1998, p. 145). The canons occupied the choir by at least 13 May 1212, the date recorded in a still extant inscription from the former choir screen (Sandon 1998, pp. 44, 90, 100, fig. 5; Beaven 1992, p. 31, fig. 2). Sandon (pp. 100–2) accepts 1212 as the date of completion of not only the choir but the crossing as well. Barnes suggests that the nave was terminated about 1230 (Carl Barnes "The Gothic Architectural Engravings in the Cathedral of Soissons," *Speculum*, 47, 1972, pp. 60–4) although Sandon (pp. 110, 237) prefers 1240. The level of the rose and galleries of the west façade, possibly the work of a Parisian architect, date to beginning of the second half of the thirteenth century (Sandon 1998, p.131). The completion of the building shortly after 1250 is also attested to by stained glass from the nave, most probably produced by a workshop of the Ste.-Chapelle of Paris (Caviness and Raguin 1981, p. 196).

Bibliography

UNPUBLISHED SOURCES: W. Drake. Album of drawings and watercolors (DIA 1/fig. 1), London, Victoria and Albert Museum, Department of Prints and Drawings, E 2399–1921, CG 51; Marilyn Beaven, verbal communication.

PUBLISHED SOURCES: *Catalogue des objets d'art et de haute curiosité... composant les collections de M. Raoul Heilbronner* [sale cat. Galerie Georges Petit, June 22 and 23], Paris, 1921, p. 62, no. 204, with notation sold to "Thomas Grosvenor"; Louis Grodecki, "Les vitraux soissonais du Louvre, du Musée Marmottan et des collections américaines," *La Revue des Arts*, 10, 1960, pp. 163–78; Caviness, Beaven, and Pastan 1984, p. 10, n. 18; Suse Childs, "Two Scenes from the Life of St. Nicholas and Their Relationship to the Glazing Program of the Chevet Chapels at Soissons Cathedral," in *Occasional Papers*, pp. 25–33; Barnet 1986, p. 41; Marilyn M. Beaven, "The Legendary Stained Glass from the 13th Century Choir of Soissons Cathedral," Masters Thesis, Tufts University, Medford Mass., 1989; Tutag and Hamilton 1987, pp. 17, 19, col. pl.; Raguin in *Checklist* III, p. 156; Madeline Caviness, "Modular Assemblages: Reconstructing the Choir Clerestory of Soissons Cathedral," *Journal of the Walters Art Gallery*, 48, 1990, pp. 57–68; Beaven 1992; Marie-Dominique Gauthier-Walter, review of *Checklist* III, *Cahiers de civilization médiéval*, 37/1&2 [nos. 145/156] 1994, p. 132; DIA *Guide*, p. 160, col. ill.; Dany Sandon, La cathédrale de Soissons, Paris, 1998.

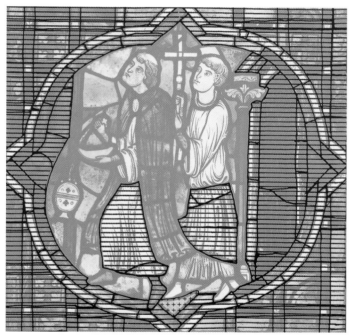

DIA I/a. Restoration chart

Condition: All but the figures is stopgap of the same period, or new. Sections of the figures, as noted in the chart, are replaced, most importantly the lower portions of the albs in both figures. Characteristic of glass of this era, there is some pitting. The white alb of the cleric to the right has very small black dots, caused by corrosion, in the areas of the glass not protected by paint. There is minor paint loss, especially in the head of the second cleric.

Iconography: The two clerics follow each other in procession. The first performs the liturgical function of censing and the second holds a processional cross. Their forward stance conveys the impression of the swift passage of their party. Processions are invariable elements in High Gothic windows since they were such common occurrences in the medieval town. Major feast days demanded elaborate liturgies, most often involving processions that moved beyond the confines of a church. The arrival of significant relics, petition in time of war, famine, or pestilence, or even a local request for donations towards a church's construction, involved processions. One may compare, for example the procession in the *Très Riches Heures* during the plague (*The "Très Riches Heures" of Jean, Duke of Berry*, facsimile ed., New York, 1969, ff. 71v–72).

Guilhermy's references to martyrs under Aurelius, a guard condemning a person and scenes of a saintly bishop with a sepulchre, suggest Saints Gervasius and Protasius, the cathedral's patrons. The clerical figures in the Detroit panel could represent a fragment of the procession where St. Ambrose, bishop of Milan, brings the relics of the saints into his cathedral. Window 104 also probably contained the panels from the story of St. Blaise now in the Musée Marmottan and the St. Nicholas panels now in the Cloisters (Grodecki 1960, pp. 163–8; Childs in *Occasional Papers*, pp. 25–33, figs. 1, 2). Although an association of these cycles with Detroit's panel cannot be ignored, Blaise and Nicholas legends do not normally contain scenes of processions; the legend of Gervasius and Protasius, where the honoring of relics figures prominently, does include such scenes (Beaven 1989).

Color: Both clerics wear white albs. The first cleric's cloak is a deep red. Bright warm yellow glass is used for the censer, cross, broach of the first cleric and shoes of the second. The first cleric's shoes are a deep warm purple (murrey), quite typical of the Soissons region.

Technique: The panel consists of pot-metal glass. The modeling is achieved via three distinct shades of grisaille mat and trace line, literally a "text-book" illustration of the method described by the twelfth-century monk, Theophilus (see General Introduction). The painting is most noticeable in the garment of the cleric on the right. The deep "v" shaped folds are constructed through a light application of mat, followed by brush strokes of a medium value starting at the bottom of the folds, and all outlined by a dense application of trace.

Style: The two figures of clerics preserved in Detroit demonstrate an extremely attractive painting style of the High Gothic era in France (see Grodecki and Brisac, 1984, pp. 33–48). This expression has been linked to contemporaneous developments in painting, metalwork, and sculpture, and frequently given the term "antiquising" because of its evocation of ancient Roman styles of modeling. The Ingeborg Psalter (Florens Deuchler, *Der Ingebourg Psalter*, Berlin, 1967), the work of Nicholas of Verdun, (e.g. the

Klosterneuburg Altarpiece: dated 1181 in Otto Demus, "Nicholas of Verdun", *Encyclopedia of World Art*, 10, London, 1965, cols. 634–40), and the sculpture of the "classical" master at the cathedral of Reims (Sauerländer 1974, pp. 54–5, figs. 202–3, 485, col. pl. p. 55) are oft-cited touchstones for this expression.

The Detroit panel must be readily recognizable in the context of other extant glass from Soissons despite the few windows surviving in fragmentary condition in the cathedral and in a number of collections in the United States and Europe. The hemicycle of the choir shows four windows: *Tree of Jesse*, panels *in situ* and in the Pitcairn Collection, Bryn Athen, Pa.; a *Last Judgment*, a *Creation and Fall*, and *Life and Glorification of the Virgin*. The ambulatory contained legends of saints. The *Martyrdom of Saints Crépin and Crépinien* is now in the Corcoran Art Gallery, Washington, D.C., and one original panel from the cycle remains in the first window to the south of the axial chapel. A window of *Relics of Saints Crépin and Crépinien* is found in the first radiating chapel to the south of the axial chapel. The *Life of Saints Nicasius and Eutropia* (see above, **History of the glass**) is divided between the Louvre and the Isabella Stewart Gardner Museum, Boston. Panels from

DIA 1/fig. 4. *Scene from the life of St. Nicholas*, from Soissons Cathedral, 1207–12. New York, Metropolitan Museum of Art, Cloisters Collection

the Legend of St. Blaise are now in the Musée Marmottan, Paris (Grodecki 1960 and Childs in *Occasional Papers*). All appear to date from about 1205–25 and are the product of a single workshop.

Beaven associates the Detroit panel with a painter she has called the "Master of the Bishop's Legends" whom she believes was responsible for the panels of St. Blaise in the Musée Marmottan. The three panels of the Blaise cycle, *Blaise preaching to a Group of Women*, *A Man brought before a seated King*, and *The Saint's Arrest*, despite restorations, display the same brilliant clarity of form and sophisticated drapery rendering, especially the differentiation between the broader scoop folds of the heavier mantles and the more fluid, thinner pleats of the tunics (see *Legend of St. Blaise*: Grodecki 1960, figs. 10–12, including a possible complement of an Angel carrying a Soul, and Childs in *Occasional Papers*, fig. 6). The "Master of the Bishop's Legends" also is given responsibility for the panels of the *Life of St. Nicholas* in the Cloisters Collection (DIA 1/fig. 4). Beaven suggests that the painter's hand is still identifiable in the high clerestory windows of the choir, for example the panels of Habacuc and "Senizin" in the Walters Art Gallery, Baltimore, dated by Caviness about 1210–25 (Caviness in *Checklist* II, p. 57). The panels have been heavily restored, primarily through amplification of the composition to approximate complete units in the High Gothic style. The extant original glass, however, is of superb quality. Moreover the evidence of a technique that employs small, thin pleating of the garments and an energetic movement of drapery across the body links the Blaise series and the Detroit panel, and testifies to the unity and longevity of the glazing program of the Soissons choir.

The Soissons glass can be associated with a number of significant glazing programs: windows of the chevet and east and north roses of the Cathedral of Laon (France *Recensement* I, pp. 162–3, figs. 87–8); Chartres Cathedral, north nave aisle, window of St. Eustache; and Saint-Quentin Cathedral, windows in the chapel of the Virgin, *Life of the Virgin* and *Infancy of Christ*, about 1200 (Louis Grodecki, "Le Maître de St. Eustache de la cathédrale de Chartres," *Gedenkschrift Ernst Gall*, eds. M. Kühn and Grodecki, Berlin, 1965, pp. 171–94); Baye, Château (Dominique Daguenet, "La chapelle du Château de Baye et ses vitraux," *CA*, 135, 1980, pp. 627–46; France *Recensement* IV, pp. 325–6); Abbey Church of Orbais, fragment of a crucifixion (Naomi Reed Kline, "The Stained Glass of the Abbey Church of Orbais," Ph. D. Dissertation, Boston University, Ann Arbor, MI, 1983, pp. 100–1, 151–6); Cathedral of Troyes, axial window of the Lady Chapel, and Notre Dame of Dijon, lancets under the north rose (Raguin 1982, pp. 92–8).

The longevity, from about 1205 at Laon and Soissons to well into the 1230s at Dijon, and extremely wide geographic range of this style suggest that we are dealing with broad-based stylistic concepts embraced by more than one

workshop. If it were one workshop, one would have to allow for a succession of master painters and assistants and the specific contextual and programmatic demands of each site as mitigating factors of stylistic identity.

Date: Barnes has argued convincingly that the choir of the cathedral was begun in 1197 or 1198. (Barnes 1967, p. 136). A commemorative tablet from the cathedral's consecration is dated 1212. By 1212, certainly, the canons were in possession of this portion of the building, evidence of a well-supported building campaign. The importance of the construction and the similarity of the Soissons glazing styles to the work of 1205 at Laon suggests that the glazing program was underway as the edifice was under construction. Beaven further suggests that the window of St. Blaise might have been commissioned immediately after 1205 as a means of commemorating the 1205 transfer of relics of the saint from Constantinople under the authority of Soissons's Bishop Nivelon de Cherizy. Bishop Nivelon played a pivotal role in the leadership of the Fourth Crusade, for example as one of the six French electors (among six Venetian) and spokesperson during the election of the emperor (Villehardouin, *The Conquest of Constantinople* in *Joinville and Villehardouin: Chronicles of the Crusades*, (trans.) Margaret R. G. Shaw, New York, 1963, pp. 53, 96, 129; Claude Dormay, *Histoire de la ville de Soissons. . .etc.*, 2, Soissons, 1664, pp. 167–72, 183–9). The cathedral's *Ordinary* notes the relics of Blaise brought by Nivelon on his return to Soissons in 1205 (Alexander-Eusebius Poquet ed., *Rituale Suessionense*, Paris, 1856, pp. 268–70 [ff. 211–3]; Dormay, ibid., pp. 185–6). The relics included the upper portion of the skull of St. Blaise and one of his ribs for the cathedral and a large portion of his arm for the Church of St. Jean of Soissons.

The similarities in the Detroit and St. Blaise panels suggest that the Detroit window could date from the same period, after the arrival of the relics and before the dedication, therefore between 1205 and 1212.

Photographic reference: DIA Neg. no. 29470 (1986/01/27)

DIA 2. Ornamental Boss
England, Canterbury, Christ Church Cathedral, Trinity Chapel, ambulatory window s: VI, Miracles of St. Thomas Becket, panel 51
Shortly before 1207 or 1213–20.
Circle: diameter: 28.5 cm (11¼ in)
Accession no. 58.190, gift of Lillian Henkel Haass
Ill. nos. DIA 2, 2/a, 2/figs. 1–2

History of the glass: During the eighteenth and nineteenth centuries the glass in window s: VI was subjected to considerable interventions (Caviness 1981, p. 205). Parts of

the border and three demi-rosettes were moved to a south transept window (s: XXVIII) by the 1790s. By 1897 panels had also been transferred to a window in the south side of the Trinity Chapel (s: II) and to openings in the triforium level of the south choir aisle. Only in 1920 were the disparate panels reunited in their present opening. The Detroit boss, however, appears to have remained in commerce (see Canterbury *Border* MDGA 1). The stock books of Thomas & Drake, New York, record the panels as having been in the Dendy Sadler Collection. Thomas sold it in 1924. It was subsequently acquired by Julius H. Haass, Grosse Pointe, and passed to Lillian Henkel Haass upon his death. She presented it to the Detroit Institute of Arts in 1958. [Medieval Treasury]

Description/Original location: The boss consists of a foliate quatrefoil within a circle, which once occupied the interstices between the round central figurative medallions of a window in the south ambulatory of the cathedral's Trinity Chapel. A modern copy now fills the position immediately below the uppermost medallion, although it is possible that the bosses could have changed place during the numerous reworkings of the panels. (DIA 2/fig. 1) The narrative scenes in s: VI present Becket's intervention in effecting the rescue of John of Roxburgh from drowning, the resurrection of Warin (?), the cure of Constance, a nun of Sixtwold, and the cure of the child Gilbert, son of William le Brun.

History of the building: Christ Church, Canterbury, occupied an important position in English ecclesiastical and architectural history from its foundation in the fifth century. Bishop Lanfranc constructed a completely new church around 1070 whose eastern end was rebuilt around 1100.

DIA 2/a.
Restoration chart

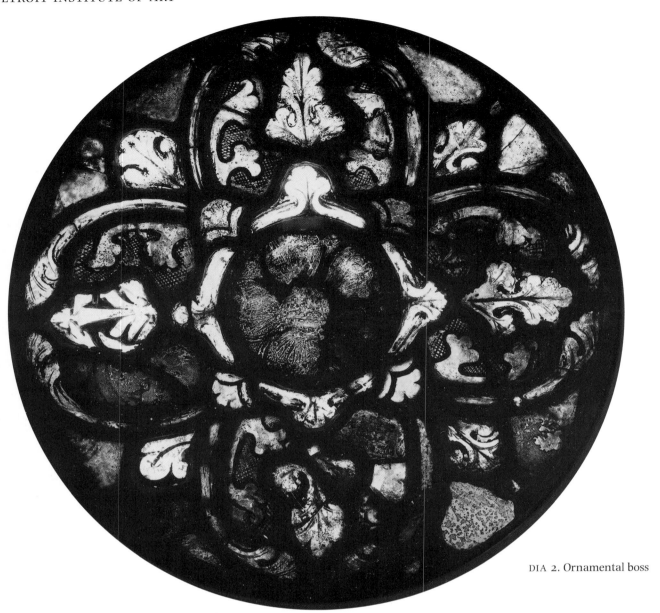

DIA 2. Ornamental boss

This was the building in which Thomas Becket was murdered in 1170 by agents of King Henry II. In 1174 a fire destroyed the eastern portions of the church and new construction began in September 1175. Due to the rising popularity of Canterbury's martyred bishop, work proceeded quickly and the first campaign was directed by a French architect, William of Sens. After the architect's fall from a scaffold in 1178 and subsequent return to France, William the Englishman directed the work. The south ambulatory of the Trinity chapel with the stonework around window s: VI was completed in under seven years, about 1182 (Caviness 1977, p. 26). See also contemporary accounts by Gervase of Canterbury (*Tractatus de Combustione et Reparatione Cantuariensis Ecclesiae* in *Gervasii Cantuariensis Opera Historica* [Rolls Series 73], ed. W. Stubbs, 1, London, 1879, pp. 19–29). The stained glass, however, due to a number of financial and political impediments was probably postponed until 1199 when the monks were preparing

the cathedral for the translation of Becket's relics. In 1207 work must have been interrupted, since under the Interdict against King John the monks went into exile in France, returning only in 1213. The translation of the Becket's relics finally took place in 1220, by which time the ambulatory windows appear to have been in place.

Bibliography

UNPUBLISHED SOURCES: Grosvenor Thomas Stockbook ms no. I, 78–9, item no. 952; Madeline Caviness, verbal communication.

PUBLISHED SOURCES: Bernard Rackham, *The Ancient Glass of Canterbury Cathedral*, London, 1949, pp. 61, 78, 103, 113; id., *The Stained Glass Windows of Canterbury Cathedral*, Canterbury, 1957, pp. 47–68; Hayward 1970, pp. 226–7; Caviness 1977, pp. 94, 154, Append. fig. 2; Caviness 1981, pp. 205, 315; Barnet 1986, p. 41; Raguin in *Checklist* III, p. 157.

Condition: The center of the boss is a fourteenth-century stopgap. Some pitting and abrasion mar the legibility of the panel, but the core is essentially intact. It is very possible that the boss retains its original leading, demonstrating a typically meticulous complexity of its early thirteenth-century date. The painting in some areas is unusually well preserved, for example the cross hatching that profiles the leaves at the side.

Color: The boss is defined by a white circle with bright cool blue ground to the inside and red in the corners outside. A foliate circle of white frames a now missing leaf cluster: from the white stems emanate four bright cool green leaves. Four pairs of bright rose-purple acanthus stems curl to meet and form a quatrefoil (Caviness 1981, similar description, p. 204).

Technique: The glass is entirely of pot-metal and uncolored glass. The grisaille paint is applied in several levels of wash tones and a trace line to articulate details. The painting is quite fine, with evidence of meticulous attention to painting refinements. The construction of the central leaves, for example, shows a double trace line. A solid cross hatching in the background to profile the leaves at the side further enriches the boss.

Style: The original disposition of the Detroit panel (DIA 2/fig. 2) can be seen in the examples from window s: VI still in the cathedral (Caviness 1981, figs. 334 and 336). In the center of the circle is a bright rose-purple leaf cluster framed in white. The rose-purple leaves repeat the curving forms of the green leaves of the outer quatrefoil. Despite the loss of the central element, the Detroit example in its extant circle of leaves conveys the delicacy and brilliance of the later style of an extremely inventive and well-supported early Gothic workshop.

In the absence of a sculptural program the windows at

DIA 2/fig. 1. Canterbury Cathedral, Trinity Chapel, ambulatory window s: VI, detail of panels 14–16

DIA 2/fig. 2. Canterbury Cathedral, Trinity Chapel, ambulatory window s: VI, restoration chart

Canterbury assumed a particular importance for they carried the entire weight of the iconographic program. They display, in addition, extremely high quality and an extraordinary sensitivity to the integration of decorative and narrative elements. The richly worked backgrounds, such as that exemplified in the Detroit panel, act as visual links between the patterned framework and the self-contained medallions.

Detroit's panel must be seen in the context of four other windows of the same glazing campaign – n: III, n: II, s: VII and s: II – by an artist whom Caviness labels the Jordan Fitz-Eisulf Master after the events recounted in window n: II (Caviness 1981, pp. 192–9; Caviness 1977, pp. 93–5). Two of the four show foliate bosses placed in central interstices between a series of vertically aligned round medallions. The system presented by window s: II comes closest to the Detroit boss, showing fronds arranged in a quatrefoil pattern leaving considerable open space for a contrast of solid background (Caviness 1981, fig. 331). The bosses in n: IV present similar circular patterns but employ a significantly denser leaf form (Caviness 1981, fig. 251 and Caviness 1977, fig. 185).

Date: Caviness dates this series to just before the exile of 1207 or after 1213 and the return of the monks to Canterbury. The figural style, medallion patterns, and ornament show continued relationships with those at Sens, where Caviness suggests the workshop produced four impressive windows of the north nave (Caviness 1977, pp. 83–100). They thus demonstrate the workshop's continued evolution. Figural style undergoes more overt transformation over time, due to changes brought by painting styles of different artists and the influence of the specific models chosen by, or presented to, the workshop. Ornament is more resistant to change, however, being more closely connected to shared workshop habits. The boss is a product of the workshop but may be firmly dated only to the total span of its activity, before 1207 or 1213–20.

Photographic reference: DIA Neg. no. 29727 (1986/05/12)

DIA 3. Half-figure of John the Baptist*
Poland, Torun, Church of Our Lady Mary the Virgin
Late fourteenth century
Circle: diameter: 33.7 cm (13¼ in)
Accession no. 55.33, Gift of John L. Booth
Ill. nos. DIA 3, 3/figs. 1–9

History of the glass: The panel showing an image of John the Baptist can be traced to the church of Our Lady Mary the Virgin in Torun, Poland. Textual sources of the beginning of the eighteenth century give some general indica-

* Catalogue entry in collaboration with Helena Malkiewicz, Corpus Vitrearum, Poland

tions about the windows then *in situ: intus variis picturis sacris diversi coloris, more antiquo et insignes vetustarum familiarum civitatis nobilium—-exornatas* (within are various sacred pictures of different colors in the ancient style and furnished with the insignia of ancient noble families of the city: J. H. Zernecke, *Thornische Chronica*, Berlin, 1927, p. 10). Most of the original fourteenth-century glazing program was damaged or destroyed through a series of natural and human events; this includes hurricanes in 1737 and 1774 and battles during the Napoleonic wars in 1806 and 1813. In 1819 and 1898 a number of panels were taken down and reinstalled in the chapel of the Teutonic Knights in Malbork. Several were described (Semrau 1892, p. 51): (i) single segment with a red and blue star pattern in flat filets on a grisaille ground; (ii) two segments showing the Virgin of Sorrows (DIA 3/figs. 6–7); (iii) two segments double lancet with the Man of Sorrows (DIA 3/fig. 6); (iv) two segments with architectural canopies.

In 1822 a description of the church in Torun (Semrau 1892, pp. 50–1) had listed extant panels: (i) in the choir, to the right where the small organ is located, an angel with a heraldic shield; (ii) over the altar of Our Savior [south aisle] a heraldic shield; (iii) over the altar of St. Anne [south aisle] below, a small heraldic shield, in the middle, the figure of a saint juxtaposed with twelve complete registers of arabesque designs; (iv) over the altar at the end with the large crucifix [south aisle], two heraldic shields below, architecture further up, then the Madonna, and higher two saints; (v) over the altar of St. John of Nepomuk [placement unknown] a large Madonna and below associated images; (vi) at the beginning of the choir stalls, windows, approximately 30 feet high and four to five feet wide, with 21 registers of ancient stained glass; (vii) in the top of the axial window five heraldic shields; (viii) two small panels in the window to the left of the high altar. Other descriptions followed. Semrau (1892, pp. 51–2) noted three heraldic shields from the fourteenth century just below the tracery in the second window of the northern wall of the choir, an angel holding a shield with a housemark, and several canopies and grisailles in a star pattern. Heise (1889, pp. 284–5) also noted, and illustrated, the grisailles in a star pattern and enumerated the panels (now in the Museum of Torun, described below) in the tracery of the window of the west facade.

During the restoration of the church at Torun and the execution of new windows between 1890 and 1916, the remainder of the original glazing was taken down and panels placed in the Museum of Torun and at the chapel at Malbork (DIA 3/fig. 6). Probably at this time, 1898–1900, several panels, including DIA 3, found their way to the art market. Three architectural panels (DIA 3/fig. 9) appear to have been conflated to form a single element now in the Schnütgen Museum in Cologne (Brigitte Lymant in

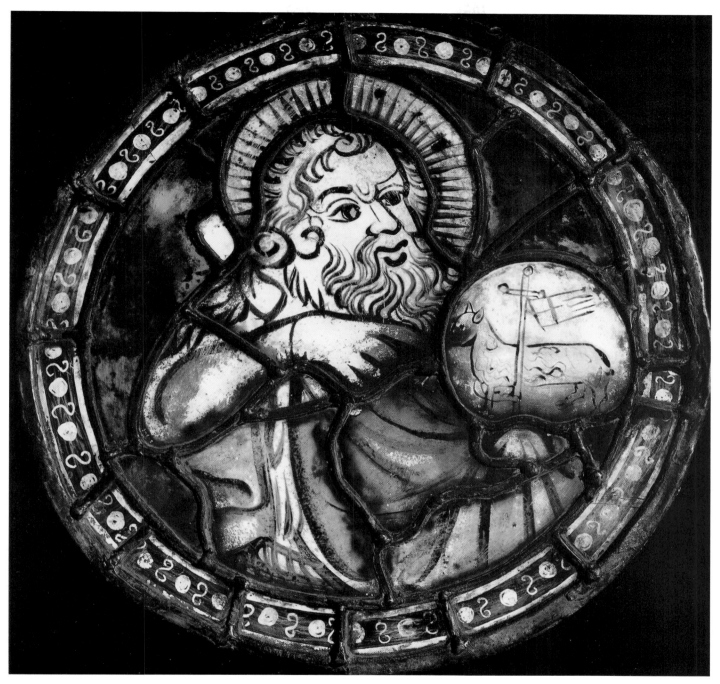

DIA 3. *Half-figure of John the Baptist*

Die Parler und der schöne Stil, p. 514; id., 1982, pp. 74–7, Inv. Nr. M 609, fig. 44, col. pl. 4). It had been purchased by the Kölner Kunstgewerbemusum in 1908, with its provenance recorded as the Church of Our Lady in Thorn. The date of arrival on American shores or previous provenance for the panel of John the Baptist has not been discovered. The DIA files record that the panel was in the possession of John L. Booth of Grosse Pointe, Michigan, and that he presented it to the Museum in 1955. [In storage]

Related material: A round medallion showing the image of John the Evangelist (DIA 3/fig. 1) also from the church of Our Lady Mary the Virgin, now in the Museum of Torun, forms a pendent to the Detroit panel.

Origin: The precise date of the execution of the windows for Our Lady Mary the Virgin is not known. The archival sources of the *Liber scabinorum Veteris Civitatis Thorunensis* mention only the names of the glass painters (*gleser*) active in Torun at the end of the fourteenth and at the beginning of the fifteenth centuries: Nicholas, Gunther, Sigismond, and Petir. From the second half of the sixteenth century until 1724, the church was occupied by the Protestants. At this time heraldic panels of the nobility

DIA 3/fig. 1. *Half-figure of John the Evangelist*, from Torun, Church of Our Lady Mary the Virgin, late 14th century. Museum of Torun

of the city were executed. Conserved in part, they are visible today in the lower portions of the windows, especially in the south aisle of the nave.

At present the museum of Torun contains fifteen fragments (Edward Kwiatkowski, "Witraze gotyckie z Torunia i Chelmna w zbiorach Muzeum u Toruniu," *Rocznik Muzeum u Toruniu*, 1, 1962, pp. 111–12, 130–3; id. and Jerzy Frycz, "Sredniowieczne witraze warstatow torunskich," *Acta Universitatis Nicolai Copernici. Zabytkoznawstwo i Konserwatorstwo 6. Nauki humanistyczno-spoleczne*, 77, 1977, pp. 106–11, figs 11–16).

1. Half figure of the *Virgin of Sorrows* [very probably highly overpainted] (DIA 3 /fig. 7), taken from Malbork, 66 × 50.5 cm (26 × 19⅞ in)

2. Panel of architecture, taken from Malbork, 66 × 50.5 cm (26 × 19⅞ in)

3. Figure of a prophet [very probably highly overpainted], 42.5 × 33.5 cm (16¾ × 13¼ in)

4–7. Four heraldic shields 40–42 × 33–44 cm (15¾–16½ × 13–17¼ in)

8. Circular panel of John the Evangelist (DIA 3/fig. 1), 32 cm (12⅝ in)

9–14. Fragments from the tracery of the east facade window: head of Christ, St. Peter, St. Paul, prophets Enoch (DIA 3/fig. 2) and Isaias [or Elias?], and *Ascension of Mary Magdalene*. It is possible that the two prophets are Enoch and Elias [Elijah], who are prophesied to return to earth during the Last Days, and convert the unbelieving. See description of the two witnesses of Apocalypse 11 in commentaries by Hrabanus Maurus and Honorius of Autun

(Adolph Katzenellenbogen, *The Sculptural Programs of Chartres Cathedral*, New York, 1964, p. 25).

15. Unidentified fragment.

History of the building: The construction of the present church of Our Lady began after the former Franciscan abbey, the third to build on the site, burned when Torun caught fire in 1351. Begun *c.* 1370, the building saw the vault of the choir completed towards 1380, the eastern facade before 1386, and the western facade *c.* 1400 (C. Steinbrecht, *Thorn im Mittelalter. Ein Beitrag zur Baukunst des deutschen Ritterordens*, Berlin, 1885, p. 36; Heise 1889, pp. 267–91; Z. Nawrocki, "Pofranciszkanski kosciol NMP w Toruniu. Proba rekonstrukcji dziejow budowy," *Zeszyty Naukowe Uniwersytetu Mikolaja Kopernika w Toruniu. Nauki humanistyczno-spoleczne*, z. 21. *Zabytkoznawstwo i Konserwatorstwo* 1, pp. 47–80; T. Mroczko, *Architektura gotycka na Ziemi Chelminskiej*, Warsaw, 1980, pp. 296–303, 308–12). Our Lady Mary the Virgin is an impressive example of a Hall church (DIA 3/figs. 3–5), giving prominence to the windows as decorative features. The architectural style emphasizes linear elegance and the decorative elements derive from the repetition of the tall narrow lancets, the line pattern of the ribs of the vault, and the insistent vertical sweep of the proportions of the nave and choir. A flat

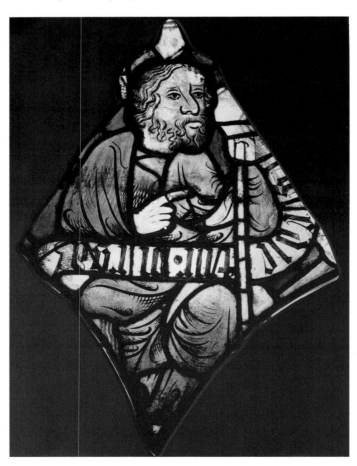

DIA 3/fig. 2. *Enoch*, east window tracery light, from Torun, Church of Our Lady Mary the Virgin, late 14th century. Museum of Torun

DIA 3/fig. 3. Church of Our Lady Mary the Virgin, from south-east, Torun, 1370–1400

DIA 3/fig. 5. Church of Our Lady Mary the Virgin, cross-section through nave, after Heise, *Die Bau- und Kunstdenkmäler der Provinz Westpreussen*

eastern wall of the church houses a five-lancet window, the largest of the building (DIA 3/fig. 5). The stained glass was coordinated with the building style, adopting a band window format. Lymant sees these architectural systems influenced by the art of both the Upper Rhenish workshops around Cologne and those of the south and southeastern limits of German speaking lands of Saxony, Thuringia, and Austria. In the 1370s and 80s these developed into a pan-European form associated with the so-called "Parler style" whose centers were Nuremberg, Erfurt, and Vienna (Lymant in *Die Parler und der schöne Stil*, p. 514; id. 1982, pp. 74–7, Inv. Nr. M 609, fig. 44, col. pl. 4).

Reconstruction: The Church of Our Lady contained 26 windows of varying heights up to 20 meters. Each window contained three lancets, with the exception of the chevet window of five (DIA 3/fig. 5), and that of the western facade of four. Since today only eighteen panels remain, the reconstruction of an iconographic program is tenuous.

DIA 3/fig. 4. Church of Our Lady Mary the Virgin, plan, after Heise, *Die Bau- und Kunstdenkmäler der Provinz Westpreussen*

It is possible, however, to suggest a decorative format for the glazing. With the exception of a typological or narrative window in the chevet, the windows were probably of grisaille, similar to that suggested for the Franciscan church at Esslingen. The extant panels and nineteenth-century evidence (DIA 3/fig. 6) suggest a star pattern for the design. In the nave, in addition to ornamental windows,

DIA 3/fig. 6. *Virgin of Sorrows and Man of Sorrows*, from Torun, Church of Our Lady Mary the Virgin, installation in Malbork, Church of the Teutonic Knights, after 1898, before 1945

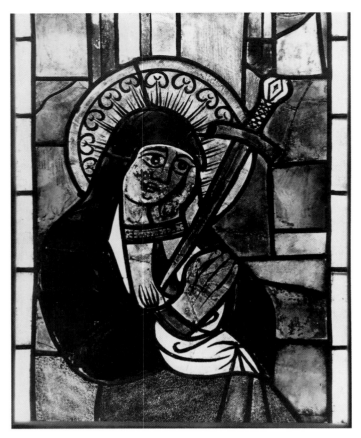

DIA 3/fig. 7. *Virgin of Sorrows*, from Torun, Church of Our Lady Mary the Virgin. Museum of Torun

there were figures under architectural canopies. The window of the apostles from the Cathedral of Erfurt dates from 1390 to 1400 and exemplifies this type (Erhard Drachenberg, *Die mittelalterlichen Glasfenster im Erfurter Dom. Corpus Vitrearum, Deutsche Demokratische Republik*, 1/2, Berlin, 1980, pp. 230–52). The proposed band windows at Torun (DIA 3/fig. 8) may have included heraldic shields within grisaille grounds, prophets under canopies, saints under canopies, and possibly grisaille decorative terminations.

The circular panels of the two Saints John may be the ones cited by Heise (1889, p. 284): *noch in dem östlichen Fenster auf der Nordseite des Langhauses zwei kleine Figuren von ähnlicher Anordnung erhalten* "two small figures of similar disposition still in the easternmost window of the north side of the nave." The panels may have originally been a part of a window filled with circular medallions. It is more likely, however, that the central section of the window had contained a figure bordered by grisaille patterns and the panels of the two Saints John had been placed at the bottom section of the window (DIA 3/fig. 8). The extant panels that once filled the lancets, such as the panel of architecture and the *Virgin of Sorrows*, now in the Torun Museum are approximately 50.5 cm (19⅞ in) wide. Since the circular panels of the two Saints John are 32–33 cm. wide, they could not have completely filled a lancet. This corroborates the supposition that they were con-

ceived of as bosses accenting formally and iconographically the termination of a predominantly grisaille window, or at least one in a band window design of figures and grisaille.

Bibliography

UNPUBLISHED SOURCES: Helena Malkiewicz, Corpus Vitrearum, Poland; provenance: suggestions from Jane Hayward and Ernst Bacher, Corpus Vitrearum, Austria; editing: Hanna Buczynska-Garewicz, College of the Holy Cross, Worcester Mass.

PUBLISHED SOURCES: A. Semrau, "Die Grabdenkmäler der Marienkirche zu Thorn," *Mitteilungen des Coppernicus-Vereins für Wissenschaft und Kunst zu Thorn*, 7, 1892; J. Heise, *Die Bau- und Kunstdenkmäler der Provinz Westpreussen*, 2, *Die Kunstdenkmäler des Kulmerlandes und der Löbau*, 6, Stadt Thorn, Danzig, 1889; Frantisek Matous, *Mittelalterliche Glasmalerei in der Tschechoslowakei, Corpus Vitrearum Czechoslovakia*, Prague, 1975; *Die Parler und der schöne Stil 1350–1400*, 2, Cologne, 1978; Raguin in *Checklist* III, p. 157.

Description: A half-figure of John the Baptist holds and points to a disk inscribed with the sign of the Lamb of God.

Condition: A uniform light weathering crust appears on the exterior surface of all glass segments. Much of the trace paint appears to have been retouched, presumably by a restorer in the early twentieth century.

Iconography: John the Baptist, with long unkempt hair and beard, holds in his left hand a circular shield bearing the image of the Lamb of God. He points to the image with his right hand, a gesture that indicates that he is the precursor. The gesture visualizes the biblical text, "I indeed baptize you in water unto penance, but he that shall come after me is mightier than I, whose shoes I am not worthy to bear" (Matt. 3:11). The position of the Baptist in the Detroit panel is quite similar to the image of the saint from the cloister of the Cistercian monastery of Ossegg,

DIA 3/fig. 8. Reconstruction of window containing panels of *St. John the Baptist* and *St. John the Evangelist*, Church of Our Lady Mary the Virgin

Czechoslovakia, dated to the second half of the fourteenth century, and now in the Prague Museum of Decorative Arts (Matous 1975, pp. 80–1, col. pl. III). Both figures hold the shield in a drapery-cloaked left hand, while gesturing vigorously with the right arm.

The image of the Lamb of God as the representation of the triumphant Messiah was established in the early Church. Christ is the Pascal Lamb, whose blood marks his people just as the blood of the Pascal lamb marked the door posts of the Israelites (Exodus 12). The Lamb reappears triumphant in the Book of Revelation set in the midst of the Heavenly Jerusalem and worshipped by the saints. The banner is the vexillum, the banner of victory carried by the Roman legions, and adopted by the early Christians as the true concept of the cross, the mark of Christ's victory over death. See the sixth-century hymn by Fortunatus, *Vexilla Regis*, sung throughout the Middle Ages during Good Friday liturgies.

The juxtaposition of John the Evangelist and John the Baptist was not uncommon. The Baptist was the last of the Old Testament prophets and the Evangelist was the first of the New Testament prophetic voices, demonstrated by his visions in the Apocalypse. Contemporaneous depictions in Torun suggest that they were frequently viewed as complements at this time. They were the titular saints of the church of John the Baptist and John the Evangelist, and appear in a wall painting in the chevet with both saints flanking the face of Christ. The two Saints John are present in a panel painting from the retable of the high altar of the Church of Our Lady Mary the Virgin, whose windows are under discussion. The panel, now in the National Museum in Warsaw (*800 Jahre Franz von Assisi. Franziskanische Kunst und Kultur des Mittelalters*, Krems-Stein, 1982, pp. 599–603, pl. 41), depicts a mystic crucifixion. Christ is surrounded by the Tetramorph, below him is the Pascal Lamb, and within close proximity, the personifications of the Synagogue to the left, and the Church to the right. To the right, St. John, with banderole and extended chalice with host, gestures as if he is explaining the doctrine of the Eucharist, the bloodless sacrifice of the Sacrament, to the Synagogue who holds a dismembered goat. To the left of the kneeling and seemingly contemplative church, John the Baptist holds a broad scroll and points vigorously to the Pascal Lamb.

Color: The color is characterized by predominantly warm hues of low intensity and of medium value. The background is a medium brownish green and the image of the saint and lamb a warm light brown. The halo is a medium value yellow, as is the border of the panel.

Style: A comparison with the circular panel of John the Evangelist in Torun affirms the identity of the work. Both panels shows the same simple border of circles alternating with reverse S shaped marks. The figures are both pre-sented half-length and both Saints John carry the same type of circular badge. The painting is expressive, favoring vigorous brushstrokes and simple outlining of features. Very little modeling in depth is attempted; rather the excitement of the work rests in the energetic pattern of line animating the surface. Particularly noticeable in the image of the Baptist is the concentration of energy toward the center of the face as brows undulate inward and meet with the strongly profiled nose. The image is extremely legible. The simplicity and directness of the painting style allow for immediate identification of the rustic physiognomy of the saint, the upheld disk of the Lamb of God, and the gesturing hand.

The artistic circle of the windows in the Church of Our Lady Mary the Virgin is certainly Bohemian. The general tendencies of this style is already apparent in the image of John the Baptist from Ossegg, Czechoslovakia, cited above as an iconographic parallel. The windows of the church of St. Procopius in Nadslav, Czechoslovakia, dated after 1370 (Matous 1975, pp. 55–61, figs. 36–8, 41–3) are also similar. Although the Nadslav windows show similar simplicity and provincial conventions of simple trace-lines for the broad features and clear, legible images, the draftsmanship is far calmer than that of the Torun glass. The great luminary of the Bohemian style is the artist known as Master Theoderich, court painter of the Emperor Charles IV, and responsible for the decoration of the Chapel of the Holy Cross in Karlstein (Jaroslav Pesina in *Die Parler und der schöne Stil*, pp. 758–63). Charles IV, Emperor from 1346 to 1378, was the son of John of Luxembourg, king of Bohemia, and born in Prague in 1316. The era of Charles IV saw a great consolidation of Imperial power and rise of prestige for the principalities and countries of Eastern Europe (Vlasta Dvorakova, Josef Krasa, Anezka Merhautova, and Karel Stejskal, *Gothic Mural Painting in Bohemia and Moravia 1300–1374*, London, 1964, esp. pp. 41–70). Master Theoderich's work was a part of this artistic renewal, a development that was to continue to influence artistic expression until well into the fifteenth century. Examples of Theoderich's art is found in the Apocalyptic Elder from the Chapel of the Holy Cross, Karlstein, about 1360 and a panel painting of the Evangelist St. Matthew about 1365, formerly Karlstein, now Narodni Gallery, Prague. The head of Enoch from the tracery of the west window of Torun and the Detroit John the Baptist show many similarities to the prototypes of Master Theoderich. The faces are similarly organized around broad noses with undulating bridges, rounded tips, and flaring nostrils, dominant horizontal brows, creases across the forehead, and very large bulbous eyes with prominently defined upper and lower lids.

Other parallels include a panel showing apostles from the high altar of the Church of Our Lady, Rathenow (Rathenow, St. Marien-Andreas, Rathenow Lutheran Church Assoc-

DIA 3/fig. 9.
Architectural canopy,
from Church of Our
Lady Mary the Virgin.
Cologne, Schnütgen
Museum

distinctively long, curved, and broad. The lips appear to protrude, framed by a beard that follows the slope of the face. The distinctive clumps formed by the hair of beard in the Torun figures are repeated in the altarpiece. The soft folds of the garments are also similar to the style of the Bohemian masters, where all curves are brought together into undulating harmonies.

Two panels from the Burrell Collection, Glasgow, show strong similarities to the Detroit roundel. The figures have the same bold stylization, simplified graphics, and rustic facial type as Detroit's John the Baptist. They share common concepts of restricted space and emphasis on energetic communication with the viewer. Wentzel suggested that the *Man of Sorrows* and the *Bishop Saint* come from a late fourteenth-century Austrian program (Burrell Collection 45.473 and 45.474, from the collection of Theodor von Auspitz, Vienna, purchased at Sotheby-Parke-Bernet, London, April 27, 1954, Lot 83, Inv. nos. 566 and 567 [Hans Wentzel, "Unbekannte mittelalterliche Glasmalereien der Burrell Collection zu Glasgow; 3 Teil," *Pantheon*, 19/3, 1961, p. 246, figs. 7, 8]).

Date: The date of the panels are determined by the construction dates of the church, 1370–1400, but probably towards the later date due to the presumed location of the windows in the nave.

Photographic reference: DIA Neg. no. 10775

iation: Edith Fründt in *Die Parler und der schöne Stil*, pp. 542–3). executed by a Bohemian Master probably between 1360 and 1370, contemporaneous with the beginnings of the construction of Our Lady Mary the Virgin in Torun. Rathenow is in the Old Province of Brandenburg, north of Thuringia and abutting Poland on its western border. The apostles show similar concepts of figure and decorative design as the windows from Torun and the panels of architecture in the Schnütgen Museum (DIA 3/fig. 9) and the Museum of Torun may be compared with the canopies over the apostles. The altar shows segmented vaults, decorated pediments with exuberant finials, and projecting windows in radical perspective. The same play of shifting loci appears in the image on opaque or translucent surface; focus changes as forms appear at first to move forward, then on a second glance to move back. Manipulation of perspective in glass and panel painting creates intersecting patterns of hue and value sculpting the planar surface. The gold background of the panel functions in a manner similar to the intense hues of the stained glass, pulling and pushing the viewer's eyes into a pattern that interweaves figure, frame, and space. Facial similarities are also similar. The brows are horizontal, or even depressed, the eyes large and deeply set, and the nose

DIA 4. The Three Marys
Germany, Boppard-am-Rhein, Carmelite Church, North Nave, Tree of Jesse Window
1444
Rectangle: 147.3 × 73.7 cm (58 × 29 in)
Accession no. 40.52, Founders Society Purchase, Anne E. Shipman Stevens Bequest Fund
 Ill. nos. DIA 4, 4/a, 4/figs. 1–7; Col. pl. 7

History of the glass: The panel was originally part of a series of windows created between 1440 and 1446 for the new north nave of the Carmelite Church of Boppard-am-Rhein. After the Napoleonic invasion of the Rhineland in the early years of the nineteenth century, the monastery, like others in the area, was secularized. The church then belonged to the town of Boppard, which, in about 1818, sold the windows to Count Hermann Pückler of Muskau (Lymant 1982, p. 105). Written accounts at the time of the Spitzer sale of 1893 state that the count planned to reinstall the glass in the family chapel of his estate at Muskau on the Polish border. The project was never realized, and all but a single window remained in packing crates. At his death in 1871, his heir, Count Pückler-

DIA 4. *The Three Marys*

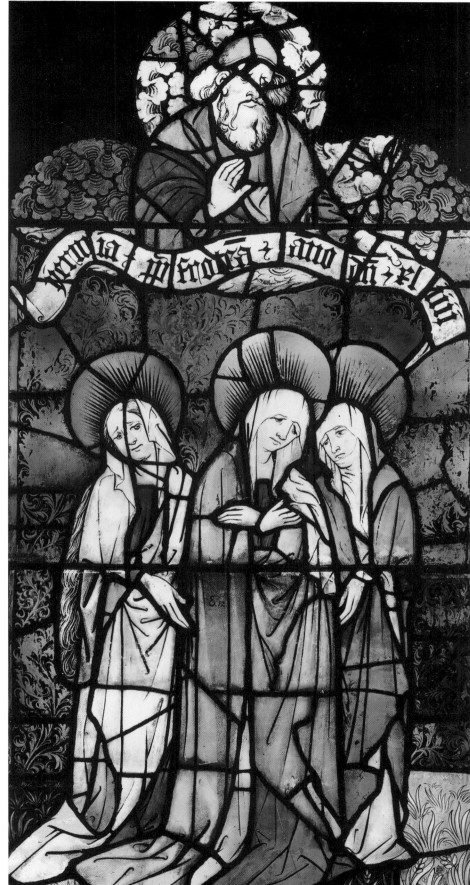

DIA 4/a. Restoration chart

Branitz of Muskau sent the glass to the Königliche Institut für Glasmalerei, Berlin, for restoration. It is probable that after the restoration all of the Pückler-Branitz collection of Boppard windows was purchased by Friedrich Spitzer of Paris. The sale catalogue of Spitzer's collection (*Spitzer Sale 1893*, no. 3359), describes the panel as the Virgin accompanied by "Two Holy Women". After the sale the panels were widely dispersed. The Detroit panel of *The Three Marys* is known to have been in the possession of A. Huber of Zurich before its purchase in 1940 from the

dealer Seligmann Rey & Co. of New York for the Detroit Institute of Arts by the Founders Society from the Anne E. Shipman Stevens bequest. (Fischer 1913, pl. opp. p. 49, mentions that the panel was in the possession of A. Huber. The DIA files record that the panel was purchased from Seligmann). [German Gallery]

Related material: See below, **Iconographic program**, Tree of Jesse Window.

History of the building: The Carmelites are first noted in Boppard in 1262, making the foundation, after that of Cologne, the second oldest in the Rhineland. About 1300 construction of the present church as a large, single-aisled structure was begun. The choir was completed with its vault toward 1330. The nave was begun in mid-century, originally with a timber roof, but about 1420/30 replaced by vaults. From 1439 through 1444 the nave was expanded by the addition of a north aisle (DIA 4/figs. 1, 2), the site of the now dispersed Boppard glass (Freiherr von Ledebur 1988, pp. 330–1).

Reconstruction: The panel is presumed to have been a part of a Jesse Tree window in a series of windows set in the north nave of the building (Hayward 1969, pp. 75–114). The program was carried in windows that consisted of two superimposed sets of three lancets each (DIA 4/fig. 3). Hayward elaborated a convincing hypothesis that places the donors Siegfried von Gelnhausen and his wife at the base and then the recumbent figure of the sleeping Jesse extending over all three lancets (DIA 4/fig. 3). In an unusual format that Hayward argues related to the Carmelite devotion to the Immaculate Conception, the scenes of the *Passion of Christ* are grouped around scenes of the *Life of Mary*. The central panels, arranged as the "stem" of the tree, all possess red backgrounds. The vertically arranged program begins with the *Birth of the Virgin*, *Annunciation*, *Visitation* (DIA 4/fig. 4), and *Nativity of Christ* (DIA 4/fig. 5) below the culminating image of the *Crucifixion* (lost). To the left and right, against blue backgrounds, are the Passion events. Reading from the bottom, left, are the *Agony in the Garden*, *Christ before Pilate*, *Mocking of Christ*, *Carrying of the Cross*, and *The Three Marys*. The Detroit panel was balanced on the right by the panel of *St. John and Longinus* (John 19:34), witnessing the Crucifixion, now in a private collection, Rhode Island. Reading then from top to bottom on the right, would have been the *Deposition*, *Entombment*, *Resurrection* and the unusual scene of *The Triumphant Christ appearing to Peter*.

The Passion window of the church of St. Dominic in Altthann, Alsace, (DIA 4/fig. 6), dated about 1430–50, has both iconographic and stylistic parallels to the general disposition of the Boppard program and to the Jesse Tree window in particular (Bruck 1902, pl. 48). The window presents the narrative in a triple lancet arrangement of tall rectangular panels without borders. Similar subjects,

DIA 4/fig. 1. Carmelite Church, Boppard-am-Rhein: plan, 1439–44, after Hayward
DIA 4/fig. 2. Carmelite Church, Boppard-am-Rhein: the north nave

DIA 4/fig. 3. Reconstruction of *Tree of Jesse* window, Boppard-am-Rhein, after Hayward

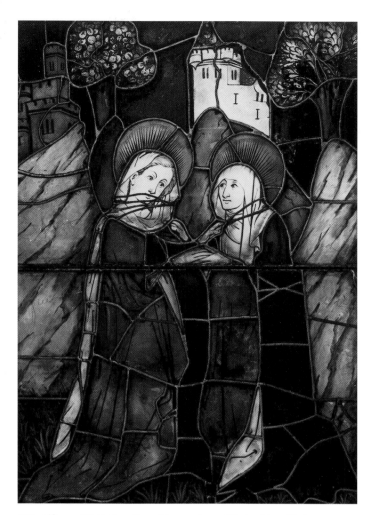

DIA 4/fig. 4. *Visitation*, from Boppard-am-Rhein. New York, Metropolitan Museum of Art, Cloisters Collection

for example, the *Agony in the Garden* in both windows share the similar motifs of Christ kneeling behind a wicker fence and angels showing him the signs of his future Passion. The upper register duplicates the reconstructed upper three panels of Boppard's *Tree of Jesse* window. In the center is the *Crucifixion*, to the left *The Three Marys*, and to the right *St. John and Longinus*. This is the only scene occupying three panels, and thus presents a compositional as well as ideological emphasis appropriate to the importance of Christ's redemptive sacrifice.

Iconographic program: The construction of the glass at Boppard occurs at precisely the time when reform movements were being introduced in the Carmelite Rhineland houses, beginning with the convents of Mörs in 1441 and Enghien about 1447 ("Carmelites," *New Catholic Encyclopedia*, 3, pp. 118–9). The Carmelites were an Order demonstrating a long standing devotion to the Virgin ("Carmes," in *Dictionnaire de Spiritualité*, 2, Paris, 1953, pp. 156–210). The Carmelite provincial, Petrus de Nova Ecclesia, had attended the Seventeenth Ecumenical Council held between 1431 and 1445 at Basle, Ferrara and Florence (Hayward 1969, p. 114, Appendix B). He added his voice to those of

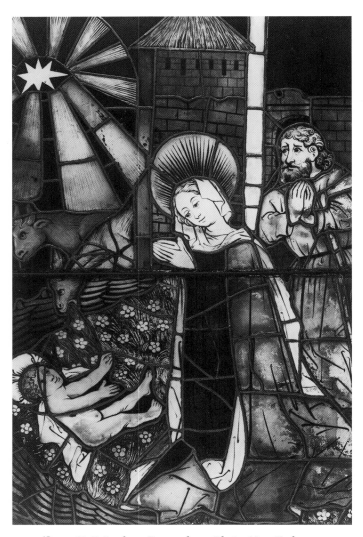

DIA 4/fig. 5. *Nativity*, from Boppard-am-Rhein. New York, Metropolitan Museum of Art, Cloisters Collection

other Carmelites arguing for the validity of Mary's Immaculate Conception, declared a universal feast by Alexander VII in 1661 and dogma by Pius IX in 1854. The themes of all the reconstructed windows of Boppard are emphatically Marian centered. Thus the unusual features of the Tree of Jesse window are more understandable when seen against the full iconographic program of Boppard's north nave. No firm written or archaeological evidence documents the program, so that it is unlikely that we will ever have complete assurance of the exact sequence of windows. Hayward (1969, p. 93) suggests a reconstruction that placed the Jesse Tree window in the first aperture on the north wall (n: IX). Internal stylistic and iconographic evidence, however, allows a plausible grouping of panels within windows:

Throne of Solomon [Hayward IV]. Known from a photograph by Kolb reproduced in Oidtmann (1912, pl. XVIII, fig. 400). It was installed during the nineteenth century in Muskau and destroyed in 1945 (Hayward 1969, p. 104. figs. 19, 28. Oidtmann 1929, figs. 418–21). The image of

DIA 4/fig. 6. Passion window, *c.* 1430–50, Altthann, Alsace, Church of St. Dominic

172

the seated Virgin that had been detached from this window is in the Hessisches Landesmuseum, Darmstadt (Beeh-Lustenberger 1973, p. 156). Hayward (1969, p. 85, n. 37) noted that nine additional panels once came to the United States. Four panels, showing three kneeling donors and three armorials presumably were in a private collection in Detroit before 1980 (present location unknown).

Ten Commandments [Hayward VII]. St. Elizabeth of Hungary with donor shields bearing the Imperial Eagle and panels showing Moses on Mount Sinai and the first five commandments are in the Schnütgen Museum, Cologne (Oidtmann 1912, pl. XVII; Lymant 1982, pp. 104–9, no. 60, Inv. no. M 596; Rüdiger Becksmann, *Deutsche Glasmalerei des Mittelalters: Eine exemplarische Auswahl*, Stuttgart, 1988, no. 43, p. 156). Panels of the sixth, seventh, ninth, and tenth commandments are in a private collection in Rhode Island (*Checklist* I, pp. 211–12; Hayward 1989, pp. 184–90, figs. 3–10; Naomi Kline, typescript of Corpus Vitrearum catalogue entry). A panel of the eighth commandment and the *Madonna clothed with the Sun* are in the Burrell Collection, Glasgow. John Dinkel (1971) made a reconstruction of the windows relating to the Burrell cycle based on photographs and drawings discovered in the collection of Robert Goelet, Newport, R.I.

Virgin of the Cornrobe [Hayward VIII]. The upper zone shows St. Servatius, the Virgin in Cornrobe (Ahrenkleide) and St. Lambert, and lower zone shows Saints Catherine, Dorothy, and Barbara. The windows are now in the Metropolitan Museum of Art, the Cloisters Collection (Oidtmann 1929, figs. 419, 420; Hayward 1969, figs. 1, 2; Hayward in *Checklist* I, pp. 118–19).

Protectors Window [Hayward X]. The upper zone shows St. Michael, now in the San Francisco Fine Arts Museums. (Hayward 1969, figs. 11, 22; Raguin in *Checklist* III, p. 83), and St. Cunibert and an unidentified bishop now in the Burrell Collection, Glasgow. (Hayward 1969, figs. 12, 13, 22; William Wells, "Stained Glass from Boppard-on-Rhine in the Burrell Collection," *Scottish Art Review*, 10/3, 1966, pp. 22–5). The lower zone contained Saints George and Quirinus now in a private collection in Rhode Island flanking the Virgin holding the Christ Child and a rose branch in a private collection, New York. Below the two side panels are the kneeling figures of the donors. Below St. Michael, are Cuno von Piermont and his sons and below St. Quirinus, Margarethe von Schönenberg, his wife, and their daughters (Oidtmann 1929, fig. 421; *Checklist* I, pp. 211–12).

"Bourgeois" Window [Hayward VI]. Lower zone, Saints James, Norbert, and Gerhard, formerly in the collection of William Randolph Hearst, then Glendale, Forest Lawn Memorial Park (Oidtmann, 1929, fig. 418; Hayward 1969, fig. 16; Hayward and Caviness in *Checklist* III, p. 62). The panels were severely damaged by fired in 1957, the inscription *ora pro me sactus [sic] Iacobus* and some ornament survive. Two small panels of Saints James and John,

and St. Agatha between a donor couple now in the Burrell collection, Glasgow (Wells 1966).

Tree of Jesse [Hayward IX] (DIA 4/fig. 3). All but the beard of the *Sleeping Jesse at the Base of the Tree*, Glendale, Forest Lawn Memorial Park, was destroyed by fire (Hayward and Caviness in *Checklist* III, p. 62). The *Visitation, Nativity, Deposition*, and *Entombment* are in the Metropolitan Museum of Art (Leland Fund, 13.64.1–4. Hayward 1969, figs. 5–8; Hayward in *Checklist* I, p. 120). *The Three Marys* is in the DIA. The *Resurrection, Christ before Pilate, Annunciation, The triumphant Christ appearing to Peter, Agony in the Garden, Birth of the Virgin* and the Von Gelnhausen donor panel are in the Burrell Collection, Glasgow. Dinkel (1971, pp. 22–5), however, suggested that the donor may actually belong to the Protectors rather than the Jesse window. The panel of *St. John and Longinus*, was discovered in 1987 in a private collection in Rhode Island (*Checklist* III, pp. 15, 282; Caviness 1994, p. 986, fig. 9), by Madeline Caviness, Naomi Kline and Virginia Raguin. The present location of the *Crucifixion* is unknown.

Life of the Virgin [?]. Hayward (1969, p. 104) suggested that the last window, for which we have no photographic or material data, probably contained the cycle of the *Life of the Virgin*, including her *Dormition* and *Coronation*.

Bibliography
UNPUBLISHED SOURCES: Jane Hayward, verbal communication.

PUBLISHED SOURCES: *Catalogue des objets d'art et de haute curiosité composant l'importante et précieuse collection Spitzer* [sale cat., 33 rue de Villejust, 17 April–16 June] Paris, 1893, supplement, "Vitraux" no. 3359; Josef L. Fischer, "Drei süddeutsche Glasgemälde aus der Mitte des 15. Jahrhunderts," *Zeitschrift für alte und neue Glasmalerei*, 1913, pl. opp. p. 49; Paul Frankl, "Das Passionfenster im Berner Münster und der Glasmaler Hans Acker von Ulm," *Anzeiger für schweizerische Altertumskunde*, NF 40, 1938, p. 242; Hans Wentzel, "Unbekannte mittelalterliche Glasmalereien der Burrell Collection zu Glasgow (3. Teil)," *Pantheon*, 19/5, 1961, pp. 240–9; Jane Hayward, "Stained Glass Windows from the Carmelite Church at Boppard-am-Rhein, a Reconstruction of the Glazing Program of the North Nave," *MMA Journal*, 2, 1969, pp. 75–115, figs. 9, 25; John Dinkel "Stained Glass from Boppard: New Findings," *Scottish Art Review*, 13/2, 1971, pp. 22–7; Barnet 1986, p. 41; Tutag and Hamilton 1987, pp. 17, 21, col. pl.; Alkmar Freiherr von Ledebur and others, *Die Kunstdenkmäler der Stadt Boppard [Die Kunstdenkmäler von Rheinland-Pfalz]* Munich, 1988, p. 342; Raguin in *Checklist* III, p. 157; Jane Hayward, "Neue Funde zur Glasmalerei aus der Karmeliterkirche zu Boppard am Rhein," *Bau- und Bildkunst im Spiegel internationaler Forschung* [Festschrift Edgar Lehmann], Berlin, 1989, pp. 190, 193; Caviness 1994, pp. 986–7, fig. 8; *DIA Guide*, p. 160, col. ill.

Inscription: *jermia pp frotea ano dn xliiii.* (The prophet Jeremias, in the year of our Lord [14]44).

Condition: There is considerable abrasion in the damascene blue background, and some replacements, as noted in the restoration diagram.

Iconography: The Three Marys, Mary the mother of Christ, flanked on the left by Mary Magdalene and on the right by Mary of Cleophas (John 19:25) stand together witnessing the Crucifixion. The Magdalene is recognizable by her long unbound hair with which she had dried Christ's feet after washing them with "ointment of great price" (John 12:3). Christ spoke to the disciples saying that the woman "is come beforehand to anoint my body for burial" (Mark 14:8). In the trefoil panel above, a bust-length prophet holds a banderole with an inscription "The prophet Jeremias, in the year of our Lord (14)44." Jeremias may very well have been selected for this scene because of the prominence given to mourning women in his prophesies, for example "Gird thee with sackcloth, O daughter of my people, and sprinkle thee with ashes; make thee mourning as for an only son" (Jer. 6:26), or "call for the mourning women, ... let our eyes shed tears, and our eyelids run down with waters. For a voice of wailing is heard out of Sion" (Jer. 9:17–19).

The prophecies of Jeremias are part of the *Biblia Pauperum* iconography for the two scenes directly below the mourning women, *Christ is Mocked* [-c-] "I am made a derision to all my people" (Lam. 3:14) and *Christ carries the Cross* [-d-] "But I was as a meek lamb, that is carried to be a victim" (Jer. 11:19). Jeremias's prophecies are also set against the image of *Christ pierced with the Lance* [-f-] "All ye that pass by the way attend, and see" (Lam. 1:12), and earlier, for the *Massacre of the Innocents* [g] "A voice was heard on high of lamentation, of mourning" (Jer. 31:15 and, rephrased, Matt. 2:18; Henry 1987, pp. 62, 94, 95, 99). For greater discussion of a *Biblia Pauperum* structure of Old and New Testament concordances, see DIA 5–16.

Color: Blue dominates the panel. The light warm blue of the Virgin's mantle and the deep blue damascene background frame the white and gold of the figure to the left, and the white and scarlet robes of the figure to the right.

Technique: The panel is constructed of predominantly pot-metal and uncolored glass. Silver stain is confined to the yellow coloring of the Magdalene's hair. The application of grisaille is typical of this style, emphasizing the traceline as a thin linear element. Under raking light one discerns a considerable use of modeling tones in the faces which often disappears in strong transmitted light.

Style: The early scholarship on *The Three Marys* panel associated it with the circle of the Master of the Bessererkapelle, in the cathedral of Bern (Fischer 1913). Frankl (1938) continued to cite Fisher's suggestion, although he

had been unable to inspect the glass since he describes the panel's whereabouts as unknown. Wentzel (1961, pp. 244, 248) identified the panel in Detroit as being a part of the Boppard series and connected to the glass in the Burrell collection, Glasgow, as well as locations in Cologne, New York, and Darmstadt, allowing it to become part of international attention. It now is securely dated and placed within a large ensemble during a brilliant period of glazing history.

The Boppard glass takes its place in the context of the extraordinary production of glazing programs of the Late Middle Ages in the Rhineland. Hayward (1969, pp. 107–13) seconded by Lymant (1982, 107–8), identified two separate workshops responsible for the Boppard nave program. One is more influenced by the trends in Cologne connected to the sophisticated French court tradition of the turn of the century, around 1400. This workshop figures in Rode's identification of the Boppard standing figures of window VIII (37.52.1–6 MMA-CC, Hayward in *Checklist* I, pp. 118–19) with the Gnadenstuhl window produced about 1420–30 for the church of the Augustinian Canons, Cologne, now in the cathedral (Rode, "Das Gnadenstuhlfenster im Kölner Dom," *Kölner Domblatt*, 18/19, 1960, pp. 107–20). The color harmonies favor predominantly pale colors offset by smaller, intense areas of pot-metal hues, and sequences of figures under arcades. The effect is more courtly and languid, as opposed to the energetic narrative style of Detroit.

The workshop responsible for the Detroit panel and the panels related to the Jesse Tree window in the Metropolitan Museum, emphasizes lively, effective narrative, contrasting pot-metal and uncolored glass and parallel compositional devices. Volume is achieved through a single layer of smear shading modified by stipple, and a rubbing off to blend edges with the lighter color of the glass. A vigorous and varied trace line cuts sharply across eyelid, nose, or drapery fold producing a highly exciting calligraphy over the surface of the glass. These panels share the regional style employing shorter body types and round heads with plump cheeks, curly hair, and large facial features. The compositions are densely packed, with fully saturated colors bringing the action across the surface. The profusion of decorative patterns in the backgrounds, frequent use of inscribed banderole, and organic or architectural frames produce a highly charged and engaging field.

The style is connected to the expressive tendencies of the Upper Rhenish school. Rüdiger Becksmann (*Deutsche Glasmalerei des Mittelalters: Voraussetzungen – Entwicklungen - Zusammenhänge*, Berlin, 1995, pp. 175–6, no. 61) suggests the center as either Koblenz or Mainz. The production included a wide area, now spread over several countries, that includes contemporaneous programs in the following churches:

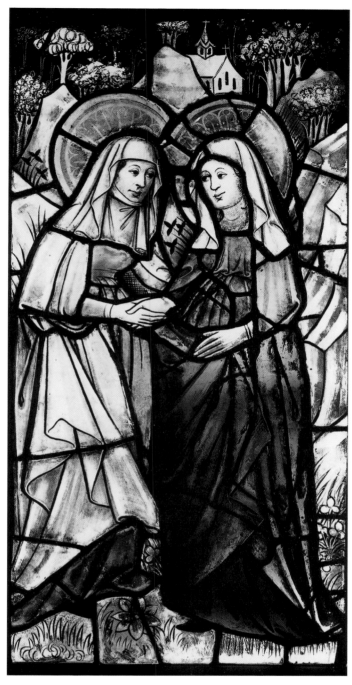

DIA 4/fig. 7. *Visitation, c.* 1440, from Partenheim, Church of St. Peter. Darmstadt, Hessisches Landesmuseum

France, Alsace: Thann, St. Theobald, *c.* 1440 (Bruck 1902, pls. 50, 52; Hayward 1969, fig. 32); Altthann [Vieux-Thann], St. Dominic, Passion window *c.* 1430–50 (Bruck 1902, pl. 48) and Schlettstadt, St. George *c.* 1430 (Bruck 1902, pl. 49).

France, Lorraine: Zetting (Setting), St. Marcel [formerly church of the Fourteen Auxiliary Saints] 1425–50 (*Vitrail en Lorraine*, pp. 40–3, 375–9, no. 159, col. pl. p.156; Beeh-Lustenberger 1973, pp. 152–3, pl. 136; Marieluise Hauck, *Die Glasgemälde der Kirche von Zettingen, Lothringen* in *Bericht der Staatlichen Denkmalpflege im Saarland*, 17,

1970, pp. 117–234, and separately published, Saarbrücken, 1970.

Germany Rhein-Hessen: Partenheim, St. Peter, *c.* 1440 (Beeh-Lustenberger 1973, p. 130, nos. 180–205; Hayward 1969, p. 107, fig. 33).

Switzerland, Canton Aargau, Zofingen, St. Maurice, *c.* 1410–20? (Hayward 1969, p. 107, fig. 26); Staufen, parish church: dated from 1419 to about 1433, (Michael Stettler and Emil Mauer, *Kunstdenkmäler der Kanton Argau*, 2, *Der Bezirk Lenzburg*, Basle, 1953, pp. 214–4, figs. 199–206.

The Visitation from Partenheim (DIA 4/fig. 7) contemporaneous with Boppard's glazing, is virtually identical to the same subject from Boppard now in the Metropolitan Museum (DIA 4/fig. 4). The Virgin and St. Elizabeth lean towards each other framed by a rocky landscape on either side and, in the distance, diminutive architecture and trees silhouetted against a dark sky. The Passion window from Altthann (DIA 4/fig. 6), discussed earlier for its iconographic parallels to the *Tree of Jesse* window, shows the same highly charged compositions and surface tension. The linear accents, so striking in folds of the garments of *The Three Marys*, appear again in the delineation of the robes of Christ in the *Agony in the Garden*, or the figures witnessing the Crucifixion. Although one cannot posit a workshop identity for any of the programs cited and the Boppard glass, it seems clear to assume the region of the Upper Rhine supported large glass painting workshops during the first half of the fifteenth century, and that the Boppard painters developed their compositional, painterly, and iconographic predispositions in this context.

Date: The date of the glazing is assured by both documentary evidence and the inscription in *The Three Marys*. The 1444 consecration of the north section of the building is recorded in a document now in the Trier Stadtarchiv Nr. 328 (1694), reproduced in full in Hayward's analysis of the program (Hayward 1969, p. 114; M. Keuffer-Kentenich, *Verzeichnis der Handschriften des hist. Archives Trier*, Trier, 1914, p. 176ff).

Photographic reference: DIA Neg. no. 30121

DIA 5–16: PROPHETS AND PSALMISTS AFTER THE "BIBLIA PAUPERUM"*

Germany, Cologne, St. Cecilia workshop
c. 1470

History of the glass: Viewed within the setting of the Gothic chapel of the Château of Lannoy, Herbéviller, in the Museum's second floor (Col. pl. 46), the series of late fifteenth-century prophets forms one of the most memorial experiences for the visitor. The windows were given officially to the museum in 1949 by Mrs. Ralph Harman Booth. The history of their acquisition, however, reveals a long-range plan of Ralph Harman Booth, First President of the Arts Commission of the City of Detroit, serving from 1919 to 1930, and his wife, Mary. A gift from the Booths to the museum had facilitated the purchase of the Late Gothic chapel of Lannoy at Herbéviller in 1922, which was installed when the new building of the Museum opened in 1927 (see DIA 33–34). From the outset, the Booths appear to have projected the eventual purchase of suitable glass to fill the chapel windows. The fulfillment of the plan rested with Mary Booth, Ralph Harman Booth having died in 1931, while he held the post of the United States Minister to Denmark.

The twelve panels of prophets were secured in 1947 via the intermediary of Dr. Ernst Scheyer, Associate Professor of the History of Art at Wayne State University who served as private curator of the Ralph and Mary Booth Collection at the Booth home in Grosse Pointe. Dr. Scheyer was aided in locating suitable panels by Dr. Paul Wescher of Switzerland (Robinson 1949?, p. 3). The *Sidney* sale of 1937 described this series as "twelve central medallion portraits from a Stem of Jesse Window, decorated in colours with the various characters with inscriptions on scrolls, about 12 in. by 11 in. – oval – German – fifteenth century – inset in leaded panes as windows." An annotated catalogue of the sale notes that the panels were purchased by an individual named Frank. Robinson wrote that Dr. Scheyer bought the pieces from a dealer in Zurich, presumably Frank, who stated that the pieces had been in the collection of F. E. Sidney of Moreton, Holly Place, Hampstead, London. The twelve medallions are described as "inset in leaded panes as windows" in the Sidney catalogue, confirming that the prophets had been detached from their original settings and placed as roundel inserts into quarried windows, possibly even serving an architectural purpose in Sidney's house. The windows were removed from this setting, either by Frank or even later after their purchase for the Detroit Institute of Arts. The current setting of grisaille strapwork was provided in late 1947 by the Philadelphia studio of Henry Lee Willet and the restructured windows were installed in February 1948 (correspondence between Henry

* Catalogue entry in collaboration with Naomi Reed Kline

Lee Willet and Mary Booth, 15 February 1949 [Willet Archives]). Shortly after the installation Francis W. Robinson produced a short pamphlet for the Detroit Institute of Arts, "The Gothic Chapel of the Detroit Institute of Arts," and suggested that the windows were fifteenth century. He thought they came from the upper traceries of a German church, perhaps from the city of Nuremberg.

Related panels (same program):
Victoria and Albert Museum, London: C77–1919 SOPHO-NIAS (DIA 5–16/fig. 1). *Inscription:* "*In die resurrectionis getes.*" Prophesy for the Resurrection. (i) [Vulgate: *In die resurrectionis meae congregabo gentes*]: In the day of my resurrection (my judgement is) to assemble the gentiles. Sophonias 3:8.

Virginia Museum of Fine Arts, Richmond: 68.9.8 (1–2) DAVID (DIA 5–16/fig. 2). *Inscription:* "*Davit gtritu et huntiatum ds no dispicies*" Prophesy for the Repentance of Mary Magdalene. (n) [Vulgate: *Cor contritum et humiliatum deus non despicies*]: A contrite and humble heart, O God, thou wilt not depise. Psalm 50:19.

Victoria and Albert Museum, London: C287–1928 DAVID (DIA 5–16/fig. 3). *Inscription:* "*David ascendie des i dns i voce tube*". Prophesy for the Ascension. (-o-) [Vulgate: *Ascendit deus in iubilatione et dominus in voce tube*]: God is ascended with jubilee, and the Lord with the sound of trumpet. Psalm 46:6.

Burrell Collection, Glasgow: 45/386 ZACHARIAS (DIA 5–16/fig. 4). *Inscription:* "*Zacarias dicite filie Sion Ecce rex tu viet tibi.*" Prophesy for the Presentation in the Temple. (d)

DIA 5–16/fig. 1. *Sophonias.* London, Victoria and Albert Museum

DIA 5–16/fig. 2. *David*. Richmond, Virginia Museum of Fine Arts

[Vulgate: *Ecce ego venqio et habitabo in medio vestri*]: Behold I come, and I will dwell in the midst of thee. Zacharias 2:10.

Iconography: The prophets once belonged to a typological program based on the forty-page blockbook model of the *Biblia Pauperum*. (Heitz and Schreiber 1903, p. 18). The texts in the banderoles are extremely close to those of the program installed between 1490 and 1517 in the monastery of Hirsau, west of Ulm in Southern Germany (Becksmann 1986, pp. 77–96, 366–8, 375–96). Although the monastery was burned by the French in 1692 the monks

left extensive descriptions, beginning in 1579, of the subject matter of their cloister's windows. The following chart compares the program of the Detroit panels, and two additional panels identified in the Victoria and Albert Museum and the Virginia Museum of Fine Arts with the Hirsau glass and the forty-page blockbook. The references are based on the recent facsimile edition of the blockbook (Henry 1987).

DIA 7.	David	Ps. 71:10	HIR III	*BP*(c)
RM.	David	Ps. 50:19	HIR XIII	*BP*(n)
DIA 9.	Ezechiel	Ez. 18:22	HIR XIII	*BP*(n)
DIA 8.	Prophet	Prov. 9:5	HIR XVIII	*BP*(s)
DIA 12.	David	Ps. 77:24.25	HIR XVIII	*BP*(s)
DIA 11.	Baruch	Bar. 4:25	HIR XIX	*BP*(t)
DIA 13.	Solomon	Prov. 19:29	HIR XXIII	*BP*(-c-)
DIA 14.	David	Ps. 21:17,18	HIR XXV	*BP*(-e-)
V&A	Sophonias	Sop. 3:8.	HIR XXIX	*BP*(-i-)
DIA 6.	David	Ps. 104:3	HIR XXX	*BP*(-k-)
DIA 5.	Osee	Os. 2:14	HIR XXXI	*BP*(-l-)
DIA 10.	David	Ps. 9:11	HIR XXXI	*BP*(-l-)
DIA 15.	Isaias	Is. 35:2	HIR XXXVI	*BP*(-q-)
DIA 16.	David	Ps. 121:3	*not included*—	

Although the twelve panels in Detroit reproduce the general iconographic disposition of the *Biblia Pauperum's* texts and images, the correspondences are not exact. The texts on the banderoles offer different contractions of phrasing and spelling. The prophets and kings are richly dressed in medieval costume, wearing crowns or hats, but the facial type and costume of the specified prophets in the printed

DIA 5–16/fig. 3. *David*. London, Victoria and Albert Museum

DIA 5–16/fig. 4. *Zacharias*. Glasgow, Burrell Collection

DIA 5–16/fig. 5. *Crucifixion*, from Netherlands *Biblia Pauperum*,
c. 1460. Boston, Mass., Boston Public Library

images do not match those of the same prophets in the glass. The Detroit panels reproduce figures found in each of the four locations of the printed page, on the left and right of the upper and lower frames (DIA 5–16/fig. 5), but do not retain any reference to a left or right orientation. It seems quite clear that the printed book was employed as a generic source for the program, but it was not in any sense reproduced on a one-to-one correspondence. The original extent of the program can be surmised by the breadth of the program for the Prophets and Psalmists. Given the inclusion of prophets from virtually the entire spread of the forty pages of the blockbook, one would assume that they once framed a very large series.

The lineage of the Detroit series is complex and rich. Images of Old Testament kings and prophets were standard features of Late Gothic glazing programs, especially in the area around Cologne. During the last half of the fifteenth century, the visual image of bust-length prophets with banderoles was the standard and almost obligatory accompaniment of any narrative Christological or typological cycle. Frequently, but not always, such figures formed part of a typological system such as that of the *Biblia Pauperum* where Old Testament figures and text frame a

systematized typological exposition of biblical scenes. The most comprehensive study of the genre is still that by H. Cornell (*Biblia Pauperum*, Stockholm, 1925). See also Hildegard Zimmerman ("Armenbibel," *RDK*, cols. 1072–84). Although the term, *Biblia Pauperum*, Bible of the poor, does not appear in the literature until the fifteenth century, the text itself can be dated to the first half of the thirteenth century and a considerable number of illustrated manuscripts date from the beginning of the fourteenth century. The earliest illustrated text contains 34 groups of images, each with one New Testament and two Old Testament images and four accompanying images of prophets. The set of correspondences and images became more standardized as it was copied. A manuscript dated 1330–40 from the cloister of St. Peter in Erfurt, marks an early definition of the work (Cod. Max 4, Hans van der Gabelentz, *Die Biblia Pauperum und Apokalypse der Grossherzogl. Bibliothek zu Weimar*, Strasbourg, 1912).

The *Biblia Pauperum* was one of the first subjects of the earliest printed books. Early chiro-xylographic editions, that is, blockbooks of images with handwritten text, date from shortly before 1450, and a decade later entirely printed editions appear, often in the vernacular (Arthur Hind, *An Introduction to the History of the Woodcut*, I, New York, 1963, pp. 236–40; *Biblia Pauperum, Facsimile Edition of the Forty-leaf Blockbook in the Library of the Esztergom Cathedral*, Budapest, 1967; *Biblia Pauperum: A Facsimile Edition of the British Library Blockbook C.9.d.2*, Pittsburgh, 1990; *Biblia Pauperum* (Facsimile Edition of MS 5 in the British Library), Lucerne, 1993; Robert Koch, "New Criteria for Dating the Netherlandish 'Biblia Pauperum' Blockbook," *Studies in Late Medieval and Renaissance Painting in Honor of Millard Meiss*, Irving Lavin and John Plummer, eds. New York, 1972, pp. 283–9; Nigel F. Palmer, "Junius's Blockbooks: Copies of the Biblia Pauperum and Canticum Canticorum in the Bodleian Library and their Place in the History of Printing," *Renaissance Studies*, 9/2, 1995, pp. 137–65). By the 1470s a very large number of examples of this text were current, texts of a lasting popularity, even as models for glazing programs of the early sixteenth century in the Rhineland. A window fragment of Jonah emerging from the mouth of the whale, conserved in the Schnütgen Museum, is dated about 1460–70 (Lymant 1982, pp. 97–9, no. 57, Inv.-Nr. 686). Lymant demonstrates that the image is based on the very same model as the *Biblia Pauperum* blockbook image of Jonah juxtaposed with the Resurrection. The Cistercian program in the cloister of Mariawald used the *Biblia Pauperum* blockbooks as models for both the iconography and for much of the imagery itself (Rackham 1944; CMA Introduction; CMA 16–17). Avril Henry has also explored stained glass from Cologne influenced by the Biblia Pauperum produced at a time similar that of the Detroit panels ("Acht spätmittelalterliche Glasmalereien aus Köln in der

Marienkapelle der Kathedrale von Exeter," *Kölner Domblatt*, 62, 1997, pp. 207–44).

Despite the devastations to glazing programs brought by iconoclasts of the Reformation and warfare and invasions of the nineteenth and twentieth centuries, a large number of still extant panels give us confirmation of the popularity in glass of the prophet format shown in the Detroit series. An early example is the bust of Moses preserved with two intact panels of episodes from the *Passion of Christ*, the *Carrying of the Cross* and the *Crucifixion* now in the Schnütgen Museum. Lymant localizes these panels to about 1420 from Cologne (Lymant 1982, pp. 77–82, nos. 45–7, Inv.-Nr. M 167 a, b, and 168). Moses holds a banderole with his name and the notation 22:6, a reference to the lines in Genesis describing Abraham placing the wood for the sacrifice on Isaac's shoulders. As with the inscriptions in many of the Detroit panels, the prophet named is not necessarily the one referred to by the specific text.

Many of these works are from cloisters programs. The glass from the cloisters of St. Cecilia in Cologne, dated 1460–70 possessed a series of prophets carrying banderoles with texts familiar from *Biblia Pauperum* representations (Lymant 1982, pp. 126–7, nos. 69 and 70, Inv.-Nrs. M 623 and M 635). Lymant also connects the head of an Old Testament king of 1465 formerly in the cloister of the Carthusian convent in Cologne, now in the Schnütgen Museum, with the *Biblia Pauperum* (Lymant 1982, pp. 117–18, no. 65, Inv.-Nr. M 626). The work, as yet unattributed and now in the German National Museum, Nuremberg, shows prophets located under arcades similar to but far more sophisticated than the blockbook's architectural frames. (Oidtmann 1926, pp. 382–3, fig. 564).

The cathedral's programs, although somewhat later, continue the tradition of prophet images. There is a constant use of the prophets in tracery during the first decade of the sixteenth century: the typological *Three Kings* window (n: XXIV), the *Tree of Jesse* (n: XXII), and the *Coronation of the Virgin* (n: XXV) (Rode 1974, pp. 193–7, 200–5). Fragments from other typological windows, now reset in the uppermost tracery light of the north transept (n: XVIII), have not been attributed to any specific origin (Rode 1974, pp. 168–70). An early sixteenth-century Cologne workshop was also responsible for a series of twenty prophets taken from ten pages of the *Biblia Pauperum* now set in the side chapel windows of King's College Chapel, Cambridge, England (window 42: Wayment 1988, pp. 179–89).

The popularity of such bust-length figures with banderoles, even in programs removed from Christological or typological systems, is attested by another German work in the collection of the Detroit Institute of Arts. The windows in the Carmelite church of Boppard-am-Rhein frequently show busts of God the Father or prophets carrying inscribed banderoles above scenes such as Detroit's *The* *Three Marys* (DIA 4) or the *Ten Commandments* now in the Schnütgen Museum, Burrell Collection, and Rhode Island collection.

Composition: The DIA series was originally located in tracery lights of either a cloister program or a multilight program in a church structure. All the inscriptions are in Gothic miniscules on banderoles carried by the figures, unless otherwise noted.

Condition: The panels exhibit some mending leads. Otherwise, they are in excellent condition with quite good paint adhesion and little corrosion of the glass.

Color: The backgrounds of predominantly medium shades of red and blue dominate the general tonality of the panels. They are set against large areas of uncolored glass modulated by a warm neutral vitreous paint. Touches of yellow in silver stain and warm bright yellows of pot-metal glass contribute to the warm tone. The red and blue contrast is modified by additional accents in the garments of the prophets. These vary from a cool blue-gray to bright light blue, to light red-purple, and deep bright green.

Technique: The figures are composed of pot-metal glass for backgrounds and some elements of the prophets' garments. Uncolored glass modulated by vitreous paint and silver stain, however, dominates the panels. The paint is applied in a variety of methods, from smooth, tonal washes, to stipple, to continuous lines. The paint was subsequently modified by lifting off with the end of a brush, quill, or needle or by smearing to blend the edges. The varieties of paint application, discussed in the following analysis of style, very probably can be linked to the separate painters in the workshop responsible for this series.

Style: The iconography leads us to assume a Cologne origin for this series, and stylistic affinities confirm this assumption. The Detroit panels relate to a large body of work produced in the region around Cologne in the latter half of the fifteenth century. Two additional panels of prophets from this same series have been discovered: the Virginia Museum of Fine Arts, Richmond, houses a figure of David (DIA 5–16/fig. 2) and the Victoria and Albert Museum, London, owns a panel of the prophet Sophonias (DIA 5–16/fig. 1).

The Rhineland supported extremely lavish glazing programs during this time, not only in the large expanse of window openings of Late Gothic naves and choirs, but in the cloisters, sacristies, and conventual buildings of the many monastic orders. For comparison, see *c.* 1460–70 prophets and biblical scenes from the Schwarzenbroich Kreuzbrüderkloster and the *c.* 1500 series of prophets and biblical scenes from the Cologne Kreuzbrüderkloster (Rüdiger Becksmann, "Die mittelalterliche Farbverglasung der Oppenheimer Katharinenkirche," in *Sankt Katharinen zu Oppenheim*, Oppenheim, 1989, pp. 390–3, figs. 27–30). The Cologne workshops developed a clarity of outline, precision

of modeling, and elegance of proportion that distinguish their work as some of the most visually appealing of its era. The Detroit figures demonstrate all of these qualities.

Three modes of execution appear in the Detroit series. Six of the figures, DIA 6, 8, 11, 12, 13, and 14, exhibit smear shading modulated by application of a stiff brush to lift off the mat, producing a smooth, metallic effect. Five panels, DIA 5, 7, 10, 15, and 16, show a softer, more fluctuating effect produced by line work favoring short strokes of the brush, including hatch and cross hatch marks defining the face and folds of the garments. The affinities in style correspond to the iconographic pairing. In the first group, prophets DIA 8 and 12 (*Solomon* and *David*) carrying banderoles with the texts associated with *The Last Supper*, and both presumably were from a window with that image. In the second group, panels DIA 5 and 10 (*Osee* and *David*) holds texts that link them to the image of the Risen Christ meeting with Mary Magdalene.

A single prophet from Detroit, *Ezechiel* (DIA 9), shows much the same modeling technique as that of second series, but a different mode of inscription, more uneven and lacking the characteristic upper and lower border lines found in the other eleven Detroit panels. The figure presents a more insistently three-quarter view, with head and torso aligned on the same axis. The image of *David* (DIA 5–16/fig. 2) in the Virginia Museum of Fine Arts, Richmond (Caviness in *Checklist* II, p. 195), repeats the same composition and style of inscription as Detroit's *Ezechiel* (DIA 9). This pair is also linked iconographically. The panels are both associated with the blockbook image of the Repentance of Mary Magdalene, and we may assume that they were once in the same window.

The panels include some interesting design interrelationships and connections to panels in collections in England and Scotland. The prophet C77–1919 in the Victoria and Albert Museum (DIA 5–16/fig. 1) can be associated with the second Detroit group. DIA 6 and 11 in the first series follow the same model, but do not use the same cut lines. DIA 5,

DIA 5–16/fig. 6. *Crucified Christ*, from Schwarzenbroich, Kreuzbrüder Cloister. Cologne, Schnütgen Museum

from the second series, reproduces the same model as that used by DIA 14, although their painting styles are totally unrelated. The model shared by these two is reproduced in a panel now in the Burrell Collection in Glasgow (DIA 5–16/fig. 4). The Glasgow panel shows much weaker draftsmanship and a more awkward and irregular lettering in the inscription. An additional panel (DIA 5–16/fig. 3) in the Victorian and Albert Museum (C287–1928) shows a model very similar to that followed by the preceding three, but reversed. The inscription, however, is in precisely the same style as the that of eleven prophets of the Detroit series, as evident in the comparison with the words *David* and *dus* in DIA 10. Such evidence leads one to posit a very large and busy workshop, one executing numerous commissions and where models were shared by a number of well trained and self-assured glass painters.

The workshop discussed above can be identified as the same responsible for a series of windows from the destroyed cloister of St. Cecilia in Cologne, a conjecture supported by Brigitte Lymant (letter dated Cologne 9 May 1987 to Raguin). This cloister series is widely dispersed but the majority of extant panels have been reset into two windows of the sacristy of the cathedral, now used as a Sacraments Chapel (Rode 1959, pp. 79–96; Lymant 1982, p. 121). Panels connected to the St. Cecilia cloister series or this workshop have also been identified in the Church of St. Catherine in Oppenheim (Oidtmann 1912, pp. 328–33, figs. 519, 520, and pl. XXXI), the parish church of Great Bookham [Surrey] (von Witzleben 1972, pp. 240–2, figs. 27–9), Trinity Cathedral in Cleveland (TC 1–2), and the Toledo Museum of Art (TMA 7). An additional connection can be drawn with the fragment of a *Crucified Christ* (DIA 5–16/fig. 6) from the Kreuzbrüder Cloister from Schwarzenbroich, now in the Schnütgen Museum, Cologne (Lymant 1982, pp. 118–22, no. 66, In.-Nr. M 35). These panels show similar facial types, figural proportions, and compositions but a variety of modelling techniques, similar to the variety of techniques evidenced in twelve panels now in Detroit.

A detail of St. John from the *Entombment* (DIA 5–16/fig. 7; TC 2/fig. 2) from a panel now in Great Bookham repeats a facial type and painting techniques familiar to the first group of prophets in Detroit. One finds the same sloping planes of eyebrow, cheek, and mouth, emphasis on outline, and the same smooth, metallic impression of the mat paint. The *Ecce Homo* panel (DIA 5–16/fig. 8) now in Cologne Cathedral, also shows strong similarities to the first Detroit group. The face of Christ and of Pilate repeat the Detroit characteristic of sharply defined planes. The garments of the first Jew to the right show the same smooth modeling achieved by brushwork removing the mat smear shading. The cathedral's panel of *Christ Before Pilate* (DIA 5–16/fig. 9) is more similar to the second group, displaying a softer modelling produced by slightly

DIA 5–16/fig. 7. *Entombment*, detail. Great Bookham (Surrey), parish church

more line work. The fragment of a *Crucified Christ* from Schwarzenbroich is even closer to the second group at Detroit, especially in the line and stick work removing mat in the hair and beard, similar to the techniques in the prophets DIA 15 and 16.

The St. Cecilia workshop has been associated with contemporaneous developments in panel painting of the Cologne area, notably the work of the Master of the Lyversberg Passion (Stange 1969, 5, pp. 37–46, fig. 86; Rode 1974, pp. 160–1). The extant side panels of the artist's altarpiece formerly in the Carthusian church of Cologne, now Wallraf-Richartz Museum (DIA 5–16/fig. 10), employ many of the same facial types, costumes, and figural proportions as the windows, but are far more restrained than their counterparts in glass. The scale of the windows and their exploitation of fluctuating transmitted light encouraged a greater clarity of form and a highly kinetic interplay of saturated colors and uncolored glass.

The original location of the Detroit prophets is unknown.

It is conceivable that the prophets had figured in the tracery lights of a cloister program such as that at Schwarzenbroich or another of the numerous monastic sites from the Cologne area. Zakin suggests that the cloister of the Kneuzbrüder in Cologne is a highly probably location for one of the series of panels associated with the St. Cecilia Cloister workshop (communication to the annual meeting of the Corpus Vitrearum, United States Committee, 13 January 1989; Zakin 1998). In the absence of the architectural setting for these panels, and the extremely fragmentary nature of this program, these suggestions remain speculative, if highly probable conjectures.

The analysis of these related panels contributes to our understanding of the nature of the late medieval workshop. It seems that the vast glazing programs of the Cologne area between 1450 through the early 1500s encouraged the development of production habits that involved the cutting up and reforming of the design and the circulation of models perhaps to other shops, and certainly the use of the same model by many different glass painters within a shop. An example of panels based on the same cartoon are prophets DIA 5 and 14. An example of panels based on the same model, but not exactly the same cartoon, are prophets DIA 6 and 11. The panel in Cologne Cathedral of *Christ before Pilate* (DIA 5–16/fig. 9) is repeated in Oppenheim; the panels at Great Bookham of *Christ carrying the Cross* and the *Crowning with Thorns* have replicas in Cologne Cathedral; the *Entombment* at Great Bookham is replicated in Trinity Cathedral, Cleveland, and in Cologne Cathedral (von Witzleben 1972, pp. 240–2, 244; Rode 1974, pp. 55, 160–1, 392, 395–8; TC2). On rare occasions we are fortunate to have detailed inventories such as those made for the Premonstratensian monastery of

DIA 5–16/fig. 8. *Ecce Homo*, from Cloister of St. Cecilia. Cologne Cathedral, Sacraments Chapel

DIA 5–16/fig. 9. *Christ before Pilate*, from Cloister of St. Cecilia. Cologne Cathedral, Sacraments Chapel

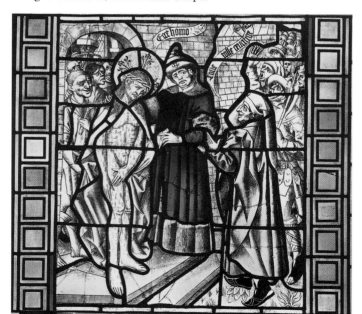

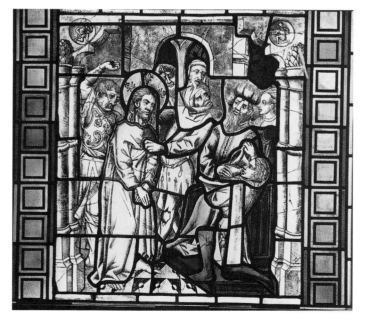

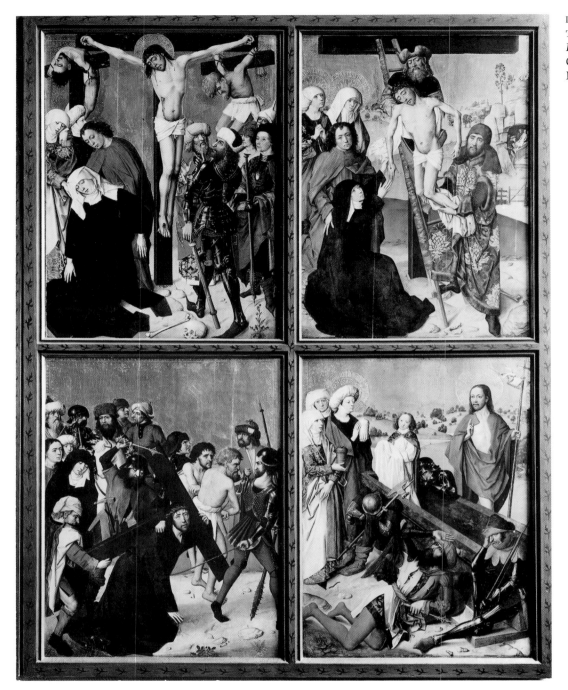

DIA 5–16/fig. 10. MASTER OF
THE LYVERSBERG PASSION:
Passion Scenes, c. 1420.
Cologne, Wallraf Richartz
Museum

Steinfeld, in the Eifel, adjacent to Cologne, in 1632 and 1719 (Willi Kurthen in Neuss 1955). With detailed verbal description of the panels before their dispersal, reconstruction is facilitated. Given the issues of the wide use of common print sources, common models and cartoons, replicated compositions, and numerous hands within a single shop, localization of program, and even dating is rendered much more problematic. (See discussions on workshops in the General Introduction.)

Date: Rode, Lymant, and Becksmann have associated a date of 1460–70 for the dispersed panels from the workshop associated with the Schwarzenbroich and St. Cecilia cloisters. These large workshops appear to have existed over a considerable period of time. The closeness of the Detroit Prophets to the panels from Cologne and Schwarzenbroich should argue for a date very close to 1470.

Bibliography

UNPUBLISHED SOURCES: DIA Curatorial files.

PUBLISHED SOURCES: *Catalogue of the Collection of English and Continental Furniture, Porcelain, and Objects of Art and Stained Glass formed by F. E. Sidney, Esq.* [sale cat. Christie, Manson & Woods, 9 December] London, 1937, p. 12, no. 74; Francis W. Robinson "The Gothic Chapel of the Detroit Institute of Arts," (DIA, 1949?); DIA *Bulletin,* 31/1, 1951–2, p. 75; Tutag and Hamilton 1987, p. 17; Raguin and Kline in

Checklist III, pp. 158–9, Kline and Raguin 1992, pp. 18–29; Neagley 1992, p. 8, fig. 117; *DIA Guide*, p. 161, col. ill.

[DIA 5–16 are all in the Chapel of the Château of Lannoy, Herbéviller, installed on the second floor of the Museum]

DIA 5. Osee (mislabeled Solomon)

Irregular circular shape: 33.66 x 28.58 cm
($13\frac{1}{4}$ in × $11\frac{1}{4}$ in)
Accession no. 49.535, Gift of Mrs. Ralph
Harman Booth

Ill. nos. DIA 5, 5/figs. 1–10

Inscription: *Salamo duca eu i solitudine et ibi loqr ad cor es* (Vulgate: *Adducam eam in solitudinem et ibi loquar ad cor eius.* Osee 2:14; Solomon: I will lead her into the wilderness and I will speak to her heart.)

Iconography: Prophesy for the *Meeting of Christ with Mary Magdalene* (-l-)

Photographic reference: DIA Neg. no. 7425 (1948)

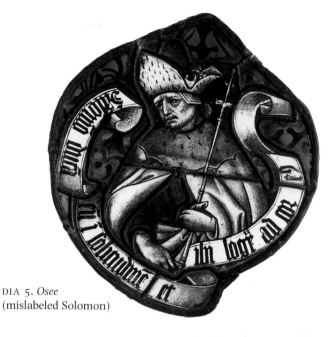

DIA 5. *Osee*
(mislabeled Solomon)

DIA 6. David

Irregular circular shape: 32.39 × 27.62 cm
($12\frac{3}{4}$ in × $10\frac{7}{8}$ in)
Accession no. 49.536, Gift of Mrs. Ralph
Harman Booth

Ill. no. DIA 6

Inscription: *David letet[.]a queretiu* (Vulgate: *Laetetur cor quaerentium dominum.* Ps. 104:3; David: Let the heart of them rejoice that seek the Lord.)

Iconography: Prophesy for the *Three Women at the Tomb* (-k-)

Photographic reference: DIA Neg. no. 7427 (1948)

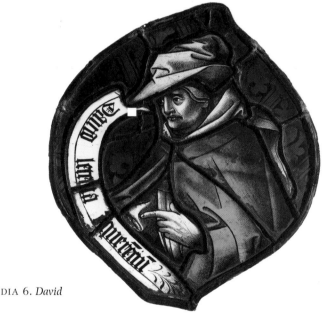

DIA 6. *David*

DIA 7. David

Irregular circular shape: 30.8 × 28.58 cm
($12\frac{1}{8}$ in × $11\frac{1}{4}$ in)
Accession no. 49.537, Gift of Mrs. Ralph
Harman Booth

Ill. no. DIA 7

Inscription: *David Reges tharsis et isule munea offeret* (Vulgate: *Reges Tharsis et insulae munera offerent.* Ps. 71:10; David: The kings of Tharsis and the islands shall offer presents.)

Iconography: Prophesy for the *Adoration of the Magi* (c)

Photographic reference: DIA Neg. no. 7430 (1948)

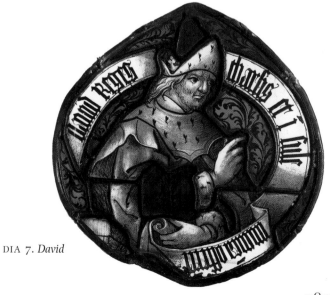

DIA 7. *David*

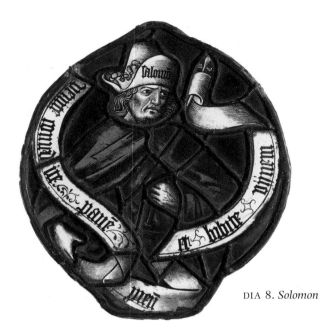

DIA 8. *Solomon*

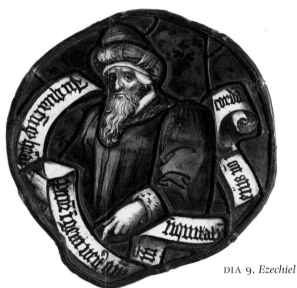

DIA 9. *Ezechiel*

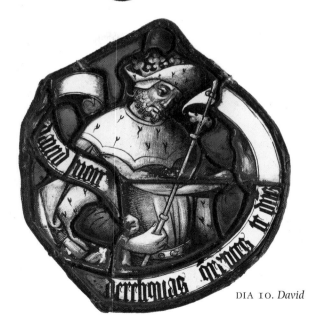

DIA 10. *David*

DIA 8. Solomon

Irregular circular shape: 32.39 × 27.94 cm
(12¾ in × 11 in)
Accession no. 49.538, Gift of Mrs. Ralph
Harman Booth

Ill. no. DIA 8

Inscription [on hat] *salomo* (Solomon); [on banderole] *venite comedite pane meu et bibite viinem* (Vulgate: *Venite comedite panem meum et bibite vinum.* Prov. 9:5; Come, eat my bread and drink the wine.)

Iconography: Prophesy for the *Last Supper* (s)

Photographic reference: DIA Neg. no. 7428 (1948)

DIA 9. Ezechiel

Irregular circular shape: diameter approx. 28 cm
(11 in)
Accession no. 49.539, Gift of Mrs. Ralph
Harman Booth

Ill. no. DIA 9

Inscription: *In qua enq hoa prem igemueit omm niquitatu eius no corda* (Vulgate: *Quacumque hora homo ingemuerit omnium iniquitatum non recordabuntur.* Ez. 18:22; I will not remember all his iniquities that he hath done.)

Iconography: Prophesy for the *Repentance of Mary Magdalene* (n)

Photographic reference: DIA Neg. no. 7424 (1948)

DIA 10. David

Irregular circular shape: 31.12 × 27.94 cm
(12¼ in × 11 in)
Accession no. 49.540, Gift of Mrs. Ralph
Harman Booth

Ill. no. DIA 10

Inscription: *david non dereliquas qerntes te dus* (Vulgate: *Non derelinques quaerentes te domine.* Ps. 9:11; David: For thou hast not forsaken them that seek thee, O Lord.)

Iconography: Prophesy for the *Meeting of Christ with Mary Magdalene* (-l-)

Photographic reference: DIA Neg. no. 7429 (1948)

DIA 11. Baruch

Irregular circular shape: 35.56 × 28.58 cm
(14 in × 11¼ in)
Accession no. 49.541, Gift of Mrs. Ralph
Harman Booth

Ill. no. DIA 11

Inscription: *baruch filii patiet sustinete ara q supue[.]et vobis*
(Vulgate: *Filii patienter sustinete iram quae supervenit vobis.*
Baruch 4:25; Baruch: My children, suffer patiently the
wrath that is come upon you.)

Iconography: Prophesy for *Christ's Prediction of His Passion* (t)

Photographic reference: DIA Neg. no. 7426 (1948)

DIA 11. *Baruch*

DIA 12. David

Irregular circular shape: 34.29 × 28.58 cm
(13½ in × 11¼ in)
Accession no. 49.542, Gift of Mrs. Ralph
Harman Booth

Ill. no. DIA 12

Inscription: *panem celi dedit eis pane angelos maducav ad ho*
(Vulgate: *Panem caeli dedit eis panem angelorum manducavit
homo.* Ps. 77:24–25; [He] had given them the bread of
heaven; Man ate the bread of angels.)

Iconography: Prophesy for the *Last Supper* (s)

Photographic reference: DIA Neg. no. 7431 (1948)

DIA 12. *David*

DIA 13. Solomon

Irregular circular shape: 33.66 × 28.58 cm
(13¼ in × 1¼ in)
Accession no. 49.543, Gift of Mrs. Ralph
Harman Booth

Ill. no. DIA 13

Inscription: *Salomo pata st risorib iudica z mallei peucietiu*
(Vulgate: *Parata sunt derisoribus iudicia et mallei percutientes.*
Prov. 19:29; Solomon: Judgments are prepared for scorners
and striking hammers for the bodies of fools. In the *Biblia
Pauperum* the prophet is not named.)

Iconography: Prophesy for the *Mocking of Christ* (-c-).

Photographic reference: DIA Neg. no. 7421 (1948)

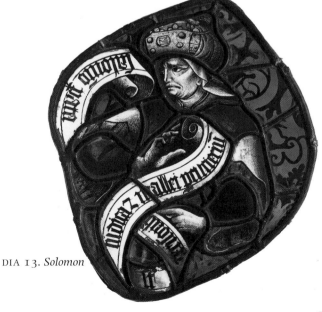

DIA 13. *Solomon*

DIA 14. David
Irregular circular shape: 31.75 × 28.58 cm
(12½ in × 11¼ in)
Accession no. 49.544, Gift of Mrs. Ralph
Harman Booth

Ill. nos. DIA 14; Col. pl. 5

Inscription: *foderut manus meos et pedes meos dinumeraverut ma ossa mea* (Vulgate: *Foderunt manus meas et pedes meos numeravi omnia ossa mea.* Ps. 21:17–18; They have dug my hands and my feet. They have numbered all my bones.)

Iconography: Prophesy for the *Crucifixion* (-e-)

Photographic reference: DIA Neg. no. 7420 (1948)

DIA 15. Isaias
Irregular circular shape: 31.12 × 28.58 cm
(12¼ in × 1 ¼ in)
Accession no. 49.545, Gift of Mrs. Ralph
Harman Booth

Ill. no. DIA 15

Inscription: *ysayas gloria libani data est ei decor carmeli in Saron* (Vulgate: *Gloria Libani data est ei decor Carmeli et Saron.* Is. 35:2; Isaias: The glory of Libanus is given to it: the beauty of Carmel, and Saron.)

Iconography: Prophesy for the *Coronation of the Virgin* (-q-)

Photographic reference: DIA Neg. no. 7422 (1948)

DIA 16. David
Irregular circular shape: diameter approx. 28 cm
(11 in)
Accession no. 49.546, Gift of Mrs. Ralph
Harman Booth

Ill. no. DIA 16

Inscription: *David Ihrlm q edificat ut civitas illi eiu ascenderut* (Vulgate: *Hierusalem quae eadificatur ut civitas cuius participatio eius in id ipsum illic enim ascenderunt tribus.* Ps. 121:3; David: Jerusalem, which is built as a city, which is compacted together.)

Iconography: Not in the *Biblia Pauperum* citations

Photographic reference: DIA Neg. no. 7423 (1948)

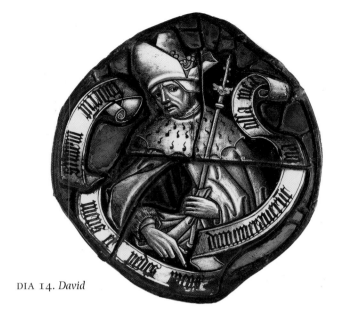

DIA 14. *David*

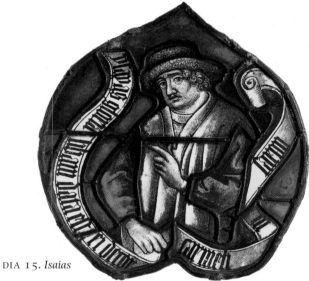

DIA 15. *Isaias*

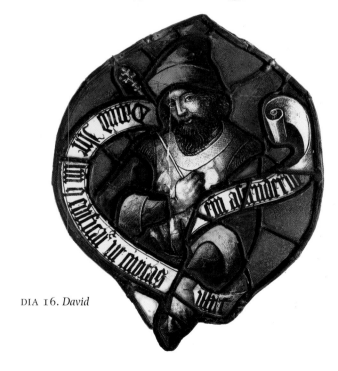

DIA 16. *David*

DIA 17. Quatrefoil Roundel with Boar-hunting Scenes

Housebook Master (circle of) Germany, Middle Rhine, Cologne?
1475–85
Quatrefoil: diameter 29.2 cm (11½ in)
Accession no. 36.98, Founders Society Purchase, Octavia W. Bates Fund
 Ill. nos. DIA 17, 17/figs. 1–4; Col. pl. 22

History of the glass: The panel was once in the large and prestigious collection of Sir Hercules Read. In the 1928

catalogue of the Read sale it was described as a sixteenth-century roundel of two impaled shields of arms surrounded by four panels of boar hunting scenes. The records of the New York dealership Thomas and Drake list the panel as having been in the collection of Read, then William Walters, Baltimore. In 1934 objects from Walters and other collections were sold through the agency of the American Art Association at the Anderson Galleries in New York. Thomas and Drake bought the panel at that time and sold it two years later, 1936, to the Detroit Institute of Arts. The purchase was made in the name of the Founders Society from the Octavia W. Bates Fund. [German/Flemish Galleries]

DIA 17. Quatrefroil Roundel with Boar-hunting Scenes

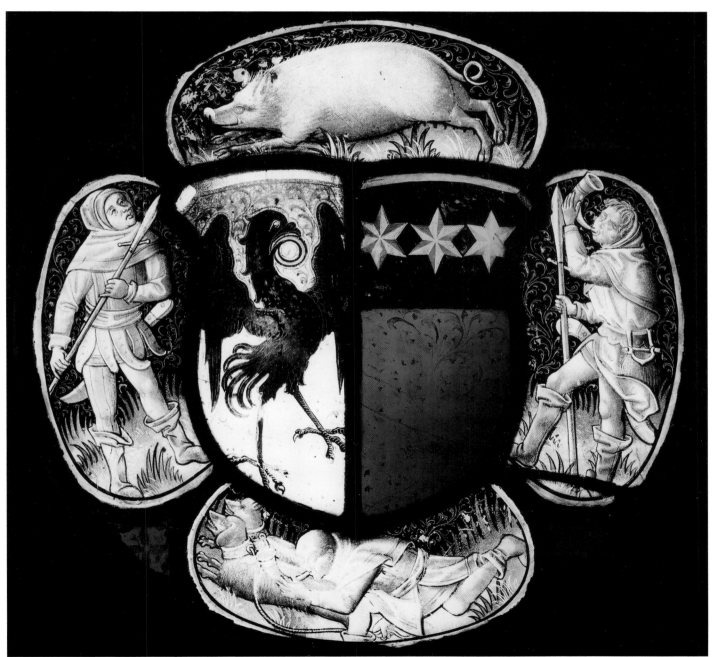

Original location: Based on the identification of the two coats of arms (Schmidt 1992: DIA 17/fig. 1), the panel can be definitely linked to Johann Rinck II (1458–1516). It may have been intended to decorate Rinck's Cologne residence (DIA 17/fig. 2) an impressive structure called the Rinckhof before its destruction in 1911.

Bibliography

UNPUBLISHED SOURCES: Grosvenor Thomas Stockbook ms no. I, 132–3, item no. M–39.

PUBLISHED SOURCES: *Catalogue of the Varied & Extensive Collection of Works of Art, The Property of Sir Hercules Read* [sale cat. Sotheby and Co., New Bond Street, 5–9 November], London, 1928, p. 69, no. 707; *Period Furniture, Paintings, Bronzes, Sculptures, Porcelains, Ancient Glass, Tapestries, Fabrics, Rugs, from the Walters, Perine, Seligsberg, Schlieren, Lulu G. Thomas and Burton Mansfield Estates* [sale cat. American Art Association, Anderson Galleries, Inc., 11–13 January], New York, 1934, p. 49, lot 288; Rüdiger Becksmann, "Das 'Hausbuchmeisterproblem' in der mittelrheinischen Glasmalerei," *Pantheon*, 26, 1968, pp. 352–67; Jane Hutchinson, *The Master of the Housebook*, New York, 1972; Timothy Husband, "The Master of the Amsterdam Cabinet, The Master of the Housebook Genre and Tournement Pages, and a Stained-Glass Panel at the Cloisters," in *Occasional Papers*, p. 139; Hayward in *Nuremberg*, p. 206, no. 65; Barnet 1986, p. 41; Raguin in *Checklist* III, p. 160; Wolfgang Schmidt, "Johann Rinck II and a Late Gothic Stained Glass Medallion with Boar Hunting Scenes," *DIA Bulletin*, 67/1, 1992, pp. 40–7; Daniel Hess, *Meister um das "mittelalterliche Hausbuch": Studien zur Hausbuchmeister-*

DIA 17/fig. 2. Tower of the Rinckenhof, Cologne

frage, Mainz, 1994; Christoph Count of Waldburg Wolfegg, *Das Mittelalterliche Hausbuch* (facsimile), Munich, 1997; id. *Venus and Mars: The World of the Medieval Housebook* [exh. cat., National Gallery], Washington, D.C., 1998.

Condition: Paint loss is noticeable in the lower and right quatrefoils and in the body of the eagle on the shield.

Iconography: The Detroit panel shows the secular imagery of a late medieval hunt. The quarry, a boar, figures in the upper segment of the quatrefoil. To the left and right are huntsmen, both with boar spears, one sounding his horn. In the bottom segment a huntsman sounds a horn and runs with a greyhound and a mastiff, the two breeds of dogs most commonly used in the hunt. The greyhound tracks the quarry and the mastiff works the animal while he is at bay. The pointed ears and narrow muzzle of the greyhound appear in the hound in the background. The hound in the foreground has the mastiff's floppy ears but lacks the characteristic square muzzle and powerful jaws. The hunt depiction can be verified by comparison with contemporaneous manuscripts, such as the fifteenth-century French text, *Le Livre du Roy Modus et de la Reine Racio*, New York, The Pierpont Morgan Library, MS M.820 (Gunnar Tilander, *Les Livres du roy Modus et de la royne Ratio*, Société des anciens textes français, Paris, 1932). Such hunting-books were derived for the most part from the richly illustrated text written in 1387 by Gaston III

DIA 17/fig. 1. BARTHOLOMEW BRUYN THE ELDER: Coat of Arms on reverse of *Portrait of Herman Rinck III*, c. 1530. Cologne, Wallraf-Richartz-Museum

Phoebus, count of Foix-Bearn (Paris, Bibliothèque Nationale MS fr. 2691: W. A. and F. Baille-Grohman, eds., *The Master of the Game*, London, 1904; Gunnar Tilander, *Livre de la chasse (par) Gaston Phébus*, Karlshamm, 1971). One can see the familiarity of the hunt and its rituals by the accuracy of details even in later satirical illustrations such as Erhard Schön's woodcut, *The Monk and Cleric Hunt* after a text by Hans Sachs (Andersson and Talbot 1983, pp. 332–3, no. 188). Schön's work, dated about 1525, shows the typical stout boar spears and differentiation between the mastiffs and greyhounds. Ascribed to the Housebook Master, and therefore of particular relevance for this panel, is the illustration of a *Stag Hunt* (L.I.67: DIA 17/fig. 3), dated *c*. 1485–90, showing the same two types of dogs (Rijksmuseum, Amsterdam, Hutchinson 1972, p. 59; Filedt Kok 1985, p.165). One mastiff is straining at the leash and the greyhound gives chase in the distance.

Heraldry: Argent an eagle rising with wings displayed inverted sable and in his beak an annulet or impaling azure in chief a fess sable three mullets of six points or (Johann Rinck II: identified in Schmidt 1992). See DIA 17/fig. 1 for Rinck family Coat of Arms. The arms are painted on the reverse of a portrait of Herman Rinck III, by Bartholomew Bruyn the Elder, Cologne, *c*. 1530, Wallraf-Richartz Museum, Cologne, no. 246.

Color: The color harmonies follow the traditional high contrast organization common to the small quatrefoil roundel. A deep red fills the interstices between the quatrefoils and a bright warm blue the lower portion of the impaled shield.

The heavy outline of the leads is integrated into the design by the dark areas in the black damascene backgrounds of the scenes and the sable of the eagle and upper portion of the impaled shield. Adroitly placed silver stain yellows help achieve a balance between shield and quatrefoil surrounds.

Technique: The panel is predominantly uncolored glass with silver stain. Pot-metal red and blue glass figure in the lower portion of shield and the frame. The application of paint is accomplished with delicately modulated mat washes. The edges of the garments are picked out by a dark trace line and a white line produced by lifting off the mat with a stylus. The same play of positive and negative contrasts appears in the grass. Tall blades of grass are silhouetted against the dark damascene ground, painted in a dark outline in the foreground, and also achieved by a stylus picking out a white line from the mat. A much thinner line, accomplished by a needle, picks out details of the hair, the bristles of the boar, and the curling tendrils of the damask ground.

The symbol scratched on the back of each of the glass segments perhaps served to identify an individual craftsman amid the workshop production. The marks could not have served as placement indications, as is sometimes the case, since all the marks are identical.

Style: The panel has been associated with the circle of the Housebook Master, also known as the Master of the Amsterdam Cabinet. Hayward (*Nuremberg*, p. 206, no. 65) was the first to make this association. In the 1986 exhibition it was grouped with two similar quatrefoil roundels with

DIA 17/fig. 3. HOUSEBOOK MASTER: *Stag Hunt*, *c*. 1470–80. Amsterdam, Rijksmuseum Rijksprenternkabinet

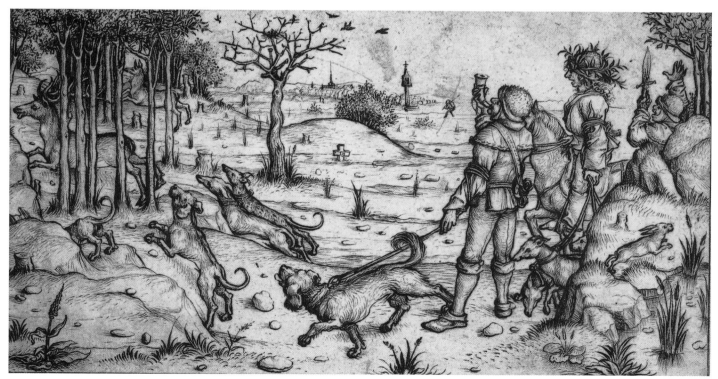

secular scenes, now in the Cloisters collection of the Metropolitan Museum of Art (Hayward in *Nuremberg*, p. 206, no. 65). Assessment of the *oeuvre* of this artist has been a complex and highly debated matter since Lehrs first associated the master's drawings with engravings. Few universally accepted definitions have emerged from a century of subsequent discussion (Max Lehrs, *Katalog der im Germanischen Museum befindlichen deutschen Kupferstiche des XV. Jahrhunderts*, Nuremberg, 1887–8, p. 30; id., *Der Meister des Amsterdamer Kabinetts*, Berlin, 1893–4; id., *Geschichte und kritischer Katalog des deutschen, niederländischen und französischen Kupferstiches im XV. Jahrhundert*, 8, Vienna, 1932, pp. 1–164, pls. 217–21; Hutchinson 1972; Filedt Kok 1985; Hess 1994; Christoph Graf zu Walburg Wolfegg, 1997 and 1998).

The artist's reputation rests on 91 drypoints surviving in 123 impressions, eighty of which are in the possession of the Rijksprentenkabinet in Amsterdam, and a series of illustrations in a manuscript belonging to the Fürsten von Waldburg-Wolfegg-Waldsee, known as the Wolfegg Housebook, attributions that have produced the interchangeable appellations of the artist. His career has been dated to about 1470 to 1500 and he is generally located as active in the region of the Middle Rhine. Stained glass was associated with the artist in some of the earliest studies of his work. Schmitz had already attributed the Cloisters's panels, then in the Kunstgewerbe Museum, Berlin, as well as other sketches and panels to the Housebook Master (Schmitz 1913, I, pp. 102–19, 150–2, figs. 171, 245a; Hayward in *Checklist* I, p. 128; Hayward in *Nuremberg*, pp. 206–7, nos. 66a and b; see also Schmitz 1923, pp. 7–8, nos. 5–11, 14, attributions of eight panels to the circle of the Housebook Master). Later scholars have addressed the complex questions of the relationship of drawings made specifically for the popular quatrefoil roundels of this time, the selective borrowing from contemporaneous print sources, the Housebook Master's among others, and the propagation of style and possible crossover of artists working in several media (Wentzel 1954, p. 72, text ills. 51–2, figs. 225–6; id., "Schwäbische Glasmalereien aus dem Umkreis des 'Hausbuchmeisters,'" *Pantheon*, 24, 1966, pp. 360–71; Becksmann 1968, pp. 352–67; Husband in *Occasional Papers*; Filedt Kok 1985, esp. pp. 271–7, stained glass; *Painting on Light*, pp. 68–74, nos. 1–3; Husband, "The Dissemination of Design in Small-Scale Glass Production: the Case of the 'Medieval Housebook'," *Gesta*, 37, 1998, pp. 178–85).

The drawings of the Wolfegg Housebook have frequently been assigned to a number of hands. Authors have often associated the artist responsible for the drypoints in the Amsterdam Cabinet with the Housebook planet scenes of *Mars*, *Sol*, and *Luna*.

An assistant, identified by his more crowded spatial arrangements and robust characters, is frequently assigned authorship of the planet scenes of *Mercury*, *Saturn*, and *Jupiter*. (Helmut Th. Bossert and Willy F. Storck, *Das mittelalterliche Hausbuch*, Leipzig, 1912, esp. pt. D, pp. 38–53, "Die künstlerische Tätigkeit des Hausbuchmeisters"; Filedt Kok 1985, pp. 57, 218–44). Becksmann (1968, p. 358) assigned all of the planet scenes to a single artist working in two campaigns. Hess (1994) redistributes the work associated with the Housebook Master over a number of artists, incorporating much greater analysis of paintings and stained glass. Butts and Hendricks (*Painting on Light*, p. 68), however, share a view presented by Christoph Count of Waldburg Wolfegg (1998, pp. 106–9) that the illustrator of the Housebook and the drypoints are the work of a single artist.

The scenes in the Detroit panel have parallels with a number of the drypoints. The *Coat of Arms with a Peasant Standing on His Head* (L.I:89) is a lively and engagingly frank depiction of common life. The figures are vivid, move energetically in space, and are of a compact body proportion (Andersson and Talbot 1983, p. 310, no. 173; Lehrs 1932, no. 91; Hutchinson 1972, p. 72, fig. 89). The animated stances of the Detroit hunters reproduce much the same sense of vivacity and charm. Facial types are also similar. The Detroit hunters show small rounded eyes with prominent lids, arched eyebrows, sloping pointed noses, full cheeks, fleshy chins, and tiny, almost pursed mouths that also appear in the Wolfegg Housebook planet scenes, dated about 1475–85 (Filedt Kok 1985, pp. 220–4, no 117; Husband in *Occasional Papers*, p. 141, figs. 2–3; Hess 1994, pp. 14–24, who dates them *c.* 1466–70). See also several Rijksmuseum drypoints such as *The Card Players* (L.I:73) about 1485 (Filedt Kok 1985, p. 170; Husband in *Occasional Papers*, p. 146, fig. 13) and *Pair of Lovers* (L.I:75) about 1485 (Hutchinson 1972, pp. 63–4, fig. 75; Andersson and Talbot 1983, p. 307, no. 171; Filedt Kok 1985, pp. 173–5).

The closest parallel for style, however, emerges from a comparison of the Detroit panel with the planet scenes of *Saturn*, *Jupiter*, and *Mercury*. In the scene showing the influence of the planet *Saturn* (DIA 17/fig. 4), the peasant disemboweling the slaughtered horse and the peasant spading the irrigation ditch display the same animation and stocky proportions as the hunters in the stained glass roundel. The figures are solidly conceived, executed in vigorous forms, turning in space and conveying a sense of muscular energy. The peasant with the spade shows the same loose boot with wide top as the Detroit hunters and the peasant slaughtering the animal wears the same tunic with bands across the hips as the hunter to the left. The drapery is molded in rounded folds around the body with smooth transitions among medium tones, showing similar articulated folds in the laboring peasant's turban and tunic and the Detroit hunters' bunched cowls. This type of tonal modeling seems quite unlike the highly animated, angular folds and dynamic crosshatching of the artist of

the Amsterdam Cabinet drypoints. The stained glass panel of the *Madonna and Child in Glory*, (Metropolitan Museum of Art, Cloisters Collection, 1982.41.1), in contrast, does display the delicate line and shading of the Master of the Amsterdam Cabinet (Husband in *Occasional Papers*, pp. 139–40, 151–2, fig. 1).

The Detroit panel, then, demonstrates sufficient parallels with the drypoints and drawings associated with the circle of the Housebook Master/Master of the Amsterdam Cabinet to argue that the painter responsible for the Detroit panel must have been familiar with this corpus of work. The universal practice of workshop borrowing from print sources, even those geographically distant, and the variety of hands involved in the production of a glass panel, however, encourage a healthy skepticism about the likelihood of narrow definition of authorship.

The actual location of the workshop that produced the panel is also problematic. The small secular panel became extremely popular at this time and these were produced in

DIA 17/fig. 4. HOUSEBOOK MASTER: *Planet Saturn*, Wolfegg Housebook, 1475–85. Wolfegg, Kunstsammlungen der Fürsten zu Waldburg-Wolfegg

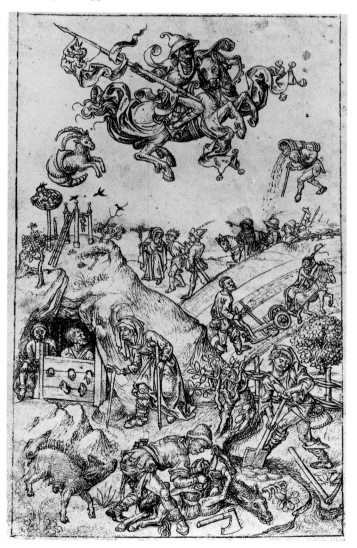

considerable numbers from a variety of locations in Germany and Switzerland. Hayward suggested Nuremberg (*Nuremberg*, p. 106). A number of techniques in the panel can be found in glass of the time in Nuremberg. For example, Heinrich Winkler ("Nürnberger Vierpass-Scheiben und ihre Entwerfer," *Pantheon* 28, 1941, pp. 243–9), discusses similar panels produced in Nuremberg from the early years of the sixteenth century and the circle around Dürer. The technique of outlining the grass with both painted and scored outlines is somewhat similar but not identical to the technique in the Cloisters panel (Hayward in *Nuremberg*, pp. 206–7, no. 66a) showing the preparation for a lovers' feast or the panel once in Berlin (Schmitz 1923, pp. 7–8, no. 9) showing four couples playing table games. The Berlin panel was attributed to the Housebook Master, and is now destroyed, and both panels are assumed to have been produced by a Nuremberg shop.

The background of the DIA panel shows a damascene pattern of curling foliate tendrils on a dark ground, a technique often present in stained glass from Swabian and Nuremberg workshops, but also used elsewhere. A Swabian example is found in a panel of the subject of dominating women now in the Stuttgart Landesmuseum (Hans Wentzel, "Kabinettscheiben aus Neckar-Schwaben," *Zeitschrift des deutschen Vereins für Kunstwissenschaft*, 19, 1965, pp. 117–32, figs. 1–3). Such damascene backgrounds, however, were painted by workshops in the Middle Rhine region, for example in a roundel of John the Baptist dated 1480–5 in the Schnütgen-Museum (Lottlisa Behling, "Eine Hausbuch-meisterscheibe im Kölner Schnütgen-Museum," *Festschrift Friedrich Winkler*, Berlin, 1959, pp. 141–8, fig. 1; Lymant 1982, pp. 140–2, no. 80, Col. pl. 9). Another comparison with work from the Middle Rhine is found in the quatrefoil roundel of lovers and wildmen in the Frankfurt Historisches Museum (Schmitz 1923, pp. 7–8, no. 15) dated about 1480. The panel came from a church in Reingau and is attributed to a workshop from the Middle Rhine. Both the DIA and the Frankfurt panels show the same elongated form of the quatrefoil lobes, a delicately damascened background, large figures occupying the whole of the pictorial space, and a modeling using predominantly smear shading and stipple. Thus it is quite possible to find the techniques in the Detroit panel being produced in the region of the Middle Rhine. Knowledge that the panel was produced for Johann Rinck II (Schmidt 1992), a merchant of Cologne, tends to suggest the area around Cologne or the Middle Rhine as the most probable place of origin.

Date: Since the panel appears most closely related to the Wolfegg Housebook planet pages, a date of 1475–85 for the Detroit panel is determined by the generally accepted date of the Wolfegg Housebook as 1475–85 (Filedt Kok 1985, p. 218). They may however, be earlier, according to Hess's arguments (1994).

Photographic reference: DIA Neg. no. 28682 (1985/03/22)

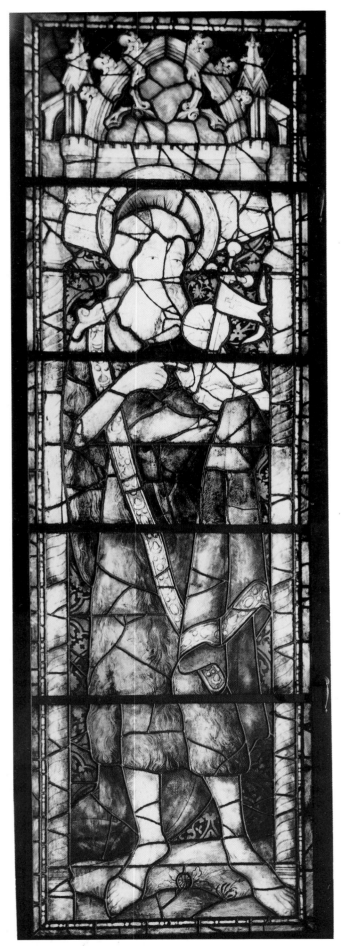

DIA 18. *John the Baptist*

DIA 18. John the Baptist

Italy, northern (?)
Fifteenth century, last third
Rectangle: 287 × 85.4 cm (113 × 33⅝ in)
Accession no. 26.125, Gift of Mr. and Mrs.
Ernest Kanzler

Ill. nos. DIA 18, 18/a, 18/fig. 1

History of the glass: The panel was purchased from C. Fougoli, Florence in 1925, presumably on the advice of William Valentiner, who had become Director of the DIA the preceding year. The window was presented to the museum through the generosity of Mr. and Mrs. Ernest Kanzler (Minutes of the Acquisitions Committee, DIA, 2 September 1926 and 19 December 1928). [In storage]

Bibliography

UNPUBLISHED SOURCES: DIA Curatorial files.

PUBLISHED SOURCES: Raguin in *Checklist* III, p. 160.

Condition: The entire upper panel of architectural motifs is a modern invention. The four remaining panels showing the image of John the Baptist are substantially intact. They contain, however, a very heavy application of restorer's blending paint throughout. The exterior, espe-

cially, is covered with a dense mat of whitish paint making analysis of the weathering patterns extremely difficult.

Replacements are for the most part confined to backgrounds and decorative motifs, including portions of the columns on either side at the level of the prophet's shoulders, the background above the hanging to the left of St. John's head, and portions of the ground between his feet. Minor replacements and stopgaps appear in sections of the hair, sections of his cloak falling over his arm, and rear portions of the lamb.

Iconography: The stance and attributes of the saint are highly traditional (*Herder Lexikon*, 7, cols. 163–90; Réau, 2/1, pp. 431–63; Künstle, 2, pp. 332–40). Already in the mid-sixth century John was depicted on the Throne of Maximian in Ravenna wear-

DIA 18/a. *Restoration chart*

ing a hair mantle and holding a disk with the Lamb of God (John Beckwith, *Early Christian and Byzantine Art*, Baltimore, 1979, p. 116, fig. 94). The Detroit panel shows little variation from the canonical representation of the Baptist on the Precursors' Portal on the north facade of the Cathedral of Chartres *c.* 1205–10 (Sauerländer 1972, figs. 83, 86). The Detroit panel presents the saint filling the architectural opening, indeed he is even larger than the opening since both his elbows extend somewhat beyond the architectural frame. He is nimbed, dressed in a simple cloak over the traditional hair garment mentioned in the Gospels ("And John was clothed with camel's hair," Mark 1:6). He holds the Lamb of God in the crook of his left arm and points to it with his right. His long beard and flowing hair are typical marks of the Baptist who functions as the link between the Old Testament prophetic traditions. "the voice of one crying in the desert" (Mark 1:3 and Isaias 40:3) and the New Dispensation, when Christ, God Himself, has no further need of prophecy. In the fifteenth century in Italy, he became linked to the Christ's redemptive suffering, with an evolving iconography that depicted the youthful St. John sharing with Christ the foreknowledge of the Passion. (Marilyn Aronberg Lavin, "Giovanni Battista, A Study in Renaissance Religious Symbolism," *AB*, 37, 1955, pp. 85–101).

John the Baptist was one of the most popular saints of the Middle Ages and the Renaissance, accorded two feast days, one commemorating his birth on 24 June and the other his martyrdom (Decollation) on 29 August. His name was one of the most popular given names of the time. He was also adopted as saintly patron by innumerable churches and thus quite reasonably became one of the most frequently depicted figures in Christian art.

Color: The color harmonies are predominantly warm colors contrasted to a somber brownish-green and areas of uncolored glass touched with silver stain. The bright red of the damascene fabric hung between the columns blends with the slightly lighter value of the reddish-brown glass of the Baptist's hair garment. His cloak is a brownish-green bordered with yellow. A bright warm blue appears in the inner circle of the saint's halo. His hair and face, arms, and the Lamb with its banner are of uncolored glass tinted with silver stain. The ground on which he stands is a medium value neutral brown.

Technique: The panel uses pot-metal and uncolored glass with silver stain. Both interior and exterior surfaces of the panel show a dense application of paint. This exterior layer appears to be predominantly from a later restorer's hand. The interior conforms to the general Italian tendency to apply paint in an even mat across the surface and then to increase density by building up with trace modeling (Marchini 1956).

Style: The proportions of the saint are long and angular, a

system that also is carried out in the head where a long undulating contour defines cheek bones and flowing beard. The eyes are large with heavy lids, slanting downwards, almost giving a sorrowful appearance. The stylistic concepts associate the window with Italian trends of the late fifteenth century (Marchini 1956). The north of Italy, with Spain, was heavily influenced by the art of the Lowlands and France, particularly at this time. Thus the panels exhibit some similarities with the vigorous graphic expression and the framing systems of France, such as the rich damask hanging behind the figure common to the windows in Burgundy. The window of Pierre Fradet, about 1464, in the north nave of the Cathedral of Bourges, is similar in its clarity of linear traceline in delineating the features (Brigitte Kurmann-

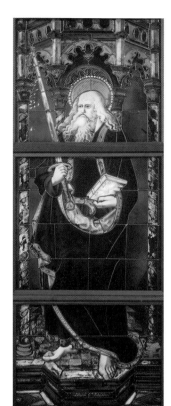

DIA 18/fig. 1. *St. Paul*, from Foligno Cathedral. Assisi, Basilica of S. Francesco

Schwarz, *Französische Glasmalereien: Ein Atelier in Bourges und Riom*, Bern, 1988, pp. 15–16, fig. 37, pl. VIII). Similar also is the technique of presenting the head in two segments of glass, separating face and hair by a leadline division. Italian works are also very close. The windows originally from the church of the cathedral of Foligno now in storage in the Basilica of S. Francesco in Assisi, exhibit compositional and figural analogies with the Detroit panel (Giuseppe Marchini, *Le Vetrate dell'Umbria. Corpus Vitrearum Medii Aevi, Italia*, 1, Rome, 1973, pp. 162–4). The panel of St. Paul (DIA 18/fig. 1) shows very much the same long, bony feet, flowing hair and beard. The halo shows the same pot-metal colored interior framed by uncolored glass. The columns at the sides in both panels are narrow and constructed of a wrapped diagonal swath. Above all, the manner of application of mat and trace paint links the window to craftsmanship traditions south of the Alps. There is literally no aspect of the panel that is left free of a paint overlay.

Date: Stylistic associations with the glass of the 1460s in Burgundy and that of the late fifteenth century in Italy indicate a date to the last third of the fifteenth century.

Photographic reference: DIA Neg. no. 10761 (1956)

DIA 19–21. THREE STANDING FIGURES OF SAINTS
Germany, Central or South?
c. 1500–1510

History of the glass: The panels were purchased from the J. and S. Goldschmidt Galleries, Inc., New York in 1931 with income from the Edsel B. Ford Fund of the Founders Society. The Gallery listed the provenance as from the collection of the Duke of Anhalt-Dessau. This provenance of Dessau, although not confirmed is highly probable. The collection of Leopold II Friedrich Franz, Duke of Anhalt-Dessau (1740–1817), is of considerable interest. One of the first collectors of medieval glass in Europe, the Duke amassed a considerable collection of German and Swiss panels, most from the fifteenth and sixteenth centuries (Reinhard Alex, *Glasgemälde Gotisches Haus Wörlitz*, Reichenbach, 1983; id., "Die Glasgemälde im Gotischen Haus zu Wörlitz, Sammlungsgeschichte, wissenschaftliche Bearbeitung und Restaurierung," in *Das Gartenreich an Elbe und Mulde* [exh. cat., Grauen Haus], Wörlitz, 1994, pp. 68–73; *Himmelslicht*, no. 92, pp. 336–7). The Zurich humanist Johann Caspar Lavater was the source of many of the panels. Although he bought a great deal of heraldic glass and *Kabinettscheiben*, the Duke did collect larger panels and religious subject matter. The Detroit panels are only slightly taller and narrower than a series of eleven panels

(77.5 by 40) now in Wörlitz from a series of Apostles with elements of the Creed. The panels are from the church of Maur am Greifensee near Zurich, and attributed to the workshop of Lukas Zeiner, dated about 1511.

Much of the Duke's collection was installed in a fanciful Neo-Gothic summer residence at Wörlitz in the midst of a progressive example of landscape architecture. There is no evidence that the three Detroit panels were part of the Duke's collection, although it is possible. It is also possible that they were part of the large collection of paintings and art objects of the princes of Zerbst, whose castle is also in the region of Dessau. The inventory of the castle is now lost, and the installation itself destroyed in 1945 (Anonymous, published by Büttner Pfauner zu Thal, *Anhalts- Bau- und Kunstdenkmäler nebst Wüstungen*, Dessau and Leipzig, 1892–99, p. 430). [Panels in the German Gallery]

Bibliography
UNPUBLISHED SOURCES: DIA Curator's file; Review: Erhard Drachenberg, Corpus Vitrearum, Germany.

PUBLISHED SOURCES: Raguin in *Checklist* III, pp. 160–1; Raguin 1998.

DIA 19. St. Andrew
Rectangle: 88 × 37 cm (34 5/8 × 14½ in)
Accession no. 31.309, Founders Society Purchase, Edsel B. Ford Fund
Ill. nos. DIA 19, 19/a, DIA 19–21/fig. 1

Condition: The panel shows almost no replacements or stopgaps other than a few extremely minor repairs to background behind the saint. The mending leads mar the perception of the complex interweaving of branches in the backgrounds, but do not detract significantly from the all-over relationship of figure to ground. The paint is in relatively good condition, with only very minor abrasion losses.

Iconography: The apostle is shown in traditional mode with long hair and beard and holds an X-shaped cross, the instrument of his martyrdom (Louis Réau, "L'origine de la croix de St. André," *Mémoires de la Société des Antiquaires de France*, 1932, pp. 157–8; *Herder Lexikon*, 5, cols. 138–52; Réau, 3/1, pp. 76–84; Künstle, 2, pp. 58–62). The *Golden Legend* (pp. 7–16) describes that Andrew, already an old man, allowed himself to be tied to a cross from which he preached to crowds for two days. On the third day the crowd began to demand his release. The ser-

vants of the proconsul Egeus, however, were miraculously prevented from coming near until Andrew had died so that he could be reunited with Christ. Andrew was the brother of St. Peter and one of the most frequently depicted apostles. He was the patron saint of Burgundian lands, and then became associated with princely protection due to the pre-eminence of Burgundy during the fifteenth and sixteenth centuries. In the Liturgical Calendar, the year begins with the 30 November feast of St. Andrew.

Color/Technique: Pot-metal colors are confined to the figure of the saint, a halo of light brownish green, a tunic of bright warm blue, and mantle of deep red lined with white. The X-shaped cross is a bright silver stain yellow. Silver stain also appears in the border of the fabric hanging behind the figure and the intertwined branches and leaves of the architectural frame.

Style: The three panels are clearly influenced by a style developed from about 1477 to 1481 that has only recently been understood as the work not of a single master, but of a cooperative uniting five independent master glass painters (Hartmut Scholz in *Painting on Light*, pp. 17–42). This seemingly modern business enterprise has been called the Strasbourg Workshop-Cooperative. Its base was Strasbourg

but its work is identifiable in churches and secular installations in a wide area including the cities of Freiburg, Constance, Tübingen, Salzburg, Ulm (*Bilder aus Licht und Farbe: Meisterwerke spätgotischer Glasmalerei: Strassburger Fenster in Ulm und Ihr künstlerisches Umfeld* [exh. cat., Ulmer Museum], Ulm, 1996), Augsburg, Munich, and Nuremberg (Veit Funk, *Glasfensterkunst in St. Lorenz, Nurnberg: Michael Wolgemut, Peter Hemmel von Andlau, Hans Baldung Grien, Albrecht Dürer*, Nuremberg, 1995). The clients were among the wealthy patricians and also the middle classes of guilds and individual citizens. The name of Peter Hemmel von Andlau was early recognized among this development and identified as the eldest of the five glass painters (Paul Frankl, *Peter Hemmel, Glasmaler von Andlau*, Berlin, 1956). Hemmel had operated an independent shop since 1447 and had made traditional window designs of small compositional units. Scholz mitigates the idea that Hemmel dominated production design, suggesting instead that the progressive direction of the Workshop-Cooperative may be due to the influence of a younger personality. He puts forward as a probable artistic leader Hans von Mauermünster who functioned for the last quarter of the century as the official glazier of the Strasbourg cathedral.

The Strasbourg Workshop-Cooperative showed a strong predilection for frames that combined Late Gothic architectural forms with lushly verdant plant forms. Of particular note may be the Earl's Window that is the axial window of the choir of the collegiate church of Tübingen, dated 1478. The tall, narrow window shows great clarity of structure and strength of composition, making it highly legible. A detail of *St. George* from this window

DIA 19/a. Restoration chart

(DIA 19–21/fig. 1: Becksmann 1986, pp. 278–80; *Painting on Light*, p. 18, fig. 1) silhouetted against a brilliant damask background, seems to almost hover in space. The saint is framed by narrow branches stemming from an architectural base that sprout into an elaborate canopy of crisscrossing branches. Often the upper reaches of the windows from the Workshop-Cooperative were transformed into fantastic worlds of intertwining branches, bedecked with blossoms, leaves, fruit, and betimes inhabited by birds and other creatures. The window of *St. Jerome in his Study* from the Münster of Ulm shows the saint framed

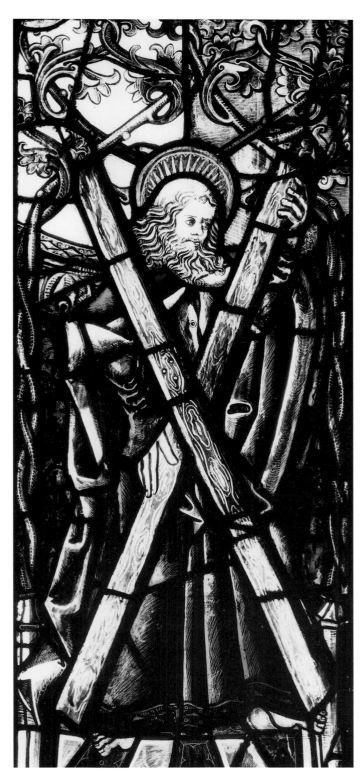

DIA 19. *St. Andrew*

by branches that merge into the Gothic canopy (Wentzel 1954, pp. 63–71, col. pl. 4). Very similar compositions are found in the Frauenkirche in Munich and numerous windows influenced by the Cooperative in the areas of Baden and Strasbourg (Becksmann 1979). A later window in the collegiate church of St. Genoult at Toul shows similar evolution in the frame as does the Detroit glass. In lancets

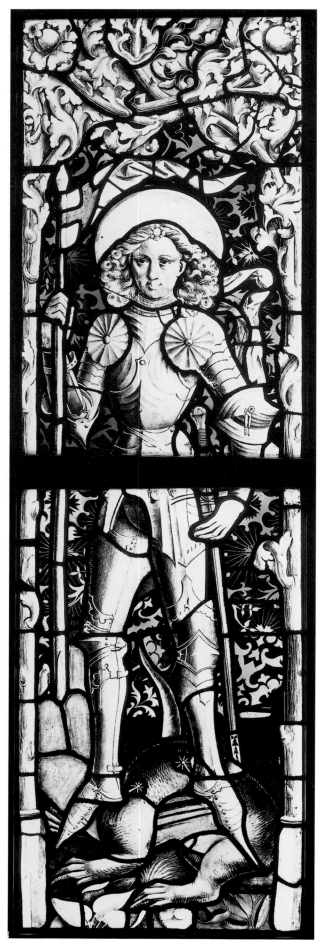

DIA 19–21/fig. 1. *St. George*, 1478. Tübingen, Collegiate Church

showing St. Genoult riding and St. George conquering the dragon, tree trunks twist along the window's edges and then meet in inhabited branches above. The windows are dated to the first quarter of the sixteenth century (*Vitrail en Lorraine*, pp. 357–61, no. 147, col. pl. p. 161).

Certainly this is the formula adopted by the Detroit painter who must have been a part of a later provincial atelier. The painting style shows a strong relationship to the line quality of an unsophisticated woodcut, for example in the series of parallel "gauges" along the surface of the branches of the trees or the bold use of negative spaces in Andrew's hair and beard. The organic framing systems of flowering trees blend with the architectural motif of the damascene hanging between two columns and act as a foil for the figure. The material and the trees, however, fuse into a unified spatial pattern inconsistent with any three-dimensional reality. Even the outdoor setting for the image of St. Christopher does not attempt to convey a physical reality to tree, sky, or water. The branches sway inwards, creating an undulating frame for the contrapuntal action of the Christ Child and saint. Renaissance perspective has not yet conquered late medieval graphic exuberance. What the panels may lack in spatial coherence, they more than compensate for with vivid, energetic forms.

Date: The relationship to the art of the Strasbourg Workshop-Cooperative, and also the incipient attempts at Renaissance spatial modeling place the work into the early years of the sixteenth century, probably 1500–1510.

Photographic reference: DIA Neg. no. 29734 (1986/05/22)

DIA 20. St. Jerome
Rectangle: 87 × 36 cm (34¼ × 14⅛ in)
Accession no. 31.310, Founders Society Purchase, Edsel B. Ford Fund

Ill. nos. DIA 20, 20/a, 19–21/fig. 1

Condition: The panel's replacements are focused on a rectangular swath of background to the right behind the saint's head, a segment of drapery, and tree branch on the left. Mending leads appear throughout. The paint is in good condition.

Iconography: Jerome is a comparatively well-documented historical figure (*New Catholic Encyclopedia*, 7, pp. 872–4). He was born around 340, made voyages to the Holy Land, acquired a command of Near Eastern languages and lived as a monk for some time. He was advisor to Pope Damasus I who in 382 directed him to make a Latin translation of the Sacred Scriptures, a translation now known as the Vulgate edition of the Bible. He died in either 419 or 420. Since the eighth century he was honored as one of the four Doctors of the Latin church (with Ambrose, Augustine, and Gregory

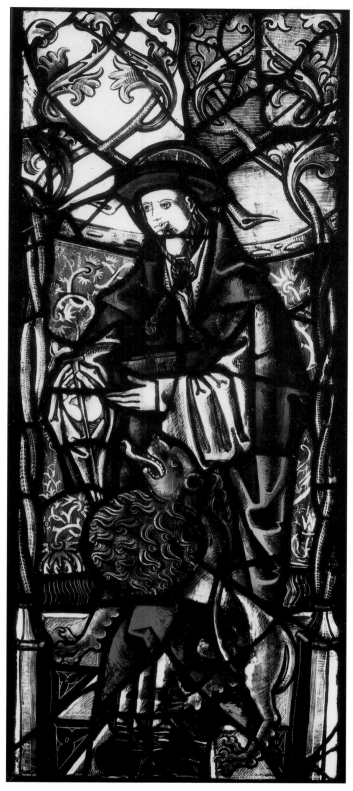

DIA 20. *St. Jerome*

for the new Humanism (*Herder Lexikon*, 6, cols. 519–29; Réau, 3/2, pp. 740–50; Künstle, 2, pp. 299– 307; *Golden Legend*, pp. 587– 92). He was, indeed a model for humanist learning, a synthesis of the desert penitent and the erudite linguist. He came to be seen as a special patron of translators, teachers, students, theologians, and lawyers.

The representation of the lion derives from the legend that Jerome healed a lion whose paw had been pierced by a thorn, and that afterwards the lion in gratitude remained near the saint's monastery to serve Jerome and his fellow monks (Grete Ring, "St. Jerome Extracting the Thorn from the Lion's

DIA 20/a. Restoration chart

Foot," *AB*, 27, 1945, pp. 188–94). The representation became a standard element in the iconography of the saint, for example in Dürer's prints, one dated 1492, showing Jerome in his study extracting the thorn from the lion, and another, dated 1496, of Jerome standing outside a building and the lion on hind legs extending his paw for help (Kurth 1963, nos. 22, 69). It is very likely that the awkward stance of the Detroit lion, appearing to float before the saint, may be caused by adaptation from such a print source or heraldic pattern book.

Color/Technique: The saint is dressed in traditional deep warm red of his cardinal's robes. His nimbus and book are a bright warm blue. The deep warm yellow of his lion is achieved with silver stain, which also appears in the ties of his hat, edge of his tunic, and page turner held in his hand. The background repeats the disposition of the previous panel.

Photographic reference: DIA Neg. no. 29735 (1986/05/22)

the Great). Thus Jerome began to be depicted as a Renaissance cardinal, a dignity anachronistically ascribed to him in the late thirteenth-century *Golden Legend* (p. 588). His cult, however, is primarily a late medieval phenomenon owing much to pious zeal of Joannes Andreas of Bologna (1330–48) who saw the saint as the ideal patron

DIA 21. St. Christopher

Rectangle: 88 × 37.5 cm (34⅝ × 14¾ in)
Accession no. 31.311, Founders Society Purchase,
Edsel B. Ford Fund

Ill. nos. DIA 21, 21/a

Condition: Repair leads in the figure and background are common but do not mar the legibility of the figure.

Iconography: Christopher, despite his lack of historical basis in fact, became one of the most popular late medieval saints (*Golden Legend*, pp. 377–82; *Herder Lexikon*, 5, cols. 495–508; Réau, 3/1, pp. 304–13; Künstle, 2, pp. 154–60). The cult is of eleventh-century origin but grew to great proportions and universal status during the fifteenth and sixteenth centuries. Christopher was associated with St. James the Greater as a patron of pilgrims and other travelers, the guise in which he appears in Van Eyck's Ghent Altarpiece (Jan and Hubert? van Eyck, *Altarpiece of the Lamb*, 1432, Cathedral of St. Bravo, Ghent, in Snyder 1985, col. pl. 16). As one of the fourteen "Nothelfer," or Auxiliary saints, he was also honored as a protector against storms and sudden death, that is a death without the administration of the Sacraments. His legend characterizes him as a man of great size and strength who desired to serve only the most powerful lord. After a long search he was instructed by a hermit who urged him to serve Christ by a task suited to his simplicity and strength. Christopher therefore built a hut by the bank of a river and carried travelers across the water. At last Christ, in the guise of a child, asked for his help and revealed himself to the saint by becoming prodigiously heavy. And as Christopher struggled with the burden the miraculous child explained to the giant that he had carried not only the world but also him who had created the world.

Christopher, in typical late medieval format strides calf-deep through a stream. He supports himself with a stout staff and the Christ Child rides upon his shoulder. He wears a short tunic and a cloak about his shoulders. The same iconographic format can be seen in the in the earliest single leaf prints (German, Upper Rhine, *Buxheim St. Christopher*, c. 1423?, Johns Rylands Library, Manchester, Snyder 1985, fig. 264). The

DIA 21/a. Restoration chart

paintings of Memling and Bouts show the same flowing robes (Dieric Bouts, *Adoration of the Magi Triptych* c. 1470–80, Munich, Alte Pinakothek, Snyder 1985, fig. 147). Dürer's modest, small woodcut of about 1500 (Kurth 1963, no. 76) shows Christopher dressed in tunic

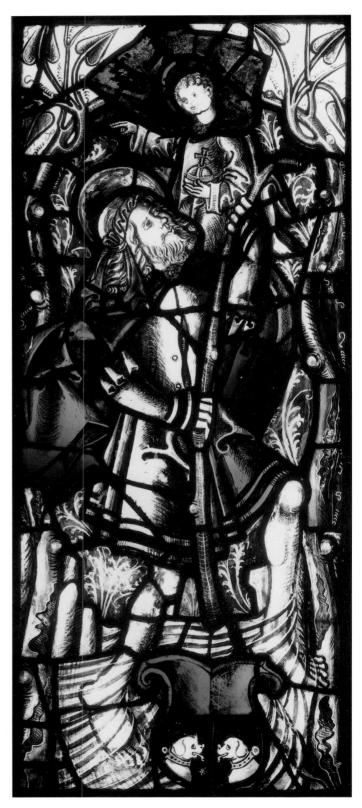

DIA 21. *St. Christopher*

and cloak and carrying the Christ Child holding the orb, symbol of his power over all creation, as in the Detroit panel.

Arms: Sable two mastiff's heads couped argent collared or on a chief gules (unidentified). The two mastiffs are common to hunting representations. Mastiffs appear in the shields of lesser nobility and also of townsfolk, especially for the families of the members of legislatures. The use of the mastiff in family heraldry appears over a large German area, including Prussia, East Prussia, Thuringia and Hamburg, and Bavaria (Siebmacher, 3/2 [Prussian nobility] pl. 473, Vultejus displaying one mastiff head; 5/4 [Nuremberg citizens] pl. 40, Riecki displaying two heads; 5/3, pls. 13 & 15, Papendorf and Schröder displaying three heads).

Color/Technique: The dull light green and deep red of the saint's garments are silhouetted against a light warm blue damascene background that is framed by the silver stain trunks of the two trees. The Christ Child's halo is deep red and his billowing cloak a russet brown. Red also appears in the upper half of the donor's shield. Silver stain achieves the deep warm yellow of Christopher's staff, his headband, and details of the Christ Child's hair, garment, and orb.

Photographic reference: DIA Neg. no. 29736 (1986/05/22)

DIA 22. St. Augustine
Germany
c. 1500–25
Rectangle: 76 × 42 cm (30 × 16½ in)
Accession no. 31.265, Gift of Mrs. Ralph
Harman Booth

Ill. nos. DIA 22, 22/a

History of the glass: There are no records of ownership until Mrs. Ralph Harman Booth, Grosse Pointe, Michigan, presented the panel to the DIA in 1931. The panel was probably purchased by Ralph Harman Booth sometime after 1922 when, as the first president for the Detroit Arts Commission, he began an active association with William Valentiner in Detroit and on European trips was associated with purchases for the Museum's collection (DIA Curator's file). [German Gallery]

Bibliography
UNPUBLISHED SOURCES: DIA Curatorial files.

PUBLISHED SOURCES: Raguin in *Checklist* III, p. 174.

Condition: Repair leads appear throughout the panel. Some paint abrasion is present, especially in the face and halo.

Iconography: Augustine is shown in bishop's robes, with cope, miter and crosier. He holds his traditional emblems,

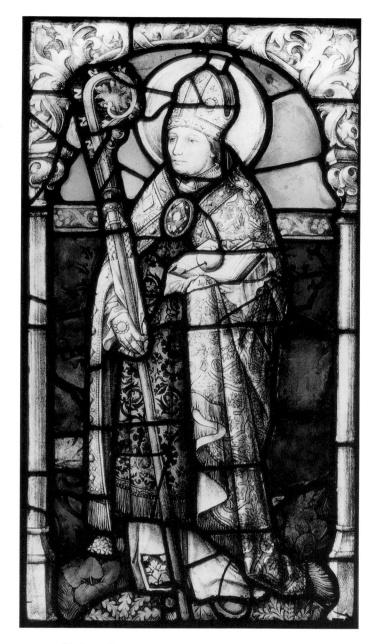

DIA 22. *St. Augustine*

an open book on which rests a heart pierced with an arrow (*Herder Lexikon*, 5, cols. 277–90; Réau, 3/2, pp. 149–56). The emblems are related to a passage in his *Confessions* concerning his conversion, when he heard a singing voice of a child in a nearby house repeating "Take and read" (*tolle lege*: Augustine, *Confessions*, Book 8:12, trans. R. S. Pine Coffin, New York, 1981, pp. 177–8). Augustine understood this to be an injunction to open the Scriptures at random, leading to his reading of Paul's Epistle to the Romans (13:14) exhorting the faithful to "put ye on the Lord Jesus Christ." The heart refers to a later passage from the *Confessions* (Book 9:2, ibid., p. 182) where Augustine speaks to God from within the community of believers, "You had pierced our hearts with the arrows of your love." In the Renaissance Augustine was

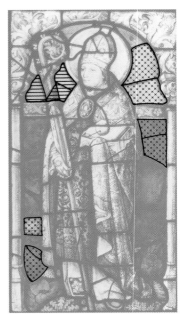

DIA 22a. Restoration chart

revered as one of the four Doctors of the Latin Church, and particularly honored as a patron of learning.

Color: The panel is dominated by the contrast of deep warm red in the damascene background and the pale to bright off-whites and yellows of figure and frame. The saint's chasuble is a deep warm yellow, and his cope a pale neutral with multiple accents of pale to bright yellow. The architectural frame is lighter still, with only a few accents of pale yellow in the stems of the sculpted foliage. Acting as foils are the light cool blue around the saint's shoulders and head and the deep bright green of the ground at his feet.

Technique: Pot-metal glass appears in the blue, red, and green of the ground and the yellow of the crosier head and chasuble. All other elements are uncolored glass and silver stain.

Style: The disposition of standing figure within an architectural niche was a standard aspect of glazing programs from Romanesque times. One sees the format at Strasbourg Cathedral in the windows of St. John the Baptist and St. John the Evangelist, possibly about 1190, now set in the north transept wall (Christine Wild-Block in *Les Vitraux de la cathédrale Notre-Dame de Strasbourg. Corpus Vitrearum France* 9/1, Paris, 1986, pp. 76–84, figs. 59–60, 65; Grodecki 1977, pp. 168–72, figs. 144, 146). The essential elements in the Detroit panel are already employed, two side columns supporting the framing arch, and the division of the background among floor, drapery hanging, and sky. In the Romanesque work the hanging is positioned much lower, however. As styles changed, so did the forms of the architecture and the stance of the figures. In the thirteenth century, the figure of *Henricus Rex*, c. 1240–45, in the nave of the cathedral utilizes an architectural frame of pointed Gothic arches (Wild-Block, pp. 191–5, figs. 165–96). Common to German art from at least the last quarter of the fifteenth century is the use of two straight columns starting from tall bases, a foliate capital and arching frame acting as a base for intertwining leaves, as exemplified by work influenced by the art of the Strasbourg Workshop-Cooperative (see entry for DIA 19–21). A panel dated about 1482 showing John the Baptist in the parish church of Lautenbach is a good example of the Late Gothic architectural conventions (Becksmann

1979, pp. XLIV, 181, figs. 230, 234). At the turn of the century, however, one finds a strong interest in linear details working with the incipient Renaissance three-dimensionality of the figure. The delight in the rich patterns and textures of the fabrics of the saint's robes and the cloth draped between the columns is typical of Rhenish and Bavarian art of this period. At this time the generic pattern for bishop saint, dressed in miter and cope and standing in a three-quarter view was refined, as exemplified by the drawing from c. 1510 of St. Nicholas (DIA 29/fig. 2) by Hans Suess von Kulmbach.

Close similarities to the Detroit St. Augustine can be found in the series of saints dated 1503–1505 from the window of the parish church of Ingolstadt (Adolf Knappe, *Albrecht Dürer und das Bamberger Fenster in St. Sebald in Nürnberg*, Nuremberg, 1961, pp. 66, 96–7, fig. 58, especially the panel of St. Barbara with the small tower). It has been suggested that the Ingolstadt panels are modeled after designs by Hans Suess von Kulmbach (Eva Ulbrich, "Die Glasgemälde der Pfarrkirche au 'Schönen unser liben Frau' in Ingolstadt," Unpublished Dissertation, University of Mainz, 1956). This attribution is not supported by Knappe or by Barbara Butts (Butts 1985; see also Frenzel and Ulrich 1974, pp. 373–97). Although one cannot include the St. Augustine panel in this program, one can discern strong similarities in the concepts of design and handling of space. The Detroit and Ingolstadt panels show similar attempts to define the facial planes, especially in the softness of the lower chin. The walls of the enframing arch are shaded with the same horizontal banding of parallel lines that serve to relieve the undulation of the foliage ornament. Common principles also link the proportions of the figure to the archway and the strong horizontal line between the hanging and the upper background.

Date: It is most probable that the Detroit panel dates to the first quarter of the sixteenth century. The figure is set comfortably in its three-dimensional setting. The glass painter responsible for the image employed Renaissance systems of modeling that became a part of German art after Dürer's interaction with Italian conventions of spatial illusion at the turn of the century.

Photographic reference: DIA Neg. no. 28727 (1985/04/15)

DIA 23–27. STANDING FIGURES OF THREE SAINTS AND TWO REPRESENTATIONS OF THE VIRGIN AND CHILD

Germany, Rhineland (?) or England by Foreign Glaziers (?)

1510–25

History of the glass: The panels are first noted as set in the Tudor manor house completed in 1505 at Stoke Poges, Buckinghamshire. The building was almost totally torn down in 1799, when a new building was erected by James Wyatt on an adjacent site (James Joseph Sheahan, *History and Topography of Buckinghamshire*, London, 1862, p. 871). In 1847 Lipscomb recorded "full-length portraits of Saints, Martyrs, &c . . . collected out of the ruins of the old Mansion at Stoke" and installed in the cloisters "of modern erection." He makes specific mention of only Adrian, Anthony, the Virgin with Child holding a Ball, and Wenceslas, referring to the beggar as "a devotee praying" (Lipscomb 1847, p. 568). In 1894 Westlake described six figures, Anthony (DIA 23–27/fig. 1), Eloi [rect. Adrian] (DIA 23–27/fig. 2), Martin or Wenceslas (DIA 23–27/fig. 3), Margaret or Barbara and the two versions of the Virgin and Child, in "a small annex of the north side of the Church of Stoke Poges" and published drawings of Anthony, Adrian, and Wenceslas (Westlake 1894, pp. 63–4, pls. LI a & c).

Colonel Shaw of Stoke Poges Manor, consigned the panels to the dealer, P. W. French & Co., New York, in 1929 and they were auctioned by Sotheby's in London, 16 May 1929. The six panels were in the possession of William

DIA 23–27/fig. 2. *St. Eloi (rect. Adrian)* from N.H.J. Westlake, *A History of Design in Painted Glass*, vol. 4

Randolph Hearst of Los Angeles until offered for sale by Gimbel Brothers, New York, through Hammer Galleries in 1941. The companion piece, *St. Adrian of Nicomedia* (DIA 23–27/fig. 4), was purchased by the Higgins Armory Museum, Worcester Massachusetts from this sale (HAW files). The other five panels did not sell, and went into storage, ultimately to be purchased by the Detroit Institute of Arts from the Hearst Foundation in 1958. The panels of *St. Anthony Abbot* and the *Virgin with Christ Child holding a Ball* were given by Mrs. Edsel B. Ford. K. T. Keller funded purchase of *St. Wenceslas of Bohemia* and the *Virgin with Christ Child holding a Top and Spinning String*. The purchase of *St. Barbara* was made possible by the generosity of Mr. and Mrs. James S. Whitcomb. [All five panels are in the German/Flemish Galleries]

DIA 23–27/fig. 3. *St. Wenceslas and detail of canopy* from N.H.J. Westlake, *A History of Design in Painted Glass*, vol. 4

Related material:

St. Adrian of Nicomedia (DIA 23–27/fig. 4), Worcester, Massachusetts, The Woodman Higgins Armory Museum, 2728. *Inscription:* O SANTE A [...] ENE ORA PRO. (Oh St. Anthony, pray for) (Lipscomb 1847; Westlake 1894; *Sotheby* sale 1929; *Hearst* sale 1941, 330 no 66–1, ill. 135; Caviness 1978, pp. 78–9, no. 38; Raguin 1987, p. 70, no. 29).

DIA 23–27/fig. 1. *St. Anthony Abbot* from N.H.J. Westlake, *A History of Design in Painted Glass*, vol. 4

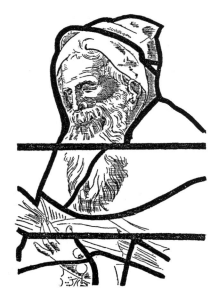

["

(Francis Bond, *Dedication and Patron Saints of English Churches: Ecclesiastical Symbolism, Saints and their Emblems*, London, 1914, p. 308). St. Barbara was one of the most popular late medieval patrons and a consistent image in Lowlands and German art of the time, in panels, glass and sculpture. The armor shown in the panel of *St. Adrian* (DIA 23–27/fig. 4) was identified by Karcheski as Northern European dating about 1500 to 1510, supporting the Lowlands or Rhenish connections of the iconography (Raguin 1987, p. 70).

Technique: Like most glass painting of this time, the panels display large expanses of uncolored glass balanced by intense areas of pot-metal color. The uncolored glass is further modulated by considerable use of silver stain and stipple, line, and mat shading. The glass is of unusually high quality, showing an attractive smooth surface, quite silken to the touch, and a high resistance to corrosion. The painting and firing skill is also of the highest level. The vitreous paint has been applied with so even a layer and the firing so controlled that the paint is completely integrated with the glass surface. The painted and unpainted surfaces flow together as a unit. In most cases it is this integrity of surface that distinguishes the replacement pieces, however well painted, from the antique object. A discussion of the variety of modeling techniques is treated under style.

Style: The Stoke Poges panels display an intriguing amalgam of styles, predominantly Lowlands and Rhenish. Such a mixture seems particularly perplexing given the extraordinarily high technical and artistic execution of the panels. Often one finds vernacular or "low" art combining a variety of iconographic and stylistic concepts because of the inexperience of the artist. An artist without a "schooled" style is far more at ease with combinations of spatial techniques, compositions, canons of proportion, etc. taken from whatever models are available. The juxtapositions are idiosyncratic since the vernacular work is produced in the context of a limited, often even solitary, service to a local and equally unschooled circle of patrons. Artists who develop concepts through long apprenticeships in great centers of production for a sophisticated patronage, as is evidently the case for the creators of the Stoke Poges panels, are far more likely to retain a hard-won command of habits of design and painting expression. The predominant effect is an extremely rich range of colors and values that both accent the individuality of the figures and retain the surface tension characteristic of medieval window aesthetic.

The issue of Rhenish and Lowlands concepts in these panels is further complicated by the evidence from this period that Lowlands artists were working in French lands, especially Normandy. The long elegant proportions of the forms seem particularly close to the art of Arnoult

de Nimègue, who began his career in Tournai around 1490 but worked in Mechelen, Antwerp, and Rouen from 1500 to about 1536. A variety of spellings of his name are recorded: Arnt Nimegen, Arnoult de la Pointe, Arnoult van der Spits, Artus van Ort de Nieumegue, Art Ortkens, and even Aert de Glaesmakere. (See Lafond 1930; id., "Le peintre-verrier Arnoult de Nimègue et les débuts de la Renaissance à Rouen et à Anvers," *Actes du XVIIe Congrès international d'histoire de l'art, Amsterdam, 1952*, The Hague, 1955, pp. 333–44; id., in *Vitrail français*, pp. 215–17; Jean Helbig, "Arnold de Nimègue et le problème de son identité," *L'Art et la vie*, 4/9, September, 1937, pp. 279–90; A. Van der Boom, *Monumentale Glasschilderkunst in Nederland*, s'Gravenhage, 1940, pp. 83–101; id., "Een Nederlands glasschilder in den vreemde, Aert Ortken van Nijmegen," *Nederlands kunsthistorisch jaarboek*, 2, 1948–49, pp. 75–103.)

An entire generation of artists was influenced by the style of Arnoult de Nimègue. An exact itinerary of the artist and the means of his influence on specific painters, however, are not yet fully understood. The connection to Arnoult de Nimègue was suggested by Caviness (1978) and supported by Raguin (1987). The Stoke Poges panels seem particularly close to works produced in the circle of Arnoult de Nimègue, especially the panels from the cycle of the *Life of St. John the Baptist* from Rouen now in the Burrell Collection (Burrell Collection, Glasgow, 45/417–424). The figure of Salome beginning her dance before Herod (45/422) is similar in its elongated proportions to the Stoke Poges *St. Barbara*. Both figures show particularly small heads atop long bodies swathed in layers of richly worked materials. The swaths of drapery circling the hips accentuate the close-fitting bodices and elegant hands as they emerge from their sleeves. Norman also are the disk haloes hovering at an angle above the head. The figure of St. Wenceslas may be compared to figures in the famous *Tree of Jesse* by Arnoult in the Church of St. Goddard in Rouen (Lafond in *Vitrail français*, p. 215, fig. 163). The seated Jesse in the center shows the same large headgear, elaborated clothing, and use of damascening to enrich the representation. The prophet to the extreme right on the first level shows the same presence of jeweled ornament and layered dress as that prevalent in the Stoke Poges panels (Lafond 1930, pl. X).

The painting style, however, shows a very close connection to Rhenish execution but finds no parallels in France or the Lowlands. Arnoult's style and that of his circle emphasize a summary description of the facial plane. Eyes are represented by short horizontal strokes. The features almost appear to float on the picture plane. The description of drapery also reveals a similar painterly approach, with brushed-in highlight and shadow building the form. The Stoke Poges panels show a meticulous application of modeling conceptions using stippling and hatch work,

much more characteristic of Rhenish ateliers. The extra-ordinary detail of the graphic execution, reminiscent of techniques in contemporaneous engravings, argues that the panels were designed to have been visible at close vantage, such as that afforded by a small private chapel. In contrast, one may cite the brilliantly executed panels by a workshop associated with the Master of the Holy Kinship and the Master of St. Severin in the north nave of Cologne Cathedral, about 1507–09, showing a more summary indication of feature, consistent with the panels' considerable distance from the viewer. (Herbert Rode, "Die Namen der Meister der Hl. Sippe und von St. Severin. Eine Hypothese, zugleich ein Beitrag zu dem Glasmalereizyklus im nördlichen Seitenschiff des Kölner Doms," *Wallraf-Richartz Jahrbuch*, 31, 1969, pp. 249–54).

The figures give evidence that at least two, and possibly three, hands were responsible for the application of paint. The *Virgin with Child holding the Ball*, as well as the images of *St. Anthony* show a radically different modeling approach than that of the *Virgin and Christ Child holding Top and Spinning String*. The first Virgin, facing frontally, is modeled in stipple technique, creating a gradual build-up of volumes. The second Virgin, like the images of Saints Barbara and Wenceslas, illustrates a linear technique of hatch and cross-hatch, especially in the faces. The garments of these last three, however, also show much stipple work.

These methods of paint application and subsequent achievement of three-dimensional modeling are common to Rhenish art of the period. In the Detroit Institute of Arts, the panels of the *Prophets and Psalmists after the 'Biblia Pauperum'* (DIA 5–16) from Cologne, demonstrate both linear and stipple modeling. In the Schnütgen Museum, Cologne, a head of St. John (DIA 23–27/fig. 5) presumably from a Crucifixion group from Cologne (Lymant 1982, p. 157, no. 89) dated to the end of the fifteenth century and a head of St. Bernard or Benedict (DIA 23–27/fig. 6) associated with the church of St. Apern of Cologne (Lymant 1982, p. 213, no. 136, Inv. Nr. M 574) dated about 1525, show the same techniques of draftsmanship. Both heads are formed by a combination of mat base modeled by brush work lifting off the mat, hatching, and a strong trace line coupled with stickwork especially in the hair. Although the heads differ in design, they show a consistency of modeling choices, thus testifying to workshop habits of paint application that remained standard even over more than a quarter of a century. Drapery modeling in the Cologne area is also similar, evidenced by the similarities between the stipple work and soft voluminous folds of St. Anthony's robe and those in a small panel of *St. Catherine* (DIA 23–27/fig. 7) attributed to Cologne and dated about 1520 (Lymant 1982, pp. 189–90, no. 117, Inv. Nr. M 548). Although radically different in scale, the two figures possess similar monumentality and simplicity of conception. One is thus encouraged to suggest that per-

DIA 23–27/fig. 5. *Head of St. John*, from Cologne, late 15th century. Cologne, Schnütgen Museum

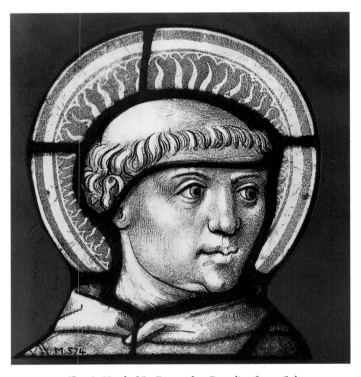

DIA 23–27/fig. 6. *Head of St. Bernard or Benedict*, from Cologne, Church of St. Apern, *c.* 1525. Cologne, Schnütgen Museum

haps we have in the Stoke Poges panels an unusual confrontation of a Franco/Flemish designer with Rhenish glass painters. At this period in the evolution of stained glass, the division of painter and designer had been firmly established. Even based only on the programs we are analyzing in this Midwest catalogue, we can see that painters were not expected to shift from one technique to another to harmonize with other painters within a workshop. In

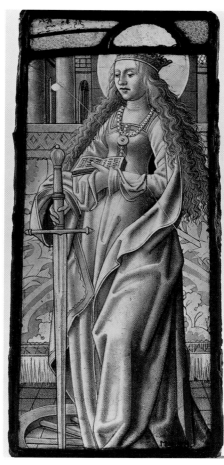

DIA 23–27/fig. 7.
St. Catherine, from
Cologne, *c.* 1520.
Cologne, Schnütgen
Museum

logue of the Collections of William Randolph Hearst,"
[International Studio Art Corp., Index compiled 2/18/
1939], Stained Glass, vols. 101–4, lot no. 66 art 1–6.

PUBLISHED SOURCES: George Lipscomb, *The History and
Antiquities of the Country of Buckingham,* 4, London, 1847,
p. 568; Westlake 1881–86, 4, pp. 63–4, pls. LI a & c;
*Catalogue of Fine Early German Stained Glass (removed from
the Private Vestibule to Stokes Poges Church) The Property of
Colonel Shaw* [sale cat., Sotheby, Ltd., 16 May], London,
1929, p. 9, lot 49; Jean Lafond, "Arnoult de Nimègue et
son oeuvre," Extrait du *Bulletin de la Société des Monuments
rouennais (1926–27),* Rouen, 1930; *Hearst* sale 1941, p.
330, nos. 66–2 to 8, (C) ill. p. 135; *Handbook, The Detroit
Institute of Arts,* Detroit, 1971, p. 123; Caviness 1978, pp.
78–9; Barnet 1986, p. 41, pl. VIII (C and D); Raguin
1987, p. 70; Tutag and Hamilton 1987, p. 17; Raguin
and Kline in *Checklist* III, p. 161; Kline and Raguin 1992,
fig. 22; DIA *Guide,* p. 162, col. ill., St. Wenceslas; Raguin
1998, pp. 244–6, fig. 4, Anthony Abbot.

DIA 23. St. Anthony Abbot
Rectangle: 180 × 59.5 cm (70⅞ × 23 7/16 in)
Accession no. 58.93, Gift of Mrs. Edsel B. Ford
Ill. nos. DIA 23, 23/a, 23–27/figs. 1–7

Inscription: O PATER SANTE ANTONI ORA PRO (Oh, Holy
Father Anthony, pray for...)

Condition: The hard late medieval glass shows only min-
uscule pitting and very minor abrasion. Thus the clarity
and delicacy of the extremely fine painting is unimpaired.
The panel of *St. Anthony Abbot* is one of the best preserved
of the five, showing only a minor stopgap from the same
series in the robe just below the rosary and the lower right
segment of the damask background. Minor replacements
in the base and lower tunic.

Iconography: Anthony was one of the best-known saints
of the later Middle Ages (*Herder Lexikon,* 5, cols. 205–17;
Réau, 3/1, pp. 101–5; Künstle, 2, pp. 66–72). His popu-
larity appeared related to two important trends, the asso-
ciation of saints as healers of specific diseases and as models
for lay piety. Anthony was associated with heroic self-
denial and bodily mortification. He was described as
undergoing heroic fasts and being subjected to the tor-
ments of demons who transported him through the air.
The most common sources for the events were the life of the
saint by Athanasius translated into Latin in 392 and the
late thirteenth-century account in the *Golden Legend* (pp.
99–103). His asceticism and temptations were ample
sources of visual and verbal narrative, for example, Schon-
gauer's engraving and altarpieces by Bosch and Grüne-
wald. (Schneider 1985, pp. 208–10, 282–3, 346–53;

fact, the unusual appearance of designers who were also
painters is revealed by the contemporaneous praise given
to Dirick Vellert. Ludiovico Guicciardini made specific
mention of the artist as one who still executed many of his
own designs (*Collectaea van Gerardus Geldenhauer Nov-
iamagus,* ed. J. Prinsen, *Werken uitgeven door her Historisch
Genootschap,* 3rd ser., 16, Amsterdam, 1901, p. 73).

Exactly how might have such a collaboration of artists
from different localities have taken place? A non-typical
workshop may have been the result of a non-typical situa-
tion. We are encouraged to consider seriously the sugges-
tion that the windows may have been produced in the
early years of the sixteenth century for the original chapel
of Stoke Poges. It is possible that an English patron could
have assembled an international group of artisans whose
cooperation on the site produced the particular amalgam
of Franco-Flemish and Rhenish features.

Date: The six panels show strong similarities to art of the
period from 1510–25. The date would correspond to the
completion of the Stoke Poges manor house in 1505,
allowing a patron to organize the mixed workshop of glass
workers.

Bibliography
UNPUBLISHED SOURCES: French & Co. Stock Sheets, pho-
tographs only; Greenvale, NY, C. W. Post Center of Long
Island University, Special Collections Library, ms "Cata-

Charles Cuttler, "The Lisbon Temptation of St. Anthony by Jerome Bosch," *AB*, 24, 1957, pp. 109–26). The issues were major elements of lay piety, in particular that practiced by women, as explored by recent scholars (Caroline Walker Bynum, *Holy Feast and Holy Fast*, Berkeley, 1987; Rudolf Bell, *Holy Anorexia*, Chicago, 1985). His powers as a healer preceded this function. Anthony's relics had been brought from Constantinople to a Benedictine priory outside of Vienne, France, possibly by 1070. In 1089 many of the provinces of France experienced an outbreak of ergotism, a painful skin inflammation, often fatal, that resulted from eating grains contaminated by the ergot fungus. The abatement of the epidemic was associated with St. Anthony's intercession, the disease acquiring the name of St. Anthony's fire. A nobleman of the region named Gaston de Dauphiné about 1095 founded a hospital near the priory to treat the disease. Pope Boniface VIII (1297) granted a religious rule to the hospital's lay confraternity which became known as the Regular Canons of St. Anthony, or Antonines (Alban Butler, *Lives of the Saints*, 1, New York, 1846, pp. 165–72). The Antonines had houses all along the Rhine, in Isenheim, Freiburg, Mainz, Frankfurt, and Cologne, as well other northern cities.

Color: The bright warm red of the damascene background and the deep cool blue of the saint's tunic frame the neutral off-white of his robe. These contrasts silhouette the figure and accent the three-dimensionality of the form. The overall warmth of the color scheme is supported by the deep orange-yellows of the saint's halo, page edges, walking stick, rosary and garment trim.

Photographic reference: DIA Neg. no. 29249 (1985/10/23)

(left) DIA 23/a.
Restoration chart
(right) DIA 23.
St. Anthony Abbot

DIA 24. Virgin with Christ Child holding a Ball

Ill. nos. DIA 24, 24/a
Rectangle: 180 × 59.5 cm (70$\frac{7}{8}$ × 23$\frac{7}{16}$ in)
Accession no. 58.94, Gift of Mrs. Edsel B. Ford
Ill. nos. DIA 24, 24/a, 23–27/figs. 1–7

Inscription: *REGINA CELORUM ORA PRO* (Queen of Heaven, pray for)

Condition: The major replacements include the area of the cloak to the Virgin's right, below her arm, the lowest sections of her blue robe, part of the base and a small segment of the inscription. A portion of the blue damascene ground is stopgap from the same series.

Iconography: The Virgin and Child holding a ball is a standard late medieval motif. The image appears relatively simple, yet actually contains the paradigm of the juxtaposition of the infant in his mother's arms as already ruler of the heavens. The ball, seemingly a child's plaything is also an image of the imperial orb, familiar to Western ruler images from the Ottonian period. See, for example, the image of Otto III enthroned receiving homage from the personifications of the four parts of the empire (*Gospel Book of Otto III*, 997–1000, Munich, Staatsbibliothek, MS Clm. 4453, f. 24: Beckwith 1973, fig. 85) or the gold antipendium showing Christ adored by the Emperor Henry II, made at Mainz or Fulda about 1019 (formerly Basle Cathedral, now Paris, Cluny Museum, Beckwith 1973, fig. 133).

Color: The panel is dominated by the medium to deep warm blue of the background and the bright warm blue of the Virgin's robe. Balancing this intensity are the pale off-white of her cloak and the light yellow of her hair. A deeper orange-yellow appears in her crown, halo, and trim of her garments.

Photographic reference: DIA Neg. no. 29250 (1985/10/23)

(left) DIA 24/a. Restoration chart
(right) DIA 24. *Virgin with Christ Child holding a Ball*

DIA 25. *St. Wenceslas of Bohemia*

DIA 25. St. Wenceslas
Rectangle: 180 × 59.5 cm (70⅞ × 23⁷⁄₁₆ in.)
Accession no. 58.111, Gift of K.T. Keller
Ill. nos. DIA 25, 25/a, 23–27/figs. 1–7, Col. pl. 42

Inscription: (on border of cloak) *OSVOSAO. VSEBDSTCGHR/ OR BIENE SOP OMNI* (unintelligible)

Condition: Replacements include the triangular area of cloak below Wenceslas's waist and a few smaller segments at both sides of the panel.

Iconography: Wenceslas was the Duke of Bohemia (later a kingdom, so he was commonly referred to as King Wenceslas). He was assassinated by his brother, in either 929 or 935 with the support of his mother, who had reverted to pagan customs (*Herder Lexikon*, 8, cols. 595–9; Réau, 3/3, pp. 1308–9; Künstle, 2, pp. 591–2). He had formed an alliance with the Holy Roman Emperor, Otto I, who invaded Bohemia to avenge Wenceslas's death. The Christian religion was restored under the subsequent king, Boleslas II. The body of the saint was transferred to the church of St. Vitus in Prague shortly after his death. His cult was furthered especially in the fourteenth century under the influence of the Holy Roman Emperor Charles IV. His earliest representations were as king. Later, in Eastern Europe he was often represented as a knight, and in the West as a nobleman, as he is in the Detroit panel. He was particularly praised for his good works, becoming something of a male counterpart for St. Elizabeth of Hungary, a model for noble personages in maintaining charitable support for the poor and for pilgrims passing through their lands. Thus Wenceslas is shown richly dressed and with a beggar at his feet.

DIA 25/a. Restoration chart

Color: The panel shows a variety of colors, but dominated by deep warm red of the saint's centrally placed tunic. The damascene background is a bright warm blue that silhouettes the pale neutral of the cloak and the pale warm green of its lining and unfolded hood. Wenceslas's deep blue-gray leggings act as a foil for his warm red shoes and pale cool blue of the tunic of the beggar at his feet.

Photographic reference: DIA Neg. no. 29253 (1985/10/23)

DIA **26. Virgin with Christ Child holding a Top and Spinning String**

Rectangle: 180 × 59.5 cm (70⅞ × 23⁷⁄₁₆ in)
Accession no. 58.112, Gift of K. T. Keller
 Ill. nos. DIA 26, 26/a, 23–27/figs. 1–7

Condition: Replacements include the Child's head and the drapery immediately adjacent, a central portion of the Virgin's cloak, the hem of her robe, and the background to the lower left. The upper portion of the damascene ground is a stopgap from the same series.

Iconography: The iconography of the Christ Child with spinning top is unusual, but consistent with Late Medieval and Renaissance religious imagery that delighted in juxtaposing the microcosm and macrocosm. The child plays with a top, controlling its movements; the omnipotent God holds the earth as a toy in his hands. Svetlana Alpers (*The Art of Describing*, Chicago, 1983), discusses the growing importance of scientific discoveries concerning the nature of the earth at this time. A similar top, with three propellers on the stem, is visible in the painting by Pieter Bruegel the Elder, *Kinderspiele*, of about 1560 (Kunsthistorisches Museum, Vienna, In N. 1017, Gustav Glück, *Das grosse Bruegel-Werk*, Vienna, 1963, pp. 54–6, pl. 14; Erica Tietz-Conrat,"P. Bruegels Kinderspiele," *Oudheidkundig Jaarboek*, 2nd ser., 4, 1934, p. 127).

DIA 26/a. Restoration chart

Color: The panel is balanced according to a major triad, the bright red damascene ground, deep cool blue robe, and warm yellow and off-white cloak and deeper yellow decorative elements. The yellows vary from pale yellow of the Virgin's hair to deep orange-yellow in crown and halo.

Photographic reference: DIA Neg. no. 29252 (1985/10/23)

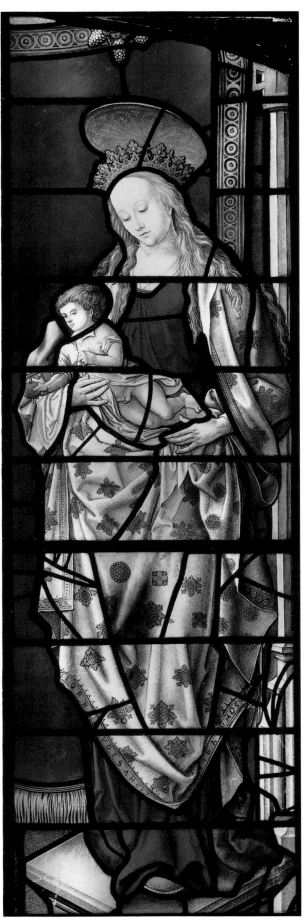

(right) DIA 26. *Virgin with Christ Child holding a Top and Spinning String*

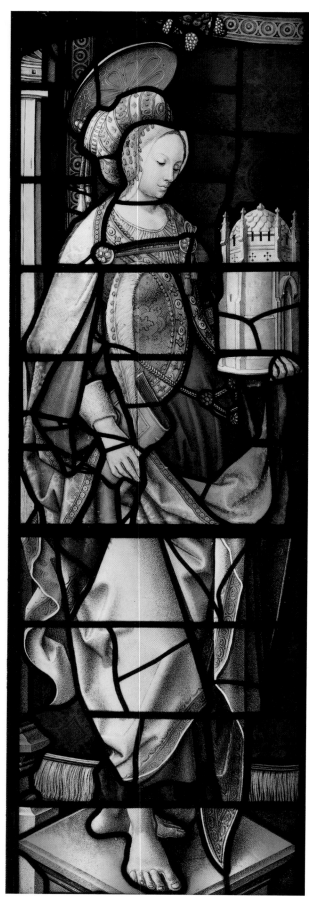

DIA 27. *St. Barbara*

DIA 27. St. Barbara

Rectangle: 180 × 59.5 cm (70⅞ × 23⁷⁄₁₆ in)
Accession no. 58.155, Gift of Mr. and Mrs. James Whitcomb

Ill. nos. DIA 27, 27/a, 23–27/figs. 1–7

Condition: The entire lower section, beginning with the lower edge of the blue lining of her cloak is a stopgap from another panel in the same series. The small blue and green elements completing the tunic and lining of the cloak are modern replacements set in to help blend the upper and lower sections. There are also replacements in the red ground at the top and bottom on the right.

DIA 26/a. Restoration chart

Iconography: Barbara was popularized in Germany as one of the three female intercessors among the fourteen Auxiliary Saints, the others being Catherine and Margaret. She is shown with her identifying attribute, the tower, recalling the tower in which her father had imprisoned her hoping, in vain, to prevent her from being indoctrinated into the Christian faith (*Herder Lexikon*, 5, cols. 304–12; Réau, 3/1, pp. 169–77; Künstle, 2, pp. 112–5). Origin sent a priest disguised as a doctor who instructed her in the faith, and her father had her beheaded. Thus she is shown with the palm of martyrdom and the book of her instruction. As a protector against untimely death, meaning without the Last Rites of the Catholic church, she is also frequently shown with a chalice and Eucharistic wafer.

Color: The light neutral of the saint's robe is set against a warm bright red damascene ground. The deep cool green of her tunic plays off the pale cool blue of the lining of her robe. The warmth of the color scheme is enhanced by the bright yellow of her halo, jeweled bodice, headdress and garment trim.

Photographic reference: DIA Neg. no. 29251 (1985/10/23)

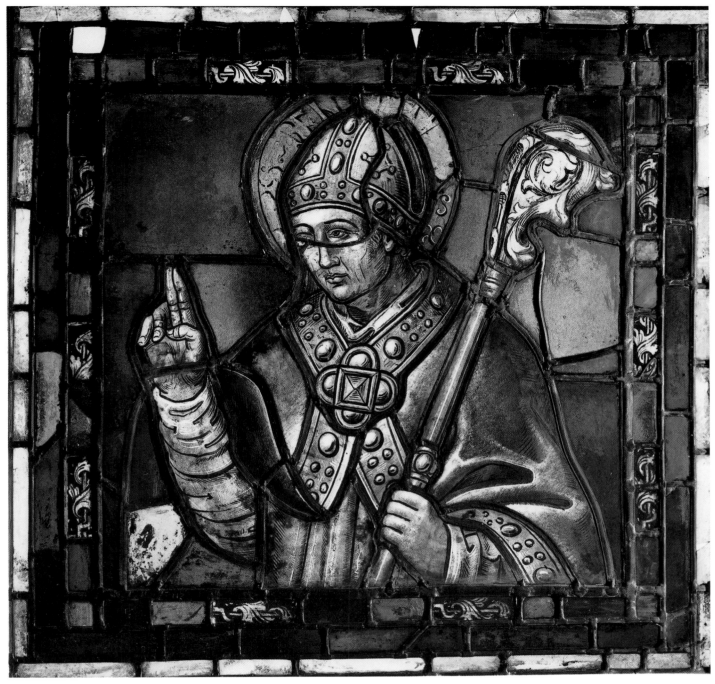

DIA 28. *Bishop Saint (Benedict?), c.* 1510–25

DIA 28. Bishop Saint (Benedict?)
Germany
c. 1510–25
Square: 43 × 44 cm (17 × 17¼ in) without borders
Accession no. 48.133, Gift of Armand Hammer
Ill. nos. DIA 28, 28/a

History of the glass: The panel is recorded to have been part of the Clarence H. MacKay collection before it was acquired by Armand Hammer, New York. The Detroit Institute of Arts received the panel through a gift of Armand Hammer. [In storage]

Bibliography
UNPUBLISHED SOURCES: DIA Curatorial files.

PUBLISHED SOURCES: Raguin in *Checklist* III, p. 162.

Inscription: (on halo) S BEN [. . .] (St. Benedict)

Condition: The panel was originally from a larger composition, presumably a standing figure framed by architecture. The border is stopgap. There are a few mending leads, most noticeable in the head. Some stopgaps and restructuring of the figure is noticeable in the lower portions of the figure, and possibly the upper part of the halo and upper part of crosier.

Iconography: The image is extremely traditional. An

211

DIA 28/a. Restoration chart

gin somewhat removed from the influence of progressive Renaissance ideas of form and rendering techniques.

Date: It is most probable that the Detroit panel dates 1510–25.

Photographic reference: DIA Neg. no. 7418 (1948)

DIA 29. Crucifixion with the Virgin, St. John, and Angels
Veit Hirsvogel, the Elder (workshop of), after design by a pupil of Albrecht Dürer
Germany, Nuremberg
1514
Rectangle: 45.7 × 34.3 cm (18 × 13½ in)
Accession no. 37.35, Gift of Mrs. Ralph Harman Booth

Ill. nos. DIA 29, 29/figs. 1–3; Col. pl. 23

History of the glass: The panel of the Crucifixion is incontestably a product of the Nuremberg circle of artists and craftspersons working in the early decades of the sixteenth century. Its small size evidently made it an object easily transported and stored, which may be the reason for its lack of provenance. The panel was part of the collection of Mrs. Ralph Harman Booth, Grosse Pointe, Michigan, who presented it to the Detroit Institute of Arts in 1937. To date no additional documentation has been discovered as to its previous owners or origin. [German/Flemish Galleries]

Bibliography

UNPUBLISHED SOURCES: Barbara Butts, St. Louis Art Museum, St. Louis; "Minutes of the Accessions Committee…Detroit Institute of Arts" (1937), record of acquisition.

PUBLISHED SOURCES: Friederich Winkler, *Die Zeichnungen Hans Süss von Kulmbachs und Hans Leonard Schäuffeleins*, Berlin, 1942; Jane Hayward in *Nuremberg*, p. 356, no. 172; Barnet 1986, p. 41; Tutag and Hamilton 1987, pp. 17, 23; Raguin in *Checklist* III, p. 163; Scholz 1991, p. 246.

Inscription: 1514

Condition: There is a crack in the center of the blue mantle of the Virgin and several cracks in the torso and head of Christ. Prior to its 1986 exhibition (*Nuremberg*), the panel was cleaned and the cracks mended with an epoxy sealant. Otherwise, the panel is in excellent condition, showing very slight abrasion, paint loss, or pitting.

Iconography: The iconography of the panel is a traditional representation of Christ on the Cross between the Virgin and St. John. The scene is set in a simple landscape with a

ecclesiastic wears miter, cope, and carries a crosier, the badge of his pastoral office. He faces us in a three-quarter view and raises his hand in a gesture of blessing, index and middle fingers joined. The inscription on the halo is the only means of distinguishing such a generic ecclesiastical representation as portraying St. Benedict, founder of western monasticism (see discussion under DIA 40).

Color: The panel is dominated by the analogous color harmonies of blue, green and yellow. A color composition is well balanced among the clear medium blue of the background, the light green of his robes, and the deep warm yellow of his halo, crosier, and trim of episcopal vestments. The one exception is the warm red of lining of Benedict's mantle framing his uplifted arm.

Technique: The panel is composed of pot-metal and uncolored glass. Silver stain and vitreous paint define the form. The sharp trace lines in the face and the scoop fold treatment of the arms, close to the linear appearance of a woodcut, shows the strong interrelations of works on paper and the art of glass painting *c.* 1500.

Style: The panel is very similar in all respects of composition, iconography, and technique to the Detroit Institute of Art's *St. Augustine* (DIA 22) or the Evansville Museum of Arts and Science panel of *Four Standing Saints* (EMAS 1). For both, comparisons are made to the windows of the parish church of Ingolstadt (Gottfried Frenzel and Eva Ulbrich, "Die Farbverglazung des Münsters zu Ingolstadt," in *Ingolstadt*, 1/2, 1974, pp. 373–97). The draftsmanship of the *Bishop Saint* is far less sophisticated than the soft volumetric rendering found in Detroit's *St. Augustine*, suggesting an ori-

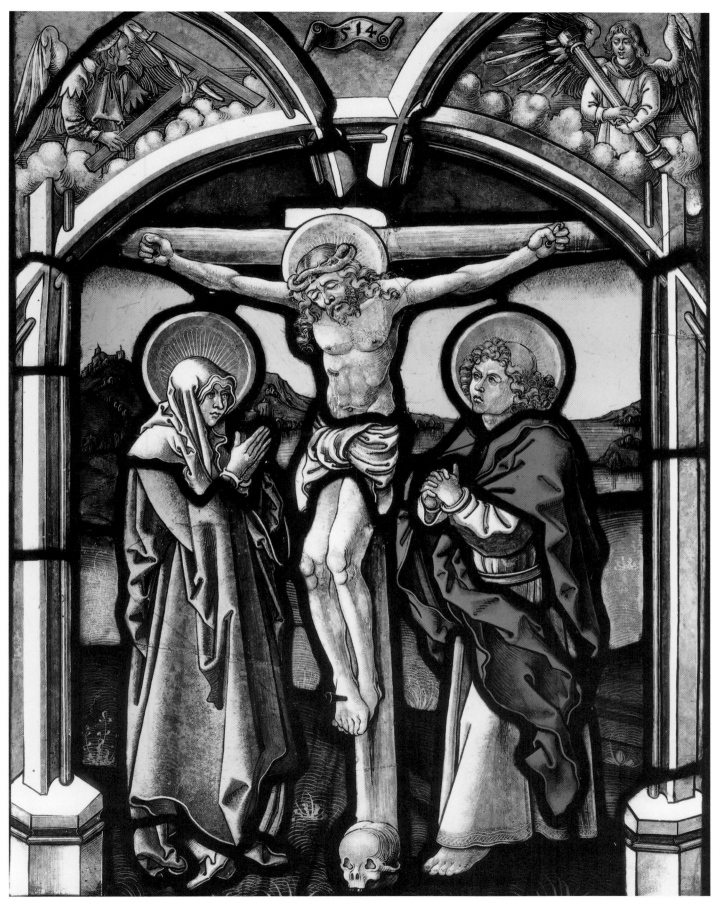

DIA 29. *Crucifixion with the Virgin, St. John, and Angels*

high horizon. The skull at the foot of the cross marks the ground as Golgotha, "the place called the Skull" (John 19:17), and also symbolizes the link between the Old Adam, humanity's first parent who lost God's love, and Christ, the New Adam, who as both man and God, restores it. Traditionally, belief connected the wood of the cross to the tree of the Fall, sometimes even localizing Adam's grave at Golgotha (Paul Thoby, *Le Crucifix des origines au concile de Trente*, Nantes, 1954; "Golgotha, Kreuzallegorie, und Kreuzigung Christi", *Herder Lexikon*, 2, cols. 163–5, 595–600, 606–42). The attenuated body of Christ, truly a Man of Sorrows, is similar to other productions in glass of the era from the region of Nuremberg, as in the panel *c.* 1508 from the church of St. Bartholomew in Wörd (Scholz 1991, fig. 130).

The simplicity of the Detroit image, restricted to Christ, the Virgin, and John, links the panel to contemporary illustrations in Mass books, particularly the images of the Crucifixion that traditionally precede the Canon of the Mass ("Kanonbild", *Herder Lexikon*, 2, cols. 492–5; Andrew Hughes, *Medieval Manuscripts for Mass and Office: A Guide to their Organization and Terminology*, Toronto, 1982, esp. pp. 150–3). The opening words of the Canon are *Te igitur* beginning the phrase "We therefore humbly beg and beseech You, O most merciful Father," and mark the commencement of the most sacred part of the Mass where the consecration itself is performed. The Tau-shaped form of the *Te* encouraged not only the illumination of the initial, often as a cross, but also the insertion of a full page illustration of the Crucifixion.

The elements of the Detroit panel, Tau-shaped cross, jawless skull, expired Christ, and meditative stances of John and the Virgin were common to Canon illustrations from the earliest printed Mass books in Germany. See a fine early example of this tradition in the Crucifixion attributed to Michael Wolgemut and published by the Nuremberg printer Anton Koberger as a Canon illustration for the 1484 Striegau Missal (woodcut from the Germanisches Nationalmuseum, Nuremberg, H 7485: Rainer Schoch, in *Nuremberg*, p. 231, no. 85). Heitz (Paul Heitz, ed., *Christus am Kreuz. Kanonbilder der in Deutschland gedruckten Messbücher des fünfzehnten Jahrhunderts*, Munich, 1910) has reviewed 55 woodcut illustrations dating from the 1480s production of Koberger through the 1530s, most of which repeat the general type of the Detroit panel. The format remained current through the early years of the sixteenth century even when detached from the context of the Mass book. Dürer, for example, retained a format very similar to the Detroit panel in his Crucifixion for the *Engraved Passion* of 1511 (Andersson and Talbot 1983, p. 267, no. 147; Erwin Panofsky, *The Life and Art of Albrecht Dürer*, Princeton, 1955, p. 146).

A Late Gothic frame of intersecting arches creates the illusion that the scene is viewed through an architectural opening. Angels depicted emerging from clouds in the frame hold a Tau-shaped cross and column from the pillory as symbols of the Passion. Christ's suffering was the means of humanity's redemption, and the glorification of the symbols of his Passion date back to Early Christian times. The representation of the lance and sponge are seen as *trophaeum*, traditional Roman standards of victory with captured arms. (For the history of the instruments of the Passion see "Arma Christi," *Herder Lexikon*, 1, cols. 183–7, and A. Berliner, "Arma Christi," *Münchner Jahrbuch* 3rd series, 6, 1955, pp. 33–152). The *Arma Christi* were standard elements in medieval art. The great portal programs of the Gothic cathedrals, Chartres being typical (Sauerländer 1972, p. 431, fig. 108), invariably contained representations of the Last Judgment with angels carrying the lance, scourge and column, nails, crown of thorns, and cross draped with a winding sheet. The later Middle Ages, with its increased emphasis on the suffering Christ and meditations on the Passion, popularized images such as the Man of Sorrows and the Mass of St. Gregory that included expanded representations of the Passion symbols, for example St. Peter's cock, the face of the guard who spat at Christ, or Pilate's hands.

Color: The panel employs abrupt shifts of hue and value to achieve sharp contrasts among frame, figure and ground. The light dull blue of the sky meets the cool dull green and bright warm greens of the landscape. The warm tones of trace paint and silver stain in the frame, cross, Christ's body, and the haloes act as foils for the major color accents of light blue in the Virgin's mantle and bright red in John's cloak.

Technique: The panel is composed of pot-metal and uncolored glass. Silver stain is used in the three halos and the wood of the cross, the hem and belt of John's tunic, and John's hair. Silver stain also appears as an accent throughout the architectural frame. An analysis of the application of paint is contained in the following discussion of style.

Style: The color and draftsmanship conventions associate the work with the workshop of Veit Hirsvogel and son, active in Nuremberg in the last years of the fifteenth and first decades of the sixteenth centuries. For a comprehensive analysis of the successive generations of Hirsvogel working in Nuremberg, see Gottfried Frenzel ("Veit Hirsvogel: Eine Nürnberger Glasmalerwerkstatt der Dürerzeit," *Zeitschrift für Kunstgeschichte*, 23, 1960, pp. 193–210) and, most recently, the extensive discussion by Barbara Butts and Lee Hendrix of over 50 Hirsvogel-attributed works (*Painting on Light*). The Detroit panel is closely related to the series of the *Life of the Virgin* and the *Life of Christ* produced by the Hirsvogels after designs sometimes attributed to Hans Baldung Grien and Hans Suess von Kulmbach (Rainer Kahsnitz in *Nuremberg*, pp. 358–67, no. 174:1–12). One observes the same alternation of

greens in the ground and dull blue sky acting as foils for the bright reds and blues in the figures. The Detroit *Crucifixion*, furthermore, uses the same striated shading in the background, a technique clearly inspired by woodcut traditions of modeling. Although there is no conclusive proof, the Detroit *Crucifixion* may also have been a part of a series of panels on the theme of the Passion. The architectural frame of the Detroit panel is common to its period, but particularly close to the color tonalities and shading systems of the Hirsvogel work.

In Nuremberg around the turn of the century, glass painting had evolved a system of production that divided the work of the designer from that of the glass painter. Every major artist of the time furnished designs for glass, including Albrecht Dürer, Hans Baldung Grien, and Hans Sebald Beham. Licensed glass painters, or *Stadtgläser*, actually produced the windows. That is, they cut the specific color sections, painted and fired the designs, and leaded the segments into panels for insertion in the architectural openings. The complexity of the workshop, with its variety of painters, color selectors, and glaziers, meant that the original designs were often profoundly modified in the process, sometimes improving the sketch, sometimes rendering it more confused and weaker. Panels in the same series were often executed by different hands, sometimes after designs furnished by different artists. The Fürst Pückler-Museum in Cottbus possesses a series of four circular panels showing the Latin Doctors of the Church that were executed after designs by Hans von Kulmbach (*Painting on Light*, pp. 142–8, nos. 36–42). Three appear to be by the same hand, probably Veit Hirsvogel the Younger. The fourth, that of *St. Augustine*, changes cutline strategies, dividing the panel into two segments instead of the multiple divisions of the other three. The paint used to model in depth, on the back, is a distinctly different color and application. Although it is uncertain as to why we find such changes, it is a highly likely hypothesis that two different artists collaborated on the series.

The Detroit *Crucifixion* indicates that at least two hands were engaged in the painting. The first painter displays a penchant for a more graphic, linear modeling with sharp lines outlining folds and contours, evident in the figure of the Virgin, the loincloth of Christ, and the cloak and arms of St. John. A second hand shows greater subtleties in the softer, more varied modeling of Christ's body and John's head and lower tunic. The painting is extremely delicate, using thin lines, soft washes, and small dots. It is possible that the sixteenth-century workshop was already making the distinction between the "flesh" and the "garment" painters that we have come to expect from nineteenth-century studios.

The question of the designer of the panel is a difficult one. Hayward (*Nuremberg*, p. 356, no. 172) suggested Hans Suess von Kulmbach as the likely author of the panel's pre-

liminary drawing. She cited iconographic similarities with a 1514 drawing of a Crucifixion in Berlin-Dahlem (Winkler 1942, no. 38) and a 1509 Crucifixion woodcut for a Würzburg missal (Würzburg, Universitätsbibliothek Rp. 270 fo.; *Meister/Dürer*, pp. 135–6, no. 230). The woodcut is now seriously disputed as an example of Kulmbach's work (Butts 1985, pp. 139–40, fig. 131, and discussion below). Hayward's attribution must be re-examined in light of subsequent scholarship that has significantly redefined Kulmbach and his *oeuvre*. Butts's evaluation of von Kulmbach's career presents a coherent definition of the artist (*Painting on Light*, p. 134), arriving at Dürer's shop about 1505 after early study with the Venetian painter and printmaker Jacopo de' Barbari who had resided in Germany for some time. Kulmbach presumably worked as a journeyman in Dürer's enterprise until he became a citizen in 1511 and was therefore able to set up an independent shop. Butts sees a strong Italian element in Kulmbach's artistic production and develops a corpus of paintings, drawings, and designs for stained glass showing his "penchant for serene expressions, soft linear rhythms and tender human relationships"(Butts 1985, p. 16; Butts and Hendrix, *Painting on Light*, pp. 134–73). She rejects many woodcuts previously

DIA 29/fig. 1. After HANS SUESS VON KULMBACH: *Angel with Coat of Arms of the City of Nuremberg*, from Nuremberg, Church of St. Sebald, parish house, 1514. Evangelisch-Lutherische Kirchengemeinde Nürnberg-St. Sebald

DIA 29/fig. 2.
HANS SUESS VON
KULMBACH:
St. Nicholas,
c. 1510.
Cambridge, Mass.,
Fogg Art Museum

also shows a style of draftsmanship sufficiently different from that of the Detroit panel to argue against associating the Detroit panel too closely with Kulmbach's circle (Jeffrey Chipps Smith, *Nuremberg, A Renaissance City 1500–1618* [exh. cat. University of Texas], Austin, 1983, p. 133, no. 37; Winkler 1942, p. 97, no. 141; Butts 1985, p. 306, fig. 102; Barbara Drake Boehm in *Nuremberg*, pp. 344–5, no. 163). Similar to the Nuremberg angels, the Fogg drawing shows a more gradual transition in the modeling. The drapery folds are rounded and softer and facial contours looser and more "painterly." The energy and power that emanates from the sharp definition of surface and contour in the Detroit *Crucifixion* is simply not a dominant trait of Kulmbach's accepted work in glass painting of the same date or the slightly earlier drawing.

If von Kulmbach is to be rejected as the designer of the panel in the light of such recent scholarship, to which of Dürer's pupils does the panel more closely adhere? The voluminously "lateral" robes of John, and the vertical columnar robes of the Virgin, even the double layers of veil around her face, are found in the drawings and prints variously attributed to Hans Leonard Schäuffelein, Hans Suess von Kulmbach, Wolf Traut, and others in the circle

attributed to Kulmbach, narrowing, but also strengthening our understanding of his personal style.

The *Angel with Coats of Arms* (DIA 29/fig. 1: Nuremberg, Evangelisch-Lutherische Kirchengemeinde Nürnberg-St. Sebald) from the Parish House of St. Sebald's Church, Nuremberg, is inscribed with both date, 1514, and the name of the fabricator, H. H., for Hans Hirsvogel the Younger, Veit's son (Fritz Traugott Schulz, *Nürnberger Bürgerhäuser und ihre Ausstattung*, Leipzig and Vienna, I, pt. 1, 1933, pp. 30–2, figs. 37–40 on pp. 48–9; Scholz 1991, fig. 194). A later series, also after Kulmbach's designs was fabricated in 1517 by Veit Hirsvogel the Younger (*Painting on Light*, pp. 162–5, nos. 51–4). These series establish a standard against which to measure Kulmbach's stained glass work at the time of the creation of the Detroit panel. The Kulmbach authorship of the designs is well accepted (Scholz 1991, fig. 194; Butts 1985, pp. 127–8, figs. 115–16; Schmitz 1923, p. 9, no. 28; Friedrich Winkler, *Hans von Kulmbach* in the series, *Die Plassenburg*, 14, 1959, p. 80; Frenzel 1960, pp. 194–6, fig. 1; *Meister/ Dürer*, p. 116, no. 186). The angels are more lyric and flowing than the figures in the *Crucifixion*. The Detroit figures more sharply hewn, their modeling a series of angular cuts defining abrupt shifts of light across the surface. Kulmbach's drawing of *St. Nicholas* in the Fogg Art Museum (DIA 29/fig. 2), dated around 1510,

DIA 29/fig. 3.
ALBRECHT DÜRER
(or a follower):
St. Leonard. Erlangen,
Graphische Sammlung
der Universität

around Dürer (Winkler 1942, [Kulmbach] pp. 59–60, nos. 38, 39 [Schäuffelein] 141, no. 11). One might consider also an equally problematic drawing for a stained glass figure of *St. Leonhard* (DIA 29/fig. 3), now in the University Library of Erlangen (Elfried Bock, *Die Zeichnungen der Universitätsbibliothek Erlangen*, Frankfurt am Main, 1929, p. 49, no. 151; Scholz 1991, fig. 60; *Painting on Light*, p. 116, fig. 20). A comparison of the drapery patterns of St. John to the densely bunched folds of the Erlangen saint argues for a close connection between both conceptions. Similar, also, is the treatment of the face. The outlines of nose, jaw, and chin emphasize short, vigorous curves in both glass and drawing. The eyes are small, but dramatically highlighted by the curves of the brow. The hair is similarly set to circle dramatically around the head. Like many of the designs of this group, the authorship of the Erlangen drawing has been disputed. Bock associated the work with the artist in Dürer's circle responsible for a cycle of drawings for stained glass of the life of St. Benedict. Winkler (1942, pp. 70–1, no. 62) was the first to propose a von Kulmbach attribution. The exhibition in the Germanishes National Museum of 1961 (*Meister/Dürer*, p. 128, no. 215) listed the drawing under von Kulmbach's *oeuvre* but with an open question, noting the quality of *Reinzeichnung eines Glasmalers*. Butts (1985, pp. 175, 178, 181, 282, 287, 298–304) rejects the drawing as Kulmbach's. Most recently, Butts and Hendrix (*Painting on Light*, p. 116, fig. 20) have identified the drawing as after Albrecht Dürer, an argument this writer feels is entirely convincing.

The authorship of the Detroit panel, like that of many superb drawings in the circle around Dürer, appears to remain an open issue. Creative exchanges during the many stages of production from the preliminary sketch to the final leading-up of a window were part of a shop as large and sophisticated as that of the Hirsvogels. These questions of workshop have been treated at length by Hartmut Scholz (1991) in a far ranging analysis of the intersection of sketch, print, and glass painting for artists whose designs were produced in all manner of media. Von Kulmbach's work is discussed (esp. pp. 130–87) including the juxtaposition of drawings and glass panels formerly in the Berlin Kunsgewerbemuseum, now destroyed. Scholz (p. 246), however, retains authorship of the design for the Detroit *Crucifixion* within von Kulmbach's influence. He points to the closeness of the depiction of the angels with the signs of the Passion to von Kulmbach's work and the Berlin-Dahlem pen-and-ink sketch of 1514. Scholz also refers to similarities in the depiction of Christ and the Virgin in the Passion cycle in the Carmelite church in Nürnberg-Wohrd, before 1510. His points of similarity, however, concentrate on the general composition and iconographic type, not the definition of the figure or the techniques of modeling. Is the intervention of the glass painter such a personal one that it can radically alter the impact of a panel? With so many more issues now open to discussion perhaps the very definition of authorship attributions will be reviewed. Such an approach may ultimately open up a more comprehensive understanding of the collaborative genesis of works of art such as this *Crucifixion* in stained glass.

Date: The panel is dated by the inscription, 1514, in the center of the architectural frame.

Photographic reference: DIA Neg. no. 28681 (1985/04/04)

DIA 30. Nativity*
Guillaume de Marcillat (*c.* 1470–1529)
Italy, Cathedral of Santa Maria dell'Assunzione, Cortona, main choir chapel
1516
Rectangle: 299.7 × 167.6 cm (118 × 66 in)
Accession no. 37.138, Founders Society Purchase, General Membership and Donations Fund
 Ill. nos. DIA 30, 30/1–2, 30/figs. 1–2; Col. pl. 15

History of the glass: The panel was made for the main choir chapel window in the cathedral of Cortona, Italy. The window appears to have been a double-lancet type that incorporated both the Detroit panel of the *Nativity* and the *Adoration of the Magi* panel, now in the Victoria and Albert Museum. The date of the windows' removal from the cathedral is unknown but in the nineteenth century both panels were the property of the Corazzi family and displayed in the Museo Nazionale [the Bargello], Florence, until 1875 (Müntz 1890–91, p. 362). Sometime later the panels passed to an unidentified owner in Rome. By the time that Charles H. Sherrill published *Stained Glass Tours of Italy* (London, 1912, p. 68), he could note that "the two masterpieces of (Marcillat) which used to adorn the cathedral at Cortona have disappeared, one to dwell in the Victoria and Albert Museum in London, and the other to cross the Atlantic and bury itself in seclusion somewhere in America."

The *Nativity* soon emerged from its "seclusion," identified in the home of Richard Mortimer, Tuxedo Park, New York. Sherrill visited in 1925 and subsequently published an article (1926, pp. 10–11) with a photograph. He reported that Eleanor J. Mortimer informed him that her late husband bought the window "over forty years ago," therefore in the 1880s, in Rome and that it had been exhibited earlier in the Bargello of Florence. Sherrill suggested that the New York and London panels should at some time be exhibited together. Earlier, William Valentiner

* prepared with the assistance of Susan Atherly

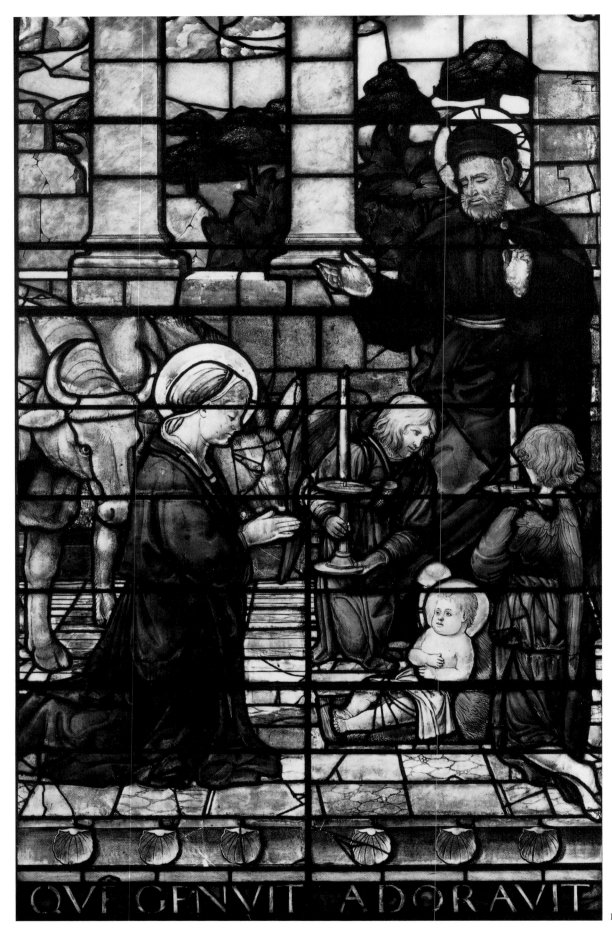

QVÎ GENVIT ADORAVIT

DIA 30. *Nativity*

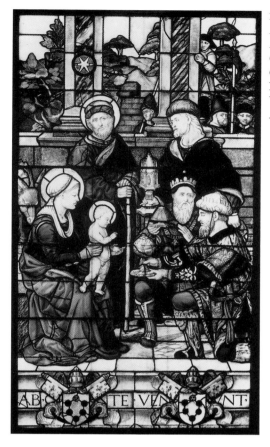

DIA 30/fig. 1.
Adoration of the Magi, from Cortona Cathedral. London, Victoria and Albert Museum

had identified the window and published an illustration in his 1922 article in *Der Cicerone*. At that time Valentiner, who would become director of the DIA in 1924, was a consultant for the museum. In 1937, under Valentiner's leadership, the museum acquired the work at the auction of the Mortimer's estate with funds provided by the Founders Society of the Detroit Institute of Arts. [Romanesque Hall]

Related work: *Adoration of the Magi* (DIA 30/fig. 1), Victoria and Albert Museum (Inv. no. 634–1902, Rackham 1936, p. 101, pl. 51).

Original location: Giorgio Vasari (*Le Vite*, Milan, 1942, p. 173) stated that the Cardinal Silvio Passerini commissioned the windows of the *Birth of Christ* and *Adoration of the Magi* in the main chapel of Cortona Cathedral. Eugene Müntz (1890–1, pp. 362–3), one of the many nineteenth-century writers interested in Renaissance stained glass and Marcillat's work repeated Vasari's attribution of the commission to Cardinal Silvio Passerini. Only in 1909 did Girolamo Mancini (1909, pp. 20–1, 76, 102), discover documents which established that the *Operai* of the cathedral, not a private donor, commissioned the panels and that the date of the commission was 1516, not 1505. The record of payment informs us that both scenes were positioned *a l'altare maggiore, cioe la grande finestra con l'istoria de la Nativita di Christo e le tre Magi* (at the high altar, a

large window with the story of the Nativity of Christ and the Three Magi: Mancini 1909, Appendix 76).

History of the building: Typical of European church construction, the site of the cathedral shows former use. A ninth-century church, possibly dedicated to San Eusebo, is traditionally thought to have stood over a former Etruscan temple. The Romanesque building of the Pieve di Santa Maria is first documented in 1086 as *plebs S. Maria sita Cortona* (Fafi 1989, p. 189); excavations suggest that the building was a three-aisled basilica less than two-thirds the size of the new cathedral (Mancini 1897/1969, p. 323). Remnants of the old facade remain in the present church to the right of the main portal.

The Renaissance reconstruction of the building extended through the second half of the fifteenth century. The presumed patron for most of the building, Mario Salvini, was a Medici supporter and protégé (Mancini 1897/1969, p 324). On 16 August 1456 the priors of the Commune and three *buonomini* elected to supervise the building of the new cathedral asked for contributions for the construction (ibid., p 325). The main chapel was completed by 1469 since statutes of 1469 refer to the feast of John the Baptist whose main celebration was to be held in the newly opened cathedral (ibid.). Work on the rest of the church advanced slowly. Financial constraints continued into the sixteenth century as two major churches outside the city walls had begun construction. The Florentine commissioners committed 6 *denari* of every *lira* collected from Cortona to the cathedral project and the commune taxed the sale of bread and the salaries of its officials to support the project (Holder 1992, p. 180). The entire church building appears finished only in 1502 (Mancini 1897/1969, p 326). With the completion of the cathedral came the transferral of the bishop's seat from St. Vincent outside the city to the new Santa Maria dell'Assunzione documented by a papal bull of 9 June 1508 (ibid., or possibly 1507 as reported by Fafi 1989, p. 190).

The interior architecture shows a strong Brunelleschian influence (Mancini 1897/1969, p 323). A three-aisled basilica contains five bays and circular windows on the upper walls. It terminates in three rectangular chapels, the central chapel being the original site of the Detroit and London windows. The patron for most of the interior decoration was Cardinal Silvio Passerini, who, on Vasari's advice, employed many Florentine artists to create a lavish setting that included paintings, liturgical vestments, and an elaborate baldacchino with gold embroidery hung over the altar (Holder 1992, p. 181). The walls were originally frescoed and the chapel on the left of the high altar was painted by Signorelli, now all whitewashed (Fafi 1989, p. 193).

Santa Maria dell'Assunzione underwent considerable alterations in the following centuries. A campanile was added in 1556. A portico, with its later second story on the

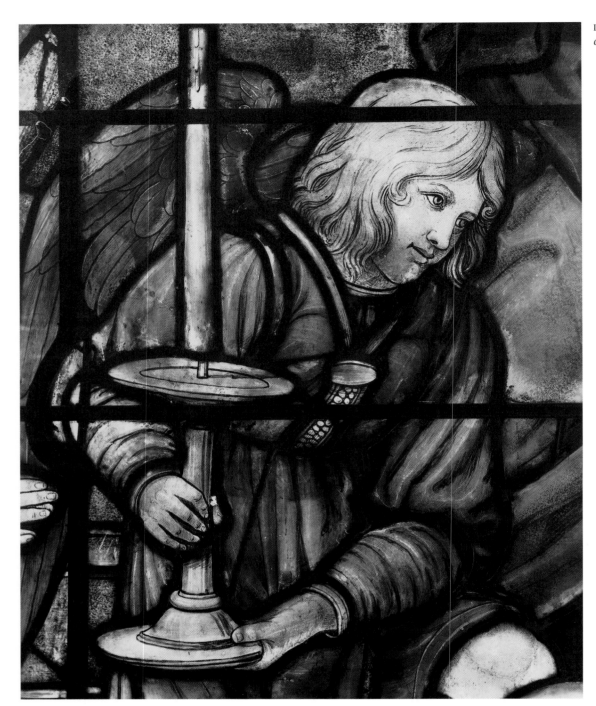

DIA 30/1. *Angel with candle*, detail of *Nativity*

right flank of the church condemned all the windows of the right aisle. In 1664 a new high altar of marble and *pietra dure* was installed and a nave vault was added in 1701. In 1729 the biforium above the high altar was closed and Marcillat's glass taken out (Fafi 1989, p. 195). Between 1731 and 1738 (authors vary) Alessandro Galilei made radical changes in the altar and crossing, relocated the altar further into the church and blocked the window above the altar. In 1700, before the removal of the glass, the window was described: *Tra le cose singolari, che adornano questa Catedrale, vi e un finissiomo Christallo formato dal famoso penello di D. Leonardo Marcilla Sacerdote Cortonese, del*

quale si discorrera nel suo luogo. In questo cristallo sono da due parti effigiate le Insegne del Pontefice Leone Decimo, Mecenate de'nostri tempi, e della real Casa de'Medici. Del medessimo lavoro e formata una finestra lunga, e grande, posta nella Tribuna del Coro, quale nelli suoi vetri dipinti rappresenta nella parte superiore la Nativita di Gesu Bambino, e nell'inferiore l'Adorazione de'Magi, opere tutte singolarissime del Sacerdote sudetto. L'altare maggiore di detta chiesa e formato, ed arricchito di frinissimi marmi, con sua balaustrata attorno al Presbiterio, parimente di marmo, fatto tutto a spese della nobil Famiglia Passerini (Among the singular things that adorn this cathedral, there is a very fine work of stained glass formed

from the famous brush of the Cortonese priest D. Leondaro Marcilla, of whom one speaks of at this place. In two sections of this window are represented the insignias of Pope Leo X, patron (of the arts) in our time, and of the house of Medici. In the same piece of work and taking the form of a window, long and large, placed in the tribune of the choir, his panels of painted glass represent in the upper part the Nativity of the Child Jesus, and in the lower part the Adoration of the Magi, works all most singularly of the aforesaid priest. The high altar of the said church is formed, and enriched of the finest marble, with its balustrade around the presbytery, likewise of marble; all have been made with the money of the noble Passerini family. [Domenico Tartaglini, *Nuova descrizzione dell'antichissima citta di Cortone*, Perugia, 1700, pp. 84–5]).

Composition: The record of payment informs us that both scenes were above the altar (Mancini 1909, Appendix, p. 76). Luchs (1985, p. 211) seems accurate in stating that the opening described by the artist was a biforium having two rectangular lights. Luchs included a discussion of the London and Detroit panels in the context of Italian glazing traditions of stained glass above Renaissance altars.

Bibliography

UNPUBLISHED SOURCES: Susan Atherly, correspondence with the author; Ena Giurescu Heller, New York, research, translations, and verbal communication with the author.

PUBLISHED SOURCES: Giorgio Vasari, *Le Vite*, Milan, 1942, p. 173; Müntz 1890–91, pp. 362–3; Girolamo Mancini, *Cortona nel Medio Evo*, Florence, 1897, reprint 1969; Mancini 1909, pp. 20–1, 76, 102; William R. Valentiner, "Ein Glasfenster Guglielmo de Marcillat in amerikanischem Besitz," *Der Cicerone*, 14, 1922, pp. 240–3; Charles Hitchcock Sherrill, "Discovery of the Companion to the Window of William of Marsailles in the Victoria and Albert Museum," *Journal of the British Society of Master Glass Painters*, 3/1, 1926, pp. 10–11, ill.; *Mortmar, Tuxedo Park, New York, Property of the late Elenore J. Mortimer* [sale cat., American Art Association, Anderson Galleries, 25 September], New

DIA 30/2. *St. Joseph*, detail of *Nativity*

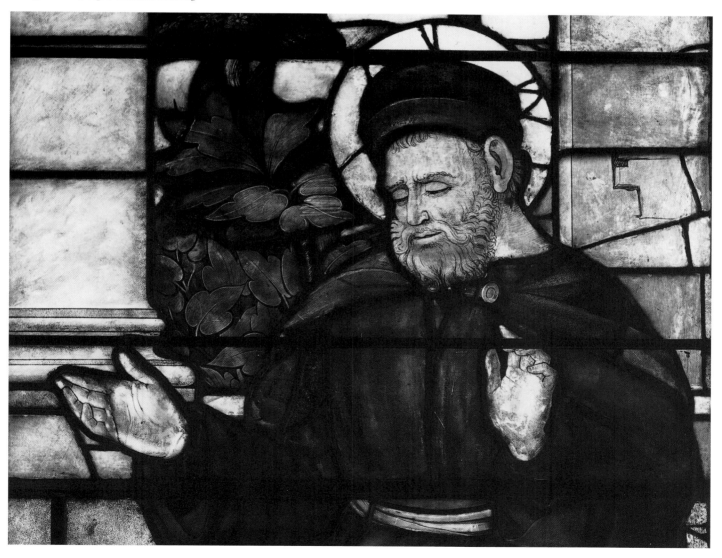

York, 1937, p. 36, no. 178, ill.; Perry Rathbone, "A Stained Glass Window of the Nativity by Guglielmo de Marcillat," *DIA Bulletin*, 17 December 1937, pp. 14–15; Atherly 1980; Susan Atherly, "Studien zu den Glasfenstern Guillaume de Marcillat (1470?–1529)," Dissertation, University of Vienna, 1981, pp. 34–9; Catherine Brisac, *A Thousand Years of Stained Glass*, (trans. of *Le Vitrail*, 1984) Edison, N.J., 1986, p. 191; Luchs 1985, pp. 209–11; Barnet 1986, p. 41; Tutag and Hamilton 1987, pp. 17, 15, col. pl.; Angelo Fafi, *Immagine di Cortona. Guida storico-artistica della citta e dintorni*, Cortona, 1989; Raguin in *Checklist* III, p. 163; Philancy N. Holder, *Cortona in Context: The History and Architecture of an Italian Hill Town to the 17th Century*, Clarkesville, Tennessee, 1992; *DIA Guide*, 163, col. ill.

Inscription: *QVE GENVIT ADORAVIT* (She worships him whom she bore)

Condition: Both the *Nativity* and *Adoration* panels, in private hands since the nineteenth century, appear to have been protected from breakage or weathering. The panels are therefore remarkably free from paint loss (DIA 30/1–2) or the many replacements appearing in three windows by Marcillat that remain in Cortona. After the recent restoration of the London window, the painting style of the few replacement segments is relatively easy to distinguish. According to Müntz (1890–91, p. 362), who saw the window before 1875 when it was on display in the Museo Nazionale, Florence, there were shepherds in the composition behind the wall and the upper portions of the window contained clouds and angels. It is possible that the angels in an upper section may have been lost, but it is improbable that shepherds were a part of the original composition. Since Müntz was writing from notes gathered some fifteen years earlier and since the background does not exhibit any serious rearrangement, it is more likely that Müntz confused his recollections of the figures behind the wall in the London *Adoration* panel with the unpopulated background of the *Nativity*.

Color: As recorded by Marcillat in his account book, French pot-metal glass was imported for this commission (Mancini 1909, p. 76). The selective use of a few colors, intense deep red, red-purple, deep blue, deep warm green, and brownish red-purple, gives the figures a vitality and compositional stability against the surrounding grisaille background. First noted by Lafond, the particular combination of brownish red-purple (*lie de vin*) and deep warm green for the angels' tunics was also used by Marcillat's famous French contemporary Jean Lécuyer of Bourges (Jean Lafond, "Jean Lécuyer, un grand peintre-verrier de la Renaissance," *Medicine de France*, 123, 1961, pp. 17–32). Other combinations of bright blue and red-purple (burgundy) for the garments and a pale blue for the angels' wings are colors which reoccur in Marcillat's mature works in Arezzo (Brown 1992, p. 104, ill.; Brisac 1984, p. 191. ill.).

DIA 30/fig. 2. *Life of St. John of Damascus*, from Milan Cathedral. Boston, Isabella Stewart Gardner Museum

Technique: The abundant use of grisaille stippling and silver stain to create an illusionistic architectural setting is characteristic of advanced Lombard Quattrocento schools, as practiced in Milan Cathedral by Antonio da Pandino [New Testament window, XVI S (5)] and Niccolo da Varallo [St. Eligius window, XV S (6)] (Pirina 1986, pp. 165–200, 271–94). See especially the panel of a baptism from the window of the *Life of St. John of Damascus* dated after 1480 (DIA 30/fig. 2) now in the Isabella Stewart Gardner Museum, Boston (C30S25–S, Caviness in *Checklist* I, p. 41). As in Milan, the economic use of leads and their placement in the pavement of the Detroit *Nativity* similarly renders a stage-like effect in relationship to the border beneath. The tonal shading of draperies achieved through surface mat and back-painting is very fine for a panel of this dimension. Although the pervasive use of grisaille mat and smear shading to tone the uncolored glass

is common in Renaissance French glass, Marcillat's delicate linear shading of faces and flowing hair is a brush technique (DIA 30/1–2) which connects him particularly to Lécuyer (Lafond 1961, p. 30, see above under *Color*). The density of the paint, however, is unlike French techniques, which employ thinner layers of mat and show more areas of clear glass. The use of sanguine for the realistic flesh tones was exceptional in Italian workshops but its mastery here parallels its use by advanced French and German artists.

Iconography: Throughout the fifteenth century, the Nativity was a standard component of the Italian and Franco-Flemish altarpiece and a popular subject of fresco and glass painting illustrating the *Life of the Virgin* and *Infancy of Christ*. As shown by the Detroit/London sequence, the *Nativity with Angels* often preceded the *Adoration of the Magi*; and in more complete Late Gothic cycles it was the first of three consecutive Adorations, followed by that of the Shepherds then the Magi. Distinctive elements in the Detroit panel, however, argue for a more theologically complex statement. The worship of the Infant by the holy parents and earthbound angels was a traditional late medieval theme, but the Detroit *Nativity* signifies an important reworking of this iconography in the Renaissance.

At the beginning of the sixteenth century, when the validity of the Sacraments, and in particular the Eucharist, underwent it first severe attack by the reformers, the papacy affirmed that the disputed dogma of Christ's presence in the Eucharistic wafer was *extra usum*, that is, actual, full and complete (Caspary 1964, p. 114, n. 309). Particularly in Italy, the ritualistic worship of the host wafer affirmed by the Roman Church conditioned the laity to want to see and experience Christ's presence during Mass through more demonstrative images of the Child (Caspary 1964, p. 109; Edouard Dumoutet, *Le Desire de voir l'hostie et les origines de la dévotion au Saint Sacrament*, Paris, 1926; id., *Corpus Domini: Aux sources de la piété eucharistique médiévale*, Paris, 1942). Respectively, Marcillat's presentation of the newborn is unlike the traditional helpless infant shown lying on a bed of straw or on the protective border of his mother's garment. The Lord incarnate shown as a weak infant is retained in Flemish and Italian painting throughout the fifteenth and sixteenth centuries. This Christ Child represents a new type of image of the "living host," sitting upright without assistance, with arms folded in a gesture of acceptance before the worshipping Virgin. Significant is the presence of the sudarium, or loincloth, over the waist of the infant. This is not Christ's swaddling clothes, but a reference to the cloth over the savior's loins in countless pietà images. The infant is at once child, suffering adult, and Eucharistic sacrament. Mary enacts the exemplary role of image of piety to the faithful who once observed this image behind the altar before the window's removal from the main

chapel (see F. O. Büttner, *Imitatio Pietatis*, Berlin, 1983, p. 78). Free from original sin, the Virgin is celebrated for her attribute of perfect faith as proclaimed in the inscription at the base of the panel, "She worships him whom she bore." The phrase is an abbreviated form of the first antiphon for the Feast of the Purification of the Virgin celebrated on 2 February (ibid., n. 44). The first line of the antiphon appears in full, *IPSUM QUEM GENIUT ADORAVIT MARIA*, on the upper border of Domenico Ghirlandaio's altarpiece of the *Adoration of the Shepherds* of about 1485 in the Sassetti chapel of Santa Trinità, Florence. Atherly has explored the implied relationship between Nera Corsi Sassetti in the chapel and the figure of the Virgin (Atherly 1980, pp. 77–8, figs. 5–6).

The direct liturgical reading is further specified by the presence of two candle-bearing angels who imitate sculptural prototypes of kneeling acolytes on Italian reliefs and wall tabernacles. As depicted in the Florentine workshops of the della Robbia, Mino da Fiesole, Benedetto da Maiano, and others, the angels are shown kneeling or standing. Kneeling acolytes appear in Cortona cathedral before a wall tabernacle of sacred oil executed in 1491 by Ciuccio de Nuccio (Mancini 1909, pp. 51, 59; also Caspary 1964, pp. 108–9). The iconographic importance of the angel acolytes, the heavenly guardians of the host, grew with the early Renaissance relocation of the host wafer from the sealed wall tabernacle to its more effective display in an altar shrine or free-standing ciborium. Between the angels, then, the image of the Child signifies the *panis angelorum* (bread of angels) of devotion. Textual reference from the time continue these visual links of angels and the host. The statement on Eucharistic belief pronounced by the Council of Trent of 1545–63 contained the phrases: "In this sacrament we believe in the presence of him God sent into the world proclaiming, 'And all the angels of God worship him'" (*Conc. Trid. Sessio* XII, Cap. 5. Caspary 1964, pp. 108–9, n. 281). The still current sequence for the feast of Corpus Christi, then attributed to Thomas Aquinas, also juxtaposes angels and the Real Presence: *Ecce panis angelorum, factum cibus viatorum* (Behold the bread of angels become the food of life).

This connection of child and host is confirmed by the liturgical forms of the gifts presented by the Magi in the London companion panel. Closest to the Christ Child is the ciborium, or covered cup in which consecrated wafers are stored. Held by the standing Magus is a monstrance to display the host in its contemporaneous form of a Gothic building form set on a tall foot. The shorter object held by the Third Magus may be a type of pyx, also used to store the consecrated host (Joseph Braun, *Das christliche Altargerät in seinem Sein und in seiner Entwicklung*, Munich, 1932, "ciborium," pp. 280–380, pls. 53–5, 57; Busch-Reisinger Museum, *Eucharistic Vessels of the Middle Ages* [exh. cat.], Cambridge, Mass., 1975, esp. nos. 16, 20–2).

Further reference to a sacramental context is provided by the unusual position of Joseph. Rather than off to the side or even asleep, he stands directly above the seated Christ Child and spreads his hands in the gesture used by the priest at mass in prayer before the bread and wine of the sacrifice. This role is rare but not unknown in Quattrocento painting. A kneeling Joseph shows the same gesture in Pietro Perugino's *Adoration of the Child* from the Altarpiece of San Agostino, about 1512–16 (Pinacoteca, Perugia). The gesture is repeated in another panel attributed to Perugino in the Accademia, Bergamo. It was used by Marcillat earlier at Santa Maria del Popolo in Rome (drawing from Giacomo Fontana, *Raccolta delle migliori chiese de Roma e suburbane*, Rome, 1855, second ed. 1889; pl. III, in Atherly, 1980, fig. 4) and appears in a miniature of the French court painter, Jean Fouquet (*Book of Hours of Etienne Chevalier*, c. 1450, in K. Perls, *Jean Fouquet*, Paris, 1940, fig. 6). The Fouquet miniature, however, shows the infant lying on his back playing with his foot. In proximity to the acolytes, Joseph's gesture can be interpreted as the acclamatory response directly after the moment of transubstantiation in a Catholic Mass. Altogether, the precise placement and function of each figure in the Detroit composition creates an unprecedented reading. In Cortona, Marcillat transformed the Late Gothic adoration into a clear sacramental statement suggestive of ideas acquired by his close affiliation with Vatican authorities in Rome. In such an interpretation it is useful to review that Marcillat appears to have been linked to papal circles and received highly favored treatment by both Julius II and Leo X. The glass painter had been a member of the Order of Preachers (Dominicans) but Julius II's bull of 19 October 1509 effected his release from the Order. He was instated the following year as an Augustinian canon, a far more flexible position that allowed Julius to grant him the prebend over the church of Thibault in the diocese of Verdun, guaranteeing the glass painter financial independence (Mancini 1909, pp. 16–17). Marcillat provided a great deal of heraldic glass for Julius II and Leo X at the Vatican palace, none of which remains today. In Cortona Cathedral it is not clear why Leo X's emblem was included in the border inscription of the companion *Adoration of the Magi* but not the *Nativity*. A possible Medici interest in the cathedral is suggested by Luchs (1985, pp. 209–10, n. 87).

Style: The French immigrant artist Guillaume de Marcillat initiated the last major revival of monumental stained glass painting in Italy. To a nineteenth-century public, Marcillat was one of the best-known of the Renaissance artists. Ottin (*Le Vitrail*, Paris, 1896, pp. 322–4) devotes over two pages of biography to the artist, citing in particular the *Awakening of Lazarus* in the Cathedral of Arezzo. Atherly (1980, n. 7) gives an overview of the many nineteenth-century claims to Marcillat's place of origin.

In the discussion of the dominance of Rome in the production of High Renaissance art, recent authors have seen Marcillat playing a significant role in understanding the sensitivity of so called provincial patrons. His work has been seen as a primary force disseminating the art of the High Renaissance of Rome to central Italy, in accordance with the provincial patrons' understanding of progressive styles. Marcillat's experience in Rome allowed him to exert considerable influence on the decoration of the cathedral of Arezzo, where he was given commissions for both its fresco and its stained glass. His work brought the innovations of composition and figural style of Raphael, Michelangelo, and Sebastiano (Tom Henry, "'Centro e Periferia': Guillaume de Marcillat and the Modernisation of Taste in the Cathedral of Arezzo," *Artibus et Historiae*, 15, no. 29, 1994, pp. 55–83; Nicole Dacos, "Un 'Romaniste' français méconnu, Guillaume de Marcillat," *"Il se rendit en Italie": Études offerte à André Chastel*, Paris, 1987, pp. 135–47).

Marcillat appears to have been called to Rome as a result of papal interest in French glass painters. After work in Rome dating from about 1510 he came to Cortona in 1515 on the invitation of Cardinal Silvio Passerini and produced frescoes and a great variety of stained glass for the city. From his arrival in Cortona until his death in 1529, Marcillat recorded all of his commissions in two account books, published by Mancini (1909, pp. 75–88). Marcillat's c. 1510 windows for Santa Maria del Populo in Rome are direct precursors of his Cortona panels (Mancini 1909, pp. 12–16, ill. on pp. 13 and 15; Luchs 1985, pp. 215–8). It is interesting to speculate on the role that Bramante, responsible for the renovation of the chapel, may have played in determining the subject and the format of the windows. The *Nativity* and the *Adoration of the Shepherds* at Santa Maria del Populo are particularly close to the Detroit and London formats. A line drawing (Atherly 1980, fig. 4), although it presents important iconographic information, does not convey the full stylistic and compositional impact of the window. Both show the shallow architectural setting confined within a low wall supporting two tall columns. The composition of the Shepherds is roughly similar to that of the Three Magi where the standing Christ Child is held forward by the Virgin. The central figures in the Nativity are essentially reversed and, as discussed above, the flanking angels added and the upright position of the Christ Child enhanced.

The panels exhibit a monumental transformation of the compartmentalized glass panel into a fully integrated composition. The spatial illusion thus rendered reveals Marcillat's application of the frieze-like organization of the Lombard wall altarpiece, the *pala*, as introduced by Giovanni Amadeo and his followers in the fifteenth century (see the *pala* of Campomorto and the altar in Como cathedral in F. Malaguzzi-Valeri, *Giovanni Antonio Amadeo*, Bergamo, 1904, pp. 112 and 298). Marcillat's adaptation

224

of the Lombard *pala* in his work for Santa Maria del Popolo is argued by Atherly ("The Lombard Glass Workshops under Visconti and Sforza Dominions," communication, Corpus Vitrearum meeting, Milan, 1988). Besides the setting adaptation of loggia, pilasters and border inscription, the windows' stylistic affinity to the Lombard *pala* is even more apparent in the overall relationship of figures to their surrounds. This is demonstrated by the triangular balance of the Detroit composition and by the strict, symmetrical disposition of figures in the London companion *Adoration*, a symmetry even more apparent in Santa Maria del Populo's *Adoration of the Magi* showing the Virgin in the center.

The balanced, monumental presentation of figures in the Detroit *Nativity* equates the visual coherence of late Quattrocento devotional panels, as expressed in the paintings of Foppa and Perugino and presented locally by the Cortonese artist, Luca Signorelli. Compare, in particular, the panel of the *Adoration of the Child with St. Benedict and Angels* by Vincenzo Foppa in the Detroit Institute of Arts (Acc. no. 68.294; Constance Ffoulkes, *Vincenzo Foppa*, London, 1909, pp. 210–13; Fernanda Wittgens, *Vincenzo Foppa*, Milan, 1946, p. 98, pl. LXVIII, then cited as Detroit, Lawrence P. Fisher collection). The figural style, however, is more eclectic. Only the angels explicitly follow Italianate models (DIA 30/1). Their coiffure of loose curls, youthful smiling faces, and dress of tunic fitting closely over forearm, more loosely on the upper arm, and belted at waist and then around the loins, appear in paintings by Pinturicchio, Fra Filippo Lippi, or Botticelli (e.g. Botticelli, *Coronation of the Virgin*, 1490, Florence, Uffizi: Lionello Venturi, *Sandro Botticelli*, New York, 1937, figs. 91–2). In contrast, Joseph's attire and features (DIA 30/2) recall his French characterization by Jean Fouquet and the Virgin's full face and unexposed hair also suggest a northern derivation.

Date: Recorded in Marcillat's account book as in begun 1515, the *Nativity* was commissioned in February 1516 by the Operai of Cortona Cathedral and installed with the *Adoration* in the windows of the choir in July 1516 (Mancini 1909, Appendix, p. 76).

Photographic reference: DIA Neg. no. 23367 (1979)

DIA 31. Last Supper, from a series of the Passion (?)

After Jacob Cornelisz. van Oostsanen
North Lowlands, Amsterdam (?)
1514–25
Circle: diameter 22.2 cm (8¾ in)
Accession no. 36.96 , Founders Society Purchase, Octavia W. Bates Fund

Ill. nos. DIA 31, 31/figs. 1–5; Col. pl. 18

History of the glass: The panel was recorded in the inventory of Grosvenor Thomas, London. It passed to Roy Grosvenor Thomas, Grosvenor Thomas's son and his partnership of Thomas and Drake, New York. In 1936 the panel was acquired for the Detroit Institute of Arts as a Founders Society Purchase, through the Octavia W. Bates Fund. [German/Flemish Galleries]

Related material:
Drawing (DIA 31/fig. 1), Jacob Cornelisz. van Oostsanen, pen and brown ink on paper, Staatliche Museen zu Berlin, Preussischer Kulturbesitz, Kupferstichkabinett, KdZ 5526 (Husband 1995, no. 38, pp. 99–100)

Woodcut (DIA 31/fig. 3), Jacob Cornelisz. van Oostsanen, from the large circular Passion series, monogrammed (Steinbart 1937, no. 20; Hollstein 1949, 5, 8, no. 67; *Ill.*

DIA 31/fig. 1. JACOB CORNEILISZ. VAN OOSTANEN: *Last Supper*, *c.* 1510–14(?). Berlin, Staatliche Museen, Preussischer Kulturbesitz, Kupferstichkabinett

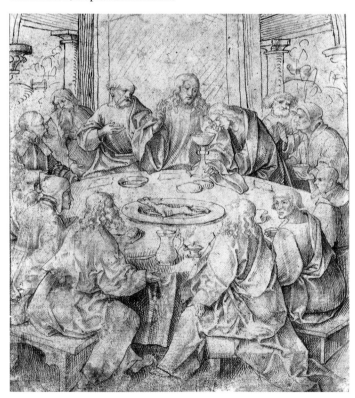

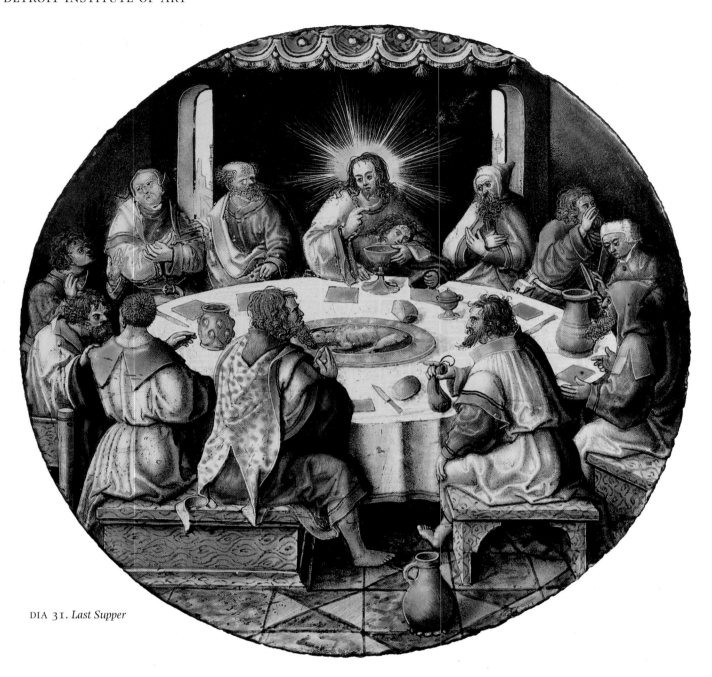

DIA 31. *Last Supper*

Bartsch, 13, no. 1). There are eleven additional woodcuts from the same series [*Agony in the Garden, Kiss of Judas, Taking of Christ, Mocking of Christ, Flagellation, Crowning with Thorns, Ecce Homo, Carrying of the Cross, Crucifixion, Lamentation, Resurrection*], some monogrammed and dated 1511–14 (Steinbart 1937, nos. 21–31; Hollstein, 8, nos. 68–78; *Ill Bartsch*, 13, nos. 2–12), and a series in which the roundels are set in surrounds containing Old Testament subjects, in the tradition of the *Biblia Pauperum* (DIA 31/fig. 4), *Ill Bartsch*, 13, nos. 67–78. On Jacob Cornelisz. van Oostsanen see Filedt Kok 1986, pp. 131–9.

A number of roundels of the *Last Supper* or of scenes from this Passion series have been identified:

Last Supper: (i) replica (DIA 31/fig. 2), King's College Chapel, Cambridge, Cambridgeshire (41/D2, Cole 1993, p. 43, no.

376; Cole 1978, p. 62; Maes 1987, fig. 151). (ii) roundel, version from a series based on the same designs, Church of St. Matthew, Watford, Hertfordshire (s: IV 3b; Cole 1993, p. 304, no. 2404; Maes 1987, fig. 150). (iii) roundel, close version, Packwood House, Lapworth, Warwickshire (48, Cole 1993, p. 130, no. 1049). (iv) roundel, another version, formerly in the Great Beginage of Louvain, now Stedelijk Museum van der Kelen-Mertens, Louvain (B/III/25: *Aspekten van de Laatgothiek in Brabant* [exh. cat., Stedelijk Museum, Louvain], Louvain, 1971, p. 183; Maes 1987, fig. 149). (v) roundel, version from a series based on the same designs, Dr. William Cole collection, Hindhead, Surrey (109). (vi) roundel, later version in rectangular format, Rijksmuseum, Amsterdam (F 961–8).

A series of eight roundels based on the same designs,

Agony in the Garden, Kiss of Judas, Mocking of Christ, Flagellation, Ecce homo, Crowing with Thorns, Christ Carrying the Cross, Crucifixion: Church of the Holy Trinity, Bradford-on-Avon, Wiltshire (2a, 2b, 2c, 3a, 3b, 3c, 5b, 5c, Cole 1993, pp. 31–2, nos. 254, 255, 256, 257, 258, 259, 264, 265).

Agony in the Garden: roundel based on the same designs, Packwood House, Lapworth, Warwickshire (49, Cole 1993, p. 132, no. 1050).

Kiss of Judas: (i) roundel, version from a replica series, Rijksmuseum, Amsterdam (RBK 1966–59). (ii) roundel, version of the same subject from a series based on the same designs, Church of St. Mary the Virgin, Addington, Buckinghamshire (s: VI. 1b, Cole 1993, p. 8, no. 55). (iii) roundel, another version of the same subject from a series based on the same designs, church of St. Mary Magdalene, Norwich, Norfolk (3b, Cole 1993, p. 164, no. 1317).

Flagellation: roundel, simplified version, *c.* 1540, Muchelney, Somerset, Church of Saints Peter and Paul (n: II. 1c, Cole 1993, p. 152, no. 1222; Woodforde 1946, p. 266).

Crowning with Thorns: (i) roundel, from a slightly earlier replica series monogrammed, Rijksmuseum, Amsterdam (N M 12563). (ii) roundel, version from a series based on the same designs Mentmore, Buckinghamshire, The Maharishi University School of Law (4, Cole 1993, p. 150, no. 1205).

Ecce Homo: (i) roundel, later version, church of St. Peter, Nowton, Suffolk (n: IV. 2a, Cole 1993, p. 171, no. 1389). (ii) version of the same subject from a series based on the

DIA 31/fig. 2. After JACOB CORNEILISZ. VAN OOSTANEN: *Last Supper*, 1515–20. Cambridge, King's College Chapel

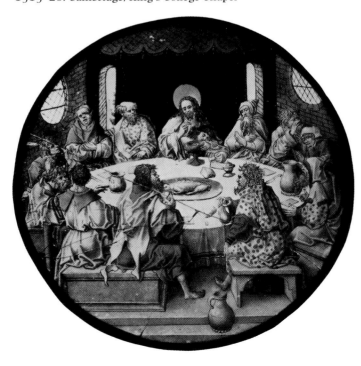

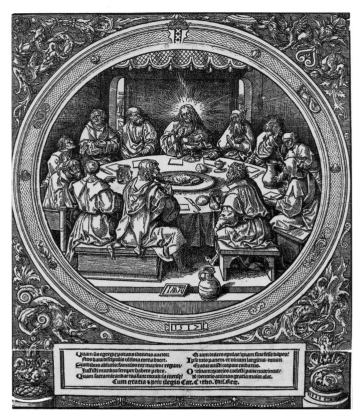

DIA 31/fig. 3. After JACOB CORNEILISZ. VAN OOSTANEN: *Last Supper*, woodcut, 1513–14; frame dated 1517. Amsterdam, Rijksmuseum, Rijksprentenkabinet

same designs, the Byloke Museum, Ghent. (iii) version of the same subject from a series based on the same designs, the Musées Royaux d'Art et d'Histoire, Brussels.

Crucifixion: roundel based on the same designs, Packwood House, Lapworth, Warwickshire (50, Cole 1993, p 132, no. 1051).

Resurrection: (i) roundel, from a replica series of Rijksmuseum RBK 1966–59 Rijksmuseum, Amsterdam (NM 126080). (ii) fragment, close version of the latter, formerly Kunstgewerbemuseum, Berlin (Schmitz 1913, 1, p. 75, fig. 129). (iii) roundel, version of the same subject, Longleat House, Horningsham, Wiltshire (11m Cole 1993, p. 111, no. 922). (iv) roundel, another version of the same subject, Musée des Arts Décoratifs, Paris (20768).

Iconographic program: The woodcut series of Passion illustrations by Jacob Cornelisz. van Oostsanen comprises twelve scenes: *Last Supper, Agony in the Garden, Kiss of Judas, Taking of Christ, Mocking of Christ, Flagellation, Crowning with Thorns, Ecce Homo, Carrying of the Cross, Crucifixion, Lamentation, and Resurrection.* A second edition (DIA 31/figs. 3, 4) placed the circular designs within a rectangular frame with fantastic creatures in the spandrels and a plaque below with a Latin inscription explaining the scene. A third edition (Ill. Bartsch, 13, nos. 67–78) amplified the woodcuts through

DIA 31/fig. 4. After JACOB CORNEILISZ. VAN OOSTANEN:
Mocking of Christ, woodcut, 1517. Amsterdam, Rijksmuseum,
Rijksprentenkabinet

lavish architectural frames with figural inserts. The framing
placed the Passion cycle in a typological format in the tradi-
tion of *Biblia Pauperum* illustrations as discussed for the
Prophets and Psalmists after the "Biblia Pauperum" (DIA 5–16).
The *Biblia Pauperum*, widely disseminated in late medieval
times, juxtaposed a New Testament image with two Old
Testament prototypes and Old Testament author portraits
accompanied by their respective prophetic texts (Arthur
Hind, *An Introduction to the History of the Woodcut*, I, New
York, 1963, pp. 236–40; Henry 1987; DIA 5–16).

The *Biblia Pauperum* Last Supper image was set against
vignettes showing Abraham receiving bread and wine
from Melchisedech, and Moses watching the Israelites
gather manna as it falls from heaven (Blockbook Leaf no.
S. Henry 1987, p. 83). Although van Oostsanen retained
the same subject matter, the compositions are quite differ-
ent. Both scenes are standard prototypes for the establish-
ment of the sacrament of the Eucharist by Christ at the
Last Supper. The prominent position of the Eucharistic
chalice in the first edition of the woodcut, however, argues
that van Oostsanen, from the first, desired to emphasize
the disputed sacramental nature of the Catholic dogma.
The Lord sustained the Israelites with "bread from heaven"
(Exodus 16:4) as they wandered for forty years in the
desert before coming to settled lands. Melchisedech, "priest
of the most high God" (Genesis 14: 18), offered bread and

wine after Abraham's victory over the four kings. His
example, with that of Abel and Abraham, was cited in the
canon of the Catholic Mass directly after the moment of
the consecration of the bread and wine.

It is impossible to know precisely what model was
employed by the glazing studio or for what context the
Detroit *Last Supper* was created, as discussed in recent
scholarship (Konowitz 1990–91, pp. 142–52; id., "A
'Creation of Eve' by Dirk Vellert," *Master Drawings*, 35,
1997, pp. 54–62; *Painting on Light*, esp. pp. 1–17). The
image might have been a part of a full cycle of twelve
images, perhaps even juxtaposed with images creating a
typological context. It is equally, and perhaps even more
likely that the Last Supper was commissioned as a single
piece portraying the centrality of the Eucharist in
Christian worship as well as the image of Christ's compas-
sion for his followers. Husband's research (*Checklist* IV, p.
112) has uncovered a single extensive series of roundels,
the eight at the Church of the Holy Trinity, Bradford-on-
Avon, Wiltshire. The subjects include the *Agony in the
Garden, Kiss of Judas, Mocking of Christ, Flagellation, Ecce
Homo, Crowning with Thorns, Christ Carrying the Cross, and
Crucifixion*. Of the other extant roundels associated with
this series, six are images of the *Last Supper*. Four roundels
each show the *Resurrection* and *Crowning with Thorns*,
three each depict the *Kiss of Judas* and the *Ecce Homo*. The
Crucifixion and *Flagellation* have been found only once.

Bibliography

UNPUBLISHED SOURCES: Grosvenor Thomas Stock Book II,
74, item no. 2002.

PUBLISHED SOURCES: P. V. Maes, *Leuvens Brandglas*, Louvain,
1987, pp. 248–50; Husband in *Checklist* IV, pp. 112, 106.

Condition: A horizontal break has been repaired with a
mending lead. The paint is rubbed in a few areas and
there are a few minor surface scratches. The roundel has
been marked with the Grosvenor Thomas Inventory num-
ber 2002.

Color: The color harmony is warm, but complex. Christ is
robed in white trimmed with deep yellow. Peter and John,
who lies across Christ's chest, wear light brown tunics.
Peter wears a white cloak across his shoulder. On the
right, the first apostle wears a white hooded cloak with
yellow trim. The next, who whispers to his companion,
wears a deep yellow robe. The listener wears a light brown
tunic, which acts as a foil for the deep yellow hooded cloak
on the next apostle. The dress of the apostles closest to the
viewer is the most complex. On the right, the apostle
wears a light brown tunic with full sleeves over which a
white, belted robe with gold trim at sleeve and neck. To
the left the garment is a light brown tunic with gold trim
at the hem, over which a robe with a spotted split hood
open down the back is also trimmed in deep yellow. Both

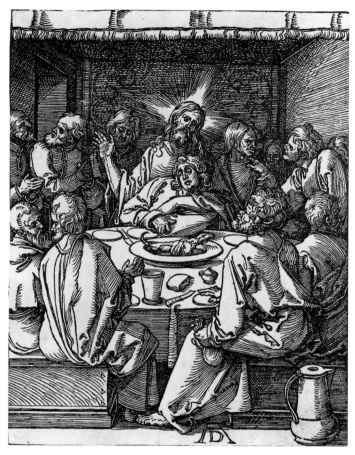

DIA 31/fig. 5. ALBRECHT DÜRER: *Last Supper*, c. 1508–9. New York, Metropolitan Museum of Art

the men sit on benches of a medium cool yellow. To the left the apostles are generally dressed in white garments with deep yellow trim, save for the apostle farthest to the left, almost hidden in the composition, who is dressed in a light brown tunic. The halo behind Christ's head is bright warm yellow that contrasts abruptly with the dark neutral damascene of the cloth set between the posts. The table setting parallels the distribution of white, deep yellow, and light brown in the colors applied to the dishes, vessels, and food against the white damascene cloth.

The close harmonies of neutrals and yellow fluctuate to give unusual depth of interest to this image. Like the varieties in the application of trace and wash, the color shifts are many and intense, especially in the contrast of the different shades of neutral on the surface, further intensified by the change in color created when the similar tones are applied as back-painting.

Technique/Style: The panel is composed of thin, uneven uncolored glass with some large elliptical bubbles and an imbedded impurity. The painter has used two hues of silver stain, sanguine, and two shades of vitreous paint. Back-painting enhances the depth and richness of the image. An example is the enrichment of the damascene

tablecloth via a decorative system applied to the back of the glass. Similar meticulous execution appears in the roundel of *Christ Being Led Away from Herod Antipas* (Text ill., page 68; MMA-CC. Husband 1995, pp. 76–7, pl. 7, no. 21). Both glass painters use silver stain with the same intensity, particularly as a uniform tone for fabrics and architectural elements. The more scraggly treatment of the hair and beards, however, are closer to the linear intensity of Dirick Vellert (MDGA 4; C-CEC 2; CMA 12–15), although the panel is far too early for any direct influence.

Iconography: The image follows the standard iconographic format for the Last Supper. Christ is seated at table with his twelve apostles. John, the "disciple whom Jesus loved" (John 20:2) is leaning across Christ's chest while the others show various attitudes of reaction to his words that one of the company would betray him. The composition is loosely based on the woodcut, c. 1509–9, of *The Last Supper* (DIA 31/fig. 5) from *The Small Passion* by Albrecht Dürer (Kurth 1963, p. 31, no. 230). The table is a round format, a model which accords well with the circular shape of the roundel. Van Oostsanen has modified the composition to minimize overlapping of the figures and increase legibility. The clarity of the image is thus enhanced, but at the expense of the dramatic compression of Dürer's narrative. Van Oostsanen retains many of Dürer's familiar motifs, especially the emphasis on the furniture in the foreground and the prominent display of the wine jug. John is held in Christ's arms and the Eucharistic cup (see above, **Iconographic program**) is close to his lips.

Date: The date is determined by the close relationship of the roundel to the woodcut model of 1514 and the stylistic similarities to work of the first quarter of the sixteenth century.

Photographic reference: DIA 4257

DIA 32. Flight into Egypt, from a Series of the Infancy of Christ (?)
Design attributed to Master of the Seven Acts of Mercy
North Lowlands, Leiden
1515–25
Circle: diameter 23.2 cm (9 in)
Accession no. 36.97, Founders Society Purchase, Octavia W. Bates Fund

Ill. nos. DIA 32, 32/fig. 1; Col. pl. 19

History of the glass: The glass was once a part of the stock of Grosvenor Thomas of London from whence it entered the collection of the dealership of Thomas and Drake, of New York. Roy Grosvenor Thomas of this partnership was Grosvenor Thomas's son who appears to have acquired

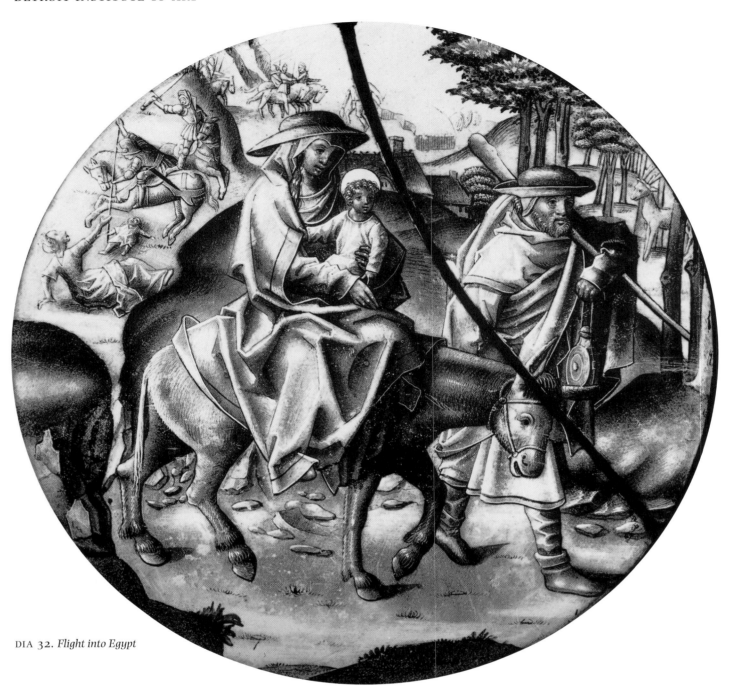

DIA 32. *Flight into Egypt*

much stock after his father's death in 1923. The panel was acquired in 1936 for the Detroit Institute of Arts as a Founders Society Purchase, through the Octavia W. Bates Fund. [German/Flemish Galleries]

Related material: Roundel, slightly later reversed replica, Dr. Henry Hood collection, Greensboro, NC (*Checklist* IV, p. 195); roundel of the *Visitation*, based on a design from a version of the same series, Bruce J. Axt collection, Altadena, CA, (*Checklist* IV, p. 37).

Bibliography
UNPUBLISHED SOURCES: Grosvenor Thomas Stock Book II, 80, item no. 2041.

PUBLISHED SOURCES: Husband in *Checklist* IV, p. 111, col. ill. p. 14.

Condition: Visually the roundel is in very fine condition despite some surface scratches and minor flaking of paint. The single break is repaired with a mending lead. The panel is inscribed with the Grosvenor Thomas stock number, 2041, near the border above the Virgin's head.

Color: The color is predominantly a warm deep neutral. The dense working of the vitreous paint produces a somber value that dominates the roundel.

Technique: The roundel is constructed of heavy, very

uneven uncolored glass with some imbedded impurities, whorls, and straw marks. The drawing is executed in silver stain and five shades of vitreous paint. Different drafting techniques appear. The glass painter has taken pains to vary his strokes to evoke the difference between the hair of the animal, the texture of the leaves, and the fabrics worn by the Holy Family. The trace and stickwork lifting off the paint for the donkey's rump shows many overlapping strokes, giving the impression of the hairs of the animal's skin. The surface of Mary's cloak, immediately adjacent, however, shows much thinner, longer strokes, resulting from a needle being used to remove the mat base paint, creating an impression of smoothness.

Iconography: The Gospel account of this event (Matt. 2:13–14) is laconic. Having been warned in a dream of Herod's plan to kill the infant Christ, Joseph, "rose, and took the child and his mother by night and retired into Egypt." Tradition embroidered the flight and the *Golden Legend* (p. 66) recounts that the Egyptian idols fell as the true Lord entered that land. The Detroit roundel shows a very real and unmiraculous depiction emphasizing, instead of the extraordinary, the very ordinary and believable aspect of the story that could be recognized in the average viewer's life. Both Mary and Joseph are dressed warmly for their trip. Joseph wears a close-fitting cap over his ears and a broad brimmed traveling hat, leggings, solid shoes, and a heavy cloak. A flask for water hangs from the club he has balanced over his shoulder. Mary is seated on the donkey's back and her long traveling cloak envelops the child she hold on her lap. She wears a similar hat. Joseph appears to be holding a loose hand on the donkey's bridle to lead him onward. Scenes of the Massacre of the Innocents (Matt. 3:16–18) are depicted in the background. A mounted soldier strikes at a prostrate child with his lance. His mother, who appears to have been thrown to the ground, tries to ward off the blow. Another mounted soldier approaches waving a drawn sword. More mounted soldiers appear in the far background. The Holy Family seems protected from this threat by the low mounds of earth and houses immediately behind them. That they are fleeing the violence of the city for safety in the wilderness is indicated by the depiction to the far left of the tall trees of a forest and a watchful stag.

The version of this scene now in the collection of Dr. Henry Hood, Greensboro, North Carolina, (Husband in *Checklist* IV, p. 195) is very close to that appearing in the Detroit roundel. The scene is reversed. Mary is depicted with long robe folded over her head and a naked Christ Child in her arms. The presentation is more traditional, evoking a timeless devotional image of the Virgin and Child rather than a contemporary family on a journey. Significantly, the more typical hairless head for the Christ Child is substituted for the golden locks so vividly displayed in the Detroit version. In the Greensboro version,

Joseph's position is shifted slightly so that the details of his traveling attire are more visible. In the absence of drawings it is difficult to suggest which is the "original" disposition of the design. It is probably more fruitful to conceive of the designs as fluid models and the painters accustomed to variances in stock imagery and to shifts in dimensions to enable them to respond to differing demands of a commission (Butts and Hendrix, *Painting on Light*, esp. pp. 4–16).

The fact that there are two extant versions of the *Flight into Egypt* and only one identified image of a *Visitation* (Bruce J. Axt collection, Altadena, CA, Husband in *Checklist* IV, p. 37) would argue that both images of the Flight may have been produced as single images, not as roundels in a series. The subject is a highly engaging, one as rich in associative meaning – vulnerable Child, foreknowledge of martyrdom, and family solicitude – as any event in the Infancy of Christ. In the medium of easel painting of this time, we find the subject of the *Rest on the Flight to Egypt* a popular single image. See, for example, the painting by Gerard David (1500–10, National Gallery of Art, Washington D.C., Snyder 1985, p. 192, fig. 189) or the same subject, in an even more monumental form by Joachim Patinir (c. 1520, Prado, Madrid, Snyder 1985, pp. 409–10, col. pl. 65).

Style: The use of silver stain to shadow the ground behind the Holy Family is distinctive. The mat of the vitreous paint applied over the stain produces a dense screen that both encompasses and silhouettes the figures. The contrast of the liveliness of the yellow in the trim of the couple's clothing, the tree to the upper left, and the trappings of the soldier to the right complement the density of the ground massing. The form of the image relates ultimately to the impact of Albrecht Dürer's prints on the entire development of sixteenth-century iconography and style. His woodcut of the *Flight to Egypt* (B 89) from the series of seventeen woodcuts of the *Life of the Virgin* is dated by most scholars to 1503 (Kurth 1963, no. 187, p. 26). Published in 1511 in book form, the series enjoyed wide influence, as testified by the version elaborated by Dirick Vellert (1532 or later, Amsterdam, Rikjsmuseum, NM 12969, Konowitz 1995, no. 76, p. 153). The Detroit roundel follows the same generic disposition that includes contemporary dress, focus on Joseph with his staff over his shoulder leading the donkey, and the wooded setting. The Detroit composition, however, divides the family's flight and the refuge of the forest from the drama of the Massacre of the Innocents over to the right. Nothing is left of Dürer's exotic landscape of palm trees. In fact a very northern stag appears to greet them from the forest.

Husband has suggested an association with a glass painter in Leiden who produced three roundels around 1510 to 1520 on the theme of the *Seven Acts of Mercy* (also known as the *Corporal Works of Mercy*): *Housing the*

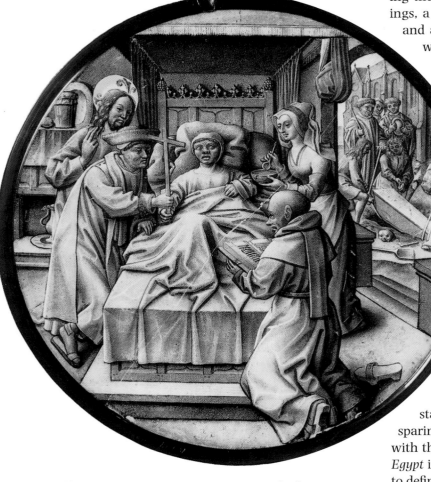

DIA 32/fig. 1. PIETER CORNEILISZ. KUNST: *Caring for the Dying*, Leiden, *c.* 1510–20. Amsterdam, Rijksmuseum

Strangers, Feeding the Hungry, and *Caring for the Dying* (Amsterdam Rijkmuseum NM 12231 a, b, and c, Husband 1995, pp. 109–12, figs. 46–7, pl. 11). The series influenced a slightly later glass painter in Leiden, Pieter Cornelisz. (died sometime between 1560 and 1561) also known as the Monogrammist PC (Jeremy D. Bangs, "The Leiden Monogrammist PC and Other Artist's Enigmatic Fire Buckets," *Source* I/1, fall 1981, pp. 12–15). Pieter Cornelisz. made drawings for the subject of the *Seven Acts of Mercy* at least three times, from which several productions in stained glass from the 1520s have survived.

The roundel dated 1510–20 with the subject of *Caring for the Dying* (DIA 32/fig. 1: Rijkmuseum NM 12231 c) is well preserved and shows strong similarities to the Detroit *Flight into Egypt*. They are of the same general size, 23.2 cm for the Detroit roundel and 22.5 cm for the *Acts of Mercy* series. One observes the same presence of short, stocky body types. The faces have rounded eyes with prominent upper lids. Most striking may be the depiction of garments as if they were all made from the same thick material. In the roundel of *Caring for the Dying*, a variety of types of fabric should be able to be identified, linen cover-

ing the pillows behind the dying man's head, bed hangings, a monk's habit, a woman's tight bodice and sleeve, and a woman's head cloth. All, however, are rendered with very similar patterns of folds, highlights, and shadows. This same unusual characteristic is noticeable in the rendering of the fabric in the Virgin's cloak and Joseph's coat and the cloak that he wraps around his shoulders in the Detroit *Flight to Egypt*. The folds are rounded and fall in unified, simple groups. They are thick enough to construct a three-dimensionality in the representation, One notices, in particular, the heavy layers of Joseph's coat and several wrappings of his cloak or again the stiff pattern of folds of Mary's cloak over the donkey's back.

Both roundels show modeling achieved with considerable use of the badger brush. Removal of paint with stick and needle, however, is somewhat different. The Detroit roundel shows more variety, especially longer parallel strokes on the donkey and the Virgin's cloak. The use of silver stain, also is different. The yellow of the silver stain, in both the pale and the deeper tint, are used sparingly, a shoe, the cross, a garment of a man assisting with the burial to the side. The silver stain in the *Flight to Egypt* is far more atmospheric than iconographic, helping to define the tones of the background and the enclosure of the Holy Family as they pass through the wood. The conclusion would be that the glass painter was working from drawings or a roundel model executed by the designer of the series of the *Seven Acts of Mercy*.

The Greensboro panel is 23 cm (9$\frac{1}{16}$ in) in diameter, 2 cm short of the dimensions of the Detroit roundel, and in technique and style is very close to those of the Detroit panel. Three shades of vitreous paint, back-painting, and two shades of silver stain demonstrate a complex execution similar to that of the Detroit roundel. The forms, however, suggest an independent hand. The treatment of the tree and the modeling of the hills in the background are distinctive, the Greensboro panel showing more emphasis on silhouettes and the Detroit example more on atmosphere. Husband believes that the Greensboro *Flight* is slightly later than that in Detroit (*Checklist* IV, p. 195).

Date: The roundel of *Caring for the Dying* from the *Seven Acts of Mercy* has been dated to *c.* 1510–20. The differences in painting style, especially the more fluid use of the silver stain to provide atmosphere, would argue for an execution for the Detroit roundel a few years later, thus 1515–25.

Photographic reference: DIA 4256

DIA 33–34. ARMS OF JEAN BAYER DE BOPPARD AND EVE D'ISENBERG AND OTHER ELEMENTS OF ARCHITECTURAL DECORATION

Château of Lannoy, Herbéviller (Lorraine), France
1522–24

History of the glass: The stained glass displaying the arms of Jean Bayer de Boppard and Eve d'Isenberg and the accompanying program were set within the windows very probably at the time the chapel was built. (Robinson 1949?; Emile Ambroise, "Le Château de Lannoy à Herbéviller," *Revue Lorraine illustrée*, 4, Nancy, 1909, pp. 60–4; id., *Les Vieux Châteaux de la Vésouze*, Nancy, 1910; Neagley 1992, figs. 2, 4, 6, 7) reproduces period photographs of the building. The George Grey Barnard Papers (Archives of American Art, Smithsonian Institution, Series I SSb12) contain a letter from George Demotte to Barnard, 1924, stating that Demotte sold the Herbéviller chapel to H. E. Huntington of California and that before that it had been in his own collection. The glass remained *in situ* until the chapel was acquired in 1927 by the Detroit Institute of Arts. Linda Neagley has traced the purchase of the building with the remnants of a glazing program still in the flamboyant tracery. Negotiations began in 1922 between the Detroit Institute of Arts and the Parisian art dealer G. T. Demotte. Drawings, preserved in the Museum's files, were made on site and the individual stone segments numbered before dismantling. A number is still visible on the exterior of the chapel as seen from the Museum's Kresge Court. For safety of transport, the glass was removed from the openings and packed into a single crate; the stone work necessitated 127 crates. The reinstallation of the glass is not recorded as a specific item in the museum's files. It presumably took place shortly before the chapel was open to the public on 7 October 1927. [DIA 33 and 34 are on display in the Museum's Chapel of the Château of Lannoy]

Reconstruction: It is most likely that the stained glass and the architecture of the chapel were designed as a whole. The architecture, although conservative, shows rich embellishments. In the chapel, a keystone shows the arms of the Bayer de Boppard family (DIA 33/fig. 1). Very probably the windows originally contained a series of saints standing on a base and under an architectural canopy. The format would not have been unlike the figures of Isaiah, the Tiburtine Sibyl, St. Raphael, and St. Faith in architectural settings in the museum's collection (DIA 35–38). The style of the windows, however, would undoubtedly have been of the same Late Gothic format as indicated by the remaining architectural elements.

History of the building: Neagley has discussed the architectural and stylistic setting of the chapel of the Château

of Lannoy. The town of Herbéviller contained two fiefs dependent on the bishop of Metz. To the north was the château known as La Tour, of the Seigneurs of Barbas. To the south was the Château of Lannoy, a name derived from a family who occupied the château in the sixteenth century. Rebuilt at the beginning of the sixteenth century, the building was typical of fortified houses, or *maisons-fortes* of the minor nobility in French countryside. As seen in photographs taken about 1900, the château was a modest, if imposing building with an interior court (Neagley 1992, figs. 2, 4, 6, 7). The château was equipped for defense with walls of two meters thickness and a watch tower. Although of possible strategic defense, the function of the building was more probably to affirm prerogatory seigneurial rights. The chapel was arguably the most sophisticated and costly of the any element in the building's construction (Col. pl. 46; Neagley 1992, fig. 6).

Bibliography
UNPUBLISHED SOURCES: DIA curator's file.

PUBLISHED SOURCES: Raguin in *Checklist* III, p. 174; Neagley 1992.

DIA 33. Arms of Jean Bayer de Boppard and Eve d'Isenberg
Quatrefoil tracery light: 24 × 36 cm (9½ × 14⅛ in)
Accession no. 26.125

Ill. nos. DIA 33, 33/fig. 1

Condition: The panel appears essentially intact. There are no replacements, and the generous use of break-away filets surrounding the glass that act as a buffer between the design and the stone architecture has helped preserve the glass. The panels arrived in a separate crate.

Heraldry: Quarterly; 1 and 4 or [rect. argent] a lion rampant proper [rect. sable] armed and langued gules crowned or (Jean Bayer de Boppard); 2 and 3, azure [rect. gules] seme crosses crosslet or an arm bent at elbow in armor proper garnished or holding between thumb and index a ring or (Eve d'Isenberg). Identified in Neagley 1992.

The glass painter clearly was not bound by heraldic rules of color. The ground of the first and third quarters should be argent (uncolored glass), but has been presented as light yellow. The lion is not sable (black), but a brownish yellow, the natural, not heraldic color of the animal. One questions if the painter worked from a black and white illustration of the heraldic device, filling in colors that seemed appropriate. For example, the fact that the ground of the second and third quarters is blue, not red, is inexplicable within heraldic rules. At this juncture it would seem inexcusable not to comment on the retardataire draftsmanship of the panel. The glass painters undoubtedly

DIA 33. *Arms of Jean Bayer de Boppard and Eve d'Isenberg*

DIA 33/fig. 1. *Keystone with Arms of Jean Bayer de Boppard and Eve d'Isenberg*, 1522–4, Chapel of Château of Lannoy. Detroit Institute of Arts

came from a local workshop, since the depiction of the bent arm, without a preconceived model of this motif, has puzzled many observers.

Jean Bayer de Boppard and Eve d'Isenberg were married in 1522 (J. Choux, *Dictionnaire des châteaux de France. Lorraine*, Paris, 1978, as quoted in Neagley 1992, n. 12).

Color: The panel is dominated by the yellow hues of the trefoils and the warm gold and yellows of the heraldic shield. The background of the four quatrelobes is green. A blue knob anchors the stem of each trefoil.

Technique: Pot-metal appears in the panel in the green background and the blue knob of the trefoils. The yellow appears to have been created by silver stain techniques and the blue background achieved with enamel paints.

Style: The shield with surrounding foliate terminations is typical of Late Gothic systems. Like the chapel itself, it is conservative for the 1520s in France. Urban centers such as Paris, Rouen, and Bourges had already moved to more Renaissance forms influenced by Italianate models of classical revival.

Date: The glass could not have been designed before 1522, the date of the marriage of Jean Bayer de Boppard with Eve d'Isenberg.

Photographic reference: DIA Neg. no.

DIA 34. Lancet Tops and Elements of Architectural Decoration

CENTRAL WINDOW: 20 × 37 cm ($7\frac{7}{8}$ × $14\frac{1}{2}$ in)
FIRST WINDOW ON LEFT AND SECOND WINDOW ON RIGHT: 20 × 37 cm. ($7\frac{7}{8}$ × $14\frac{1}{2}$ in)
SECOND WINDOW ON LEFT AND FIRST WINDOW ON RIGHT: 20 cm × 37cm. ($7\frac{7}{8}$ × $14\frac{1}{2}$ in)

Ill. no. DIA 34

Condition: Despite replacements, it appears certain that the tops of the lancets present the original program of architectural canopies. All five windows of the chapel contain a heterogeneous selection of glass from the early sixteenth century and later. Flamboyant tracery creates distinctive openings for glazing programs. Most of the glass shows considerable stopgaps and replacements, and presumably repositioning of segments.

DIA 34. Elements of architectural decoration, 1522–4 and later, from Herbéviller (Lorraine), Château of Lannoy

DIA 35–38. FOUR STANDING FIGURES IN ARCHITECTURAL SETTINGS
France, Ile-de-France or Berry?
1525–50

History of the glass: The panels were a part of the Raoul Heilbronner collection, Paris, until offered for sale at the Galleries Georges Petit in May 1924. They were purchased by the dealership Arnold Seiligmann, Rey & Co., New York, and sold in 1926 to William Randolph Hearst of Los Angeles. They were catalogued for the Hearst inventory in 1939 and appear in the sale catalogue by Hammer Auctions in 1941. Supported by a gift from K. T. Keller, the Detroit Institute of Arts purchased them from the Hearst estate in 1958. [DIA 35–38 in storage]

Related material: Panels of *St. Joan of France* (DIA 35–38/ fig. 1) and *St. Catherine of Alexandria* (DIA 35–38/fig. 2), Glendale, California, Forest Lawn Memorial Park, F.L. lots 97 and 102. The panels appear to be of the same series as the Detroit figures (Hayward and Caviness in *Checklist* III, p. 58). The image of *St. Catherine* is unusual, since instead of the usual attributes of wheel and sword, she holds what appears to be a saw. The inscription panel, however is authentic and intact, but possibly from another window in the series. It is possible that the figural segment is not of Catherine but of St. Agatha whose breasts were mutilated, most often by pincers but sometimes with a saw. See Italian Gothic manuscript illumination showing Agnes' breasts removed by saws, (private collection, George Kaftal, *Saints in Italian Art: Iconography of the Saints in the Painting of North East Italy*, Florence, 1978, pp. 8, 12, fig. 9 and *Herder Lexikon*, 5, cols. 44–8).

Iconographic program: The known panels in this series consist of images that can be associated with the Franciscan Annunciades (see, for the Annunciades, "Gabriel-Maria," *Dictionnaire de Spiritualité*, 6, Paris, 1967, cols. 17–25; J. F. Bonnefoy, "Le B. Gabriel-Marie O.F.M., *Revue d'ascétique et de mystique*, 17, July–Sept., 1936, pp. 252–90). Certain of the images are almost obligatory inclusions in a series of saints for the fifteenth or sixteenth centuries. St. Catherine of Alexandria, for example, patron of virgins and of Renaissance learning was one of the most frequently depicted saints and one of the three "holy maidens" renowned as intercessors (*Herder Lexikon*, 7, cols. 289–97; Réau, 3/2, pp. 739–40). These maidens, St. Catherine, St. Margaret of Antioch, and St. Barbara were the three women included among the Fourteen Auxiliary Saints. If the figural image is of St. Agatha, as discussed above, one sees once again a heroic female martyr very popular in French hagiographic traditions. St. Faith of Agen, however, is a particularly French nationalistic image.

Most significant is the presence of Joan of France. She was beatified in 1742 and canonized in 1950, although

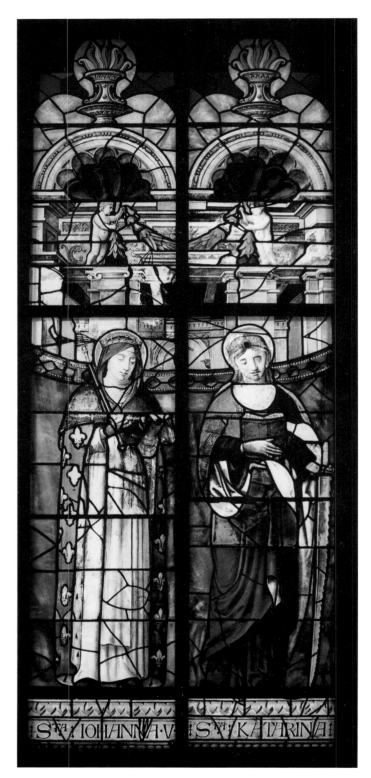

DIA 35–38/figs. 1 & 2. *St. Catherine of Alexandria* and *St. Joan of France*. Glendale, California, Forest Lawn Memorial Park

her cult in the nineteenth century certainly assumed her sainthood (*Herder Lexikon*, 7, cols. 80–1; Réau, 3/2, pp. 739–40; Hébrard, *Sainte Jeanne de Valois et l'Ordre de l'Annunciade*, Paris, 1878; André Girard, *Sainte Jeanne de France, duchesse de Berry*, Bourges, 1950). Joan, also known as Jeanne de Valois (in Latin, *Johanna*) was born in 1464,

daughter of king Louis XI. She was married at the age of twelve to Louis Duke of Orleans. When Charles VIII died without direct heirs, Louis ascended to the throne as Louis XII in 1498. To prevent the loss of the Duchy of Brittany, he divorced Joan and married his predecessor's widow, Anne de Bretagne (Anne of Brittany). Joan, who was then 35, retired to Bourges where she founded the Order of the Franciscan Annunciades. The rule was approved in 1501, the year she established a second foundation devoted to caring for the sick. Joan's spiritual guide in these matters was the Franciscan Gabriel-Maria (1462–1532) who, as guardian for the convent of Amboise, had become Joan's confessor during the last years of her marriage and who accompanied her to her estates of the Duchy of Berry (Françoise Guyard, *Chronique de l'Annunciade: Vie de la bienheureuse Jeanne de France (1556) et du bienheureux Gabriel-Maria* [augmented ed., 1561], J.-F. Bonnefoy, ed. in *La France franciscaine*, 19–21, 1936–38, and separate printing, Paris, 1937, second ed. Villeneuve-sur-Lot, 1950). Joan is known to have given a window to the church of the Cordeliers in Salins [Jura] (France *Recensement* III, p. 209). She died in 1505 in Bourges and her tomb was pillaged in 1562 during the religious upheavals (Réau 3/2, p. 739). Copies of her funeral mask are conserved in several locations, particularly the archbishop's palace in Bourges, where she is considered the patron of the diocese.

The panel in the Forest Lawn collection may be the earliest image of St. Joan of France in art. Her representation became important in the context of the nationalistic agenda of nineteenth-century glazing programs. See church of St. Médard, Paris, window with Isabelle de France and St. Clotilde, by Champigneulle (France *Recensement* I, p. 53). See also St. Sulpice, Nogent-le-Roi, axial chapel, south, life of "Jeanne de France" by Hucher; Church of St. Pierre-le-Guillard, Bourges, c. 1850 by Thévenot (destroyed); Church of St. Ulface, Saint-Ulphace, single figure; and Church of Notre-Dame, Béhuard, originally a chapel constructed by Louis XI, father of St. Joan, axial bay, showing the founding of the Dames de l'Annunciade by Joan of France (France *Recensement* II, pp. 77, 188, 268, 303).

The groupings of the windows are not only stylistically but also iconographically coherent and demonstrate an adherence to the spirituality espoused by the order founded by Joan. Central to the Annunciades was a devotion to Mary coupled with traditional Franciscan virtues of poverty and service to the poor. In the Detroit groupings, Isaias as the prophet of the Annunciation stands next to the Tibertine Sibyl, whose vision revealed the enthroned Virgin and her son. St. Raphael as patron of healing, important to an order caring for the sick, stands next to St. Faith, a virgin martyr from the very beginnings of Christian Gaul. St. Catherine can be associated with St. Joan in several ways. Catherine refused to marry Max-

entius, and suffered martyrdom. Joan, it seems, also was bitterly opposed to marriage, but was constrained as a royal child to suffer a marriage of dynastic convenience. Both saints carry books, and in the Renaissance, Catherine was sometimes seen as a patron of lawyers and other scholars.

The program presents not only women, but also women who triumphed over men. Thus one is encouraged to see a relationship between the program and the first account of Joan's life, *La Vie de la Bienheureuse Jeanne de Valois*, written in 1556 by Françoise de Guyard, a religious in the Order at Bourges and also Joan's niece. The life vindicates a wronged woman and a sainted founder. In the program there are no male saints, Isaias being admitted only because of his prophecies honoring Mary. The Sibyl tells the Emperor that he will be eclipsed by the Virgin's Son. Catherine spurns an emperor's proposal of marriage, defeats the pagan philosophers, and before her own death God's angels destroy thousands of pagan spectators who had come to watch her being tortured on the wheel. St. Faith's power has grown so that crowned monarchs journeyed to implore her intercession. Raphael is not a man, but an angel, and a model for women's work of healing the sick. The program honors a woman founder, and presents her as fully in the company of the saints no more than forty-five years after her death, thus certainly within living memory for many of her followers.

A number of foundations developed in the early year of the Order, with dates clustering in the first third of the century. The abbey at Bourges was founded in 1501 and in 1506 the newly constructed chapel was consecrated by the Cardinal Georges d'Amboise, but other locations are possible. Then followed Albi in 1507, Bruges in 1517, founded by Marguerite of Austria, the ruler of the Low Countries, Béthune in 1517, Bordeaux in 1521, Rodez in 1524, Louvain in 1530, and Agen in 1533 (I. Dupont, "Le monastère des Annunciades de la Réole (Gironde)," *La France franciscaine*, 4, 1921, pp. 90–2). Very possibly the program is substantially intact and the windows may well have been designed for a restricted space, such as that of a Late Gothic oratory and the tall, narrow openings of the period. Missing would appear to be a double lancet with a Marian subject, most probably an Annunciation with Gabriel and Mary in separate lancets of an axial bay, and an additional opening with another pair of saints.

Composition: The panels are typical of Renaissance glazing programs in France. The architectural framing in groups of two suggests that the windows were double-light lancets.

Technique: The panels show large amounts of uncolored glass treated with silver stain, two colors of vitreous paint, and sanguine. The pot-metal glass is reserved primarily for the figure. The jeweled clasp of Raphael's mantle and

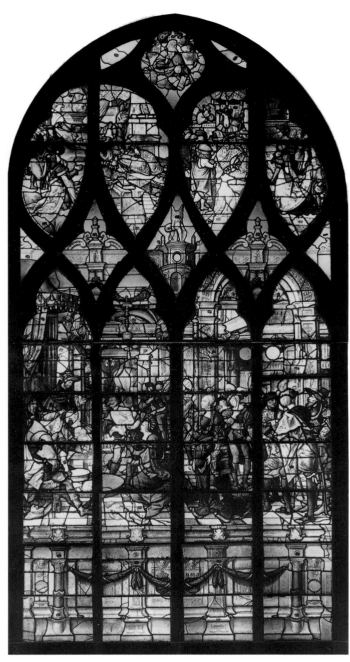

DIA 35–38/fig. 3. *Judgment of Solomon*, 1531. Paris, Church of St. Gervais

the jewel of Isaias's turban are *chef-d'oeuvre* inserts. The most common method of paint application is a mat textured with badgering and stipple. Virtually no area of the panels are without the painted mat, which is typical of French Renaissance methods. The painting emphasizes smooth transitions; the application is very painterly, stressing the modulation with brush. There is very little stickwork or hatch shading with trace.

Style: The style of the six panels is linked with developments in the Ile-de-France in the second quarter of the sixteenth century. This era saw a great surge in church construction and embellishment, registering the full im-

pact of Italianate ideas on French draftsmanship and composition. The trends were universal, evidenced by the work of printmakers and painters, as well as glass painters across Northern Europe. This is evidenced by the surprising similarity of the Detroit panels with works as geographically distant as the designs of Hans Burgkmair the Elder (1473–1533) for the *Seven Planets* series from Augsburg showing putti with garlands, urns, Renaissance pilasters, and vaulted niches (*Ill. Bartsch*, 11, p. 52, no. 45 (215)).

Gone were the Gothic forms, and in their place vast architectural vistas crowded with dramatic figural compositions, such as that represented in the Detroit collection by the *Martyrdom of St. Eustache* (DIA 41) from the church of St. Patrice of Rouen. The Rouen panel uses architecture as a backdrop and perspectival locus, but the window of the *Judgment of Solomon* (DIA 35–38/figs. 3, 4), dated 1531, in the Church of St. Gervais, Paris, balances figure and architecture, as do the four panels under discussion (bay 16, in the south choir, Jean Lafond in *Vitrail français*, p. 250, fig. 190; France *Recensement* I, p. 49, pl. IX; Françoise Gatouillat, Claudine Lautier, Guy-Michel Leproux, "Un chef d'oeuvre de la Renaissance: la verrière de la Sagesse de Salomon à Saint-Gervais," in *Vitraux parisiens*, pp. 92–121, ills.). The Detroit and Forest Lawn series fall into three groups of two, each with distinguishing architectural traits, two conch shell arches, a coffered vault extending over two panels, or an arch flanked by pairs of columns supporting an architrave. The architecture in the *Judgment of Solomon* shows many similarities with that of the Detroit panels. The intersecting arcs of vault and archivolts are repeated in the lancets of *St. Raphael* and *St. Faith*. The same complex ribbings of the vaults with the oculi filled with deeply colored insets in the segment containing the false mother appear in the *Isaias* and *Tiburtine Sibyl* panels in Detroit. The Detroit panels also include agitated centaurs in foreshortened poses seen from the rear on either side of the oculus.

The windows donated by François de Dinteville 1525–45 or Charles de Villiers, 1524, in the collegiate Church of St. Martin at Montmorency, or the huge program of windows in the Church of St. Pierre, Montfort l'Amaury, show additional variants of the architectural frame, but all clearly place the Renaissance architecture as major elements in the design (*France, Recensement* I, pp. 121–4, 132–5, figs. 78–9, pls. 9 and 10). One may also compare the format of architectural canopy and base with the 1532 Tullier window by Jean Lécuyer in the Cathedral of Bourges, particularly in the simple trefoil termination of the lancets (Jean Lafond in *Vitrail français*, p. 237, pl. XXVII; id, "Jean Lécuyer, un grand peintre-verrier de la Renaissance," *Medicine de France*, 123, 1961, pp. 17–23).

The individual figures also show similarities to the figures in the *Judgment of Solomon* window. The Tiburtine

Sibyl's elegant dress and stance recalls that of the false mother (head restored) addressing Solomon. Clothes swirl dramatically around the figures and the richness of costume is a vivid aspect of both windows' appeal. Isaias, one of the best preserved of the Detroit panels, shows an exoticism in costume that parallels that of male figures in the Parisian window, such as the young man in slashed sleeves and tunic in back of the false mother (DIA 35–38/fig. 4). Elaborate hair styles and hats, for both St. Faith and the Sibyl are echoed in the costume of the women in both the lancets and tracery of the *Judgment of Solomon*.

Date: The date of 1525–50 is argued from stylistic affinities between the Detroit panels and the dated works from the Parisian region discussed above.

Bibliography
UNPUBLISHED SOURCES: Greenvale, NY, C. W. Post Center of Long Island University, Special Collections Library, ms. "Catalogue of the Collections of William Randolph Hearst," [International Studio Art Corp., Index compiled 2/18/1939], Stained Glass, 101–4, lot no. 540, art. 1–4.

PUBLISHED SOURCES: *Heilbronner* sale 1924, no. 99, ill.; *Hearst* sale 1941, 329, nos. 540 1–4, (B) ill. p. 139; Raguin in *Checklist* III, pp. 164–5.

DIA 35–38/fig. 4. *Judgment of Solomon*, detail

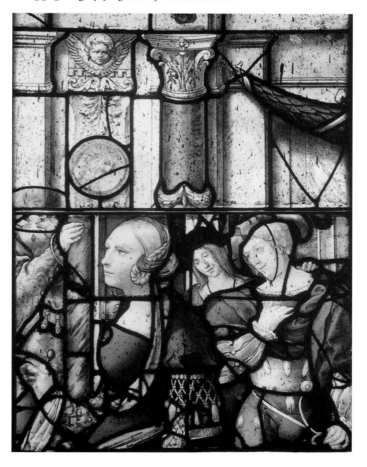

DIA 35. Isaias
Rectangle: 330.2 × 73.7 cm (130 × 29 in)
Accession no. 58.114, funds from a gift of K. T. Keller
Ill. nos. DIA 35, 35–38/figs. 1–4

Inscription: *ISAIS PROA* (Isaias, Prophet)

Condition: The figural area is substantially intact. There are replacements in the lower and uppermost panel and some minor retouching and stopgaps. Given the problematic nature of the examination of the panels, a precise chart may be misleading and is therefore omitted.

Iconography: Isaias was regarded as one of the three great prophets of the Old Testament. He was associated with Christological and Marian themes, as opposed to the more penitential and eschatological themes of Jeremias and Ezechiel. (See for continuing iconographic references, *Herder Lexikon*, 2, cols. 354–5; Réau, 2/1, pp. 365–9; Künstle, 1, pp. 303–12.) Isaias often appears in proximity to images of the Annunciation because of his prophesy "Behold a virgin shall conceive" (Isaias 7:14). The representation of the Tree of Jesse, developed in the mid-twelfth century and continuing throughout the late Middle Ages, took as its source Isaias's prophesy about the lineage of the Messiah, "And there shall come forth a rod out of the root of Jesse" (Isaias 11:1). The prophet was also seen as a prototype for Christ due to both biblical and apocryphal traditions. He was purified when his lips were touched with a burning coal by a seraphim (Isaias 6:5–7) and it was believed that he, like Christ, died at the hands of the wicked, being sawed in half while hiding from his enemies in the cleft of a tree trunk, a tradition current by at least the thirteenth century.

Color: Isaias wears a bright red long-sleeved tunic and an equally intense deep blue cloak. His leggings are deep warm purple, recalling the lighter warm purple of his turban. Inserts of bright red, blue, and green in the vaults set off the predominantly golden tones of the architecture.

Photographic reference: DIA Neg. no. 29194 (1985/09/03)

DIA 36. The Tiburtine Sibyl
Rectangle: 330.2 × 73.7 cm (130 × 29 in)
Accession no. 58.115, funds from a gift of K. T. Keller
Ill. nos. DIA 36, 35–38/figs. 1–4

Inscription: *SA. TIBVRTINA* (Holy Tiburtine)

Condition: There are many replacements but all are well integrated into the general design. Given the problematic nature of the examination of the panels, a precise chart may be misleading and is therefore omitted.

Iconography: The sibyls functioned as symbols of the concordance of pagan and Judaic prophetic traditions. In the

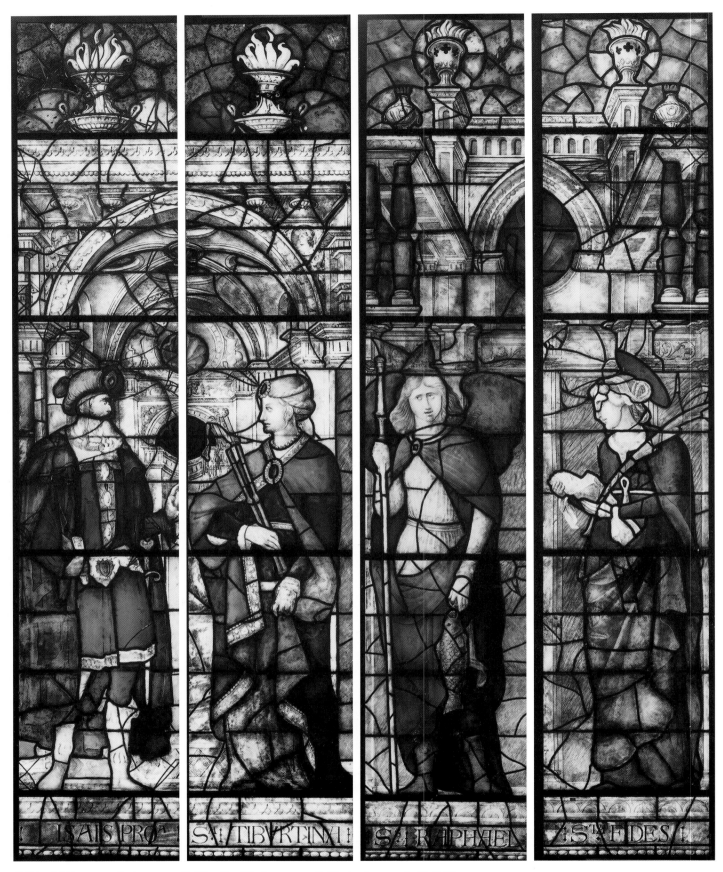

(left to right) DIA 35. *Isaias.* DIA 36. *Tiburtine Sibyl.* DIA 37. *St. Raphael.* DIA 38. *St. Faith*

late Middle Ages, for example, on the exterior of the *Ghent Altarpiece* the prophets are contrasted to the sibyls. The Tiburtine Sibyl gained a particular place of prominence due to her association with her prophesy to the Emperor Augustus of the birth of Christ (*Golden Legend*, pp. 46–51, the Sibyl discussed, p. 49). Augustus did not wish to assume the title of Emperor until he asked the Sibyl if one would come who was greater than he. On the day of Christ's Nativity, the Sibyl showed him a golden ring around the sun in the midst of which was an image of the Virgin holding the Christ Child. A voice proclaimed "This is the altar of heaven" (*Ara Coeli*), and the Sibyl told August that this child would surpass him. This legend is portrayed in the *Altarpiece of Peter* by Rogier van der Weyden (Gemäldegalerie, Staatliche Museen, Berlin, 1452–55: Snyder 1985, fig. 129). In the left wing the Emperor Augustus is shown the vision of the Virgin and Child. The concordance of pagan and Christian traditions is made clear by its juxtaposition with the scene in the right wing showing the Three Magi. They adore a star that has become a vision of the infant Jesus surrounded by a celestial radiance.

Color: The Tiburtine Sibyl wears a tunic of deep cool green over a skirt of bright blue. Her cloak is a bright warm red lined in a warm pink. The trim of her robe is a silver stain yellow, acting as a foil for the deep blue jewel at her throat. In her hair is a ruby and on her feet there are red slippers. A red background silhouettes the finial surmounting the building.

Photographic reference: DIA Neg. no. 29195 (1985/09/03)

DIA 37. St. Raphael

Rectangle: 330.2 × 73.7 cm (130 × 29 in)
Accession no. 58.116, funds from a gift of K. T. Keller
Ill. nos. DIA 37, 35–38/figs. 1–4

Inscription: *SS RAPHAEL* (Most Holy Raphael)

Condition: The replacements appear mainly in the architecture. Given the problematic nature of the examination of the panels, a precise chart may be misleading and is therefore omitted.

Iconography: Raphael is one of God's archangels whose name signifies "God had healed", or the "medicine of God," clearly meanings associated with his actions in the biblical accounts of his appearance. He was honored particularly in the late Middle Ages as patron of physicians, pharmacists, and protector of wayfarers (*Herder Lexikon*, 3, col. 495; Réau, 2/2, pp. 53–5). His most significant association was the biblical story recounted in the Book of Tobias, where Raphael protected against spiritual as well as physical maladies. Tobias was a honorable man who defied the

commands of the state and gave alms, aided the poor, and gave decent burial to the dead. One day, weary with his labors he slept by a wall and the hot dung from swallows fell in his eyes and blinded him. Believing that he was about to die, he summoned his son, also called Tobias, and instructed him to claim a debt from a certain Gabelus in Rages, a city of the Medes. Raphael, "a beautiful young man," presented himself, offering to serve as guide for Tobias. Tobias assumed the angelic guardian to be a man, whom he called Azarias. On their journey Tobias caught a large fish, and Raphael instructed him to preserve the entrails, gall, and flesh. He burned portions of the liver as a means of exorcising the demon that had prevented Gabelus's daughter Sarah from joining any man in wedlock, and then took her as his wife. Upon the young man's return to his father, Raphael instructed Tobias to take the gall of the fish and anoint his father's eyes. The old man's sight was restored and Raphael revealed himself as an angel "one of the seven who stand before the Lord." (Tobias 12:15) Raphael is most typically depicted as a beardless youth holding a walking stick and/or a fish.

Color: Raphael is dressed in a light off-white garment that contrasts sharply with the bright warm red of his cloak. A bright green jewel is set in gold is at his throat. His wings are a cool dull blue, his leggings a deep blue-green and his boots a warm light brown. Touches of deep warm blue appear in the sky between the two deep purple columns and the half-vault of the architecture is the same bright red as his cloak. These intense colors harmonize with the predominantly golden hues of the architecture and the yellow tints of his hair, fish, and staff.

Photographic reference: DIA Neg. no. 29196 (1985/09/03)

DIA 38. St. Faith

Rectangle: 330.2 × 73.7 cm (130 × 29 in)
Accession no. 58.117, funds from a gift of K. T. Keller
Ill. nos. DIA 38, 35–38/figs. 1–4

Inscription: *STA FIDES* (St. Faith)

Condition: There are, as for the previous panel, considerable replacements all well integrated into the design. Retouching is also evident, notably in the head. Given the problematic nature of the examination of the panels, a precise chart may be misleading and is therefore omitted.

Iconography: The cult of St. Faith is a long-standing one in France. She was revered as a virgin martyr meeting her death in the persecutions of 303 (*Herder Lexikon*, 6, cols. 238–40; Künstle, 2, pp. 229–31; Réau, 3/1, pp. 513–6). Tradition believed that she was burned on a grill but finally beheaded. Her cult was greatly augmented with the

translation of her relics to the Abbey Church of Ste. Foi of Conques in 866 or 883. Her cult statue, possessing at its core a golden Roman parade helmet, became a celebrated object of pilgrimage, and enjoyed a long history of veneration and accretions of precious objects to its iconic core of a seated hieratic figure (Ilene H. Forsyth, *The Throne of Wisdom*, Princeton, 1972, pp. 40–1, 67–9, figs. 13–15; Lasko 1972, p. 105, fig. 98). By the eleventh century the statue and the church had become one of the major sites along the pilgrimage roads to St. James of Compostela (Pamela Sheingorn, trans. and ed., *The Book of Sainte Foy*, Philadelphia, 1995). Sainte-Foi was revered as a patron of the imprisoned, an advocacy that became increasingly important as Europe witnessed the Crusades and the frequent issue of captives and hostages. Her efficacy in gaining the release of prisoners is attested to by the *ex votos* of manacles hanging in the church accompanied by the supplicating figure of the saint carved on the tympanum of the facade of Sainte-Foi of Conques (M. F. Hearn, *Romanesque Sculpture*, Ithaca, 1981, p. 180, fig. 136). This historic position encouraged the depiction of St. Faith as a specifically French heroine, thus justifying her representation throughout later French art, for example, in the clerestory window in the south nave of Chartres (Delaporte and Houvet 1926, pp. 417–19, pl. CLXXXVI).

Color: St. Faith is dressed in a long deep warm purple robe the same color as the columns. Her cloak is bright cool blue and she carries a bright green palm. Touches of deep warm red appear in her halo and in the vault of the apse.

Photographic reference: DIA Neg. no. 29197 (1985/09/03)

DIA 39. Welcome Panel of the Scherer Family (Heinrich or Jacob Scherer of Uri?)

Attributed to Anton Schiterberg (fl. *c.* 1520–61)
Switzerland, Lucerne
c. 1530–35
Rectangle: 39.37 cm × 29.21 cm (15½ × 11½ in)
Accession no. 23.5, Gift of George G. Booth
Ill. nos. DIA 39, 39/a, 39/fig. 1

History of the glass: The panel was in the distinguished collection of Lord Sudeley, Toddington Castle, Gloucestershire until the Helbing auction of 1911. Lehmann's catalogue for the sale attributed the panel to Schiterberg, *c.* 1530, and suggested that the donor might be Heinrich Scherer from Uri. George G. Booth, Bloomfield Hills, purchased the panel from the dealer Theodor Fischer, Lucerne, on 18 March 1922 and presented it to the Detroit Institute of Arts in 1923. The panel was part of a lot of twelve sold to Booth, "all positively guaranteed Antique quality more than 150 years old" (Cranbrook Archives, Transcription of

Fischer invoice and record in George G. Booth's 1922 notebook). Booth appears to have given the more artistically sophisticated panels to the museum and installed the rest in his home in Bloomfield Hills, now Cranbrook House. Lehmann published the panel much later (Lehmann 1941, p. 56, fig. 97) calling it Schnyder of Sursee, and incorrectly identified it as in the collection of the Schweizerisches Landesmuseum, Zurich. [Italian Galleries]

Bibliography

UNPUBLISHED SOURCES: Cranbrook Archives, notebook of George G. Booth, entry of 20/3/1922; Sibyll Kummer-Rothenhäusler of Zurich and Barbara Giesicke, letters and verbal communication.

PUBLISHED SOURCES: *Sudeley* sale 1911, p. 64, no. 78, ill.; DIA *Bulletin*, 4/7, 1923, pp. 59–60, Lehmann 1941, p. 56, fig. 97; Hermann H. Hüffer, *Sant'jaco. Entwicklung und Bedeutung des Jacobuskultes in Spanien und dem Römisch-Deutschen Reich*, Munich, 1957, Raguin in *Checklist* III, p. 165.

Condition: There is pitting throughout and numerous cracks. The panel was restored in 1988 by Mary Higgins of New York. A considerable number of mending leads, especially in the figure of the wife, were removed and replaced with edge-bond repairs. Copper foil repairs were

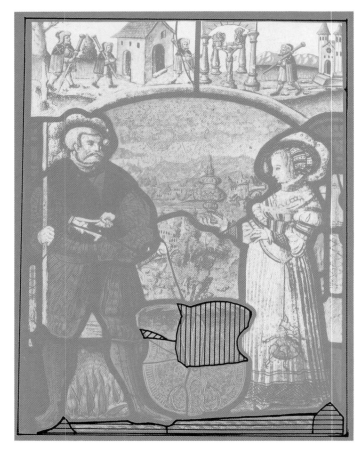

DIA 39/a. Restoration chart

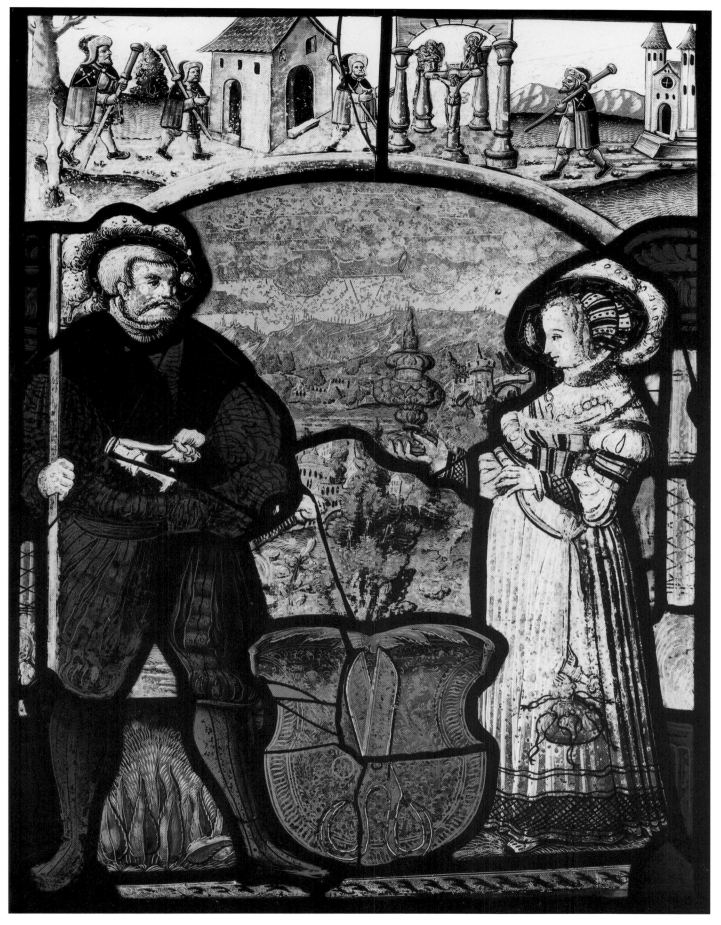

DIA 39. *Welcome Panel of the Scherer Family*

used for most other cracks. The lower border is a replacement. The original state of the panel must have included an inscription panel, now lost, at the bottom.

Iconography: The scene in the upper register shows men engaged in pilgrimages, one of the most time-honored means of entering into a personal religious experience. Traditional in Christian devotion since the Early Christian era, a pilgrimage is a journey undertaken to venerate the remains of saints, called relics, or their special images, housed in various churches (Peter Brown, *The Cult of the Saints in the Early Church*, Princeton, 1985). These images or relics were thought to have been gifted with miraculous powers; they therefore could act as focal points for communication between this world and the next. Although early pilgrimages to Rome or the Holy Land were the first practiced, this site-specific form of homage became popular in Western Europe in the ninth century with the purported discovery of the grave of the Apostle James the Great (*Santiago*) in northwestern Spain (Maryjane Dunn and Linda Kay Davidson, *The Pilgrimage to Santiago de Compostela: A Comprehensive Annotated Bibliography*, New York, 1994; Paula Gerson, Alison Stones, et al., *The Pilgrim's Guide: A Critical Edition*, 2v., London, 1998). By the eleventh and twelfth centuries the worship of relics peaked and popular pilgrimage routes to all major pilgrimage churches throughout France, Italy, and Spain were established.

St. James's veneration extended into the sixteenth century and became of increased importance with the split between Catholic and Protestant Europe. Historically, James was one of the original disciples around Christ. The Gospels record that he witnessed the Transfiguration and was present while Christ kept vigil in Gethsemane. His martyrdom in Jerusalem around the year 42 A.D. was the first among the apostles. The stories of events after his death became far more elaborate. Tradition asserted that the body of the saint was soon moved from Jerusalem to Iria Flavia in northwestern Spain. In the ninth century, during the reconquest of Spain from the Muslims, the relics were discovered and Alfonso el Casto, ruler of León, ordered them transferred to the city of Compostela which became a major pilgrimage site. The presence of St. James in Spain became a rallying point for the progressive incursion of the Christian rulers into Muslim-held territory. Reports of apparitions of James as a mounted soldier aiding the Christian forces against the Moors were recorded as early as the battle of Clavijo in the ninth century. A military order of St. James was instituted by Ferdinand II in 1175. At the battle of Jerez in the thirteenth century he was seen appearing on a white horse with a sword in one hand and a white banner in the other, and followed by a legion of knights dressed in white. To Catholics under attack, such as those in Switzerland of the early sixteenth century, St. James's crusading spirit against the Moors

could be seen as prefiguring a crusade against the religious dissenters of the incipient Protestant movements. In Switzerland, for example, the *Jakobusbrüderschafter* were active since *c.* 1475 in Freibourg, a major point of origin for pilgrimages from Southern Germany, the Tyrol, and central Switzerland (Hüffer 1957, pp. 46–7). See also the illustration of two pilgrims with similar short cloaks, badges, and staffs labeled *Die Jakobs Brüder* by Jost Amman in the *Eygentliche Beschreibung aller Stande auff Erden*, Frankfurt-am-Main, 1568, repr. Hanau, 1966, B2.

The panel shows an image of the *Virgén del Pilar*, the statue that commemorated the apparition of the Virgin, seated on a column of jasper, to St. James and his followers at Saragossa (*El pilar es la columna: historia de una devocion*, [exh. cat., La Lonja], Saragossa, 1995). This image of the Virgin only began to be copied in the sixteenth century (*Herder Lexikon*, 7, col. 36; woodcut c. 1500 in Jose Camon Aznar, "Un grabado de la Virgén del Pilar," *Boletín del Museo e Instituto "Camón Aznar"*, 48–9, 1992, p. 5), so that the Detroit panel represents an unusually early example of the cult object. In 1629, Nicolas Poussin painted an image of St. James experiencing the vision (Louvre, Paris; Anthony Blunt, *The Paintings of Nicolas Poussin : A Critical Catalogue*, London, 1966, p. 71, no. 102).

On the left a group of pilgrims, distinguished by their characteristic broad brimmed hats, images of crossed staffs on the shoulder of their cloaks, and their staffs, are leaving a small church. On the right a man is departing from a large basilica with towers. He has acquired the pilgrim's badge of the scallop shell on his hat, the mark of the pilgrimage to Santiago da Compostela (Hüffer 1957).

The scissors in the shield presumably relates to the name and or the profession of the husband, the family name Scherer, or having the profession of a tailor or cloth merchant.

Color: The bright red of the husband's garments and the shield dominate the tonality of the panel. The landscape is a bright warm blue highlighted by warm green tones achieved via application of silver stain. The wife is dressed in white hemmed with bright yellow at the hem, cuffs, and bodice. The capitals and bases of the columns are a deep warm purple. Extensive use of silver stain for ground and architecture achieves a predominantly light yellow tone for the upper sections.

Technique: The panel contains uncolored and pot-metal purple with red and blue flashed and abraded glass. The blue as well as the uncolored glass is treated with silver stain. The vitreous paint is applied with great subtlety, exhibited by mats of different densities and constantly varied stickwork.

Style: The glass has been associated with Anton Schiterberg since Lehmann's attribution in the Sudeley catalogue. Schiterberg, active *c.* 1520–61, is best profiled by

DIA 39/fig. 1. ANTON SCHITERBERG: *Arms of Jakob Troger*, c. 1530. Zurich, Schweizerisches Landesmuseum

Lehmann (1941, pp. 56–125) in his analysis of glass painters in Lucerne. See also another panel once in the Sudeley collection, showing the arms of Jakob Troger (DIA 39/fig. 1), c. 1530, now in the Schweizerisches Landesmuseum, Zurich. (Lehmann 1941, p. 70, fig. 96; Schneider 1970, p. 77, LM 12103, no. 193, without mention of attribution to Schiterberg in the text or the catalogue of glass painters). The simple description of the columns, especially the inscribed diamond pattern, is similar. The upper panel is set into the same broad curve with thick, unadorned molding at the lower edge.

Conventions of dress are additional links. The female supporter shows the same general style of head-dress and striped fabric as that of the cap and bodice and sleeve of the wife. Most convincing, however, appears to be the similar modeling conventions and the parallel quality of the glass itself. The dress of the female supporter and of the husband display the same subtle treatment of overlapping folds, especially the outline of edges with stickwork. The variety of marks, differing in tile floor, damask background, feathers, or grass, and stockier proportions of figures in both upper scenes point to similar workshop habits. In addition, the glass shows similar patterns of wear, a general corrosion of the red or blue background,

and blotchy patterns of paint loss. Compare, for example, the patination on the torso of the female supporter and the head of Scherer.

Additional comparisons can be made with panels associated with Schiterberg. Closest, perhaps, may be the heraldic panel of the canton of Uri, of about 1532 from Schloss Oberhofen on Thunersee, present location unknown (Lehmann 1941, pp. 63, 73, fig. 84; Hans Dürst, *Vitraux anciens en Suisse*, Zurich, 1971, fig. 53). The upper register showing William Tell shooting the apple from his son's head displays much the same short, squat figures and solid, three-dimensional draftsmanship as that evident in the pilgrims to Compostela in the Detroit glass. The stance of the husband, especially the rather squat head and closely cropped hair and beard are similar to those in a panel showing the shield of Batt Käch, dated 1554 in the collection of Lord Sidney, Hampstead, London. (Lehmann 1941, pp. 86, 90, fig. 121).

Date: The date of *c.* 1530–35 is established by the quality of the draftsmanship and the simplicity of the design. Only pot-metal and silver stain are used. Enamel painting, popular after 1550, does not appear. The feathery detailing at the top of the shield, however, is more of a Renaissance than a Gothic characteristic, placing this work in a transitional phase of Swiss glass painting.

Photographic reference: DIA Neg. no. 31855 (1988/11/30); Pre-Restoration: DIA Neg. no. 29200 (1985/09/05)

DIA 40. St. Benedict
Master of the St. Alexis Roundels
Germany, Cologne
1530–40
Circle: diameter 22.8 cm (9 in); with border: 32.3 cm (12$\frac{11}{16}$ in)
Accession no. 40.126, Gift of Lillian Henckel Haass and Mrs. Trent McNath

Ill. nos. DIA 40, 40/fig. 1

History of the glass: The roundel is listed in later inventories as having been in the possession of the Earl of Essex, Cassiobury Park, in Hertfordshire. The dealer Grosvenor Thomas of London seems to have acquired the piece early in the twentieth century. After his death in 1923, it apparently became a part of the inventory of his son Roy Grosvenor Thomas, who had established a dealership in New York, and who sold the panel that same year to Julius Haass of Grosse Pointe, Michigan. From there it passed to the possession of Lillian Henckel Haass and Mrs. Trent McNath, Detroit. Lillian Henckel Haass and Mrs. Trent McNath donated the panel to the Detroit Institute of Arts in 1940. [German/Flemish Galleries]

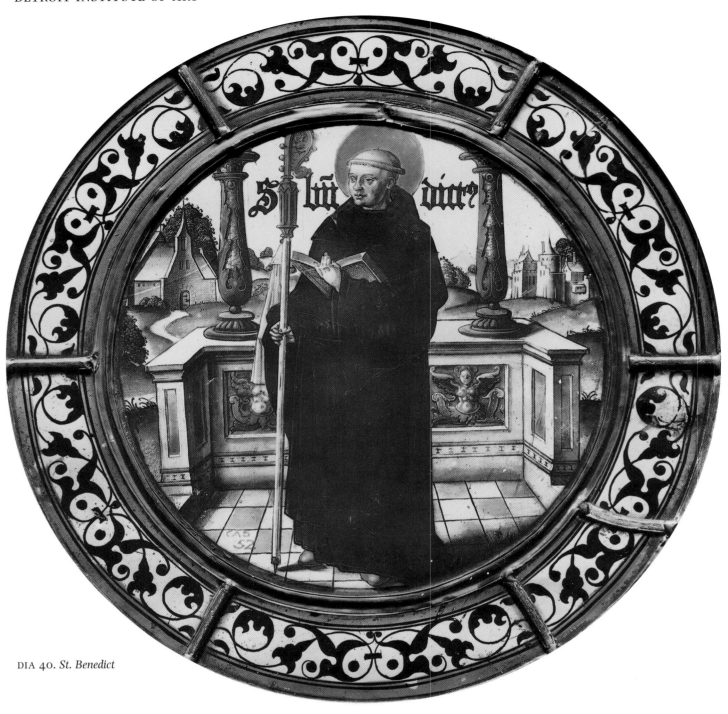

DIA 40. *St. Benedict*

Bibliography

UNPUBLISHED SOURCES: Grosvenor Thomas Stock Book I, 120, item no. C-52; Myra Orth, Boston, communication to the author.

PUBLISHED SOURCES: Husband in *Checklist* IV, pp. 111, 114.

Inscription: *S bñdict'* (St. Benedict)

Condition: The panel is in very fine condition despite minor surface abrasion and a few surface scratches. The upper three sections of border are replacements, obviously produced by a very skillful glass painter using the lower portions as a model.

Composition: Benedict stands within a Renaissance loggia, with a tile floor, elaborately-carved columns, and relief panels with harpies. In the background, across a well-tended countryside, a walled city appears on the right and a church to the left. The path leading to the church from the proximity of the loggia very probably suggests the monastery's location outside of heavily populated areas. A similar composition can be seen in the roundel of *St. Egidius and a Donor* (c. 1520, Leuven, Stedelijk Museum Vander Kelen-Mertens, Husband 1995, p. 185, fig. 2). St. Egidius is framed by two Renaissance columns of the same general proportion to the figure of the saint. Closer, however

is the splendid panel produced in Augsburg after designs by Hans Burgkmair the Elder, *Allegory of Charity*, dated *c.* 1510–20 (Staatsgalerie im Hohen Schloss Füssen, Füssen: Butts and Hendrix, *Painting on Light*, no. 77, p. 201). The figure of Charity, holding a child with another at her feet, extends the entire height of the panel, similar to the position of St. Benedict. The columns of the portico, however, terminate in a coffered vault just visible as a frame for her head. In both roundels, the broad shelf of the portico creates a clear definition of architectural volume. As described by Butts and Hendrix "a classical, harmonic sense of three-dimensional space permeates and unites the composition." Surrounding the Detroit roundel is a wide border of mauresque design. Such a flat, abstracted system of floral pattern is not dissimilar from the red border that surrounds the Augsburg roundel. It is clear that progressive artists across a wide geographic area of Northern Europe were adapting well-articulated Renaissance concepts of space to the highest quality of roundel production.

Ornament: The decorative border of mauresques is similar to those popularized by Francesco di Pellegrino in *La Fleur de la science de pourtraicture: Patrons de broderie, façon arabicque et ytalique*, Paris, 1530 (facsimile ed., intro. Gaston Migeon, Paris, 1908. pl. XLVIII; Alain Gruber, assisted by Bruno Pons, *L'Art décoratif en Europe*, Paris, 1, 1993, pp. 62, 70, 91, 92, esp. 275–345, "Mauresques," by Marc-Henri Jordan and Francisca Costantini-Lachat). The banding (DIA 40/fig. 1) published by Pellegrino shows the

DIA 40/fig. 1. FRANCESCO DI PELLEGRINO: Mauresque design, from *La Fleur de la science de pourtraicture*, Paris, 1530

same type of floral motifs. By such intertwining of swell of leaf and stem, a flat, animated pattern provides an open but elegant border closure.

Color: Despite the complexity of tones of paints and silverstain yellows, controlled by the dark figure of Benedict, the roundel is of a subdued neutral tonality.

Technique: The panel is composed of smooth, uneven uncolored glass with ridged whorls and several large elliptical bubbles. The painter has used three hues of silver stain and four shades of vitreous paint. Back-painting enhances the depth and richness of the image.

Iconography: St. Benedict, widely revered as the founder of western monasticism (*Herder Lexikon*, 5, cols. 352–64; Réau, 3/1, pp. 196–203), is also represented in DIA 28 and CMA 20. Born about 480 in Nursia (Umbria) in central Italy, Benedict presumably studied in Rome, but while still a young man took up the life of a hermit. He lived this singular existence for several years near Subiaco. In the early years of the Christian era, the dominant form of monastic life was of the hermetic form. Individuals, male or female, took on themselves the heroic task of withdrawing into desert areas, islands, or mountains. The desert fathers, perhaps best known in the model of St. Anthony, defined this mode of Christian spirituality. Benedict, however, began to attract a number of followers for whom he designed a community structure. He founded this new type of monastery at Monte Cassino (between Rome and Naples) and drew up a rule that has stood as the foundation for virtually all subsequent monastic communities in western Europe. The rule is remarkably concise, extending to about 40 pages (*St. Benedict's Rule for Monasteries*, trans. Leonard J. Doyle, Collegeville, MN, 1948). Benedict is the focus of multiple legends about his heroic virtues and miracles performed both during his life and in response to petitioners after his death. This image, however, presents the saint simply as a leader of a religious community. He is shown with the abbot's crosier of authority in one hand and an open book in the other, and presented as an ageless, clean-shaven man with monastic tonsure, dressed in the black habit of the original Order of Benedictines.

The decade of 1520–30 in the Rhineland was a defining moment. The solidification of the traditional modes of spirituality against the Lutheran Reformers was, if not quite yet a matter of blood and politics, still very much a pervasive issue. This roundel, like other monastic programs, presents the corporate structure and power of the tradition. Benedict is depicted not so much as a miracle worker or great penitent, but as the able governor of secular matters. In the cycle of St. Bernard's life installed between 1510 and 1530 at the Cistercian monastery of Altenberg, a short distance from Cologne, for example, the majority of the scenes showed St. Bernard's worldly influence. Of the 68 extant scenes from the cloister series, only eighteen

relate to the monastic life, most of these as part of Bernard's early career just after his entrance into Cîteaux and his founding of Clairvaux (Arno Paffrath, *Bernhard von Clairvaux. Leben und Wirken – dargestellt in den Bilderzyklen von Altenberg bis Zwettl*, Cologne, 1984). Detroit's roundel of St. Benedict appears to be part of a monastic statement by members of the Orders themselves about their importance to the body politic.

Style: The Master of the St. Alexis roundels takes his name from a series of roundels on the life of St. Alexis that Schmitz (1913, pp. 77–80, pls. 20–3; figs. 76–97) localized at Cologne around 1515. One of the panels (fig. 78) from the St. Alexis story shows the saint being brought into a school where the teacher is seated in a centrally placed chair in a manner that evokes the spatial sophistication of Detroit's St. Benedict. The roundel is beautifully executed. Meticulously applied tonal washes structure the three dimensionality of the scene. The architecture is rendered in strokes that bespeak an artist of considerable confidence and sophistication. Although executed with great detail, the roundel still maintains a freshness of application that avoids any hint of mechanical rigidity. Despite the difficulties of handing so symmetrical a composition, the artist varies the two background architectural images. One is set closer through its larger scale and winding path that connect foreground and background, contrasted to the more powerful but more remote city. Most telling, however, is the artist's manipulation of shade through the cast shadow of the saint and of the interior of the porch on the left to create a dialogue of spatial directions within the scene.

A comparison can be developed with a similar, if earlier, head of a monk, probably Bernard or Benedict, very likely from the Cistercian monastery of St. Apern in Cologne (DIA 23–27/fig. 6: Schnütgen Museum, Cologne, Lymant 1982, p. 213, no. 136). Both heads show the characteristic rounded proportions of the head, fleshy cheeks, and small rounded chin pushing forward out of the rounded planes of the cheek of this region. Extremely similar are the tightly molded lips framed by an undulating line dividing the upper and lower lips and the shadowed areas under the lower lip that emphasize its fullness. The soft, fleshy termination of the nose is similar in both monastic portraits. The large-scale head in the Schnütgen Museum is modeled with a stipple technique. The roundel image, developed within a much small scale, uses tonal washes to define the three-dimensional form.

Date: The emphasis on fully developed Renaissance style in the architecture and the accomplished depiction of modeling in the round, as well as the mauresque pattern would suggest a date of 1530–40.

Photographic reference: DIA 5523

DIA 41. Martyrdom of St. Eustache

Follower of Engrand le Prince
France, Rouen, Church of St. Patrice (central window of north transept)
1543
A: 214 × 87 cm (8 1/4 × 34 1/4 in)
B: 213 × 86.4 cm (83 7/8 × 34 in)
C: 212.7 × 87 cm (83 3/4 × 34 1/4 in)
Accession no. 58.113, funds from a gift of K. T. Keller
Ill. nos. DIA 41, 41/a, 41/figs 1–5; Col. pl. 14

History of the glass: The window was once the lower register of the triple-light window in the center of the north transept, now called the Chapel of the Virgin in St. Patrice. The Detroit window must have been removed from St. Patrice for repairs early in the twentieth century. The history of the nineteenth-century restorations has been noted for many of the windows, but precise indication of the date of the restoration of the legend of St. Eustache has not been forthcoming. The need for restoration of the window, however, was cited specifically in a letter of 1839 by Deville, Inspector for the Historical Monuments Commission: *Peut-être pourrier vous exiger de la fabrique de St. Patrice qu'elle fit en même temps à ses frais les restaurations nécessaires, specialement aux deux magnifiques verrières, connues sous le nom de "l'annonciation" et "du martyre de St. Eustache. The window of St. Eustache cède en rien à celle de l'annonciation, si même elle on lui est supérieure, c'est une des plus belles vitres que possède la ville de Rouen.* (Perhaps you could insist that the management of the church undertake at the same time, at its own expense, the necessary restoration, especially for the two magnificent windows,

DIA 41/a. Restoration chart

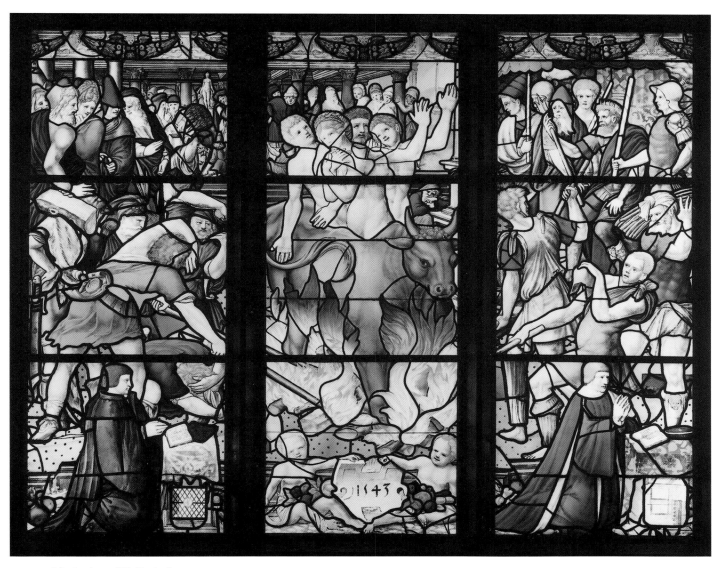

DIA 41. *Martyrdom of St. Eustache*

known by the title of Annunciation and Martyrdom of St. Eustache. [The window of St. Eustache] does not take second place to the Annunciation, in fact it is superior, and is one of the most beautiful windows in the city of Rouen.) Deville continues with additional praise and refers to the opinion of Langlois (Paris, Archives des Monuments Historiques, Dossier 1403; report of 20 November 1839).

Restoration campaigns are noted in the archives for windows at St. Patrice throughout the nineteenth century (ibid., various documents: 1843 the *Birth of Christ* and the *Adoration of the Magi* repaired by You and Renaud; in 1854 *The Story of Job* restored by You; in 1899 restoration of the three windows of the chevet; in 1920 the reinstallation of windows in the north nave aisle taken out in 1918). From the variety of repairs in the window, some of very high quality, such as the head of one of the putti, and others of mediocre execution, such as the lower leg of the soldier on the right, a variety of hands worked on the window at number of stages. Prosper Merimée, in the 1830s

Inspector General of the Historical Monuments Commission, commented perceptively on the ability of modern glass painters to repair these Renaissance windows: *On sait que les vitraux de cette époque sont beaucoup plus faciles à réparer que ceux des XIIIe et XIVe siècles parceque les procédés de fabrication se rapprochent beaucoup du systèmes actuellement en usage.* (One knows that windows of this era are much easier to repair that those of the thirteenth and fourteenth centuries since the methods of production so closely approximate those in use today: Paris, Archives des Monuments Historiques, Dossier 1403; letter of 7 November, 1839). Obviously, at this time, repair involved the fabrication of new elements, even entire scenes, to complete missing or damaged sections. The windows were also taken out at the beginning of World War II and reinstalled in 1948 (Jean Lafond, "Vitraux de Rouen, à propos de la 'repose' de Saint-Patrice," *Revue française d'élite*, 2/8, Paris, 25 May 1948, pp. 41–5).

It is evident from inspection of the copy now installed in

the church that the glass painters produced it after the present restorations in the Detroit window had been accomplished. The insertion of the man carrying the wood in the panel to the left and the damaged figures of the putti at either side of the inscription panels (DIA 41/fig. 2), among others, are all reproduced. It is certain that the studio was working with the Detroit panels and was able to make exact tracings over a light board. A close inspection of the

DIA 41/fig. 1. *Martyrdom of St. Eustache* (full window, lower panel – a replica). Rouen, Church of St. Patrice

heads of Eustache, his wife, and his sons (DIA 41/fig. 3) shows a careful, uniform application of paint, with no true effects of deterioration over time. Only modern glass was used and no attempt was made to produce a false patina of age on either the interior or exterior surface. The copy was reinstalled and the original passed into the art market at an undetermined time. This is not an unusual practice. It is documented that restorers replaced a great deal of original glass at Saint-Julien-du-Sault (Yonne) with copies, or mingled copies and original fragments so that one panel became two (Raguin 1982, pp. 67–8). The dismemberment of European glazing programs, especially those of the Rhineland and Normandy, was common in the eighteenth and nineteenth centuries, especially after the campaigns of secularization accompanying the reforms of Napoleon (Lafond 1960, esp. pp. 5–8). Nothing is known of the window's subsequent history until it appeared in the collection of William Randolph Hearst, Los Angeles. At least one other case of local forgery is documented through study of the Hearst collection. Two panels of stained glass had been removed and replaced with copies in the Norman Abbey of Fécamp (Lafond in *Vitrail français*, p. 180). After being informed of the situation, Hearst returned the original panels, sold through the Demotte dealership, to France. Hearst's collection was put up for auction in 1941, but the Rouen panel was unsold. These panels were purchased with the support of K. T. Keller by the Detroit Institute of Arts from the Hearst Foundation in 1958. [Gallery 5351]

Related material: DIA 41/fig. 1, window in the Church of St. Patrice, Rouen (Perrot 1972, p. 39, fig. 23), lower register replica of DIA 41; DIA 41/figs. 2–3, details of replica

History of the building: The church was built in 1535 on the site of much smaller church constructed in the thirteenth century. Additional stained glass from before the construction of the new edifice was preserved and reset into present structure. (Jean Lafond, "Les plus anciens vitraux de Saint-Patrice de Rouen," *Revue des Sociétés Savantes de Haute Normandie*, 8, 1957, pp. 5–17).

Reconstruction: The Detroit window is comprised of the three large panels (A, B, C) that filled the lower register of the triplelight window (DIA 41/fig. 1). The upper portion of the window contains the vision of St. Eustache of the miraculous stag with the cross between its antlers. The tracery lights contain the narrative of St. Eustache watching his sons carried off by a wolf and a lion.

Iconographic program: Eustache was a popular saint throughout the Middle Ages and Renaissance. Protector against fire, in this life and in the next, as one of the fourteen Auxiliary Saints, he was also a figure honored by hunters (*Herder Lexikon*, 6, cols. 194–9; Réau, 3/1, pp. 468–71; Kunstle, 2, pp. 220–2; *Golden Legend*, pp. 555–61; A. Paffrath, *Die Legende des heiligen Hubertus*, Hamburg,

DIA 41/fig. 2. Replica putti, *Martyrdom of St. Eustache*, Rouen

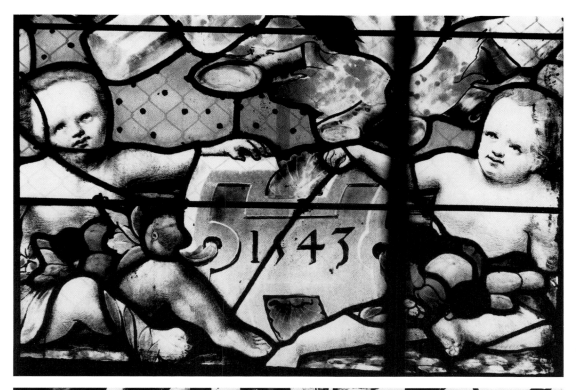

DIA 41/fig. 3. Replica heads of St. Eustache and family, *Martyrdom of St. Eustache*, Rouen

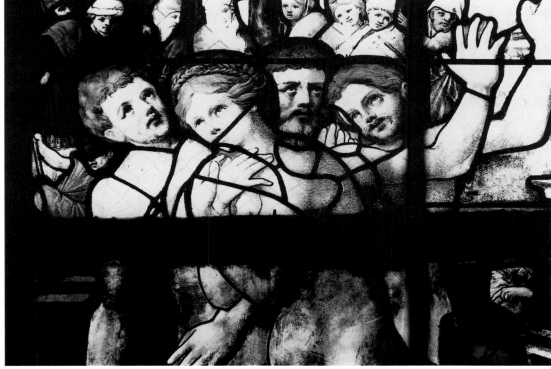

1961). The legend identifies Placidus as a general under the Roman emperor Trajan. While hunting one day, he was given the vision of Christ crucified between the antlers of a stag and converted to Christianity. He, his wife, and their two sons were baptized and Placidus took the name of Eustache. His faith, however, was sorely tested. Pestilence decimated his estates forcing him to flee to Egypt with his family. His wife became the property of the ship's captain and his sons stolen by wild beasts. After many years he was reunited with his wife, who had escaped the ship's captain, and his sons, who had been raised by shepherds. Upon his return to Rome, Eustache was welcomed by the new emperor Hadrian with great honor. When Eustache refused to sacrifice to the Roman gods, however, Hadrian ordered the family to be sealed in a bronze bull and burned. Eustache and his family expired, but on the third day the bodies were found to be intact and given honorable burial by fellow Christians.

The full window in St. Patrice shows three key episodes from the legend: in the upper register Eustache's conversion through the vision of the stag carrying the image of the crucified Christ between his antlers; in the tracery Eustache stands in the middle of the stream while a wolf and a lion carry off his two sons; and in the first register, the family undergoes martyrdom. The iconography is traditional, common to the story since the thirteenth-century representations in the windows of Chartres, Sens, and Auxerre (Lucien Bégule, *La Cathédrale de Sens*, Lyon, 1929, pp. 48–9, fig. 56, pl. XVI; Delaporte and Houvet 1926, pp. 398–404, pls. CLXVII-CLXXIV, col. pls. XVII-XVIII; Raguin 1982, pp. 47–52, 142–3, figs. 38–40). The selection of only three major episodes of the life, each played out across a full register, as well as the models for the compositions, however, are completely Renaissance in concept.

The churches of Rouen contained at least one other window of this subject. A chapel in the south transept of the cathedral bore the name of the Chapel of St. Eustache and in 1511 Jean Barbe, a local glazier, attested to having made a great amount of glass for the chapel, although he did not mention the subject. (Ritter 1926, p. 18, n. 7; Archives du Département du Seine-Inférieure, G 2524. Compte de la fabrique de la Saint-Michel). It is probable that the remnants of a window of St. Eustache now installed in the lower register of the window of the life of St. Romain date from this 1511 glazing program. The window was restored in 1911 from the glass kept in storage (Ritter 1926, p. 18, pls. XCV-XCVI). Réau (3/1, p. 471) states that the sculpture of the cathedral's Portail de la Calende shows Eustache between the lion and the wolf each with a son in its jaws. This subject is not mentioned by Louise Lefrançois-Pillion (*Les Portails latéraux de la cathédrale de Rouen*, Paris, 1907).

Bibliography

UNPUBLISHED SOURCES: Research and authentication – David O'Connor, University of Manchester, England; Chantal Bouchon, Corpus Vitrearum, France.

PUBLISHED SOURCES: E. Hyacinthe Langlois, *Essai historique et descriptif sur la peinture sur verre, ancienne et moderne . . .*, Rouen, 1832, pp. 64–5; P. Baudry, *L'Eglise paroissiale de Saint-Patrice: Description des vitraux*, Rouen, 1850, pp. 4, 22–3; Baron François de Guilhermy, Paris, BN, MS nouv. acq. fr. 6107, f. 206, dated 1842 and 1864; Künstle, 2, p. 221; *Hearst sale* 1941, p. 329, nos. 159–75,–76,–77, ill. 141; (Chanoine) Reneault, *La Paroisse Saint Patrice de Rouen*, Fécamp, 1941, p. 351; Barnet 1986, p. 41; Raguin in *Checklist* III, p. 166, col. pl. p. 6; Anne Granboulan, review of *Checklist* III, *Bulletin monumental*, 149, 1991, p. 336; Marie-Dominique Gauthier-Walter, review of *Checklist* III, *Cahiers de civilization médiéval*, 37 1 & 2 [nos. 145/156] 1994, p. 132; *DIA Guide*, p. 163, col. pl.

Inscription: 1543

Condition: Most of the restorations are skillfully accomplished and the panels thus exhibit a great sense of stylistic and iconographic unity. Even the stopgap segments comprising the figure of the man carrying the bundle of faggots on the left, blend into the overall effect of the panel. In such large Renaissance windows one is confronted with the new definition of a workshop containing a number of glass painters executing designs often provided by an out-of-house designer. In addition, as observed by Merimée, discussed above, the painting style of the nineteenth century was unusually close to that of the sixteenth. Thus the scholar is forced to evaluate whether a segment's variation is the product of the then standard variation of style within a workshop or the product of a highly sensitive restorer. Effaced paint, especially in these large formats, can radically alter our perception of a panel. In addition we are now realizing that repainting of partially effaced elements by later restorers was a prevalent practice. For example, the two putti holding the shield show little variation in the exterior surface of the glass, yet the figure on the right is much more defined. His hair shows more of the sanguine color, darker accents at mouth and eyes, and greater modelling definition. Is this case, the author has accepted this distinction as one resulting from a difference in firing, not as a later restoration or retouching. A case of overt overpaint, however, appears in the figure with the staff and conical cap close to the seated emperor. A clear example of a restoration, with its clumsy approximation of drapery folds, appears in the trousered leg of the man seen from the back in the panel on the right.

Color: The color harmonies balance between intense hues against a wide range of yellows, some of which even achieve a deep orange-yellow, and uncolored glass modified by trace paint and sanguine. The tonalities are warm: brownish green, reddish brown, deep warm purple, and bright red predominate. The adroit positioning of the scattered reds, especially, leads the eye through the composition of the two side panels. The intense reds of the tips of the flames against the deep orange-yellow of the bull then act as a frame for the key image of the central panel, St. Eustache and his family lifting their arms in praise of the Lord at the very moment of their martyrdom.

Technique: The panel is composed of a balance among intense pot-metal segments and expanses of uncolored glass modified with vitreous paint and silver stain. The flesh areas are further modified with sanguine, especially in the face. The glass is quite hard and flat, often showing highly interesting streaky colors, particularly in the flames around the bull. The paint is most commonly applied with a soft mat and stippling technique, especially for the delineation of the flesh and hair.

Iconography/Donor: The window is reputed to have been given by the *Premier Président au Parlement*, either François de Marsillac or Pierre Rémon in 1543, when they changed office. Originally the donor could have been identified by the armorials, destroyed in the French Revolution and now showing as stopgap replacements (Perrot 1972, 39).

Style: Comments on the quality of the window have been many and universally laudatory. See with particular confidence, Jean Lafond (*Vitrail français*, p. 216). He cites, by the same artist, the *Annunciation* and *Triumph of Christ and the Virgin* as *les plus beaux vitraux de l'église* (the most beautiful windows of the church). Commentators in the nineteenth century, in particular, shared a belief that, if not the most important period of painting on glass, the Renaissance was, at the very least, the rival of the first great moment of the art of glass painting during the early Gothic era. One of the first writers on Rouen's churches, Hyacinthe Langlois, compared the work's style to the very best of the Italian Renaissance, seeing in the composition of the martyrdom *le mâle energie de Michel-Ange et de Jules Roman* (the virile energy of Michelangelo and Julius Romano: Langlois 1832, pp. 64–5), a quote often cited in later literature. He also noted the reliance of the window's designer on Dürer's print of St. Hubert for the scene of conversion in the upper register, an observation supported by subsequent writers (Lafond in *Vitrail français*, p. 216; Perrot 1972, p. 39). Guilhermy, after observing massive amounts of France's glass during his site visits and atelier excursions, noted that the St. Eustache window was *une très belle verrière* (very beautiful stained glass window) and carefully described both registers and tracery glass. P. Baudry's monograph on the Church of St. Patrice saw the window as the *principale gloire* of the church *à la plus éclatante période de la peinture sur verre en France*, (the chief glory [of the church] during the most brilliant period of glass painting in France: Baudry 1850, p. 4), an opinion previously put forth by Langlois (1832, p. 57).

Rouen, beginning around 1500, underwent a particularly distinguished period of church construction, reconstruction, and embellishment. The great era of Renaissance glass was ushered in by Arnoult de Nimègue of Tournai and slightly later Engrand and Jean Le Prince of Beauvais. One of Arnoult de Nimègue's most distinguished works appears in the Rouen Church of St. Goddard, with its magnificent *Tree of Jesse* dated about 1506 (Jean Lafond in *Vitrail français*, pp. 215–17, fig. 163). The Le Prince family completed windows in Beauvais, notably the *Tree of Jesse* (DIA 41/fig. 4), in the Church of St. Etienne, about 1522, the window of the Virgin of Pity in the cathedral, the *Legend of Saints Crépin and Crépinien*, Church of St. Gervais, Gisors (DIA 41/fig. 5), about 1531, and other commissions in the region (ibid., pp. 220–34, figs. 174, 180, 181, and col. pl. XXIV). At Rouen, the Le Prince collaboration has long been recognized in the *Triumph of the Virgin, Life of John the Baptist*, and the *Corporal Works of Mercy*, made for the Church of St. Vincent about 1525, now in the Musée du Vieux Marché. The construction St. Vincent extended from 1514 to 1529 (Françoise Perrot, "Les vitraux de l'ancienne église de Saint-Vincent," in *Le Vieux Marché de Rouen: Les Amis des monuments rouennais: Bulletin*, numero special, 1978/9, pp. 49–98, esp. 52–3, 68–70, 75–9). Lafond saw a merging of the Lowlands tradition of draftsmanship introduced by Arnoult de Nimègue with the compositions and palette of the French tradition represented by the family of Le Prince (*Vitrail français*, p. 216).

A comparison with the Beauvais *Tree of Jesse* (DIA 41/fig. 4) and the Gisors *Flagellation of Saints Crépin and Crépinien* (DIA 41/fig. 5) demonstrates the stylistic precedents for the Detroit window. One observes a delight in extreme torsion of the human form, especially in the muscular figures of the guards. The compression of the Renaissance architectural elements serve as an effective backdrop for a densely packed composition. The Le Prince and Detroit heads reveal similar schematization of the form. The faces are rounded and the hair forms a tight

DIA 41/fig. 4. LE PRINCE FAMILY: *Tree of Jesse, c.* 1522, Beauvais, Church of St. Etienne

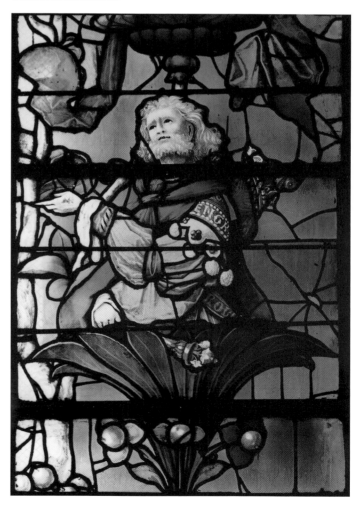

cap about the head. The features are modeled by soft transitions of mat complemented by linear accents at points of transition, the mouth line, tip of the noses, or the upper eye lid. A brilliant contrast of color, especially the intense

DIA 41/fig. 5. NICHOLAS LE PRINCE: *Flagellation of Saints Crépin and Crépinien, c.* 1530. Gisors, Church of St. Gervais

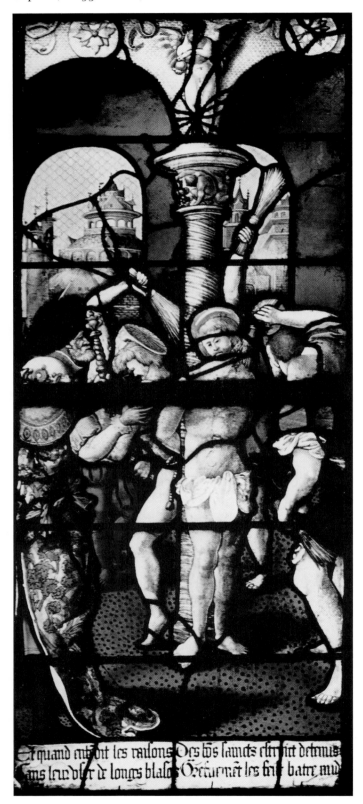

Ct quanb cuf ont les raifons Ocs tős lauxts cltr fit ortmus
ms ine bl r x longrs blafo Oxctarnft les fnf batrr mu

blues and reddish purples continue the Le Prince tradition. The approach is a highly painterly one, with isolated touches of color, mass, and line coalescing into an undulating surface interplay.

Date: The date of 1543 is established by the inscription.

Photographic reference: DIA Neg. no. 29264 (1985/10/14)

DIA 42. Huntsmen and a Dice Thrower
After Dirick Pietersz. Crabeth?
North Lowlands, Gouda?
1549–60
Square: 23.4 cm × 21.3 cm ($9\frac{3}{16}$ × $8\frac{3}{4}$ in)
Accession no. 36.99, Founders Society Purchase, Octavia W. Bates Fund

Ill. nos. DIA 42, 42/fig. 1

History of the glass: The panel was recorded in the inventory of Grosvenor Thomas, London. It passed to Roy Grosvenor Thomas, Grosvenor Thomas' son and his partnership of Thomas and Drake, New York. In 1936 the panel was acquired for the Detroit Institute of Arts as a Founders Society Purchase, through the Octavia W. Bates Fund. [German/Flemish Galleries]

Bibliography

UNPUBLISHED SOURCES: Grosvenor Thomas Stock Book II, 72, item no. 1999; Myra Orth, correspondence with the author.

PUBLISHED SOURCES: Sophie Schneebalg-Perelman, *Les Chasses de Maximilien: les enigmes d'un chef-d'oeuvre de la tapisserie*, Brussels, 1982; Husband in *Checklist* IV, p. 112.

Condition: Six breaks have been repaired with mending leads; one remains unleaded. Lost glass in the upper left and right corners has been replaced with modern infills. The lost segments do not appear to have carried any significant figural elements.

Color: The use of sanguine, coupled with several hues of vitreous paint and silver stain create an overall reddish tonality to the warm neutrals of the traditional roundel.

Technique: The panel is composed of heavy, uneven uncolored glass with numerous small bubbles, impurities, whorls, and straw marks. The painting is accomplished with two hues of silver stain, sanguine, and three shades of vitreous paint.

Iconography: Hunting was one of the most important activities of the nobility throughout the Middle Ages and the Renaissance. One of the most impressive depictions of this time is the series of twelve tapestries showing the

Hunts of the Emperor Maximilian, commissioned by Charles V and finished at the latest by 1552 (Louvre, Paris: Schneebalg-Perelman 1982; Roger d'Hulst, *Flemish Tapestries from the Fifteenth to the Eighteenth Century*, New York, 1967, pp. 171–82; Heinrich Göbel, *Tapestries of the Lowlands*, New York, 1924, rep. 1974, figs. 70–1). The final scene reflects a fourteenth-century hunting treatise *Le Livre du roy Modus et de la royne Racio* (Brussels, Royal Library, BR 10–218–219). King Modus and Queen Racio are depicted as representing Good Judgment, and sit enthroned; under their feet the vices of Laziness and Gluttony lie vanquished by the virtues of the hunt. The series is a reflection of the glamour of hunting parties at the court of Brussels.

Costume: The hunters in the roundel show a style of dress worn about 1550, especially the tight mid-thigh or knee-length leggings with slashes. Sleeves also show these gathers and slashes at the shoulder. Collars are decorated with a narrow ruff, and hats have long brims to shade the eyes and are decorated by a braided chord or other narrow decorative band. The kneeling dice thrower shows perforated designs in both close-fitting tunic and bloomers. His hat is round and provided with a soft, flat crown with a narrow brim. His more courtly dress can be compared to that worn by the Emperor Maximilian II (Vienna, Kunsthistorisches Museum, Schneebalg-Perelman 1982, p. 44).

The panel, like much of Lowlands art of this time, incorporates a moral lesson within a genre scene. The three men are throwing dice, an action that also absorbs the interest of the three hounds, two greyhounds and a mastiff, on leash. In the background a handsome hare bounds away unnoticed. The distinction between the hunters dressed for their sport and the more elegantly dressed dice thrower allows the significance of the story to be seen. The men are distracted from their work by their lust for gambling. The hunters themselves become the prey. Not only do they lose their quarry, but also they are now in danger of losing their substance. The dogs, however, appear to have been constructed as narrative foils. One, in its suspicious position with ears laid back and tense body, takes on the moral stance of resistance that should be that of its master. This reading corresponds to the common pattern in Lowlands art of the transformation of genre to the moral allegory. Compare the *Allegorical Scene with Gambling* by Pieter Coecke van Aelst (1529 ?), Rotterdam, Museum Boymans-van Beuningen (Husband 1995, p. 158, fig. 1). The casting of dice for Christ's garment invariably lies behind admonitions against the practice. For wide ranging examples of moralizing representations from 1525 to 80 in the North Lowlands, see Filedt Kok 1986.

Style: Dirick Pietersz. Crabeth (Husband 1995, pp. 198–211) was a major designer of stained glass in the Lowlands of the mid-sixteenth century (Charles Hitchcock Sherrill,

Stained Glass Tours in Spain and Flanders, London, 1921, p. 191). He was born in Gouda about 1520 and appears in various records of the city from 1545 through 1574, the year of his death. His best known works are a series of monumental windows for the Church of St. John at Gouda, executed 1555–70 (Filedt Kok 1986, pp. 282–95, 358–67, nos. 158–68, 240–6). The medieval church had been struck by lightning and burned in 1552. Dirick and his brother Wouter were engaged to glaze the newly constructed church. The windows were of extraordinary height, the transept with Renaissance openings of 60 feet. The east window of St. John's, on the subject of the *Baptism of Christ by St. John* was given by George van Egmont, Bishop of Utrecht in 1555. Crabeth's responsibility as designer is documented by full scale cartoons, still extant (Brown and O'Connor 1991, figs. 64–5). The *Last Supper* window is also by Dirick Crabeth (Brown 1992, pp. 106–7, ill.). The Gouda figures are thin and elongated, set into compositions with dominant horizontal and vertical organizational systems. In the cartoon as well as the executed window, John stands erect to one side. Christ kneels and his legs and arms form horizontal counterpoints to the verticals of his torso and head.

Dirick Crabeth also designed for the roundel (Altena van Regteren, "Klein glas van 1543 door Dirck Crabeth," *Oud Holland*, 57, 1940, pp. 200–6). A series for a house in Pieterskerkgracht 9, Leiden (Husband 1995, nos. 170–20, pp. 200–8) is dated 1543. An important series on the theme of the *Christian's Search for Salvation*, a clearly Protestant subject, can be dated *c.* 1560. Although relying heavily on prints by Franz Huys, an engraver in Antwerp (Daniel R. Horst, "Een zestiende-eeuwse reformatorische prentenreeks van Frans Huys over de Heilsweg van de Mens," *Bulletin van het Rijksmuseum*, 38, 1990, pp. 3–24; Filedt Kok 1986, pp. 359–41), the drawings and executed panels still show Crabeth's characteristic style. Several can be compared to the Detroit roundel: *The Creation and the Fall* (DIA 42/fig. 1: Amsterdam, Rijksmuseum) and *Man is Rendered Deaf by Intellect to Christ* (Paris, École Nationale Supérieure des Beaux-Arts, M 698 Paris, 1560, Emmanuelle Brugerolles, *Renaissance et maniérisme dans les écoles du Nord. Dessins des collections de l'École des Beaux Arts* [exh. cat., l'École des Beaux Arts], Paris, 1985, p. 130, no. 5; Husband 1995, pl. 20, nos. 127–8, pp. 208–11). Husband (p. 210) describes Crabeth's construction: "Typically, Crabeth filled the picture field with large, tightly massed figures that bleed off the edges, and provided only the slightest indication of landscape." The Detroit composition of the hunt fills the composition with the figures, allowing the foot of the dice thrower and dogs on the right to extend beyond the composition.

Most striking is the mannerist canon of proportions employed by Crabeth. His figures are tall and elongated and presented as if separate from each other. Each participant

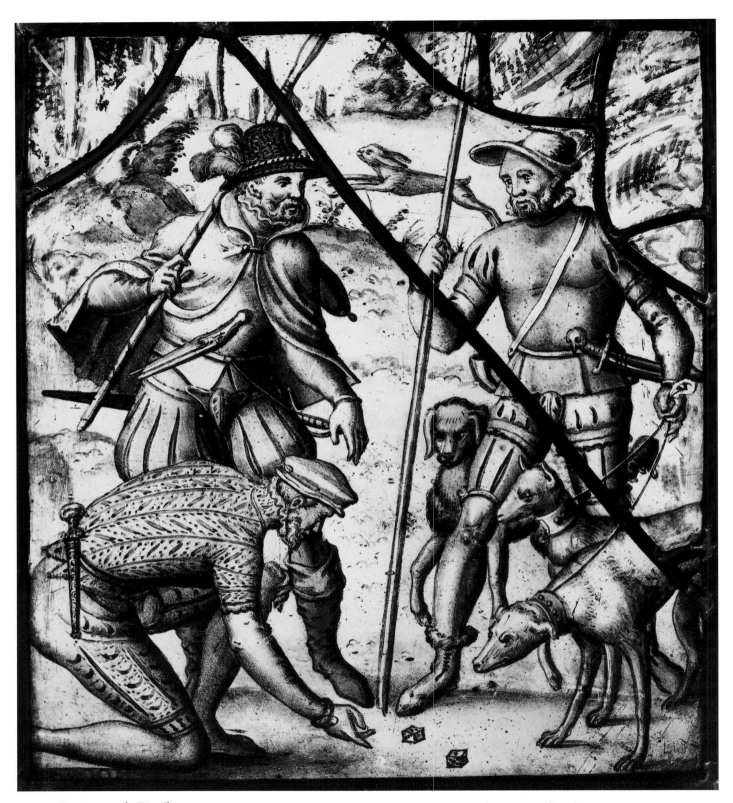

DIA 42. *Huntsmen and a Dice Thrower*

DIA 42/fig. 1. After
DIERICK PIETERSZ.
CRABETH: *The Creation
and the Fall*. Amsterdam,
Rijksmuseum

in his designs appears to have a coherent and logical place in the composition. Crabeth's rendering of the environment never absorbs the figures or groups them in a way that they lose their individuality. The figures in *Man is Rendered Deaf by Intellect to Christ* are self contained, separate entities, despite the dramatic nature of the subject, just as the characters in the hunt scene seem clearly defined. The modeling of the torso of the "Man" and his proportions are not unlike those of the men in the Detroit composition. The faces in the compositions are similar, showing short noses, small, deeply set eyes, and curly hair and beards. The proportions of Adam's body in *The*

Creation and the Fall (DIA 42/fig. 1) show the same lean musculature with relatively narrow shoulders and graceful legs.

Date: The date of 1549–60 places the roundel of *Huntsman and a Dice Thrower* within the execution of the windows at Gouda and the designs for the series of the *Christian's Search for Salvation*. The closeness of the costume worn by the dice thrower to the dress displayed in the portrait of Maximilien II, *c.* 1552–60, supports this date.

Photographic reference: DIA 4259

DIA 43–44. TWO HERALDIC ROUNDELS: ROYAL ARMS OF ENGLAND
England, Toddington Castle or Hailes Abbey, Gloucestershire ?
Mid-sixteenth century

History of the glass: These two panels and six others of the same type were in the collection of Lord Sudeley, Toddington Castle, Gloucestershire and described in the Helbing sale catalogue of 1911 (DIA 58. 120, 121, 122, 124, 156, and 157; *Sudeley* sale 1911, p. 132). All eight panels eventually entered the Detroit collection; only these two, however are authentic. The others are extremely well executed copies made by a restorer probably during the late nineteenth or early twentieth century (Text ill. 11). The copies use modern cathedral glass and the effects of aging are achieved by adroit handling of the mat paint. One assumes that the two authentic panels had been acquired by an individual who desired a set of eight for an architectural emplacement. The owner, very possibly Lord Sudeley, must have made the originals available to a studio that furnished the six replicas after close study of the model.

It seems that this division of the set was known, or at least suspected by Helbing, for in the 1911 *Sudeley* sale catalogue he illustrated only the authentic panels although he listed the other six as forming a set all included under the rubric, "15th century." It is tempting to surmise that Lord Sudeley may have been the owner who commissioned the replicas. Previous to the acquisition by the Detroit Institute of Arts, the set of eight panels had been in the William Randolph Hearst collection. They were purchased in 1958 from the Hearst Foundation with funds from a gift of K. T. Keller. [The panel of the Arms of Henry VIII, DIA 43, has been exhibited in the English Renaissance galleries since 1988; DIA 44 is in storage]

Related panels: Burrell Collection, Glasgow, 45/257 (DIA 43–44/fig. 1), Arms of Edward VI (*Heraldic Glass from the Burrell Collection* [exh. cat., Kelvingrove], Glasgow, 1962, no. 158).

Composition/Condition: Both panels have been modified from the standard oval garter presentation to achieve a round format. One may compare them with a panel in the Burrell collection (DIA 43–44/fig. 1) showing the arms of Edward as Prince of Wales. The purported royal crowns for the Detroit panels have been lost and the extending lower belt of the garter truncated. Both panels were given modern jeweled borders in an outer rim and between shield and garter. Compare the similar circular format for the arms surrounded with the Garter for four panels reset in a window of the Parish Church of St. Mary, Fawsley, Northamptonshire (Marks 1998, pp. 65–8). The shields were originally from Fawsley Hall and date 1537–42. They show the same foliate rinceaux patterned ground and undulating form of shield as present in the two Detroit panels. The Fawsley glass was not given jeweled borders when it was installed, probably between 1810 and 1813, in a clear glass matrix in a standard Georgian rectangular leading system.

Color/Technique: The organization around strong primary colors enhances the stability and the readability of the panels. Red, yellow, and blue are apportioned different surface areas in order to equalize their differing impacts. The bright warm yellow of the devices is reiterated in the gold elements in the garter. The bright warm blue of the first and fourth quadrants appears in the garter, allowing the larger expanse of this more reticent color to achieve balance with the warmer and more dominant red and yellow segments.

The panels are made up of pot-metal colors and uncolored glass treated with silver stain. In both panels the fleur-de-lis were inserted into an unbroken blue ground (Text ill. 12), a rather sophisticated technique called a *chef d'oeuvre*. Stress has caused cracks, now strengthened by mending leads or edge gluing. The six replicas (Text ill. 11), however, adopted the less demanding technique of dividing the blue fields into leaded segments, allowing the fleur-de-lis to be more easily set into the field. The replicas also substitute acid etching for the original abrasion used to achieve the gold lions on red flashed glass.

Style: The style of painting is similar to English heraldic art of the sixteenth century. The panel of the royal arms in the Burrell Collection is quite similar to the Detroit panels although the lions are of a slightly different format with much longer faces. The Detroit lions' shorter faces allow their manes to be seen across their chests. Both Burrell and Detroit panels employ mat washes and stickwork to produce foliate grounds in the quadrants of the shield and the surround between shield and garter.

Date: The style as well as the heraldry would argue for a date in the mid-sixteenth century. The heraldry appears to be retrospective and commemorative, since Edward VI was never Prince of Wales, nor was he a Knight of the Garter until he succeeded as sovereign of the Order on the death of Henry VIII. It is possible that individuals during the reign of Mary I (1553–58) would have wanted to commemorate Henry and Edward in a relationship showing the last two male rulers of England.

Bibliography
UNPUBLISHED SOURCES: Hearst sale (not in 1941 Hammer Gallery catalogue): A: 9, S/B Lot 1427, Art. 197; B. 10, S/B Lot 1427, Art. 201; heraldry researched by Nicholas Rogers, Cambridge, England.

PUBLISHED SOURCES: *Sudeley* sale, 1911, A: 131, No. 195, B: 132. No. 197; Raguin in *Checklist* III, p. 174.

DIA 43. *Royal Arms of England: Henry VIII*

DIA 43. Royal Arms of England: Henry VIII
Circle: diameter: 47 cm (18½ in)
Accession no. 58.119, funds from a gift of K. T. Keller
 Ill. nos. DIA 43, 43/a, 43–44/fig. 1, Text ill. 12

Inscriptions: *H/ K/ HONY SOYTT QVI MALL Y PANCE* (H K/ Henry King/ Let him be ashamed who thinks ill; the motto of the Order of the Garter)

Condition: A complete restoration of the panel was accomplished in fall 1988 by Mary Higgins of New York. (DIA, Conservation Department files). Most of the lead was retained. Epoxy edge-glue repairs were made in the first and fourth quadrants and copper foil repairs in the third.

Heraldry: Quarterly 1 and 4 azure three fleurs-de-lis or (France Modern) 2 and 3 Gules three lions passant gardant or (England). Flanked by the crowned initials H and K within a garter (Henry VIII).

Photographic reference: DIA Neg. no. 31134 (1988/03/04); before restoration: DIA Neg. no. 429500 (1986/ 01.18)

DIA 43/a. Restoration chart

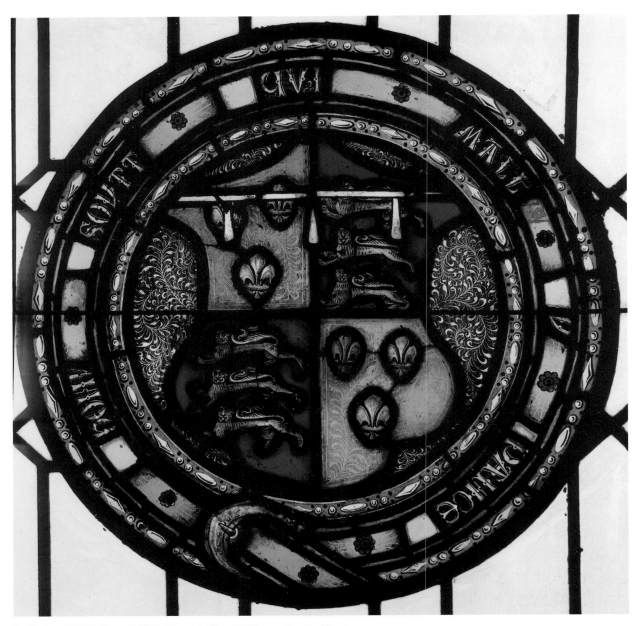

DIA 44. *Royal Arms of England: Edward, Prince of Wales*

DIA 44/a. Restoration chart

260

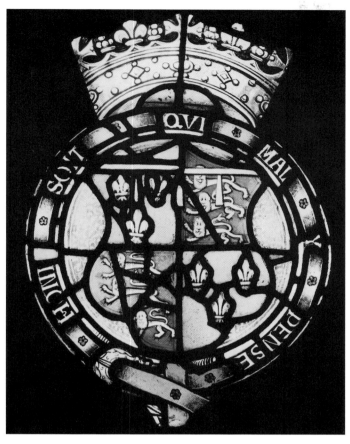

DIA 43–44/fig. 1. *Royal Arms of England: Edward VI.*
Glasgow, Burrell Collection

DIA 44. Royal Arms of England: Edward, Prince of Wales

Circle: diameter: 47 cm (18½ in)
Accession no. 58.123, funds from a gift of K. T. Keller
Ill. nos. DIA 44, 44/a, 43–44/fig. 1

Inscription: *HONY SOYTT QVI MALL Y PANCE* (Let him be ashamed who thinks ill; the motto of the Order of the Garter).

Condition: The panel is still housed in the modern window setting that was acquired from the Hearst Foundation in 1958.

Heraldry: The same as in DIA 43 without initials but with label of three points argent (Edward, the son of Henry VIII and Jane Seymour). The arms appear to be retrospective, since Edward (1547–53) was never Prince of Wales nor was he a Knight of the Garter until he had become king. Posthumous portraiture was common in the Tudor reign. See discussion of such motivations concerning the painting *Edward VI and the Pope* (National Portrait Gallery, London, 4165), where the authority of the knights of the garter surround Edward and Henry VIII on his deathbed (Margaret Aston, *The King's Bedpost: Reformation and Iconography in a Tudor Group Portrait*, Cambridge, 1993).

Photographic reference: DIA Neg. no. 29504 (1986/01.18)

DIA 45–46. SUPPORTERS OF THE TUDOR ARMS
England, Northamptonshire, Warkworth Manor?
Sixteenth century, second half

History of the glass: The panels are recorded set into the uppermost sections of the staircase window at Hassop Hall in 1910 (Shaw 1910, photo opp. p. 103). The glass appears to have come originally from the manor house of the Chetwode family in Warkworth, Northamptonshire, as first proposed by Shaw, since the heraldry depicted in the program associates the glass with the Chetwode family history (DIA 50–53). Contemporary photographs reveal that the stopgap from a Chetwode armorial panel, found in the lower left of the panel of the dragon before 1957, was already a part of the panel when it was in Hassop Hall. This was removed in the restoration of 1987 but is recorded in the pre-restoration photograph. Previous to the acquisition by the Detroit Institute of Arts, the set of two panels had been in the Grosvenor Thomas and William Randolph Hearst collections. P. W. French and Company, New York dealers, were the agents dealing with the Hearst estate. The panels were purchased in 1958 from the Hearst Foundation via French and Company with the funds from a gift of K. T. Keller. [British Galleries]

Technique: The panels are composed of pot-metal and uncolored glass. Silver stain is used in the uncolored glass and blue enamel in the tongue and claws of the dragon.

Style: As made more evident by the recent restoration and cleaning, the heraldic supporters are powerful, animated figures. The original lead line defines the lion's chest, head and right paw as a single unit. Around this locus extend his left paw, left foot, tail, elongated body, and tail portions. Complementing the lion, the design of the dragon also concentrates the strongest emphasis on the head and chest. The strong diagonal of the body is counterbalanced by the angle formed by the wings and left paw. As in the stance of the lion, the striding hindquarters provide a strong base to support the weight of the torso. See an earlier depiction of heraldic supporters, from the late 1530s, a greyhound and dragon now in Stanford Hall, Northamptonshire, east window. They appear less robust or animated, and more confined to the surface plane of the window (Marks 1998, pp. 190–1).

The strong three dimensional quality of the heraldic beasts, as well as their vigor of stance argue for a date during the reign of Elizabeth I (J. H. and R. V. Pinches, *The Royal Heraldry of England* London, 1974, pp. 141, 150, 154). See *Nine Heraldic Panels* (DIA 54–62) for discussion of conjectural program and placement.

Date: The heraldic association with the Chetwode series (DIA 50–3) would suggest that the supporters belong to the same commission, dated in the late sixteenth century.

Bibliography

UNPUBLISHED SOURCES: Thomas Files MMA; French & Co. Stock Sheets, item no. 5694, photograph only; Virginia Raguin, "Stained Glass: Imports and Insular Products," paper given at the session, "Late Gothic and Renaissance Art during the Reigns of Henry VII and Henry VIII: England and Currents across the Channel," Alan Phipps Darr, organizer, College Art Association, 1991.

PUBLISHED SOURCES: Shaw 1910, pp. 183, 189, (A1 and D1) pl. opp. p. 183; Raguin in *Checklist* III, p. 168.

DIA 45. Lion rampant guardant crowned or
Rectangle: 73.7 × 48.3 cm (29 × 19 in)
Accession no. 58.139, funds from a gift of K. T. Keller
Ill. nos. DIA 45, 45/a

Condition: During its installation in Hassop House the panel contained a long banner across the top. The panel was cut down and a new background and border added after its removal from Hassop Hall. It was housed in a modern lattice window when it was purchased from the Hearst Foundation in 1958. A complete restoration including releading was carried on in the fall of 1987 by Mary Higgins of New York (DIA, Conservation Department files). Mending leads were removed and the cracks in the lion's left paw and midsection were repaired with epoxy edge-gluing techniques. Copper foil repairs were employed in the lion's thigh, legs, and tail and in several segments of the tile floor. The post 1910 border was removed. A contemporaneous stopgap and a modern replacement were removed from the floor and replaced with neutral glass.

(left) DIA 45. *Lion rampant guardant crowned or*
(below) DIA 45/a. Restoration chart

(right) DIA 46. *Dragon rampant gules armed and langued azure*
(above) DIA 46/a. Restoration chart

Iconography: The lion rampant guardant crowned or and the dragon rampant gules armed and langued azure were supporters of the Tudor arms and used by Henry VII, Edward VI and Elizabeth I.

Color: The color scheme of the panels is dominated by the warm browns of the body of the lion, a tonality supported by the light warm red-brown and bright medium yellow of the floor tiles.

Photographic reference: DIA Neg. no. 31135 (188/03/04); before restoration: DIA Neg. no. 29520

DIA 46. Dragon rampant gules armed and langued azure

Rectangle: 73.7 × 48.3cm (29 × 19 in)
Accession no. 58.140, funds from a gift of K. T. Keller
Ill. nos. DIA 46, 46/a

Condition: Same as DIA 45. Higgins replaced mending leads by copper foil repairs in the dragon's face, paw, and chest. Several cracks in the tile floor were edge-glued. A stopgap from one of armorial panels from the same series was removed from the floor and one tile section repositioned from the right to the left side.

Color: The red pot-metal glass used for the figure of the dragon is a rich streaky type, lending animation to the form. The dark cool color counterbalances the light warm brownish red and bright medium yellow of the floor tiles.

Photographic reference: DIA Neg. no. 31136 (188/03/04); before restoration DIA Neg. no. 29521 (1986/01/18)

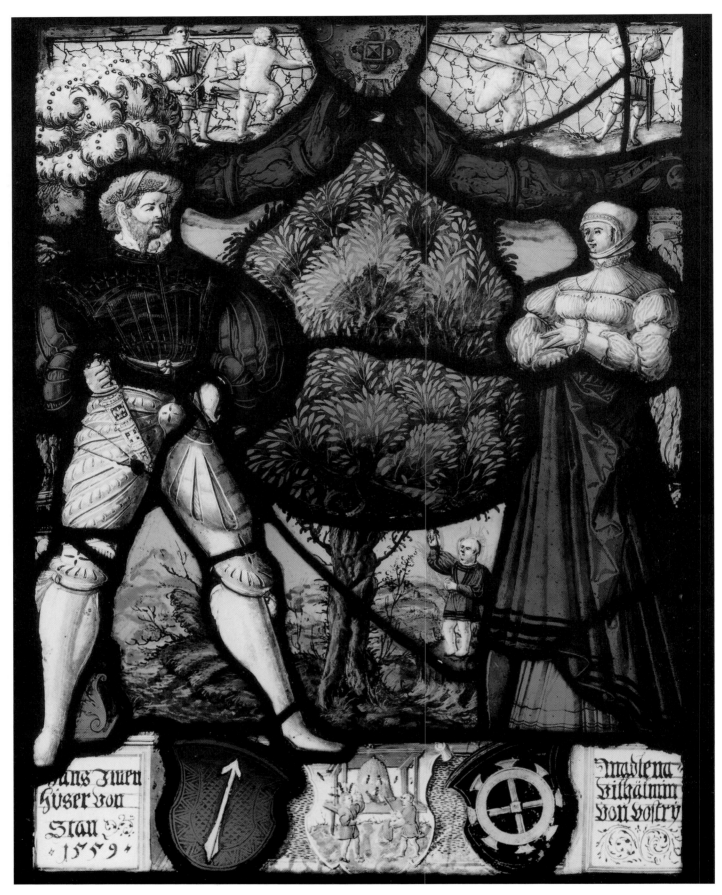

DIA 47. *Heraldic panel of Immenhuser and Vilhälmin*

DIA 47. Heraldic Panel of Immenhuser and Vilhälmin

Circle of Felix Lindtmayer the Younger (d. 1574)
Switzerland, Schaffhausen ?
1559
Rectangle: 39 × 29 cm (15⅜ × 11⅜ in)
Accession no. 23.6, Gift of George G. Booth

Ill. nos. DIA 47, 47/fig.1

History of the glass: The panel was in the distinguished collection of Lord Sudeley, Toddington Castle, Gloucestershire until the Helbing auction of 1911. Lehmann's catalogue identified the panel as the work of Felix Lindtmayer the Younger. George G. Booth, Bloomfield Hills, purchased the panel from the dealer Theodor Fischer, Lucerne, on 18 March 1922 and presented it to the Detroit Institute of Arts in 1923. The panel, as well as DIA 48 and 49, were part of a lot of twelve sold to Booth.

Bibliography
UNPUBLISHED SOURCES: Cranbrook Archives, notebook of George G. Booth, entry of 20/3/1922; Sibyll Kummer-Rothenhäusler of Zurich and Barbara Giesicke, letters and verbal communication.

PUBLISHED SOURCES: *Sudeley* sale 1911, p. 107, no. 157, ill.; DIA *Bulletin*, 4/7, 1923, p. 60; Friedrich Thöne, *Daniel Lindtmayer 1552–1606/7: Die schaffhauser Künstlerfamilie Lindtmayer*, Zurich, 1975; Raguin 1987, p. 39; Raguin in *Checklist* III, pp. 166–7.

Inscription: *Hans Imen/ Hüser von Stan/ 1559/ Madlena/ Vilhälmin/ von Vostry* (Hans Immenhuser of Stein (on the Rhine) and Magdelena Wilhalmine of Usteri [von Usteri], 1559).

Condition: Repair leads appear in the lower edge of the wife's skirt, the upper cartouche to the right, and the segment of glass beneath the tree. Minor paint loss has occurred in the upper and lower segments of the panel. The panel was cleaned in 1988.

Color: The colors balance throughout a tightly controlled composition. The medium green in the tree focuses the deep reds in the swags above, the husband's sleeves and the shield to the left, and the long vertical of the wife's skirt to the right. Below the tree, in small patches of sky at the left of the couple's faces, and in the architectural element anchoring the swaths above, appears a medium blue tone sporadically shifting to green via the application of silver stain. The borders above and below are predominantly uncolored with minor touches of yellow. A delicate warm yellowish pink is used for the capitals just at the level of the couple's heads.

Technique: All of the colors are achieved by pot-metal glass or uncolored glass and silver stain. Notable is the use of silver stain on the blue glass at the center area to achieve the effect of green.

Iconography: The panel shows a canting arms of the beehive derived from the words for bees *Immen*, thus "Immen huser" referring to the house of the bees. At the top of the panel two naked children engage each other in staff play while a man plays the flute to the right, and another a drum on the left. The husband wears a jacket with slashed sleeves as well as pantaloons with slashes at the thighs and the knees. He rests his hand on the ubiquitous personal weapon, the *schweizer Dolch* (see DIA 49). The wife gathers her overskirt to reveal her petticoat. Her elaborate blouse is gathered into a series of tiny folds accented by horizontal bands at wrist, elbow, upper arm, and shoulder. Her shoulders are covered by a sheer fabric gathered at the neck, and a close cap hides her hair. In the center, a young boy stands under a large tree, and appear to be reaching for its fruit.

Heraldry: (*left*) Gules an arrow or; (*middle*) argent a beehive tended by two men or; (Immenhuser) (*right*) sable a mill wheel or (Vilhälmin)

Style: The association with Lindtmayer had been accepted since Lehmann's evaluation of the Sudeley collection panels in 1911. Recent scholarship has attempted to establish a much stricter definition of workshops than that current earlier in the century. Friedrich Thöne (1975, pp. 24–31) attempts to sort out the family and the production of its several members. Although the brilliance of painting style may link this work with Felix Lindtmayer the Younger, the irregular proportions of the figures argue against the work being designed by so sophisticated an artist. In the figures of the husband and wife, we find unusually small heads and reduced torsos surmounting elongated lower portions of the body. These tendencies are not evidenced in any documented work of the Lindtmayer family.

Lindtmayer was the family name of several printmakers and stained glass designers (Thieme-Becker, 23, cols. 250–1). Felix the Elder died about 1543 in Schaffhausen and is credited with the stained glass panels from the monastery of St. George in the Museum of Schaffhausen. His son, Felix the Younger (d. October 1574 in Schaffhausen) trained in his father's shop. Felix's son, Daniel Lindtmayer the Younger (1552 Schaffhausen – 1602/07 Lucerne) was a major designer of stained glass. His work was considerably influenced by the innovations of Tobias Stimmer and the evolution of figural and perspectival rendering in Renaissance prints and drawings (Paul Ganz, *Die basler Glasmaler der Spätrenaissance und der Barokzeit*, Basle, 1966, pp. 42–5; Schmitz 1913, I, p. 201; Wilfrid James Drake, *A Dictionary of Glasspainters and "Glasyers" of the Tenth to Eighteenth Centuries*, repr. New York, 1955, p. 89; Gisela Bucher, *Weltliche Genusse; ikonologishe Studien zu Tobias Stimmer 1539–1584*, Berne, 1992).

DIA 47/fig. I. FELIX LINDTMAYER THE YOUNGER: *Two Lansquenets with the Standard of Schaffhausen, c.* 1550–75, from Switzerland, Schaffhausen. Boston, Museum of Fine Arts

Felix the Younger's work is of great technical brilliance, both in the handling of the sketch and the selection of color and exploitation of painterly effect in the medium of glass. A drawing of a halberdier and standard-bearer with the banner of Schaffhausen (DIA 47/fig. I), now in Boston (BMFA 44.828, William A. Sargent Fund; Raguin 1987, p. 39, no. 7), shows great facility in the handling of outline and shading via variegated neutral washes. A panel presenting Felix the Younger's own arms, dated 1552 (collection of Dr. Bernhard Peyer, Schaffhausen, Thöne 1975, p. 292, Cat. III C II, fig. 461) is considered a touchstone of Lindtmayer's work and shows many similarities to the Immenhuser panel. The vigorous stance of the figures, the puffy sleeves, the volumetric handling of the drapery and even the dimensions of the heraldic shields show affinities. This manner of handling subtle shading is evident in the Detroit panel, making it quite likely that the painter was well acquainted with the work of Lindtmayer, probably as an associate in the master's shop.

Date: The date of 1559 is established by the inscription.

Photographic reference: DIA Neg. no. 29201 (1985/09/05)

DIA 48. Heraldic Panel of the Town of Brugg

Jakob Brunner (attributed to)
Switzerland, Brugg
c. 1565–89
Circle: diameter: 32 cm (12⅝ in)
Accession no. 23.4, Gift of George G. Booth

Ill. nos. DIA 48; 48/fig. I

History of the glass: The panel was in the distinguished collection of Lord Sudeley, Toddington Castle, Gloucestershire, until the Helbing auction of 1911. Lehmann's catalogue attributed the panel to Jakob Brunner. George G. Booth, Bloomfield Hills, purchased the panel from the dealer Theodor Fischer, Lucerne, on 18 March 1922 and presented it to the Detroit Institute of Arts in 1923. The panel was part of a lot of twelve sold to Booth (see DIA 47). [Italian Galleries]

Bibliography

UNPUBLISHED SOURCES: Cranbrook Archives, notebook of George G. Booth, entry of 20/3/1922; Sibyll Kummer-Rothenhäusler of Zurich and Barbara Giesicke, letters and verbal communication.

PUBLISHED SOURCES: *Sudeley* sale, 1911, p. 61, no. 75, ill.;

DIA 48/fig. I. Arms of Berne, 1675, from Switzerland, Berne. Zurich, Schweizerisches Landesmuseum

DIA 48. *Heraldic panel of
the Town of Brugg*

DIA Bulletin, 4/7, 1923, p. 59; Michael Stettler and Emil Mauer, *Die Kunstdenkmäler des Kantons Aargau, 2, Die Bezirke Lenzburg und Brugg*, Basle, 1953; Schneider 1959, p. 97; Raguin in *Checklist* III, p. 166.

Inscription: Brugg (replaced)

Condition: The panel has been repaired at the top and bottom with replacements, including the inscription. The illustration in the 1911 sale catalogue (*Sudeley* sale 1911, p. 61) shows the panel within a laurel border and provided with presumably modern scroll work rounding out the truncated circle. Repair leads mar the perception of the bear to the left, but the panel is otherwise in excellent condition. It was cleaned in 1988.

Iconography: The use of animals as supporters is a long-standing tradition in heraldry. Most common in Swiss city or state panels are two lions on either side of paired or single shields. Bears do appear, but rarely, such as the shield of Berne, dated 1603 in the Schweizerisches Landesmuseum, Zurich (Schneider 1970, IN 98, p. 276, no.

461) where a bear stands on the dexter (left) side holding the banner of Berne and a lion holding a banner charged with a lion stands on the right. The bear is not actually dressed but wears a sash over its shoulder and across its chest. A panel dated 1675 carrying the arms of Berne (DIA 48/fig. 1), in the same museum (Schneider 1970, LM 6979a, p. 327, no. 653), shows the short mail coat with triangular fringe on the sleeves that is similar in style to that worn by one of the Brugg supporters. The bears wear similar sashes at the waist and ties around the shoulders connected to a bunched mantle. Plumes appear around the heads of each animal.

Equally important in Swiss heraldry is the representation of the halberdier and standard bearer as supporters for the shield. Compare, for example, the drawing by Felix Lindtmayer the Younger (DIA 47/fig. 1) executed *c.* 1550–75, about the same time as the Brugg panel, showing two men as soldier and citizen flanking the shield of Schaffhausen (BMFA 44.828; see for further discussion DIA 47). The panel for Brugg conflates these two heraldic representations by showing animals standing in place of the men

but wearing human dress, the mailed coat to the left and the citizen's parade dress to the right.

Heraldry: Argent a tower bridge sable. Supported by two bears with halberds (Brugg)

The heraldic image of the city of Brugg is of long tradition, based on the still extant bridge over the Aare River adjacent to the black tower, *der schwarze Turm*, that dates from early Romanesque times, possibly 1050–1150. In 1238, this tower was already mentioned in the literature as "the tower of Brugg" (Stettler and Mauer 1953, pp. 271–9). The 1654 engraving by J. Zehender in Matthaus Merians's *Topographie*, published in 1654, shows the town of Brugg with an emphasis on the bridge over the Aare River (ibid., p. 259, fig. 234). See also the arms of Brugg in stained glass panels in the Historische Sammlung of Zofingen (ibid., pp. 339–40).

Color: The panel is a masterful balance among the deep warm yellow of the silver stain background, the deep red tunic of the bear to the right, and cool medium gray, white, and black of the rest of the elements. The plumed hats, both halberds, background of the shield, and tunic of the bear to the right are silver, the animals' skins gray, the bridge motif and straps of the costume of the bear to the right black. The gray fur of the animals is enriched by subtle touches of warm brown. The warm brown appears unmitigated in the sack over the shoulder of the bear to the left.

Technique: The panel employs pot-metal flashed and abraded red in the garments of the bear to the right. The rest of the panel is uncolored glass treated with silver stain and several tones of vitreous paint.

Style: Jakob Brunner is the only glass painter whose career can be documented at this time in Brugg in the Aargau region, an area to the west of Zurich (Schneider 1970, p. 493). He exercised more than a single profession, however. He was a member of a family originally from Glarus, but living in Brugg, where he married the daughter of the innkeeper of Brugg in 1564. He exercised the profession of innkeeper as well as that of painter and glass painter. He is recorded as having renewed the shield of Bern in the town hall of Schenkenberg in 1566 and in 1574 painted the clock design on the new tower in Brugg. This was typical of even the most distinguished painters of this time. Tobias Stimmer produced designs for house facades, painted the astronomical clock for the Cathedral of Strasbourg, and subsequently produced the several woodcuts publicizing the clock (*Stimmer*, Basle, pp. 35–106). In 1576 Brunner was given the commission of twelve heraldic panels from the city council of Brugg, presumably for the town hall. From 1585 to 1587 he was supervisor of buildings, *Bauherr*, of the city and died in 1589 (Schneider 1970, p. 485; *Sudeley* sale 1911, p. 61; Max Banholzer, "Jakob Brunner, Glasmaler und Sternen-

wirt 1546–1589," *Brugger Neujahrsblatt*, 1968, p. 11, ill.).

The painting style is very fine, displaying excellent handling of both the application of the paint and the draftsmanship of the figures. A similarly well executed and preserved panel by Brunner, dated 1577 and representing the shield of Bern with shields of professions is found in the Schweizerisches Landesmuseum, Zurich (Schneider 1970, LM 8783, 121, no. 351, col. pl.). From 1575 and signed with the initials I. B., is a heraldic shield inscribed *Hanns Friderich von Mülinnen* in the Historisches Museum of Berne (Fischer 1914, pl. 96), where the monogram is noted but not identified as that of Brunner. Compare, especially the panel in the Historische Sammlung of Zofingen by Jakob Brunner after the design of Daniel Lindtmayer, dated 1586 (Stettler and Mauer 1953, pp. 339–40).

Date: In the absence of a dated commission or inscribed dates, the active years of Jakob Brunner serve as termini: about 1565–89.

Photographic reference: DIA Neg. no. 29199 (1985/09/05)

DIA 49. Heraldic Panel of Hans Stöckli
Switzerland, central region
1589
Rectangle: 30.8 × 19.69 cm ($12\frac{1}{8}$ in × $7\frac{3}{4}$ in)
Accession no. 23.3, Gift of George G. Booth
Ill. nos. DIA 49, 49/a, 49/figs. 1–2

History of the glass: The panel was in the distinguished collection of Lord Sudeley, Toddington Castle, Gloucestershire, until the Helbing auction of 1911. George G. Booth, Bloomfield Hills, purchased the panel from the dealer Theodor Fischer, Lucerne, on 18 March 1922 and presented it to the Detroit Institute of Arts in 1923. The panel was part of a lot of twelve sold to Booth (see DIA 47). [Italian Galleries]

Bibliography

UNPUBLISHED SOURCES: Cranbrook Archives, notebook of George G. Booth, entry of 20/3/1922; Sibyll Kummer-Rothenhäusler of Zurich and Barbara Giesicke, letters and verbal communication.

PUBLISHED SOURCES: *Sudeley* sale 1911, p. 122, no. 183; *DIA Bulletin*, 4/7, 1923, p. 59, Raguin in *Checklist* III, p. 167.

Inscription: 1589/ *Hans/ Stöckly* (Hans Stöckli)

Condition: The loss of a considerable amount of surface paint diminishes the readability of the panel, especially in the inscription. The panel was repaired in 1988 by Mary Higgins of New York. Among the changes, she replaced the mending lead in the upper panel and that across the midsection of the figure with edge-bond repairs.

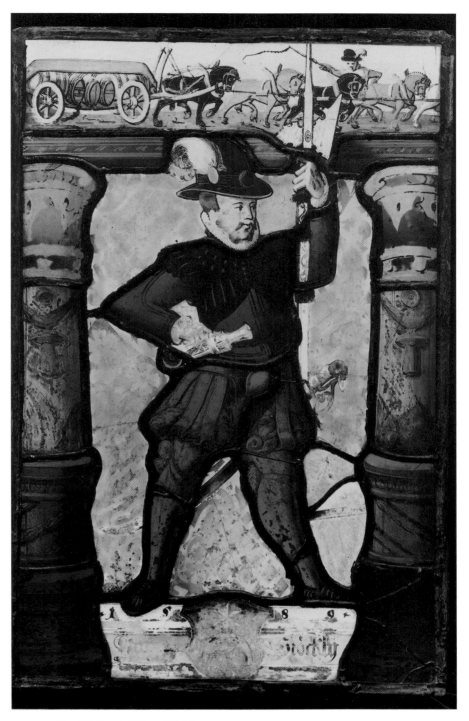

DIA 49. *Heraldic Panel of Hans Stöckli*

DIA 49/a. Restoration chart

DIA 49/fig. 1. *Heraldic Panel of Bircher and Bruterin*, from Switzerland, 1593. Zurich, Schweizerisches Landesmuseum

DIA 49/fig. 2. BARTHOLOMÄUS LINGG THE ELDER: *Heraldic Panel of Bartholomäus Lingg*, from Switzerland, central part, 1553. Paris, Musée du Louvre

Color: Red, yellow, and green dominate the composition. Stöckli is dressed completely in red and is set against a bright yellow background. The background varies with two shades of yellow, creating visual interest. The signature panel at the bottom and the genre panel at the top are predominantly white with some silver stain yellow. One of the most engaging elements of the panel is the treatment of the enframing columns. Their colors rise in successive waves from their bases, beginning with bright warm red, then bright green, light blue-green, and bright warm pink, to terminate at a light green lintel.

Technique: The glass is pot-metal colors with uncolored glass and two shades of silver stain. The red of Stöckli's torso is flashed and abraded to allow depiction of his dagger and the staff of his halberd. Silver stain is used in the pink capitals, providing an unusual brownish orange accent. The vitreous paint is applied in washes of a limited range.

Iconography: The single figure in the panel stands in citizen's parade dress holding a halberd in his left hand, his right resting on his waist where a short dagger, the Swiss

Dolch, is attached to his belt (Hugo Schneider, *Der Schweizerdolch*, Zurich, 1977; id. with Karl Stüber, *Waffen im Schweizerischen Landesmuseum: Griffenwaffen*, 1, Zurich, 1980). These actions refer to the cherished right of the Swiss citizen to bear arms. The scene above shows a driver urging on a long team of horses pulling a heavy wagon filled with barrels, presumably a reference to Stöckli's merchant status.

Heraldry: Sable (mostly effaced) in chief a mullet of six points or in fess a crescent reversed or (Stöckli).

Style: The Stöckli panel has not been precisely located through genealogical research, and thus the surmises here must remain tentative. The name of Stöckli, identified from the town of Unterlunkhofen in the Canton of Aargau, appears in a panel dated 1621 bearing the inscription *Michel Stockhlj von Under Lungkhoffen* (Schneider 1970, p. 292, IN 64/28, no. 517). The man's arms, however, sable a rebmesser argent, are different from those of the Detroit panel. Hans Stöckli's clothing, weapons, and stance repeat almost exactly those of Niklaus Bircher in a panel dated

1593 (DIA 49/fig. 1) now in the Schweizerisches Landes-museum, Zurich (Schneider 1970, p. 258, LM 660/ IN 80, no. 398). The inscription reads *Niclaus Bircher under uogt zu Vilmärgen und Agly Brudterin sin Eliche huss Frouw: 1593*. The panel is of similar size to the Detroit panel, 30 x 20 cm (11⅞ × 7⅞ in), and the similarity of composition and script may suggest a workshop affinity. Of particular note are the large, rounded columns, swelling at the center with large fleshy leaves springing from the moldings at the divisions of shaft and capital. Both panels display the same bright yellow backgrounds with damask enrichment, now faded.

The modeling in both panels is restrained and the definition of eyes, noses, hair lines, or even drapery, achieved with a short unmodulated trace line with very little smear or stipple shading. The panel now in Zurich was made for a resident of the town of Villmergen in the canton of Aargau (Peter Felder, *Die Kunstdenkmäler der Schweiz, Aargau*, 4, Basle, 1967, p. 403, not ill.) whose closest large city is Zurich. Bircher's family, however, came from the city of Lucerne The precise artistic original of the panel, like that of the Detroit panel of Hans Stöckli, remains unknown.

One can, however, associate the general compositional heritage of both panels with precedents from central Switzerland designed by Bartholomäus Lingg (or Linck), the Elder, active in Zug from at least 1552 (Paul Boesch, "Bartholomäus Lingg, Glasmaler aus Zug," *Zuger Neujahrsblatt* Zug, 1938, pp. 1–4, 3 ill. a). A panel dated 1553 now in the Louvre (DIA 49/fig. 2), shows Lingg's own shield supported by a fool holding a hooded falcon (ibid.; W. Wartmann, *Les Vitraux suisse au Musée du Louvre*, Paris, 1908, pp. 67–9, no. 17, pl. XIV; Wyss 1968, pl. 8). Large, festooned columns, beginning at the base, frame the image and support an upper panel of four costumed half-wild men. The disposition of figure and architecture show the same proportions as those in the Bircher and Stöckli panels. In particular, the richness of the architecture provides a dignified foil for the single figure.

Date: The date of 1589 is established by the inscription.

Photographic reference: DIA Neg. no. 31856 (1988/11/29); before restoration DIA Neg. no. 29198 (1985/09/09)

DIA 50–53. FOUR HERALDIC PANELS OF KNIGHTS OF THE ORDER OF THE GARTER
England, Northamptonshire, Warkworth Manor House
1589–93

History of the glass: The glass almost certainly came originally from the manor house of the Chetwode family in Warkworth, Northamptonshire, as first proposed by Shaw (Shaw 1909, pp. 193–4). The heraldry depicted in the entire lot associates the glass with the Chetwode family history. The glass was transferred to the Eyer family, owners of Hassop Hall, through inheritance and purchases. In 1620, Sir Richard Chetwode, conjointly with his son Richard Chetwode and grandson, Knightly Chetwode sold the manor of Warkworth to Philip Holman Esq. (d. 1669). In October 1740 William Holman, Esq., Philip's grandson, died without issue and the half of his estate with the Warkworth manor house passed to his nephew, William Mathias, 3rd Earl of Stafford. The other half passed to his sister Mary, wife of Thomas Eyre of Hassop, Derbyshire, Esq. (d. 1749). In April 1746 Thomas Eyre purchased Warkworth manor from his nephew. It eventually passed to Eyre's grandson, Francis Eyre (d. 1827), who disposed of the house at public auction in 1805. The manor was purchased by Thomas Bradford of Ashdown Park, Sussex, Esq., who dismantled the house in 1806 and sold the land in 1807 to James Smith of Berkhampsted (George Baker, *The History and Antiquities of the County of Northampton*, 1, London, 1922, pp. 739–41). It is presumed that just prior to the sale of the house in 1805 Francis Eyre removed the panels and reinstalled them in his residence of Hassop Hall, Derbyshire. The panels are recorded set into the staircase window and bay window in the dining room in 1910. Previous to the acquisition by the Detroit Institute of Arts, the set of panels had been in the Grosvenor Thomas and William Randolph Hearst collections. P. W. French and Company, New York dealers, were the agents dealing with the Hearst estate. The panels were purchased in 1958 from the Hearst Foundation via French and Company with the funds from a gift of K. T. Keller. [DIA 52 and 53 in British Galleries; DIA 50 and 51 in storage]

Related material:
Burrell Collection, Glasgow: 25/243, Arms of Hastings, Earl of Huntingdon; 25/244, Arms of Talbot, Earl of Shrewsbury (DIA 50–53/fig. 1); 45/245 Arms of Cary, Baron Hunsdon (*Heraldic Glass from the Burrell Collection* [exh. cat. Kelvingrove], Glasgow, 1962, nos. 241–3).

Philadelphia Museum of Art: 69–226–10, 69–226–111, and 69–226–12 Arms of Robert Dudley, Earl of Leicester (DIA 50–53/fig. 2); 69–226–2, Arms of Ratcliffe and 69–226–9, Arms of William Grey, Lord Grey of Wilton or his son, Arthur, Lord Grey of Wilton (Morgan in *Checklist* II, pp. 172–3).

DIA 50–53/fig. 1. *Arms of Talbot, Earl of Shrewsbury*, from England. Glasgow, Burrell Collection

Iconography: The Order of the Garter is the oldest and most illustrious of the orders of knighthood of England. It was founded by Edward III, most probably between 1346 and 1348. Some have connected the institution of the Order to the victory at the Battle of Crécy in 1346. The most commonly repeated story of the origin of the name is that at a court function a lady may have dropped her garter in the midst of a hectic and crowded assembly. A great variety of devices and mottoes were used by Edward III; they were chosen for the most trivial causes and were most commonly of a gallant rather than a military nature. It is indeed possible that the title of the Order reflects the honored qualities of "courtoisie" or generous, charming, and refined exchange even in the most importune or trying of circumstances. Edward III is reputed to have smoothed the embarrassment by picking up the lady's garter and putting it on his own knee, and stating "Dishonored he who thinks ill of it." The original number of knights of the Order consisted of the sovereign and twenty-five knights. No change was made in this respect until 1786 to accommodate the sons of George III, however the additions might overpass the original restriction on numbers.

Color/Technique: The panels are dominated by the yellow

silver stain and light blue enamel on uncolored glass. The most prominent decorative feature is the shimmering deep warm yellow and light enamel blue of the coronet and belt of the order of the garter. The shields are set against a deep warm pot-metal purple masked by foliate patterning of the surface. The colors of the shields are evenly balanced among flashed and abraded reds, pot-metal yellow, silver stain, blue enamel and white in the requisite heraldic formats.

Composition/Style: The four panels consist of a rectangular shield against a circular ground surrounded by the garter. The blason within a wide border of the Order of the Garter and crowned with a coronet was a standard heraldic representation, varying very little throughout the sixteenth century. The panels are quite similar to several series from England that are now in the collections of the Burrell Collection and Philadelphia Museum of Art (Shaw 1909, pp. 193–4). The series closest to the Detroit panels presents the arms of Robert Dudley Earl of Leicester (DIA 50–53/fig. 2), from Ashridge Park, Hertfordshire, about 1575. The format of the coronet with its five narrow spikes interspersed by trefoils, although in Detroit more foliate, the non-figural pendant to the garter, and the ground of uniform color link the two series. The sizes also correspond,

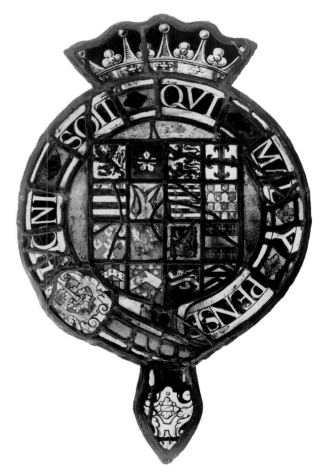

DIA 50–53/fig. 2. *Arms of Robert Dudley, Earl of Leicester*, from England. Philadelphia, Museum of Art

the panels all measuring about 70 × 43 cm (27½ × 17 in). Most telling is the style of lettering, showing the same broad proportions to the letters, although in the Philadelphia panels the letters are isolated from the garter by the addition of a darker ground surrounding each word. One can posit neither a workshop identity nor a series identity, however. The Burrell series shows lettering closer to the Detroit panels, although instead of a plain ground, scroll work fills the interstices between shield and garter in a format more similar to that of the Philadelphia pair showing the arms of Ratcliffe and Grey. See entry for the *Nine Heraldic Panels* (DIA 54–62) for discussion of conjectural program and placement.

Date: The date of 1589–98 is argued from the dates of the arms of the individuals honored in the panels.

Bibliography

UNPUBLISHED SOURCES: Thomas Files MMA; French & Co. Stock Sheets, items no 5696 (1), 5688 (2), 5689 (4), photo only; heraldry researched by Nicholas Rogers, Cambridge, England; Virginia Raguin, "Stained Glass: Imports and Insular Products," paper given at the session, "Late Gothic and Renaissance Art During the Reigns of Henry VII and Henry VIII: England and Currents across the Channel," Alan Phipps Darr, organizer, College Art Association, 1991.

PUBLISHED SOURCES: Shaw 1909, pp. 191–220, pl. opp. 194; Shaw 1910, pp. 182–208, pl. opp. 183; Hearst sale (not in 1941 Hammer Gallery catalogue), p. 9, S/B Lot 1427, Art. 205; Raguin in *Checklist* III, pp. 168–9.

DIA 50. Arms of William Cecil, Baron of Burghley
Irregular: 73.7 × 43.2 cm (29 × 17 in)
Accession no. 58.135, funds from a gift of K. T. Keller
Ill. nos. DIA 50, 50/a, 50–53/figs. 1–2

Inscriptions: HONI SOIT QVI MAL Y PEN (Let him be ashamed who thinks ill) The motto of the Order of the Garter

Condition: The leading is extremely fragile and has detached in numerous areas. A segment of the background has been lost and the lower right shield is a modern replacement. The original crest is also missing. There are considerable repair leads in the garter and background as well as two in the shields.

Heraldry: Quarterly of 6: 1 and 6, Barry of ten argent and azure six escutcheons sable, three, two, and one, each charged with a lion rampant argent (Cecil); 2, Per pale gules and azure a lion rampant argent sustaining a tree erased vert (Winstone); 3, Sable a plate between three towers triple towered ports open argent (Caerleon); 4, Argent on a bend cotised gules three cinquefoils or (Heckington); 5,

Argent a chevron between three chess rooks ermines (Walcot). Within a garter (original crest missing).

In 1910 the original crest was still visible in the dining room window of Hassop Hall, "on a wreath argent and azure, a sheaf of nineteen arrows, eighteen in saltire and one in pale, or, feathered and surmounted by a kerchief of the second, bound about gules (Shaw 1910, pp. 200–1, pl. opp. p. 183).

William Cecil (1521–98) educated at St. John's College, Cambridge, and solicitor at Gray's Inn, rose to great prominence through service during the reigns of Edward VI, Mary Tudor, and Elizabeth I. He was befriended by the Earl of Somerset, the Lord Protector during the minority of Edward VI, whose arms (DIA 58) were also displayed in Warkworth House. On Somerset's fall, William Cecil was also imprisoned but his title and lands were restored in 1551. On the accession of Elizabeth in 1558, he was made Secretary of State, an office he held until 1572 when he was named Lord High Treasurer. Thus for forty years he was one of the leading ministers of the Crown. In 1570–1 he was created Baron of Burghley and in 1572 Knight of the Order of the Garter. He was also Chancellor of the University of Cambridge from 1559 until his death (*Complete Peerage*, 2, pp. 428–9).

Photographic reference: DIA Neg. no 29516 (1986/01/18)

DIA 51. Arms of Thomas Sackville, Baron of Buckhurst, Earl of Dorset
Irregular: 69.9 × 43.2 cm (27½× 17 in)
Accession no. 58.136, funds from a gift of K. T. Keller
Ill. no. DIA 51, 50–53/figs. 1–2

Inscription: HONI SOIT QVI MAL Y PENSE (Let him be ashamed who thinks ill) The motto of the Order of the Garter.

Condition: There are a number of repair leads in the garter. In 1910 the now lost coronet was still visible in the dining room window of Hassop Hall (Shaw 1909, p. 195, pl. opp. p. 194).

Heraldry: Quarterly or and gules a bend vair (Sackville, Baron of Buckhurst). Within a garter (original crest missing)

Thomas Sackville (between 1527 and 1536, died 1608) was created Baron of Buckhurst in 1567 and made a Knight of the Garter in 1589. He served in various positions during the reign of Elizabeth and James I, being Lord High Treasurer from 1599 until his death. James I created him Earl of Dorset in 1603/4 (*Complete Peerage*, 2, p. 384, and 4, pp. 422–3). He was also a distinguished poet (*Mirror for Magistrates*, ed. Lily B. Campbell, Cambridge, 1938, pp. 297–317, "The Induction"; John William Cunliffe, *Early English Classical Tragedies*, Oxford, 1912).

Photographic reference: DIA Neg. no 29517 (1986/01/18)

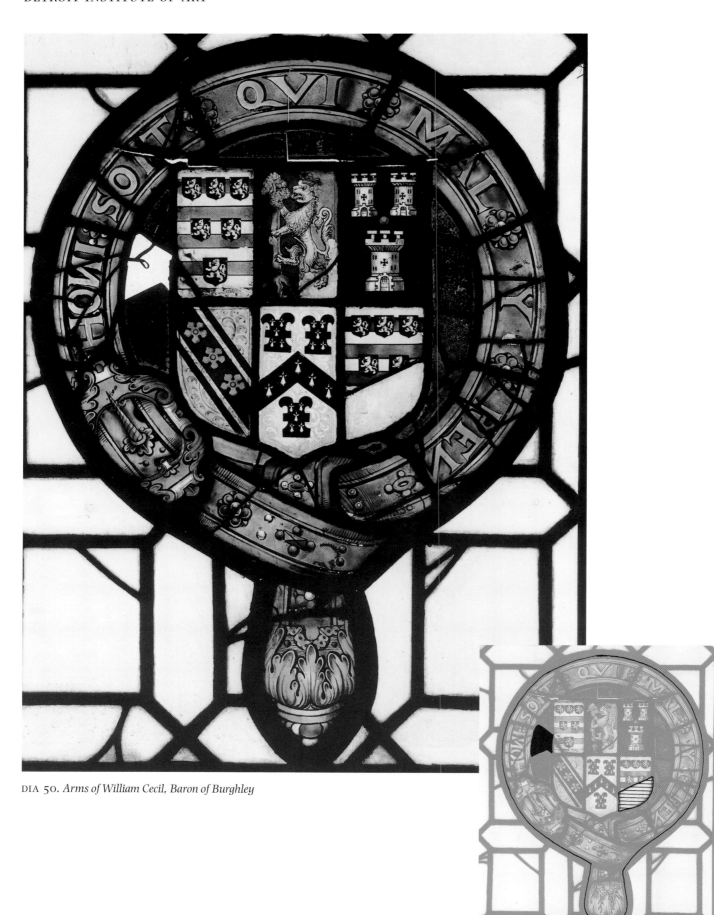

DIA 50. *Arms of William Cecil, Baron of Burghley*

DIA 50/a. Restoration chart

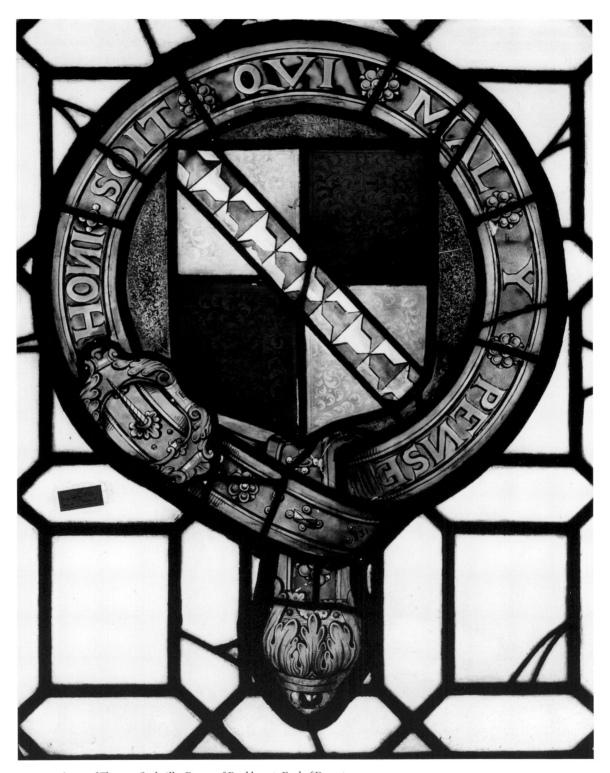

DIA 51. *Arms of Thomas Sackville, Baron of Buckhurst, Earl of Dorset*

DIA 52. Arms of Henry Herbert, 2nd Earl of Pembroke

Irregular: 68.6 × 43.2 cm (27 × 17 in)
Accession no. 58.137, funds from a gift of K. T. Keller
Ill. nos. DIA 52, 52/a, 50–53/figs. 1–2

Inscription: HONI SOIT QVI MAL Y PENSE (Let him be ashamed who thinks ill) The motto of the Order of the Garter

Condition: A full restoration was made in fall 1987 by Mary Higgins of New York (DIA, Conservation Department files). The panel was completely releaded and the considerable repair leads in the garter removed and replaced with copper foil or edge glued repairs. The central

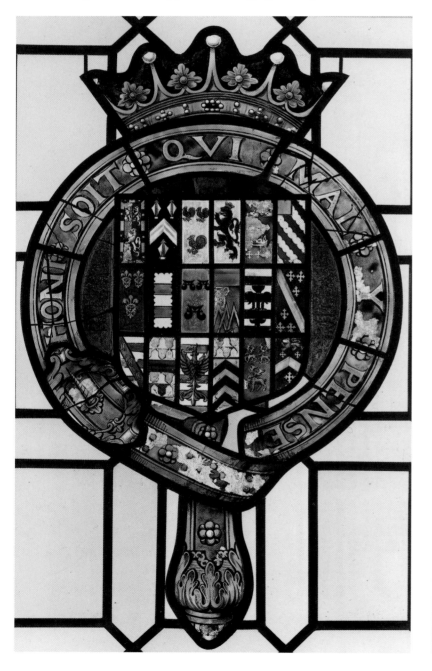

lower segment of the garter was readjusted to reproduce the original format and the gaps filled in with neutral gray glass. There is some loss of blue enamel, noticeably in the right and lower portions of the garter and the fifth, fourteenth, and sixteen quarterings.

Heraldry: Quarterly of 18: 1, Per pale azure and gules three lions rampant argent within a bordure compony gules bezantée and or (Herbert); 2, Sable a chevron between three spear-heads argent and or points upwards (Bleddin ap Maenarch); 3, Argent three cocks gules (Gam); 4, Argent a lion rampant sable crowned or (Morley); 5, Azure crusilly and three boar's heads couped argent (Cradock); 6, Argent four [*recte* three] bendlets engrailed gules, a canton or (Horton); 7, Gules three lion's heads jessant-de-lis or (Cantilupe); 8, Argent two bars azure within a bordure engrailed sable (Parr); 9, Or three water-bougets sable (Ros of Kendal); 10 Azure three chevronels in base interlaced or, a chief or (FitzHugh); 11, Barry of eight argent and gules, over all a fleur-de-lis sable (Staveley); 12, Gules a bend between six crosses crosslet or (Fourneys); 13, Barry of six argent and azure on a bend gules three martlets or (Gray); 14, Vair a fess gules (Marmion); 15, Barruly argent and azure an eagle displayed gules (Garnegan); 16, Or three chevrons gules a chief vair (St. Quentin); 17, Azure three bucks trippant or (Green); 18, Gules a chevron between three crosses crosslet or in chief a lion passant guardant or (Mabelthorp). Within a garter, ensigned with an earl's coronet (Shaw 1909, 204–5).

Henry Herbert (*c.* 1538 to 1600/1) was the second earl of Pembroke and served during the reigns of Mary Tudor and Elizabeth. He was made of a Knight of the Garter in 1574. His first marriage to Katharine Grey, second daughter of Henry Grey, first Duke of Suffolk, was declared null and void after the fall of the Grey family. His third marriage, in 1577, was to Mary Sydney, the sister of the poet Sir Philip Sydney (*Complete Peerage*, 10, pp. 410–2).

Photographic reference: DIA Neg. no. 31133 (1988/02/29); before restoration DIA Neg. no. 29518 (1986/01/18)

(*left*) DIA 52. *Arms of Henry Herbert, 2nd Earl of Pembroke*
(*right*) DIA 52/a. Restoration chart

DIA 53. Arms of Henry Stanley, Earl of Derby

Irregular: 68.6 × 43.2 cm (27 × 17 in)
Accession no. 58.138, funds from a gift of K. T. Keller
Ill. nos. DIA 53, 53/a, 50–53/figs. 1–2

Inscription: HONI SOIT QVI MAL Y PENSE (Let him be ashamed who thinks ill) The motto of the Order of the Garter

Condition: A full restoration was made in fall 1987 by Mary Higgins of New York (DIA, Conservation Department files). The panel was completely releaded and the considerable repair leads in garter and shield removed and replaced with copper foil or edge-bond repairs. Several stopgaps were removed and the central lower segment of the garter was readjusted to reproduce the original format. The gaps were filled in with the same neutral gray glass used in the surrounding lattice work. There is some loss of blue enamel in the garter and second quartering.

Heraldry: Quarterly of 8: 1, Argent on a bend azure three stag's heads caboshed or (Stanley); 2, Or on a chief indented azure three plates (Lathom); 3, Gules three legs embowed and conjoined in the fess point in armor proper (Isle of Man); 4, Checky or and azure (Warenne); 5, Gules two lions passant argent (le Strange of Knockyn); 6, Argent a fess and a canton gules (Woodville); 7, Or a cross engrailled sable (Mohun); 8, Azure a lion rampant argent (Monhault). The whole charged with an escutcheon of pretence, quarterly: 1 and 4, Barry of ten argent and gules a lion rampant or ducally crowned per pale argent and gules (Brandon, duke of Suffolk); 2 and 3 Azure a cross flory or (Bruyn) and lozengy ermine and gules (Rockley) quarterly. Within a garter, ensigned with an earl's coronet (Shaw 1909, 211–12, pl. opp. 194).

Henry Stanley (1531–93) was the fourth earl of Derby. He succeeded his father as the Lord Lieutenant of the counties of Lancaster and Chester, posts he held until his death. He was named a Knight of the Garter in 1574. He married on 7 February 1555 Margaret, first daughter of Henry, second earl of Cumberland, the only child to survive infancy of his first wife, Eleanor, daughter of Charles Brandon, duke of Suffolk. Eleanor was second and youngest daughter of Mary Tudor, daughter of Henry VIII, and seen by many as the heir presumptive to the Crown (*Complete Peerage*, 4, pp. 211–12).

Date: 1589–93

Photographic reference: DIA Neg. no. 31130 (1988/02/29); before restoration: DIA Neg. no. 29519 (1986/01/18)

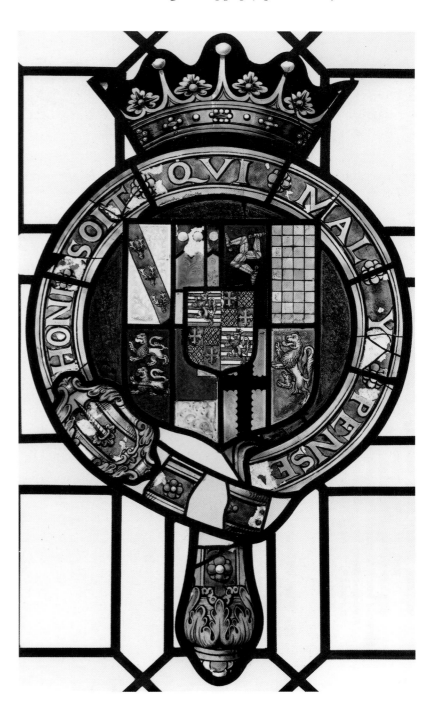

(*right*) DIA 53. *Arms of Henry Stanley, Earl of Derby*
(*left*) DIA 53/a. Restoration chart

DIA 54–62. NINE HERALDIC PANELS
England, Northamptonshire, Warkworth
Manor House
Late sixteenth century

History of the glass: The windows almost certainly came originally from the manor house of the Chetwode family in Warkworth, Northamptonshire, as first proposed by Shaw (1909, pp. 193–4). The heraldry depicted in the entire lot associates the glass with the Chetwode family history. The glass was transferred to the Eyre family, owners of Hassop Hall, through inheritance and purchases. In 1620, Sir Richard Chetwode, conjointly with his son Richard Chetwode and grandson, Knightly Chetwode sold the manor of Warkworth to Philip Holman Esq. (d. 1669). In October 1740 William Holman, Esq., Philip's grandson, died without issue and the half of his estate with the Warkworth manor house passed to his nephew, William Mathias, 3rd Earl of Stafford. The other half passed to his sister Mary, wife of Thomas Eyre of Hassop, Derbyshire, Esq. (d. 1749). In April 1746 Thomas Eyre purchased Warkworth manor from his nephew. It eventually passed to his grandson, Francis Eyre (d. 1827) who disposed of the house at public auction in 1805. The manor was purchased by Thomas Bradford of Ashdown Park, Sussex, Esq., who dismantled

the house in 1806 and sold the land in 1807 to James Smith of Berkhampsted (Baker 1922, pp. 739–41). It is presumed that just prior to the sale of the house in 1805 Francis Eyre removed the panels and reinstalled them in his residence of Hassop Hall, Derbyshire. The panels are recorded set into the bay window of the dining room and the staircase window at Hassop Hall in 1910. Previous to the acquisition by the DIA, the set of panels had been in the William Randolph Hearst Collection. P. W. French and Company, New York dealers, were the agents dealing with the Hearst estate. The panels were purchased in 1958 from the Hearst Foundation via French and Company with the funds from a gift of K. T. Keller. [DIA 54, 55, 57, 62 are in the British Galleries; DIA 58, 59, 60, 61 are in the Elizabethan Period Room; DIA 56 is in storage]

Related material/Panels in the same series: Arms of Anne Chetwode, Louisville Kentucky, J. B. Speed Museum, 33.31.23 (DIA 54–62/fig. 1); Arms of Sir Giles Bray and Anne Chetwode, Ibid., 44.31.24 (DIA 54–62/fig. 2) (Hayward in *Checklist* III, pp. 143–4).

Reconstruction: Two panels now in the J. C. Speed Museum, Louisville, Kentucky, showing the arms of Anne Chetwode née Knightly (*c.* 1555–1618) (DIA 54–62/fig. 1) and Sir Giles Bray (*c.* 1580–1641) and his wife Anne, née Chet-

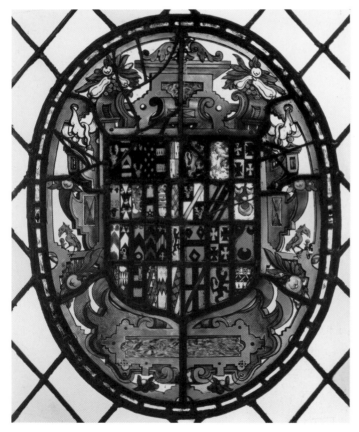

DIA 54–62/fig. 1. *Arms of Anne Chetwode, née Knightly*, from Warkworth Manor House, Northamptonshire, late 16th century. Louisville, Kentucky, J. B. Speed Museum

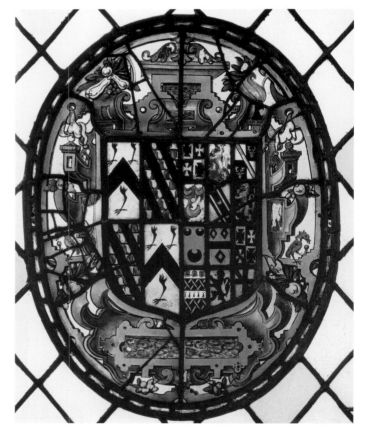

DIA 54–62/fig. 2. *Arms of Sir Giles Bray and Anne, née Chetwode*, from Warkworth Manor House, Northamptonshire, late 16th century. Louisville, Kentucky, J. B. Speed Museum

wode (DIA 54–62/fig. 2) are precisely the same dimensions and format (Baker 1922, p. 740). Anne, one of three daughters of Sir Richard Chetwode, married Sir Giles Bray of Barrington, county Gloucester. Her eldest brother, Richard Chetwode, who inherited the title, married Anne, eldest daughter and co-heir of Sir Valentine Knightly of Fawsley. The next Chetwode heir, Knightly, was evidently named after his maternal grandfather. It is highly probable that these Chetwode family panels were commissioned at the same time as the Detroit series. That the Detroit series was once larger is argued from the presence of stop-gap border sections from other panels in the same series. The panels with the arms of Anne Chetwode and Sir Giles Bray were not recorded in the survey of the Hassop House decoration, however. They may have been removed from Warkworth manor house in 1805 and given to another one of the Chetwode descendants before their purchase by the dealer Grosvenor Thomas, who owned them until 1913.

An example of the setting for which the panels were originally made can be found in extant Lancastrian and Tudor buildings in England such as Ockwells Manor (Berkshire) and Sutton Place (Surrey). Domestic building programs incorporated heraldic and figural programs that articulated the concerns of status as reflected in arms and heraldic display. Glass was essential to this atmosphere.

Ockwells Manor (DIA 54–62/fig. 3) was constructed shortly before 1467. The will of John Norreys of Ockswells, 4 April 1465, speaks of the building "not yet finished." He died in 1467 (Brown 1992, 93, ill.; "Country Homes and Gardens Old And New: Ockwells Manor," *Country Life*, 12 January, 1924. See also, ibid., 19 January, 1924). From an analysis of the heraldic devices, the array of glass was probably made between the years 1455 and 1460, when Henry VI was still king. The curving forms of the shields, the archaic depiction of crowns and helms, and the late medieval mode of mantling are very different from the Renaissance styles of the Tudor era. The display of a wide range of relationships, however, including powerful friends such as the bishop of Salisbury, duke of Somerset, Henry VI, and Queen Margaret of Anjou, as well as family members, is the same (*Country Life*, 19 January 1924).

The interest in glass as an obligatory decorative element of a building continued during the Tudor reign, but with newer, more progressive forms. The temporary palace built in 1520 by Henry VIII near the castle of Guisnes in the Pas-de-Calais for the Field of Cloth of Gold inspired a French commentator to write that *la moitié de la maison estoit toute de verrine* (half of the house was all in glass: Howard 1987, p. 51, fig. 24). The courtyard of Sutton Place built by Richard Weston in the 1520s must have

DIA 54–62/fig. 3. Great Hall, Ockwells Manor (Berkshire), shortly before 1467

been patterned after Henry's temporary structure in its extent of heraldic glass (Howard 1987, pp. 51–5, 78, figs. 43, 58, 59, 75, 77, 81). Much of the heraldic panels are happily extant, giving a means to appreciate the pervasive nature of heraldic badges both as decoration and as sign of presence or relationship.

Maurice Howard's survey of the furnishing of homes discovered very few easel paintings in Tudor inventories (Howard 1987, pp. 108–19). Imagery appeared much more carried by glass, tapestry, and wall painting, the architectural arts, arts difficult for us to appreciate today, given the dismantling or renovation of so many Renaissance structures. It is clear, however, that an increased market for heraldic imagery developed with the creation of a new courtier class under Henry VIII. With the creation of a new Tudor nobility and restructuring of the English Church following the 1536 Act of Dissolution, new types of buildings were necessitated. Often the new family seats developed from rehabilitation of the conventual buildings of the dissolved monasteries, such as Byron's estate at Newstead Abbey (Nottinghamshire), or William Wriothesley's manor house in the abandoned Premonstratensian Abbey of Titchfield (Hampshire) (Howard 1987, pp. 39–42, 149, 151–62, 206, 213, figs. 93–4, 99, col. pl. 5). The placement of heraldic glass in both manor house and palace and the increasingly complex system of display of arms of the Tudor period became a standard for later eras. In both the roof line of buildings, the increasingly richly articulated wall surfaces, such as the royal badges and supporters in King's College, and those in the chapel of Henry VII, Westminster Abbey, Tudor heraldic badges became both sign and pattern to their audience. With the death of Henry VIII, in addition, and the triumph of Reformation in many parts of northern Europe, glass painting was directed chiefly towards heraldic display.

Color/Technique: The panels are predominantly uncolored glass modulated by silver stain. In the surrounds the warm bright yellow of the silver stain is accented by touches of light blue to dark blue enamel, mostly all of a cool tone. The brilliance of the surrounds sets off the deeper values of the packed heraldic changes in the center of the panels. Red flashed and abraded glass and light bright blue enamel appear with some frequency as minor accents in the shields.

Style: The panels are similar to a several sets of heraldic panels now in the Philadelphia Museum of Art (Philadelphia, 52–90–30; 52–90–25 and 52–90–26; 52–90–29; 52–90–14; 52–90–15; 52–90–27 and 52–90–28: Morgan in *Checklist* II, pp. 175–8). Many of the arms are the same as those presented in the Detroit series but the particular configuration of the scroll work, fruit, and birds are not exactly duplicated. A panel in glass showing somewhat similar border design to the Detroit series, but originating in

Hertfordshire, Cassiobury House (Philadelphia Museum of Art, 52–90–14, Morgan in *Checklist* II, p. 177) bears the arms of Thomas Manners, Lord Ros (1492–1543) Earl of Rutland or a descendant. These arms also appear in Detroit (DIA 60). In both series one observes the same pattern of deteriorated blue enamel. The central rectangular crest in both series anchors the movement of the scrollwork which moves forward around the shield to create a three dimensional effect in the cartouche.

The nine panels, although dating from the late sixteenth century, reflect continental forms of about 1550. Such decorative framing was common to the era and appeared in furniture, architectural relief, and book illustration as well as glass. Tobias Stimmer's highly popular illustrations of sacred texts, or *Bilderbibel* (DIA 66/fig. 1), are but one example of the wide distribution of such Renaissance architectural motifs through printed forms. The introduction of the Italian style of the "architectural grotesque" in Northern Europe is usually attributed to Cornelis Floris after his trips to Rome, hence the term, the "Floris style." He produced two highly influential books of *Grotesque Ornaments and Tomb Designs* (*Veelderley Veranderinghe van grotissen. . .* of 1556 and *Veelderley niewe inuentien. . .* of 1557), both published by Hieronymus Coecke (*Ornament and Architecture: Renaissance Drawings, Prints and Books* [exh. cat. Brown University], Providence, 1980, pp. 54–7). Jan Vredeman de Vries, following Floris, was at some time affiliated with all the major publishers of the North and produced a great number of prints intermingling architectural and figural motifs (ibid., pp. 96–100; Alain Gruber, assisted by Bruno Pons, *L'Art décoratif en Europe*, Paris, 1, 1993, esp. pp. 347–432, "Cuirs et cartouches" by Margherita Azz-Visentini, Floris *c.* 1566, p. 403, and Vredeman de Vries *c.* 1565, p. 414). A border proba-

DIA 54–62/fig. 4. JAN VREDEMAN DE VRIES: Privilege page, *Excertitio Alphabetica*, 1568–9. New York, Cooper-Hewitt National Design Museum, Smithsonian Institution

bly devised by de Vries for the privilege page of *Excertitio Alphabetica* (DIA 54–62/fig. 4), 1568/9, shows such typical scroll work with fruit, animals, and figures. The patterns were also common in stained glass of the era, and de Vries was also a stained glass designer. Similar borders appear in a series of panels showing heraldic badges and the Story of Joseph from the hospital of St. Elizabeth in Lièrre now Musées Royaux d'Art et d'Histoire (Inv. No. 2017-III, etc., Helbig and Vanden Bemden 1974, pp. 154–64, fig. 135). Helbig and Vanden Bemden suggest that the six decorative panels dating to the mid-sixteenth century were probably all made at one time and that the several panels left with blank escutcheons were to receive a corporate of family crest at a later date (ibid., p. 162).

In the seventeenth century the new forms became a part of the everyday setting of rooms. Architects published books of furniture design to insure a stylistic unity to the interiors of their buildings. The craftspersons, who presumably included workshops of stained glass, could have a ready reference to designs that could be applicable to beds, tables, chests, mirror frames, and windows. See, for example, Paul Vredeman's *Verscheyden Schrywerck*, with its depiction of swags of fruit, cartouches, harpies, masks, and volutes applied to two beds (Paul Vredeman, *Verscheyden Schrynwerck (Plusiers Menuiseries)* in Peter Thornton, *Seventeenth-Century Interior Decoration in England, France and Holland*, New Haven, 1981, fig. 91). Similar motifs appear in stained glass.

Date: The series has as a terminus ante quem the sale of Warkworth manor house by the Chetwode family in 1620. Given the inclusion of two arms of Richard Chetwode, and the inclusion of his son's, daughter-in-law's, and daughter's arms as well, it is reasonable to suggest that the series was commissioned by Richard (1560–1635), or those closely associated with him. The architectural style of scrolled fantasies and three-dimensional treatment also point to a late sixteenth-century context.

Bibliography

UNPUBLISHED SOURCES: French & Co. Stock Sheets, items no. (1) 5684, (2) 5686, (3) 5691, (4) 5693, (5) 5685, (6) 5683, (7) 5695, (8) 5682, (9) 5690, photographs only; Hearst sale (not in 1941 Hammer Gallery catalogue) p. 9, S/B Lot 1427, Art. 205; heraldry researched by Nicholas Rogers, Cambridge, England; Virginia Raguin, "Stained Glass: Imports and Insular Products," paper given at the session, "Late Gothic and Renaissance Art During the Reigns of Henry VII and Henry VIII: England and Currents across the Channel," Alan Phipps Darr, organizer, College Art Association, 1991.

PUBLISHED SOURCES: Shaw 1909; Shaw 1910; George Baker, *The History and Antiquities of the County of Northampton*, 1, London, 1922, pp. 739–41; Raguin in *Checklist* III, pp. 170–73.

DIA 54. Arms of Henry Wriothesley, 2nd Earl of Southampton

Oval: 55.9 × 43.2 cm (22 × 17 in)
Accession no. 58.125, funds from a gift of K. T. Keller
Ill. nos. DIA 54, 54/a, 54–62/figs. 1–4

Condition: A small stopgap from the same series appears in the lower right surround. The ducal coronet does not appear in 1910 photographs of the Hassop Hall installation and must be a stopgap from the same series. Some loss of blue enamel appears in the shields. A complete restoration was carried on in fall 1987 by Mary Higgins of New York (DIA, Conservation Department files). The panel was totally releaded. Several copper-foil repairs were made in the coronet and several cracks edge-bonded in the lower surround.

Heraldry: Quarterly of 8: 1, Azure a cross between four falcons close or [*recte* argent] (Wriothesley); 2, Argent a fret within a bordure engrailed gules, on a canton gules a lion passant argent [*recte* or] (Dunstanvile); 3, Argent a pale fusilly gules, a border sable bezantée (Lushill); 4, Per pale indented gules and argent [*recte* azure] a lion rampant or (Drayton); 5, Argent a chevron between three martlets sable, a crescent or at fess point for difference (Croston); 6, Sable a chevron or between three crosses crosslet fitchy agent (Peckham); 7, Checky or and azure a fess gules fretty ermine (Cheney); 8, Argent a lion party per fess gules and sable armed and langued gules (Lovetot). Ensigned with a duke's coronet within a cartouche decorated with fruit and birds. For Hassop Hall placement see Shaw 1910, 201–2, pl. opp. p. 183.

The panel could be the arms of Henry Wriothesley, second Earl of Southampton (1545–81) who succeeded in 1550. The Wriothesley importance was established by Henry's father, who distinguished himself in the service of Henry VIII, being raised to the peerage as first earl of Southampton. Although he remained loyal to the Roman church, he nonetheless demonstrated sufficient zeal in Henry's cause to be granted the Premonstratensian Abbey of Tichfield (Hampshire) during the Dissolution of church lands begun with the 1536 Act of Suppression. He immediately converted the abbey into a residence, transforming the cloister into a courtyard and setting a great gate house in the middle of the nave with lodges built into the bays on the east and west. Contemporary accounts record the transformation: "Mr Wriothesley hath buildid a right stately house embatelid, and having a goodely gate and a conducte castelid in the middle of the court of it, in the same place wher the late monasterie of Premostratenses stoode caullyd Tichefelde" (*The Itinerary of John Leland in or about the Years 1535–1543*, ed. Lucy Toulmin Smith, 1, Carbondale, IL., 1964, p. 281; David Knowles, *The Religious Orders in England*, 3, Oxford, 1979, p. 386). The choir and

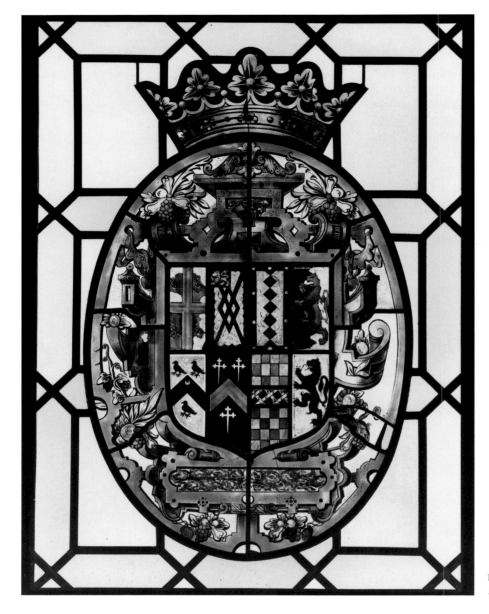

DIA 54/a. Restoration chart

DIA 54. *Arms of Henry Wriothesley,*
2nd Earl of Southampton

the transepts were pulled down, and later the tower. The reconstruction was almost finished by midsummer 1538. The house is now in ruins (W. H. St. John Hope, "The Making of Place House at Tichfield, near Southampton, in 1538," *Archaeological Journal*, 63, 1906, pp. 231–43). This was the home, then, that supported a continued Roman confession on the part of its earls. The second Earl was imprisoned from July 1570 to May 1573 during the reign of Elizabeth I for suspected complicity in the contemplated marriage of Queen Mary of Scots to the Duke of Norfolk. The arms could also refer to his son, Henry, the third Earl of Southampton (1573–1624), who was a distinguished soldier during the reign of James I (1603–25), dying of pestilence during a campaign at Bergen-op-Zoom, Holland (*Complete Peerage*, 12/1, pp. 126–30).

Photographic reference: DIA Neg. no. 31131 (1988/02/29); before restoration DIA Neg. no. 529506 (1986/01/18)

DIA 55. Arms of Clinton, 1st – 4th Earls of Lincoln
Oval: 55.9 × 43.2 cm (22 × 17 in)
Accession nos. 58.126, funds from a gift of K. T. Keller
Ill. nos. DIA 55, 54–62/figs. 1–4

Condition: The upper right segment of the surround is probably a stopgap from the same series. A complete restoration including total releading was carried on in fall 1987 by Mary Higgins of New York (DIA, Conservation Department files). The panel now conveys the original leading design of eight symmetrically placed divisions in the surround. Epoxy edge gluing was used in the crown and right half; some edge-gluing and copper foil in the left half.

Heraldry: Quarterly, 1 and 4 argent six crosses crosslet fitchy sable, three, two and one, on a chief azure two mullets

pierced or (Clinton, Earl of Lincoln) and 2 and 3 quarterly or and gules (Say, Baron Say). Ensigned with an earl's coronet within a cartouche decorated with fruit and birds. For placement of the window in bay window of dining room at Hassop Hall, see Shaw 1909, p. 201, pl. opp. p. 194.

These arms were born by four earls of Lincoln (from 1572 to 1667). Edward Clinton, otherwise Fiennes (1512–84/5) was a remarkable individual, having served successfully during the four radically different reigns of Henry VIII, Edward VI, Mary Tudor, and Elizabeth I. In 1569 he commanded the army that put down the great rebellion in the North, after which he took command of the fleet in the North Sea. He was rewarded by being created Earl of Lincoln in 1572 and a Lieutenant of the Order of the Garter in 1570 and again in 1573. His successors were less distinguished. Henry Clinton, the second earl, died in 1616. He served in a number of obligatory posts, such as

functioning as one of the nine earls judging the trial of Mary, Queen of Scots, but he is recorded to have been of an irascible, even unbalanced temperament. Thomas Clinton, the third earl, was born about 1568 and died 1618/19, holding the title for only three years. Among his eighteen children, a daughter, Lady Arabella Clinton, who married Isaac Johns, emigrated to New England with the expedition of John Winthrop in 1629 (whose arms are shown in DIA 65; Col. pl. 31), dying in Salem the following year. Another daughter, Lady Susan Clinton was also involved in the settlement of New England. Theophilus Clinton, the fourth earl, (1600–1667) was judge of the King's Bench and was engaged in the draining of the Lincolnshire Fens (*Complete Peerage*, 7, pp. 690–7).

Photographic reference: DIA Neg. no. 31131 (1988/02/29); before restoration DIA Neg. no. 29506 (1986/01/18)

DIA 55. *Arms of Clinton, 1st–4th Earls of Lincoln*

DIA 56. Arms of Russel, 2nd–4th Earls of Bedford

Oval: 68 × 43.2 cm (26¾ × 17 in)
Accession no. 58.128, funds from a gift of K. T. Keller
Ill. nos. DIA 56, 56/a, 54–62/figs. 1–4

Condition: Some repair leads and stopgaps from the same series appear in the upper central area and lower left sections of the surround. The 8th quarter of the shield is a stopgap. During the fall 1987 restoration campaign, the panel was removed from the modern window frame in which it had been set when it was acquired from French and Company.

Heraldry: Quarterly of 8: 1, Argent a lion rampant sable on a chief sable three escallops argent (Russell); 2, Barry of eight or and gules, a crescent gules in chief for difference (Muschamp of Barmoor); 3, Azure a tower embattled with a cupola argent (De la Tour); 4, Gules three herrings hauriant in fess argent (Herring); 5, Argent on a cross gules five mullets or (Seamark); 6, Sable three chevronels ermine, in dexter chief a crescent or for difference (Wise); 7, Sable three dovecotes argent in chief a mullet or for difference (Sapcotes); 8, Per pale azure and gules a lion rampant argent [stopgap] (Foxmore?) [This should be Argent a griffin segréant between three crosses crosslet sable] Ensigned with an earl's coronet within a cartouche decorated with fruit and birds. For placement in the bay window of Hassop Hall, see Shaw 1909, 195–6, pl. opp. p. 194.

The Earldom had been created in 1549/50 for John Russell, Baron Russell since 1538/9, an important member of the courts of Henry VIII and Edward VI. On the Dissolution of the monasteries in 1536 he obtained the

DIA 56. *Arms of Russel, 2nd–4th Earls of Bedford*

DIA 56/a. Restoration chart

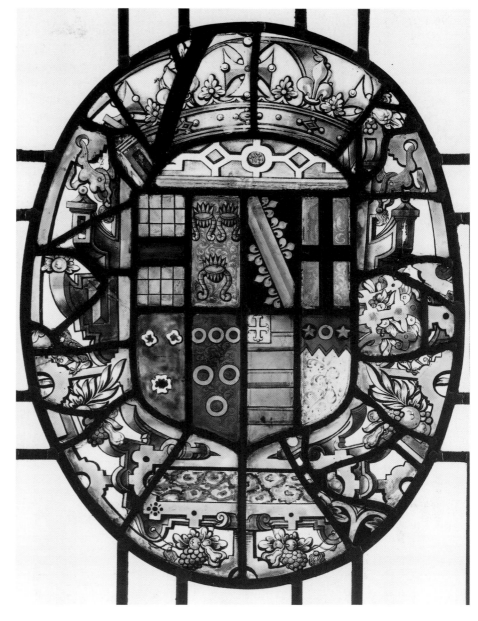

DIA 57. *Arms of Henry, Lord Clifford,
1st Earl of Cumberland or a Successor*

DIA 57/a. Restoration chart

abbeys of Tavistock and Dunheswull, both in Devonshire, as well as other lands. The arms represented could belong to three of his successors (1527–1641). Francis Russell, second Earl of Bedford (1527–85), was active in government as a soldier, ambassador and judge, founding two studentships of Divinity at University College, Oxford University. Edward, the third earl (1572–1627), was involved in the insurrection of the Earl of Essex in February 1600–1 for which he was briefly imprisoned. Francis, the fourth earl (1593–1641) was an impressive figure and an early advocate of individual liberties. In 1630 he took up the project of draining the fens of the counties of Northampton, Cambridge, Huntington, Norfolk, and Lincoln, the present level being known as the "Bedford level." His premature death prevented his being appointed Lord High Treasurer (*Complete Peerage*, 2, pp. 75–9).

Photographic reference: dia Neg. no. 29509 (1986/01/18)

DIA 57. Arms of Henry, Lord Clifford, 1st Earl of Cumberland or a Successor

Oval: 68 × 43.2 cm (26¾ × 17 in)
Accession no. 58.130, funds from a gift of K. T. Keller
Ill. nos. DIA 57, 57/a, 54–62/figs. 1–4

Condition: Stopgaps from the same series include all of the coronet, a central area of the right surround, and a few minor sections elsewhere. The decorative frieze above the shield is also stopgap. There is some loss of enamel throughout. A restoration campaign was completed in the summer of 1987 by the Thompson Glass Company of Novi, Michigan (DIA, Conservation Department files). A few mending leads were removed and replaced with edge-gluing repairs. Most of the many repair leads were simply replaced with new leads of the same thickness.

Heraldry: Quarterly of 8: 1, Checky or and azure a fesse gules (Clifford); 2, Azure three chain-shot or (Clifford Augmentation); 3, Sable a bend flory counterflory or (Bromflete); 4, Or a cross sable (Vesci); 5, Vert three flintstones argent with centers sable (Flint); 6, Gules six annulets or three, two and one (Vipont); 7, Barry of seven or and azure, on a canton gules a cross flory argent [*recte* gules] (Aton); 8, Argent on a chief indented gules an annulet or between two ogresses each charged with a mullet or (St. John); within a cartouche decorated with fruit. For placement of the glass at Hassop Hall, see Shaw 1910, pp. 206–7, pl. opp. p. 183.

Henry Clifford (1493–1542), the first Earl of Cumberland, was an important member of government during the reign of Henry VIII and on the Dissolution of the monasteries in 1536 received large grants of land in Yorkshire. His son Henry Clifford (c. 1518–69/70), became the second earl. His son, George Clifford, the third earl, was educated as Trinity College, Cambridge and was a mathematician and navigator, conducting nine voyages, mostly to the West Indies. In 1592 he was inducted into the Order of the Garter. On his death the line then passed to Francis Clifford (1559–1640/1), the younger son of the second earl, shortly after to devolve upon his son, Henry Clifford (1591–1643) fifth Earl of Cumberland who was schooled at Oxford and served in several Parliaments. On this last earl's death the Earldom of Cumberland became extinct (*Complete Peerage*, 3, pp. 566–9).

Photographic reference: dia Neg. no. 31200 (1988/02/29); before restoration DIA Neg. no. 29511 (1986/01/18)

DIA **58. Arms of Sir Edward Seymour, Earl of Hertford, Duke of Somerset**

Oval: 68 × 43.2 cm (26¾ × 17 in)
Accession no. 58.131, funds from a gift of K. T. Keller
Ill. nos. DIA 58, 58/a, 54–62/figs. 1–4

Condition: The arms of Williams are restored since 1919. There are some repair leads and minor stopgaps from the same series throughout. A central sliver of the coronet is missing.

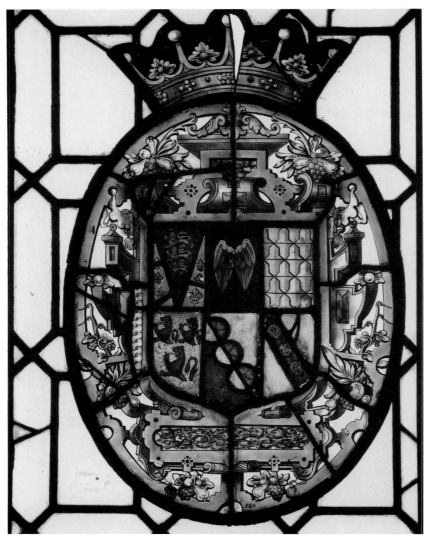

DIA 58. *Arms of Sir Edward Seymour, Earl of Hertford, Duke of Somerset*

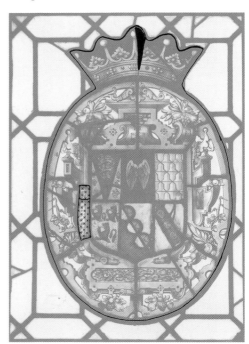
DIA 58/a. Restoration chart

Heraldry: Quarterly of 6: 1, Or on a pile gules between six fleurs-de-lis azure three lions passant guardant or (Seymour Augmentation); 2, Gules two wings conjoined in a lure or (Seymour); 3, Vair (Beauchamp of Hache); 4, Azure three demi-lions rampant gules (Esturmy); 5, Per bend argent and gules three roses bendways counterchanged (Williams [restored since 1909] Shaw (1909, p. 213) notes that at that time the charge was an incorrect insert showing argent a chevron or); 6, Argent on a bend gules three lion's faces or (Coker); Ensigned with an earl's coronet within a cartouche decorated with fruit and birds. Compare the arms with those borne by Edward Seymour on a seal used in 1544 (William de Gray Birch, *Catalogue of Seals*, 3, London, 1894, p. 504, no. 13424, differing in 3rd quarter, Sturmy, and 5th quarter, MacWilliams). For placement in the bay window of Hassop Hall, see Shaw 1909, p. 213, pl. opp. p. 194.

Edward Seymour was the first Duke of Somerset (c. 1500–1551/2) and gained great prominence, including the augmentation to his arms (first quartering), when his sister, Lady Jane Seymour, became the third wife of King Henry VIII. In 1537 Lady Jane gave birth to the future Edward VI, Henry's only male heir. The same year Edward was made Earl of Hertford. When Edward succeeded his father at the age of nine, Somerset became Lord Protector. He later fell out of favor and was beheaded in 1552 during the final years of Edward's brief reign (1546–53) (*Complete Peerage*, 6, p. 504, and 12/1, pp. 59–65).

Photographic reference: DIA Neg. no. 29512 (1986/01/18)

DIA 59. Arms of Sir John Talbot, 2nd Earl of Shrewsbury or a Successor

Oval: 68 × 43.2 cm (26¾ × 17 in)
Accession no. 58.132, funds from a gift of K. T. Keller
Ill. nos. DIA 59, 59/a, 54–62/figs. 1–4

Condition: The arms of Talbot in the 1st quarter were restored since 1909, and those of Marshall in the 11th quarter since 1910. Many repair leads appear throughout. Stopgaps from the same series are numerous in the right side of the surround.

DIA 59. *Arms of Sir John Talbot, 2nd Earl of Shrewsbury or a Successor*

DIA 59/a. Restoration chart

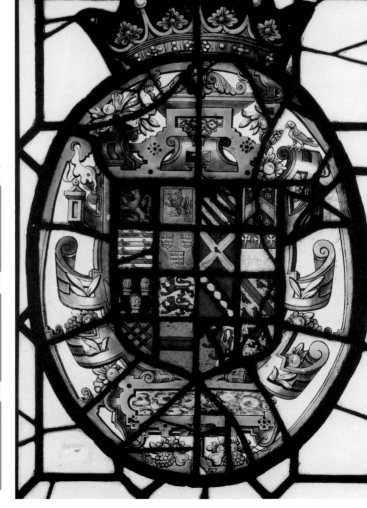

Heraldry: Quarterly of 16: 1, Gules a lion rampant or (Talbot [restored since 1909]) [*recte* Gules a lion rampant within a bordure engrailed or]; 2, Azure a lion rampant within a bordure or (Montgomery); 3, Bendy of ten argent and gules (Talbot Ancient); 4, Gules a chevron between ten crosses paty argent (Berkeley) within a bordure argent [This quartering should be gules three garbs within a double tressure flory counterflory or (Comyn)]; 5, Barry of ten argent and azure ten martlets in orle gules (Valence); 6, Or three escutcheons barry of seven vair and gules (Montchensy); 7, Gules on a saltire argent a martlet sable (Neville); 8, Argent on a chief azure three crosses paty fitchy argent (Clare); 9, Sable three garbs argent (Mc-Morogh); 10, Argent two lions passant in pale gules (Strange); 11, Gules on a bend sable five lozenges conjoined in bend or (Marshall [restored since 1910]); 12, Argent a bend between six martlets gules (Furnival); 13, Or a fret gules (Verdon); 14, Or a fess gules (Lacy); 15, Per pale or and vert a lion rampant gules (Bigod); 16, Argent a lion rampant gules armed and langued azure [*recte* Argent a lion rampant party per fess gules and sable armed and langued azure] (Lovetot). Ensigned with an earl's coronet within a cartouche decorated with fruit and birds. For placement in the staircase window of Hassop Hall, see Shaw 1910, pp. 202–4, pl. opp. p. 182.

The Earls of Shrewsbury were some of the most important peers of England. The earldom was created in 1442 in gratitude for the distinguished service given by John Talbot, Lord Furnivalle, (1384–1453) during the Hundred Years War between England and France. His son, John (1413–60) was made a Knight of the Order of the Garter in 1457. The third earl, John was born in 1448 and died in 1473 at the age of 24. George Talbot, the fourth earl, lived from 1468 to 1538, achieving a distinguished career during the reign of Henry VIII. The Earl of Shrewsbury guarded the royal insignia of the queen. His successors, in general, achieved similarly distinguished careers (*Complete Peerage*, 11, pp. 698–717).

Photographic reference: DIA Neg. no. 529513 (1986/01/18)

DIA 60. Arms of Thomas Manners, Earl of Rutland or a Successor
Oval: 55.9 × 43.2 cm (22 × 17 in)
Accession no. 58.133 funds from a gift of K. T. Keller
Ill. no. DIA 60, 54–62/figs. 1–4

Condition: Some repair leads appear in the surround. The earl's coronet is missing.

Heraldry: Quarterly of 16: 1, Or two bars azure a chief quarterly azure and gules, the first and forth quarters each charged with two fleurs-de-lis or the second and third each charged with a lion passant guardant or (Manners, with Augmentation). The augmentation was granted to Thomas Manners, Lord Ros, on his creation as earl of Rutland in 1525; 2, Gules three water-bougets argent (Ros); 3, Gules three cart-wheels argent (Espec); 4, Azure a catherine wheel or (Trusbut); 5, Or a fess between two chevrons sable (Lisle); 6, Gules a chevron between ten crosses paty, six in chief and four in base, argent (Berkeley); 7, Checky or and azure a chevron ermine (Newburgh); 8, Gules a fess between six crosses crosslet or (Beauchamp); 9, Or a lion rampant gules (Charlton); 10, Argent a saltire engrailed gules (Tiptoft, Earl of Worcester); 11, Gules three lions passant guardant or within a bordure argent (Holland, Earl of Kent); 12, Gules a lion passant guardant argent crowned or (L'Isle, Baron de l'Isle); 13, Argent a fess between two bars gemelles gules (Bradlesmere); 14, Checky argent and gules (Vaux); 15, Or on a chief sable three martlets or (Owgan); 16, Or two chevrons within a bordure gules (D'Albini). Within a cartouche decorated with fruit and birds.

Thomas Manners (1494–1543) was named Knight of the Order of the Garter and created Earl of Rutland by Henry VIII in the same year, 1525. His son Henry Manners, the second earl, was born in 1526 and died of the plague in 1563 at the age of 37. He was made a Knight of the Garter in 1559. The third earl, Edward Manners, was educated at Cambridge and Oxford. When he died in 1587 at the age of 38, his title then passed to his younger brother, John Manners, who died less than a year later. The fifth earl, Roger Manners (1576–1612), took part in the insurrection of the Earl of Essex for which he was imprisoned and fined. His lands were restored to him by James I in 1603. He married Elisabeth Sidney, daughter and heir of the famous poet and soldier Sir Philip Sidney. The sixth earl Francis Manners (1578–1632) was brother to the young Roger. He was made Knight of the Order of the Garter in 1616. Upon his death the title passed to his brother George (1580–1641) who became the seventh earl (*Complete Peerage*, 11, pp. 252–63).

Photographic reference: DIA Neg. no. 29514 (1986/01/18)

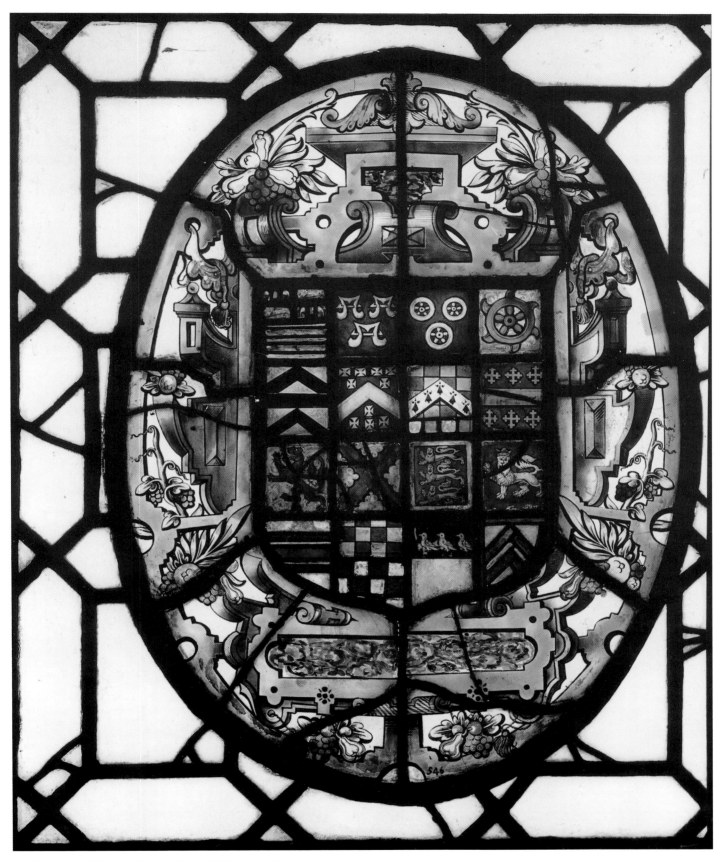

DIA 60. *Arms of Thomas Manners, Earl of Rutland or a Successor*

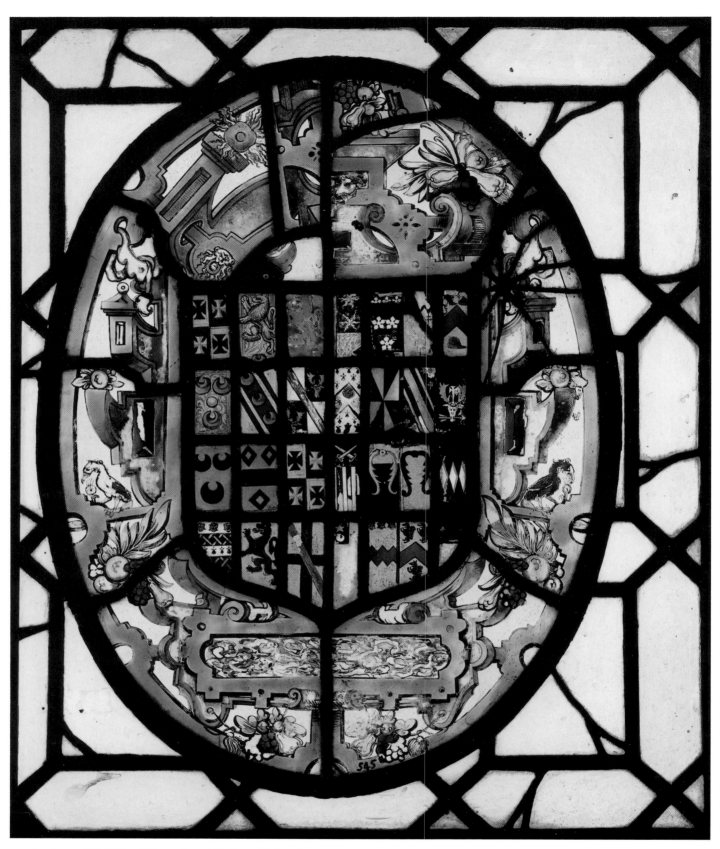

DIA 61. *Arms of Sir Richard Chetwode and his first wife, Jane Drury*

DIA 61. Arms of Sir Richard Chetwode (1560–1635) and his first wife, Jane Drury

Oval: 55.9 × 43.2 cm (22 × 17 in)
Accession no. 58.134, funds from a gift of K. T. Keller
Ill. nos. DIA 61, 61/a, 54–62/figs. 1–4

Condition: The left upper segment of the surround is composed of stopgaps from the same series. On the right, a small segment at the top is also a stopgap from the same series and one segment is badly cracked and repaired with numerous mending leads.

Heraldry: Quarterly of 12: 1 and 9, Quarterly argent and gules four crosses paty counterchanged (Chetwode); 2, Azure a lion rampant argent [*recte* langued gules], in base a crescent or (Crew); 3, Purpure a lion rampant or (Sounde); 4, Azure a plate between three crescents or (Ree); 5, Argent on a bend cotised gules three crescents or (Rowley); 6, Quarterly argent and sable in the second and third quarters a stag's head caboshed or over-all a bendlet gules (Henhull); 7, Or three crescents gules (Wodhull); 8, Or a fess between three mascles pierced gules (Hockley); 10, Sable fretty or a fess ermine on a chief argent three lion's faces gules (Okeley); 11, Argent a lion rampant gules armed and langued azure (Lyons); 12, Argent a cross gules, over-all a bend azure (Newham); Impaling Quarterly of 16: 1, Argent on a chief sable two estoiles argent (Drury of Edgerly, Bucks); 2, Sable six cinquefoils argent three, two and one (Freschill); 3, Argent six crosses crosslet fitchy gules three, two and one, a chief indented azure (Saxham); 4, Argent a chevron gules between three chapeaux azure, their points to the sinister (Brudenell); 5, Ermine on a chevron gules three escallops or (At Grove); 6, Gyronny of eight or and sable (Raans); 7, Sable a bend cotised between six crosses crosslet fitchy or (Blakett); 8, Sable a stag's head caboshed argent attired or, between the attires a cross paty

DIA 61/a.
Restoration chart

fitchy argent, through the nostrils an arrow or feathered argent (Bulstrode); 9, Paly of six argent and azure, on a chief sable two swords in saltire argent, hilts or (Knyffe); 10, Per fess argent [*recte* azure, blue possibly abraded] and gules a horse barnacle argent (Wyat of Sherwell, Devon and Bexley, Kent); 11, Argent a barnacle gules (Barnack); 12, Sable three fusils conjoined in fess argent (Thorne); 13, Argent four cinquefoils gules one, two and one, on a canton sable a crescent argent and a mullet or (for difference? possibly a branch of Driby); 14, Argent a fess dancetty gules in chief three lion's faces sable (Pulteney); 15, Argent a chevron gules between three squirrels sable (Shobington); 16, Argent on a chief vert two mullets or (Drury), differenced by a crescent at fess point. Within a cartouche decorated with fruit and birds.

The first marriage of Sir Richard Chetwode (1560–1635) was to Jane Drury, eldest daughter and co-heir of Sir William Drury of Edgerley, Buckinghamshire (Baker 1922, p. 740).

Photographic reference: DIA Neg. no. 529515 (1986/01/18)

DIA 62. Arms of Sir Richard Chetwode and his second wife, Dorothy Needham

Oval: 68 × 43.2 cm (26¾ × 17 in)
Accession no. 58.129, funds from a gift of K. T. Keller
Ill. nos. DIA 62, 54–62/figs. 1–4

Condition: In the shield to sinister, the eighth quarter is a non-heraldic stopgap; the sixth is leaded upside down. In the shield to dexter, the fourth quarter is upside down. A complete restoration was carried out in fall 1987 by Mary Higgins of New York. (DIA, Conservation Department files). The panel was totally releaded. The numerous mending leads in both the shield and the surround were removed and replaced with epoxy edge-bond repairs.

Heraldry: Quarterly of 12: 1 and 9, Quarterly argent and gules four crosses paty counterchanged (Chetwode); 2, Azure a lion rampant argent [*recte*, langued gules], in base a crescent or (Crew); 3, Purpure a lion rampant or (Sounde); 4, Azure a plate between three crescents or (Ree) [upside down]; 5, Argent on a band cotised gules three crescents or (Rowley); 6, Quarterly argent and sable in the second and third quarters a stag's head caboshed or over-all a bendlet gules (Henhull); 7, Or three crescents gules (Wodhull); 8, Or a fess between three mascles pierced gules (Hockley); 10, Argent on a chevron sable three quatrefoils or (Eyre); 11, Argent a lion rampant gules armed and langued azure (Lyons); 12, Argent a

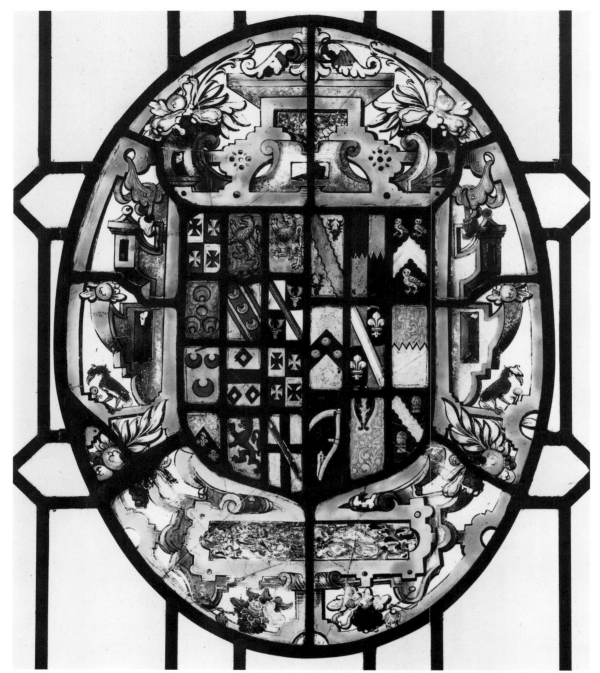

cross gules, over-all a bend azure (Newham); Impaling Quarterly of 9: 1, Argent a bend engrailed azure between two stag's heads caboshed sable (Needham); 2, Quarterly per fess indented or and gules (Bromley); 3, Sable a chevron engrailed between three owls argent (Hewit); 4, Argent on a chevron gules three bezants (Chetleton); 5, Quarterly gules and sable in the second and third quarters a fleur-de-lis argent, over-all a bendlet argent (Hextall); 6, Per fess indented azure and argent [upside down] (Acton); 7, Gules a scythe in pale argent (Praers); 8, Or in chief (?) two wings in a lure sable [non-heraldic stopgap; this should apparently be Argent a garb vert (Shaw 1910,

p. 206)] ; 9, Gules a bend engrailed between two garbs or (Walworth). Within a cartouche decorated with fruit and birds. For placement in the staircase window of Hassop Hall, see Shaw 1910, pp. 195–200, pl. opp. p. 183.

Sir Richard Chetwode (1560–1635) took as his second wife Dorothy Needham daughter of Robert Needham of Shavington, Cheshire (*Case of Mrs. Constantia Elizabeth Chetwood-Aiken (Widow) on her claim to the dignity of Baroness de Wahull in the Peerage of England in Fee*, London, 1891, pedigree, pt. 3, opp. 1: *Complete Peerage*, 12, p. 294).

Photographic reference: DIA Neg. no. 31172 (1988/02/ 29); before restoration DIA Neg. no. 29510 (1986/01/18)

DIA 63–64. TWO HERALDIC PANELS COMMEMORATING THE MARRIAGE OF CHARLES VIII OF FRANCE AND ANNE OF BRITTANY AND THE TREATY OF SABLÉ, 1490
Germany or Switzerland?
Late sixteenth or early seventeenth century

History of the glass: The panels were in the possession of John W. Palmer of New York before 1923. In the auction catalogue of Palmer's collection, the panels were identified as French, fifteenth century, and attributed to Nicholas Desangives, "famous French Glass painter, Paris 1462–1541." At some time later they entered the collection of William Randolph Hearst of Los Angeles. They were purchased by the DIA in 1958 from William Randolph Hearst and the Hearst Foundation, with the funds provided by a gift from K. T. Keller. [In storage]

Iconographic program: The panels commemorate the treaty of Sablé of 1490, by which Charles VIII, king of France (1483–98) married Anne of Brittany the following year, thereby annexing the duchy of Brittany to the French crown. The marriage defied two previous contracts. Charles had been betrothed to the daughter of Maximilian of Austria, who declared war on France in 1490. Maximilian was elected Holy Roman Emperor in 1493, a position he held until his death in 1519 when he was succeeded by his grandson Charles V. Anne, in turn, had been betrothed to Maximilian. Charles and Anne left no children and at his death, the crown passed to Charles's cousin, the Duke of Orleans, who succeeded as Louis XII. Louis then married Anne to insure that Brittany remain linked to France.

Technique: The inscriptions, crown, and collar are composed of uncolored glass treated with vitreous paint and silver stain. Pot-metal colors are confined to the backgrounds and shields.

Style: The panels' attribution to Nicolas Desangives (*Palmer* sale 1923, nos. 27 & 48) appears to be without foundation. Nicolas Desangives (1462–1541) was one of the French Renaissance artists mentioned in the early literature on stained glass. The modern tendency to value objects only when assigned to an artistic personality contributed to the common association of panels in commerce with any number of plausible authors. Desangives's name appears in the earliest modern surveys beginning with Le Vieil who emphasised biographical details and included a monogram of the letters N D F superimposed for *Nicholas Desangives Fecit* (Pierre Le Vieil, *L'Art de la peinture sur verre et de la vitrerie*, Paris, 1774, p. 65). Ottin devoted a number of pages to Desangives and attributed windows primarily in the Parisian area to the master

(Louis Ottin, *Le Vitrail. Son histoire, ses manifestations à travers les âges et les peuples*, Paris, 1896, pp. 329–31). Werck, who rarely included qualifications to the list of artists at the end of his text, called Desangives a "très célèbre peintre-verrier français (1465–1551)," responsible for the glass at St. Paul, Paris, and St. Denis, Paris (Alfred Werck, *Stained Glass, A Handbook on the Art of Stained and Painted Glass, Its Origin and Development from the Time of Charlemagne to Its Decadence, 850–1650*, New York, 1922, p. 141). Research of the notary archives by Guy-Michel Leproux (1988, p. 124), however, has failed to uncover the name of Desangives on contracts of Parisian commissions or in the member lists of the master glass painters of Paris.

The early texts, however inaccurate they now appear, furnished a mine of possible attributions for a dealer in stained glass. The style of the inscriptions of the Detroit panels, however, is inconsistent with glass painted from the early sixteenth century in France or attributions to Desangives. Rather, the style suggests a Swiss or German origin for the panels.

Date: The lettering and format of the panels suggest a late sixteenth or early seventeenth-century date.

Bibliography
UNPUBLISHED SOURCES: Nicholas Rogers, Cambridge, England, communication with author.

PUBLISHED SOURCES: *The Collection of Stained Glass Panels by XV and XVI Century Artists Assembled by the late John W. Palmer* [sale cat., American Art Galleries, Inc., 17 December, Paris, 1923], n. p., no. 27 (1), no. 48 (2); Raguin in *Checklist* III, p. 167.

DIA 63. Heraldic Panel commemorating the marriage of Charles VIII of France and Anne of Brittany and the Treaty of Sablé, 1490
Oval: 43.5 × 36.5 cm (17⅛ × 14⅜ in)
Accession no. 58.95, Gift of Mrs. Edsel B. Ford
Ill. nos. DIA 63, 63/a

Inscriptions: (top) *Mont Ioye S. Denis* and (on flanking scrolls) *Anno Dni/ MCCCXC compo. v.j.*; (at base) *Insign regu o [.]pido[.]u francoru* (Mount Joy and Saint Denis; the year of our Lord 1490; the motto is a part of the insignia of the King of the France)

Condition: The panel is substantially intact with minor stopgaps or replacements, such as the fleur-de-lis on the upper left. The are substantial repair leads, however, marring somewhat the clarity of the design.

Heraldry: (Center) Azure, three fleurs-de-lis or (France Modern) surrounded by the collar of the Order of St. Michael and ensigned with a closed crown.

(Borders, from dexter base) Argent a cross azure (Noyon); gules a fleur-de-lis or (Soissons); gules three cinquefoils or pierced argent on a chief azure three fleurs-de-lis or (town of Orleans); gules three keys in fess or (town of Avignon); or a lion rampant sable (Flanders); azure three towers or (possibly the arms of Tournon, which are three towers argent). The shield was incorrectly identified as Angers in the description of the panel in the Palmer collection catalogue.

Color: The panel is dominated by the warm harmonies of deep to pale and dull to bright pot-metal and silver stain yellows playing off the whites of the inscription segments. The bright warm purple red (murrey) of the background echoes the warm tonality of the yellows. The deep blue of the central shield as well as the cooler deep red and deep blue accents in the surrounding shields serve as foils against this warm tonal balance.

Photographic reference: DIA Neg. no. 29498 (1986/01/ 18)

DIA 64. Heraldic Panel commemorating the marriage of Charles VIII of France and Anne of Brittany and the Treaty of Sablé, 1490

Oval: 44 × 36 cm ($17\frac{5}{16}$ × $14\frac{3}{16}$ in)
Accession no. 58.118, Gift of K. T. Keller

Ill. nos. DIA 64, 64/a

Inscriptions:

(top) *Mont Ioye S. Denis* and (on flanking scrolls) *Anno dni/ M ccccxc compo. v.J.*; (at base) *Insign regu [.]pido[.]u francoru* (Mount Joy and Saint Denis; the year of our Lord 1490; the motto is a part of the insignia of the King of the France)

Condition: The panel demonstrates a more problematic condition than its companion does. There are substantial stopgaps and replacements including most of the inscrip-

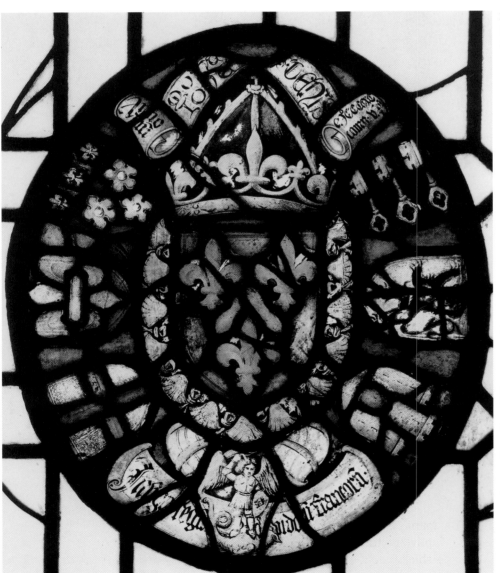

DIA 63. *Heraldic Panel commemorating the marriage of Charles VIII of France and Anne of Brittany and the Treaty of Sablé, 1490*

DIA 63/a. Restoration chart

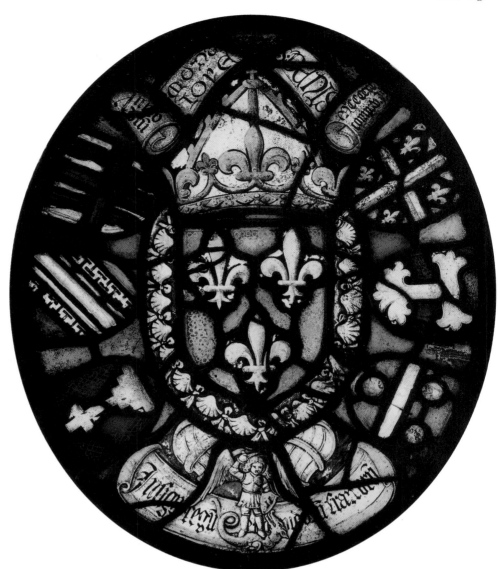

DIA 64. *Heraldic Panel commemorating the marriage of Charles VIII of France and Anne of Brittany and the Treaty of Sablé, 1490*

DIA 64/a. Restoration chart

tions. The inscriptions appear to have been painted on old stopgap thus arguing that the restorer was in possession of the first panel and used it as a basis for completing a damaged complement.

Heraldry: (Center) Azure, three fleurs-de-lis or (France Modern) surrounded by the collar of the Order of St. Michael and ensigned with a closed crown.

(Borders, from dexter base) Gules a cross calvary or (unidentified) [the shield had been incorrectly identified as Peronne in the description of the panel in the Palmer collection catalogue]; azure a bend sinister argent cotised potent-counterpotent or (Champagne); argent [rect or] a cross between four keys in pale gules (Beauvais); azure a cross argent between four fleurs-de-lis or (Châlons-sur-Marne); gules a tau cross flory or (Toul); azure a fess argent between three bezants (Cherbourg?).

Color: The panel is less unified than its companion. The bright warm green background is more disruptive, isolating rather than integrating the surrounding shields with and the central coat of arms. The panel appears to evenly distribute attention among elements of bright to dull green, red, and blue, rather than attempting to blend colors into a frame for the central shield.

Photographic reference: DIA Neg. no. 24499 (1986/01/18)

DIA 65. Arms of John Winthrop of Groton and Thomasine Clopton

England, Suffolk, Groton (Manor House ?)
c. 1615
Oval: 68.6 × 38.1 cm (27 × 15 in)
Accession no. 58.127, funds from a gift of K. T. Keller
Ill. nos. DIA 65, 65/a; 65/fig. 1; Col. pl. 31

History of the glass: J. J. Muskett (1900, 1, p. 1) refers to "several fragments of ancient glass with Winthrop Arms, which are believed to have come from the Church or Manor House" at Groton, Suffolk. These may be connected to the panel now in the Detroit Institute of Arts.

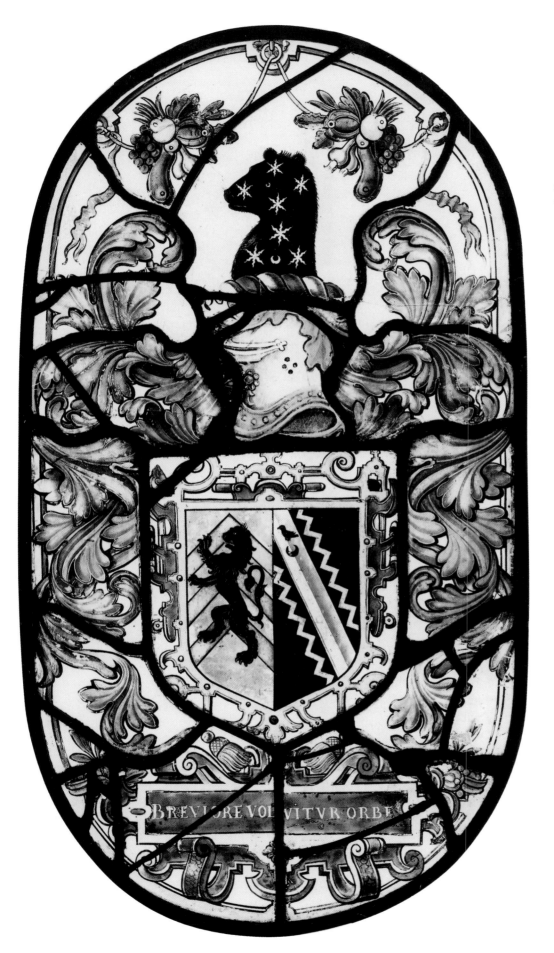

DIA 65. *Arms of John Winthrop of Groton and Thomasine Clopton*

DIA 65/a. Restoration chart

Previous to the acquisition by the Detroit Institute of Arts, the panel had been in the William Randolph Hearst Collection. It was purchased in 1958 via the agency of French & Co., New York, from the Hearst Foundation with the funds from a gift of K. T. Keller. [British Galleries]

Bibliography

UNPUBLISHED SOURCES: French & Co. Stock Sheets, item no. 5692, photograph only; Hearst sale (not in 1941 Hammer Gallery catalogue): A: p. 9, S/B Lot 1427, Art. 205; heraldry researched by Nicholas Rogers, Cambridge, England.

PUBLISHED SOURCES: Muskett 1900, I, p. 1; Raguin in *Checklist* III, p. 170, col. pl. p. 24.

Inscription: *BREVIORE VOVITVR ORBE* (devoted to smaller sphere of influence).

Condition: The panel retains almost all of its original glass except for minor stopgap replacements, as noted. The mending leads, however, mitigate the overall legibility of the design. In addition, there is some loss of paint especially in the reddish-brown enamel of the mantling. In the summer of 1987, the panel was restored by the Thompson Glass Company of Novi, Michigan (DIA, Conservation Department files). The process involved releading the panel and eliminating a number of mending leads and substituting edge-bond repairs. The edge-bond repairs are most numerous in the upper sections of the panel in the section containing the crest and mantling immediately to the left and right as well as the lower right third of the panel.

Heraldry: Argent three chevrons or, over-all a lion rampant sable (Winthrop of Groton); impaling sable a bend argent between two cotises dancetty or, differenced with a martlet and a crescent sable at dexter chief (Clopton); helm with torse azure and or and mantling gules lined with argent; Crest: A bear's head sable semy of estoiles or, differenced with a crescent or at middle base.

John Winthrop of Groton, Suffolk (1587–1649) took in a second marriage Tomasine Clopton, daughter of William Clopton of Castleins, Suffolk, on 6 December 1615. John Clopton, an ancestor, is known from his rebuilding of the church of Long Melford around 1480–1500 with extensive personal inscriptions and family heraldry, especially in the Clopton Chapel to the north of the chancel (Eamon Duffy, *Stripping of the Altars*, New Haven, 1992, pp. 97–8, pl. 8). Thomasine died, however, after having given birth to a child, little more than a year later, 8 December 1616. She and the child were buried in the chancel of Groton Church, next to Winthrop's first wife. Musket (1900, I, p. 26) shows the pedigree of Winthrop of Boston and a copy of Tomasine's marriage settlement of 1615 (ibid., pp. 22–3). A moving account, deeply informed by religious sentiments, of Tomasine's last days was recorded by her husband: "the day before was 12 months she was married

to me & now this day she should be maried to Cht Jesus, who would embrace her wth another manner of love than I could" (Robert C. Winthrop, *Life and Letters of John Winthrop*, Boston, 1869, I, p. 88).

John Winthrop's career was distinguished. He studied at Trinity College, Cambridge, and his early years were spent in the practice of the law and in the management of the family estate of Groton Manor. His Puritan tendencies led him to become interested in the colonization of the New World. After converting his hereditary estate to a cash income of £600–700, he sailed in the *Arabella* from Yarmouth with some 900 fellow colonists, arriving in Salem, Massachusetts, in June 1630. He served as governor of the Massachusetts Bay Colony from 1630 to 1634. In the following years he served either as governor or deputy governor and during the last three years of his life, 1646–49, he held the governor's office. His third wife Margaret, whom he married on 29 April 1618, was the daughter of Sir John Tyndal of Great Maplested, Essex. She accompanied him to the colonies and died in Boston on 14 June 1647. The Governor took as his fourth wife, Martha, daughter of Captain William Rainsborough and widow of Thomas Coytmore of Boston in December 1647 (Musket 1900, I, p. 26). Withrop's son, also called John (1606–1676), was the son of his first marriage and also distinguished. After a career in the army, John joined his father in Massachusetts in 1631. Skilled in law, science, and diplomacy, he eventually founded settlements further south and served almost continually from 1657 to the end of his life as governor of Connecticut (Leslie Stephen and Sidney Lee, eds., *The Dictionary of National Biography*, 21, Oxford, 1900, repr. 1965, pp. 769–803).

Color: Soft neutral tones predominate. With the exception of the bear's head, the black of the sinister side of the shield and the striking blue inscription panel, soft gray, reddish brown, and yellow silver stain are the most commonly occurring colors. The exploitation of the mantle and its lining to develop an undulating color contrast is particularly effective. The enamel details of green, blue, and violet in the fruit clusters form minor accents at the top and bottom of the work.

Technique: The panel is almost exclusively uncolored glass modulated by silver stain and enamel. The shield has red flashed and abraded glass in the dexter half.

Style: One can compare the style and composition of the arms with a slightly earlier panel now in the Victorian and Albert Museum. The Arms of Edward Lucas (DIA 65/fig. 1) originally from Filby Hall, Norfolk, dated 1582, is less complex than that of the Arms of Winthrop, but displays the same design elements (Christopher Woodforde, *English Stained and Painted Glass*, Oxford, 1954, p. 40, fig. 47). A narrow border of scrollwork frames the entire oval panel. The shield appears to float in the midst of highly

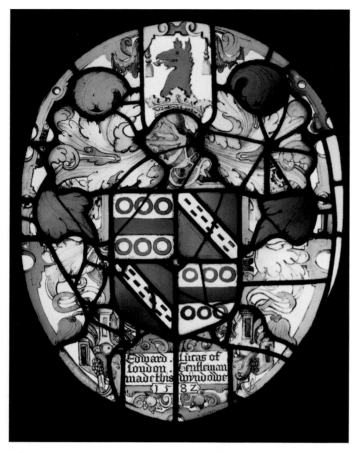

DIA 65/fig. 1. *Arms of Edward Lucas*, from Filby Hall, Norfolk. London, Victoria and Albert Museum

dynamic play of mantling. The great curving tendrils undulate to reveal their richly colored lining. The crest is a similar unmodeled silhouette and the inscription panel is framed by similar architectural scroll work and clusters of fruit.

Date: As the arms correspond to the marriage of Winthrop and Clopton, it is reasonable to see the panel dating from that year, 1615, or just before Thomasine's death a year later.

Photographic reference: DIA Neg. no. 31199 (1988/02/29); before restoration DIA Neg. no. 29508 (1986/01/18)

DIA 66. Heraldic Panel with Shipping Image

Alsace, circle of Barthomäus Lingg the Younger?
1620
Rectangle: 42 × 32.4 cm (16½ × 12¾ in)
Accession no. 23.8, Gift of George G. Booth
Ill. nos. DIA 66, 66/a, 66/fig. 1

History of the glass: George G. Booth, Bloomfield Hills, purchased the panel from Theodor Fischer, Lucerne, on 18 March 1922 and presented it to the Detroit Institute of Arts in 1923. The panel was part of a lot of twelve sold to Booth, "all positively guaranteed Antique quality more than 150 years old" (Cranbrook Archives, transcription of Fischer invoice and notations in George G. Booth's 1922 notebook). This panel was one of two in this lot not from the collection of Lord Sudeley, Toddington Castle, Gloucestershire. Booth appears to have given the more artistically sophisticated panels to the Museum and installed the rest in his home in Bloomfield Hills, now Cranbrook House. [Italian Galleries]

Bibliography

UNPUBLISHED SOURCES: Cranbrook Archives, notebook of George G. Booth, entry of 20/3/1922; Sibyll Kummer-Rothenhäusler of Zurich and Barbara Giesicke, letters and verbal communication.

DIA 66/a. Restoration chart

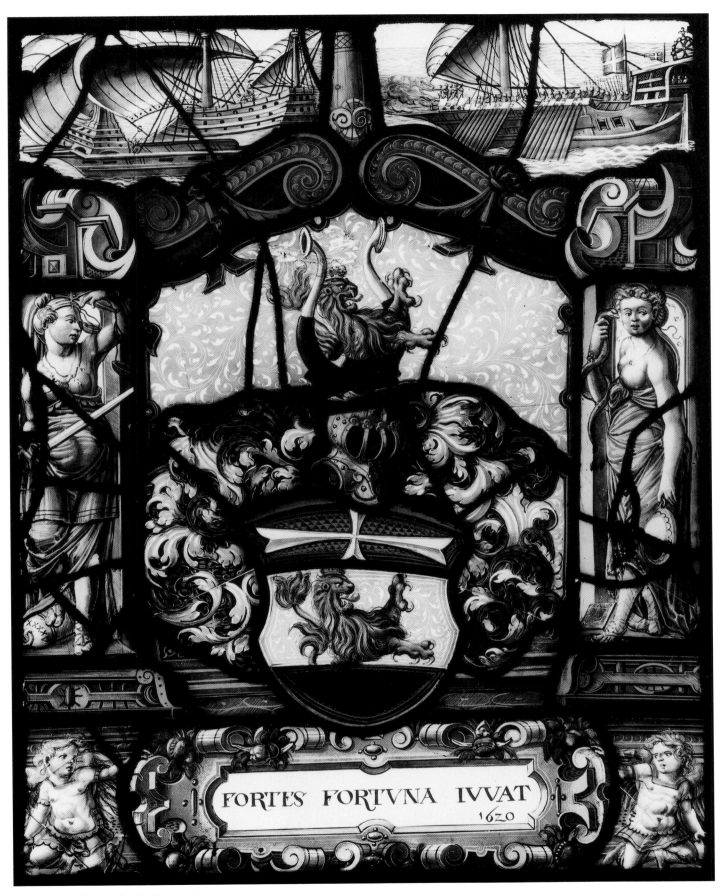

DIA 66. *Heraldic Panel with Shipping Image*

PUBLISHED SOURCES: *DIA Bulletin*, 4/7, 1923, p. 60; Raguin in *Checklist* III, p. 173.

Inscriptions: *FORTES FORTVNA IVVAT/ 1620* (replaced) (Fortune favors the strong, 1620)

Condition: Considerable repair leads diminish the impact of the composition. The inscription appears to be a palimpsest, consisting of an old piece of glass recut and painted in a seventeenth-century style. The panel was cleaned in 1988.

Heraldry: Gules on a fesse argent a demi-lion rampant contourné argent crowned or on a base sable in chief a cross moline argent; crest: on a barred helm to sinister a demi-lion rampant argent crowned or between two buffalo's horns argent and sable (unidentified)

Color: The predominantly uncolored glass is balanced by almost equal touches of the primary colors. Blue defines the drapery of the female personifications and the column separating the scenes of ships at the top. A bright warm red in the volutes of the upper part of the frame is echoed by a lighter pinkish shade below the women's feet. Yellows dominate the upper and lower sections, linked visually by the yellow details of the pilasters behind the two women.

Technique: The range of techniques are representative of the time. Pot-metal glass appears in the red, blue, and

DIA 66/fig. 1. TOBIAS STIMMER: Illustration for Daniel, *Neue künstliche Figuren biblischer Historien*, Basle, 1579

green architectural elements. The upper light blue volutes at the side are also treated with silver stain creating a color contrast with bluish-green. Enamel blue appears in the garments of the allegorical figures and sanguine for their flesh tones. All else is uncolored glass with silver stain.

Iconography: The image of the ship may indicate that the donor of the glass was a ship-owner, as was suggested in the *DIA Bulletin* when the panel first entered the museum's collection. The inclusion of allegorical figures is a common tendency in German, Alsatian, and Swiss heraldic panels. On the left Justice holds a sword and scales, and, on the right, Prudence stands with a serpent around her right arm and a looking glass in her left. These are images of long-standing tradition, going back at least as early as the c. 1210 Virtues and Vices cycle of Notre-Dame of Paris (Adolf Katzenenellenbogen, *Allegories of the Virtues and Vices in Medieval Art*, New York, 1964, pp. 75–84, fig. 73a). In addition to a sword, scales were an obligatory attribute for Justice. In the later Middle Ages, see in particular, the sculpture of Temperance in 1507 by Michel Colombe for the tomb of François II de Bretagne, cathedral of Nantes, or the woodcut of Justice with scales and sword in the early sixteenth-century *Hours of Simon Vostre* (Mâle 1908, pp. 315–74, figs. 161 and 174). The panel at the DIA is of the type frequently set in guild halls, displaying arms, the virtues that assure commercial success, and the representation of a commercial transactions, here shipping, in the upper panels.

Style: The panel shows the influence of the workshop of the Barthomäus (or Bartli) Lingg the Younger, originally from Zug (Hermann Meyer, *Die schweizerische Sitte der Fenster- und Wappenschenkung*, Frauenfeld, 1884, pp. 159–60; Thieme-Becker 23, cols. 253–4; Wyss 1968, pp. 25–44, 60–2). The glass painter learned his profession from his father of the same name active in Zug from at least 1552. Bartli the Younger appears to have left Zug to work in Zurich for a brief period, and then to have established himself in Strasbourg at least by April 1581 when his marriage is noted in the Lutheran church of St. Thomas (Wyss 1968, pp. 38, 61). Of Bartli the Younger's four sons, Lorenz, born in 1582 and Hans Conrad, born 1593, were both glass painters of whom little is recorded. Wyss surmises that Bartli Lingg's residence in Zurich probably precipitated his conversion to the Lutheran faith, which had made it difficult to return to Zug, but encouraged his establishment in Strasbourg. During his years of productivity, from 1581 until at least 1629, Lingg's was incontestably the most important workshop for glass painting in Strasbourg.

Bartli Lingg the Younger's style is close to that of Tobias Stimmer (1539–84), a highly influential designer for books, single prints, and stained glass panels (es\p. Elizabeth Landholt "Von Scheibenrissen, Kabinettscheiben und ihren

Auftraggebern," in *Stimmer*, Basle, pp. 383–498). Stimmer in the late 1560s worked for editors and printers in Zurich and Strasbourg and in 1570 settled permanently in Strasbourg. In 1579 appeared his enormously successful collaborative work with the author Johann Fischart, *Neue künstliche Figuren biblischer Historien*, published by Thoma Gwarin, Basle (*Stimmer*, Basle, pp. 187–92, no. 66). The illustration of sacred texts, or *Bilderbibel*, contained 135 Old Testament and 34 New Testament illustrations with image and text in rhymed couplets below. Both text and image are set within elaborate Renaissance frames with allegorical figures (DIA 66/fig. 1). The image of Habacuc brought by an angel to Daniel, for example, shows draped female figures with attributes of Temperance and Truth at the sides and scrolled architectural elements inhabited by a phoenix, pelican, and putti. The clarity of design, clear definition of pictorial elements, and especially the Renaissance architectural frame using allegorical figures as supporters were to have an enormous influence on Lingg and his entire generation of artists in northern Switzerland and the Upper Rhine (Wyss 1968, pp. 41–2). Lingg's sketch from 1580 copies Stimmer's sketch *Der Verleumder* (The Slanderer) of 1572. Personal contact between Bartli the Younger and the brothers Abel and Tobias Stimmer is also documented. Such use of framing devices was widespread. See for example the fragmentary panel of the Crucifixion with arms of Simon Armschwanger dated 1589 (Leo Balet, *Schwäbische Glasmalerei: Katalog der kgl. Altertümersammlung in Stuttgart*, 2, Stuttgart, 1912, pp. 120–1, no. 78).

One may compare the Detroit panel with panels from the Strasbourg area in general and with Lingg's work in particular. Two panels in the Musée de l'Oeuvre Notre-Dame, a panel of Johannes Seuppel, dated 1608, and of Zacharias Didike, of about 1600 show similar architectural framing, supporters at the sides and figures on either side of the inscription cartouche. (Dietrich Rentsch in *Die Renaissance im deutschen Südwesten* [exh. cat. Badisches Landesmuseum], Karlsruhe, 1986, I, pp. 293, 295, nos. D48 and D50; Victor Beyer, *Les Vitraux des musées de Strasbourg*, Strasbourg, 1978, pp. 53–4, nos. 112, 119). A panel dated 1599 from the Guild Hall of the Tailors' Corporation, Strasbourg, with the arms of Johann Hugwart now in Darmstadt, Hessisches Landesmuseum, shows similar use of allegorical figures (Inv. Kg 54:166: Beeh-Lustenberger 1967–73, p. 247, fig. 213).

Date: The date of 1620 in the inscription cannot be trusted because of the modern date of the segment. The style of the work is consistent with panels by Lingg. Closest, however, is the panel displaying the arms of Niklaus von Türkheim, dated about 1600 (private collection, Wyss 1968, p. 43, fig. 20).

Photographic reference: DIA Neg. no. 29203 (1985/09/05)

DIA 67. Arms of the City of Steckborn
Wolfgang Spengler (attributed to)
Southern Germany, Constance
c. 1645–84
Rectangle: 45.45 × 33.66 cm (17½ in × 13¼ in)
Accession no. 23.7, Gift of George G. Booth
Ill. nos. DIA 67, 67/a, 67/figs. 1–2

History of the glass: The panel was in the distinguished collection of Lord Sudeley, Toddington Castle, Gloucestershire until the Helbing auction of 1911. It was illustrated in the sale catalogue and attributed to Wolfgang Spengler. George G. Booth, Bloomfield Hills, purchased the panel from the dealer Theodor Fischer, Lucerne, on 18 March 1922 and presented it to the DIA in 1923. The panel was part of a lot of twelve sold to Booth (see Cranbrook Archives: Transcription of Fischer invoice and entry in George G. Booth's 1922 notebook). [Italian Galleries]

Bibliography

UNPUBLISHED SOURCES: Cranbrook Archives, notebook of George G. Booth, entry of 20/3/1922; Sibyll Kummer-Rothenhäusler of Zurich and Barbara Giesicke, letters and verbal communication.

DIA 67/a. Restoration chart

DIA 67. *Arms of the City of Steckborn*

PUBLISHED SOURCES: *Sudeley* sale 1911, p. 117, no. 177; DIA *Bulletin*, 4/7, 1923, p. 60, ill.; Schneider 1959, p. 97; Tutag and Hamilton 1987, pp. 17, 27, col. pl.; Raguin in *Checklist* III, p. 173.

Inscriptions: (Above shield) *Frid ernert/ Unfrid ver Zert* (bottom) *Die Statt Und [.]ummun/ Steckborn im Thurgaüw/ Anno 1661* (Peace renews, unrest destroys. The town and commune of Steckborn in Thurgau in the year 1661).

Condition: In the summer of 1988 the panel was restored by Mary Higgins of New York. A number of mending leads were replaced with edge-bond repairs, among them a crack through the center of the image of the town of Steckborn, several in each lion, several in the upper inscription panel, and other minor cracks in the shield. The lower half of inscription and lower segment of the right half of the shield, which were missing in the illustration of the panel in the Helbing auction catalogue (*Sudeley* sale 1911, p. 117), were renewed before 1922, very probably after contemporaneous models. The superbly executed replacement pieces in the body of the lion on the left must date from some time earlier.

Color: The overall impression of the panel is that of sharp contrasts of deep warm yellow/orange and bright blue against clear uncolored glass. The silver stain of the lions, varying from bright yellow to almost deep orange, balances the bright warm blues in the shield and the border of the cartouche showing the view of the city of Steckborn. The panel is therefore structured dynamically around the contrast of two complementary colors, orange and blue, which activates the visual plane.

Technique: No pot-metal glass is used. The blue and yellow contrasts are achieved by two hues of silver stain, sanguine, and enamel on uncolored glass. The painted mat is lifted off with a variety of means. In the body of the lions modeling is accomplished with a soft rubbing coupled with thin parallel trace lines for curves of the flesh. The technique changes to vigorous, broader strokes in the mane. The lions show slightly different types of execution, on the left with thinner and to the right with thick linear treatments. The difference may be due to execution by several painters in the same workshop, possibly different family members, as noted below in the discussion of artist and style. The city scene shows a variety of application of trace and stickwork over a tonal mat. A light to medium gray wash forms the basis of the water, relieved by very fine stick or needle work in a pattern of marks resembling straw. The lines are roughly parallel but intersect to achieve a natural, rather than mechanical impression. A darker mat outlines the hills. The most intense trace line and mat infill accent the outlines of the buildings and their shadowed areas. Sanguine is used on the roofs of the buildings to approximate the color of the tile. The meticulous delineation of subject in the cartouche makes it the object of the viewer's attention.

Heraldry: Azure impaling argent on a chief azure crossed batons piercing wreaths or repeated in both (Steckborn).

Steckborn is located on the southern shore of Lake Constance, a short distance west of Constance in the northernmost part of Switzerland. The shield of Steckborn was sometimes represented without crossed batons in the sixteenth century. See the panel of the city, dated 1543 in the city hall of Stein-am-Rhein (Inv. Nr. 30 B.M. ST, attributed to Caspar Stilhart, Constance: Dietrich Rentsch, in *Die Renaissance im deutschen Südwesten* [exh. cat., Badisches Landesmuseum], Karlsruhe, 1986, I, p. 278, no. D 33).

Style: Wolfgang Spengler was a member of a large family of glass painters extending over several generations (Thieme-Becker, 31, cols. 356–7; *Sudeley* sale 1911, p. 117; Paul Boesch, *Die alte Glasmalerei in St. Gallen; Neujahrsblatt historischen Vereins des Kantons St. Gallen*, St. Gallen, 1956, pp. 35–6; Jenny Schneider, "Konstanzer Glasmalerei im 17. Jahrhundert," *Bodenseebuch*, 37, 1960, pp. 62–6). His

DIA 67/fig. 1. WOLFGANG SPENGLER: *Arms of the City of Lucerne with the shields of the members of the City Council*, 1673. Lucerne, Historisches Museum

DIA 67/fig. 2. MARIA SALOME SPENGLER: *View of Constance*, 1684.
Zurich, Schweizerisches Landesmuseum

work, like that of most members of his family, included painted glass vessels as well as roundels and leaded glass panels. The family was centered in Constance, where Wolfgang was born in 1624 and registered as a Master Craftsman in 1645. He lived from about 1641 to 1651 in Rapperswill where he married Maria Sibylla Richenmann in 1649. He returned to Constance about 1651 and was most active for patrons in eastern Switzerland (Schneider 1970, pp. 490–1, 493). See especially a wedding panel of Sebastian Huber, signed *Wolffganng Spenngler Glasmaller von Constantz* (Schneider 1970, LM 20564, pp. 313–14, no. 601). Wolfgang was active until at least 1684, the date of a marriage panel of Freienmuth and Bürgermeister in the Zurich Landesmuseum signed with Wolfgang's monogram (Schneider 1970, LM 23500, pp. 336–7, no. 1684).

Spengler was known for his views of cities, undoubtedly taken from print sources of the day. One can compare the 1662 print of the city of Stein-am-Rhein by Johann Jakob Mentzinger showing the city with each of its houses detailed in an aerial perspective of land and water (Reinhard Frauenfelder, *Die Kunstdenkmäler des Kantons Schaffhausen. Der Bezirk Stein am Rhein*, Basle, 1958, p. 16, fig. 16). Such maps developed from the early sixteenth-century views of Renaissance cities, such as the famous watercolor by Hans Wurm of the city of Nuremberg, executed 1515–20 (Germanisches Nationalmuseum, *Nuremberg*, p. 11, fig. 1). A view particularly close to that of the Steck-

born panel is Spengler's panel of the city of Lucerne (DIA 67/fig. 1) with the shield of the members of the city council, dated 1673 (Historisches Museum of Lucerne, Hans Lehmann, *Geschichte der luzerner Glasmalerei*, Lucerne, 1941, pp. 193–4, fig. 255). The image shows the same aerial perspective and meticulous detail of surrounding landscape, streets, buildings, and ships as the Steckborn panel. A glass vessel painted in 1667 by Spengler shows a similar view of the city of Constance but surrounded by laurel branches. The vessel also displays the shield of Johann Gaudentz von Rost and is signed *W.SP. i.Cost"* (private collection, *Barock in Baden-Württemberg* [exh. cat. Badisches Landesmuseum], Karlsruhe, 1981, 1, p. 470, no. G 37). See also a beaker by Wolfgang Spengler dated 1676 and a beaker by Maria Salome Spengler dated 1689 (ibid., p. 471, nos. G38, G39). A member of the family, Maria Salome Spengler designed a panel in 1684 in the Landesmuseum, Zurich, also showing a view of Constance (DIA 67/fig. 2). The panel is signed with her monogram, and a long inscription that includes the date. She died in 1726 in Constance, but the precise relationship of Maria Salome to Wolfgang is not known (Schneider 1970, p. 490, LM 8664, 337, no. 686 and Schneider 1960, p. 66). Her work shows the use of a more pervasive mat and less closely spaced stickwork in the modeling. The detail of the water shows cross-hatching whereas Wolfgang's technique employs predominantly horizontal strokes. Although classified as a roundel, a single piece of glass painted with vitreous paint, we see an analogous conceptualization of the city perspective. Whether as a more complicated leaded panel with surrounding shields and heraldic supporters, or a single view, the image of the city was a highly desired product in the seventeenth-century glass painters' workshop. For examples of Wolfgang Spengler's work in America, although they are not city views, see two panels now in the possession of the Pierpont Morgan Library, New York (ML, unaccessioned). The *Vision of the Crucifixion with Saints and a Franciscan Donor and Arms* is dated 1670–79, and signed W. von Constanz. Another, from the same decade, *St. Catherine and Three Canonized Nuns*, is signed WSP Constanz (Husband in *Checklist* IV, p. 182).

Date: The inscription of 1661 is a replacement and although it may presumably reproduce a lost original, cannot be relied upon. Wolfgang Spengler's dates thus provide the most reliable termini: about 1645 to at least 1684.

Photographic reference: DIA 31854 (1988/11/29); before restoration DIA Neg. no. 29202 (1985/09/05)

Gresford

Ludlow Warkworth Norwich
Groton Amsterdam
Leiden
Harlow
Antwerp
Salisbury
Louvain
Doddiscombsleigh Canterbury M

Keynedon House

Soissons
Rouen
Paris Marne
Seine
Melle
Sens
Concarneau
Loire

EUROPE
Locations referred to
in this catalogue